Fellini's Films and Commercials

From Postwar to Postmodern

Frank Burke

Bristol, UK / Chicago, USA

First published in the UK in 2020 by
Intellect, The Mill, Parnall Road, Fishponds, Bristol, BS16 3JG, UK

First published in the USA in 2020 by
Intellect, The University of Chicago Press, 1427 E. 60th Street,
Chicago, IL 60637, USA

A catalogue record for this book is available from
the British Library.

Cover image: ©Elisabetta Catalano

Copy editor: Gabby Wood
Cover designer: Aleksandra Szumlas
Production manager: Jelena Stanovnik
Typesetting: Newgen

Print ISBN
Cloth 978-1-78938-220-4
Paper 978-1-78938-208-2

ePDF ISBN: 978-1-78938-210-5
ePUB ISBN: 978-1-78938-209-9

Printed and bound by Gomer, UK.

To find out about all our publications, please visit
www.intellectbooks.com.
There, you can subscribe to our e-newsletter,
browse or download our current catalogue,
and buy any titles that are in print.

Part of the Trajectories in Italian Cinema and Media series.
Series editor: Flavia Laviosa
Print ISSN 2632-487 | Online ISSN 2632-488

To Tyler, Wylie, Gabe, Margie, and Bill

Contents

Preface to the 2020 Edition

The centennial of Fellini's birth, 2020, has served as the catalyst for an updated edition of this study, which was first published in 1996 but received limited promotion and distribution.[1] Intellect and I believe the work is historically important, engaging as it did with Fellini's relations to modernism and postmodernism—an issue unaddressed at the time, particularly in a book-length study. I also believe that the readings and approach of the original remain valid today.

For these reasons, changes to the original have been limited. Errors have been corrected, stylistic infelicities diminished, and arguments sharpened. But for the most part, the theoretical approach and the readings have been maintained. Original references have been kept with some updating in the endnotes. The original Selective Bibliography has been replaced with Works Cited.

Nonetheless, there have been several important additions and changes beyond the merely "technical":

— A new chapter on Fellini's commercials, based on my 2011 essay "Fellini's commercials: Biting the hand that feeds" in *The Italianist* (31: 205–42).
— A reworking of the analyses of *City of Women* in chapters 9 and 12, in light of continuing undervaluation of the complexity of Fellini's representation of masculinity and gender.[2]
— A discussion, in chapter 12, of "whiteness" in Fellini, inspired by postcolonial scholar Shelleen Greene.[3] A consideration of race and racialization seems a crucial component of Fellini's relation to the political, especially given issues of national identity and immigration that were reaching a flash point toward the end of his career.
— Some selective updating of references to include, for example, Fellini's *Il libro dei sogni/The Book of Dreams*.
— The elimination of certain judgmental statements about Fellini's work.

In terms of the last, as I explain in greater detail in the volume, the first edition was written amidst a rather shocking dismissal of Fellini on the part of the

academic film studies community in the English-speaking world, after he had played a crucial role in the emergence of film studies, often in English departments, in conjunction with the rise of auteurism and the valorization of the international art film. The shift away from Fellini's work was largely the result of the importation of post-1968 cultural and political theory into film studies. I set myself the task of trying to create a bridge between the enthusiastic acceptance of Fellini's work within Italian cinema studies and the larger, unappreciative, film studies community. I sought to demonstrate that, read with attention and openness, his work—especially from the 1970s on—was consistent with, even ahead of, the kinds of post-1968 theorizations that film studies academics were inclined to employ. As part of my bridging work, I was inclined to acknowledge certain "limitations" to Fellini's representations, based on what I assumed to be the reasons for Fellini's academic neglect. The moment of hyper-politicization in film studies has passed, and though the passing has not brought with it a major rediscovery of Fellini, I no longer feel that I am writing in the shadow of systemic exclusion. More important, my assessments of Fellini's "limitations" were never consistent with my own responses to Fellini; they were strategic, and I came to regret them.

My study of Fellini reflects a general movement in film studies from a traditionally humanist and philological approach, with an attention to close reading inspired by the postwar New Criticism, to poststructuralist, "deconstructive" approaches. In both its more traditional and poststructural forms, my analysis has been meaning-centered: seeking "the" meaning of Fellini's early films but then recognizing the contested and multivalent nature of meaning in, and with the help of, his later work. We are now witnessing a powerful "post-semantic" approach to Fellini, highlighted in Wiley Blackwell's *A Companion to Federico Fellini* (2020) that I have edited with Marguerite Waller and Marita Gubareva.[4] A significant number of essays address a new, largely phenomenological, approach to Fellini that considers his work in terms not of interpretation but of intensity, hapticity, liquidity, and the sensorimotor effects of his work, wherein lies so much of his appeal with a global public.

Because the *Companion* fulfills the task of both pushing existing approaches to Fellini in new directions and redefining the field in new ways, I have felt comfortable revising and strengthening this volume instead of attempting to transform it into something different.

Since my 1996 volume was published, two major Fellini documents have appeared: his *Il libro dei sogni/The Book of Dreams*[5] and the screenplay of the never produced "The Journey of G. Mastorna."[6] Because my study focuses on Fellini's audiovisual work, extensive analysis of these two works would be out of place. The appearance of neither alters my analyses of the audiovisual work, and, as I note in discussing Fellini's Banca di Roma "dream" commercials, critical

examination of the sketches and commentaries in *The Book of Dreams* would require a very different methodology from that required by what are, above all else, moving-image and sound narratives.[7]

In terms of methodology—both mine and Fellini's—I feel a strong sense of serendipity in being able to conclude my most intensive textual analyses with Fellini's commercials. At the outset of his cinematic career, Fellini was a screenwriter, and, as recent scholarship has revealed, he was meticulous in that work. Vincenzo Mollica in particular emphasizes his scrupulous preparations for everything—even interviews.[8] Despite the myth that Fellini was an inveterate improviser, his early films tended to be carefully scripted. Early in his career, he also had a clear interest in psychological processes, which culminated in his study of Jung and Jungian notions of individuation in the 1960s. Part of my attraction to Fellini was the fact that, at the same time I encountered Fellini, I was heavily invested in "process philosophy"—the work of Alfred North Whitehead—and in Jungian psychology. That plus my training in the close reading methods of the New Criticism inclined me to approach Fellini's films as coherent, readable processes. As Fellini's career developed and his films became more episodic and fragmentary (perhaps a reassertion of his origins as a cartoonist) an insistent "process" approach was no longer adequate. Both Fellini's films and a changing theoretical climate marked by strategies such as "deconstruction" required methods that emphasized disjunction, rupture, and contradiction or repeated qualification for approaching all his films from *La Dolce Vita* to *The Voice of the Moon*.

With the commercials, however, Fellini returns to "readable" stories. Each one is, in a sense, an extended narrative cartoon, with a tight structure. Every second counts—partly because Fellini is trying to get something across to the viewer: presumably a sponsor's message, but as we shall see in chapter 11, something much different from mere brand marketing. Close "process," reading is again warranted. Such analysis reveals the meticulousness of Fellini's imagination—his ability intuitively, not rationally (no one could figure this all out step by step), to generate condensed but intricate and highly nuanced meanings. A return to close reading, particularly in the context of such complex texts, also taught me something crucial. I had begun my career doing *explication de texte* that I thought would lead me to "the truth" about certain texts, authors, etc. (I have always seen the New Criticism, regardless of the attitudes of some of its practitioners, as part of an emerging scientific spirit in the postwar—an attempt to establish more "rational" grounds upon which to found arguments and justify conclusions.) Close reading of the commercials, however, revealed that Fellini's work is not susceptible to definitive interpretations. This is consistent with a progressive multivalence in his film texts over the course of his career—and with the illimitable interpretive possibilities of his sketches and commentaries from *The Book of Dreams*. In addressing

the commercials, I settled on certain readings, not to the exclusion of others, but merely to model one possibility amidst many. I was repeatedly forced to admit to myself, "oh, but one could also say…"

That confirmed for me the excitement of close reading—something I always felt despite misguided assumptions in my New Criticism days. It came not from nailing down texts, but from opening them out to the infinite possibilities of reading, thinking, rethinking, and exploring—of examining not only the words, images, and issues within a particular text but my own mental habits and modes of processing them. Close reading led me not to mastery but humility, and though it is certainly not the only method for approaching cultural and other texts, I do not think it is deserving of the dismissal it has often suffered in an age in which theory is so often imposed upon and replaces the texts it is supposed to illuminate.

The most chastening implication of what I have just said is that nothing I have written in the original or revised edition of this book is anything more than pro-visional. Were I to return to any of the works I have discussed in this volume, I would have to admit to myself "oh, but I could also say …"

I thus offer what follows as incentive for dialogue and for keeping Fellini in dynamic play as we celebrate his centenary and, ideally, renewed appreci-ation of his work. I hope it impels people to re-engage with his oeuvre and enjoy what has been my experience of Fellini: an encounter with an infectious, centri-fugal, and (despite claims to the contrary) honest imagination struggling with crucial issues in complex ways that promote sincere engagement, reject facile solutions, and challenge the viewer to carry the struggle—profoundly articulated and contextualized—forward.

NOTES

1. The 1996 edition was reviewed positively and named a *Choice* Academic Book of the Year, but the Macmillan Reference Library, to which the book belonged, was sold shortly after the book's publication. After the sale, the film directors series of which the book was a part was cancelled, and the book quickly went out of print. I have met numerous people familiar with Fellini's work and Fellini criticism who did not even know it existed.

2. My thanks to Marguerite Waller for her input as I was rethinking *City of Women*.

3. "Racial Difference and the Postcolonial Imaginary in the Films of Federico Fellini," in *A Companion to Federico Fellini*, 331–46 (Chichester, UK: John Wiley & Sons, 2020).

4. Chichester, UK: John Wiley & Sons, 2020.

5. Federico Fellini. *Il libro dei sogni*, ed. Tullio Kezich and Vittorio Boarini with a contribution by Vincenzo Mollica (Milan: Rizzoli, 2007), and *Federico Fellini: The Book of Dreams*, trans. Aaron Maines and David Stanton (New York: Rizzoli, 2008).

6. Federico Fellini, *Il viaggio di G. Mastorna*, ed. Ermanno Cavazzoni, intro. Vincenzo Mollica (Macerata, Italy: Quodlibet, 2008), and *The Journey of G. Mastorna: The Film Fellini Didn't Make*, trans. Marcus Perryman. (New York: Berghahn, 2013).

7. Two books have appeared in recent years that might initially seem relevant to my work. András Bálint Kovács's *Screening Modernism: European Art Cinema, 1950–1980* (Chicago: University of Chicago Press, 2007) addresses a number of matters that I address in this book, including the birth and death of the auteur and a certain kind of romantic modernism. However, there is very little mention of Fellini and little attention to how his work (apart from *8½*) forms an important part of the modernist cinematic landscape. In addition, Kovacs's context for his discussion of modernism is exclusively European, whereas mine, though embracing European modernism, includes North America as a major site of Fellini's international success. As I note in chapter 12, Andrea Minuz's *Political Fellini: Journey to the End of Italy* (New York: Berghahn, 2015) has a sense of politics very different from mine and from what I consider to be "political Fellini."

8. See "Fellini the Artist and the Man: An Interview with Vincenzo Mollica," in *A Companion to Federico Fellini*, 13–26. Fellini even, in effect, "edited" a television news report Mollica was preparing—paring it to the precise minimum. See also Giaime Alonge's "Ennio, Tullio, and the Others: Fellini and His Screenwriters" in the same volume (165–76) for a discussion of Fellini's screenwriting work.

Acknowledgments for the 2020 Edition

I owe enormous thanks to Flavia Laviosa, editor of Intellect's *Trajectories of Italian Cinema and Media Studies* series, for proposing publication of this revised edition of my 1996 *Fellini's Films: From Postwar to Postmodern*. She has been a great supporter of Fellini studies in her work as editor of the *Journal of Italian Cinema and Media Studies* and in her organization of conferences related to the journal. It is a great honor to have her support.

Jelena Stanovnik, my Intellect Project Development Manager, has been a joy to work with. Sometimes I feel like Fellini in his relations with producers—single-minded, stubborn, and self-centered—when I am broaching various things with her. But she never makes me feel that way and is always surpassingly patient and generous.

I am greatly indebted to all the contributors to the Wiley Blackwell *A Companion to Federico Fellini*, which will appear more or less at the same time as this volume. Their new and exciting work on Fellini has given me great energy and numerous new perspectives for this update of my 1996 study.

Infinite thanks to my partner in Fellini crime and not only, Margie Waller. She is a constant source of illumination, elevation, and spirited reinforcement in the joy of Fellinifying.

Needless to say, my acknowledgments for the first edition of this book are still very much in order. Permissions cited there have been obtained anew.

Preface to the 1996 Edition

Federico Fellini would seem to need little by way of introduction. He may be the best known of the postwar Italian directors, and he is among the most acclaimed filmmakers in the history of the medium. In 1980 Harry Reasoner claimed on CBS's 60 Minutes that Fellini was "maybe the premier filmmaker of the age"—a pronouncement that may seem a bit exaggerated from the perspective of the 1990s but that also suggests the role Fellini played in international cinema from 1954 (La Strada) to at least 1973 (Amarcord). He was awarded five Oscars, and though his popularity declined through the 1980s and early 1990s, his final Oscar was the 1993 lifetime achievement award of the Academy of Motion Picture Arts and Sciences. He received a similar award at the Cannes Film Festival as early as 1974, as well as the outstanding cinematic achievement award of the Film Society of Lincoln Center (New York City) in 1985.

Perhaps more important, Fellini's work continues to be a significant influence on the contemporary filmmaking scene. In 1992 Sight and Sound asked international film critics and filmmakers to rank their favorite directors, and though Fellini did not make the critics' top 10 list, he was the top choice among the filmmakers surveyed. As Geoffrey Nowell-Smith put it in a subsequent issue of Sight and Sound, "The word is out. Federico Fellini is the directors' director par excellence."[1] Fellini's continued importance to contemporary filmmakers shows his, posthumous influence on contemporary visual culture.

This study is an amalgamation of my 1984 text for Twayne—Federico Fellini: From "Variety Lights" to "La Dolce Vita"—and a new manuscript, analyzing Fellini's work from 8½ (1963) through his final film, La voce della luna (1990; The Voice of the Moon). The first study was conceived in the shadow of the international art film movement, in which the Italian director held the status (along with Ingmar Bergman, Akira Kurosawa, Michelangelo Antonioni, Alain Resnais, Satyajit Ray, Jean-Luc Godard, and others) of a great "auteur," a filmmaker who helped elevate cinema to an art form. The earlier study suffered, I feel, from excessive reverence for Il Maestro or Il Poeta, as he came to be called in and beyond Italy. Coupled with this, the first study, in addressing certain themes such as

individuation in Fellini's work, treated them as though they were objectively valid, rather than the products of a specific cultural context within which Fellini was working. By "individuation" I am referring partly to the notion, popularized by Carl Jung and his followers and embraced by Fellini both in and outside his films, that the goal of life is to become a whole and fully individualized human being. However, I also refer more broadly to an emphasis on the individual that is part of a longstanding Western and American ideological tradition.

Hindsight, post-1968 cultural theory, and Fellini's own later work have altered my perspective. In amalgamating my earlier study, I have sought to rid auteurism of its reverential aspect and situate Fellini's individualist emphasis culturally and historically. I still think the analyses of the early films remain valid (for example, individualism-versus-conformity was, I still believe, a thematic cornerstone), but I now treat them in terms of postwar Western individualism and, more specifically, an evolving cold war rhetoric of individual freedom versus totalitarianism. I have sought to establish this context in my opening chapter and later in the study, while leaving the individual film analyses pretty much as they initially appeared. By sticking with the original analyses, I am able to use them as foils for Fellini's later work, which becomes a sustained questioning of the values his earlier films affirmed.

In keeping the early more humanist readings of Fellini intact—and in fact building my initial discussions of 8½, *Giulietta degli spiriti (1965; Juliet of the Spirits),* and *Toby Dammit* (1968) upon them—I risk losing the post-humanist (as well, perhaps, as the feminist) reader and critic who does not await the moments of deconstruction and revaluation provided both by Fellini's later work and my own rereading of crucial issues in Chapters 6–12. To that reader/critic, I address the immortal words of Yogi Berra, "It ain't over till it's over," requesting a willing suspension of disbelief until my later analyses rewrite or at least contextualize the earlier discussions.

It might strike the reader as ironic that, while acknowledging the limits of auteurism, I remain engaged in a heavily author-centered enterprise. The pragmatic justification is that I am writing for a series that is itself author-centered. A more academically relevant justification is that Fellini's own films, particularly from 8½ on, critique many of the underlying assumptions of auteurism.[2] The most significant justification for me lies in certain implications of "death-of-the-author" theorizing. A central tenet of the theory (which I explore in more detail in Chapter 1) is that a filmmaker—or for that matter any artist—is not a free creative genius but a product of his or her social environment. If this is the case, then it seems to me that the work of a filmmaker/artist is an ideal place to locate social significance, particularly if—as happened with Fellini—that figure has captured significant public attention. This is all the more the case in a society that markets

individuals by turning them into cultural icons (Fellini again is a major case in point). In this respect, the study of Fellini becomes useful not as a tribute to a Great Artist, but as the analysis of particular cultural issues in postwar Western culture. In short, the implications of death-of-the-author theory point not to the elimination of all author-centered criticism but to its reorientation. Accordingly, it is my intent in this study to exceed and at times subvert the myth of Fellini as a self-determining author, indicating pressures within his work of which he is clearly unaware and offering interpretations of his work that occasionally contradict his own published statements.

Although the notion of art has come under attack in post-1960s theory, especially when it is treated as a privileged or "authentic" form of cultural expression and contrasted with mass culture, I have not eliminated the term from my vocabulary. For one thing, as should already be clear, I do not see art as "pure," superior, or beyond cultural determination. For another, I think important distinctions continue to exist between art and popular culture in terms of modes of production, funding, distribution, advertising, exhibition, popular press criticism, academic legitimation, and reception. In other words, the distinction between art and popular culture, while not a "natural" one (between "good" and "bad," high and low), is a culturally constructed one whose persistence requires that it continue to be addressed rather than denied. Fellini films, for the most part, conform to cultural codes of art, and Fellini himself, despite his origins as a caricaturist and cartoonist, to cultural codes of "the artist." Finally, and in light of the preceding points, it is simpler and more colloquial to use the term "art" rather than the more precise and appropriate term "cultural production." When overused, the latter quickly takes on the character of jargon, so I have restricted its use to situations in which I am referring to multiple forms of cultural expression.

To a large extent, my study emphasizes the relationship of Fellini to international—and often American—influences rather than locating him principally within Italian culture. This is partly because this study was written for an English-speaking and, for the most part, North American audience. But more important, it is because the Fellini that North America has encountered has been as much an international as a purely Italian figure: the product, as I argue shortly, of global as well as specifically Italian forces.

Finally, because this is a study of Fellini's work rather than his life, and because there are already three extensive biographies in English,[3] I refer to Fellini's personal experiences only when they have had direct analytical relevance to his work.

NOTES
1. Geoffrey Nowell-Smith, *Sight and Sound*, April 1993, 12.

2. See my "Fellini: Changing the Subject," *Film Quarterly* 43, no. 1 (Fall 1989): 36–48; reprinted in *Perspectives on Federico Fellini,* ed. Peter Bondanella and Cristina Degli-Esposti (New York: G.K. Hall, 1993), 275–92.

3. Hollis Alpert, *Fellini: A Life* (New York: Atheneum, 1986), and John Baxter, *Fellini* (London: Fourth Estate, 1993); both hereafter cited in text. There is also a fine Italian biography now available in English by Tullio Kezich, *Fellini: His Life and Work*, trans. Minna Proctor (New York: Faber and Faber, 2006).

Acknowledgments for the 1996 Edition

My thanks are due first of all to those who made Fellini's films available to me at the outset of this project, more than 20 years ago, when I was still in the United States: Myron Bresnick (Audio Brandon), Saul Turell (Janus Films), and Doug Brooker (when he was with IFD). I have received assistance far beyond the call of duty from media specialists Paul Owen at the University of Kentucky and Nancy Lane and Irene Thain at the University of Manitoba. I have also been generously funded by the University of Manitoba, the Queen's University Advisory Research Committee, and the Social Sciences and Humanities Research Council of Canada.

I am grateful to the Canadian Academic Center in Italy (especially Amilcare and Susan Ianucci and Egmont Lee) for providing facilities, assistance, and support—as well as guidance in acclimating myself to Rome. Thanks as well to Gilbert Reid of the Canadian Cultural Center in Rome. I owe a great deal to the hugely supportive environment of the Queens University Department of Film Studies: Jill, Peter, Blaine, Derek, and Clarke. They have allowed me to continue teaching courses in Fellini and postmodernity—in the hope, I assume, that I will finally get it right. A major thank-you to film studies student Barry Yuen for giving me access to *The Voice of the Moon*.

Some of the material in this volume has appeared in *Literature/ Film Quarterly, Film Criticism, Romance Languages Annual, Film Studies: Proceedings of the Fifth Annual Purdue University Conference on Film, Film Studies: Proceedings of the Sixth Annual Purdue University Conference on Film,* and *Film Quarterly* (vol. 43, no. 1, © 1989, the Regents of the University of California). I thank the periodicals for permission to use the material here.

I thank Bill Robinson, who introduced me to movies and to a method of watching them that I still employ. Professionally, for me, it all began with him. I thank Warren French for his moral support, friendship, and editorial advice. He brought me on board the Twayne series and made this project possible. Dick Sugg, Steven Snyder, and Armando Prats have, at early stages of my work on Fellini, provided invaluable input. Ben Lawton, Peter Bondanella, and Millicent (Penny to her

friends) Marcus have been there for two decades, helping me conceptualize Fellini, and, in Peter's case, generously sharing rare and invaluable research materials.

Thanks to all those currently involved in the Twayne series—Mark Zadrozny, Patricia Mulrane, Frank Beaver, Karen Day, and Barbara Sutton—for their patience and support. And thank you as well to Marguerite Waller and Annette Burfoot for feedback on various stages of the manuscript.

This study owes a special debt to Walt Foreman. He and I have talked Fellini for years, and at one point he was to author part of the text. Circumstances made that impossible, but his involvement in the project kept it alive while all else seemed to conspire against its reaching completion. His contributions to some of the film analyses are specifically acknowledged, but the more profound contribution of his long-term involvement requires its own, inevitably inadequate, acknowledgment.

1

Fellini in Context

This study addresses two persistent "narratives" operating throughout Fellini's career. The first, which is largely thematic, is the rise and fall of individualism. The second, which is initially aesthetic (though with crucial cultural implications), is the movement from a relatively realist cinema, generally concealing the act of filmmaking itself, to a highly self-conscious examination of cinematic and narrative technique. This self-reflexive phase has a movement of its own: from an exploration of principally cinematic representation to a questioning of the underlying conditions of representation and meaning themselves. At this point it becomes epistemological, ontological, and semiotic as well as aesthetic, though Fellini's focus on fantasy and imagination has always involved all four.

The fall of individualism is, interestingly, linked to the trajectory of Fellini's critical reputation. In a 1950s and 1960s ideological climate of heightened individualism, in which artists were marketed as cultural heroes and film was elevated to an art form, Fellini became, as Joseph McBride put it, the "director as superstar," for academics as well as the public.[1] More recently, however, in a cultural and theoretical climate that has come to deny the autonomy of the individual, as well as the artwork, the concept of the modern artist-as-romantic-hero was debunked, and Fellini became viewed as an egoistic anachronism. To a large extent, of course, his image as superstar persisted in the popular press and imagination, and, as I note in the Preface, his work has continued to be highly respected among filmmakers. Having been a favorite among many (largely literary) academics in the 1960s, however, he became an outcast among film academics of the 1970s and 1980s, most of whom were schooled in the highly politicized theories that emerged from Europe in the wake of the revolutionary activity of the 1960s, and particularly May 1968 in France.

I address Fellini's critical reputation more extensively, in relation to issues of politics and gender, in the concluding chapter. Here I seek to establish the cinematic and cultural background of Fellini's work in relation to the two aforementioned

"narratives," so that my close readings of his films have a historical—as well as an aesthetic— context.

Neorealism

Fellini's predirectorial schooling in film consisted largely of his collaboration with Roberto Rossellini, particularly in scripting *Roma città aperta* (1945; *Rome Open City)*,[2] in scripting and directing parts of *Paisà* (1946; *Paisan)*, and in scripting and acting in *Il miracolo* (1947; *The Miracle*). That collaboration, in turn, made Fellini a significant figure in the movement that has come to be called "Italian neorealism" and that comprises films made by directors such as Rossellini, Luchino Visconti, and Vittorio De Sica roughly between the years 1943 and 1951.

Defining neorealism is not a simple matter. There is a substantial gap between the theories of Cesare Zavattini, the movement's foremost apologist, and the films themselves, many of which included Zavattini's involvement. The difference lies in the way in which realism is addressed. In many of Zavattini's writings realism entailed an extremely objective, reportorial method—one that approached the pure recording of reality without formative intrusion on the part of the director.[3] Yet all the major neorealist films were, in large part, fictional: clearly the result of directorial shaping rather than mere mechanical replication. Recognizing this, scholars began to emphasize the fabricated, staged aspects of neorealist film as well as its documentary realism. They also started to point out how often neorealist filmmakers drew attention to the filmic and fictional nature of their work.[4] It has become clear that neorealism—in practice as opposed to theory—was not an attempt to deny the role of the artist. It was an attempt to redefine the task of film through reconnection with the quotidian and concrete.

With the preceding as needed qualification, we can posit the following general goals of neorealist filmmaking: (1) to counteract the kind of illusions promulgated by Italian films of the 1930s and 1940s (both the "White Telephone" escapist comedies that centered on the monied classes and were shot in highly artificial studio surroundings, and the regime-positive films of the Mussolini regime); (2) to reveal the social and economic conditions of postwar Italy (leftist in spirit, neorealism sought to redirect Italian consciousness from bourgeois ideals to proletarian reality); (3) to awaken a new sense of human solidarity following the oppression and fragmentation of the Fascist period; and (4) to develop a new sense of national cinematic identity, freed of dependence on Hollywood for either technique or romantic subject matter.

These goals implied certain methodological and technical choices, implemented with varying rigor depending on the filmmaker and the film. Common within

2

neorealist films were (1) a documentary openness toward life, designed to expose both artist and audience to what is there in the "real" world and to destroy bourgeois preconceptions; (2) a privileging of "fact" or at least "reconstituted fact" over make believe; (3) the use of real locations rather than sets; laborers and peasants rather than professional actors; (4) an emphasis on the commonplace and the common man over the exceptional; and (5) the use of mise-en-scène over montage to preserve the integrity of reality and minimize its manipulation.

Fellini's films clearly share neorealism's opposition to bourgeois illusion, escapism, preconception, and the kind of authoritarianism associated with Fascism. (*Lo sciecco bianco* [1952; *The White Sheik*] is almost a textbook study of these problems.) His early films also share a relatively realist aesthetic, and through much of his career Fellini cast his films principally with nonprofessionals: he'd place an ad in the newspaper saying that he was making a new film and would then choose among the hundreds upon hundreds of people who would show up to audition. Despite Fellini's casting techniques, however, the social milieu he represents (with some important exceptions, such as *La Strada* [1953]) is far more bourgeois than working or peasant class. Moreover, his later films emphasize imagination or fantasy far more than reality, and his growing insistence on shooting in the studio rather than on location subjects him to the charges of escapism and artifice levied against earlier Italian films. The eventual gap between traditional neorealism and Fellini's work is suggested by the late Italian filmmaker, writer, and theorist Pier Paolo Pasolini when he quite rightly associates Fellini's work with "the great productions of European decadence" rather than with a neorealist heritage.[5]

In fact, in matters of emphasis, subject matter, and method, Fellini and the neorealists ultimately seem to diverge almost to the point of radical opposition. There are, however, points of underlying kinship. Both were vitally concerned with the transformation of consciousness. The neorealists sought to bring it about by showing the negative consequences of war. Fascism, and bourgeois ideology and assuming the audience would be enlightened by what it saw. Fellini, particularly from *Le notti di Cabiria (1957; Nights of Cabiria)* through *Toby Dammit* (1968) sought to offer narrative models of transformation, rooted in the experience and imaginative growth of individual characters. Like the neorealists, Fellini was passionately dedicated to human solidarity. Many of his films are "love stories" in the broad sense of advocating such solidarity. In speaking of *La Strada*, he has described his concern with community and brotherhood in a way that applies not only to the story of Gelsomina and Zampanò but to nearly all his work: "Our trouble, as modern men, is loneliness, and this begins in the very depths of our being ... Only between man and man, I think, can this solitude be broken, only through individual people can a kind of message be passed, making

them understand—almost discover—the profound link between one person and the next."[6]

Fellini was motivated by the same quest for openness that lies at the heart of neorealism. Zavattini has identified this quest in words that seem to undercut or at least qualify his insistence on objectivity: "to exercize our poetic talents ... we must leave our rooms and go, in mind and body, out to meet other people ... This is a genuine moral necessity" (Zavattini, 220). And Fellini, in his oft-quoted description of neorealism, has pinpointed openness as the defining characteristic of the movement: "For me neorealism is a way of living without prejudice and a means of liberating oneself completely from bias; in short, a way of facing reality without preconceived ideas."[7] This need to be free of prejudice, of fixed ideas and categories, of habits that blind one to the world, is in the largest sense a desire for renewed vision, recovered authenticity. It is here perhaps more than anywhere that Fellini and neorealism most fully converge. Each was engaged in a revolution against disabling tradition, institutionalization, and false consciousness. Fellini, in addressing this aspect of his work, could well be speaking for any neorealist filmmaker in the 1940s: "Doubtless a motif returns incessantly in my films, and it is the attempt to create an emancipation from conventional schemes ...; that is to say the attempt to retrieve an authenticity of life rhythms, of life modes, of vital cadences, which is opposed to an inauthentic form of life. There, I believe, is the idea that is found in all my films."[8]

Postwar individualism, American influence, and neorealism revisited

While neorealism may have been Fellini's postwar cinematic context, individualism was the prevailing ideological current as he emerged as a scriptwriter and director. Individualism, of course, has a long history in Western culture. In the last 200 years, however, it has become synonymous with American ideology, and Fellini was heavily influenced in his youth by the American popular culture promise of individual freedom, "In the world of Fascism, Fred Astaire and Ginger Rogers showed us that another life was possible, at least in America, that land of unimaginable freedom and opportunity. It is not possible to put into words what Hollywood meant in the life of a little boy in Rimini." And, "The individual was everything in American stories. I could identify with that. I *wanted* to identify with that."[9]

American influence acquired a dramatic intensity and immediacy during Fellini's young adulthood, with the role the United States played in the liberation of Italy. (One of Fellini's earliest sources of income came from drawing caricatures for American G.I.s in the Rome of 1944.) American individualism, in turn,

enjoyed a huge postwar boom amid the anti-collectivist reaction to Nazism and Fascism. This quickly evolved into the ideology of the Cold War, as American-style "freedom" was insistently championed over and against "communist repression," while all forms of communism were collapsed into conformist totalitarianism.[10] American ideology was further fueled in the late 1940s and 1950s by American economic and political intervention in Italy, largely via the Marshall Plan, which provided economic aid for postwar reconstruction. The United States also intervened directly, with money and rhetoric, to affect the outcome of the 1948 Italian elections, which brought the pro-U.S. Christian Democrats to power.[11]

Within the larger context of Western and American ideology, Fellini fashioned his own brand of individualism as an anti-authoritarian response to his Fascist and Catholic upbringing. In interviews and written statements, he repeatedly attacked dogma or abstraction and championed individual perception and experience. His abhorrence of dogma applied not only to the excesses of his political and religious upbringing in 1930s Italy but also to the responses of Italian Marxist critics to neorealism and his own departure from it in the 1950s. In fact, 1950s Marxist dogmatism made it easy for him to lump leftist radical thought with extreme authoritarianism, just as the United States conflated all communist thought with totalitarianism. At the same time, his linking of Fascist oppression with Marxist intolerance created a lifelong suspicion of politics itself, which he tended to equate with abstract and blinkered thought and, concomitantly, with demagogues and ideologues.

Though Fellini abhorred Catholic dogmatism, this did not prevent him from fusing individualism in his early work with a secularized form of Christian humanism: a belief in the "salvation" of the individual via psychological individuation. The road to salvation was not the Way of the Cross but the evolution of consciousness from the unconscious and the integration of all the fragmented and repressed aspects of the individual psyche. Fellini became quite taken with the teachings of Carl Jung, the psychologist who developed a psychospiritual theory of individuation, though it appears that Fellini had begun to articulate human development in Jung-like terms before his direct encounter with Jung's work. Fellini's interest in the psychospiritual dovetailed perfectly with the expanded consciousness movements of the 1960s: a utopic intermingling of drug culture, Eastern mysticism, cybernetics, and techno-avid futurism. It is safe to say that the international notoriety of films such as *8½* (1963), *Giulietta degli Spiriti (1965; Juliet of the Spirits)*, and *Fellini-Satyricon* (1969) derived at least in part from a larger cultural climate predisposed toward head-tripping and the suprarational.

Fellini's fusion of American-style individualism and (veiled) Christian humanism is not far removed from the ideology of the Christian Democrats, the Italian

conservative party that came to power with American economic and political assistance in 1948 and remained there virtually throughout Fellini's filmmaking career. Though Fellini never claimed any political allegiance or took a specifically political position against communism or socialism (despite his frustration with Marxist intolerance); though he formed friendships with major figures across the political spectrum; and though, he came to be embraced by the Left intelligentsia in Italy, his values were closer to those preached (but often betrayed) by the Christian Democrats than to those of a militant Italian Left.

Fellini's Christian/American ideology would seem to accentuate even more the gap between his work and neorealism, given not only the latter's leftward leanings but its disavowal of classic Hollywood cinema. Yet Fellini's mentor, Rossellini, arguably the most influential of the neorealists, was himself a Christian humanist, and we might well suspect the highly sentimental Vittorio De Sica— *Ladri di Biciclette* (1949; *Bicycle Thieves*); *Sciuscì* (1946; *Shoeshine*), *Umberto D.* (1952)—of the same. Moreover, as Peter Bondanella has demonstrated in detail, Italian neorealism often worked *with* rather than *against* codes of Hollywood cinema. Bondanella demonstrates how films such as *Paisan, Senza Pietà* (Alberto Lattuada, 1948; *Without Pity*), and *Il Cammino della Speranza* (Pietro Germi, 1950; *The Path of Hope*), all of which Fellini contributed to, were highly indebted to America and American cinema.[12]

In addition, and particularly relevant to (American) individualism, while neorealist films emphasized socioeconomic environment, they also emphasized the effects of that environment on sharply defined protagonists with whom the audience could readily identify. In this respect neorealism never became, like the films of revolutionary Russia, a cinema that focused consistently on groups of workers or the peasantry.

High modernism, American ideology, and the art film

Fellini's individualism dovetailed with three major movements in the arts and in film in the 1950s and 1960s: high modernism, the art film, and auteurism. All three were interrelated, and all three were fundamental to Fellini's international success.

In one sense high modernism refers to the alignment of modern art with high (versus popular) culture and can thus be applied to certain implications and uses of modern art from the mid-nineteenth century to the present. In another sense, the term refers to the role that modern art came to play in the postwar period, partly in conjunction with U.S. interests and with certain assumptions about art that helped define its role. The second sense of the term flows from the first, but I am using the latter in relation to Fellini.

Serge Guilbaut details how, in the wake of World War II, capital-C Culture became an extension of the Marshall Plan, which was designed not only to assist in reconstruction but to ensure the development of American markets and investment opportunities, consonant with the huge production capacity American industry had developed during the war. American expansion required not only money but the infusion of American ideology to ensure that European countries "bought" America, literally and figuratively. "Improving the cultural image of the United States was identified in 1948 as the most important goal for American propaganda" (Guilbaut, 193).

A principal strategy became the promotion of abstract expressionism as a symbol of American creativity and initiative. In effect, American ideology enlisted high art and, equally important, the cult of the artist, as symbols of American individualism and freedom of thought and as propaganda against totalitarianism, conformity, the "red menace," and so forth. (Part of the Marshall Plan's purpose, of course, was to prevent European countries—and Italy was crucial in this respect—from moving toward communism.) This cultural strategy accelerated in the 1950s,[13] precisely when Fellini began to emerge as an internationally respected artist, in part through the favorable reception of his work in the United States.[14]

The American turn to high art and the artist as symbols of democracy was part of the terrain on which the art film movement was formed. Another part was widespread postwar American movie interests overseas. American film, far more than abstract expressionism, served as a vital national tool for self-promotion: "As Allied troops liberated Europe, American motion pictures followed in their path, with exhibition arranged by the Bureau of Psychological Warfare ... The propaganda value of such pictures was clearly recognized ... [and t]he cold war reinforced this ... The exportation of American media materials was deemed essential to the government's effort because they favorably depicted the American system."[15] The period of massive export was brief, because European countries quickly sought to impose restrictions on American films for both economic and cultural reasons. In particular, they froze American earnings within their borders. However, this intensified Hollywood overseas involvement in ways that helped create an economic base for the art film. Unable to repatriate earnings, Americans reinvested in foreign films. More than that, American subsidiaries sought and received foreign government subsidies originally intended to aid local filmmakers struggling against Hollywood domination. And Hollywood found out that it was significantly cheaper to shoot films in Europe. Labor regulations were more flexible and exchange rates favorable.[16]

This had a particularly strong bearing on Fellini's career because of American film involvement in Italy. In the 1950s Rome became known as "Hollywood on the Tiber," a phenomenon reflected in Fellini's use of American actors in *La Strada*

and *Il Bidone* (1955; *The Swindle*) and clearly evoked in *La Dolce Vita* (1960) via Sylvia and her fiancé, Robert. In the 1960s in Italy "the distinction between the national film industry and Hollywood film became blurred. Italians worked on large-scale American runaway productions (e.g., *Cleopatra*, 1963), Italians made their own large-scale spectaculars with American stars ... Italians began making distinctive and successful Spaghetti Westerns ... Americans appeared in Italian films" (Lev 24–25).

At the same time that Hollywood became more involved in foreign film production, it became enamored of foreign film distribution. Cutbacks in its own production and diminishment in movie audiences because of television made it opportune for Hollywood to import, and consequently to generate a new kind of audience with new kinds of films. Again Italy proved crucial, as the success of *Rome Open City*, *Paisan*, and *Bicycle Thieves* in the American market in the late 1940s had pointed to the marketability of European films. The "artsiness" of European film suited precisely the kind of atmosphere that was being created to promulgate abstract expressionism, and the "sexiness" of the art film (exceeding Hollywood norms of nudity and sexual explicitness) made it appealing even to a non highbrow audience.

The growth of American foreign film distribution was directly related to Fellini's success, since he was a principal scriptwriter on *Rome Open City* and *Paisan*. *La Strada* in a sense piggybacked on their success, enjoying a three-year run in New York City and bringing Fellini his first Oscar. By the late 1960s the level of direct American investment in Fellini's work became a major factor in his ability to make movies. The extent to which Fellini experienced the impact of Hollywood throughout his filmmaking career is reflected by Peter Lev's claim that "Italy ... was a favored partner for American motion picture activities in Europe in the years 1950–1975" (19). These years bracket almost precisely the trajectory of Fellini's success as a director,[17] as well as the halcyon days of the art film.

One of the effects of the conjunction of high modernism and American ideology was the refurbishing of a traditional, romantic view of the artist as Great Individual. This new incarnation of the creative romantic hero was both a testament to democratic freedom of speech and a marketing device (a "brand name" such as Fellini or Bergman).[18] In film, the reincarnation of the great individual occurred via the "auteur theory," which, though originating in France, was consistent with the ideology of Americanized high modernism, as it asserted the creative control of (select) directors despite the collective and institutional conditions under which they made films. Moreover, an American version of auteur theory took hold in the 1960s and was part of a general celebration of international filmmakers, such as Fellini, as artist-geniuses. This, in turn, became the basis for the admission of

film study into academia, as film was able to combine the appeal of popular culture (helping to generate student enrollments) with its newfound status as art (satisfying the needs of English and foreign language departments to justify film as high culture).[19]

Fellini benefited enormously from all this, as the entertainment press cultivated his image as maverick artist *(Il Poetà* and *Il Maestro)*. This plus the modernist "seriousness" of his work guaranteed him a place on course lists alongside Joyce, Eliot, Proust, Mann, and even Dante and Shakespeare. As this was before the days of widespread academic film departments and highly specialized film journals, many of the people who taught film also reviewed for the popular press and for broad-based intellectual publications, so film's entrance into the academy was accompanied by recognition in a much larger intellectual and cultural context. And because the United States was the most important movie market in the world, notoriety in America helped promote continued marketability for Fellini. Fellini's success in the United States was partially reflected at the box office (*La Strada's* three-year run, *La Dolce Vita's* success even in mainstream distribution), but it was even more evident in the fact that Fellini won the Oscar for best foreign film four times—*Nights of Cabiria, 8½,* and *Amarcord* (1973), in addition to *La Strada*—putting him in a class by himself, at least as far as Hollywood was concerned, during the heyday of the art film in America.

High modernism's view of the artist as great individual was part of a more general romantic aesthetic in which the artist had unmediated and unique insight into the authenticity of being and was thus in a privileged condition to salvage a civilization that had gone awry. There was often a universalizing strain to all this: humanity was everywhere the same, and all problems were susceptible to a totalizing solution. Art itself could then be seen as universal, and the artist capable of speaking for all "mankind." This, of course, has roots in colonialism and its privileging of European civilization and experience. The artist as high priest and savior had been a recurrent theme of twentieth-century modernism—a modern*ism* radically disillusioned with modern*ization*—but it took on particular urgency given the atrocities of World War II and the fear of nuclear annihilation. The issue of authenticity was, of course, linked to postwar existentialism's search for meaning amidst the rubble of (European) civilization.

Fellini's investment in the artist as privileged seer is perhaps best reflected in the following comments, made during a series of interviews that surveyed his entire career:

> Artistic creation is nothing more than humanity's dream activity. The painter, the poet, the novelist and even the director function by elaborating and organizing with their own talent the content of the collective unconscious and expressing

and revealing it on the page, on canvas, or on the screen … That is the archetype of creation which renews itself over and over, the journey from chaos to cosmos, from what is jumbled and elusive to order, statement, completeness.[20]

Within high modernism, the quest for the true origins of being often involved a retreat from the real and into the purely aesthetic. Particularly in the wake of World War II, the realm of the political, social, and economic was so problematic that meaning had to be sought elsewhere, in some metaphysical realm. Abstract expressionism became emblematic of this kind of retreat, and creative individuality became measured by one's capacity to deny the existing and the given. (The depoliticization of high modernism was at odds with a strong, earlier, avant-garde tradition of engaged art or art as critique, wherein the artist's function was, indeed, social and political.)[21] Fellini connects this largely aesthetic philosophy with his broader ideology of individualism in two complementary ways: treating individuals as "artists" or "narrators" of their own life (for instance, Cabiria in *Nights of Cabiria* and Juliet in *Juliet of the Spirits)* or focusing on individuals who are, in fact, artists (Guido in *8½* and Fellini himself in such films as *The Clowns* [1970]). Individuation becomes an aesthetic process in which Fellini characters withdraw from concrete reality into a world of the psychological—that is, the realm of symbols and creative imagination where we are all, presumably, artists and where we all can become whole. Ultimately—and *8½* and *The Clowns* are excellent examples—Fellini's work begins to emphasize art or the artwork rather than characters as the locus of individuation.

Paradoxically, although the emphasis on art and, more specifically, aesthetic unity is entirely consistent with (Fellini's) high modernism, it also begins a movement beyond the primacy of the individual and of individualism itself, which proves central to Fellini's postmodern films.

Postmodernism and critical theory[22]

In many ways the individualist/high-modernist ideology I have just discussed is still with us. Certainly U.S. individualism is going strong. In fact, in Reaganite America, it seemed to take on renewed intensity. Auteurism is also alive and well, although, as Timothy Corrigan has pointed out (101ff), it has become more a commercial than an aesthetic phenomenon, with the blockbuster director (for instance, Steven Spielberg) replacing the artist-hero. There is also lingering adoration of art, capital-C Culture, and even the art film. As countless observers have noted, however, a crucial cultural shift began to take place in the 1960s, accelerated in the 1970s, and became formalized (counter to its own anti-formulaic strategies)

10

as "postmodernism." As I argue in the latter part of this study, this shift dramatically affected Fellini's work, despite his frequently strong resistance to it.

Although the term "postmodernism" covers vast and highly disputed territory, I restrict myself here to its history and manifestations in relation to high modernism, and even more specifically to the manner in which it becomes reproduced in Fellini's work. In so doing I oversimplify: in particular, I construct an image of postmodernism that is excessively negative in its view of social and individual possibility. (The reader is referred in Notes and References to more sustained discussions of the subject.)[23] My readings of individual Fellini films, such as *Roma* (1972) and *Intervista* (1987), will restore some of the more subversive and invigorating aspects of postmodern thought that are missing from my brief portrait. And in the final chapter I relate what often seems a highly depoliticized postmodernism in Fellini's work to cultural politics.

One of the most important themes of postmodern thought is the "death-of-the-subject"—the demise of the kind of self-determining individual or center of consciousness that Fellini sought to represent in his early work. Disillusionment with individual autonomy derived from several sources. To the extent that 1960s political dissent viewed the individual in heroic opposition to the system (certainly the case in the United States), the failure of the 1960s and the crushing reassertion of institutional power struck a powerful blow to the rhetoric and ideology of self-actualization. The international economic crises of the 1970s, the worst since World War II, as well as ensuing unemployment further eroded confidence in the possibilities of self-determination. The explosion of advertising, media outlets, and new information technologies in the 1960s through the 1980s led to claims by social observers that, on the one hand, our senses were becoming thoroughly externalized and, on the other, our mass-produced environments were becoming thoroughly internalized, so that all conventional notions of self-determining consciousness were obsolete. Jean Baudrillard became the prophet extraordinaire of media and technological determinism, emphatically proclaiming the reduction of the individual in postmodernity to "a pure screen, a switching center for all the networks of influence."[24] At the same time, the glut of processed images that has become our daily environment led to the conclusion that originality and creativity, the cornerstones of individualist ideology, are dead. Everything has "always already" been seen and produced (including the notion of individuality itself). All we are left with is reproduction, duplication, citation, "plagiarism," and (again to invoke Baudrillard) simulation: the production of copies not from originals but from models or culturally coded templates.

In conjunction with the effects of media and the economy, the political agitation of the late 1960s (especially May 1968) brought with it a radical rethinking of the individual's relation to power. Simple notions of domination as an external

force (pitting the individual against the system), which allowed for clear identi-
fication of the "enemy," as well as a pure political stance in opposition to it, no
longer sufficed. Instead, power began to be analyzed as an internalized force,
something that individuals assimilated en route to *self*-subjugation within society.
Central to this was a rethinking of the notion of ideology. No longer just viewed
as a general mind-set or "philosophy" pretty much evident to all, ideology came
to be seen as the set of cultural myths, beliefs, and values through which individ-
uals internalize and accept existing relations of power without realizing it. The
persuasive power of ideology was seen to lie in its invisibility: the fact that it pre-
sents itself as *natural*—as "the way things are"—rather than as *ideological* (that
is, selective, culturally constructed, coercive/persuasive, and so forth). Theories
of ideology were linked to theories of language, the unconscious, and discourse,[25]
and it was persuasively argued that these determinants—not the free activity of
creative consciousness—were responsible for the production of subjectivity. In
this respect it would probably be more accurate to speak not of the "death-of-
the-subject" but of the "death-of-the-individual" and its replacement *with* the
"subject-ed." Because "death-of-the-subject" is the accepted theoretical term,
however, I will continue to use it.[26]

Clearly, in light of all this, the Fellinian/high-modernist values I enumerated
earlier are nullified. In the broadest sense, humanism, which sees man as both a
special creature and a universal category at the center of the universe, is overturned.
Gone too is the "creative imagination" or any authentic and universal space out-
side or prior to the cultural and institutional, which the imagination could access.
Gone, then, is the privileged role of the artist, who, like everything else, becomes a
mere effect of ideology. And if the "author" is as dead as the subject, then so, too,
is auteurism. Finally, if the artist too is a mere "switching center" for ideological
networks of influence, so must be the artwork itself. Gone are the ideals of aes-
thetic unity, wholeness, and salvation-through-art. The whole edifice of capital-
C Culture, which supported high modernism and the art of film, comes crashing
down. This is abetted, of course, by the twentieth-century spread of mass culture
and the growing acknowledgment that here—not in the realm of high culture—is
where the transmission of social values most effectively occurs.[27]

One might be inclined to ask just how much the theoretical postmodernism
I have just surveyed applies to Fellini's work. He repeatedly expressed aversion
to abstract thought and theory. In addition, even relatively late in his career he
retained strongly high-modernist values. This becomes clear in his sustained attack
on television, but even the remarks I quoted about "artistic creation" and "the
journey ... to order [and] completeness" were made as late as 1983. Nonetheless,
his interviews and written statements do indicate that he was aware of postmod-
ernist theory. He refers specifically to structuralism and semiology (also in 1983),

both of which contributed to death-of-the-subject theorizing (*Comments*, 181). He talks positively of Mao's *Little Red Book,* which was conceptually central to the political movements of the late 1960s (*FF* 154–55). (He was even tempted at one point to make a film on Mao.) And his comments about self-consciously political films in the late 1960s and 1970s make it clear that he is aware of changing theoretical attitudes within cultural production.[28] Moreover, collaborators such as scriptwriter Bernardino Zapponi were in tune with contemporary intellectual movements and brought their knowledge to bear on his work. More generally, of course, as the 1970s progressed, postmodernism became part of the cultural atmosphere in which Fellini lived and worked.

Postmodernism and Fellini's biography

It is probably safest to say that Fellini's postmodernity was only partly a matter of theoretical and cultural ambience—and equally a matter of his own experience in relation to that larger context. A brief discussion of various Fellinian crises from the late 1960s on should help link the personal to the cultural, particularly in relation to the death-of-the-subject and the death-of-the-artist.

Following the making of *Juliet of the Spirits,* Fellini suffered serious artistic, economic, and physical crises, the third of which appears related to the first two (Alpert, 190–99). These, in effect, seemed to comprise *his* version of May 1968, promoting his own shift into postmodern modes of expression. Artistically, he experienced the most severe creative block of his career: the inability to complete a project entitled "The Journey of G. Mastorna." Both cause and effect of this failure were, in the words of his longtime assistant, Liliana Betti, a "paralyzing confusion" and "state of depression."[29] In the course of the project, Fellini became heavily committed financially to producer Dino De Laurentiis, and when Fellini tried to drop the project, De Laurentiis responded with strong legal pressure. The affair took most of 1966, negotiations with De Laurentiis redeveloped in the new year, and then in March 1967 Fellini became seriously ill. His doctors feared cancer, and Fellini feared his illness was terminal. It turned out to be a rare but curable disease, but the experience, coupled with his artistic and economic problems, constituted a major midlife crisis. It is at this point, particularly in films such as *Toby Dammit* and *Fellini-Satyricon,* that his cinematic project of individuation begins to dissolve.

In addition, the death-of-the-subject, and more particularly of the author/artist, which becomes so prominent in his later work, can be directly tied to his own increasing difficulties as a filmmaker. Again, the late 1960s proved momentous. Although conflicts with producers were notorious throughout his career (Fellini claims to have gone through 11 trying to get *Nights of Cabiria* made),[30]

and although he never accumulated great wealth from his films,[31] he was able, through the first 15 years of his career, to work consistently on projects that he himself developed. The failure to complete "Mastorna" proved a major harbinger of change. A crisis in the Italian film industry was instrumental in making Fellini turn to television for *The Clowns*, and following *The Clowns*, as Hollis Alpert put it, "financing became [Fellini's] major problem" (227). In fact, the financial exigencies of the late 1960s and 1970s meant that Fellini's projects reached completion only as the result of (1) American money, (2) fragmented packaging *(The Clowns* and *Roma* each had four funding sources), (3) television *(The Clowns, Prova d'orchestra* [1978; *Orchestra Rehearsal*]), and *Ginger and Fred* (1985) through his final film, *La voce della luna* (1990; *The Voice of the Moon*), (4) acrimonious turnover of producers *(Il Casanova di Federico Fellini* [1976; *Fellini's Casanova*] and *La città delle donne* [1980; *City of Women*]) and (5) extensive interruptions in production *(Fellini's Casanova* and *City of Women* again). The success of *Amarcord* midway through the 1970s did little to ease Fellini's financing situation, coming as it did in the midst of an international recession, coupled with inflation, which, for a host of reasons, affected Italy even more dramatically than most of the other industrialized nations (Ginsborg, 351ff). The diminishment in filmmaking opportunities over the course of Fellini's career is perhaps most dramatically illustrated by the fact that he made 15 films in his first 20 years as a director, and only 9 in his last 23.

One particularly cruel paradox in all this is the fact that the decline in Fellini's ability to mount films coincided with high points in his career as media buzzword and star—a figure I like to call "Fellini," emphasizing the quotation marks. "Fellini" had been around, of course, at least since *La Dolce Vita*, but "he" really took off with direct U.S. involvement in his films. Around the time of *Satyricon*, the U.S. television network NBC contracted Fellini to make a film about himself *(Fellini: A Director's Notebook*, 1969). An American journalist (Eileen Lanouette Hughes) wrote a book about the making of *Fellini-Satyricon*.[32] Gideon Bachman made a movie *(Ciao, Federico!*; 1970) about the film and Fellini. And Paul Mazursky asked Fellini to make a cameo appearance in *Alex in Wonderland* (1970). At the same time, *Fellini-Satyricon* received more advance press than any other Fellini film before or since, and United Artists put Fellini on constant display in the United States. Finally, the American Film Institute showcased him at a seminar at the Center for Advanced Film Studies, the transcript of which became the first instalment of AFI's long-running *Dialogue on Film* series.

Despite all this hype, *Fellini-Satyricon* was a highly problematic production, not least of all because of American involvement. Fellini agreed to make the film largely in exchange for producer Alberto Grimaldi assuming his "Mastorna" debt

and taking over the project. Grimaldi involved him with United Artists, and his battles with the American company over what he asserted to be serious under-funding prompted this diatribe: "The picture industry is ... so vulgar that if the film author tried to oversee what happens to his work he would quickly die of a broken heart. Between censorship, the vulgarity of the advertising, the stupidity of exhibition, the mutilation, the inept dubbing into other languages—when I finish a picture it's best to forget I ever made it" (quoted in Alpert, 208).

The "Fellini"/Fellini discrepancy was perhaps most pronounced by the time of *City of Women*. On the one hand, as John Baxter says, "Fellini's triumphal return to Cinecittà in the spring of 1979 [after *City of Women* had been temporarily shut down] seemed an affirmation of his standing. With Visconti dead, he was, in the eyes of most people, Italy's undoubted king of cinema" (324). Moreover, as Alpert reported, "There was a new saying in Rome: everyone who visited the city wanted to meet or see only three people—Fellini, Pertini [president of Italy], and the Pope" (273). On the other hand, by now Fellini, Italian cinema, and the Euro-pean art film were in sharp decline. Daniel Talbot of New Yorker Films claimed that by the time of *City of Women* Fellini "had lost most of his audience," espe-cially in the United States (Alpert, 277). In June 1981 (shortly after the release of *City of Women*) Fellini complained that "I am out of work. I have four screenplays ready, but I can't find a backer to put up the money for them" (quoted in Alpert, 279). Following *City of Women*, Fellini was to make only four more films before his death, two of which did not receive theatrical release in the United States.[33] At the very end, to quote John Baxter again, "Not even his honorary Academy Award in 1993, presented by Mastroianni, could persuade his many Hollywood admirers to invest in a new Fellini film" (358–59).

Ultimately, Fellini's persona only came to signify a kind of clout that Fellini himself was entirely lacking. Moreover, "Fellini" was even more produced and controlled than Fellini himself: the construction of an international media market still enamored of a high-modernist art scene that attached great monetary value to big-name art and big-name artists. Though Fellini conspired in this by promoting a marketable image, he also saw himself as victimized by his persona: "The only thing I have wanted to do is work, and being a legend, it seems, is not a help but a handicap to being a working director" (quoted in Chandler, 189). He even saw "Fellini" as a principal cause of the failure of "Mastorna": "Before the pic-ture could exist there was the Fellini business. No one thought about the picture I wanted to do. Instead they thought about the picture they wanted to do with Fellini, and an atmosphere of misunderstanding was created. It was difficult for me to see my picture" (quoted in Alpert, 192).

If Fellini's brush with death in 1967 contributed to a questioning of the creative freedom of the ever-evolving individual, his repeated brush with producers and

with financial constraints from the late 1960s on inevitably accelerated his questioning of the autonomy of art and the artist. This is implied in his diatribe about postproduction decisions at the time of *Fellini-Satyricon*. It becomes explicit in his attitude toward project development by the time of *Fellini's Casanova*. Once able to define a filmmaker as "someone who … has total control over that means of expression and that art we call the cinema" (Alpert, 204), Fellini suddenly claims to accept a dependency on patronage that bespeaks the very opposite of creative control: "A contract with an advance is one of the most valid things for me today. I'd even be in favor of a situation similar to what existed in the 1400s, when a Pope or a grand duke commissioned a work from a painter or a poet. If the artist didn't do it, they wouldn't feed him. I've discovered that at one time I had to like a film to do it; now I like a film because I make it."[34] Moreover, his treatment of Casanova as artist marks a radical shift from his treatment of Guido in *8½* and even himself in *The Clowns* as relatively self-sufficient, creative figures. Casanova, as I argue at length later in this study, represents the artist-storyteller as compliant hack, with no control over himself or his art.

Fellini's treatment of Casanova becomes emblematic of his treatment of all artists in his later work, as products rather than sources of the systems that define them. At the same time, his perpetually unresolved "Mastorna" crisis, in conjunction with his increasing dependency on adaptations pushed on him by producers (the work of Petronius, Casanova, and Edgar Allan Poe), marks a shift from original work to reproduction. In both respects, Fellini's personal and professional experience becomes the basis for the kind of filmmaking or storytelling that has come to be known as postmodern. Hence the Fellinian postmodern, while dovetailing with the theoretical and aesthetic shifts I outlined earlier, has its own specific origins.

One additional factor that I suspect contributed to Fellini's postmodern narratives of individual and authorial disempowerment was a concern with aging—linked to a concern with the loss of inspiration. I do not think it was pure accident that creative blockage and a confrontation with mortality coincided at the time of "Mastorna," a project focused on death and the afterlife, or that this was also the moment when the subject-author begins to become highly problematic (*Toby Dammit*). Moreover, though a fear of aging and death had been an important theme for Fellini at least since *8½* and Guido,[35] death becomes the central concern of *Toby Dammit*, linked specifically to art and performance (Toby is an actor and, as I argue later, a storyteller). A host of later films—*The Clowns*, *Fellini's Casanova*, *City of Women*, *E la Nave Va* (1983; *And the Ship Sails On*), *Ginger and Fred*, and *Intervista*—also deal with aging and performance. (In the case of *City of Women*, the problem of performance is sexual rather than artistic.) From *Fellini-Satyricon* onward we also find a strong emphasis on history and the past—that is, insistent temporality.

Of course, the death-of-the-author remains a conflicted theme for Fellini. Though it seems a fait accompli in nearly all his final films, he can still, as late as 1983, assert supreme powers for the artist-filmmaker: "Film is a divine way of telling about life, of paralleling God the Father!" (*Comments*, 101). Moreover, at the very moment the autonomy of the subject and artist first begin to be questioned in his work—in *8½*—the phrase "conceived and directed by Federico Fellini" appears in the titles. (The irony here is all the stronger as *8½* was born of enormous authorial anxiety, confusion, and helplessness.) Finally, partly for the auteur marketing reasons noted above, Fellini's own name begins to appear in the title of films such as *Fellini-Satyricon* and *Fellini's Casanova* that undermine individuality and, in the case of the latter, launch an all-out assault on the autonomy of the artist. This serves as just further manifestation of an endlessly divided Fellini: the artist as illusory high-modernist god, and the struggling, increasingly disempowered, artist-in-the-flesh.

From realism to representation to signification

When Fellini moves from original or self-conceived projects to adaptation and reproduction, the emphasis in his films begins to shift from individuals (and artists) in search of authenticity to art about art, texts about texts. This brings us to the second "narrative" I posited at the outset of this chapter, the movement of Fellini's career from a relatively realist aesthetic to a self-conscious concern with issues of representation and meaning.

Although Fellini's quarrel with Italian Marxists over his departure from neorealism in the 1950s might imply that he was antirealist from the start, I would argue that his early films were far more realist than not. They might not have adhered to some of the documentary and social realist tenets of Zavattinian neorealism, but they did adhere, by and large, to the classic realism of conventional narrative film. Filmmaking technique worked "transparently," remaining invisible in its construction of a world that, though fictional, was like the real world (operating on a principle of verisimilitude). The emphasis was on the *product*, not the *process* of construction: what was in front of the camera rather than the camera itself as cinematic and narrative device. This begins to change with *Nights of Cabiria* and *La Dolce Vita*. Here the camera eye begins to acquire an identity as an active force, a metaphor for creative intelligence. With *The Temptation of Dr. Antonio* (1962) and, of course, *8½*, the cinema itself becomes a central part of the story of the film, not merely the invisible means of telling it. And from here on in, virtually all Fellini's films foreground or question the conditions of representation itself, making his oeuvre one of the most self-reflexive in the history of the medium.

17

This is not to deny that certain of Fellini's earliest films focus on the construction of illusions and even—as in the case of *The White Sheik*—create analogies between cinema and other popular culture forms such as the *fotoromanzi* ("photo novels," an immensely popular type of romantic magazine serial with ties to the comic strip but using photographs instead of drawings). In these instances, however, Fellini is far more concerned with the theme of illusion than with exploring the nature and implications of cinematic representation per se.

Fellini's shift from realism to issues of representation is reflected in a movement from characters who merely live life to those who (learn to) imagine it. From *Luci del Varietà (1950; Variety Lights*, co-directed with Alberto Lattuada) through *Il Bidone*, characters are pretty much victims of experience (that include cultural fictions imposed on them). Cabiria, however, becomes capable of self-transformation when she goes up on stage at the Lux theater, imagines herself as "Maria," and envisions a dream lover "Oscar." Moreover, Guido is able to arrive at a brief moment of seeming integration by the end of *8½* through a process of imagining, as well as living, his life.

Through the middle period of Fellini's work, voice-over narration becomes a major strategy of self-representation. Toby in *Toby Dammit*; Encolpio in *Fellini-Satyricon*; and Fellini himself in *Fellini: A Director's Notebook, The Clowns*, and *Roma* do not just experience, they articulate their experiences. Linked to this is the Second Coming motif that runs so richly through Fellini's work: characters such as Toby, by narrating in the past tense, are able to "come again" through representation, rewriting history and getting right the second time what did not work the first.

The rewriting of history, of course, moves us beyond personal experience and toward "pure" or "hyper" representation, which is precisely the direction all Fellini's middle and later work takes. Beginning with *The Temptation of Dr. Antonio*, his films insistently become art about art. First there are the films principally about film: *8½, Fellini: A Director's Notebook, The Clowns, Roma*, and *Intervista*. Then there are the films largely about film: *The Temptation of Dr. Antonio* (1962), *Toby Dammit*, and *And the Ship Sails On*. Next there are the films based on literary texts: *Toby Dammit, Fellini-Satyricon, Fellini's Casanova*, and *The Voice of the Moon*. Finally, there are the films on art forms other than film and literature: *The Clowns, Orchestra Rehearsal*, and *And the Ship Sails On* (which is about an opera company). When we move outside the realm of art, we still remain within the realm of representation. *Amarcord* (the title means "I remember") presents itself as a series of reconstructed memories; *City of Women* is principally a dream; and *Ginger and Fred* is about the consummate representational medium of our age: television. The only one of the 15 films from Fellini's middle and late period that I have not included is *Juliet of the Spirits*,

which, though not about one specific form of representation, is shot through with many: fantasies, visions, circuses, school plays, performance art, psychodrama, and so on.

Fellini's movement from realism to representation reflects a broader renunciation of the real that has characterized Western art for the last 150 years or so. This renunciation, and a consequent turn toward self-questioning art, has been one of the hallmarks of aesthetic modernism (that is, modernism in painting and literature). A brief discussion of the underlying issues involved in this movement away from the real should further clarify Fellini's relationship to modernism. Equally important, it enables me to distinguish between the modernist and postmodernist moments of his later work and, in so doing, lay important groundwork for my later analysis of individual films.

Traditional realist aesthetics assumed a stable and representable real and consequently tended to place art and language in direct relation to reality, via concepts such as *mimesis* and *representation*. Traditional language theory, along with aesthetics, posited a relationship based on *reference,* in which the word (or, in the case of aesthetics, the artwork) is the *sign* and the real its *referent.* Within a referential relationship, the word/artwork *represents* the real. Beginning in the mid-nineteenth century, however, the notion of an unproblematic reality began to be challenged for a variety of reasons, social as well as philosophical. The focus of art thus shifted from what was represented (the real) to how to represent (that is, codes, specific artistic media themselves, the forms—rather than the referents—of expression).[36] Cubism was an important moment in this shift. Its emphasis on multiple realities and perspectives rather than a single, unified real became, simultaneously, an emphasis on representation itself. Still, within modernism, though the relation between sign and referent and representation and reality became strained and far more complex than in a conventionally realist aesthetic, the relation did, for the most part, hold. Reality might be multiple and difficult to access, but new and more appropriate modes of representation were conceivably up to the task.[37] With postmodernism the conviction emerges that there is no reality, or, more accurately, that the real is entirely constructed out of the tools and codes of representation. ("There is nothing outside language" is one version of this conviction.) The relation between sign and referent and artwork or language and reality is thus dissolved, and because there is no real to be represented, the notion of representation becomes as problematic as the notion of reality. Postmodern theory thus speaks of *signification* more than *representation,* and *signification* describes a situation in which meaning and representation derive not from any reference to a real but only in reference to other meanings and representations.[38] In this context the term "representation" relates to absences more than presences: to a "real" that is (1) constructed and (2) in lieu of any tangible "real" outside the process of

representation. Consequently, representation ends up with a far different meaning from what it held in realist and even modernist aesthetics.

Within signification, the relation between sign and reality is replaced by that between *signifier* (the material component of a sign; for instance, a sound or image, a spoken or written word) and *signified* (the mental component; that is, the concept evoked by the signifier). Moreover, not only is meaning not produced by a relation between sign and referent, but it is also not produced by a relation between signifier and signified. It is, rather, produced by the relationship *among* signifiers: "We don't translate the individual words or signifiers that make up a sentence back into their signifiers on a one-to-one basis. Rather we read the whole sentence, and it is from the interrelationship of its words or signifiers that a more global meaning ... is derived. The signified—maybe even the illusion or the mirage of the signified and of meaning in general—is an effect produced by the interrelationship of material signifiers."[39] Consistent with this way of looking at signification, postmodernism in the arts—and included here is much of Fellini's later work—revels in the proliferation and interplay of signifiers and in the rigorous deferral of meaning that is seen to be implicit in the act of signifying itself.

Fellini, of course, was no semiologist (the kind of theoretician who deals with the issues I have just summarized). In fact, abstraction of this sort was clearly on his ideological hit list. Nonetheless, his final films, made within the ambience of a postmodern aesthetics of signification, prove remarkably consistent with those aesthetics.

More precisely, once Fellini moves from realist to self-reflexive filmmaking, he also moves from representation to signification. There is no one indisputable moment at which the change occurs. For this reason, close analysis of individual films is the best way to explore the complex relations between representation and signification and modernism and postmodernism in his work, rather than trying to divide things up neatly, a priori. Nonetheless, I think one can generally assert that films such as *The Temptation of Dr. Antonio, 8½,* and *Juliet of the Spirits* are principally modernist examinations of representation and of the complex relationships among art, the imagination, and reality. Reality may be increasingly defined *as* representation, particularly when multiple (psychological) perspectives are introduced. Nonetheless, the real is retained, largely in the form of individual experience filtered through the organizing consciousness of a main character. That reality begins to dissolve—and art or "pure" representation begins to replace it—in such films as *Toby Dammit, Fellini-Satyricon,* and *The Clowns.* "Art" still tends to imply "reality" as its opposite and its ground in these films, but with *Roma* purely self-referencing signification begins to emerge. ("Roma" as city, symbol, religious and historical site, and so on, produces meaning—and even Fellini himself—solely through the collision of its associations.) With *Fellini's*

Casanova signification is paramount, with reality and even art (as an implied opposite to reality) under erasure. From *Fellini's Casanova* to the end of Fellini's career, Fellini films are almost all explicitly about systems of signification lacking an "outside" (the orchestra in *Orchestra Rehearsal*, dream or projection in *City of Women*, cinematic codes in *And the Ship Sails On*, a film studio in *Intervista*). In his two most "realistic" films of the period, reality is largely the product of either television *(Ginger and Fred)* or insanity *(The Voice of the Moon)*.

Although Fellini's work ends up in the realm of signification, it does so with substantial discomfort. The (high) modernist dies hard—much more so than did the realist. As a result, Fellini's final films often not only exemplify but dispute postmodernity, especially the relative "meaninglessness" that endless signification seems to imply.

Having conducted this rather hasty tour of issues and contexts related to Fellini's work, I now return to the beginning of his career and both ground and qualify much of the preceding generalization in close analyses of his films.

NOTES

1. See Joseph McBride, "The Director as Superstar," *Screen* 41, no. 2 (Spring 1972): 78–81.

2. In most cases, I will provide the Italian title of films upon first mention, with English titles in parentheses, and then employ the English title thereafter. In cases where the difference between Italian and English is minimal—a matter of initial caps (*La strada* vs. *La Strada*, *La dolce vita* vs. *La Dolce Vita*) or slight changes in articles or conjunctions (*I clowns* vs. *The Clowns*, *Ginger e Fred* vs. *Ginger and Fred*)—I will avoid cluttering the text with both and employ only the English.

3. See Cesare Zavattini, "Some Ideas on the Cinema," in *Film: A Montage of Theories*, ed. Richard Dyer MacCann (New York: Dutton, 1966), 216–28; hereafter cited in text.

4. See especially Peter Bondanella, "Early Fellini: *Variety Lights, The White Sheik,* and *I Vitelloni,*" in *Federico Fellini: Essays in Criticism*, ed. Peter Bondanella (New York: Oxford University Press, 1978), 220–23; and Ben Lawton, "Italian Neorealism: A Mirror Construction of Reality," *Film Criticism* 3, no. 2 (1979): 8–23. This entire issue of *Film Criticism* is devoted to neorealism and contains much useful material. A useful introduction to neorealism is Roy Armes, *Patterns of Realism: A Study of Italian Neorealist Cinema* (London: Tantivy Press, 1971). Peter Bondanella's *Italian Cinema: From Neorealism to the Present*, New Expanded Edition (New York: Continuum, 1990), provides a useful overview and update on scholarship (see especially chapters 2–5).

5. "The Catholic Irrationalism of Fellini," *Film Criticism* 9, no. 1 (1984); reprinted in *Perspectives on Federico Fellini*, 104.

6. *Fellini on Fellini*, ed. Anna Keel and Christian Strich, trans. Isabel Quigley (New York: Delacourte/Seymour Lawrence, 1976), 61; hereafter cited in text as *FF*.

7. Federico Fellini, "The Road beyond Neorealism," in *Film: A Montage of Theories,* 379.

8. "Federico Fellini," *Interviews with Film Directors,* ed. Andrew Sarris (New York: Avon, 1967), 178–79.

9. Charlotte Chandler, *I, Fellini* (New York: Random House, 1995), 235–36 and 313; here-after cited in text.

10. For an excellent discussion of American ideology vis-a-vis communism and totalitarianism, see Serge Guilbaut, *How New York Stole the Idea of Modern Art: Abstract Expressionism, Freedom, and the Cold War* (Chicago: University of Chicago Press, 1983); hereafter cited in text.

11. Paul Ginsborg notes that "American intervention was breath-taking in its size, its ingenuity and its flagrant contempt for any principle of nonintervention in the internal affairs of another country" *(A History of Contemporary Italy: Society and Politics, 1943–1988* [New York: Penguin, 1990], 115; hereafter cited in text).

12. Peter Bondanella, "America and the Post-War Italian Cinema," *Rivista di Studi Italiani 2,* no. 1 (June 1984): 106–25.

13. "The use of culture as a propaganda weapon became blatant and aggressive after 1951. . . . It was after 1951—when the Communist threat loomed ever larger in the United States (Hiss, Chambers, the Korean War)— . . . that the American avant-garde [i.e., abstract expressionism] was most forcefully represented . . . throughout Europe" (Guilbaut, 204–5).

14. Fellini also became greatly respected in France, in part through the writings of fellow Christian humanist Andre Bazin. France, too, however, was under the influence of postwar American ideology. It might even be argued that the *politique des auteurs* ("auteur theory," as it became known in America), which began to celebrate filmmakers as artists, was related to the American appropriation of (high) art and artists in the interests of cold war anti-Communist ideology.

15. Thomas Guback, "Hollywood's International Market," in *The American Film Industry,* rev. ed., ed. Tino Balio (Madison: University of Wisconsin Press, 1992), 473.

16. Peter Lev, *The Euro-American Cinema* (Austin: University of Texas Press, 1993), 22; here-after cited in text.

17. One can gauge that trajectory in numerous ways: critical success, commercial success, awards, and so on. To a large extent, Fellini's critical success peaked with *8½* (1963). Yet *Amarcord* (1973) was both a commercial success and an Oscar winner—the last of his films to accomplish either.

18. Timothy Corrigan deals with the individual as brand name in his chapter "The Commerce of Auteurism," in *A Cinema without Walls: Movies and Culture after Vietnam* (London: Routledge, 1991), 101–36; hereafter cited in text.

19. In *Architectures of Excess: Cultural Life in the Information Age* (New York: Routledge, 1995) Jim Collins offers a useful summary of the interrelation of auteurism, romantic indi-vidualism, commerce, and academia:

> The Romantic ideology of artistic creation as pure invention by the singular genius had, by the 1950s, already been institutionalized for decades . . . The legitimation of "the cinema" depended on the appropriation of this ideology and, not so coincidentally, the institutionalization of film study within the academy was in large measure a very successful reclassification and "reframing" of the medium by auteurist professors. By the mid-sixties, auteurism had become the basis of a *critical* authority that was itself entirely dependent upon *creative* authority in the most unambiguous, Romantic sense of the term—genius as source and guarantee of value. (198–99).

20. *Federico Fellini: Comments on Film,* ed. Giovanni Grazzini, trans. Joseph Henry (Fresno: Press at California State University, 1988), 201–2; hereafter cited in text as *Comments*.

21. For an excellent discussion of modernism and the avant-garde as a tradition of opposition—in contrast to postwar high modernism—see Andreas Huyssen, "Mapping the Postmodern," in *After the Great Divide: Modernism, Mass Culture, Postmodernism* (Bloomington: University of Indiana Press, 1986), 178–221. Part of the insistence on a separate, more meaningful realm of the aesthetic did have political roots and justification. It was a reaction to the all-out attack launched on modern art by Nazism, Fascism, and Stalinism and an attempt to defend art against political suppression by claiming a privileged moral status for the aesthetic.

22. Much of the thought I am summarizing in this section has come to be known as "poststructuralism." Moreover, there have been judicious distinctions made between postmodernism (formal and expressive practices associated with art and other kinds of cultural production) and poststructuralism (theoretical practices). However, I do not want to introduce yet another highly specialized term into my discussion, so I have used postmodernism as an umbrella term to include all practices—including theoretical—that characterize postmodernity (the age in which, arguably, we currently live). This kind of usage has ample precedent.

23. See, for instance, Hans Bertens, *The Idea of the Postmodern: A History* (New York: Routledge, 1995); *Postmodernism: A Reader,* ed. Thomas Docherty (New York: Columbia University Press, 1993); *The Anti-Aesthetic: Essays on Postmodern Culture,* ed. Hal Foster (Port Townsend, Wash.: Bay Press, 1983); David Harvey, *The Condition of Postmodernity* (Oxford: Basil Blackwell, 1989); Andreas Huyssen, *After the Great Divide;* Fredric Jameson, *Postmodernism; or, The Cultural Logic of Late Capitalism* (Durham, N.C.: Duke University Press, 1991); *Art after Modernism: Rethinking Representation,* ed. Brian Wallis (New York and Boston: The New Museum of Contemporary Art in association with David A. Godine, 1984).

24. Jean Baudrillard, "The Ecstasy of Communication," in *The Anti- Aesthetic: Essays on Postmodern Culture,* 133. For Baudrillard's theories of internalization or, more accurately, implosion, see also *Simulations* (New York: Semiotext[e], 1983) and *In the Shadow of the*

Silent Majorities; or, The End of the Social and Other Essays (New York: Semiotext[e]], 1983). Fellini had an Italian translation of "The Ecstasy of Communication" in his library.

25. "Discourse" in this context refers broadly to the interrelations of power, knowledge, and representation at any given moment in a specific cultural context. It is more appropriately used in the plural, as any given historical or cultural moment involves the interaction of numerous, competing discourses.

26. One way of resolving the terminology dilemma is to distinguish among "individual," "subject," and "agent." The first is the old humanist conception of the self that postmodern theorists argue is obsolete. The second is a thoroughly deterministic view of subjectivity "subjected to" culture. The third offers the possibility that "subjects" still have agency—some ability to effect change. Clearly change does occur within the social, and the notion of agency addresses the extent to which subjects play a part in change. For further discussion of this issue, see Paul Smith, *Discerning the Subject* (Minneapolis: University of Minnesota Press, 1988).

27. Fellini himself is, of course, testimony to the power of popular (though not mass) culture. He was greatly influenced as a child by cartoons and the circus, in addition to American movies and comic books. Consequently, he became a caricaturist and cartoonist as well as a moviemaker—inclined endlessly to reproduce circus motifs in his films. For a more extensive discussion of Fellini's relation to popular culture, see Peter Bondanella, *The Cinema of Federico Fellini* (Princeton, N.J.: Princeton University Press, 1992).

28. For instance, "Personally I have nothing against a political cinema. If the number of films with a political and sociological background is increasing, it means that they are the result of profound, authentic demands" *(FF,* 113); and, "Fascism is not viewed [in my film], as in most political films that are made today, from (how can I put it) a judgmental perspective. That is from the outside" (*"Amarcord:* The Fascism within Us: An Interview with Valerio Riva," in *Federico Fellini: Essays in Criticism,* 20). Fellini's use of the words "judgmental" and "outside" refer to the kind of theoretically politicized filmmaking that began to emerge a few years prior to his making of *Amarcord.*

29. Liliana Betti, *Fellini: An Intimate Portrait,* trans. Joachim Neugroschel (Boston and Toronto: Little, Brown & Co., 1979), 121; hereafter cited in text.

30. See Gilbert Salachas, ed., *Federico Fellini: An Investigation into His Films and Philosophy,* trans. Rosalie Siegel (New York: Crown, 1969), 105; hereafter cited in text.

31. Fellini received little financial benefit even from the enormously successful *La Strada* and *La Dolce Vita,* having given up his share of the profits in exchange for greater artistic autonomy. The economic stability brought to him by *8½* was short-lived.

32. *On the Set of* Fellini-Satyricon (New York: William Morrow and Company, 1971).

33. *Intervista* and *The Voice of the Moon* did, finally, get shown in New York City, largely through the intervention of Martin Scorsese, in the late fall and winter of 1993.

34. "Conversation with Federico Fellini," *Oui Magazine,* January 1977, 154; hereafter cited in text as *Oui.*

35. The issue of aging appears as early as *Il Bidone,* but here it is more an abstract thematic concern than a personal one, given that the character who is getting older—Augusto—has nothing in common with Fellini in terms of age (Fellini is in his thirties at this point), profession, or personality.

36. This is even the case in the work of modern realist writers, whose passion for the concrete was a revolt against the growing abstractness of contemporary life and had its roots in romantic opposition to modernization. An intense concern with being realistic, concrete, or "imagist" on the part of figures such as Ernest Hemingway, Sherwood Anderson, and William Carlos Williams was more a matter of style and aesthetics than of reproducing a "real." It was a clear indication that the relationship between reality and representation was becoming increasingly troubled, requiring extraordinary attentiveness to craft and method. Their realism was a form of modernist self-reflexivity, modernist questioning of art.

37. For a discussion of the relation between modernist art and reality, see Harvey, *The Condition of Postmodernity,* 20ff and 49ff.

38. In "Cinemas of Modernity and Postmodernity," Maureen Turim critiques the validity of the process I have just sought to identify: "To say as some have that the modern texts abstract the referent [i.e., withdraw from reference into abstraction] while postmodern texts disturb the signified [i.e., devalue the signified in favor of the signifier] is semiotically so oversimplified as to be simply irrelevant. Modernism was seen in the same terms, as a crisis in meaning, as a void in clear signification. Closer analysis of the processes of signification in postmodern art, films, and video will, I think, find the signifiers less disturbed than they have already been by modernism" (in *Zeitgeist in Babel: The Postmodernist Controversy,* ed. Ingeborg Hoesterey [Bloomington: University of Indiana Press, 1991], 183). I would argue that the signifieds are not "less disturbed" in much postmodern work; rather, they are reproduced as signifiers. In fact their role as signifieds is fleeting and effectively close to nil. They become unstable signifiers of the continual play of meaning—rather than merely troubled sites of meaning. For instance, postmodern photography reintroduces not only signifiers but what used to be called referents—images of the "real"—to emphasize the fact that they are not really signifiers and referents but, at most, *arbitrary signifiers of reality.* Moreover, these images are meaningful not insofar as they relate to any "real" but insofar as they operate within a system of differences in relation to other signifiers (signifiers, say, of "culture," "fantasy," "representation," etc.).

39. Fredric Jameson, "Postmodernism and Consumer Society," in Foster, *The Anti-Aesthetic: Essays on Postmodern Culture,* 119.

2

Individuation Denied: *Variety Lights*
to *Il Bidone*

Each of the films discussed in this chapter focuses on the failure of characters to get beyond conventional illusions and illusory conventions. The fact that the characters are failures rather than victims of crushing determinism—potentially able to break out of their conventional traps—becomes clear in the hindsight of *Nights of Cabiria,* where the protagonist seems to cast off socially imposed illusion and achieve some measure of self-definition. However, it is also suggested by the increasing capacity on the part of Fellini's protagonists from *Variety Lights* through *Il Bidone* to push back the boundaries of social constraint and push out the boundaries of self-assertion. The ability to grow beyond the given and the conventional is where Fellini's secularized Christian symbolism tends to come into play, as characters develop the urge to undergo psychological death and rebirth that, in later films, becomes more explicitly linked to the theme of the Second Coming.

Variety Lights

Variety Lights (1950) was Fellini's first major directing venture. (The title refers to the lights of the "variety" or vaudeville theater.) Though the film was co-directed by Alberto Lattuada, it is entirely consistent with subsequent Fellini work. Moreover, Fellini himself has expressed a strong sense of authorship in discussing the film: "For *Variety Lights* I wrote the original story, wrote the screenplay, and chose the actors. Moreover, the film recalls some worn-out routines I saw presented by a vaudeville troupe with Aldo Fabrizi. ... I can't remember exactly what I directed or what [Lattuada] directed, but I regard the film as one of mine."[1]

The film opens with a shot of a town clock, as a bell tolls the time. Quickly, the camera tilts down to pick up the image of an aged hunchback who leads the camera to a display, outside a theater, advertising Checco's show within. (**Figure 2.1**) Suddenly, the camera is inside, watching the show from a distance, and then from close up. Just as suddenly the camera is up on stage, looking out at the audience from

26

FIGURE 2.1 Despite the co-authorship of *Variety Lights*, this early shot of a marginal figure gazing at a variety theatre poster seems distinctly Fellinian. While establishing the lure of illusion in small-town Italy, it also honors difference and the power of fantasy and spectacle. Source: *Variety Lights* (1950). Directed by Federico Fellini and Alberto Lattuada. Produced by Capitolium. Frame grab captured by Frank Burke from the 2000 DVD.

the point of view of a performer. It has become, in effect, a member of Checco's troupe, caught up in make-believe just like him.

Here the twin poles of the film are established: a world ruled by convention (clock time, bells) and physical determinism (the age and disability of the hunchback), and a world of escape or "freedom," where one can forget the constraints of reality. Moreover, the ultimate dominance of make-believe will recur in each of the film's narrative processes: the geographical progression from the provinces to Rome, the growth of Liliana from a child of the provinces to a soubrette in Parmesani's revue, and the struggle of Checco, via Liliana, to break away from Melina and his troupe and pursue a variety of artificial "lights" or ideals.

The provinces are presented largely as a world of physical activity (especially walking), physical needs and processes (hunger, thirst, eating, drinking), and physical environment (extreme heat, torrential rain, and so on). Moreover, in the provinces, the troupe remains bound by practical considerations: train timetables,

27

performance schedules, expenses, contracts, business commitments. (This is not to say that Checco and company do not endlessly bemoan and try to avoid their environment and obligations.) In contrast, Rome is a world of "International Fantasy," to borrow the title of one of Checco's numbers. It is composed of artists' hangouts, decadent nightclubs, theatrical rehearsals and performances, and it is a gathering place for bohemian artists from distant lands, uprooted and lost in private vision. The epitome of this is the Hungarian choreographer who, unable to communicate the "great significance" of her ballet to her dancers, reduces them all to stasis. The culmination of the Roman phase is Parmesani's revue, where mechanized illusion and escapism rule supreme. In Rome, Liliana and Checco lose whatever ability they may initially have had to relate to others in a concrete and direct way. Though each may leave Rome behind in body at the end, neither abandons the realm of fiction it comes to signify.

Liliana's quest from the beginning is to abandon home, family, and personal ties and become part of a vaudeville world of invention and fantasy. More precisely, her goal is to become a "Star": the creation or projection of other people's dreams. Consequently, her progression from reality to illusion is presented largely in terms of loss of identity. She is forced to rely entirely on males such as Checco, Conti, and Parmesani. She does little to develop her own talents so that her success might be at least partially a reflection of her capabilities. And she sacrifices the energy and independence she possesses early in the film to become a mere decoration in Parmesani's revue. Her growing objectification is suggested when she abandons her dress with her initial L on it, when Checco abbreviates her first name to "Lilli" for advertising purposes, and when she adopts a short, unflattering hairdo and begins wearing tailored suits.

Liliana's loss of identity is accompanied by her growing separation from those around her. The first time we see her, she is in the midst of an audience, and through the early part of the film she has a remarkable ability to connect with people (in fact to force connections). At Parmesani's revue, however, she is high above her audience, and as the act concludes she withdraws still farther, to be covered by a curtain. In the final scene, she is far above Checco in her first-class train compartment, insulated by a fur coat that is far more ample than weather would demand.

Just as Liliana gets swept up by the dream of stardom, Checco gets captivated by his dream of Liliana. In this respect he resembles a later Fellini character, Dr. Antonio, also played by Peppino De Filippo, who becomes obsessed with the billboard image of Anita Ekberg (see Chapter 4). The nature of the Checco-Liliana relationship is suggested by their names. "Checco" is similar in sound to *cieco*, the Italian word for "blind," and Checco clearly becomes blinded by his attraction to Liliana. Liliana's name recalls the mythological Lilith, a symbol of lustful temptation. However, as with Antonio in *The Temptation of Dr. Antonio*, it is

Checco's own susceptibility to delusion that makes woman "evil"; the fault does not lie with Liliana.

As the movie progresses, Checco stops seeing Liliana for what she is (an attractive young woman with her own potential for development) and begins turning her into a symbol of his own advancement. By the time he has arrived in Rome, she has become (in his mind) his ticket to fame, artistic acclaim, wealth, power, and so on. She also becomes his symbol of lost youth, which he feels he can recapture by possessing her.

As the film makes clear, Checco's penchant for falsification and illusion is largely an ego or "head" problem. He sets his head apart from his body by keeping the top button of his coat buttoned. He draws further attention to it by wearing a ridiculous beret. And Melina establishes quite early in the film, as she feels his forehead, that he has a sick or fevered head. It is Checco's head that is emphasized at crucial moments in his abandonment of reality. It is captured by Liliana—both physically and psychologically—when she grabs and kisses it at the lawyer La Rosa's mansion. It is further possessed in a Roman pensione, as Liliana fills it with visions of theatrical glory ("What success lies ahead! ... In every theater we play in. With ... my name this high ... and yours too, in lights up on the marquee").[2] Finally, it is "blown," when Liliana announces that she is leaving Checco, and he passes out.

Although Checco is restored to conscious life by the end of the film, he is not cured. In fact, in the final sequence he is lost entirely in pretense. He tells Liliana that he has become a great success. (The troupe's destination clearly undercuts this.) He pretends that his troupe includes a Viennese ballet. (There is no evidence whatsoever.) He tells Melina he loves her. (He immediately contradicts this by flirting with a young woman.) He pretends that the woman has initiated the conversation. (The opposite is the case.) And, in trying to impress her, he claims a directorial role in the troupe that we have never seen him perform. In doing all this, Checco clings to—in fact, reasserts—all the illusions he had earlier associated with Liliana: success, artistic acclaim, and so on. The young woman now replaces Liliana as his symbol of youth, beauty, and love, and there is no suggestion that Checco can distinguish between reality and fiction. More egoistic and *cieco* than ever, he has turned all the world into a stage and himself into the main attraction.

Variety Lights provides a useful introduction to Fellini's films. Even the title, while referring principally to a world of illusion, also implies art and enlightenment, which will be of major concern to Fellini in more affirmative movies such as *Nights of Cabiria*, *8½*, and *Juliet of the Spirits*. The problem of self-deception will be central to all Fellini's films. The problem of the alienated ego or head will confront all Fellini's major characters from Ivan and Wanda in *The White Sheik* through Ivo in *The Voice of the Moon*.

Although *Variety Lights* is relatively conservative in terms of cinematic style, the opening moments, in which the camera itself proves the most important "character," hint at the extraordinarily complex role the camera eye will come to play in Fellini's later films.

Finally, and perhaps most important, *Variety Lights* establishes the problem of growth as the crucial issue in Fellini's early work. For all their failings, Checco and Liliana are trying to make life better for themselves. The struggle for self-realization—and the varying ability of characters to achieve it—will be a major component of Fellini films through the 1950s and 1960s.

The White Sheik

The White Sheik (1952), Fellini's first film as sole director, evolved from a script by Michelangelo Antonioni that focused on the *fotoromanzi* ("photo novels") that had become so popular in Italy at the time. Antonioni had no direct input into the film itself, and it is clearly identifiable as Fellini's rather than Antonioni's work.

The White Sheik and *Variety Lights*

Much as the title of *Variety Lights* suggests that all its world is theater, the title of *The White Sheik* suggests that all its world is a photo novel. Despite differences in locale and characterization, both films assert the all-encompassing presence and problem of make-believe. (To some extent, locale is not all that different, since Rome is the headquarters of illusion in each.) Not only is the underlying problem the same, but the same basic processes recur. A male and a female character begin, in a sense, married to each other (strictly speaking, Checco and Melina were, at best, engaged). They are temporarily "divorced" as one of them pursues an ideal love. Then they reunite, under false pretenses, when the ideal fails. Put another way, characters move from reality to fantasy, and when the object of fantasy is removed (Liliana for Checco, the White Sheik for Wanda), they return to reality only to impose fantasy on it. Seen in this light, the final scenes of *The White Sheik* and *Variety Lights* are quite similar. Just as Checco lies about his success and claims to love Melina, Ivan and Wanda dissemble about their recent past, and Wanda decides that Ivan is now her "Sheik."

There is, however, one significant difference. While Checco is completely self-satisfied in his dream world at the end of *Variety Lights,* Ivan is not. He remains troubled by the sense that something went wrong the day before. And though he is pretty much forced to accept the fictive "solution" provided by Wanda, he ends the film in a state of puzzlement. In this respect, he serves as a

link between the wholly accepting Checco and Moraldo of Fellini's next film, *I Vitelloni,* who will respond to his world with dissatisfaction to the point of outright rejection.

As in *Variety Lights,* growing illusion is accompanied by loss of identity. This is even more pronounced in *The White Sheik* and is expressed largely through a seduction/"rape" motif. It is in the midst of a *fotoromanzo* episode about mass abduction that Wanda is seduced out to sea by the Sheik and stripped (in mind) of her identity as Ivan's new bride. (Significantly, Wanda is only known by "aliases" in the world of the Sheik: "Fatma," the name she is given as a character in the episode, and "Passionate Doll," the pen name she adopts for the Sheik.) At the same time, while Ivan's relatives are watching the seduction-studded opera *Don Giovanni,* Ivan is at the police station having his identity dragged out of him and "killed" by a typewriter that sounds like a machine gun. The loss of identity culminates, of course, in the final scene when Wanda must, in effect, turn her relationship with Ivan into a *White Sheik* episode in order to preserve it. (From the perspective of the 1990s, the treatment of rape as a metaphor that can encompass male as well as female experience is clearly problematic. In the 1950s the inappropriateness would not have been so obvious.)

Finally, as in *Variety Lights,* illusion is seen largely as a head or ego problem. Wanda is accurately diagnosed as having a headache that pills cannot cure. Ivan is, like Checco, both a hat fetishist and a supreme egotist. And like Checco, he "loses his head" (fainting) near the film's end. The sickness of the head is so severe (and comical) that Ivan and Wanda are united in an insane asylum just prior to the conclusion.

While *The White Sheik* addresses many of the same issues that appeared in Fellini's preceding movie, it does so in a more extensive way. For instance, in *Variety Lights,* the issue of illusion or make-believe was pretty much restricted to the theatrical world that embodied it. In *The White Sheik,* however, it is extended both through and beyond the *fotoromanzi* to include an entire Roman world of institutionalized authority—a world of almost exclusively masculine hierarchies epitomized by church and state.

The *fotoromanzi* themselves subtly bear the influence and authority of the church. With their White Sheik "god" who descends from on high (**Figure 2.2**), with episodes entitled "Sins of Damascus" and "Souls in Torment," with characters such as "Fatma" (cf. Our Lady of Fatima), they are Catholic mythology rudely transformed into romantic fantasy. Thus Wanda, in submitting to the world of the *fotoromanzi,* is submitting in surrogate form to Catholicism. This helps "explain" her later submission to the overt Catholicism of the papal audience, Saint Peter's, and Ivan's uncle. Present implicitly in the *fotoromanzi,* institutionalism is a blatant source of fantasy in Ivan's world. As Fellini has said, "While Wanda follows

FIGURE 2.2 The apparition of Wanda's White Sheik "deity," prefiguring the white angelic figure at St. Peter's at film's end (a stand-in for the Pope)—and implying patriarchal fantasy at the heart of both Italian popular culture and Catholicism. Source: *The White Sheik* (1952). Directed by Federico Fellini. Produced by OFI and P.D.C. Frame grab captured by Frank Burke from the 2003 DVD version.

The White Sheik as her dream romantic hero, [Ivan] follows his own mythology, consisting of the Pope ... *bersaglieri,* the nation, the king" *(ED,* 125). Through Ivan, Fellini identifies institutional authority with abstraction, falsehood, and the destruction of individuality. Moreover, by accentuating Rome as the seat of Institution, he prepares for later films such as *La Dolce Vita* and *Roma* in which he will see the Eternal City not just as a source of distinctly Italian problems but as a center of illusion for the broader Western world.

The problem of dependency

One of the greatest limitations of the film's characters is their extraordinary dependency. Ivan's quest is for conformity and security within some fixed structure. He (even more than Wanda) lives in a world of uniforms: priests, nuns, boy scouts, soldiers, porters, policemen. He himself is always uniformed, as is his uncle.

Their ever-present suit, tie, and hat make them soldiers in the army of Respectable Bourgeois Citizens.

Moreover, all the major characters try to become or remain a child in some sort of family unit. Ivan's activity in the film is little more than a sustained search for the father—his uncle and the pope being the two primary embodiments of that parental role. Wanda initially seeks inclusion in the "family" composed of the crew making *The White Sheik* episode, a group presided over by a clearly paternal/patriarchal director. When that does not work, she settles for inclusion in Ivan's extended family. Ivan's uncle, of course, is a child within the family of the Vatican, and he, too, is off to see the Father *(Il Papa)* at the end. Even the White Sheik/Nando is revealed to be nothing more than a child when he and Wanda return to shore and he must answer to his "parents"—the director and his (Nando's) matronly wife.

The characters' inability to grow beyond childish dependency lies at the center of one of the film's major recurring patterns: "break out" followed by "cop out." At the beginning of the film, Ivan and Wanda are (potentially) in the process of getting free of the provincial world of their immediate families. Shortly thereafter, Wanda breaks away from her restrictive relationship to Ivan and, in so doing, breaks beyond Rome to Fregene. Nando momentarily forsakes his director and his oppressive marriage as he abducts Wanda in a sailboat. Ivan repeatedly deserts his extended family as he tries to conceal and solve the problem of Wanda's disappearance. However, Ivan and Wanda leave their immediate families only to submerge themselves in his at the film's end. Wanda's break-out ultimately lands her in an insane asylum, where she capitulates to Ivan's obnoxious authority ("You have five minutes to get dressed. I don't want to hear anything now. First comes the honor of the family ... Get dressed right away" [ES, 194]). Nando ends his adventure a cowed, repentant little boy. And Ivan breaks away only to rely on other parental figures—the police commissioner, a motherly prostitute, the authorities at the insane asylum—and only to return to uncle and *Il Papa*.

The illusion/delusion of marriage

One of the ways in which *The White Sheik* addresses both fantasy and childishness is by demystifying marriage. In the course of the film, it is revealed to be little more than disguised alienation—a fiction compensating for the fact that characters cannot truly communicate. This is discernible even among secondary characters such as Ivan's aunt and uncle and Nando and Rita. But it is most evident in the relationship between Ivan and Wanda. The first thing they do on reaching the hotel is lose each other. Then Ivan yells orders and reads his appointment book while Wanda dreams abstractly of pursuing the Sheik. Their honeymoon, if such it

can be called, consists of dissimilar experiences that leave them with even less in common by the end than they had at the beginning, making the presumed papal authentication of their wedding at the end extremely ironic. Throughout their final conversation, they never appear in the same shot.

Fellini's view of marriage was no doubt inspired at least in part by the harshness of Italian marriage laws at the time. An annulment—the only form of divorce acknowledged in Italy—was virtually impossible to get, leaving many people trapped in loveless relationships. From here on in, marriage will be a recurrent motif for Fellini in his examination of the problem of love. In *I Vitelloni, Agenzia Matrimoniale (1953; Marriage Agency),* and *La Strada* it will reappear as a false solution; in films such as *Nights of Cabiria* and *Juliet of the Spirits* it will be expanded beyond institutional limits to become "marriage to everyone," a spiritual and ideal relation based on individuation rather than dependency.

Differences and their denial

The characters in *The White Sheik* are marked by profound closure, profound avoidance of the unknown. Ivan's scrupulously planned trip to Rome (the Pantheon, the Colosseum, the Palatine, the Forum, the Vatican) is designed to avoid any unscripted experience—anything that is not, on some level, already known. The hotel clerk's humorous attempt to sell Ivan postcards on two occasions underscores the Roman experience as something already captured, documented, and up for sale. Wanda's pursuit of the White Sheik, while significantly more adventurous than Ivan's itinerary, is also an attempt to meet a figure she has already encountered via her *fotoromanzo* perusals. She has no interest in exploring the city or discovering something radically new. Concomitantly, the plot of the film is largely driven by an appointment (the papal audience) arranged before the action of the film begins and fulfilled at its very end.

The film links closure to clannish exclusivity. It is no accident that the major threat to Ivan's world is a figure who presumably represents significant cultural difference.[3] However, the threat is neutralized from the start, as is implied by the fact that this Sheik is white—alluding to a history of Italian imperial designs on Africa and other regions with Arab populations.[4] As a Mediterranean culture, Italy has a complicated relationship to whiteness, and it would be a mistake to simplistically equate Italy and whiteness, but it seems clear from the film that Fellini sees Italian culture as appropriating whiteness in its prejudicial differentiations—something that has been done consistently in northern Italians' references to southerners as "neri" or "africani," and in much recent hostility toward black immigrants. The fact that this White Sheik turns out to be such a ridiculous figure places the imperialist whitening of darker cultures, including its own, in a strongly negative light.

34

The color dynamics of the film are heightened by the fact that the Sheik's enemy is the dark and evil Bedouin Oscar, whom we might view as the uncolonized North African, though the actor is Roman and his darkness is as much a matter of make up as of skin tone. At the same time, *fotoromanzo* "darkness" is completely in the hands of "white" culture: i.e., the staff at Incanto Blu and, most noticeably, the director of the shoot, a white-haired old man who dons a colonial helmet as the shoot begins. The film carefully eradicates darkness by the end, renouncing the pseudo difference of the *fotoromanzo*; moving from the dark nights of the soul experienced by Ivan and Wanda to a cloudless and sun-bright day at St. Peter's; promising a visit to the Pope, whose association with white (habitual white cassock, white smoke upon election) turns him into the true White Sheik of Ivan and family; and, of course, fixating on the white statue of a saint that, along with the white-scripted "Fine," ends the film.

In part through her link to the whitened sheik, Wanda is the character through whom difference is most consistently denied. Despite the conventionality of her attraction to the *fotoromanzi*, she also represents a significant degree of nonconformity. She encounters the unexpected, and in so doing drives the action of the film, commanding, even in her absence, the constant attention of Ivan and his relatives. She ruptures protocols around her stifling marriage, overbearing husband, and newly acquired[5] social status. She is unfaithful in her fantasy life and saved only by the sail boom that smacks Nando in the head from being so in the flesh. She even tries to commit the most unpardonable of Catholic sins: suicide— a sin which, as with infidelity, she seems to commit in spirit. She is also the one who initiates the conversation with Ivan at the end of the film that effects a highly unconventional, even troubled, reconciliation.

Part of Wanda's difference lies in her ability to inhabit numerous identities— Wanda, Passionate Doll, Fatma—even to the point of self-loss. "I seem to no longer be me," she observes, as she closes her eyes to be kissed by Nando. Her seduction is made possible because she inhabits not only identities but subject positions. Nando makes up a ridiculous story of how his true love, Milena, was done away with by his wife Rita on the day of his and Milena's planned wedding. Wanda empathizes fully with him as he weaves this tale, making herself vulnerable to his advances. At the same time, she identifies with Milena, exhibiting not jealousy with a competitor but compassion for Milena's tragic fate. Wanda effectively puts herself in the place of Milena, the rightful wife, thus legitimizing her surrender and remaining "pure and innocent" as she claims at the end.

Wanda's embodiment of difference extends to class. Unlike her husband and his family, she connects immediately and persistently with non middle-class characters. The porter Fulvio points the way to the site of the Incanto Blu magazine. (Ivan is outraged that she took the elevator up to the room alone with the porter.)

Her first points of contact there are two men cleaning the offices. The actors—and Nando, in particular—are proletarian. She gets a ride back to town with Mambroni, who sports underwear, in contrast to the hyperdressed Ivan and family. She has a poignant conversation with Fulvio just before leaping into the Tiber, And she is "rescued" by Ciriola, a man who lives in a shack by the river.

Both Wanda's difference and its denial are most obviously operative in the realm of gender. She is treated dreadfully as a wife and a woman. She is bullied by Ivan before her escape, sexually targeted by Nando, propositioned by Mambroni, placed in an insane asylum, bullied again there by Ivan, and dragged into the family unit and the consecration of their marriage. She is never asked at the asylum why she attempted suicide. She is handed over to Ivan as an object, with no concern for her wellbeing. Ivan effaces her experience ("I don't want to know anything now"), and permanent effacement is inevitable once she arrives at St. Peter's. The scene there is oppressively phallic/patriarchal. It begins with a tilt down from the Vatican obelisk. The uncle sports a rigid umbrella that he attaches to one of the arms with which he embraces Wanda. And she is now in the hands of Ivan, the Uncle, the Pope, and the stone angel on high. The umbrella replaces Nando's sword, a symbol of his unstable—but for that reason less obliterating—masculinity, which he has trouble unsheathing during the shoot, then leaves on the boat for Wanda to carry and hold as he shrivels in the presence of his powerhouse wife.

Stasis and motion, word vs, image

The suppression of difference in *The White Sheik* can be linked to two major conflicts that relate to the medium of movies: stasis versus motion and word versus image. Within Fellini's earlier work, motion and image are often seen as cinematic and life-affirming, while stasis and language are often seen as uncinematic and repressive. Fellini's love for motion is arguably linked to his fascination with American ideology—hence with the American ethos of living life "on the move." (America, motion, and Fellini come together more specifically in Fellini's passion in the 1950s for driving a large and fancy Chevrolet.)[6] The word/image dichotomy is part of a larger distinction between concreteness and abstraction that posits language as the embodiment of the latter—and of social coercion—forcing us to think only in terms of cultural lexicons. In this context, language has been blamed for dissociating us from our senses and from the immediacy of experience on which creative imagination depends. The sense often privileged within this kind of discourse is sight, and this privileging coincides with the importance of image and vision in the movies.[7] The denigration of language runs counter to much 20th-century philosophy and to the theoretical dominance, even within film studies, of

semiotics. Fellini's privileging of the visual is part of a certain modernist tendency to seek to identify and champion the specificity of each art form. In this case, movies are seen as a fundamentally image-based medium.

One of the principal characteristics of the *fotoromanzi* is their stasis. Because they cannot capture live action, they must present a world that is fixed: permanent and absolute in its fictiveness. Fellini emphasizes the killing of motion by having the actors in the *fotoromanzo* freeze into stop-frame poses during the shooting of the rape sequence. It is precisely this quest for permanence that we have identified as Ivan and Wanda's problem. More precisely, it defines Wanda's inability—despite her seeming capacity for adventure—to get free of the rigid and linear Ivan. Though she wanders and wonders far more than he, it is only in search of something that can provide happiness ever after and free her from the responsibility of struggling to live moment to moment.

Language proves perhaps even more of a problem than stasis,[8] and Wanda is the character most directly affected. Words in the film are associated principally with the institutional world—the world of tradition and authority. As a humble servant of that world, Ivan is a consummate word person, with his appointment book, his poetry, his repeated use of the phone, his elaborate explanation of Wanda's absence, and his reliance on her note to the White Sheik as his only piece of evidence. To the extent that Ivan uses his eyes, it is either to read words or to stare bug-eyed at the world in utter incomprehension.

Wanda, on the other hand, is far more sensitive to images. Not only is she enthralled by the predominantly visual world of the *fotoromanzi*, she herself is a visual artist who draws a large sketch of the Sheik. In addition, especially early in the film, she tries to let her eyes get her where she wants to go. (Even her initial meeting with the Sheik is presented more as a visual apparition than as the result of any directions Wanda has received.) Her desire to see, in turn, is linked to a far greater capacity than Ivan's to live life with spontaneity and imagination.

Unfortunately, she lives in a world dominated by words. The *fotoromanzo* episode is controlled entirely by the director and his megaphone; script proves far more important than image. Ultimately Wanda and her visual orientation end up victimized by language. The Sheik tells lies that humiliate her, and with her vision of love destroyed she must succumb to Ivan's absurd verbal demands at the insane asylum. The culmination of this, of course, is the final scene, where she closes her eyes and allows words *("You* are my White Sheik" [*ES*, 197]) to take over, once and for all.[9]

Although Fellini's analysis of institutional aesthetics and his use of the *fotoromanzi* refer only obliquely to film, they do—like the role of the camera at the beginning of *Variety Lights*—suggest a sensitivity to the medium that will become consummately self-conscious in films like *The Temptation of Dr. Antonio* and *8½*.

37

The White Sheik marks the introduction of Giulietta Masina's Cabiria as a streetwalker who comforts and accompanies Ivan. A dynamic and compassionate figure who is far less interested in prostitution than in spectacle and self-expression, she will prove the inspiration for *Nights of Cabiria*.

Though the focus of my analysis has been on the structure and significance of *The White Sheik*, we cannot ignore the fact that this tale of hapless honeymooners is nonstop entertainment. Despite the fact that it was underappreciated upon its release, it has accumulated a legion of followers, among whom Gene Wilder, whose *The World's Greatest Lover* (1977) is a homage, and Woody Allen, who has called it perhaps the greatest comedy of the sound era.[10]

I Vitelloni

I Vitelloni (1953) was the first of Fellini's films to receive substantial critical acclaim. It was awarded the Silver Lion at the Venice International Film Festival, and it became the first Fellini film to gain international distribution. The title of the film derives from dialect, and its precise origin is in dispute. It has been translated as "the big calves," which accurately reflects the film's portrayal of postadolescent males who refuse to grow up—remaining unemployed, at home, and reliant on their (usually middle-class) families.

Like *The White Sheik* and *Variety Lights*, *I Vitelloni* is largely about characters who become accommodated to lives of illusion and social convention. At the same time, there is a more intensive analysis of the way society generates conformity. In fact, while Fellini's earlier films tended to emphasize individuals, *I Vitelloni* tends to pay equal attention to the subtle sociopolitical pressures that erode individuality and make submission to institutional illusion virtually inevitable. As a result, *I Vitelloni* is somewhat of an anomaly among Fellini's films and more acceptable than most of Fellini's work to critics who favor social realism.

Social analysis in *I Vitelloni* is built to a large extent on the seductive conservatism of the commonplace. We are given a typical situation to which characters react in perfectly normal ways. The events are so typical that we are inclined to accept them uncritically. Yet if we look closely, we discover that they (and our own inclination to accept) conceal and justify conservatism, the quest for security, fear of the "open air." The thunderstorm at the film's beginning is a case in point. Everyone scurries for cover—perfectly understandable it would seem. Yet the storm and the mad dash for shelter help define a society that, in the largest sense, cannot face the elements.

As this event might suggest, there is an implicit distinction in *I Vitelloni* between the concrete immediacy and unfolding of life and experience and organized

society—structures and abstractions created to keep the immediate and unpredictable at a distance. This will evolve into a nature/civilization dichotomy central to *La Strada*. Also emerging in relation to the life/society dichotomy is a profound absence of love. Love, it is implied, is the kind of creative engagement that would evolve naturally among individuals and within communities were life able to unfold undeterred by social constraints. Beginning with *I Vitelloni,* love in this broad sense begins to function as a kind of umbrella theme in Fellini's work, linked to the issue of loneliness and noncommunication that Fellini has noted as central to *La Strada*. It has links, of course, to notions of authenticity, and Fellini's later films, such as *Fellini's Casanova* and *City of Women,* will do much to undercut its presumed naturalness.

The life-denying world of the *vitelloni* is clearly defined by its response to Sandra's pregnancy. ("New life," of course, is an especially privileged sign of the world unfolding.) Sandra herself responds to the pregnancy by fainting. For one thing, this is a movie cliché, emphasizing the conventionality of her behavior. Second, it is one more instance in which Fellini characters "lose their mind," making the cliché part of a broader analysis of the tenuousness of (self)conscious life among his characters. Third, it metaphorically marks Sandra's desire to escape her situation. When she comes to, she emphatically states, "I want to die. I want to die,"[11] signifying an escapism and, simultaneously, a death-in-life attitude characterized by bourgeois society throughout the film. (**Figure 2.3**)

Sandra's will to evade is mirrored in her brother Moraldo, who keeps telling their mother "It's nothing" *(TS* 13–14), and by the doctor, who orders the room cleared before disclosing his diagnosis. He never does disclose anything, thus acknowledgment of the pregnancy remains suppressed until the following scene.

Consistent with their negative response to the pregnancy, the characters prove far more attuned to endings than beginnings. The Miss Siren contest celebrates not spring but the end of summer. Leopoldo reacts to the thunder and lightning by predicting that it will be the end of the party. Just before Sandra faints, Moraldo remarks that it "looks like the end of the world" (*TS,* 11). And, at the beginning of the next scene, Fausto notes that it is the end of the season.

Society never does treat Sandra's pregnancy as pregnancy. At first, it is dealt with only as a violation of convention. Then, through the institution of marriage, it is turned into a convention itself. As a result, even the wedding is an ending more than a beginning. It puts a *stop* to a socially unacceptable situation. All this again seems quite normal. (It must have seemed particularly so at the time.) Yet the subtly self-serving conservatism that underlies the characters' actions is made clear when Fausto's father insists on marriage not to provide a stable family environment for the child but to preserve his honor and that of Sandra's father.

A world that cannot live openly—that must turn life into convention—is, within the logic of the film, incapable of love. In fact, it must turn love into

FIGURE 2.3 In the life-denying world of *I Vitelloni*, Sandra responds to her pregnancy with a death wish. Source: *I Vitelloni* (1953). Directed by Federico Fellini. Produced by Citè Films and Peg-Films. Frame grab captured by Frank Burke from the 2004 DVD version.

convention—into symbols and objects that can be manipulated, kept at a distance, and substituted for real involvement. The Miss Siren contest makes this clear. Love is reduced to the female as sex object, and that object, in turn, is neutralized, "sterilized," by being put on a pedestal for all to see but no one to touch. (The fact that Sandra has indeed been touched is the ultimate affront to the repressive-projective psychology of the beauty pageant.) Moreover, the love object herself has no autonomy. She has (we are told) been pressured by her mother into entering the contest. She is insulted and interrupted (albeit playfully) by Riccardo when she is about to make her acceptance speech. She is led, pawed, pulled, and hemmed in by her admirers. And by the end of the scene she is prostrate in the care of a doctor whose severe patriarchal image introduces the world of male authority that will repeatedly assert its control during the film.

The absence of love as anything other than convention is, of course, evident in the marriage of Sandra and Fausto. They are never seen together before the wedding. (Fausto spends the evening of the contest pursuing another woman.) They are united not out of love but out of social and paternal pressure. (Fausto tries to run away but is bullied by his father into facing up to his responsibilities.) As in

The White Sheik—but in a much less comic way—marriage comes to deny rather than promote true interaction.

As the movie progresses, the inability of characters to free themselves from social constraints remains clearest in the Sandra-Fausto relationship. Once Sandra is neutralized in the opening scenes—both by her world and by her own implicit "death wish"—she comes to embody social convention herself: playing the traditional roles of dependent wife and mother and failing to make a life of her own. (The possibility for her to do so at the time in provincial Italy is minimal, which is part of Fellini's point. On the other hand, Fellini was married to a woman who did develop an independent identity—though one might argue that it was circumscribed, at least until Masina became a television star in the 1970s, by her status as Fellini's wife.) Fausto, on the other hand—like Wanda—tries to escape the institutionalized life of marriage. However, again like Wanda, he escapes only into new and greater dependency relationships, and when Sandra temporarily deserts him, he discovers how reliant he is on her. They end up reconciled out of weakness rather than strength, need rather than love, much like the characters of Fellini's preceding movies.

The way the reconciliation comes about reveals just how dependent Fausto has become. First of all, unable to find Sandra on his own, he visits the town's religious articles shop and places himself in the hands of Signor Michele. As an authoritarian figure, linked to Catholicism through his work, Michele is *the* supreme embodiment of convention in the film. (He also is trapped in a marriage of convention more than love.) Moreover, as Fausto's former boss, he has already been associated with Fausto's forced capitulation to the social order. Fausto's return to Michele's authority marks a second, far more absolute, capitulation. Second, Michele takes Fausto to Fausto's father, who soundly thrashes him as the condition of reunion with Sandra. This scene recapitulates the prewedding encounter in which Fausto is bullied into marrying Sandra, but here the authoritarianism of the father is even more pronounced. Finally, the Sandra to whom Fausto reconciles himself has become an authority figure. She is a parent, not a wife, and Fausto submits as a child, not a husband:

> SANDRA *(severe):* ... If you get me mad another time, I'll do just like your father. Even worse!
> *Fausto stops and smiles at her. For the first time he sees Sandra in a new light. She is no longer the little girl who suffered every wrong, submissive and humble, playing the role of the victim.*
> SANDRA *(decidedly):* I'll beat the hell out of you!
> *Fausto looks at her again.*
> FAUSTO *(smiling):* That's the way I like you! (*TS,* 129–30)

41

"Youth fades away, love fades away" (*TS*, 100). So says the aging actor Sergio Natale during a stage monologue, and his words capture a crucial reality, not just in the Sandra-Fausto relationship, but in the lives of all the characters as they continue to substitute objects, symbols, and illusions of relatedness for more direct engagement. At its most mundane, this consists of relating to one another merely to borrow a cigarette, a light, money, or some other mediating article (another instance of Fellini using the commonplace to sketch social evasions and conventions). On a more profound level, Alberto replaces love with dependence on his sister, Leopoldo supplants communication (his urge to be a dramatist) with worship of the washed-up Natale, the town feigns community through a carnival where everyone is disguised or drunk, and Catholicism reduces itself to the artifacts bought and sold at Signor Michele's emporium.

The theft of the wooden angel is emblematic. Here a presumed symbol of the spiritual becomes the only means for Fausto to avenge the fact that he has been fired, and the statue becomes the sole source of connection between Fausto and Michele, Fausto and Moraldo, and the two *vitelloni* and their world. Moreover, when the *vitelloni* entrust the angel to the mentally impaired Giudizio, who paws it reverentially, the angel comes to define a world where "love" can degenerate into forms of idolatry. The culminative expression of this is Natale's revue. After a series of maudlin routines, the revue presents a dancer (with whom Fausto later spends the night) dressed as the Italian flag. Society's symbol of love is no longer Sandra or Miss Siren; it is Italia. Her concluding number, which captivates the audience, suggests that love reduced to dependency, objectification, and illusion leads to the kind of patriotism that gave rise to Fascism.

In many ways the key figure in *I Vitelloni* is Moraldo. As his name suggests, he embodies the "mores" of his world. He repeats the phrase "It's nothing" five times within a few moments of the opening scene, making clear that, like everyone else, he is given to suppression. Furthermore, in a more significant way than anyone else, he responds to Sandra's pregnancy in a conventional rather than a fully human way. He is Sandra's brother. Yet when she has regained consciousness and is lying on the floor in both physical and spiritual distress, he makes no effort to comfort her. Instead, he immediately begins to suspect "the worst" and to cast questioning glances at both Sandra and Fausto. Then he leaves her on the floor and pursues Fausto to convey his concern with this disturbing violation of convention. (Though he has not yet become openly censorious, his presence at Fausto's house is clearly a reminder to Fausto of his obligations.) Subtly, yet unmistakably, he can view Sandra and Fausto only as transgressors—not as sister and friend. It never crosses his mind to see his sister's pregnancy in a positive way.

As the film progresses, Moraldo's mores harden into morality. His tendency to adopt a critical stance toward life becomes far more pronounced. His escapism

and detachment (he is always star-gazing or staring absently off into space) lead him to withdraw behind standards of right and wrong, to relate to people only in a spirit of judgment.

His quiet concern regarding Sandra's pregnancy becomes explicit but entirely misplaced criticism of Michele for firing Fausto. This is followed by a "righteous" act of vengeance, as he helps Fausto steal the wooden statue. (Here Moraldo is kin to Michele and to Fausto's father, each of whom subscribes to a morality of retribution.) Next, he wrongfully accuses Michele's wife (to Sandra) of making advances to Fausto. Then he becomes uncompromisingly critical of Fausto for his evening with the woman from Natale's revue. His behavior as he tries to make Fausto feel guilty outside the woman's hotel prompts Fausto to ask, "Want to *preach* to me? Is that why you waited?" (subtitles). Moraldo's judgmentalism becomes even more extreme after Sandra has disappeared with the baby. Fausto, distraught, tells Moraldo, "If she doesn't come back, I'll kill myself." Instead of supporting his friend or focusing on the potentially tragic implications of his sister's and nephew's disappearance, Moraldo says, "You won't kill yourself, you're a coward (TS, 123)—suggesting that suicide would, under the circumstances, be a positive act. By this point Moraldo is unable to relate to life in anything other than negative and moralistic terms. Consequently, his departure in the final scene becomes his conclusive moral "statement" about his friends, his town, his life to this point, his world.

Moraldo is not presented unsympathetically in *I Vitelloni*. His growing inclination to censure is, like so much in the film, normal and understandable. What it serves to do, however, is illuminate a world in which life reduces to morality, an extremely authoritarian form of convention. Morality, in fact, becomes the final and most destructive love surrogate as human relations become arbitrated in terms of how people should and should not behave. *I Vitelloni* is careful not to identify this solely or even principally with the Church. The point instead is to show how thoroughly such morality has come to infect every aspect of provincial existence, even the most secular.

Because Moraldo's decision to leave town is merely another form of rejection and escape, rooted in precisely the kind of mentality that has created all the problems in the film, it fails to solve anything. His departure is yet another end, not a beginning. This is strongly suggested when his train begins to leave the station and he looks out the window, ahead, presumably to the future. All he can see is a vision of the past: images of the other *vitelloni,* Sandra, and Sandra's child at home, in bed, asleep. Wounded by a past he cannot leave behind, he slumps to a sitting position, eyes full of tears, and lowers his head to his hands. (**Figure 2.4**)

Moraldo's dead-to-the-world companions suggest the loss or denial of consciousness; the surrender to security, home, and family; the isolation; and the

43

FIGURE 2.4 Moraldo's final moments in the film, slumped with head on hands, belie common interpretations of his behavior and departure in *I Vitelloni* as positive. They bespeak dejection, even defeat, rather than adventure and promise. Source: *I Vitelloni* (1953). Directed by Federico Fellini. Produced by Citè Films and Peg-Films. Frame grab captured by Frank Burke from the 2004 DVD version.

death-in-life that provincial existence fosters in the film. An even more poignant representation is provided by the film's brief concluding sequence. Guido, a young, cheerful acquaintance of Moraldo who works at the railroad station, has followed Moraldo's train part way down the tracks. With Moraldo gone, he turns around and heads back."[12] He does a tight-rope walk, with arms extended, on one of the rails; receives a paternal pat on the head from a uniformed male; slips momentarily off the rail; quickly steps back on; and freezes when a stop frame immobilizes his image in a pose both birdlike and cruciform. Among other things, this concluding sequence reduces Guido's helical dance down the street in an earlier scene to a mere "toeing of the line"; entraps Guido in a world of male authority and uniformity (Guido, too, is uniformed); and replaces the arm-in-arm linkage of the *vitelloni* from the credit sequence with Guido's arms that touch no one. By freezing the young Guido as a cruciform figure—a Christ symbol—the concluding image sacrifices the new to the old, the unique to cultural abstraction. It asserts once and

for all that the world of *I Vitelloni,* in its hostility toward the new, can eventuate only in endings.

On the basis of the above, I find it strange that so many commentators see Moraldo's departure as an unambiguous breakout, leading to greener pastures and a more fulfilling future. They may be swayed by the positive ending of Fellini's unfilmed script "Moraldo in the City," but certainly the trajectory of Moraldo's cinematic successor Marcello in *La Dolce Vita* does not encourage an optimistic retrospective reading of Moraldo's leave-taking. On the other hand, as numerous critics have noted, Fellini always viewed his characters with kindness and compassion, and though I am drawing conclusions based on the sum of Moraldo's behavior and world, Fellini would not have been as totalizing as I in his assessment of his protagonist. (My reading turns me into a bit of a moralizing Moraldo.)

In fact, the possibility of a doubled or ambivalent response becomes increasingly characteristic of Fellini's work—and one of its most appealing attributes-reflecting Fellini's oft expressed repugnance (despite the closing freeze frame of *I Vitelloni*) for putting "The End" at the conclusion of his films. In Fellini's mind, the film is an act of transmission to be carried forward and retransmitted by its spectators.

The White Sheik could be seen as a movement beyond *Variety Lights* principally because it told the same story (characters submitting to illusion) with greater complexity. *I Vitelloni* not only tells it through Fausto, Sandra, Leopoldo, Alberto, and Riccardo, but it also tells a new and crucial one through Moraldo: the rejection of illusion and convention. His attempted self-liberation starts Fellini's work on the road to stories of individuation. The false marriages that have provided a principal motif in Fellini's first two films give way to "divorce" and uprootedness as Fellini's characters get beyond town and family.

I Vitelloni also marks a change for Fellini in terms of narrative technique. There is greater complexity in characterization, which is evident not only in the increased number of major figures but also in the subtle narrative function of the five *vitelloni*. Each ultimately comes to "specialize" in a single facet or power of personality: Fausto is the physical figure, Alberto the emotional, Leopoldo the intellectual (pseudo though it is), and Moraldo the institutionalized conscience or superego. Riccardo—the entertaining emcee of the Miss Siren contest and a talented tenor who sings at the wedding—is played by Fellini's brother, resembles the filmmaker, and suggests Fellini's creative function. At the film's beginning he is the town's unifying voice and expressive force, but consistent with the nature of his community, he remains subsidiary and becomes even less important as the film progresses.

The film also introduces voice-over narration, with interesting metaphoric implications. In a world where inner harmony and relatedness are absent, the

narrator offers a kind of imposed harmony—the disembodied authority to whom the characters and their world owe their existence.

Marriage Agency

Marriage Agency (1953) is one of several episodes in a neorealist film anthology produced by Cesare Zavattini and entitled *L'amore in città (Love in the City)*.[13] Zavattini himself contributed an episode, as did Antonioni, Lattuada, and Dino Risi. Zavattini intended *Love in the City* to fulfill his neorealist notions of film as objective reportage: "In [*Love in the City*] real events were to be related, with the real-life characters in those events talking about themselves in front of the camera, without the interference of a director. It was to be, purely and simply, a documentary."[14] Refusing to embrace Zavattini's aims, Fellini made the most obviously fictional of *Love in the City's* episodes. Moreover, the nature of Fellini's story subtly subverts the intent of Zavattini's project. Though Fellini makes his main character a reporter (providing surface consistency with the project), he makes the reporter's professional detachment the symptom of profound blindness.

As a story of mediation and detachment, *Marriage Agency* has much in common with *I Vitelloni*. It also focuses—as do all Fellini's preceding movies—on dependency, convention, and the absence of love. All three are suggested by the role of the agency: a commercial institution on which people rely to provide marriages based on contractual arrangement rather than emotion and attraction. The extent to which love is compromised is implied by the agency's striking resemblance to a brothel. It is presided over by a "madam" (the "Signora"), guaranteed protection by the police (Attilio, the Signora's associate, is an ex-cop), and set up to procure young ladies for males. In this respect, the film satirizes the paradoxical combination of Italy's strict marriage laws, suppression of sex, and permissive attitude toward houses of prostitution.

Marriage Agency consists of two interrelated tales: the awakening of sensitivity on the part of the reporter through his encounter with Rosanna, and the growth to adulthood. However, the positive nature of each is subverted by the film's overall vision. The reporter's awakening is revealed to be mere self-delusion, and he grows to maturity by losing the ability to relate to others, especially Rosanna. The two stories merge into a single process of "divorce" and "*adult*eration" in which everything potentially unitive and childlike is destroyed.

Early on, the world of the film is populated principally by children. The most important character, aside from the reporter himself, is a young girl who leads him to the agency's doorstep. The adults who appear are ineffectual and seem to exist largely as support systems for the young (for instance, mothers caring for

their babies). Not only are children everywhere in evidence, but the film conveys an atmosphere of childhood. The action is fluid and irrational as children magically appear, weave their way through the labyrinthine passages of the apartment building, then disappear. Childhood intuition is a major force as the reporter's young guide realizes that he is looking for the agency without being told so. Even the reporter has many of the positive qualities of a child: openness, curiosity, spontaneity. Despite his journalist's singularity of purpose, he remains largely in tune with everything around him.

Of course, coexisting with the image and character of the reporter is his voice-over narration, describing in the past tense what he earlier underwent. Whereas the character represents the reporter when he was a visible and concrete figure, the narrative voice represents what the character has become as a result of his experiences: invisible, distanced, capable only of disembodied re-creation. The voice is, in effect, the reporter as adult. Moreover, since it is the reporter as narrator (not as character) who is responsible for the story being told, the reporter as character, even at his most childlike, is at the mercy of adulthood.

Once the reporter is led to the matrimonial agency, a radical change occurs. Most obviously, children are left behind. The only reasonable facsimile is Attilio, who conducts the reporter from the agency's waiting room (where children are still in evidence) to the childless world of the Signora. Though middle-aged, he is restless and incessantly talkative (like many children in Fellini's films) and given to cutting out paper dolls.

As children are left behind, events become static, segmented, and controlled, and concrete reality gives way to abstraction. This is epitomized by the Signora, who replaces the reporter's vibrant, intuitive young guide as the principal female figure. Authoritarian and coldly efficient, she works out of an office whose isolation contrasts sharply with the populous connective hallways predominant earlier. Inside her office, people are replaced by lifeless representations (a tailor's mannequin, a bust, photographs), the experiential world is replaced by a globe of the world, and speech (direct communication) is replaced largely by writing.

Instead of the vital interaction (true "marriage") of responsive individuals so evident among the children, we now have "Marriage" with a capital M, rooted in cold, abstract, motive (money on the part of the agency; social propriety and financial security on the part of clients). Marriage, as we have seen so often in Fellini's early work, has become the very opposite of intimacy. Indicatively, the Signora and Attilio—the "parental couple" of the agency—have no real relationship.

At this point, the split between child and adult, which has been implicit all along in the narrative structure, becomes explicit in the activity of the reporter as character. He enters the Signora's office as a "child," curious and unarmed with any rational explanations for his presence: "As I sat down before the agency woman,

I suddenly realized I had forgotten to make up a story, a reason for being there."[15] His sudden realization marks the movement toward adulthood, and a concomitant capacity to act with conscious intent, deliberation, and so forth. Nevertheless, though he submits to the adult world by providing a "reason for being there," his explanation (that he is a doctor representing a werewolf who thinks that marriage might cure him) is childlike. Moreover, the doctor-werewolf twosome he invents reflects the kind of division he is undergoing. As someone capitulating to the adult, institutional world, he takes on the role of doctor. But as someone reluctantly abandoning the world of childhood, he temporarily salvages the child within through the werewolf, a figure anathema to rationalized adult society. The werewolf itself is, of course, a divided figure: part man, part beast.

Though the werewolf tale bespeaks division, it also embodies some metaphoric potential for unity, through the urge of the lycanthrope to marry. However, because institutional marriage is, as we have seen, a less than positive state for Fellini, the potential is qualified from the start. Moreover, both the desire to marry and the lycanthrope himself are ultimately denied, leading to a conclusive victory of adult over child and the destruction of unity on every level. This is reflected principally in the failed relationship between the increasingly adult reporter/"doctor" and the childlike Rosanna. Part of the problem lies with Rosanna. She is the least vital of the prominent female figures in the film, reflecting the diminishment of energy and spontaneity as the film progresses. And she embodies childhood not as a stage of promise but as mere arrested development.

Most of the blame, however, lies with the reporter. He functions more and more as a voice of reason and conventional order, discouraging Rosanna ever more explicitly from marriage to his lycanthrope client. In so doing, he destroys the last traces of childhood in the film. He shatters Rosanna's optimism and hope—a diminished but still valuable form of the openness and dynamism of the earlier children. Even more important, he repudiates the werewolf figure he invented, insisting that the werewolf is not suitable for marriage. He thus negates the child half of the werewolf/doctor division within him. At the same time, he repudiates both the tale and the childlike inventiveness that gave birth to it.

In killing off the werewolf, the reporter eliminates the principal basis for communication between himself and Rosanna. As the film concludes, he makes no attempt to be even courteous, much less kind. He abruptly shuts off conversation ("forget all about it") as they sit by the roadside in the country. He neither walks with her as they return to his car nor holds the door for her, as he prepares to drive back to the city. On the return trip, he does not speak a single word to her. When they arrive in the city, he drops her in the middle of a busy intersection—lacking even the decency to pull over to the curb—then he drives off alone. (**Figure 2.5**)

FIGURE 2.5 The reporter in *Marriage Agency* dumps Rosanna in the middle of a square, while Fellini emphasizes the unceremonious end to their encounter with a distant view of Rosanna and the car dwarfed by a large and seemingly (though in Fellini never) insignificant figure in the foreground. Source: *Marriage Agency* episode directed by Federico Fellini in *Amore in città* (*Love in the City* 1953). Produced by Faro Film. Frame grab captured by Frank Burke from 2014 Blu-ray version.

Even more revealing than the reporter's behavior is his concluding voice-over narration:

> We returned to the city in silence. I wanted to say something to her. Not to justify myself or apologize, but something that would really help. I wanted to tell her to have more confidence in herself. To open her eyes to the countless possibilities that life presents each day. But I knew it would all sound like a lot of hot air, useless. Her immediate problems, her daily needs—these would have seemed to her the only real and important things. So I said nothing. When we parted, I sincerely wished her good luck.

This "sincere wish" is never presented in the film. Much more important, the reporter's words are nothing but conventional journalistic condescension, delivered

in a tone of smug self-congratulation. Though a short and little-known movie, *Marriage Agency* proves quite significant in Fellini's career. By rejecting neorealism (at least as it was viewed by Zavattini), Fellini asserts his independence from the principal cinematic tradition or "convention" that he had inherited. This opens the way for a new and more personal kind of cinema, evident as early as his next movie, *La Strada*.

Marriage Agency is also an advance in characterization. Although the reporter (unlike Moraldo) fails to experience real crisis or disillusionment, he is the first Fellini character to use his powers of invention in a way that gives form to the problems in and around him. Moreover, his voice-over is more creative than that of the narrator in *I Vitelloni*. Whereas the latter seemed merely to be recording past events, the former shapes them, at least to the extent of trying to tell a story of maturation and self-discovery. In addition, the reporter is the first fully uprooted, hence potentially independent, Fellini figure. Moraldo got from the heart of town to the outskirts; the reporter, in a sense, has taken the train all the way to Rome (a "Moraldo in the City," as it were). He has no provincial past (Rosanna substitutes for it in the film). He has no family, no community, and no friends, and his home is a single small unshared room. In his aloneness he prepares the way for Zampanò and *Il Matto* of *La Strada* and Augusto of *Il Bidone*. Though he, like them, proves unable to act in a truly constructive way, he serves—as they will—to move Fellini's work toward stories of self-realization.

La Strada

With *La Strada* (1954) we come to a landmark both in Fellini's career and in the European art film movement of the 1950s. Though the film created controversy among Italian Marxists, who were angered by its poetic (versus realist) style, it was enormously successful, receiving more than 50 international awards and bringing Fellini his first Oscar. The film's historical importance seems equaled by its importance to Fellini himself: "*La Strada* will remain the crucial point in my life" (quoted in Solmi, 116). And, even at the time of *Juliet of the Spirits*, he could still claim that "*La Strada* is really the complete catalogue of my entire mythical world."[16]

Fellini's continued concern with conformity, mediation, and estrangement is reflected in the way the film's title relates to the story. A road is something already laid out, encouraging everyone to travel the same restrictive route. (The railroad has similar significance in some of Fellini's preceding films.) Its capacity to separate eventually exceeds its ability to unite, and in failing to lead people to fulfillment,

the road becomes an avenue to violence, death, abandonment, and alienation. Fellini's road is clearly different from Walt Whitman's open road, which expands to become a comprehensive symbol of freedom and unification.[17]

One of the principal concerns in *La Strada* is the loss of potential, the elimination of creative possibility. A sense of loss is established right from the beginning with the reported death of Rosa, Gelsomina's sister whom Zampanò is seeking to replace. Though Rosa remains undefined, "unrealized" in the film, her name links her with a mandalic symbol of wholeness. She comes from a time in Zampanò's life when things unattainable in the present may still have been possible. She may well derive from that period when Zampanò acquired his marvelous van or mobile home, which offers the promise of an adventurous life. Whatever else she may be, she embodies something unrecoverable in the film. Her loss and Zampanò's inability to come to terms with it may well explain his brooding, repressive nature—his determination never to be vulnerable again.

Loss is not only implied through Rosa, it becomes the film's central theme through the diminishment of all three of the film's major figures—Gelsomina, *Il Matto,* and Zampanò. They are the most advanced characters to this point in Fellini's career. Gelsomina is the first Fellini figure capable of significant growth. Her active intelligence and her ability to respond creatively to experience set her apart from the Checcos, Wandas, Moraldos, Sandras, and Rosannas who preceded her. *Il Matto* is a superb *artiste* (violinist, high-wire performer, clown) who uses his artfulness with great ingenuity to mask his loneliness and vulnerability. Zampanò, though less gifted, is associated with a full range of positive human values: love (his relation with Rosa, his need for Gelsomina), creation and communication (his life as an artist), the synthesis of home and profession (his van), as well as an active life on the move. Moreover, he surrounds himself with evocative symbols—an owl, a snake, a mermaid, and crossed swords—that bespeak an imagination struggling to express itself. Even his strong-man routine, the breaking of a chain with his pectoral muscles or "heart," is a metaphoric representation of his urge to free himself through love. However, the failure of Gelsomina, *Il Matto,* and Zampanò to realize their potential—and, in fact, their ultimate loss of potential—make *La Strada* an intensely tragic film.

The narrative process of *La Strada* is, like that of *Marriage Agency,* one of *adult*-eration. Gelsomina, the childlike naif, is brought by Zampanò into an adult environment of work, money, discipline, convention, and linear thought, and she is destroyed. She is forced to sacrifice her identity, and her intelligence is compromised to the point of madness. Though Zampanò's crudeness has often inclined critics to view him as representative solely of bestiality rather than civilization, he initially represents not some violent, pre-civilized state but rather civilization in its worst form, characterized by brute instrumental reason, domination, and

exploitation. It is only late in the film that he reverts to the pre-social, and even here he represents not nature as a negative state so much as the failings of civilization.

In the opening sequence, Gelsomina is an image of childhood promise and a figure clearly in tune with her natural surroundings. Though described as "strange" by her mother, her difference bespeaks the limits of perceived normalcy and of her mother's perceptions more than limits on Gelsomina's part. The Italian word *gelsomina* means "jasmine," a shrub, and with a bundle of brushwood on her back, Gelsomina looks like a moving bush. Once she is summoned to her mother and to Zampanò, she enters the world of civilized structure. Zampanò leans heavily against the stone post of a building, and the wooden frame of a small boat appears next to Gelsomina's head. Money is introduced as we discover that Zampanò has in effect bought Gelsomina. (He also gives two children money to buy food.) Social propriety is emphasized as the children are ordered to say "thank you." Subtly, but most significantly, discipline and domination manifest themselves as Zampanò equates the education he intends to give Gelsomina with the training of dogs.

As someone who introduces Gelsomina to planned, rather than purely spontaneous, behavior (repetition, rehearsal, memorization, performance), Zampanò embodies a rudimentary form of civilized intelligence crucial to the awakening of Gelsomina's mind. As soon as Gelsomina enters Zampanò's world, she drops her bundle of wood. Moreover, she immediately accepts adult forms and "grows up." She accedes to the deal between her mother and Zampanò. She bids a reverential farewell to the sea (an act of deliberation in contrast to her earlier impulsiveness). She identifies goals (becoming a singer, dancer, and provider for the family). Then she breaks her childhood ties with home, even disregarding her mother's sudden plea that she stay. She runs toward Zampanò's van—the most sophisticated product of civilization in the sequence—and prepares to embark on the road and the socially constrained life it bespeaks. Gelsomina suffers diminishment from the moment she leaves the natural world. As a commodity and tool in the service of Zampanò, she is forced to derive her identity from him (in fact, her face only becomes visible at the moment she is brought into his presence). Moreover, as she waves good-bye, she covers her face with her cape, and after she has mounted Zampanò's van, she disappears behind its black curtains. By the scene's end she is, in effect, obliterated.

The nature/culture division in *La Strada* accords with the child/adult division both here and in *Marriage Agency,* as well as the life/organized society split in *I Vitelloni. La Strada* introduces a strongly evolutionary model of psychospiritual enlightenment, in which the former element in each division ideally "marries" the latter within creative human experience. The model does not reach fruition in *La Strada* but appears to in certain ways in some of Fellini's films from *Nights of Cabiria* to *Toby Dammit.*

From the beginning, Gelsomina's life with Zampanò is compartmentalized and based on role. The nature/civilization division of the first sequence becomes a split between personal and professional aspects of existence. The presence of each is evident in Gelsomina's function as both a companion ("wife") and a theatrical assistant, and in Zampanò's use of the van as both home and workplace. An alternation between roadside (personal) activity and public performance suggests a relative balance at first. The balance, however, proves more apparent than real. The first and most extensive roadside scene is given almost entirely to theatrical training, and Zampanò only turns to more "intimate" matters (forcing Gelsomina to spend the night in the van, with all that implies) after she has succumbed to his brutal professional "education." Though Zampanò eventually seems to develop a sense of appreciation for Gelsomina, it is the result not of genuine personal interaction (he refuses to answer any of her questions about himself or Rosa) but of their success (largely through Gelsomina's performance in the gun and duck routine) as *artistes*. In fact, what he seems to value most about her—the fact that she is "amusing"—is the very thing that has helped make them professionally successful.

As Zampanò refuses to deal with Gelsomina in a truly personal way, she is forced to rely on her professional identity for satisfaction. She experiences a series of contrasts between acceptance as an *artiste* and rejection as a person. After enjoying tremendous crowd response to the gun and duck routine, she is temporarily abandoned by Zampanò for a prostitute. (Even this early in the film, the potential intimacy of the roadside has been left behind for a crowded restaurant, and Zampanò has begun to deny Gelsomina even the role of sexual partner.) The following morning, she puts on a well-received comedy routine for a young girl, immediately after being ignored by a dead-to-the-world, hungover Zampanò. Most significant, after captivating a group of children and entertaining the secluded Osvaldo at a wedding celebration, Gelsomina is crushed as Zampanò abandons her to have sex with the mother-in-law.

The subordination of personal identity to artistic persona is particularly clear from the way in which Gelsomina's powers of awareness awaken. During the roadside training sequence, as Zampanò tries a variety of comedic hats on her, Gelsomina's face, eyes, and imagination come fully alive. She responds with a little dance, only to be quashed by Zampanò and forced to repeat the phrase "Zampanò is here"[18] while she mechanically beats a drum. The fact that Gelsomina is awakened only by costuming suggests her need—given the limitations of personal life—to escape into make-believe. The fact that her attempt to unite make-believe with her own natural expressiveness is thwarted by Zampanò suggests that when she *does* escape into art and persona, it will mean a loss of personhood.

During the wedding sequence, Gelsomina's awakening consciousness is again linked to costuming and her life as an *artiste*. She has two vivid moments of

53

awareness: her encounter with Osvaldo and her recognition that Zampanò is going off to have sex. (**Figure 2.6**) Yet in each case the face that is illuminated by sudden understanding is that of a clown. Moreover, for the first sustained period in the film, Gelsomina is dressed wholly as a performer and has abandoned her own cape whose "wings" had suggested a lightness and capacity for flight. She is now dressed in a long military overcoat. Furthermore, both moments of awareness occur in the midst of play-acting. She is in the process of entertaining Osvaldo when she has her epiphany of kinship and wonder, and she and Zampanò exchange highly theatrical winks of complicity (their moment of greatest—yet most artificial—rapport) just before Gelsomina realizes what is really going on.

Her experience with Osvaldo is particularly significant as an indication of what has happened by this point in the film. Like Gelsomina at the beginning, Osvaldo is a child. He is "not like the others" (the phrase used to describe Gelsomina by her mother), and he is mysterious and unfathomable in his "strangeness." However, while Gelsomina was willing and able to display her uniqueness at the beginning,

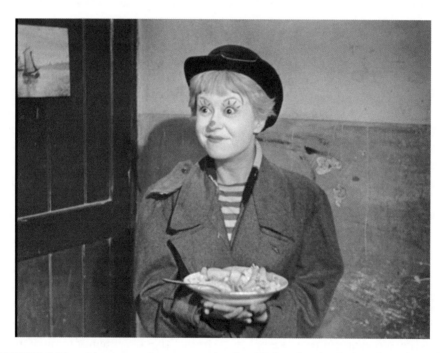

FIGURE 2.6 The wide-open sunburst eyes and smile of Gelsomina, just before she realizes what Zampanò is up to with the mother-in-law at the wedding, associates her intelligence with her life as an *artiste*—and, ultimately, with profound misrecognition. Source: *La Strada* (1954). Directed by Federico Fellini. Produced by Ponti-De Laurentiis Cinematografica. Frame grab captured by Frank Burke from 2017 Blu-ray version.

Osvaldo is reduced to mute withdrawal. And while Zampanò and his rudimentary world of civilization were willing at least to appropriate the qualities Gelsomina embodied, society now can view them only as an embarrassment. Osvaldo is hidden away, in the jealous custody of a nun, where the only people who visit him are children who are forced to view him largely as a freak.

As the nun and the religious ritual of marriage suggest, Zampanò and Gelsomina are entering a world of institutions. Uniforms—military, religious, and social—abound here, and Zampanò uses sex to acquire a pinstripe suit. In its emphasis on growing institutionalization, the wedding sequence serves as the threshold between agraria and the world of the city. Succeeding sequences move to a large town and then to the outskirts of Rome.

Through Osvaldo, Gelsomina encounters the very things that are being muted—or preserved only at the level of art or spectacle—in herself. Seeing herself in him, she experiences (her own) uniqueness only as abnormality, leading to isolation and fear. Self-consciousness becomes consciousness only of alienation. As a result, she is further inclined to suppress her originality and to deny true awareness by finding less demoralizing substitutes.

The Osvaldo sequence also highlights an emerging split between head and spirit, body and matter. Osvaldo's name implies godly power;[19] Gelsomina must ascend a flight of stairs to reach him; he is guarded by a religious representative; and Gelsomina's encounter with him is profound, numinous, and awe-inspiring. At the same time, Zampanò is on ground level, gulping down food, talking with the self-assertively physical mother-in-law, and about to descend into the cellar to have sex. As Gelsomina's intelligence develops and as Zampanò continues to repress his own, they begin to live their lives on separate levels. In this instance—and indicative of what will recur throughout the film—she ends up back down on his level, defeated by his unfeeling behavior.

Gelsomina's next moment of awakening—following Zampanò's sexual adventure—indicates that she is beginning to live largely through external substitutes for her own identity and intelligence. Angered and depressed by Zampanò's infidelity, she is suddenly revived by the memory of a song she heard on the radio, and she asks Zampanò to teach her the trumpet. Her brightening of mood seems largely inspired by the light bulb she has been standing next to. The song and the radio are also external and, even more than the light bulb, can be seen as forms of surrogate consciousness: "voices" that enter and fill the mind. The song is particularly significant, for it will later be associated with *Il Matto,* who clearly comes to function as Gelsomina's borrowed intelligence.

Gelsomina's sudden preoccupation with the song is a denial of her present situation. For the first time since she started communicating with Zampanò, she fails to confront him directly with her concerns about his behavior. Moreover,

enlightenment, which was earlier equated with self-expression and creativity (her dance with the comedic hats), is now tinged with distraction or escape. This urge to escape, in turn, leads to a failed attempt to leave Zampanò, which is established largely in terms of the personal/professional division I discussed earlier. As she prepares to desert, Gelsomina announces, "I'm fed up. Not from the work. I like the work. I like being an *artiste*. It's you I don't like." Here, in setting out the alternatives of work versus personal relationship, she explicitly chooses her "career." Her return to him will thus imply not direct or personal relatedness but her need for the life of an *artiste*.

By the time Gelsomina makes her temporary break with Zampanò. her identity and individuality have been eroded to the point that she has little initiative. As soon as she reaches a major thoroughfare, she runs out of energy and sits down by the side of the road. She must be fueled by the appearance of three musicians, dressed in military outfits, and lost in their own performance (they do not relate to Gelsomina at all). Once they appear, she is reduced to a follower. Moreover, she is led to a town filled with narrow streets and alleys (the "road" at its most restrictive), where a gloomy, even frightening, religious procession is in progress. Here she is pushed and pulled, directed and redirected, forced to go with the flow of the mob. Throughout her journey she is associated with images of crucifixion and martyrdom. And when she is confronted by the procession, Gelsomina does, in a sense, martyr herself by kneeling and adoring the images paraded in front of her.

Born out of this is *Il Matto*. A heavenly apparition on his high wire, he evokes awe (less absurdly than the White Sheik). Known only by a stage name, he is pure role. First seen as a shadow on the side of a building, he is a projection more than a person. Dressed as an angel (a religious and theatrical cliché) and born out of the religious, institutional life of the town, he is strongly associated with tradition and convention. Finally, "crucified" on the cross formed by his tightrope and balancing pole, he is another image of martyrdom. He personifies, in short, everything to which Gelsomina is falling prey. He also introduces a new phase in the film's analysis of the civilizing process. Whereas Zampanò introduced civilization at the point where it met and dominated nature (hence something of nature still remained), *Il Matto* embodies it at the point where the natural turns into illusion. Whereas Zampanò introduced rudimentary, practical intelligence, *Il Matto* promotes fantasy and false consciousness. His false consciousness, in turn, becomes a form of "madness" as the meaning of his name—"the mad one"—suggests. (He is called "The Fool" in subtitled and dubbed prints, a name that is also indicative of his function in the film though far less precisely than "the mad one.")

Although Gelsomina does not realize it, *Il Matto's* appearance in effect provides a "solution" to her dilemma with Zampanò. She can compensate for living with the latter by projecting everything of value onto the former. The fact that her

identity is about to become inextricably caught up in his is suggested moments before she is tracked down by Zampanò, when she is called *matta* (the feminine of *matto*) by a *vitellone* in a town square.

Once Gelsomina and Zampanò are reunited, the action moves to the outskirts of Rome. (Although we don't actually see the Eternal City, Gelsomina asks, "Where are we?" and is told "In Rome. That's Saint Peter's.") As always in Fellini's early work, Rome is associated with institutional abstraction and illusion. However, here the city is not the direct source of illusion. Rather, it is the Giraffa circus to which Gelsomina, Zampanò, and *Il Matto* now belong. As the Giraffa sequences indicate, the circus institutionalizes personal life. People spend all their time on their "job site," and the life of family and extended family is dedicated not to personal relationships but to work, money, performance, and make-believe. More than ever characters are defined by role rather than true identity. In addition, once the three characters join up, they sacrifice the freedom and mobility of earlier scenes for the shelter of "the big top," and they begin living under the restraint of authority: Colombaioni, the patriarchal head of the circus, and the police who apprehend Zampanò.

Gelsomina's life becomes even more restrictive and impersonal. She is treated solely as a theatrical assistant by Zampanò, not at all as a companion. She, in turn, no longer asks Zampanò about himself, only about *Il Matto*. Moreover, though as a circus member she is defined more than ever as an *artiste*, she is given no freedom to express herself. Zampanò uses her only to beat the drum, and he prevents her from developing a new act with *Il Matto*.

Faced with the continued failure of personal experience, Gelsomina relies more than ever on substitute sources of fulfillment. Living in a circus world of spectacle, she becomes a consummate spectator, looking outside herself in starry-eyed fascination with *Il Matto*. (**Figure 2.7**) In addition, the division between personal and professional that was initially situated within Gelsomina becomes projected outward into a split between Zampanò and *Il Matto*. She relies on Zampanò for her domestic existence, while her professional or artistic excitement derives entirely from *Il Matto's* routines and music, and Zampanò, who has denied Gelsomina a truly personal relationship, can now only symbolize one for her.

Because the split is outside Gelsomina, the possibility for synthesis no longer exists, only the possibility for balance (*Il Matto*, as an equilibrist, introduces the notion at the appropriate narrative moment.) Moreover, balance is ruled out as soon as the two men are brought together. Instead, Gelsomina must resort to alternation—taking turns being with each. Even alternation does not work as the relationship between the men leads to open conflict that can only be resolved by imposed peace at the hands of Colombaioni and eventually the police. Finally, peace can be sustained only by elimination and separation. The police take

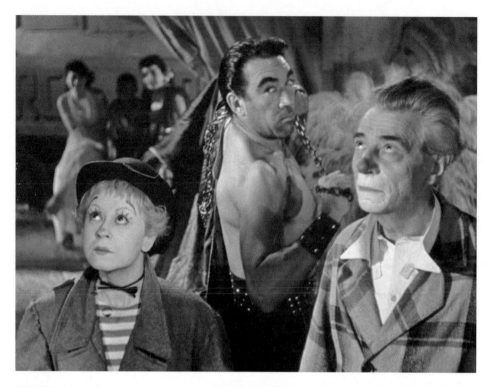

FIGURE 2.7 Gelsomina, Zampanò, and Colombaiano look skyward as *Il Matto* (offscreen) performs his aerial acrobatics, emphasizing his role as a radically external influence upon whom Gelsomina will come tragically to depend. Source: *La Strada* (1954). Directed by Federico Fellini. Produced by Ponti-De Laurentiis Cinematografica. Frame grab captured by Frank Burke from 2017 Blu-ray version.

Zampanò off to jail, and Colombaioni kicks both men out of the circus, sending them in separate directions.

The conflict between *Il Matto* and Zampanò comes to embody the split between head and body, spirit and matter that emerged in the Osvaldo episode. While Gelsomina's bodily existence remains tied to Zampanò, her mind and imagination live through *Il Matto*. (The first time she hears him playing the song from the radio, she moves over to the circus tent and places her chin on a rope strung across the entrance, "severing" her head from her body, and the name of the circus in which this occurs—Giraffa—further suggests a great gap or distance between head and body.) Consistent with the growth of abstraction in Gelsomina's experience, the *Il Matto*-Zampanò relationship turns into allegory: the angel versus the beast. The two men are so lacking in personal identity that they begin playing the role of each other's opposite. *Il Matto* cannot be near Zampanò without tauntingly

implying his superiority; Zampanò cannot be near *Il Matto* without becoming bestial. Though both initially embodied something of the other (Zampanò was a comedian as well as a strong man; *Il Matto* a physical *artiste* as well as a musician and "angel"), each becomes one dimensional.

Inclined toward the angelic over the bestial, Gelsomina lives more and more through *Il Matto,* and he ultimately becomes her surrogate self. In keeping with this, he displays many of the characteristics she possessed earlier: childlikeness, humor, adventurousness, spontaneity, creativity, awareness, the capacity for transcendence. However, while she embodied all these as personal qualities, he merely symbolizes them through art and affectation. As his irritatingly phony giggle suggests, he tends always to be play-acting. Once Gelsomina projects all meaning and identity onto *Il Matto,* all that remains for her is the mere illusion of each. The crucial moment in this process occurs when Zampanò is jailed and *Il Matto* is momentarily given free rein to fill Gelsomina's head with his philosophy of the pebble: "I don't know what this little stone is good for...[only] God Almighty... knows everything... but it must serve for something, because if it's useless, everything is useless... Even you serve some purpose." *Il Matto* confesses that his philosophy comes from the books he has read, and a moment's thought reveals that his "insight" is nothing more than the conventional Christian doctrine of Divine Providence. His philosophy is so commonplace that for decades critics and other viewers have accepted it unquestioningly, even claiming it was Fellini's "message" to his audience. Instead, we are beyond *I Vitelloni*'s seductive conservatism of the conventional—deadening but not deadly—and into its killing consequences: Gelsomina's death is in no small part a result of her embracing *Il Matto*'s platitude.

In adopting *Il Matto's* words as the basis for her existence, Gelsomina ends once and for all the struggle to develop her own consciousness. The words themselves, of course, deny individual awareness, asserting that only God is in the know. Since purpose and interrelatedness in *Il Matto's* scheme of things are only provided and known by "God," there can no longer be any inherent meaning to experience. Moreover, relationships become reduced to instrumentalism—a natural outgrowth of the purchase of Gelsomina. *Il Matto's* words are largely in response to Gelsomina's despairing remark: "I am no good to anyone." At first, he tries to determine what skills she has (what she *is* "good for"). When she indicates that she does not have any, he resorts to his mystifying philosophy of service and use.

Reassured by his instrumental view of things, Gelsomina uses *Il Matto's* rhetorical question—"If you don't stay with [Zampanò], who will?"—as her rationale for staying with her abuser. This is the slimmest basis yet for their relationship. Moreover, by adopting "service" as the principal condition of their relationship, she accepts the most traditional, the most unliberated, of female roles. The extent

to which her adoption of *Il Matto's* words has severed her from reality is suggested when she takes the stone and stares foolishly at it, shutting out everything including *Il Matto* and investing the pebble with overdetermined symbolic import.

The characters' forced abandonment of the circus following the fight between Zampanò and *Il Matto* is a seeming return to something other than a world of performance and make believe. However, the roles and illusions acquired in the circus environment rule this out. Zampanò plays "the beast" even more completely and assumes the new role of criminal that his night in jail has given him. He tries to steal silver hearts at a convent, he beats Gelsomina when she refuses to assist, then he beats up *Il Matto* and becomes an unwitting murderer. Gelsomina ignores the reality of Zampanò's worsening behavior, as she clings to her symbolic pebble and *Il Matto's* words. The dramatic change that has occurred since the beginning is highlighted by a brief scene in which she and Zampanò return to the sea. Though she rushes down to the water in initial excitement, she quickly turns away to pester Zampanò with her new fantasies about their relationship—and to renounce her original home ("now . . . my home is with you"). As the scene concludes she is moving farther and farther from the sea and, by implication, from the natural world in which she originated at the film's start.

The denial of nature and reality is best exemplified by the convent sequence. Within the logic of the film, convent life seems an even further retreat from the real than the circus. Moreover, as a rather simple-minded nun who befriends Gelsomina says, "We change convents every year . . . so we don't get attached to worldly things. Like the place where we live. Or a plant even. Thereby forgetting the most important thing: God." These words, like *Il Matto's*, are commonplace Christian wisdom, yet—in the context of the film—they seem life-denying and escapist. At the convent, Gelsomina is coaxed even further into the kind of abstraction introduced by *Il Matto*. The nun, believing that she is married, remarks, "You follow your husband, and I, Mine [that is, God]." Darker shades of Wanda's "You are my White Sheik." Acting on this notion, Gelsomina turns Zampanò into her god and actually broaches the subject of marriage: "Once I wanted to [die] rather than stay with you. But now I'd even marry you." This strengthening resolve to follow Zampanò, no matter what, is evidence of Gelsomina's growing tendency toward self-sacrifice and martyrdom (echoing certain aspects of convent life). Like *Il Matto*, the nun is associated with crucifixion, standing, the last time we see her, in the shadow of an enormous cross.

The withdrawal of Zampanò and Gelsomina into separate realms of criminality and pseudo-theology is one of the many ways in which divisiveness continues to grow. A more obvious indication lies in the absence of *Il Matto*. The "angel" and the "beast" can no longer live in the same world. The moment they come together, one is destroyed. In the absence of *Il Matto*, Gelsomina takes the role of

angel on herself. She begins to call Zampanò a beast and to imply sharp distinctions between mental activity and mere mindless, physical existence: "You're a beast. You don't think." In so doing, she further erodes any chance for unification. Instead of trying to balance or alternate opposites through *Il Matto* and Zampanò, remaining open to both options, she now becomes one half of the division herself. Consequently, despite her expressed willingness to marry, she is irrevocably alienated from Zampanò.

By now, the division between angel and beast, mind and body, has become an outright divorce between ineffectual consciousness and brute physical necessity. This is made clear when *Il Matto* reappears and encounters Zampanò. All his angelic powers are gone. Once a skywalker, he is now literally and figuratively grounded with a flat tire. (In fact, he ultimately merges with the earth, grabbing a handful of grass as he dies.) With the "angelic" effectively nullified, the "bestial" has its way, exacting full vengeance for earlier humiliation.

The killing of *Il Matto* marks the end of everything even remotely associated with higher consciousness. Not only is *Il Matto* gone, but Gelsomina reacts to his death by withdrawing into a state of shock. That leaves Zampanò, who at the convent had explicitly repudiated conscious life ("there's nothing to think about. Go to sleep") and who now more than ever represents irredeemably instrumental reason: the unreflective pursuit of work and subsistence and the continuing use of Gelsomina for that end.

Though Zampanò, by the time of *Il Matto's* death, has been reduced almost entirely to brutish behavior, he has not sacrificed his humanity altogether. He can still feel an extraordinary sense of need for Gelsomina, becoming solicitous as she falls ill and can no longer assist him. Moreover, Gelsomina serves as his conscience, as her condition repeatedly reminds him of *Il Matto's* death. Both his sense of need and his surrogate conscience link him, however tenuously, with a social universe. When he casts Gelsomina off, however, the links dissolve and there is nothing left to prevent Zampanò's final decline.

In the film's final phase, years after he has abandoned Gelsomina, Zampanò hears a young woman humming the song Gelsomina had inherited from *Il Matto*. She is, for a moment, "reincarnated." However, the manner of her reincarnation only serves to emphasize that she is irrevocably gone. Moreover, she and everything she embodied are "dead on arrival" in the very act of reincarnation—as proclaimed by a poster behind Zampanò advertising the American film *D.O.A.* Not only do we discover that Gelsomina has died, but she has no identity in the present. She is referred to only as a "girl" by the woman and is not referred to at all by Zampanò. Furthermore, Zampanò is told that the local mayor could not determine who she was upon her death. Even Gelsomina's consciousness is dead in the retelling: "She never spoke. She seemed crazy. (*Matta* is used, linking her

again with *Il Matto*.) She never said anything, she just cried. One morning she just didn't wake up."

Like Gelsomina, Zampanò is largely dead on arrival. When we first see him in this sequence, he is solitary, mechanical, and unfeeling. He has apparently cast off his van, the emblem of his independence. He has made no attempt to replace Gelsomina, as he once replaced Rosa. With the absence of his mobile home and female companionship, he is definable solely in terms of work. The story of Gelsomina offers him one last opportunity to awaken. Unfortunately, as his failure even to refer to her suggests, he is not up to it. He remains mute at the end of the woman's story and does not act on her suggestion that he find out more from the mayor. The next time we see him, he is performing his chain act in a numbed state, failing to break the chain before we dissolve to the next scene. Then, he further represses awareness by getting violently drunk.

At this point, the final stage of regression occurs. Zampanò abrogates all social bonds by getting in a fight, hitting the one person who identifies himself as his friend, and, most important, shouting "I don't need anyone. I just want to be alone." These final words make clear that Zampanò has jettisoned one remaining tie to the human race: a sense of need. He then stumbles in darkness and in a stupor beyond the town and circus, beyond all civilized structure, out to the sea. He returns to the origins of the film, with the crucial absence of Gelsomina. He douses himself with water in a clumsy, drunken way that bespeaks the very impossibility of baptism or a sacramental relation to nature. He then stumbles back onto the shore and collapses to a sitting position. Looking distinctly simian, he experiences one final burst of sentience as he looks to the heavens, but unlike similar moments in *The White Sheik* and *Fellini-Saytricon*, Fellini does not give us a reverse shot of the stars, a suggestion that his protagonist is capable of seeing and deriving significance from the night sky. Zampanò can respond only with grunts of terror. Then he slumps forward, face down, turned away from the last bit of dim illumination offered by the night sky. He lies motionless, "dead" upon the beach. The fall back to the beast and even beyond, to inanimate existence, is complete, perhaps presaging something similar to the fish on the beach at the end of *La Dolce Vita*.

My view of the final scene, as of Moraldo in *I Vitelloni* and *Il Matto*'s philosophy of the pebble, runs counter to critical tradition, which sees Zampanò redeemed—a view Fellini himself has tended to encourage by talking of the film in terms of an awakening. The evidence, it seems to me, is compellingly to the contrary. Zampanò experiences a sense of terror and loss that is visceral, but not aware or transformative. The film is indeed about an enlightenment, Gelsomina's, but one that is negated.

On the other hand, the power of Fellini's empathy in these final moments of the film elicits a strong desire for redemption, for some kind of awakening on

FIGURE 2.8 Zampanò's strongly simian demeanour, followed by his motionlessness on the beach at the end of *La Strada*, makes it difficult to accept traditional consensus that he is somehow redeemed. However, the empathic intensity of the ending fuels a desire on the part of the spectator that this be so. Source: *La Strada* (1954). Directed by Federico Fellini. Produced by Ponti-De Laurentiis Cinematografica. Frame grab captured by Frank Burke from 2017 Blu-ray version.

Zampanò's part, and the "duplicity" of the ending reveals yet again the potential for multiple and even simultaneously conflicting responses to Fellini's work. His films are not over when they're over; they continue to evolve in the hearts and minds of their viewers. (**Figure 2.8**)

The importance of *La Strada* in the development of Fellini's work should be self-evident. The narrative has a richness and complexity that was only hinted at by earlier films and that point toward the highly elaborate structures of *La Dolce Vita* and *8½*. The growing strength of the characters move us closer to Cabiria and Guido and a capacity for imaginative experience that remains impossible in *La Strada*. In acknowledging the importance of *La Strada*, one must give equal recognition to Giulietta Masina. Her Gelsomina is one of the unique portrayals in the history of cinema. As Fellini put it, "Giulietta is a special case. She is not just the main actress in a number of my films, but their inspiration as well. ... So,

in the case of Giulietta's films, she herself is the theme" (*FF*, 105). The centrality of Masina to *La Strada* underscores her centrality to Fellini's success as a film director. *La Strada* was the film that launched Fellini's international reputation, making possible the successes of *Nights of Cabiria* (to which Masina was also central), *La Dolce Vita,* and *8½.*

Il Bidone

Il Bidone (1955) was often considered the least successful of Fellini's early films, partly because of the inexpressive nature of its main character, Augusto. However, Broderick Crawford's performance as a closed and alienated petty crook is perfect in terms of what the story demands, and close viewing reveals a tragic intensity and significance to Augusto's fate that in some ways surpasses even that of Gelsomina, Zampanò, and *Il Matto.*

Il Bidone introduces two elements to the Fellini canon: the midlife crisis and "creative negation." Augusto is the first Fellini character to confront visibly the fear of aging and dying without having lived a meaningful life. (Something of this is happening for Zampanò at the end of *La Strada,* but on quite a subliminal level.) Though his efforts end in failure, he tries throughout the film to redeem an unfulfilling past and to create something of value in the present. "Creative negation" is the capacity on the part of Augusto to push tragedy to the point where it annuls itself, turning two negatives into a positive and restoring the possibility of creative activity. The tragic in this respect becomes purposeful and redemptive rather than meaningless and determined.

Il Bidone is divided into five "days." They are highly artificial in that the events within them often seem discontinuous and could well have taken place on separate days. Moreover, substantial periods of time often seem to have elapsed between one "day" and the next. In both respects, they point to the structure of *La Dolce Vita.* However, they are unified by their chronological progression from morning to afternoon and, on three occasions, through night to dawn.

Day One

The opening scene of *Il Bidone,* like that in *La Strada,* offers a relatively promising setting. However, the rolling countryside where the crooks meet is the only congenial setting in the film—and one from which the characters remain largely detached. Their conference takes place on a stone bridge, their clerical garb makes them look out of place, and Picasso's appreciative remarks about the landscape go unacknowledged by the others. Their lack of autonomy is clear in their reliance on

"Boss" Vargas, and all their relationships are mediated by money, work, roles, and the common goal of cheating others. There is much less sense of possibility here than at the beginning of *La Strada*. There is no potentially creative figure such as Gelsomina. Picasso is the closest we get, but concealed beneath a pseudonym and a priest's cassock, he is much closer to *Il Matto* (play-acting, false consciousness) than Gelsomina. The fact that Richard Basehart plays both Picasso and *Il Matto* inevitably invites comparison.

Augusto is established from the start as the most withdrawn. He exemplifies his last name, Rocca ("fortress" as well as "rock"), concealing all emotion behind a hard and sullen exterior. Here, as through much of the film, the effort he makes to conceal his feelings is evidence of extraordinary inner struggle—and of a tragic insistence on suppressing personal experience.

Much as the brief opening scene offers the only appealing setting in *Il Bidone*, the first extended sequence—which takes place on a farm—offers the best example of a potentially integrated life. Both home and workplace, the farm seems free of the division between personal and public or professional that we saw early in *La Strada*. In keeping with the valorization of nature and the critique of dependency at this point in Fellini's career, the farm also seems to allow for both organic and self-sustaining existence. However, there appears to be farm *ownership* but no *farming*, and nothing seems to be growing. Moreover, a young girl and baby are expelled from the farmhouse as soon as the crooks arrive, leaving only two sisters whose advanced age further implies a world beyond fertility. The thieves then proceed to devalue the very nature of farming. Their method of swindling—burying fake treasure with a "corpse," digging both up, then selling the treasure to farm owners—is a travesty of planting and harvesting, and it makes the only crops grown in the film fake jewelry and old bones.

In setting up the fraud, Augusto pretends to produce a letter of confession and remorse, written at the point of death by a thief who killed his accomplice and buried him on the farm. Some stolen jewelry is supposedly buried with the corpse—jewelry that can be kept by the two sisters if they pay Augusto for 500 Masses to be said for the salvation of the murderer's soul. As a story of death and betrayal among thieves, Augusto's tale serves as prophecy: he will later try to swindle his accomplices and end up being killed by them. As a quest for atonement and salvation, the letter introduces renewal and redemption as major themes. In fact, the burial and disinterment of jewelry parodies death and resurrection and introduces renewal as a purely bogus and material exercize. Augusto will prove particularly culpable on this count, responding to his midlife crisis only through monetary schemes of self-improvement.

The farm fraud has huge political and socioeconomic overtones. The thieves' impersonation of religious figures is only plausible because the Church has become

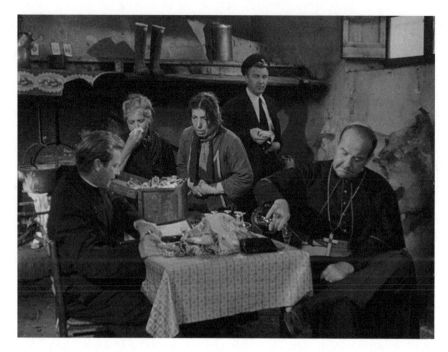

FIGURE 2.9 A jaded Augusto, dressed as a Monsignor (screen right), supervises the burial and "resurrection" of old bones and jewelry in heists that imply the corruption of the Church, the substitution of material goods for spiritual development, the death-within-life of a society that has lost touch with a sense of meaning and possibility, the consequent desperation and greed underlying an emerging Italian Economic Miracle, the dissociation of agrarian and urban Italian society, and the impossibility of personal renewal. Source: *Il Bidone* (1955). Directed by Federico Fellini. Produced by Titanus, Société Générale de Cinématographie (S.G.C.). Frame grab captured by Frank Burke from 2013 Blu-ray version.

materialistic and *does* expect payment for its religious services. At the same time, the victims are caught up in the capitalist game; otherwise they would not be easily fooled and so accepting of the premise that money can buy atonement. In both respects, *Il Bidone* clearly references the growing secularization and materialism of Italian society that resulted in the so-called Economic Miracle (1958–63). It is both prescient and harsh in its critique of a society headed very much in the wrong direction. Its sociopolitical critique will be taken up again in *La Dolce Vita*, and return, in the context of Italian terrorism, in *Orchestra Rehearsal* and, in the context of a postmodern Italy, in films such as *Ginger and Fred* and *The Voice of the Moon*. (Figure 2.9)

The film's first night sequences reintroduce one of the principal themes from *La Strada:* the failure of the personal. Picasso is the principal representative of

a potentially engaged, emotional existence, and he goes home to wife, Iris, and daughter, Silvana, while Augusto and Roberto go out to a nightclub. This private/public split recalls the personal/artistic division in *La Strada*. Private is not necessarily personal, however, and marriage and family are inevitably problematic in Fellini's early films, so Picasso's relation to the personal is effectively doomed from the start. Home, as representative of the personal, never really materializes. Picasso gets only as far as the staircase to his apartment and insists that Iris and Silvana join him outside. Then personal contact is quickly replaced by an exchange of gifts and the discussion of money, debts, and Picasso's ambitions as a painter. As this occurs, Silvana is picked up, carried around, and put down, but never really treated as a human being. By the sequence's end, Picasso and family, like the two farm sisters, are "evicted": moving down a public thoroughfare, away from the camera eye and, by implication, away from whatever home they share.

Meanwhile, at the nightclub, Augusto commits himself to the first in a series of false renewals, drunkenly claiming, "I'm going to go back to working alone" (*TS*, 164). As an equation of independence with isolation, it recalls Zampanò's words at the end of *La Strada* and points to the radical alienation Augusto will experience by the end of the film, when he does try to "work alone" by turning on his partners.

Days Two and Three

During the second and third days, home, family, and the (implied) personal continue to be devalued. Augusto, masquerading as a government official, allots new apartments to people stuck in the slums, in exchange for a down payment. Unlike the farm sisters, the slum tenants are so dissatisfied with their living conditions that they are, in effect, rootless. Moreover, obsession with housing replaces concern with family, as is poignantly illustrated by the prominent image of a child unattended on a rooftop. In a scene reminiscent of the beginning of *Bicycle Thieves*, bureaucratic inefficiency (the slumdwellers have been waiting years for their new accommodations) breeds intense self-interest, as desperate people ruthlessly seek to be the first served, with no sense whatsoever of community.

This time Picasso never gets home following the swindle. Moreover, Silvana never appears. Iris, in turn, gets dragged into the world of Augusto's old Mafioso friend Rinaldo, who has exiled his family to Switzerland. Following Rinaldo's party, she and Picasso get into a heated argument. As they talk things through, Fellini again suggests that their relationship is based on material mediation rather than intimacy. As they reconcile, Picasso kisses her hand rather awkwardly, and she reacts with embarrassment, turning away from him. It is only when he offers her a cigarette, she accepts, and they both light up, that they come near to each

other, and he immediately suggests they go off and check out the sounds of New Year's firecrackers that have suddenly erupted as though in mock celebration of their reconciliation.

By the end of the third day not only have Iris and Silvana disappeared, but Picasso can do nothing but drunkenly bemoan the failure of his home life. Home, in a most profound way, is reduced to homesickness and family is rejected in Augusto's words to Picasso: "In our kind of work you can't have a family. A man's got to be free. ... You have to be a loner" (*TS*, 218).

At the same time, Augusto becomes more and more dependent on others. He makes one brief attempt to fulfil his promise of working alone, but it is an instant failure as his mark turns out to be an older and wiser crook. He is then forced back on the authority of Vargas for the housing fraud. When he tries to revitalize his career through Rinaldo, he becomes little more than a supplicant, following his old friend around and entreating him to take him on as anything from partner to secretary. His entreaties get him nowhere, and by the third day he is reliant on Roberto, who sets up the film's third swindle, ripping off gas station attendants for a paltry 10,000 lire.

The disappearance of family life for Picasso, Augusto's explicit renunciation of family, and the latter's increasing inability to act for himself all create the context in which Patrizia, Augusto's daughter, is introduced. Instead of making genuine personal experience possible for Augusto, she is (unwittingly) used by him merely to compensate for its lack. This is underscored when Patrizia's appearance comes as a surprise—in fact, a shock—not only to Augusto but to us. We discover that he has had a family throughout the film, which he has chosen to ignore until it was thrust upon him. He fails to recognize Patrizia (she has to call out to him), and we learn that he has not seen her in two years. She is presented entirely as an outside force (an apparition), and Augusto will become dependent on her just as he has been on Vargas, Rinaldo, then Roberto. He will try to redeem himself through her in a way that, though quite touching, is doomed to failure.

As Patrizia's role might suggest, there is a growing association of renewal and regeneration with empty symbolism. Rinaldo's party—a thuggish and brawling celebration of the new year—establishes this early on. (Rinaldo's "toast" has nothing to do with the promise of the new: "It's midnight. Everything that's no good any more gets thrown out". [*TS*, 192].) It is most poignantly suggested through Picasso, however. At one point in his drunken state following the third swindle, he pulls himself together with Augusto's assistance, and his moment of recovery is associated with the sound of a baby's cry. Neither he nor Augusto responds. Moments later he is "baptized" by a few drops of falling rain, but as with Zampanò's trudge into the water at the end of *La Strada*, the potentially healing water has no effect. He is then abandoned by his fellow thieves, who go off with

a woman who, though married, is also a sex worker, and, left alone, as a church bell rings, he mutters "home … I'm going home." This is more a reflex response to his aloneness than a meaningful goal, for home no longer exists for him in the film. (In a scene not present in even the recently restored version, Augusto runs into Iris, who tells him she and Picasso are no longer together.)[20]

Day Four

The Patrizia-Augusto relationship takes up the whole of day four. In the transition from day three to day four, a verbal parallel is drawn between the sex worker telling Roberto and Augusto that she must be home at midnight and Patrizia telling Augusto she must be home by seven. Though the analogy seems harsh, she comes to function figuratively as a prostitute, a woman whom Augusto tries to "buy" by volunteering to underwrite a bond she must post to finance her education. In fact, their relationship is mediated repeatedly by money. Augusto buys her a flower as soon as they meet; then he buys her lunch, a movie, and ice cream before offering to pay for the bond.

Patrizia represents a number of values that seem positive in the context of the film: home, family, femininity, youth, beauty, affection, innocence, love. Yet, she is the most rootless—and ultimately the most compromised—female thus far. Unlike Picasso, she is never shown to have a home and family. Her mother (Augusto's wife) never appears, and Patrizia herself always begins and ends her appearances in the streets of Rome.

The limitations of her relationship with Augusto are most fully clarified during their two sustained conversations. First of all, during lunch, they both make an effort to initiate personal discussion. Augusto talks of his age; she talks of her mother. However, neither is able to respond appropriately to the other's remarks. Augusto, especially, evades the topic of his wife and, shortly thereafter, decides to retreat behind his dark glasses. As he takes them out, a cheap watch he tried to pawn off earlier appears and catches Patrizia's eye. It dominates the conversation, replacing (as did the cigarettes of Picasso and Iris) attempts at more intimate dialogue, and Augusto offers it to her as a gift. In effect, the watch becomes the basis of their relationship, implying (given its original purpose) that the relationship itself is a "swindle" or deception.

Second, at the movie theater, their conversation becomes part of a "love scene" whose illusory nature is emphasized by the setting. Augusto claims that the usherette thinks they are engaged. (Not only is there no evidence of this, but the idea is perverse.) Then he plays the role of the possessive lover, asking her to keep her Sundays open for him. After this, their "love" is "sealed with a kiss" as she responds effusively to his willingness to pay the bond. The kiss coincides with the

romantic, happy-ending music of the film that is just concluding. As though this were not enough to emphasize the parody, the music from *The White Sheik*—Fellini's most satiric view of deluded "lovers"—begins to play.

At this point, the film's title suggests not so much a world in which people fool or cheat one another but one in which they fool themselves. Unfortunately for Augusto, an old mark spots him and has him arrested. He ends up being marched off to the police station, and his concluding words to Patrizia—a harsh "Go home"—undercut yet again any positive associations with home.

Day Five

On the fifth day, with Picasso and Patrizia—Augusto's two representatives or surrogates for personal life—removed, he goes back to work. Having become temporarily expansive in the company of Patrizia, he now withdraws more than ever into his "fortress" of self-protection. To the extent that anything even illusorily personal remains, it is muted, repressed—notable, as with Gelsomina in the final scenes of *La Strada,* principally in terms of absence.

The day begins with Augusto's release from jail, another instance of potential renewal. Yet renewal means only repetition as Augusto goes back to Vargas and duplicates the farm fraud that opened the film. The one bit of novelty introduced is Augusto's attempt to swindle his accomplices as well as the farm family.

The death of home and family is again evident—this time through the lack of relationship among the fraud victims. The father gets swindled indoors while the mother waits outside. Susanna, the invalid daughter who, in her naïveté, recalls Rosanna from *Marriage Agency* and the young nun in *La Strada,* lives in a world of her own both spatially and mentally. The sister, who (reportedly) works in the fields, never appears on screen. Equally important, the family suffers from the kind of instrumentalism that became so pervasive near the end of *La Strada,* as the members evaluate one another in terms of usefulness. Susanna is praised because of her skill at accounting ("she can calculate better than a teacher" [*TS,* 239]) and because of her embroidery. Her sister is discussed in terms of the amount of difficult labor she does.

The most significant event at the farm is not the swindle itself but Augusto's encounter with Susanna. Fellini's characterization of her is twofold and requires a twofold response—reflecting psychological complexity and toughness on the director's part and ensuring that, like Patrizia, Susanna does not function as a simplistic symbol of innocence and positivity. As a victim of infantile paralysis, Susanna merits and evokes our sympathy. At the same time, she is wedded to her victimization. When Augusto raises the possibility that she might recover,

not only does she say "It's impossible" (*TS*, 240), but she responds with amazement, fear, and dismay. Though she claims to believe in miracles, she seems unwilling to entertain one for her own situation. She says "I'm always happy even when I'm in terrible pain", which suggests a degree of delusional "happiness" that will be mirrored by Augusto in his final moments. Susanna's affliction proves emotional and moral as well as physical; she remains fixated at age nine, when she contracted her disease. Although she initially seems to display strength and courage in her role, her underlying weakness and fear become clear in her desperate reverence for Augusto, and from her agonized entreaties as he pulls away from her tight grasp: "Don't go away. ... Pray for me!" (*TS*, 240). One might expect Susanna to replace Patrizia as someone for whom Augusto can provide parental support and thus derive a sense of validation. (Susanna does, of course, replace Patrizia narratively, as Patrizia replaced Picasso.) However, Susanna's limitations and Augusto's own depressed moral state are such that she elicits not support but nihilism: "Our life ... the life of so many people I know has nothing beautiful in it. ... I have nothing to give you" (*TS*, 240).

It is within this context that Augusto's final swindle occurs, as he tries to keep the money for himself. To a large extent, it is an enactment of his nihilism. In seeking to persuade his companions that he returned to money to Susanna because of her situation, he claims for himself a host of fundamental human qualities: compassion, empathy, and so on: "How could I take the money? Poor girl, stuck to a wheelchair since she was nine, knowing she will never be healed. She looks you in the eyes, kisses your hand, tells you to pray for her. I'd like to see what you would have done. ... I have a daughter, and I couldn't. ... Can't I have a conscience too?" (translation mine). But in merely using a feigned sensibility and conscience to steal money, he effectively negates them.

His reference to Patrizia suggests a positive, humane, motive behind his betrayal of his friends—that he is stealing the money for her schooling—but his psychology here is undecidable. It was clear from the last time Patrizia saw Augusto—being carted off to jail—that she was gone from his life forever. Is Augusto aware of that and thus merely using Patrizia as a tool to fool the others and steal money for himself? Or, in his radical dissociation from family, community, the social, has he entered into a state of Susanna-like delusion, still thinking Patrizia is part of his life? His final mention of her, as he is dying ("Oh Patrizia, my little girl"—*IPF*, 322), is hallucinatory. But here at least we might impute a semi-positive motive for Augusto's actions.

Augusto's final actions and words reflect the disappearance of the personal in at least two ways. When he makes his speech to his fellow thieves, he is utterly persuasive; he seems truly to believe in all the human values he espouses. But in reality,

performance has entirely effaced inner life: the latter has become pure simulation. This consequence was pretty much built into Augusto's work from the beginning. Secondly, because we can't entirely be sure if Augusto is doing this deludedly for Patrizia or cyncially for himself, his real feelings have become inaccessible to us, the viewers—a powerful indication of the extent to which, by film's end, communication, even on the film-spectator level, has been ruptured.

Augusto's attempted theft cannot possibly work. The viciousness of his associates and his own history of deceit ensure that he will not be believed. In effect, then, his attempted swindle is suicidal, a kind of empty "martyrdom" in response to the futility of his life.

Augusto's movement toward death is presented in terms of yet another meaningless renewal or enlightenment, an ascent lacking in any spiritual significance, a final and tragically ironic "salvation." After being stoned and losing consciousness at night, (the stoning is another suggestion of martyrdom) Augusto is "reborn" to "see the light" at dawn. Not only does he awaken, he struggles from well down the hill all the way to the top, where he calls out to a group of passing women and children. As delirious and oblivious to reality as Gelsomina was after *Il Matto's* death, he insists "I'm coming with you" (*TS*, 252), and his words are accompanied by a smile of satisfaction, of salvation attained. The transformation in Augusto's face following his film long reticence and gloom is a remarkable achievement on the part of both Crawford and Fellini, and its delusively radiant consciousness distinguishes Augusto from the insentient Zampanò at the end of *La Strada*.

At this moment, unnoticed by the women and children, Augusto dies. Unfortunately for Augusto, his death *is* his salvation; the only solution to a life no longer worth living. Alone on a barren, stony cliff, he is excluded once and for all from human community, as well as from the community of the living. He ends the film as just another rock (*rocca*) on the hillside, reduced even more emphatically than Zampanò to inanimate existence.

Though *Il Bidone* was not as well received as other Fellini films of the 1950s, it was quite important to Fellini's development as a filmmaker. Reading back from the perspective of *Nights of Cabinet,* we can see that the end of *Il Bidone* gets beyond the tragedy of Augusto himself, preparing for the later film. As Augusto moves inexorably toward his own destruction, he also annuls all the limitations with which he has been associated, paving the way for a "miracle," a moment of genuine renewal to emerge within the narrative. The women and children who appear so unexpectedly are the opposite of everything Augusto has become. They are a community representing harmony, self-expression, motion, and spontaneity—precisely the kind of community Cabiria will enter at the end of her story.

Augusto introduces a new possibility to Fellinian characterization. Though he seems utterly unaware of what he is doing, he functions as a kind of "artist" of alienation. In this respect he is precursor to Marcello in *La Dolce Vita*, who will also take negation, though far more purposively, as his ultimate mode of activity. In so doing, he will ultimately perform a creative function—not for himself but within the context of the film. Both Augusto and Marcello, in turn, anticipate Toby in *Toby Dammit*, whose very name—"To Be, Damn It"—implies the positive within the negative, salvation within damnation.

Conclusion[21]

The progression toward creative experience in Fellini's early films is reflected principally in the development of consciousness within his main characters. The characters of his first two films—*Variety Lights* and *The White Sheik*—are so bound to convention and illusion that they possess little in the way of conscious life. The first real advance occurs in *I Vitelloni*, where Moraldo, instead of being absorbed by his conventional world, takes a critical stance toward it. His judgmental attitude hints at a desire for a self-determining existence. Moreover, his rejection of his past, his home town, and his friends might—under better circumstances— reflect emergent self-awareness. In fact, this is precisely the kind of negative act on which, in the minds of certain psychologists, self-consciousness is built: "To become conscious of oneself, to be conscious at all, begins with saying 'no.' ... And when we scrutinize the acts upon which consciousness and the ego are built up, we must admit that to begin with they are all negative acts. To discriminate, to distinguish, to mark off, to isolate oneself from the surrounding context—these are the basic acts of consciousness."[22] Though Moraldo's act of rejection does not work for him, it introduces into the Fellini canon a model of behavior that will appear to lead to more positive results when Cabiria is able to renounce her past and seek a radically new life.

Marriage Agency marks the next major advance. As a reporter, the main character proves far more verbal and intellectual than Fellini's preceding heroes. He is also the film's narrator, who, by retelling his story, is engaged in highly reflective activity, though his story substitutes the illusion of self-awareness for the real thing,

This leads to *La Strada*, in which Gelsomina becomes the first Fellini figure to experience visible awakening. Moreover, *La Strada* is structured almost entirely in terms of consciousness, focusing on the tragic consequences of a world in which intelligence is born, suppressed, projected, then destroyed.

By the time we get to *Il Bidone,* Fellini's subject is no longer the birth and partial development of consciousness but the suppression of a consciousness that is

painfully present. Augusto's constant brooding and depression bespeak an intense effort not to confront the alienated consciousness burning within him. In fact, through both his awareness and his refusal to acknowledge it, he becomes the most complicated of Fellini's characters to this point, as well as the most resourceful, forever adopting new strategies to evade self-knowledge.

The development of consciousness is, in turn, associated with a growing emphasis on possibility and absence as opposed to mere givenness. Part of what makes Moraldo's actions at the end of *I Vitelloni* so significant is that they are the first major indication that a Fellini character senses something missing. (Ivan's puzzlement at the end of *The White Sheik* was a minor hint.) A sense of possibility is forcefully articulated for the very first time (albeit inauthentically) in *Marriage Agency,* when the reporter-narrator talks of the "countless possibilities life presents each day." Following this, *La Strada* becomes the first Fellini film to give real preeminence to possibility (Gelsomina's potential for growth) and to what is missing (Rosa and ultimately Gelsomina). With *Il Bidone,* we have a story conceived almost entirely in terms of absence. The opening swindle hinges on something buried. Augusto sublimates everything of value, then makes a series of substitutions based on that sublimation. The subsidiary characters (until Susanna accepts her role as suffering saint) talk repeatedly of change: Roberto wants to become a singer, Picasso dreams of being a successful painter, and Iris desires a far different relationship with Picasso.

As possibility replaces mere givenness, the nature of illusion changes. The fantasies of Fellini's early characters are all false attempts to deny a given reality, because they are derived from that reality (for instance, Wanda's "White Sheik"). Because this kind of illusion is not self-created, it does not answer to the needs of the characters who embrace it: it merely leads to loss of identity. In contrast, the illusions Cabiria will come to embrace always correlate precisely with what she needs in order to grow. She will even be able to transform conventional fantasies into means of self-fulfillment so that something like "marriage" becomes not a mere social or religious institution but an empowering metaphor for personal integration.

The increase in creative capability on the part of Fellini's characters is accompanied by a growing emphasis on redemption and resurrection. Implicit in both is a sense that the past is not inalterably given, that it can be re-created and ultimately transcended by acts of imagination. I have dealt with this at some length in *Il Bidone,* but redemption and resurrection are also crucial to *La Strada.* Zampanò's attempt to replace the dead Rosa with her sister clearly emerges from a wish to resurrect Rosa, and it makes his relation with Gelsomina at least potentially an attempt to redeem the past. Gelsomina shows an even greater talent for resurrecting things. When Zampanò fails her as a companion, she reinvents him (with

Il Matto's help) as an abstraction (a potential husband and purpose for living). When she and *Il matto* are separated, she resurrects *him* through his song. Resurrection is so prominent that it actually becomes the final killing force. It is in response to the young woman's re-creation of Gelsomina (in memory and song) that Zampanò ends the film in a state of collapse.

As Fellini's films move toward a redemptive view of life, patterns of experience evolve from the merely linear to the circular, semicircular, and helical. His initial films place great emphasis on railway imagery. Checco and Liliana in *Variety Lights* first meet aboard a train and end the film back on the tracks, en route to different destinations. *The White Sheik* begins with Ivan and Wanda arriving by rail in Rome and ends with the two of them as part of a "train" or procession of Ivan's relatives, chugging all in a line to Saint Peter's. (The train is precursor to all the parade and procession imagery of later Fellini films.) In *I Vitelloni* Moraldo ends up in a railway compartment as Guido is freeze-framed on the tracks. The rigid linearity of the railroad gives way to the somewhat greater flexibility of the road in Fellini's next three films. The narrator of *Marriage Agency* enjoys the freedom of an automobile, yet he ends his story in much the same way as prior Fellini figures, traveling in a straight line, screen center, away from the camera eye. Zampanò's motor home and the various cars in which Augusto rides provide greater options for travel and experience in the two films following *Marriage Agency*. Moreover, in *La Strada* the linear thrust of the road is balanced by circularity. Zampanò's principal act involves wrapping himself in a chain. He always moves in a circle as he describes his act to the audience. And much of his time (as well as that of the other characters) is spent in a circus. In *Il Bidone* circularity lies less in specific imagery than in the sense of a past tragically repeating itself. (Augusto lives out the words of a dead man's letter, Patrizia's appearance resurrects a dead personal past, and Augusto is driven at the end to repeat the farm swindle from the beginning.)

The line and the circle are both, obviously, expressions of limitation. The line allows for motion and forward thrust, but only in a regimented, predetermined way. The circle allows for a kind of wholeness, but wholeness born of closure, exclusion, repetition, and ultimately stasis or at least staying in the same place. The "solution" is a spiral or curvilinear process that moves both forward and back, that sweeps wide and far as it progresses and recapitulates. The spiral becomes a model of dynamic wholeness, of encompassing thrust. This model is first suggested at the end of *Il Bidone* through the community of women and children weaving among each other and moving around a bend. It will be dominant at the end of *Nights of Cabiria* in the movement of the heroine in relation to her newfound companions. In fact, as the next chapter suggests, Cabiria's movement resembles a concentric spiral, wherein she continually recapitulates

75

her past in a way that makes her present more embracing as she (without losing her center) expands outwardly in widening arcs of experience that keep her always on the move.

As Fellini's story and characters evolve through the early films, so does narrative method. Most noticeable is the diminishment in realistic plot and conventional story line and the emergence, instead, of a more complex kind of narrative structure. *Variety Lights* and *The White Sheik* are traditional and linear in development; a summary of their plots even seems to serve as a summary of the films. *I Vitelloni,* composed as it is of multiple stories, is much less straightforward. However, each story is itself plotted, and effort is still required to see beyond the plot to something less obvious and more complex (that is, the underlying *significance* of plot). With *Marriage Agency* and *La Strada,* we move from realistic story to narratives conceived principally in symbolic terms. The latter is structured entirely as a spiritual and psychological tale, so that plot is secondary.

As the organizational nature of Fellini's films changes, so does the nature of characterization. Fellini's earliest figures—particularly Ivan, Wanda, Checco, and the White Sheik—are mere caricatures. (The fact that *The White Sheik* is named after a comic-strip hero accentuates the stereotyping in that particular film.) Later figures such as Fausto, Alberto, Moraldo, Zampanò, and Augusto are more realized, "rounded" characters. Gelsormina and *Il Matto,* however, introduce a kind of portrayal other than caricature or dramatic characterization, representing symbolic values and possibilities more than concrete human qualities. For instance, Gelsomina acquires coherence not from the fact that she brings a stock set of responses to every situation (as a stereotype would). Nor does she derive it from acting like a "real person." She gains it almost entirely from the potential she holds for consciousness, wholeness, and so forth.

The shifts in narrative structure and characterization that occur through the early films all anticipate *Nights of Cabiria,* where conventional plot (particularly in the final sequence) will be superseded in the interests of the "miraculous" or "spiritual," and where Cabiria will be far more spirit than person or even character. In both respects, *Nights of Cabiria* will point toward films such as *8½* and *Juliet of the Spirits.* The title of the latter marks the explicit culmination of Fellini's experiments in transforming material reality and identity into representations of spirit.

NOTES

1. Quoted in Charles Thomas Samuels, *Encountering Directors* (New York: Putnam's, 1972), 118; hereafter cited in text as *ED.*
2. *Federico Fellini: Early Screenplays: "Variety Lights," "The White Sheik," trans. Judith Green (New York: Grossman, 1971), 60; hereafter cited in text as ES.*

3. My thoughts on otherness in *The White Sheik* have been inspired by Linde Luignenberg and by Shelleen Greene's "Racial Difference and the Postcolonial Imaginary in the Films of Federico Fellini," in *A Companion to Federico Fellini*, ed. Frank Burke, Marguerite Waller, and Marita Gubareva, 331–46. (Wiley Blackwell: Chichester, UK: 2020).

4. After unification (1861), Italy joined the European "scramble for Africa," annexing Eritrea and Somalia, controlling Libya, and seeking unsuccessfully to conquer Ethiopia. Under Mussolini, Italy was ultimately able to colonize Ethiopia and had unfulfilled designs on Tunisia and on portions of Iraq, Egypt, Algeria, and the Sudan, among other places. Following its defeat in the second world war, Italy lost all its colonies, including the Greek islands of the Dodecanese.

5. Given her demeanour and preference for the *fotoromanzo* troupe over Ivan's family, we can safely assume that Wanda comes from a slightly lower social echelon than Ivan's.

6. "Interview with Federico Fellini," George Bluestone, *Film Culture* 3 (October 1957): 3.

7. Fellini's commitment to cinema as a principally visual medium is reflected in his comment that "film should be like painting rather than literature. The thing I care most about is the light; I'm interested only in the results I can get from working with light" (interview with Alberto Arbasino, *Vogue*, October 1974, 246). His visual orientation seemed to intensify in the 1960s, so much so that one of his scriptwriters on *Juliet of the Spirits* objected: "His concern was less with human feelings than with images" (Alpert, 183). For a representative view of the word-image dichotomy in romantic/modernist thought, particularly with reference to movies, see W.R. Robinson, "The Movies Too Will Make You Free," in *Man and the Movies* (New York: Penguin, 1969), 112–34; "If You Don't See You're Dead: The Immediate Encounter with the Image in *Hiroshima Mon Amour* and *Juliet of the Spirits*," Part 2, *Contempora* 2, no. 4 (January—April 1973): 11–22; and "The Visual Powers Denied and Coupled: *Hamlet* and *Fellini-Satyricon* as Narratives of Seeing," in *Shakespeare's "More than Words Can Witness": Essays on Visual and Nonverbal Enactment in the Plays*, ed. Sidney Homan (Lewisburg, PA: Bucknell University Press, 1980), 177–206. All the W.R. Robinson essays have been reprinted in *Seeing Beyond: Movies, Visions, and Values— 26 Essays by William R. Robinson and Friends*, ed. Richard P. Sugg (New York: Golden String Press, 2001).

8. For a somewhat different perspective on word and image, stasis and motion in *The White Sheik*, see Stephen Snyder, "*The White Sheik*: Discovering the Story in the Medium," *The 1977 Film Studies Annual: Part I, Explorations in National Cinemas* (Pleasantville, N.Y.: Redgrave Publishing Company, 1977), 100–110.

9. Of course, Wanda's visual life is ultimately as culturally conditioned as her verbal experience. It is circumscribed by the *White Sheik* fiction and all the institutional values reproduced by that fiction. Although subsequent Fellini films such as *Nights of Cabiria* and *Juliet of the Spirits* will suggest a capacity for vision beyond cultural determinism, his final films will reflect the postmodern view that even what we see acquires meaning only through preexisting codes, which would nullify certain distinctions between word and image.

10. Goffredo Fofi and Gianni Volpi, eds., *Federico Fellini. L'arte della visione*. (Rome: AIACE, 1993), 97.

11. *Federico Fellini: Three Screenplays: "I Vitelloni," "Il Bidone," "The Temptation of Dr. Antonio,"* trans. Judith Green (New York: Grossman, 1970), 14; hereafter cited in text as *TS*. Use of subtitles rather than the screenplay is noted in the text.

12. Guido, of course, presages the main character of *8½*, who, in one of his guises, is also a uniformed youth. A principal problem in each film is one of "guidance" (hence the name Guido). In *I Vitelloni* guidance becomes imposed control, and freedom is impossible. In *8½*, Guido will seek to outgrow his own penchant, as film director, to guide or control everyone else, while also attempting to become self-guiding.

13. Although the Italian title is *Agenzia Matrimoniale,* Fellini's episode was titled *Love Cheerfully Arranged* in North American prints of *Love in the City.*

14. Quoted in Angelo Solmi, *Fellini,* trans. Elizabeth Greenwood (Atlantic Highlands, N.J.: Humanities Press, 1968), 104–5; hereafter cited in text.

15. Quotations from the film are taken from English subtitles and the English-language voice-over narration.

16. "The Long Interview: Tullio Kezich and Federico Fellini," in *Federico Fellini's "Juliet of the Spirits,"* ed. Tullio Kezich, trans. Howard Greenfield (New York: Ballantine, 1966), 30; hereafter cited in text as "Long Interview."

17. For further discussion of the road as both a positive and a negative symbol, see my "Peckinpah's *Convoy* and the Tradition of the Open Road," *Film Studies: Proceedings of the Purdue University Sixth Annual Conference on Film* (West Lafayette, IN: Purdue Research Foundation, 1982), 79–84.

18. Quotations are based on the film's subtitles, except when accuracy has demanded direct translation from the Italian.

19. The name derives from language that denotes "God's rule," "divine power," and similar notions.

20. *Il Primo Fellini. Lo sceicco bianco, I vitelloni, La strada, Il bidone* (Bologna: Capelli, 1969), 310—12); hereafter cited in the text as IPF.

21. My concern in this section is with the movement of Fellini's films toward stories of self-realization. However, I would direct the reader to the two scripted projects by Fellini—*"Moraldo in the City"* and *"A Journey with Anita"*—edited and translated by John C. Stubbs (Urbana: University of Illinois Press, 1983), which reveal that, as early as 1954, Fellini was beginning to imagine characters accomplishing some degree of self-definition.

22. Erich Neumann, *The Origins and History of Consciousness,* trans. R.F.C. Hull, Bollingen Series, no. 42 (Princeton: Princeton University Press, 1970), 363.

3

Individuation and Creative Negation: *Nights of Cabiria* and *La Dolce Vita*

Nights of Cabiria and *La Dolce Vita* follow upon Fellini's preceding films in significantly different ways. Whereas the former takes the movement toward more individualized characters a major step forward by offering a protagonist who seems able to break free of the limitations (conventional, institutional, and so forth) of her world, the latter takes Augusto's self-negation yet further in an orgy of "annulment" that ends with a more pronounced moment of renewal than we see at the end of *Il Bidone*. Each, in its own way, is part of a sustained period of affirmation that grows out of Fellini's earliest films, first manifests itself fleetingly in the final moments of *Il Bidone*, and then extends—in varying ways and with various degrees of qualification—from *Nights of Cabiria* through at least *The Clowns*.

Nights of Cabiria

Because *Il Bidone* was not well received, Fellini found it difficult to find backing for *Nights of Cabiria* (1956). By his count, it took 11 producers to get it made (Salachas, 105). The struggle to finance *Cabiria* proved well worth it, however. The film was immensely successful, not only in Europe but also in America, where it brought Fellini his second Oscar. The impact of *Nights of Cabiria* was largely the result of a marvelous performance by Giulietta Masina. In range and subtlety, her Cabiria is arguably an even more impressive portrayal than was her Gelsomina.

The character has precedents by way of both her name and Masina. Not only did Masina play the prostitute Cabiria in *The White Sheik*, but another Cabiria lent her name to an extraordinarily successful Italian silent film (Giovanni Patrone; 1914). While Fellini's two Cabirias have much in common, they differ sharply from the silent film character. Even though the film bears her name, the silent Cabiria is a minor and passive figure perpetually saved and ruled by external forces, particularly men. The nature of her captivity tends to change, but she is no more liberated at the end when she "finally ... finds peace in the sincere love of a Roman

patrician,"[1] than she was earlier in the hands of pirates and the enemies of Rome. She proves to be little more than a stereotypical movie heroine, a mere projection of male fantasies. In naming his heroine after the silent screen figure, Fellini may have been out to redeem the original Cabiria from this kind of implicit patriarchal prostitution.

Cabiria also serves to redeem Gelsomina. The connection between the two is present not only through Masina but through several subtle yet unmistakable allusions to *La Strada*. At the first crucial moment of growth for Cabiria—when she faces the fact that her lover, Giorgio, has tried to kill her—she casts him off symbolically by burning all his belongings, recalling her unfulfilled boast to *Il Matto* that she is going to do the same with Zampanò's things. Cabiria's ability to act, not just talk, shows that, from the beginning, she has a capacity for self-assertion that was lacking to Gelsomina. Moreover, once she has committed Giorgio's memory to flame, Cabiria arrives at her workplace (the Passeggiata Archeologica) in a motorcycle cart, reminiscent of Zampanò's van and also driven by a male. However, it is much lighter and far more open than the van and, even more important, once Cabiria descends from it, she never relies on it again. Finally, as she packs to go off' with her final treacherous lover, Oscar, Cabiria makes a point of leaving behind a statuette of an owl, an image that recalls the artwork on Zampanò's mobile home.

Although *Nights of Cabiria* is far more redemptive than Fellini's preceding films, it incorporates many of the problems dealt with earlier in his career, largely through the leitmotif of prostitution. Prostitution not only characterizes a world in which emotion, love, and intimacy are reduced to sexual commodity in a male-dominant society, but it functions figuratively to signify the willingness of characters to sell themselves out to illusions such as the bourgeois ideal of financial security, salvation through institutionalized religion, happiness-ever-after in marriage, and so on. Consequently, Cabiria's ability to abandon her life of prostitution becomes her ability also to free herself from self-protective and escapist fantasies.

Above all else, *Nights of Cabiria* is a film of insistent religious symbolism.[2] It is part of a sustained revaluation of traditional religious concepts that originated in Fellini's preceding work. *The White Sheik* treated the Church satirically, as an institutional authority with little or no theological or spiritual substance. *La Strada*, however, began to address notions such as Divine Providence, renunciation of the world, "marriage to God," and martyrdom with a good deal of seriousness. *Il Bidone*, as we have seen, was conceived largely in terms of (failed) redemption and martyrdom. And though theology itself was a problem in *La Strada*, in *Il Bidone* the problem lay more with the characters. Augusto was swindled not because he sought to redeem his life, but because he chose false means to that end. In *Nights of Cabiria* Fellini takes the religious patterns he used in *Il Bidone* and tells a far more positive story of death, resurrection, and salvation.

At the same time, he seeks to rescue Christian doctrine from its institutional and repressive context, affirming the psychological validity of religious motifs on the individual level of spiritual renewal.

In so doing, *Nights of Cabiria* charts an evolution from physical and bodily experience to imaginative, spiritual life. As part of its secularization of Catholicism, the film seeks to ground evolution in the world, making it immanent rather than transcendent. Cabiria is, at least symbolically, in touch with reality at the end. She is in vital contact with the earth as she "dies" and is "reborn," and in the final moments she is back on the road en route to new life challenges. Nonetheless, there is ultimately a denial of the flesh and a choice of spiritual over material life that remains strongly Catholic and confirms the Christian humanism of Fellini's work at this stage in his career—attempted secularization notwithstanding. Accordingly, the equation of prostitution with "mere" physical love, in conjunction with its other metaphorical connotations in the film, might be seen as a kind of judgmentalism that, again, seems markedly Catholic. At the very least, the film sidesteps the real conditions of prostitution particularly in the Italy of the times. Its use largely or principally as a metaphor would not find critical favor today.

In the opening moments of the film, Cabiria is little more than a body, seen from such a distance that she has virtually no individuality. When Giorgio steals her purse and shoves her into the Tiber, her near drowning and rescue (also shot from a distance) are principally physical events, and her "virtues" (energy, endurance, resilience) are likewise physical. However, there is a strong hint of baptism, death and resurrection, and incipient consciousness. More precisely, Cabiria's physical rebirth or resuscitation marks the birth of individuality, independence, and intelligence. When she comes to, her face is clearly revealed for the first time; a passerby identifies her as "Cabiria," she rebels against her rescuers, and she begins to wonder about Giorgio's whereabouts. Her awakened mental powers lead Cabiria to her first major moment of personal development. After trying to ignore the fact that Giorgio has tried to rob and kill her, she begins to use her friend Wanda as a sounding board, relentlessly asking questions about Giorgio's motives. Her questioning leads her not only to acknowledge the truth about him but also to ask, "What if I'd died"[3]—marking the awakening of self-consciousness. (**Figure 3.1**)

Cabiria's self-consciousness expresses itself in largely physical terms, as she uses her body to create poses and strike attitudes to impress the world. Seeing herself as a body, she sees herself as separate from everyone else. (In the Fellinian matter/spirit dichotomy, the former consists of separate, solid, entities; the latter is flowing, fluid, and permeable.) The words "Notice the difference between you and me," shouted by Matilde as Cabiria arrives at the Passeggiata, capture Cabiria's own sense of separation. Her accompanying defensiveness and alienation manifest

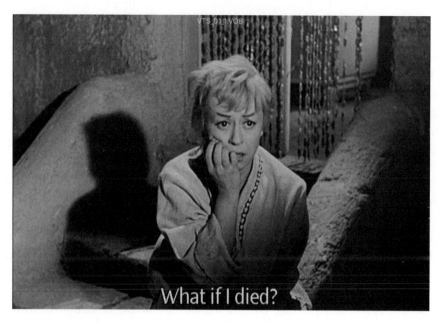

What if I died?

FIGURE 3.1 Cabiria experiences a crucial awakening of self-consciousness. Source: *Nights of Cabiria* (1957). Directed by Federico Fellini. Produced by Dino de Laurentiis Cinematografica and Les Films Marceau. Frame grab captured by Frank Burke from the 1999 DVD version.

themselves when she immediately gets into a fight with Matilde. The symptoms of emerging self-consciousness are not all so limited. In responding to her alienation, Cabiria senses something missing, as well as the need for change. Not only does she temporarily abandon the Passeggiata in a comic and futile attempt to compete with the more sophisticated hookers of the Via Veneto, she experiences the awakening of idealization, wonder, and rudimentary love through her encounter with the movie star Alberto Lazzari.

As his name suggests, Lazzari is a resurrective figure. His occupation enables him to move from one character and movie to the next. He is not only resurrective, he is resurrectable. In the course of his appearance, he is virtually brought back to life by Cabiria (the first time she significantly affects her world), as her company dissolves his surly self-centeredness and makes possible his reconciliation with his girlfriend, Jessy. With the appearance of Lazzari, death and resurrection evolve beyond mere physical events that Cabiria passively experiences. They become something that can be envisioned, made to happen. Through Lazzari, Cabiria refines four different ways of getting beyond herself: role-playing, vision, projection, and make-believe. All of these are obviously associated with movies, marking a crucial moment in Fellini's career when film begins to become an explicit thematic

presence, a medium whose qualities become examined in light of their potential to promote imaginative activity. The emphasis on vision recalls the word/image opposition in *The White Sheik* and anticipates the celebration of seeing as a key to imaginative experience at the end of Cabiria's own story, as well as in films such as *Juliet of the Spirits*.

Role-Playing: A role-player by profession, Lazzari appears at a point when Cabiria has taken to play-acting herself, affecting a "cool" exterior at the Passeggiata. In response to the sensed limitations of her given identity, Cabiria is trying to improve on it, and Lazzari helps things along by "casting" Cabiria in the role of replacement or "understudy" for Jessy. She adapts admirably, becoming a suitable and refreshing companion for Lazzari.

Vision: When Cabiria is transported by Lazzari's appearance, it is his image that astounds her and her eyes that reflect her wonder. Consistent with his work in movies, Lazzari lives in a highly visual world—from his stagy fight with Jessy (played before the "audience" of Cabiria and a doorman), to the nightclub where he takes Cabiria, to the multi-mirrored, glassed, and imaged world of his villa. Within this context Cabiria learns to relate to the given—and particularly Lazzari—as image rather than matter. She settles for Lazzari's photograph instead of Lazzari himself when Jessy reappears, and she ends her evening watching the reconciliation of Jessy and Lazzari through the bathroom keyhole. A room normally reserved for bodily functions becomes a "screening room" and Cabiria turns their relationship into a "film," as is made clear by the concluding iris shot of the two lovers.

Projection: When Cabiria is transported by Lazzari's appearance, it is clear that she is projecting onto him her dreams of romantic fulfilment—then worshiping him as the illusory object of her dreams. Narcissistic as this may be, it still marks the beginning of Cabiria's capacity for something other than the physical love the film associates with prostitution.

Make-Believe: Like the movies he stars in, Lazzari traffics not just in images but in fantasy. Though he is surrounded by visual objects, he is also ruled by things unseen, whose presence is wholly mental. He refers to people absent (his maid) or who no longer exist (Beethoven), and his entire evening with Cabiria is predicated on the fact that Jessy is not there. Cabiria, too, begins to relate to things not present: she asks Lazzari if he has any fish, talks passionately of her home, and describes in detail a scene from a movie. Ultimately, she outdoes Lazzari. Whereas he remains tied to things that, though absent, either were or are real, Cabiria moves to hypothesis: predicting that her friends will never "believe" (a word that will take on immense importance in succeeding scenes) that she spent the evening with him. She gravitates, in short, closer to the realm of the nonexistent and the merely possible.

This becomes even clearer the following morning. For one thing, she leaves behind Lazzari's photo when she leaves his villa. For another, when she awakens in his bathroom she gazes out the window and off into the distance, not back into the bedroom. For the first time, she looks *beyond* rather than at her world. This gets her into immediate trouble. As she is trying to find her way out of the villa, she focuses so intensely on the distance that instead of seeing a glass door, she sees through it, and is rewarded with a stunning smack on the head. The awakening of her head, to which the entire Lazzari sequence has conspired, is here "confirmed."

Seeing into the unseen prepares for the next major event in Cabiria's development, which is, appropriately, religious. Her readiness for it is established in a brief scene at the Passeggiata. While she and her friends debate whether they will attend a pilgrimage to the shrine of Divino Amore, a small procession appears. Cabiria again displays the capacity for wonder that was awakened by Lazzari. but here, as at the end of the preceding sequence, her attention is directed beyond her immediate world. As the pilgrims move through the Passeggiata and down the road, they take Cabiria's eyes with them, far into the distance—in effect, to the vanishing point.

When Cabiria arrives at the pilgrimage, she is wearing a bright white raincoat, which suggests an unconscious urge for enlightenment and reveals a growing capacity on her part to symbolize her inner feelings. The theme of the pilgrimage—Divine Love—takes Cabiria beyond the mere romantic attachment embodied by Lazzari. Moreover, through her absorption in the religious excitement, Cabiria acquires the incentive for transformation. She begs the Madonna, "Help me change my life," and following the religious services she bemoans the fact that she and her friends have not been changed. Actually, her prayers and complaints—as well as her assertion that "I'll sell my house and everything … I'm going away"—make clear that she *has* changed dramatically, and is taking a major step toward spiritual death and rebirth.

Consistent with my earlier remarks about Catholic dualism, the pilgrimage is given entirely to renunciation of the body. The events progress from bustling activity at the bottom of a hill to ascent and purely spiritual activity at the top. The ascent itself is given largely to mortification of the flesh, as many of the pilgrims inch their way forward on their knees, reciting the Stations of the Cross, itself a record of bodily suffering and death. The intent is to liberate the head or mind for contemplation of the divine. Accordingly, words (incantations, prayers, hymns) become the dominant form of experience, continuing Cabiria's progress beyond the visible. The images that appear (in contrast to those at Lazzari's) tend to be evocative or mandalic rather than representative: mere outlines or hollow symmetrical forms that one looks through as well as at. When they are representative, they refer to spiritual rather than physical reality.

Within this environment, Cabiria becomes predominantly cerebral for the first time. She isolates herself from the picnickers following the pilgrimage, states "I'm thinking," and contemplates the apparent failure of the pilgrimage to bring about the changes she seeks. More important, though it is not clear until the following sequence, Cabiria acquires a crucial mental tool—the symbol of the Virgin Mary—to assist her in her attempts to change. One of the principal incantatory phrases at the shrine is "Viva Maria," a phrase that is also electrified and elevated as a dominant visual sign. Under hypnosis at the Lux Theater, Cabiria will take the name "Maria" as a way of articulating her quest for renewal and her journey beyond the kind of entrapment implied in the film by prostitution,

At the end of the picnic scene, Cabiria's urge for transformation removes her from a shared and familiar world. She rejects the company of her friends. She also rejects the institutionalized religious quest that she has been part of, violently mocking a group of pilgrims off in a field. Yet even as she mocks them, she looks longingly after them, with regret that she is no longer part of their search. Her gaze makes clear that, though she has abandoned the quests of orthodoxy, she has not abandoned the quest *per se*. And, as the procession becomes ever smaller in the distance, it draws Cabiria's vision even farther into the vanishing point than did the procession at the Passeggiata. She is now on the verge of a personal pilgrimage that will take her beyond her existing world, into the realm of creative fantasy.

This transcendence occurs at the Lux, whose name and fiercely illuminating spotlight imply its function. At the Lux, Cabiria shuts her eyes to reality and withdraws completely into her mind. Two of the more important things featured here are magnetism and miracles. Magnetism, a power of attraction so intense that one person can enter and influence another's mind, is a model of spiritual affinity. Though it is employed manipulatively by the Conjuror in his stage routine, Cabiria engages in it authentically through her imagined love relation to "Oscar." Miracles appear largely as metamorphosis: the Conjuror turns male head into female, woman into ape, a stage and a bench (through hypnotic suggestion) into a voyage at sea. Cabiria has entered a world where anything can seemingly become anything else and where her Divine Love dream of radical change can be fulfilled. In going to the Lux, Cabiria has done something both new and entirely on her own for the first time. She has abandoned prostitution, at least for this evening. She has, in effect, "gone away," as she predicted she would at the picnic. Her growing independence is confirmed by her experience here. Instead of being exposed to merely conventional and external solutions to the problem of self-fulfillment (for instance, movie stars and religion), she appears to discover redemptive powers growing within her. Cabiria's independence can also be seen in her changing relation to the Conjuror. At first, he dominates her, putting her in and out of hypnosis

at will. However, when the topic of Oscar is introduced, Cabiria in a subtle but crucial way chooses to become entranced.[4] As the Maria-Oscar story unfolds, she gradually takes over: picking flowers, inventing dialogue, and making the Conjuror, in his role as Oscar, respond to her rather than vice versa. Finally, she becomes so active and powerful in her role that she startles the Conjuror, and he is forced to end the trance. The full extent of Cabiria's growth becomes clear from the nature and content of the Maria-Oscar tale. The Conjuror describes it as a feat of "auto-suggestion" ("self-suggestion"), and the phrase is even more accurate than the Conjuror intends. In identifying and acknowledging her innermost dreams, Cabiria "suggests" or creates Maria as her ideal self. She lays the foundations for self-love and self-acceptance, necessary for her to face life in even its most threatening aspects. Her growing faith is reflected here in her willingness to open out to the imagined Oscar.

As Cabiria becomes more open, she must come to accept death as part of life. For one thing, she must be willing to face her own psychological death in order to be reborn. For another, her ability to love must become not just a matter of romance but a full acceptance of all that life offers, including death.[5] Consistent with this, the stage at the Lux confronts Cabiria with images of decapitation, skulls, and stopped clocks, and just prior to the Maria-Oscar trance, the Conjuror hypnotizes several men into a vision of shipwreck. Death, however, is no longer a physical threat for Cabiria, as the shipwreck recreates Cabiria's earlier near drowning on the level of fantasy. Even more important, Cabiria undergoes two imaginative deaths and rebirths during the sequence. First, she dies off as Cabiria (through hypnosis) to become Maria. Then she dies as Maria to become a new Cabiria. The latter is especially significant. When the Conjuror brings the trance to an end, Cabiria/Maria slumps unconscious to the floor, and before he can bend all the way down to assist her, she pops up, reawakened. Again, the opening scenes are recalled, but Cabiria can now bring herself back to life without the intervention of others.

Cabiria's development through the Lux sequence, though extensive, is incomplete. It requires her withdrawal from reality, her escape into fantasy. It is also largely unreflective. Rather than being truly conscious of what she is doing, Cabiria tends merely to sense inadequacies or possibilities in response to what happens to her. This is clear even in her most cerebral of moments—at the picnic—where her promise to sell everything and go away is more a momentary outburst of confused emotion than a lucid, concrete decision. Following the Lux, Cabiria must reconnect with the tangible and concrete. She must also develop a formative and fully conscious intelligence that can act on the given, transform it, and create the conditions necessary for spiritual fulfillment. This is what makes her spiritual journey immanent instead of transcendent.

Cabiria's first encounter with the "real" Oscar is quite pointedly associated with a return to reality. She stands in the Lux lobby after the show, refusing to go outside and face some lingering male hecklers. When the cleaning woman insists that she must, Cabiria finally exits, and Oscar materializes virtually out of the wall of a building. He immediately begins to function as Cabiria's bridge back from the ideal to the real as he explains to Cabiria what she did under hypnosis and thus actualizes it for her in the realm of conscious awareness. Their first meeting also establishes Oscar's role as a stimulant for Cabiria's practical intelligence. He introduces himself as a *ragioniere*—an accountant or, in its root sense, "reasoner"—and throughout their first scenes together he repeatedly "accounts for" Cabiria's experiences with rational explanations. Early in their relationship, he serves largely as her surrogate intelligence, but she quickly makes his power of reason her own.

Oscar is also a consummate role-player. Capable of disguising his fraudulent nature, he is by far the most metamorphic, the most self-transformative, figure Cabiria encounters. Even more important, the role he adopts serves as the final bridge for Cabiria between prostitution and love. He presents himself as an unconditional giver, who asks nothing in return for his kindness and generosity. He talks repeatedly in terms of empathy and profound understanding. In making no demands on Cabiria, he allows her to be what she wants to be, encouraging her to pursue all her strongest inclinations. Offered both a model of perfect love and the freedom to develop her own capacity to give, Cabiria becomes increasingly open, loving, and trusting. The result is suggested by Oscar's own words: "when we are suddenly faced with purity and candor, then the mask of cynicism falls. All that is best in us is awakened." Moreover, by the time Oscar reveals his true intent, Cabiria has developed the spiritual strength to neutralize him, and to live beyond the need for him.

With the appearance of Oscar, Cabiria begins yet another cycle of growth beyond physical and material reality. In her first two scenes with him, she is content to be a mere recipient of gifts. As she says to Wanda, "Who cares, as long as he pays?" However, when she is nearly arrested at the Passeggiata, she has a moment of awakening similar to when she asked herself, "What if I'd died?" She realizes that prostitution is a dead end, and she begins to view Oscar as the avenue to a new life.

During the next several scenes, Cabiria becomes much more active and responsive, and her responsiveness is linked to a growing capacity for intense thought. Her scene of awakened concern at the Passeggiata is followed by one of pensive attention as she listens to Oscar recount his presumed personal history. This is followed by a scene in which Cabiria, home alone, slowly rises from bed, leaves her house, and wanders down the road, lost in meditation. Born out of her thoughts are the otherworldly voice and image of Brother Giovanni. A virtual apparition,

he brings revelation from the realm of spirit: telling Cabiria that she must be in the grace of God to be happy and that she should be married because "matrimony is a holy thing." His words alter radically Cabiria's relationship to Oscar. She no longer views him solely as a vehicle of escape from the Passeggiata; in fact, her initial response is to tell him that she will not see him any more. From here on, she insists on spiritual rather than utilitarian value. In accepting Oscar's offer of marriage, she comes to see transformation in terms of movement beyond self and movement beyond all that is known and familiar. She prepares to give up prostitution, sell her house, and leave behind the maternal Wanda. Even more important, as Cabiria comes to view Oscar in spiritual terms, he disappears as a character. He is absent from five of six scenes in which Cabiria makes crucial decisions and takes crucial actions regarding her life.

Cabiria's competence, decisiveness, and self-confidence are evident in the scene of packing and departure, when it becomes clear that she has made arrangements for everything (sale of the house, disposal of goods, withdrawal of money). Moreover, by the time she walks out the front door and surrenders the keys to her house (a film-long refuge and image of closure), she is completely opened out. She tries to communicate with everyone she is leaving behind. She expresses immense love for Wanda—love so strong that even Wanda abandons her habitual coolness and responds in kind. As she awaits the bus, Cabiria is able to balance both profound joy (the anticipation of union with Oscar) and profound sorrow (the pain of losing Wanda and severing all ties with the past). As she bids Wanda good-bye, she assures her that she, too, will experience a "miracle," revealing that she now sees her life as miraculous.

Cabiria's spiritual and moral power is such that she dominates Oscar during their final scenes. She overwhelms him with her candor, forcing him repeatedly to retreat behind his dark jacket and dark glasses. She has reversed their relationship since their meeting outside the Lux. She has, in fact, become Oscar to the extent that she has assimilated all his positive qualities. She says as much, without realizing it, when she tells him they are *uguali*, a word that means not only "equal" but "the same" or "identical." Even after she has discovered Oscar's real intentions, she remains dominant, although her sense of devastation might initially suggest otherwise. The power of her fear and disillusionment drives Oscar to defensive silence. More than that, it partially redeems him. Not only can he not bring himself to kill her, but he is turned from murderer into savior as he pulls Cabiria away from the brink and says, "Can't you see, I don't want to hurt you." Furthermore, he does not actually rob her. He only takes the money she drops at his feet—money that is no longer of value to her.

Obviously, Cabiria's confrontation with Oscar reenacts her near drowning at the hands of Giorgio. In contrast with the opening scene, where only physical

well-being was the issue, spiritual health is at stake here as well. Cabiria is challenged with the destruction of all external sources of faith, love, hope, and grace. The fact that Cabiria's activity takes place on a much higher moral and spiritual plane is reflected in the location of the action far above sea level. The water, which was an immediate and tangible threat in the opening scene, is now far distant, symbolic of a death more profound than drowning. Most important, Cabiria *chooses* her "death" here. She tells Oscar, "Kill me. Throw me in. I don't want to live." In terms of the film's logic, she is seeking the death that precedes enlightenment, the death of all she has ever been, so that she can be reborn anew. This occurs once Oscar has gone. Cabiria gradually lapses into unconsciousness, and as she does her sobs become those of a little girl, her final cry that of a baby. She then lies dormant, at a moment prior to infancy, prior to birth.

Cabiria's death is the end of singular identity and selfhood, that sense of separate, alienated individuality that was born the moment she confronted her mortality. As she comes back to life in the final scene, picks up the bouquet she had gathered earlier, and moves back through the woods, Cabiria is presented as a "bride of life," married to no one in particular but to the world at large. Her willingness to keep on keeping on, despite her recent devastation, seems to generate the youngsters whose music and dance celebrate their life and hers. Though their appearance is miraculous, it is not arbitrary. Within the film's vision of individuation, they are her own powers released into the world, her own capacity for resurrection and renewal acting on her in a realm where separation between self and world has vanished.

Brief as it is, the final sequence recapitulates all the major processes of the film. Cabiria moves from alienation to engagement. Male dominance (among the youths) gives way to female liberation. Most important, body gives way to spirit, weight to lightness. When Cabiria awakens, her movements are ponderous, and even when she begins to walk, she is leaden and slow. However, she becomes increasingly fluid as she mingles with the youngsters. At the moment she is bid "*Buona sera*," her materiality—and that of her world—vanishes. In the final images there is no road, no bouquet (the last of Cabiria's "possessions" to disappear), no "world's body." There is only the enlightened image of Cabiria's face and upper body, floating weightlessly in space, amidst the upper-body images of the youths who float behind her. They, in turn, are present through rear projection, which makes them lighter and larger than life.

In performing their restorative service, Cabiria's companions function in quite a complex way. Their actions and movement bespeak a world in which all motion has become dance, all sound music, all life harmony.[6] Their orderly yet spontaneous progression reenacts all the many processions that have occurred before. The boys in the group reincarnate the adolescents who rescued Cabiria in the opening

scene. They also redeem the pimps from the Passeggiata and recall nightclub musicians from the Lazzari sequence. The young girls, of course, are the recovery of innocence. The dark-haired figure who says *"Buona sera"* clearly incarnates Maria from the Lux and resurrects Cabiria as an adolescent. (As Oscar and Cabiria left the seaside restaurant, Cabiria had remarked, "You should have seen me when I was fifteen. I had long black hair down to here.") She is another manifestation of Cabiria's inner self released into the world.

As Cabiria comes to accept the evening and all it signifies, she becomes a figure of intense vision. Not only do Cabiria's eyes embrace the visible, they gaze into the unseen. Just before the film ends, her eyes focus briefly on the camera eye, seeing into our eyes and destroying the conventional mediation between spectator and film. In acknowledging the audience, Cabiria sees what is present but (logically) invisible. This serves to symbolize her capacity to live in a realm of spirit, defined by the paradoxical presentness of absence and experienced only by seeing beyond the seen. (**Figure 3.2**)

Nights of Cabiria is extraordinarily sophisticated in its rendering of psychospiritual development. It seems strongly Jungian, though Fellini will not enjoy full exposure to Jung's thought until he encounters the psychoanalyst Ernst Bernhard in the 1960s. The spiritual dimension of the film no doubt contributed to its enormous power within the 1950s ideological context in which it was made. From a contemporary perspective, one might object to the fact that

FIGURE 3.2 Cabiria sees into the unseen: her graceful look into the camera acknowledges our presence and her ability to transcend realms and barriers. Source: *Nights of Cabiria* (1957). Directed by Federico Fellini. Produced by Dino de Laurentiis Cinematografica and Les Films Marceau. Frame grab captured by Frank Burke from the 1999 DVD version.

prostitution and attempted murder (femicide in fact) are addressed much less as social issues than as tropes leading to personal, symbolic salvation. Problems that the film seeks to solve on a symbolic level remain unaddressed in the real world that has been left behind. In practical terms, Cabiria renounces home, workplace, Wanda, and—except on an ethereal level—intimacy. Something of the sort will recur in Fellini's later Giulietta Masina-based film, *Giulietta degli spiriti*. This of course is the sort of thing that seriously troubled the Italian Marxist, pro-neorealist, critics of the 1950s. However, Fellini was seeking to explore the psychology not just the material reality of his protagonist—and, in so doing, he was far from alone at that moment in the emergence of art cinema. For many, *Nights of Cabiria* offered and continues to offer powerful insight into emotional and psychological experience and the historical moment in which it was made.

La Dolce Vita

La Dolce Vita (1960) derived from "Moraldo in the City," a project that Fellini had contemplated after *I Vitelloni*, and from Fellini's impressions of the Via Veneto, which had recently become an international hangout for the trendy and symbolized for Fellini the effects the Economic Miracle and internationalization were having on Italy. The film was enormously successful, with the furor it raised contributing to its box office appeal. Partly because of the outrage it triggered among the Italian clergy, *La Dolce Vita* acquired a reputation as a scandalous celebration of decadence. The film helped highlight the ongoing division in Italy between Catholicism and Marxism. While much of the Catholic *intelligentsia* found the film irreligious and prurient (though there were crucial exceptions even among the clergy), Marxists applauded it as an indictment of bourgeois society— reversing positions taken by the two sides *vis-à-vis* Fellini on *La Strada*. Partly because of the attention it received and largely because of its scope and power, *La Dolce Vita* did much to confirm Fellini's reputation within high modernist circles of the time, promoting comparisons of Fellini to Dante, T. S. Eliot, James Joyce, and other major literary figures past and present.

This monument in the history of cinema and Western culture opens itself out to endless interpretation and contemplation. However, in what follows, I restrict my discussion to the conceptual context I established in my introduction and preceding chapters—and that will ensue through my discussions of Fellini's work from *8½* through *Toby Dammit*.

Like *Nights of Cabiria*, *La Dolce Vita* is concerned with religious and spiritual patterns of experience. Unlike *Cabiria*, however, *La Dolce Vita* focuses on the

inability of people to transform their lives. Characters repeatedly, though unwittingly, avoid the challenge of growth by escaping into self-gratification. This is reflected both in the film's title and in the heavy emphasis on dissociated sexuality. Like *La Strada, La Dolce Vita* is a film of failed moral development.

The film's emphasis on sexuality is related to the characters' need for renewal through love, something suggested in the opening scene by the statue of Christ, in a gesture of embrace, being whisked by helicopter "back" to the world in a Second Coming of sorts. But Maddalena, who claims to want a "whole new life,"[7] substitutes serial sex for more sustained forms of engagement. Marcello has sex with Maddalena and does his best to do the same with Sylvia even though he is in a relationship with Emma. Marcello's father tries to recapture lost youth by courting a woman 30 years younger. And Emma, sensing Marcello's lack of commitment, tries to lure him home to make love during Sylvia's press conference, though she also pursues conventionally religious avenues, praying at the miracle site for the renewal of Marcello's love.

The brief opening sequence of *La Dolce Vita* introduces the problem of false spirituality. The power of flight ("transcendence") is possessed only by a couple of whirlybirds. The presumed embodiment of spirit and love (Christ) is rigid, heavy, and mechanically controlled. Both the spiritual reawakening and renewal promised by a Second Coming are destined to fail. The impossibility of the former is suggested humorously when the statue of Christ actually *does* trigger an "awakening" of four female sunbathers, who respond by saying "It's Jesus Christ" (*DV*, 2). Obviously it is *not* Christ, just a statue, and one that, significantly, never makes it back to earth in the film. The sensational and theatrical effect of the statue's appearance points to a society in which spectacle has replaced more spiritual forms of renewal, a world that relies on movie stars, media, and gossip journalism to rescue it from boredom. The emphasis on a media-driven society of the image makes *La Dolce Vita* Fellini's first potentially postmodern film, an issue I address in further detail in Chapter 9. (**Figure 3.3**)

Marcello's situation is rapidly sketched for us. Caught between a petrified image of spiritual love and more vital physical alternatives, he is moved toward the latter, as his helicopter abandons Christ for the sunbathers. And when the sunbathers respond with an emphatic "No" to a request for their phone numbers, Marcello is exposed for the first time to negation or denial as an appropriate response to life.

Despite the fact that neither helicopter lands, there is a persistent downward thrust to the sequence—and to Marcello's gaze. We never see him look up at the statue of Christ. He looks down at the sunbathers on the roof, then, the last time we see him in the sequence, he looks over the side of the helicopter and straight down to earth (recalling the downcast eyes of Moraldo at the end of *I Vitelloni*). Unlike Cabiria, he has no capacity for looking beyond the immediate, seeing beyond the

FIGURE 3.3 The empty promise of a Second Coming. Source: *La Dolce Vita* (1960). Directed by Federico Fellini. Produced by Riama Film/Cineriz. Frame grab captured by Frank Burke from 2014 Blu-ray version.

seen. Instead he is prey to a gravitational pull that eventually captures everyone except Paola, and reduces the Second Coming to inexorable descent.

This downward thrust recurs in Guido's nightmare at the beginning of *8½*, when he is soaring far up in the sky but has a rope tied to his ankle and is yanked back to earth as a figure on horseback says, imperiously, "down, definitely down." There, the implication is that Guido must stop escaping and find solutions in, not away from, the world. This might be seen as a reconsideration of both *Nights of Cabiria*'s and *La Dolce Vita*'s negative take on material, physical, reality—perhaps even a critique of an implicit transcendental bias in both films.

Through the first half of *La Dolce Vita*, Marcello is exposed to the same stages of development as was Cabiria. In the opening scene, he is an unselfconscious respondent to events, at the mercy of his job, his helicopter, and life in general. When Maddalena appears, she brings with her an intense sense of self-awareness, talking of her alienation and her desire to be separate and alone. This recalls Cabiria's self-consciousness at the Passeggiata Archeologica and the Via Veneto, as well as Matilde's remark "Notice the difference between me and all of you." Marcello himself experiences a moment of potential awakening when he is shocked into full alertness (and shot in extreme close-up) on discovering the overdosed Emma. Then, with the introduction of the movie star Sylvia, Marcello is moved to visual astonishment, projection, romantic wonder, and idealization, just as Cabiria was with Lazzari. Sylvia's appearance is followed by a brief scene in church (with Steiner) and by Marcello's visit to the miracle site, both of which correspond with the brief procession scene at the Passeggiata, followed by the

pilgrimage, in *Cabiria*. Then, just as Cabiria visited the Lux, where she could escape into her mind, Marcello visits the home of Steiner, a disembodied intellectual who lives in a world of art and abstraction. Cabiria's absorption in the fictional tale of Maria and Oscar are roughly comparable to Marcello's attempts to create "literature" (presumably fiction) by the sea.

Unlike Cabiria, Marcello is unable to internalize these stages of potential growth. Events that occurred *to* or *through* Cabiria only occur *outside* Marcello. (Marcello's extravert profession as reporter helps define his dilemma.) For instance, Cabiria's drowning and resuscitation—her "death and rebirth"— become Emma's attempted suicide and recovery, and Cabiria's "What if I'd died?" becomes Marcello's confrontation not with his own mortality but with Emma's. During the religious scenes it is Emma who prays for a miracle, not Marcello. Because all remains external, Marcello fails to develop Maddalena's acute self-awareness, his idealization of Sylvia never gets beyond romantic delusion, he cannot create meaning for himself at the miracle, and he relies on Steiner as a surrogate intelligence. Inevitably, he is unable to find inspiration when he tries to write at the beach.

Every sequence confirms the impossibility of evolving consciousness. When Emma is out of danger at the hospital and Marcello has the opportunity to contemplate what has happened, he instead calls Maddalena, whose dead-to-the-world image seems to reflect Marcello's own state of mind. Though Sylvia sparks a temporary increase in Marcello's mental activity, he ends up closing his eyes, immersing himself in the waters of the Trevi, and celebrating Sylvia's nonreflective ways: "Yes, yes, she's perfectly right. I've been wrong about everything" (*DV*, 79).

At the miracle site Marcello shows no signs of emerging religious sensibility, and the quest on the part of others for a miracle culminates with the words of a woman— "he's dead, he's dead" (*DV*, 11), arguably alluding to the death of God and, by implication, a spiritual dimension to experience. Steiner, who as an intellectual should be a vital force for enhanced awareness, promotes instead a kind of paranoid detachment—"We need to live in a state of suspended animation"— which is the antithesis of an engaged mental life. And finally, Marcello, after a half-hearted attempt, abandons creative writing at the beach.

As much of the preceding would suggest, the first half of *La Dolce Vita* offers seeming progression from physical experience (Marcello's relation with Maddalena, Emma's illness) to idealization (Marcello's pursuit of Sylvia), to transcendence (the miracle site, where the Madonna is wholly invented and conspicuous by her physical absence), to attempted self-transformation (Marcello seeking to become a literary artist). Not only does this parallel (albeit negatively) Cabiria's movement from Giorgio to Lazzari to the Divine Love pilgrimage to the Lux, it recurs as a basic pattern in the second half of *La Dolce Vita*. The sequence

94

with Marcello's father focuses on the sexual and physical (his illness even paral-
lels Emma's). Then, at the Castle, idealization takes over as Marcello—left in the
"Chamber of Serious Discourse"—rhapsodizes over Maddalena. Idealization is
replaced by forms of spiritual transcendence as aristocrats engage in a ghost hunt
or "pilgrimage" that ends in a seance. Finally, back at the birthplace of his own
quest for self-transformation, Steiner's apartment, Marcello encounters the corpse
of Steiner, who has chosen his own nihilistic form of "self-transformation" through
suicide and through the murder of his children, which annuls any potential Steiner
might have had to serve as a moral or ethical model.

In each case the second-half version is a radical diminishment of the first—and
part of a marked diminishment in the film's moral climate. Through much of the
first half there was a strong sense of possibility. During the second half possibility
is replaced by mere givenness, and the challenge to create something new becomes
merely the attempt to respond to what is already there. We might say that while
the first half moved to the denial of *creative* consciousness, the second culmin-
ates in the death of merely *responsive* consciousness. The past comes to dominate
(Marcello's father, the aristocracy and its 500-year-old villa), and, consistent with
this, the only major new figure Marcello meets—the American painter Jane—is a
walking denial of significant change. Not only has she forsaken the New World
for the Old, she becomes the standard bearer of the dying aristocracy, the leader
of the ghost hunt to the ruined villa.

Inevitably, Marcello is unable to initiate change. He has to be awakened out of
a deep sleep to be informed of Steiner's death, and by this point he is barely able to
react to experience, much less create it. His visit to the scene of the murder-suicide
confirms the loss of meaningful intelligence. Not only has Steiner shot himself in
the head (we have already noted Fellini's emphasis in earlier films on the head
as a symbol of consciousness) but the detectives who fill the apartment can only
measure and tape-record, proving utterly unable to determine motive. (**Figure 3.4**)

When questioned by the police, all Marcello can say is "I don't know anything.
I really don't know anything" and "I don't think so" and "I don't know" (*DV*,
226–27). (Moraldo says "I don't know" three times in response to Guido's ques-
tions at the end of *I Vitelloni*, suggesting *his* short-circuited intelligence at the end
of his story and suggesting again that Marcello is a "Moraldo in the city.") Even
the one seemingly active thing Marcello does—accompany the police to the bus
stop in order to identify Anna Steiner—serves only to emphasize his inability to
respond. He is too numb to comply with the commissioner's request that he tell
the paparazzi not to harass Anna. Moreover, though he is presumably acting in
a personal capacity (Anna is a friend), he acts only as a "reporter," pointing out
her arrival. He makes no effort to speak with or console her, and he merely acqui-
esces in the police commissioner's lie that her children are only wounded. Actually,

Left wall to bullet hole:
13 feet.

FIGURE 3.4 The death of consciousness, as *La Dolce Vita*'s principal intellectual shoots himself in the head, leaving forensic measurement in his place. Source: *La Dolce Vita* (1960). Directed by Federico Fellini. Produced by Riama Film/Cineriz. Frame grab captured by Frank Burke from 2014 Blu-ray version.

Marcello is even less than a reporter here, for reporting entails some re-creation. He is mainly a "camera" that registers external happenings. The analogy is suggested in the final shot of the sequence: an extreme close-up of a paparazzo's camera, which asserts the prevalence of merely replicative, dead-eye vision in a world from which both formative and engaged intelligence have vanished. This close-up, in turn, dissolves into a shot of headlights, more mechanical "eyes."

The Annulment Party

The sequence following Steiner's death is a party celebrating not only the annulment of a marriage but, as Marcello puts it, "the annulment of everything" (*DV*, 236). Intended to honor Nadia's newfound freedom and her "becoming a virgin again" (*DV*, 236–37), it shows only her attachment to a new lover and a world-weariness that is the opposite of innocence. Sacraments of cleansing or of preparation for a new life are mimicked and debased, a process that culminates with Marcello's violent dousing and slapping of Pasutt. Her "baptism" and "confirmation" are accompanied by a vicious mockery of self-transformation, as she is turned into a chicken, with pillow feathers, by Marcello. The sequence concludes with a benediction of sorts, as Marcello showers the departing guests with feathers, and his actions make a procession out of their departure into a new day. However, the ritual here is as ineffectual as were Zampanò's and Picasso's baptisms in *La Strada* and *Il Bidone*.

The drunken outpouring of nihilistic energy on the part of Marcello and his companions annuls (yet again) meaningful intelligence. Marcello—sardonically designated the party "intellectual"—brags of his inventiveness: "I have a thousand, two thousand ideas" (*DV*, 252), but his "ideas" are solely and debasedly sexual in nature. Concomitantly, the only form of idealization left is drunken and for the most part dispassionate staring at Nadia's naked body, accompanied by detached commentary. Marcello's repeated, mindless slapping of Pasutt is part of an all-out assault on the head. Marcello tosses a drink in Laura's face. Lisa draws a caricature of Marcello's head on a glass ball that Marcello proceeds to smash with a whiskey bottle. His new boss, Sernas, slams Marcello in the face with a pillow and, shortly thereafter, grabs him in a headlock. Marcello not only douses and slaps Pasutt's face, he pounds her over the head repeatedly with a pillow.

Marcello's engages in repeated acts of self-annulment. His urge to repudiate himself is immediately suggested when he appears in a white suit and black tie that are the "negative" of his evening attire earlier in the film. He has also abandoned all literary or even journalistic ambitions in favor of producing vacuous and fake fluff for celebrities. His brutalization of Pasutt is largely self-brutalization, for he sees her as a reflection of himself.[8] His destruction of the glass caricature is a ritual annihilation of what little identity he has left.

The Beach: Marcello

As the party comes to an end and the guests leave the annulment villa, the process of emotional depletion is complete. "I've lost all interest in this life" (*DV*, 268), proclaims Domino as he walks with Marcello, speaking for Marcello and everyone else. Marcello, in turn, reacts to the enormous dead fish that seems to be staring at him by saying, "What is there for it to look at?"

The exhausted revelers' brief journey back to the sea recalls Zampanò's at the end of *La Strada*. The monstrous fish, reflecting the state of Marcello's society, is an image of solid matter devoid of spirit. Dragged up from the sea, it implies, in Jungian terms, the impossibility of transition from unconscious life (the sea) to consciousness (the shore, the light of dawn). In apocalyptic terms, the fish suggests the death of Christ, the death of Christianity. *Ichthys*, the Greek word for fish, was used in early Christianity to designate the Savior, and in this instance the fish is specifically linked to Christ by a fisherman's remark that it has been dead for three days. Moreover, as marvelous apparition, the fish replaces the statue of Christ from the opening moments. The fact that this Ichthys will not rise again becomes another—and conclusive—denial of regeneration for Marcello and his society.

Throughout the sequence, Marcello remains numb. He does not share in the astonishment (the last, diminished sign of idealization) generated among his

companions by the beached monster. When he is confronted by the potentially revitalizing image and voice of Paola, his intelligence is so deadened that he can neither recognize nor identify her. He slumps to a sitting position in the sand, he can rise only to his knees when Paola gets his attention, then he sinks back on his heels as his attempts to understand her fail. The gravitational pull of the opening sequence is again strongly in evidence. He does regain his feet, which is an improvement over Zampanò's and Augusto's final moments in their films, but he is obviously far closer to them in his spiritual defeat than to the transformed and transformative Cabiria.

The Beach: Paola

In terms of Marcello, the annulment process is pretty much finished when the party is over. In terms of the film as a whole, however, the annulment is complete only when Marcello and his companions exit. Like Augusto's death and Oscar's escape into the woods, the disappearance of Marcello's society from the world of the film cancels out all that has been negative. His end becomes a beginning, as Paola takes over the screen.

Paola's name makes her a feminine incarnation of Saint Paul, the most influential of early Christian theologians. (Fellini will again refer to Paul in 8½, when a priest suggests to Guido that the hero of his film is undergoing a "journey to Damascus.") Paul's writings have much in common with the evolutionary theology we have seen building through *La Strada* to *Nights of Cabiria*. They emphasize the need for evolution from physical existence to spiritual life—and from a life ruled by the law (convention and authority) to a life of liberation through love.

In a sense, Paola enacts the transformations spoken of by Paul in the final moments, as she undergoes a visual process similar to Cabiria's at the end of her film. Initially, Paola is tied to the world's body—shot from a distance in full length, located three-dimensionally in space, and visibly rooted to the earth. Mentally, she is tied to the past as she tries to repossess Marcello through pantomime reminders of their prior meeting. However, when Marcello cannot respond, she is released. Instead of trying to capture his attention, she waves good-bye. At the same time, her image becomes etherealized as she is shot in increasing close-up. Her feet and lower body disappear and so, finally, does all but her head. The physical environment behind and around her metamorphoses from images of specific objects to shades and forms of light. (**Figure 3.5**) (Even the initial "objects" are fluid, dynamic, creatively insubstantial: a vibrant sea, children at play, and open see-through structures.) Three-dimensionality gives way to two-dimensionality as objects separated in space give way to a single, unified plane in which Paola and her environment are one. The moment Marcello is

FIGURE 3.5 The world's body dissolves into vague hints of structure (screen left) and the sea (screen right) as Paola waves goodbye to Marcello. Source: *La Dolce Vita* (1960). Directed by Federico Fellini. Produced by Riama Film/Cineriz. Frame grab captured by Frank Burke from 2014 Blu-ray version.

gone she, like Cabiria, discovers the camera eye and the eyes of the viewers—the unseen but present.

In effect, the final moments of *La Dolce Vita* combine the endings of *Il Bidone* and *Nights of Cabiria,* as the process of "annulment" carried out by Marcello (shades of Augusto) reinstitutes the world of spiritual connection attained by Cabiria and represented here by Paola. Through this narrative "miracle," the Second Coming, both promised and parodied in the film's opening scene, has, in its own way, come about.

Conclusion

Nights of Cabiria and the developing function of the camera

The role of *Nights of Cabiria* in relation to plot, character, theme, and structure in Fellini's early work should be self-evident in light of this chapter. In terms of the first two, conventional realism dissolves more than ever, in favor of psycho-symbolic organization. Thematically, the growing emphasis on death and resur-rection reaches a moment of culmination in Cabiria's feat of self (re)-creation. Structurally, the "concentric spiral" becomes, as I noted, the dominant narrative form. The one area that deserves extended attention, particularly in relation to Fellini's preceding films, is the use of the camera. Naturally, in any discussion of

this sort it is important to acknowledge Otello Martelli, the director of photography of Fellini's films through *The Temptation of Dr. Antonio*—except for *The White Sheik* and *Marriage Agency*. Martelli was crucial in helping to develop a visual style consistent with Fellini's evolving narrative concerns.

In the earliest films, the camera tends to function principally as a photographic mechanism, replicating the external world. Like Fellini's early characters, it is at the mercy of what is there. To the extent that there is a discernible style, it lies more in what is placed in front of the camera than in "camera creativity" or in a significant relationship between camera and world. Of course, the early films do provide hints of the cinematic intensity that characterize Fellini's later work. As early as the opening scene of *Variety Lights*, in the relation between audience and stage, and *The White Sheik*, as Ivan and Wanda disembark in Rome, the camera movement, activity of people and objects on screen, and rapid-fire editing create a world which could only be rendered through movies. The same is true during the shooting of *The White Sheik* comic strip. But, much as the live action is turned into still photos for the *fotoromanzo*, the visual dynamic of Ivan and Wanda's world is ultimately sacrificed as they succumb to the devitalizing authority of bourgeois family and Church.

I Vitelloni introduces a kind of fluidness and transparency that will later be employed to suggest the lightness of spiritual experience. This is achieved through the coupling of a moving camera with dissolves. The most resonant cinematic moment in relation to Fellini's later work is the late-night walk of Leopoldo and Natale from a cafe to the beach. The powerful sounds and gusts of wind; the flickering, shadowing lights; the unsettling soundtrack music; the swirling movement of characters and objects; the shifting perspectives of the camera all conspire to create the sense of mystery and magic that will, in a much less ominous way, inform the *Asa Nisi Masa* sequence in *8½*; the early-morning fog sequence in *Amarcord*, and numerous other moments in more recent Fellini work.

La Strada, in addition to presenting the same kind of visual and aural magic in the brief Osvaldo scene, offers the most distinctly cinematic moment in Fellini's films prior to *Nights of Cabiria:* the transition from country to town during Gelsomina's short-lived abandonment of Zampanò. The shift in lighting (bright to gloomy), in music (airy to ponderous), in space (open to closed), in human image (from few and free to many and trapped)—as well as the use of camera placement and dissolves to emphasize Gelsomina's sudden absorption and subordination— convey in specifically cinematic terms not only the facts but the implications of what is going on. Fellini here makes full use of the medium instead of relying principally on one aspect, or on literary or dramatic means.

Il Bidone does not offer much in the way of single distinctive, purely cinematic moments, however the pacing and use of dissolves demonstrate a growing commitment within Fellini's films to represent a world on the move. The automobile is

a major "character." The real breakthrough occurs with *Nights of Cabiria*, which reveals a greater willingness than ever before to replace the spatial and temporal continuity of dramatic perspective (that is, the viewpoint of a spectator watching a play on a stage) with multiple, discontinuous, cinematic spaces and times created through the use of varied camera placements and frequent cuts.

In addition, in *Nights of Cabiria*, Fellini repeatedly strives for visual expression that has the lightness of cinema rather than the solidity of physical life—or of theater. There is no attempt to preserve the three-dimensionality of human figures—their status as "real people" being photographed. Emphatic camera movement (tracking shots, pans, tilts) coupled with shots from the waist (or higher) up creates the sense of images floating in a noncorporeal universe. The use of dissolves (again) heightens the sense of airiness and insubstantiality.

By far the most important development in specifically cinematic terms is the active role taken by the camera. No longer is style principally what happens in front of the camera; it is created by the camera through its relationship to what it sees. Even at its most passive, the camera communicates a sense of "thereness" or purposeful omnipresence not evident in earlier films. It does so through a combination of infrequent long shots with frequent intimate (though not necessarily extreme close-up) shots. By using both, Fellini gives the camera its multiperspectival quality. However, he uses long shots so infrequently that they do not emphasize the camera's capacity for distanced vision—nor do they suggest a predisposition toward it. Quite the contrary. They establish a distanced view as an option that the camera eye prefers to forgo in favor of working "on the inside." The sense of intimacy is further accentuated by the slightly low-angle position the camera tends to take in relation to characters, placing it clearly in their world. (The beginning of the pilgrimage sequence offers a good example of the camera "mingling" with its subjects.)

Not only is the camera there and on the inside, but it also moves with the world it sees, following characters or events in a manner that conveys active interest in what is happening. Very often it will initiate its activity with a pan, suggesting a search for something worth focusing on. Once the search is rewarded, it will track or resume panning in order to keep its attention squarely on the object of curiosity.

This sense of visual engagement is enhanced by the activity of the heroine herself. As we have suggested earlier, Cabiria comes to live by and through her eyes. Not only does she see the world, but she also sees the world seeing her, and that two-way dynamic becomes a means of dissolving the self/world dichotomy that exists early in the film. The combination of camera use and Cabiria's visual orientation makes vision, to a large extent, the subject of Cabiria's story; the function of Lazzari and the camera eye at film's end makes movies part of that story as well. In both respects, *Nights of Cabiria* prepares for the self-reflexivity of Fellini's films

101

about film that will mark his work from *The Temptation of Dr. Antonio* to *Roma* and be central to *Intervista*.

La Dolce Vita and developments in characterization, narrative, and use of the camera

While *La Dolce Vita* seems to reverse the growing power of individuation within Fellini's films, there is a significant overall strengthening of awareness on the part of characters, even in relation to *Nights of Cabiria*. Marcello, as a writer with literary aspirations, is Fellini's first intellectual protagonist, and his ultimate self-negation is arguably even more the result of disillusionment—hence some capacity for awareness—than Augusto's. In terms of self-conscious anxiety, Maddalena and Steiner are far more advanced than prior Fellini characters. They painfully and articulately acknowledge the conditions of their life, and neither is very successful at suppression or self-evasion. Particularly through Steiner, the problem of self-knowledge is pushed far beyond the level of Augusto's alienation in *Il Bidone* to the point of extreme anxiety it will occupy at the beginning of Guido's struggle for self-realization in *8½*.

In terms of Fellini's changing narrative technique, *La Dolce Vita* is probably most notable for its radical discontinuity. In addressing the film principally in terms of the spirit/matter dichotomy and as a negative version of *Nights of Cabiria*, I have tended to slight its originality. (I redress this in my discussion later in the book of *La Dolce Vita* and postmodernity.) In particular, I have implied a far greater tightness of narrative construction than really exists. Conventional plot is even less evident here than in *Nights of Cabiria*. In fact, each sequence is as much a "short story" on its own as part of any overall scheme. For this reason, the film just seems to explode from event to event with a fragmented energy that has made it a favorite among proponents of modernist literary works. Character, too, is less continuous than in prior Fellini films (except *I Vitelloni*). Sequences begin and end without Marcello, and even in the middle of scenes the camera will abandon him to focus on something of greater interest.

As the camera's abandonment of Marcello would suggest, discontinuity in both plot and characterization is tied in part to an increasing dynamism and freedom of the camera, making the visual more important than the dramatic. The aerial photography of the opening sequence is unlike anything that had been seen at the time. (Unfortunately, its originality is difficult to detect today, given all the developments in cinematic technology since the 1960s.) Coupled with innovative camera placement and editing, it gives the camera eye a kind of "divine" omniscience and omnipresence that accords perfectly with Fellini's growing concern with Second Comings and spiritualization. (In *The Temptation of Dr. Antonio* camera

perspective will be explicitly identified with a god: Eros.) In addition, in a scene such as Marcello's arrival at the hospital with Emma, the combination of pans, tilts, and dissolves creates the kind of constant visual motion that will characterize the spa scene in *8½*, one of the most famous, stylistically, in all Fellini's work.

Perhaps the most significant technical advance is the use, for the first time in Fellini's career, of widescreen cinematography. The expanded potential that wide-screen affords for the pure visualizing of experience seems to have contributed directly to Fellini's growing concentration on the specifically cinematic.

In terms of this study, the increasing emphasis on the camera and the specific-ally cinematic is far less important in terms of pure style or technique than in rela-tion to the two "narratives" I trace in the course of this study: the movement of Fellini's work toward and beyond individualism and the movement from realism through representation to signification. The shift in *La Dolce Vita* away from dramatic, realist considerations of plot and character will lead to the films of "de-individualization" and fragmented identity that characterize the latter part of his career. The abandonment of realism, in turn, becomes the basis for the intense self-reflexivity of Fellini's work as he moves to films about film, films about art, and films about the arbitrariness of codes and meanings. In both respects, an interesting paradox will emerge: the changes in filmmaking strategy that accompany his most emphatic films of individuation and spiritualization (*Nights of Cabiria, La Dolce Vita, 8½,* and *Juliet of the Spirits*) ultimately lead to the death-of-the-subject and the death-of-the-spirit—that is, of psychologized Christian humanism—in his work.

NOTES

1. Quoted from intertitles.

2. With regard to the religious or spiritual dimension of Fellini's vision—especially in *Nights of Cabiria*—see Andre Bazin's essay "*Cabiria:* The Voyage to the End of Neorealism," in *What Is Cinema?*, vol. 2, trans. Hugh Gray (Berkeley: University of California Press, 1971), 83–92, where he discusses Fellini's recurrent efforts to "angelize" his characters. Bazin's essay is reprinted in *Federico Fellini: Essays in Criticism*, 94–102. For further insight into the religious dimension of Fellini's vision in general, see Charles B. Ketcham, *Federico Fel-lini: The Search for a New Mythology* (New York: Paulist Press, 1976), passim, but espe-cially, 81.

3. My quotations of dialogue from the film are usually based on the Italian-language, sub-titled Criterion Collection DVD of *Nights of Cabiria*. Where the subtitles prove inadequate, I provide my own translation of the Italian.

4. The fact that the choice is Cabiria's is clear from the way she responds to the Conjuror. Prior to the Maria-Oscar trance, when the Conjuror puts Cabiria under, she goes immediately limp, and her limpness is contrasted sharply with her aggression toward the crowd when

"awake." But when the Conjuror says, "Let me present Oscar," Cabiria responds aggressively. She turns to the Conjuror in full control of her senses and asks quite forcefully, "I wonder ... who is this Oscar?" When the Conjuror actually does "present" Oscar, Cabiria willingly closes her eyes and submits to the hypnotic trance.

5. This vision of love is, of course, consistent with a host of religious and spiritual traditions—with their psychological counterparts—to which this film, and Fellini's work through at least *Toby Dammit,* have strong links.

6. For some helpful comments on the function of music in *Nights of Cabiria,* see Claudia Gorbman, "Music as Salvation: Notes on Fellini and Rota," *Film Quarterly* 28, no. 3 (1974–75): 17–25; reprinted in *Federico Fellini: Essays in Criticism,* 80–94.

7. *La Dolce Vita,* trans. Oscar DeLiso and Bernard Shir-Cliff (New York: Ballantine, 1961), 14; hereafter cited in text as *DV.* Where the subtitles for the Italian-language print are accurate and the screenplay edition is not, I quote from the subtitles. In instances in which neither the screenplay nor the subtitled version is correct, I provide my own translation.

8. Marcello notes that she is from the same part of the country and that she came to Rome "to make a fortune too" (*DV,* 257).

4

Film about Film and Modernist Self-Reflexivity: *The Temptation of Dr. Antonio*

The Temptation of Dr. Antonio (1962) is an episode in the film anthology *Boccaccio '70*, produced by Carlo Ponti, with other episodes directed by Luchino Visconti, Vittorio De Sica, and Mario Monicelli. *The Temptation of Dr. Antonio* reverts to a story of failed consciousness and unfulfilled spirituality—without the redemptive ending of a *La Dolce Vita*—linking it with Fellini films of the early 1950s. At the same time, it is very much a "head trip," taking place largely inside the fantasy-driven mind of its protagonist and is thus very much a film of the 1960s, alongside *8½*, *Juliet of the Spirits*, and *Toby Dammit*. Moreover, its hilarity and parody are redemptive in and of themselves, making the film closer in spirit to *Nights of Cabiria* and, again, the 1960s films.

The Temptation of Dr. Antonio is most notable for its cinematic and narrative innovativeness. Not only is its representation of interiority a dramatic shift in Fellini's work, but it is the first sustained treatment of cinematic and narrative form as thematic meaning. For this reason, it becomes Fellini's first true film about film, his first self-reflexively modernist exploration of representation itself. From here to the end of his career, all his work, in one way or other, will engage the issue of representation, making form as important as content or, perhaps more accurately, turning form itself into content.

The decline of Eros

Much like *La Dolce Vita*, *The Temptation of Dr. Antonio* begins with a god of Love. Here, instead of a statue of Christ in a posture of embrace, we have a genderbending Eros who speaks in a little girl's voice but refers to himself as a god and identifies himself as the traditionally male Greek love deity.[1] "He" also establishes himself as the narrative source of all we see. As a result, the function of

105

the camera eye as omniscient and omnipresent spirit—which seems implied in the opening sequence of *La Dolce Vita,* particularly given the presence of the Christ statue—becomes more pronounced here.

There are significant differences between the divinities depicted at the beginning of each film, pointing to major differences in the films themselves. The statue of Christ was associated with a decadent world in which spirit had been replaced by institutions and external and material forms of gratification. Eros, in contrast, is of an earlier age, before the rigidifying effects of 2,000 years of Christianity. (Fellini will return to this age, in much greater detail, with *Fellini-Satyricon.*) Accordingly, Eros is dynamic, alive, bubbling over with good feeling, narratively engaged, and attracted to scenes of vitality, motion, and fun. He is the spirit and voice of creation rather than an abstract symbol such as Christ's statue. Perhaps most important, Eros is actively trying to better the human condition ("if I didn't make such an effort to give happiness to people, it would be a catastrophe").[2] He represents the natural outpouring of transformative, engaged, life—of "love" in the fullest sense. And, as narrator/creator, he is initially able to fulfill the role Eros possessed at his apogee in Greek myth: the binding force of all things.

Unfortunately, though he is not *of* the world represented by Christ's statue, Eros is trapped *in* it. All around him, spirit has become compartmentalized and sterile. The opening shots reveal uniformed faceless nuns, separated from uniformed faceless girls, who in turn are separated from uniformed faceless priests. Despite his attraction to the vital and the whole, he can for the most part only narrate a world that is diametrically opposite. In addition, he must act upon people who have lost touch with their own potential divinity—which is why, as he notes, he must "make such an effort" to create happiness.

The price of involvement in this flawed contemporary world is his "tragic" fall. (Actually, Eros' doubled gender but insistence on identifying himself as male can be seen as an immediate sign of his decline—especially as Fellini has tended to link wholeness and vitality with the feminine in figures such as Gelsomina, Cabiria, and even in rather parodied form, Sylvia.) During the opening sequence he suffers diminishment similar to what he has undergone in mythology. In the latter, he was a cosmogonic spirit of creation and unity, reduced to merely a symbol of love and beauty.[3] In the film, he moves from narrating images of presumed spirit and eternal love (priests, nuns, and churches) to scenes of mere sexual pursuit and attainment (two men in a paddle boat chasing two women in another boat; two lovers reclining on a hillside). The fact that the representatives of eternal love are purely institutional is, of course, a symptom of the problem.

In fact, Eros falls prey to a world divided between morality (that is, the false spirituality that prevails in a world of institutionalized religion) and "carnality."

When the hillside lovers appear so does Dr. Antonio, superimposed over them in a photograph. He comes prepared to vanquish Eros with repressive Catholic doctrine rooted in sexual obsession and alienation. Antonio is named after the father of monasticism who, after renouncing a social existence, was besieged by numerous sexual "temptations" or visions.[4] Terrified by love and openness in any form, Antonio copes by reducing love to prurience and attacking it. With Antonio's appearance, Eros is further diminished. Distracted by Antonio's idiocy, he stops narrating scenes of romance and begins showing only scenes of Antonio doing battle against sex. Moreover, he turns from god of love into vengeful satirist, ultimately narrating a black-and-white silent film comedy that is a blatant parody of Antonio. Having allowed himself to get caught up in Antonio's harshly dualistic world (spirit versus flesh, morality versus sexuality, "Logos" versus "Eros"), Eros has, in effect, canceled himself out—which explains, in part, his sudden disappearance as narrator once the black-and-white film ends.

As soon as Eros vanishes as voice-over, he is reborn on screen as a mysterious little girl, matching now the voice he has had from the start. In reincarnated form, Eros has lost his divinity. As mere character, he has sacrificed his invisibility, transcendence, and narrative powers of creation and unification. He also loses his androgyny, responding to the polarization of Antonio's world by adopting a single sexual identity that is the opposite of Antonio's. In fact, this reduction of Eros to a little girl references yet another stage in his "actual" mythological diminishment: to a petty, mischievous, child. In addition, Eros-as-little-girl, though a highly promising image at first, proves to be ineffectual. She initially possesses the narrator's youthful ebullience, spontaneity, playfulness, and sense of joy. She embodies, in short, what is most alive and "divine" in the world of mortals. However, she remains unacknowledged by that world, virtually unnoticed by everyone around her.[5] Instead of recognizing Eros's vestigial presence, the world creates its own love divinity: Sex Goddess Anita Ekberg. Moreover, with the appearance of Anita, Eros becomes mechanized. His (now a little girl's) voice, once the narrative breath of creation, becomes a mere tape recording that accompanies the billboard of Ekberg and mindlessly repeats the advertising theme: "Drink More Milk."

As Anita Ekberg takes over for Eros and for the child, she also suffers decline. Initially, though her image is visible to the world, she herself remains absent, free—enjoying a "divine" capacity for invisibility plus presence, transcendence plus immanence. In addition, as an evocative and provocative image, she is more a creature of imagination than of flesh. However, when she comes to life in Antonio's vision, she becomes completely present, "given." She remains miraculous only in size (a bit like the fish at the end of *La Dolce Vita*). Moreover, when Antonio's viciousness goads her into undressing, she reduces herself solely to a body. In this most mortal of forms, Antonio is able to kill her off.

FIGURE 4.1 The fall of Eros from the binding force of all things to a contrary brat. A concluding image from *The Temptation of Dr. Antonio*. Source: *The Temptation of Dr. Antonio*, episode of *Boccaccio '70* (1960) directed by Federico Fellini. Film produced by Cineriz, Concordia Compagnia Cinematografica, Francinex, Gray-Film. Frame grab captured by Frank Burke from 2017 Blu-ray version.

At this point, godliness is reduced to costume and play-acting. The little girl reappears in the final scene dressed as Cupid, a puerile Roman descendent of Eros. (My distinction between Eros and Cupid is only partially justified historically, but is, I believe, accurate in terms of the film.) In this guise, she has little in common with her divine prototype. Moreover, she has little in common with the girl she once was. Gone is her natural urge to celebrate and applaud. Present instead is an obnoxious, mechanical compulsion to insult, as she repeatedly sticks out her tongue and makes bug-eyed faces at the camera and at us. (**Figure 4.1**) Her final appearance is the diametric opposite of the concluding appearances of Cabiria and Paola. Her negative transformation recapitulates Eros's decline from love god to satirist. Love unacknowledged, unfulfilled, and repressed has become contrariness in every respect.

The dominance of fiction

Dr. Antonio's vertiginous fall into obsession and delusion is reflected in the proliferation of fictional forms: narration, photography, theater, film, advertising,

music, hallucination, painting. The first hint of fictionalization is, of course, the narrator—and one of mythological origin.[6] Yet Eros is presented as a narrator not of make-believe but of life. He is clearly not telling a story: he is out in the world, envisioning and describing the natural unfolding of events. Moreover, to the extent that fiction is present at this point (fashion photography in progress in front of a church, filmmaking under way on a street corner), it is part of the world rather than dissociated from it. This changes abruptly with the arrival of Antonio. Introduced through two black-and-white photos superimposed over the hillside lovers, then by an iris-out that reveals him in live action, he personifies the substitution of artifice for experience. Within a few moments of his appearance he goes from a public park to the stage of a theater, then to a movie "role" (in the silent film) that is described by Eros as "one of his outstanding *performances*" (my italics).

As Eros's words and its own contrived nature suggest, the silent film marks a major transition from a concrete world to illusion. Eros himself has either lost the ability to distinguish between the two or has become a liar. Instead of acknowledging the fictional, parodic nature of the film, he claims that it is a mere recording of events by someone who happened to be there (a "documentary" in effect). The god of natural unfolding, has fallen victim to Antonio's world of falsification and become an unreliable narrator. This, like his involvement in satire, confirms his demise. The movement into the fictional is confirmed by Eros's words at the moment of his disappearance: "At this point our *story* begins" (my italics). Literally, this makes no sense, as the story of Dr. Antonio, the film itself, has been under way for some time. However, it makes perfect figurative sense if Eros has indeed been a narrator of life rather than make-believe, and his disappearance thus means the loss of the real. The little girl who replaces Eros also reflects the movement toward illusion. Despite all the positive things that we have noted about her, she is ultimately quite phony. Not only is she born out of a film-within-a-film, but she is dressed up as a fancy little bourgeois princess. In effect she is a *symbol* of naturalness and vitality, rather than their genuine embodiment, harkening back to figures such as *Il Matto* in *La Strada*, Patrizia in *Il Bidone*, and Sylvia in *La Dolce Vita*.

As soon as the "story" begins, the fictionalization process occurs anew. Though Antonio begins by moving out and about in a public world of churches and newsstands, he quickly gravitates to a field outside his apartment, signaling a movement toward home, privacy, and subjectivity. Accordingly, he moves into his head and recalls (for his Boy Scout troop) the childhood incident in which the aunt of a friend undressed in his presence. He is presumably recalling a real event, yet he grossly distorts what happened so that it can serve as a lesson to the boys on the dangers and indecencies of women. The fact that he is fictionalizing is underlined when he describes the event as an "episode" and himself as a "protagonist." With no justification whatsoever, he calls the aunt a "fallen creature" and then

refers to the nakedness of a beautiful woman as a "diabolical spectacle." At this moment women are turned into fantasy, and the billboard of Anita is virtually born out of Antonio's words.

The billboard comes to function as another "story" within Antonio's childhood story, and once it is in place we have yet another process of fictionalization. At first Antonio treats the poster as a real entity. But when he fails to get it removed through political means, he withdraws into his apartment and into verbal attacks that misrepresent the poster and its effect on people. This leads to hallucination— his vision of Anita's hand and the glass of milk in the mirror—which leads to even more violent denunciations and finally to outright attack with ink bottles. At this point, the poster and Anita become distorted into "the Golden Calf of yore," among other things, in Antonio's imagination. Antonio's ink attack marks the end of his ability to relate to an outside world. The real, smudged-up, billboard is covered over, and Antonio falls prey to an extended fantasy of Anita and his delusional billboard. Fictionalization becomes so advanced that his fantasy turns into a "movie" or pure projection, which, unlike the earlier pseudo-documentary, loses all ties with reality, all relation to a filmmaker or an act of filmmaking.

This transformation has, to some extent, been prepared for by the shape of the billboard. It is a perfect replica of the cinemascope screen on which *Dr. Antonio* itself is shown. It has its own "soundtrack" (the tape recording of Eros's voice). And, just prior to Antonio's fantasy, it is covered in white, turning it into a blank screen. The billboard, in short, has been a latent movie all along. When Anita comes to life, she turns the world into a "moving billboard," which is, of course, precisely what a movie is. Not only that, as a "monster" who "threatens" the city of Rome and picks Antonio up in her giant "paw," she turns Antonio's vision into a homage to *King Kong* and the Japanese horror films of the 1950s. Antonio himself finally acknowledges that his vision has become a movie when, as Anita begins to undress, he turns to the camera eye and addresses us-as-audience, telling us not to watch and begging us to take the women and children out of the theater.

At this point Antonio is "fictionalized" into a mere image on a screen and, worse still, a piece of celluloid. He has even disappeared as the source of his own vision. (If there were still an Antonio dreaming up what we see, the Antonio within the movie would have addressed the camera eye as his own imagination, not as an audience in a theater.) Just as Eros the narrator became projected out into (and replaced by) his "story," Antonio the dreamer has been projected wholly onto his "movie." Since we now have a movie instead of a vision, human agency has been replaced by mechanical unfolding, and human, psychological, projection has been supplanted by film projection. In fact, the latter two become equated, for the film implies that, based on compulsion rather than a free creative response to life, psychological projection is as much a mechanism as theatrical projection; it takes on

a life of its own, sweeping up the projecting subject in a process of which he or she is no longer the author.

Even as a celluloid figure, Antonio is able to acknowledge and address the audience—retaining some shred of identity and individuality. This ends when he becomes Saint George, a historical figure out of a painting we have seen in his living room. At the same time, his transformation, which brings about the confrontation between "Satan" (Anita) and the Saint, turns his "movie" into simpleminded allegory that, as we saw in *La Strada*, is an extreme and deadly form of abstraction. This completes Fellini's set of fictional "Chinese boxes." We have an allegory based on a painting, within a vision that has turned into a movie, inspired by a billboard within a "story" that has replaced Eros's narration. Even after the vision is over and non-hallucinatory reality returns, Antonio remains in the realm of make believe. Draped over the poster in a comic parody of intercourse, he has become one with Anita and her billboard.

Much like *La Strada* and *La Dolce Vita, The Temptation of Dr. Antonio* ends in the destruction of intelligence. The problem of consciousness is implied in Fellini's choice of Eros as a major narrative figure. Even in his days as a cosmogonic power, he was viewed by some as the enemy of reason: "in all gods, in all human beings / [Eros] overpowers the intelligence in the breast, / and all their shrewd planning" (Hesiod, quoted in Grant, 97). And as he devolved into a mere god of romantic infatuation and physical love, his role as an enemy of rationality and the mind became all the more pronounced—hence his reduction in sculpture and painting to a child and, even in some instances, to a sleeping infant.

It is worth noting how carefully the film is structured in terms of declining consciousness. There are, in effect, five distinct phases: (1) enlightened, unitive consciousness (Eros at his best, out and about, narrating the world); (2) false consciousness gaining control (Antonio, the self-righteous intellectual, bringing about Eros's demise as narrator); (3) the birth and growing power of the unconscious (the appearance of the billboard as a projection of Antonio's repressed sexuality; his growing obsession with Anita); (4) the victory of the unconscious (the billboard comes alive and, through Antonio's hallucinations, takes over for Antonio's conscious life); and (5) the death of both conscious and unconscious articulation (the killing of Anita, the last incentive for mental life for Antonio, followed by his delirium).

By the final scene, with mind and spirit denied, Antonio is a dead weight—much like Zampanò, Augusto, and, to a lesser extent Marcello, at the end of their stories. He is injected, tied up, lowered from the billboard, carried in a stretcher, and dumped into an ambulance. There is only one brief sign of life. Just prior to his disappearance, in response to the mechanical tape recording of Eros's voice, he opens his eyes and weakly wails "Anita." The last flicker of intelligence, it recalls

Zampanò's momentary visceral sense of cosmic angst and Augusto's delusive "I'm coming with you" before they surrendered consciousness.

The Temptation of Dr. Antonio *and subsequent Fellini films*

We need not belabor the aspects of *The Temptation of Dr. Antonio* that place it in the company of Fellini's early work; the shared themes of alienation, false consciousness, and the destruction of love should be obvious. It is much more interesting to see all the ways in which this short but crucial film points to the future.

First of all, as suggested earlier, although the film is not ultimately affirmative, it is certainly not tragic: a comic perspective and energy help redeem the negativity. This might just be seen as a return to the satiric style of *Variety Lights* and, especially, *The White Sheik*. Eros symbolizes a kind of creative activity that is lacking in those two films, however, and his activity, in turn, allows for a kind of cinematographic innovation—particularly the rapid cutting and sense of "omnipresence" of the opening sequence—that will lead directly to the visual experimentation and virtuosity of *8½*.

Second, despite his many limitations, Dr. Antonio is far more complex and imaginative than any of Fellini's earlier heroes (even Cabiria). As a "visionary," he is clearly kin to his immediate successors, Guido and Juliet, and he introduces the sustained "head trip" into the Fellini canon, which is one of the aspects of his work for which Fellini became best known.

Third, the extensive use of myth signals not only a growing concern with imaginative constructs in Fellini's films but a reliance on other artistic forms and texts. This will lead to Fellini's high modernist concern with art about art and a later concern with the postmodern process of textual reproduction.

Fourth, the film marks a radical break with the lingering realism that had characterized Fellini's work even though *La Dolce Vita*. The opening sequence of *Dr. Antonio* is a proliferation of seemingly unrelated images, locales, and individuals, fracturing the traditional unities of space, time, and action. (The opening scene of *La Dolce Vita*, as bold as it was, still observed the three unities). Though the function of Eros as narrator ends up binding the seemingly discontinuous together, the seeds are sown for the kind of nonlinear emotionally intensive expression that tends to compete with narrative in much of Fellini's later work.

Though the appearance of the ultra-conventional Antonio and the disappearance of Eros's "divine" power notably diminish stylistic innovation (entirely apropos "aesthetically"), the film never reverts to the realistic level of Fellini's prior work. Moreover, Antonio himself is responsible for yet another major stylistic development: the

movement to a completely invented reality in front of the camera. Though Fellini had used sets before (reconstructing the Via Veneto in shooting *La Dolce Vita*), the effect was principally realistic. Such is definitely not the case with Antonio's sci-fi/ horror vision of Anita Ekberg looming over the EUR district, followed by the eerie procession of Antonio's former associates that concludes the vision. The pure fantasy that prevails here is precursor to the entirely fabricated worlds of *Juliet of the Spirits, Fellini-Satyricon, Fellini's Casanova,* and *And the Ship Sails On.*

Fifth, *Dr. Antonio* is Fellini's first color film. The mere fact of this is far less important than what the film works out in terms of a color aesthetic. Color characterizes a world of richness, multiplicity, vitality, and freedom—the world, in effect, of Eros. Black and white, on the other hand, is seen as diminishment, abstraction, exclusion, or "censorship"—hence it is associated with Dr. Antonio. In addition, white serves as the embodiment of unity (the combination of all hues) in a world of color, while, in a world of black and white, white can only be part of a duality (the opposite or "negative" of black). Starting from these distinctions, the film presents a conflict between black and white and color. Every major negative development is set up as an intrusion of black and white into a color world (the photos of Dr. Antonio, the silent film, and so forth). The billboard of Anita is a giant black-and-white "abstraction" that blocks the view of a color world. Antonio's vision, which occurs at night and consists of Anita's billboard-come-to-life, is largely black and white. To the extent that color remains, it loses its positive capabilities. The red of Antonio's bathrobe is singular and alienated in the black-and-white world of his vision. No longer part of a multiple world of colors, it gets caught up in duality and becomes the color of aggression, violence, and domination. Color here is forced to act divisively, like black and white. Though Fellini momentarily reverted to black and white for *8½* (he was intimidated by the problems of controlling the color process in *Dr. Antonio*), and though his symbolic privileging of color over black and white did not remain a central factor in his late work, he did return to color for *Juliet of the Spirits,* never to abandon it again. Moreover, in films such as *Juliet of the Spirits* and *Fellini-Satyricon* color is a crucial thematic component.[7]

NOTES

1. Although at the beginning of the film Eros is double-gendered or beyond gendering, with the voice of a little girl while claiming to be "he," I refer to him in the early part of the film in the masculine to emphasize the extent to which "he" insists on limiting himself gender-wise, thus representing, from the start, a god in decline.

2. Eros's voice-over is dubbed in English even in subtitled (Italian-language) prints, so this quotation is directly from dubbing. Other quotations from the dialogue are also from dubbing, which has been checked for accuracy against the Italian-language prints.

3. See H.J. Rose, *A Handbook of Greek Mythology Including Its Extension to Rome* (New York: Dutton, 1959), 123, and Michael Grant, *Myths of the Greeks and Romans* (New York: New American Library, 1962), 96–97.

4. Both Saint Anthony and the monastic tradition are, of course, held in high regard in orthodox Catholic tradition. They are seen as models of spiritual willpower overcoming worldliness. The film, however, tends to place them in a different light—as models of "spiritual" development bought at the expense of love or relatedness. They become symptomatic of a civilization created through repression. So, for that matter, does the symbology of Saint George.

5. The only contact between the girl and others occurs during her first appearance, when Eros still presides as a link between the divine and the human. Even here, the contact is purely instrumental (a waiter serves her ice cream), and she sits by herself, unnoticed by Antonio and his luncheon companions. In her second appearance, she and Antonio are alone in front of the billboard, but Antonio, in his absorption with Anita, does not see her until she nearly runs him over—then he does everything he can to avoid her. In her third appearance she is isolated on screen and never related to anyone else, even though she appears in the midst of a carnival with crowds of people around. Here Antonio's absorption is so complete (this is the ink-throwing scene) that there is no chance of his becoming aware of the girl.

6. One might say that the film as a whole, precisely because it is a film, necessarily begins in fiction and is therefore a denial of reality. However, Fellini's work of this period (note my discussion of the end of *Nights of Cabiria*) uses cinematic metaphor to try to break down divisions between reality and illusion, viewer and viewed. Moreover, Fellini has always tended to argue that the best films offer the viewer not fiction but reality infused with imagination, and that a creative spectator is not a mere consumer of fictions but rather the co-creator of this heightened reality. (For some interesting remarks by Fellini on the film experience and on the active role of the viewer, see "Federico Fellini: "The Cinema Seen as a Woman" an interview with Gideon Bachman, *Film Quarterly* 34, no. 2 [1980–81], especially p. 5; hereafter cited in text.) Metaphorically at least, the kind of division that occurs in *Dr. Antonio* between reality and fiction occurs only because all possibility for unity has been lost.

7. For Fellini's thematic use of color in *Juliet of the Spirits,* see Robinson, "If You Don't See You're Dead." For color in *Fellini-Satyricon,* see Stephen Snyder, "Color, Growth, and Evolution in *Fellini-Satyricon,*" in *Federico Fellini: Essays in Criticism,* 168–87. In *And the Ship Sails On* (1983) Fellini uses color film, then drains the color out of it in order to accentuate the limitations of the media-filtered, elitist world of the film. This is the closest he gets to black and white later in his career.

5

Individuation and Enlightenment:
8½, *Juliet of the Spirits*, and *Toby Dammit*

The three films discussed in this chapter pick up where *Nights of Cabiria* left off, marking the culmination of the "drive to individuation" in Fellini's work. Individual autonomy seems paramount, accomplished through numerous symbolic deaths and rebirths, which confirm Fellini's psychologized Christian humanism. Consistent with the expanded-consciousness ethos of the 1960s, these films emphasize imaginative transformation to a degree unprecedented in the earlier films.

Following upon *The Temptation of Dr. Antonio,* which was largely film about film, *8½* is principally focused on the medium, making it Fellini's first thoroughly self-reflexive film and one of the prime examples of cinematic high modernism not only within Fellini's work but within the art film in general. Accordingly, *8½* pushes visual and cinematic experimentation much further than did *Dr. Antonio*. Partly for this reason and partly because the film is largely a reflection of the protagonist's psyche, plot becomes far more fragmented than in Fellini's preceding work. And even though the fragmentation is generally grounded in the activity of a single and relatively coherent protagonist, its effect is to present the protagonist as himself at times fragmented, marking an initial movement toward decentering the self that will characterize Fellini's later work. In this chapter, I treat *8½*, *Juliet of the Spirits*, and *Toby Dammit* in the context of the early films and thus concentrate on the more unitive, "individuationist," aspects of character development. In Chapter 6, I treat them as mid-leading-to-later work, and thus emphasize their deconstructive aspects.

8½

8½ (1963) marks a radical shift not only in Fellini's filmmaking but in his experience of the process. It was highly personal, as Fellini's remarks about its origins make clear; "The conception came after a process of lengthy self-examination. I went for a rest cure, at a moment when things were at a low ebb. I was in limbo, taking

stock of myself. ... I felt I needed to find the answers to countless questions. ... Thus, a journey into the inner self" (quoted in Alpert, 154). As a highly personal film, it seemed to involve a kind of risk-taking made possible by the enormous success of *La Dolce Vita*. At the same time, it was a film whose production experience was characterized by confusion, uncertainty, self-doubt, and moments in which Fellini nearly abandoned the project (see Alpert, 153ff and Baxter, 170ff). In this respect *8½* presages much of the remainder of Fellini's career, which will be marked by repeated failures to make the highly personal "The Journey of G. Mastorna," a turn more to adaptation and producer-motivated projects rather than self-conceived films, and highly conflicted production processes (especially *Fellini's Casanova* and *City of Women*).

In terms of character development, *8½* seems to rework *La Dolce Vita* via *Nights of Cabiria*. It takes the same actor who starred in *La Dolce Vita*, Marcello Mastroianni, and transforms him from the passive, reality-bound reporter Marcello into the inventive film director Guido. This movement from the real or given to the creative recapitulates Cabiria's development, and like Cabiria, Guido undergoes an extensive growth process characterized by increasing awareness and self-determination. As in *Nights of Cabiria*, the world of *8½*—along with the protagonist—seems to evolve to the point where imagination and reality converge in a "higher" or transformed reality in which the material world is infused with spirit. The penultimate sequence, in which Guido is joined by major figures from his past and present, links hands with his wife, Luisa, and joins a circle formed by his life's companions, seems to offer a conclusive moment of psychological integration. Fellini has described it as: "Not a fatalistic resignation, but an *affirmative acceptance* of life, a burgeoning of love for life. ... When [Guido] finally realizes that he will never be able to resolve his problems, only to *live* with them ... he experiences an exhilarating resurgence of energy, a return of profound religious sentiment. ... He is at peace with himself at last. ... That is the optimistic finale to *8½*."[1]

Guido's quest for personal development is underscored through *8½*'s "Pinocchio" motif. At the beginning of the nightclub scene, Guido is playing with a large, dough-shaped nose that covers his own, and throughout the film he tends to tap his nose at moments of fantasy and escape. In the harem sequence, he is clearly identified as Pinocchio by Rossella, when she refers to herself as "Pinocchio's conscience." Though the references to Pinocchio highlight Guido's tendency to lie, they also reflect his struggle to evolve from a mean-spirited puppet controlled by others and resorting to willful, selfish behavior into a fully human being.[2] (Fellini has also drawn the link between Pinocchio and selfhood in discussing his own situation as a filmmaker: "Money has so many strings to it that I can identify with Pinocchio, who didn't wish to be a marionette and wanted to be a 'real boy'—that is to say, his own self" [quoted in Chandler, 85].)

Crucial to Guido's integration is his engagement in filmmaking. Most, if not all, Guido's major problems are illuminated through the film's examination of itself as movie and art form. Guido's accountability (or lack thereof) is highlighted by his relationship with actresses, agents, journalists, production assistants, and his producer. His tendency to manipulate and impose fantasies on others is indicated by his function as director (specifically his compulsion to cast people into roles and to exert mastery over his life) and by the cinematic and psychological motif of projection. The last culminates with the screen tests, as Guido's failed attempts to make art imitate life—and vice versa—are screened for all to see.

The life/art, reality/fantasy conflict that besets Guido is reflected in two radically different kinds of films or narrative forms Guido is exploring: autobiography, with actors and actresses playing the real-life figures of Carla, Luisa, Saraghina, the Cardinal, and his father; and science fiction, with characters escaping nuclear holocaust by fleeing to another planet. The first can be seen as an attempt to come to terms with reality (though Guido is as prone to evasion here as everywhere else in the film). The latter clearly expresses a desire for transcendence (Catholicism-become-film genre) that is both escapist and at the same time indicative of Guido's strong urge to alter the conditions of his life.

The complexity of Guido's struggle to grow is implied in the film's title. Fellini claims the film was his eighth and one-half (by his reckoning, there were six previous features and three "halves": *Variety Lights,* which he co-directed; *Marriage Agency;* and *The Temptation of Dr. Antonio*). The title also refers, however, to the film's child figure, who is approximately eight years old.[3] In this context the title comes to symbolize all the qualities that the child will himself come to embody at the film's end, especially Guido's desired capacity for self-reinvention. Moreover, as the "8" on its side is the symbol of infinity, "8½" dramatically juxtaposes the infinite and the finite, as well as wholeness (the shape of the "8" makes it a symbol of harmony and interconnectedness) and the "fractional" or fragmented, suggesting the "both-and-ness" of experience rather than, simply, some perfect, reachable, state of resolution. Even in symbolizing wholeness, the "8" is closed in upon itself, separate from what is outside. For these reasons, the title qualifies Guido's seeming moment of integration in the penultimate scene, suggesting that 8½ may be about the impossibility of individuation as well as its (attempted) attainment.

What follows is my hypothesis of a process of individuation that recalls Cabiria's, though as I have mentioned, I will "deconstruct" that later in the volume. For me, the specialness of 8½, apart from its obvious cinematic brilliance, lies in the fact that Fellini can, on the one hand, offer a vision of psychological development that rivals Jung at his most profound and at the same time balance it with a skepticism that suggests that a mature outlook on life and personality development demands not unqualified or progressive affirmation but a recognition that

117

individuation and wholeness, as models of human possibility, are as problematic as other teleological narratives that have dominated Western thought.

Guido's psycho-symbolic odyssey takes place over five days,[4] although time shifts become quite abrupt and nonrealistic as the film progresses. At the beginning of Day One, Guido is in a state of collapse at a health spa, trying to piece together his life and a film. By Day Five he has abandoned the latter—an act that momentarily frees him to experience the concluding, symbolic, coming-together of the former. An economical way of detailing Guido's development is to examine his changing relationship to the various "fictions" or non-realist moments that he experiences in the film. Briefly summarized, Guido's fictions move from dreams (his opening tunnel nightmare and the cemetery sequence), to memories (the *Asa Nisi Masa* and Saraghina sequences), to fantasies (his steam-bath audience with the Cardinal, the harem sequence), to screen tests (incipient attempts to realize his fiction film), and then to visions that seem to be, somewhat paradoxically, beyond private fantasy, individual authorship (the press conference, the concluding epiphany of integration).

Nightmares are Guido's most limited form of fiction. They are unconscious mechanisms over which he has no control, and they narrate him rather than vice versa. Of course, they are, as they were for Fellini, propulsive: the seeds for meaningful waking activity. His memories, in contrast, are conscious, and they reflect some control on his part. Although they are triggered by other people (a mind-reader and her assistant in the first instance, a large peasant woman in the second) and recount a past that Guido cannot alter, he uses the past to help alter his experience in the present. They "interfere," disrupt, and redirect what is going on in the moment for him. His fantasies, though also triggered externally, are not only conscious but avoid the determined reproduction of an immutable past. In fact, they seek to abrogate historical context and necessity by creating a realm of wish fulfilment. Finally, the screen tests are the product of extensive planning, sustained and disciplined activity, as opposed to the more indulgent, spur-of-the-moment, memories and fantasies. Moreover, they reflect Guido's attempts to create not just a momentary vision but an entire fictional world: a movie. In terms of "awakened" activity, they would appear to be at the opposite end of the spectrum from his nightmares.

Growing consciousness and control are evident not only in the progression from nightmare to screen test but in the more specific movement from dream to dream, memory to memory, fantasy to fantasy. Guido is given no initiating power over the first nightmare. The dream just materializes on screen after the film's title, devoid of a dreamer. The nightmare, in fact, gives birth to Guido as a conscious, individualized, character. We cut from the dream, in which his face has remained undisclosed, to his room, where he awakens in terrified reaction and is gradually unveiled as an identifiable person.

In contrast, Guido is clearly established as the source of the second nightmare, as we see him in bed, asleep, before the dream images begin. In addition, this nightmare emerges directly from his experiences: his relationship with his mistress, Carla, and his guilt about that relationship. And while the opening nightmare merely tended to reflect Guido's existing condition (his death-in-life alienation, his urge to escape, and his sense of being hopelessly tied to the earth), the second shows Guido beginning to struggle toward change. His mother, father, and producer all take Guido to task for his failings, introducing the kind of moral accountability that Guido is not yet willing to face consciously. In fact, Guido is invested with a cape by his father, who then dies off, challenging Guido with the responsibility of *becoming* the father, of growing up.

When memories replace dreams as Guido's principal fictional mode, a similar progression occurs. The initial control of the *Asa Nisi Masa* sequence seems to lie as much with the mind-reader, Maya, as with Guido. She must virtually extract the triggering phrase from Guido's mind and raise it to a conscious level by writing in on a blackboard, before the memory can unfold. The Saraghina sequence, on the other hand, is much more actively generated by Guido, as he sits with the Cardinal and chooses not to pay any more attention to the prelate's ramblings. At the same time, while the *Asa Nisi Masa* sequence seems primarily a recording of past events, the Saraghina sequence is clearly inventive: a narrative with a structure and coherence that show Guido is not merely recalling but is also creating and organizing. The sequence has three distinct phases: the encounter of Guido and his friends with Saraghina, the imposition of church/school discipline and dogma on the encounter, and the return of Guido to the beach. In the final phase he kneels before and salutes a miraculously transfigured Saraghina. She is no longer a frightening creature thunderously dancing the rhumba but a gentle figure elevated on a chair, with a white veil on her shoulder, who blesses Guido with a beatific, thoroughly affirming, "ciao" and then sings equally beatifically.

Not only is this last phase invented rather than recollected, it implies a newfound capacity on Guido's part to face things he has previously avoided. Saraghina is, among other things, an awe-inspiring embodiment of the unknown, whose terrifying aspects have been partly constructed and greatly magnified by the Church's insistence that she is the Devil. Guido's willingness to return and honor her indicates his growing ability to confront what is repressed within, as well as issues and people (especially his wife, Luisa) whom he finds threatening from without. In addition, Guido undertakes an important feat of synthesis here, seeking to conjoin the immense physical presence of Saraghina with the urge for spiritualization promoted (albeit perversely) by the Church. Immediately preceding his kneeling at the beach before Saragina, he kneels outside the confessional, apparently before the statue of a strikingly wise and beautiful Madonna.

However, we do not see Guido in the same shot as the statue, so it appears that even she is his invention, his revision of Church "spirituality," in the figure of a woman. (**Figure 5.1**) He thus moves to dissolve the deadly Whore/Madonna split that characterizes Catholicism's view of women.

Guido's ability to transfigure his past prepares for his movement beyond memory to fantasy, and the movement from his first fantasy to the second reveals the same kind of development that we have seen from nightmare to nightmare, memory to memory. His imagined steam-bath audience with the Cardinal seems to originate largely outside him. He is summoned by a voice (associated later in the film with a stewardess), and only after the voice is heard does a close-up of Guido designate him as the source of the fantasy. The harem sequence is introduced in a far different fashion. As Luisa—having spotted Guido's mistress, Carla— vents her frustration and anger at Guido's dishonesty, he withdraws into his own space, raises his eyebrows behind his glasses, and says, "but what if" (translation mine). Immediately we cut to the fabricated dance of conciliation between Luisa and Carla, then to the harem sequence itself. Guido is isolated on screen as clear author before the harem sequence unfolds.

In terms of content and implicit motive, the harem sequence is clearly an advance over the audience with the Cardinal. The former is largely escapist. Physically, it is an attempt to get out of the deathly world of the steam bath. Morally,

FIGURE 5.1 The image of a beautiful Madonna dissolves into Saraghina's bunker by the sea, as Guido's strengthening imagination seeks to fuse spirituality and sexual energy. Source: *8½* (1963). Directed by Federico Fellini. Produced by Cineriz. Frame grab captured by Frank Burke from the 2009 Blu-ray version.

it is an attempt to find salvation from without—evident in Guido's reliance on counsel from a religious authority and in his dependence on a stewardess (a secular voice-from-on-high). It does, on the other hand, lead to the harem sequence in a sense. The Cardinal's mechanically orthodox advice—"outside the Church there is no salvation"—demonstrates the foolishness of Guido's search for answers from institutional authority. Moreover, on an imaginative level, the Cardinal's words imply that, in order to grow, Guido must become part of a community of love—a process he has recently accelerated by inviting Luisa to join him at the spa.

Accordingly, though the harem sequence derives partly from a desire to escape Luisa's wrath, it is also Guido's attempt to synthesize, as he did with Saraghina, elements of his life that have been divided. Moreover, he attempts to do so in specifically (albeit problematically) communal terms. The envisioned dance of Luisa and Carla (the first time Guido has not tried to keep the two apart) reflects his urge to reconcile the accountability embodied by his wife with the spontaneity and rejection of propriety embodied by his mistress. More important, what begins as escape ends with confrontation and self-knowledge. As a character within the fantasy, Guido comes to sense his failure as harem master (the failure, in fact, of his desired master-slave and director's relation to women). Then, in her closing soliloquy about her years of service to Guido, Luisa turns into Guido's own conscience, providing a poignant revelation of the kind of exploitation involved in his treatment of women. Fantasy turns into harsh truth and the dissolve from Luisa to Guido at the screen tests, where Guido is expressing contrition to Luisa in interior monologue, makes clear that the revelation has had its impact. (**Figure 5.2**)

The screen tests prove the turning point for Guido in a number of ways. I have already suggested that they represent the capacity for sustained conscious activity. They are also the furthest Guido has come in opening himself out to others and to his own weaknesses. This is reflected in the changing surroundings of his fictions. His nightmares were restricted to the privacy of a bedroom, and his memories and fantasies—though somewhat less private—were still triggered within the retreat-like ambience of the spa.[5] The screen tests, however, are projected in a theater beyond the boundaries of the spa. Equally important, Guido has allowed Luisa and her friends, as well as his professional associates, to attend what proves to be an exposé of his failed attempts not only to make a movie but to make sense of his life. The screen tests, in effect, make public a film-long process in which Guido has been forced into moral accountability through his dreams, memories, and fantasies—as well as his conflicted relation with Luisa.

Yet despite Guido's increased openness, the tests remain an essentially private creation, one man's version of reality. The cloistered atmosphere of the theater, which, we are told, has been closed to the public for the evening, and Guido's isolation from those around him strongly qualify the growing publicness of his

FIGURE 5.2 Luisa as the tireless, understanding wife is dissolved into Guido's head, suggesting her role as his conscience, as the harem sequence gives way to Guido's (self)exposé at the screentests. The frequency of dissolves in the film reflects an "urge to merge" that has questionable results (see Chapter 6). Source: *8½* (1963). Directed by Federico Fellini. Produced by Cineriz. Frame grab captured by Frank Burke from the 2009 Blu-ray version.

fictions. Having moved from the passivity of dreams and triggered memories and fantasies to directorial domination, he must move yet further: beyond individualized consciousness and its need to impose order on the world. This, of course, recalls Cabiria's need to get beyond ego and self and become wedded to the world at large. In this context the screen tests represent not only the apogee but the end of ego-centered fiction. In their chaos and absurdity, they reveal the failure of Guido to make sense of life and of others with his self-serving impositions. Luisa, in her anger as she leaves the theater, rightly accuses Guido of showing only what he chooses to show, of turning his life and the lives of those closest to him into a lie.

Guido's readiness to go beyond authorial control is suggested by a paradox in his relation to the screen tests. While he controlled their creation, he is helpless to change them as they are projected before him. In fact, we can identify at least two principal Guidos in this sequence: the director/tyrant, on screen, who is an obvious failure, and the spectator, struggling to come to terms with himself in the audience. (Guido also became a spectator of sorts at the end of the harem sequence, but because it was his own fantasy, he was still "in charge.") His will to dominate is already eroding; his ability to submit—in a constructive rather than merely passive way—is already being tested and developed. I say "constructive" because,

in contrast to earlier moments of passivity, Guido is choosing to allow things, such as self-exposé, to occur. They are not happening to him entirely unwilled.

Consistent with this, at the end of the screen tests, when Claudia Cardinale appears (the real Claudia, not the fantasy woman in white who appears earlier and is played by Cardinale), Guido abandons his film and, with it, the egoistic authority of being a director. He tells Claudia, "There is no part for you in the film ... there is no film," and immediately, a new kind of narrative emerges. People associated with Guido's producer Pace appear with no plot motivation (there is no way they could have known where Guido was) and announce a press conference to "launch the film" that Guido has just abandoned. Then the press conference itself explodes on the screen. At first glance, the appearance of the film production people and the ensuing press conference seem just another of Guido's fantasies. However, in contrast to the earlier memories, fantasies, and visions of Claudia in white, there is no point-of-view coding of Guido, no shot or dialogue of any sort establishing him as the author of what we are seeing. Consequently, there is no clear-cut distinction between reality (Guido the author) and imagination (the fantasy being created). With Guido gone as author, gone also is that aspect of himself that was formerly *outside* his narratives. He is now, in effect, immanent.

Before addressing the press conference in some detail, I would like to turn briefly to the apparitions of Claudia Cardinale as the woman in white. Although these apparitions spring from the same kind of imaginative activity that characterizes Guido's dreams, memories, and fantasies, I have not dealt with them till now because they tend to be more iconic than narrative in nature, lacking the kind of temporal unfolding that characterizes Guido's (other) fictions. However, taken together, the three apparitions comprise a process quite consistent with that of the fictions. The first occurs when Claudia offers Guido water from the mineral springs. Her function here is purely physical, and her relation to Guido reflects his passivity and dependency on maternal and external symbols of salvation. The second occurs as Guido enters his room at night after being told by a longtime associate, "You're not the man you used to be." This apparition elicits a strong display of awareness on Guido's part. He reacts to it by criticizing his own penchant for symbolism and by acknowledging that Claudia is a symbol he himself has authored. Moreover, Claudia, as a product of Guido's imagination, reflects his growing capacity for accountability. She mocks his script and says she is there, forever, to create cleanliness and order. In effect, she combines the role of Guido's mistress (catering to his needs) with that of his wife (making demands, implicitly criticizing, seeking her own version of order). In the third apparition, as Guido and the real Claudia arrive at the square, Claudia offers Guido nothing directly—no water, no criticism, no cleanliness, no order. Instead, she merely descends with a lamp from the second story, places the lamp on a table in the otherwise empty

square, then leaves. She helps set the table with light, as it were, leaving it up to Guido to act on his own. As the image and occasion of Guido's empowerment Claudia has become far more a medium or conduit for change than an external symbol. This proves true as well in her final appearance, at the outset of the final sequence.

Because the press conference is not authored by Guido but continues to work solely toward his individuation, it seems to signify—much like the magical appearance of the adolescents in the final scene of *Nights of Cabiria*—the fusion of his now ego-transcendent consciousness with the world. In this reading the individualized intelligence that Guido struggled to develop and that was reflected in his attempts to create a film is now poured outward, and life has become, in effect, the unfolding of "decentered" consciousness. The fact that the press conference and concluding vision are carefully structured and purposively transformative makes clear that, though there is no consciousness outside directing them, they are informed with creative intelligence.

In keeping with the fact that separation and privacy are being left behind, the conference takes place in the most open environment thus far. (The same set was used earlier, but it was hemmed in by darkness and fragmented into isolated conversations.) In keeping with Guido's openness and willingness to risk himself, he is surrounded by the largest crowd till now, and the sequence is dedicated principally to accountability and criticism as the large media corps question his integrity on a personal as well as a professional level. The conference also culminates with the negation of Guido's film and Guido as director. In the final moments Guido annuls all aspects of himself that are implicated in his need to direct film fantasies—especially his escapism and immaturity. He crawls under a table (as we saw him do as a little boy in the *Asa Nisi Masa* sequence) and ritualistically shoots himself in the head. In effect, he kills off his childishness, his arrested self. Moreover, the "killing of the head" (yet another instance in Fellini's work) can be seen as yet another, symbolic, killing of the ego. (We saw this ritual carried out with tragic finality by Steiner in Fellini's preceding feature film, *La Dolce Vita*.)

This generates the concluding sequence, which confirms the death of Guido's film and himself as director but also envisions that death in terms of integral self-surrender rather than escapism and childishness. Again, there is no sense of a narrative controlled by Guido. As Guido's scriptwriter Daumier boringly intones the virtues of Guido's decision to abandon the film, the mind-reader's assistant from the *Asa Nisi Masa* sequence appears, summoning up the image of Claudia in white, who in turn triggers the appearance of numerous white-clad figures from Guido's life. Although Guido is initially identified through close-up as the scene's point of origin, as the vision unfolds, he enters the scene, relinquishing his dissociated, external, subject position. Here visionary experience evolves more fluidly from the

real than it did with the press conference, which ruptured the narrative flow and was blatantly different in style and content from the scene into which it erupted.

With life operating on the level of imaginative experience, everyone functions as a "power" or "spirit" rather than as a real person. This, of course, emerges from the final scenes of *Nights of Cabiria* and *La Dolce Vita* and paves the way for Fellini's next film, *Juliet of the Spirits*. The whiteness of the figures suggests that Guido is seeing them transfigured through love. Moreover, because the figures are the same as before except in color, their whiteness conveys the moving paradox that love transfigures without altering. Guido can now see others in a new light without imposing change. As spirits rather than fixed identities, the figures are pliant, permeable, and ready to assimilate the qualities of other characters. They are no longer locked into fixed identities. Guido initially manifests the same things he did before—especially isolation and distance—but these tendencies dissolve as he interacts with others. Luisa is the spirit of accountability, born out of Guido's willingness to face his own weaknesses. However, she is also now able to display the tolerance that Guido's mistress, Carla, and Luisa's own constant companion, Rosella, embody. In response to Guido's invitation to "accept me as I am. Only then will we discover each other," she says, "I'm not sure that's true, but I can try if you'll help me."

Luisa's willingness to try to accept Guido becomes Guido's *self*-acceptance. The moment she consents to his plea for tolerance, the principal "spirit" of the concluding sequence—the child in white—appears. This serendipitous figure is Guido renewed through acceptance, Guido's image of a reborn and loved self. He is also Guido-as-child redeemed from arrested development and transformed into a symbol of possibility and openness as well as love (he plays a flute, aligning him with Pan). He is "8½" in its affirmative connotations, and "8½" comes to signify self-creation and the regenerativeness of spiritual experience.

The child is also accompanied by the clown musicians, the powers of comic harmony that Guido's self-acceptance has released. As the spirit of openness and love, the child becomes Guido's medium for reconciliation with the images of his past and present. Guido sends the child to attend the opening of the curtain, which allows Guido's life companions to flood into the circus ring. As Guido is, in a crucial sense, a composite of all these human images, his acceptance of them is yet another moment of self-acceptance. This in turn becomes part of a dramatic change that occurs in Guido's way of relating to others. At the beginning of the final vision, Guido acts out his familiar role as director: using a megaphone, telling people what to do, assuming he is in control of the situation. Once the ring is filled with his life companions, however, he spends time trying to connect as well as direct. Finally, he abandons his directorial distance, taking Luisa's hand and joining the circle of companions that has formed on the circumference of the ring.

He is able to choose both the many (the group) and the one (Luisa). At the same time, he is able to assimilate his role as director into social relatedness: joining the dance that he initiated and holding his megaphone in his hand as he also links hands with others. In so doing, he relinquishes the alienated individuality that has characterized him throughout.

In merging with the whole, Guido performs a second suicide—far gentler and less dramatic than that at the end of the press conference. He disappears. His presence becomes purely symbolic as the child in white. Then the child too disappears, exiting screen right. By becoming the many, Guido can no longer be the one, even in symbolic form. His evolution from fixed identity to decentered spirit is complete.

Such would be a largely Jungian, individuationist, reading of *8½*—one that will be strongly qualified in the succeeding chapter.

Juliet of the Spirits

Juliet of the Spirits (1965) has often been described as *8½* remade from a woman's perspective.[6] Fellini's desire to represent reality from a woman's point of view is clearly linked to an interest in female protagonists that extends back to *La Strada* and *Nights of Cabiria*. However, *Juliet of the Spirits* is also clearly influenced by issues of women's liberation prevalent in the 1960s. On the other hand, the film preceded the women's movement of the 1970s and feminist emphasis on radical differences in gendered experience that made it extremely risky for a male director to represent a woman's consciousness. Many years later, Fellini expressed the wish to participate in a musical theatre adaptation of the film that would have addressed Giulietta Masina's concerns, at the time of the film, to certain of his choices about her character (Chandler, 383–384).

The film also, as I noted earlier, marked Fellini's permanent move to color. In fact, *Juliet of the Spirits* is one of the most vivid explorations of color in the history of the medium, though the extravagance of the color has tended to distract attention from other of the film's strengths.

Like *8½, Juliet of the Spirits* is principally about the imaginative development of its protagonist. The trajectory of Juliet's inner life is similar to Guido's in that it is initially fueled by unconscious activity (a seance, her dream at the beach), moves to the conscious activation of memories (the circus, the school play), becomes sustained and disciplined rationality (observation and interpretation, triggered largely by the detective "Lynx Eyes"),[7] then evolves into supraconscious activity (the interpenetration of self, spirits, and world in the lawn party and the final scenes of the film). At this point inner life becomes an inappropriate term, as Juliet's mind and world seem, from the point of view of her psychospiritual development, conjoined.

Juliet's imaginative development begins, by and large, at the seance early in the film. Although it involves an apparent suspension of consciousness in which all thought and information seems to come from outside (from departed spirits) and though Juliet ends up losing consciousness altogether at the end, the seance provides several crucial goads to consciousness that Juliet will act upon almost immediately. It introduces three different spirits: Iris, who proclaims "Love for everybody";[8] Olaf, who tells one of the guests she is a "big fat whore"; and an unnamed figure whose message to Juliet is "Who do you think you are? You are nothing to anybody." The first two polarize experience into do-goodism and transgressive sexuality: that is, self-sacrifice and self-indulgence: two poles of a conventional bourgeois Catholic upbringing. The third offers a violent incitement to self-awakening. Juliet will respond by seeking to found an identity in relation to both her religious upbringing and the models for transgression her world and unconscious offer her.

Despite the implications that Juliet lacks consciousness and selfhood at this point, there are clear suggestions that she has strong potential for both. At the film's beginning, though she is initially without identity (seen from the back) and reflected only in a succession of mirrors, Juliet lights the candles for the anniversary dinner she has planned for herself and Giorgio, and it is within this light that her face first becomes visible.[9] Moreover, as she prepares for the celebration, she casts off a host of garish costumes and chooses to wear only a simple dress that allows a relatively unadulterated (self)image to show through.

Equally important, the seance itself turns out, on close analysis, not to be wholly external to Juliet but causally linked to her perceptions and emotions. For instance, the knock that initiates the visitations from the spirit world immediately follows upon Juliet seeing two men doing a comical goose-step out in the garden. We later find out that Juliet has encountered a link between militarism and a short rapping sound early in her life: in her school play her character was led to her martyrdom by two child centurions who tapped their lances on the floor. In the seance, as in the school play, the "knock" serves Juliet as a summons to radical reorientation; it derives not merely from the spirit world but from the conjunction of Juliet's childhood experience with what she sees in the present. There will be another such summons in her visionary experience near the film's end, when Roman soldiers approach Juliet and bang *their* lances on the ground. She will respond by moving into her room, confronting her mother, and freeing the image of herself as a child. Moreover, it is more than likely that all three spirits are not "departed" but reflections of Juliet herself. Not only does the spirit-sex dichotomizing of the first two come directly from her upbringing,[10] the arrival of the third comes directly from her experience. Outside the circle of the seance the phone rings. Though Juliet is in darkness, we can see her lower her head—almost slump in a gesture of defeat.

She then looks up and screen right, troubled. A guest answers the phone but there is no response on the other end, and the guest hangs up. As soon as the phone is hung up, Genius receives the message telling her she is nobody and that "Nobody needs you." Because, as we soon discover, mysterious phone calls in Juliet's household have become linked to Giorgio's lover, Gabriella, this voice clearly articulates Juliet's sense of self loss, resulting from the threatened failure of her marriage.

The awakening of Juliet's unconscious gains momentum the following day when she closes her eyes at the beach and "sees" Fanny, a circus ballerina from Juliet's childhood. Fanny is both an object of veneration (Juliet's grandfather fell madly in love with her) and a figure who proclaimed Juliet "beautiful" as a child. In each respect she embodies lovableness, and Juliet's vision of her marks Juliet's recovery or discovery of self-esteem. Moreover, as a sexually provocative figure, Fanny links self-esteem with the transgressive sexuality introduced by Olaf. The appearance in the same sequence of the bikini-clad Susy—Juliet's neighbor, played by the same actress who portrays Fanny—gives Juliet a real-life, conscious counterpart to the fantasy image of Fanny.

Following her vision, Juliet falls asleep and dreams of self-empowerment. A man (who will reappear as Lynx Eyes) hands her a rope and tells her, "This really is your concern" (203). Juliet's unconscious is, in effect, telling her to take things into her own hands, and she obliges: pulling on the rope and dredging up a raft full of half-naked, "primitive" male figures. They represent Juliet's anxieties around sexuality but also seem to signify the emergence of her "dark," masculine powers of self-assertion, which will help her confront Giorgio's infidelity, define herself apart from him, and cast off the bonds of middle-class conformity. The Eurocentric association of dark-skinned people with primitiveness—suggests the extent to which Juliet starts out as a classically Eurocentric bourgeois.

Juliet's ability to take things into her own hands strengthens through her visit to the guru Bhisma, whose androgyny reflects Juliet's growing willingness to venture beyond her world of stifling normality. Not only does she choose to see "them" despite her conventional reservations, she talks openly about her marital problems and, at the end of the visit, takes her first strongly oppositional stance in the film. Her reaction to Bhisma's counsel that she treat Giorgio as a god and serve him as a prostitute is so powerfully negative it triggers a fit on Bhisma's part, which, in turn, generates images of violent intensity, principally of Fanny and Susy. In sharp contrast to Bhisma's gospel of female servitude, the images place women in positions of dominance (astride a horse and astride a man). (**Figure 5.3**) In so doing they wed Juliet's symbols of sexual transgression with her anger and self-assertiveness and give the latter a female dimension they were lacking in her dream. The link between conscious activity and a dynamized unconscious suggests that the latter is beginning to act in concert with the former. (Bhisma's message to

FIGURE 5.3 Juliet envisions Susy/Fanny astride a horse in an image of female strength and empowerment. Source: *Juliet of the Spirits* (1965). Directed by Federico Fellini. Produced by Rizzoli Film. Frame grab captured by Frank Burke from the 2018 Blu-ray version.

Juliet is a more demonstrably problematic version of *Il Matto*'s pebble advice to Gelsomina in *La Strada*.)

On the drive home from Bhisma's, Juliet engages in her first sustained conscious act of imagination. She narrates her childhood memory of the circus in which Fanny was star performer. She also re-creates the fantasy of her grandfather, Fanny, and herself escaping her mother, sisters, and patriarchal headmaster by taking off in the circus plane. The latter scene is clearly memory turned into fiction. More important, it reveals newfound problem-solving mechanisms. The first is narrative itself: the ability to tell liberating stories. The second is the figure of the grandfather, a guardian and rebel who serves as an alternative to Juliet's imperious mother and the stifling social system she and the headmaster represent. The third is the plane, whose capacity for flight lies solely within Juliet's imagination. (By the looks of it, it should go nowhere.)

The awakening of Juliet's consciousness, reflected in her storytelling, is also accompanied by a strong emphasis on visual and intellectual perspective. Visually, both before and after Juliet's narrative, the highway in front of her car keeps receding to a vanishing point, marked by a flashing light. Within those memories, both she and Fanny occupy the vanishing point, at different times, in relation to two converging lines formed by rows of men. The emphasis on perspective is an emphasis on intense and directed vision. The emphasis on the "gendered"

vanishing point suggests the need for women to escape male perspective in order to maintain their visibility and identity. In terms of intellectual perspective, the flashback allows Juliet, for the first time, to view herself as an object of analysis.

Visual and intellectual scrutiny accelerate when Giorgio's friend José arrives with a telescope through which Juliet observes Susy—and when he stages a "bull-fight" for Juliet's benefit in which Giorgio becomes a "monster" to be "defeated." José's dramatic enactment acquires huge import the same night when Juliet over-hears Giorgio on the phone with Gabriella. This in turn leads to Lynx Eyes, the detective whose very name bespeaks vision and whom Juliet seeks out in response to growing indications of Giorgio's philandering. Lynx Eyes turns perspective into omniscience. Dressed in religious garb, he claims, "We have telephone lenses which make intimacy and secrecy outdated concepts. Neither doors nor walls exist for us. You'll participate in [Giorgio's] most secret hours. You'll penetrate those shadowy portions of his life which otherwise you could never enter" (248). Juliet, in turn, leaps at the opportunity for the promise offered by Lynx Eyes for total consciousness.

In the next sequence she visits her friend Dolores and recalls a school play in which, as a martyr, she refuses to renounce her religion and earns the right to see God. Here we have omniscience not just as the pragmatic/technological vision of Lynx Eyes but rather as seeing the face of the divine and, in effect, imagining the unimaginable. Despite the conventionally Catholic context of the play, Juliet's quest for god will not ultimately mean self-denial, martyrdom, and salvation sought from without. It marks the birth of Juliet-herself-as-God. For the "god behind the door" who never materializes during the school play will become Juliet the child whom Juliet as adult will free in the closing moments of the film.

Juliet's growing imaginative sophistication coupled with a growing sense of self are reflected in her increased talents as a narrator. She is able both to center herself within the flashback and to diffuse herself throughout it in a far more complex set of relationships than existed in the circus flashback. In terms of self-centering, she is the "star" of the flashback, replacing Fanny from the circus sequence. More specifically, she replaces Fanny as the object of her grandfather's attention. (He rescues Juliet from the play, much as he had rescued Fanny from the circus.) In so doing Juliet becomes far more the object of her own "narrative gaze" than she was at the circus, linking omniscience to self-scrutiny, self-knowledge.

Self-confrontation, omniscience, and self-knowledge are all enhanced when Juliet visits Susy's home. From watching herself in a mirror over Susy's bed, Juliet moves to a bird's-eye view of her box-like house and encounters a telling image of her boxed-in life. Most important, in Susy's tree house, she sees her relation to Giorgio with new clarity: "Giorgio was my first love. As soon as I saw him I fell in love and didn't want anything but to live with him. ... He became my whole

world—my husband, my lover, my father, my friend, my house. I didn't need anything else" (271). Not only is Juliet on the way to conceiving of herself as a hidden and suppressed god(dess), she is coming to acknowledge that her dependence on Giorgio as virtual god has been a principal reason for her suppression.

As Juliet's growing consciousness becomes more self-attuned, Lynx Eyes appears again, but with a dramatically altered message about vision and the visible. Having earlier emphasized objective truth, he now turns subjective. As he prepares to show Juliet evidence of Giorgio's infidelity, he apologizes for the imperfect photography and notes the difficult conditions under which the investigation took place. More important, he shifts the emphasis from facticity to interpretation by asserting, "Reality at times may be quite different [from what it appears to be]." This makes his comment at the outset of the sequence— "We're able to show you what you want to know"— richly ambiguous, implying that Juliet will take from him precisely what she needs.

Juliet's developing awareness is linked to an increasing ability to take matters into her own hands. Accordingly, once she has been given evidence of Giorgio's infidelity, she decides with no prompting to attend Susy's party. (She needed intense lobbying by Valentina to go to Bhisma's, and she needed her sister Adele's company to follow through on her first visit to Lynx Eyes.) Here consciousness is no longer equated only with knowledge or self-awareness but with self-transformation, as Juliet witnesses the enactment of an Egyptian rite of passage and participates in the role-playing of some of Susy's guests. First, she plays a prostitute. This does not work for her, so she tries out something more religiously inflected: love-sacrifice to Susy's young, handsome, and suggestively named "Godson." Like prostitution, this role is a form of negative transcendence (transformation as self-loss), and, again, it does not work.[11] Juliet's rejection of the Godson—and, more to the point, the way in which she rejects him—reveal her growing ability to solve problems for herself. As she prepares to give herself to the Godson, the saint-on-the-grill from her school play appears and asks, "Juliet, what are you doing?" directing Juliet away from the religious/erotic martyrdom proffered by the "son of god." This sets in motion a process in which Juliet's spirits, her multiple selves and expanded consciousness, will appear with accelerating intensity to facilitate decisions necessary to her liberation. (Juliet herself was the saint-on-the-grill in the school flashback, but here it is her ethereal maid Elisabetta, suggesting Juliet's ability to see people around her as reflections of herself and her needs.)

By the lawn party, Juliet is not only multiple but everywhere, as her spirits appear in the bathroom, the garden, wherever she looks. The omnipresence she exhibited within the imaginative realm of her school flashback now characterizes her real world. Moreover, though Juliet's spirits and her real world are in conflict early in this scene (Juliet keeps trying to banish the former), the appearance of José

and the psychodramatist Dr. Miller makes them virtually seamless. On the one hand, we know José to be a real personage from earlier in the film. On the other, he appears here only in relation to Juliet. He is seen nowhere else throughout the sequence, and the mysterious specificity of his appearance prompts Juliet to ask "Are you real?" In the case of Dr. Miller, though she is introduced independently of Juliet, she asserts such intimate knowledge of Juliet that she seems a facet of Juliet's own mind. Without any presumed basis, she knows all about Juliet's marital problems. Even more shocking, she speaks Juliet's mind for her: "I'm bold enough to state that I understand your trouble. …You're afraid of being alone, of being abandoned. … And yet you want nothing more than to be left alone; you want your husband to go away. … You think you're afraid. Actually you fear only one thing—to be happy" (300–301). On the one hand, this is professional hubris. On the other, it makes Dr. Miller, along with José, a bridge figure, inhabiting the real world but from the point of view of Juliet's own needs and desires.

The integration of spirit and reality, imagination and world, accelerates with Juliet's visit to Gabriella, which, while realistic in many respects, also has a sense of the unreal about it, as though it is partly shaped by Juliet's consciousness. There is something excessive about the decorations of Gabriella's apartment, especially the sexual symbolism of the countless mortars and pestles. Moreover, Gabriella never appears, except as a voice on the phone, giving her the status of spirit more than reality. Most important, we actually see Juliet creating her own mise-en-scène. Just before the phone rings, as Juliet sits on the sofa talking with Gabriella's maid, we can see the table behind her, and there is no phone visible. However, when Gabriella's maid answers the phone and asks Juliet if she would like to speak with Gabriella, a phone suddenly appears. Then, Juliet goes around the table to take the phone, and a picture of Giorgio appears where none had been before. Furthermore, the photo shifts position: first facing us, then, as Juliet picks up the receiver, turning around and emphatically facing her. It seems that Juliet is planting all the painful evidence she needs to free herself from Giorgio. If she is not inventing the entire scene, she is at least directing reality to her own ends.[12]

Accordingly, when we cut from Gabriella's apartment to a point-of-view shot of Juliet approaching her house, the world has been "subjectified" by her pain. It has suddenly become late fall or winter, extremely dark and gloomy. (Sunny summer will be restored when Juliet's pain is banished.) Moreover, Juliet's interpretation of reality is what determines the outcome of events. While Giorgio denies that anything definite or irreparable has happened between him and "that person" and says he merely needs a "short rest," Juliet narrates to herself the life and death of their relationship. She imagines the moment she introduced Giorgio to her family (their engagement), the two of them happy in bed together (their marriage), and, finally, Giorgio in a car with Gabriella, looking as though he is

dead (their "annulment").[13] This "death" of Giorgio actually precedes his leaving the house, confirming that it is Juliet, not he, who effectively leaves the marriage.

Having imaginatively confirmed the death of her marriage, Juliet has in effect renounced the role on which her sense of stability has been founded. The result is extreme anxiety that, in conjunction with the intense grief of separation, leads to an all-out invasion of the spirits. As the term "invasion" suggests, the spirits are not all beneficence and support. Though they have embodied Juliet's growing capacity to imagine and transform, they have remained culturally inscribed fragments of personality, competing for her compliance. This is clear in the implied moralism of even the most helpful figures, such as the saint-on-the-grill at Susy's. As Juliet moves to a point of self-realization that will include the casting off of cultural conditioning, they become violently agitated, clearly wishing Juliet to remain in their sphere of influence.

The danger is that Juliet, having abandoned her prior grounding and identity, will succumb to pure psychic conflict. However, with her new emotional resources, she is able to "simplify" the battle for her psyche being waged by her spirits. She envisions a final, symbolic, struggle between cultural authority and self-affirmation. Her mother represents the former, appearing at the foot of Juliet's bed and responding to Juliet's pleas for help with a terrifying, even vengeful, demeanor. The latter is represented by Juliet as child—herself now become the "goddess behind the door"—next to Juliet's bed. When Juliet is able to disregard her mother's orders, and, more specifically, when she is able to answer her mother's insistent "Obey me" with "You don't frighten me any more," the door opens and Juliet is able to enter and untie the child, still affixed to the grill. Perhaps equally important, she is able to embrace the child in full self-acceptance. (**Figure 5.4**) In so doing, she banishes her mother and the other fierce and threatening spirits. She also enables her most supportive of spirits, her grandfather, to land and announce that he is only her invention—and no longer necessary. (Juliet, in fact, has already confirmed his obsolescence by freeing herself from the grill and thus carrying out the task he performed at the school play.) Even the child, Juliet's symbolic self, dissolves away.

When Juliet moves into the field in front of her house, the wrought-iron gate she opens becomes her grill transformed into a threshold. It also is the "god door" deprived of its forbidding solidity. In opening it and leaving it open, she implicitly renounces all barriers and divisions, especially those that have marked her life: consciousness versus the unconscious, reality versus spirit, repression versus eruption. Juliet's final encounter with her spirits—and her ensuing relation to the camera eye—clarify, in largely metacinematic terms, what has been at stake in Juliet's self-liberation. When Juliet moves back toward her house and hears spirits saying, "If you want us to we can stay ... listen to us, listen closely" (318), she

FIGURE 5.4 Juliet frees and embraces the "goddess behind the door"—herself. Source: *Juliet of the Spirits* (1965). Directed by Federico Fellini. Produced by Rizzoli Film. Frame grab captured by Frank Burke from the 2018 Blu-ray version.

looks all around her. She looks directly at the camera eye, the voices cease, and the camera jumps back in apparent response to the power of her gaze. Her look identifies the camera as one of her spirits. This is quite consistent with the opening shot of the film, in which the camera wafts through trees into Juliet's house. Because Fellini, as author, has presumed control over point of view—and has quite specifically identified himself with the camera eye in films such as *The Clowns* and *Roma*—we may infer a link between the camera eye and Fellini. And because the camera eye's point of view is ours, we might also align ourselves with the spirits. In this context Juliet's look at the camera creates a new relationship with *all* her spirits, including Fellini-as-author, and us as "voyeurs." She determines their/our proximity in calm cohabitation. The camera jumps back but does not leave the scene, much as Juliet does not object to her spirits willingness to stay. What seems to occur is that Juliet, having been object of the camera gaze throughout the film, finally acquires equality with it. Moreover, when she looks at us and the camera, she appropriates the gaze, becoming the seer and making us the seen. (This may also be seen to occur, in a more subtle way, at the end of *The Nights of Cabiria*.) Or more accurately, she establishes a circuit in which seer and seen are reciprocal, without any fixed or final determination of subject and object.

Finally, Juliet's ability to see the camera eye and us, like Cabiria's and Paola's look into the camera at the end of their stories, seems to imply an ability to see

into the unseen—confirming, as it did for the two prior female figures, the marriage of visible and invisible, film and reality, spiritual and worldly, all that has heretofore been distinct.

Toby Dammit

With *Toby Dammit* (1968) we enter quite conflicted territory in terms of individuality and individuation—related in part to the major artistic, economic, and physical crises discussed in Chapter 1. Loosely based on an obscure Edgar Allan Poe short story ("Never Bet the Devil Your Head"), *Toby Dammit* was part of a film anthology entitled *Spirits of the Dead*, which included Louis Malle's *William Wilson* and Roger Vadim's *Metzengerstein*. It is a fascinating film both on its own terms and in relation to Fellini's career.

As a film about consciousness, *Toby Dammit* culminates the decade of Fellinian individual "head trips" so appropriate to the 1960s. (*Fellini-Satyricon* does not represent a single protagonist's head trip; the entire film is one.) Of equal significance, it functions as the most explicit film of "creative negation" ("to be, damn it") in the Fellini canon, carrying to new levels the strategy of (self)annulment first associated with Augusto in *Il Bidone* and more explicitly embodied by Marcello in *La Dolce Vita*. (Again, *Fellini-Satyricon* does not represent a protagonist's acts of negation; the entire film is an aesthetic annulment of Fellini's prior filmmaking styles and tendencies, particularly narrative and psychological development.)

As a head-tripper Toby Dammit initially seems to put his Fellinian predecessors to shame. His world is entirely distorted by alcohol and no doubt drugs—1960s mind-bending par excellence. In some ways, however, his progression seems to reverse that of Guido and Juliet, in that he gradually stops tripping to become capable of a productive encounter with the real, mirrored in his ability to drive a Ferrari at breakneck speeds over unfamiliar terrain. Yet in the long run his story mirrors theirs, for his drugged state is really one of annihilated consciousness, equivalent to their initial thralldom to the unconscious. In the course of the film, his intelligence clarifies itself to the point that he can engage, Cabiria- and Guido-like, in a symbolic death and rebirth.

Toby's growth or individuation is perhaps most clearly revealed in the motif of acting.[14] Toby is a British Shakespearean performer come to Rome to receive an "Italian Oscar" and to star in a film. As an actor, he speaks other people's lines and is produced and directed by others. He has no voice and no identity. This metaphor is extended, virtually from the outset, to embrace Christian (particularly Catholic) society. When Toby arrives at the Rome airport, he is greeted by a priest who says he "represents the producer." Literally this refers to the producer of the film, but

135

figuratively the "producer" represented by all priests is God. In fact, Toby's predicament comes to symbolize that of any individual seen to exist in a world ruled by a Supreme Being whose "script" (Divine Providence as inscribed in Christian Doctrine) determines his or her role. Within this scheme of things, life is hierarchical, and one derives one's meaning from forces above. At the awards dinner, we see this in the crudely despotic way Toby's film producer treats him. At the same event, the religious implications are conveyed through a series of toasts. Toby makes one to his producer, seated slightly above. The producer stands up and toasts a priest (his "representative" from the airport) high above him. At the same time, we can discern on the wall behind the priest a huge shadow that, though created by the priest, seems to imply the ghostly power (the "Eternal Padre") that indeed "backs him up." The religious implications take an interesting and highly parodic twist when we discover that Toby's film is to be "the first Catholic western," showing the return of Christ to earth in a desolate frontier land. Toby takes the Christian myth of death and resurrection and makes it his own to escape his condition as socially, religiously, and artistically produced.

Though Toby's alcoholism is disabling in certain ways, it is the first sign of his resistance to entrapment, preventing him from serving as the kind of performer everyone wants him to be. As the film progresses, he demonstrates an increasing capacity to create the conditions of his escape. First, he demands the Ferrari that will free him geographically and take him to the physical brink of his symbolic transformation. The seeming pettiness and materiality of his demands for the car belie the use to which it ultimately gets put. Then, during a television interview, he becomes quite sober and thoughtful when asked if he believes in God or the devil. He says no to the former, yes to the latter, and thus begins to articulate the means of rebellion against his conformist social script.

Toby has, in fact, already seen his "devil"—and so have we—as she appears to him in a car on the way to the studio. (Though the devil appears outside Toby—and my discussion tends to treat her as such—she is, like Juliet's spirits, a projection, hence fundamentally internal.) She is, above all else, contrary to conventional religious typology. In fact, she is "contrariness" itself, recalling Eros by the end of *The Temptation of Dr. Antonio*—a negation of the symbols and norms of the society that up till now has controlled Toby. Not a "cat" or a "bat" (the television interviewer's notion of what a devil should be) but a beautiful little girl; not black, the conventional color of evil, but radiantly white. She even undermines the associations her own image would conventionally engender. Rather than being sweet, she is garish—with a tendency to shake her head in violent negation. In fact, she is an image of contradiction, good *and* evil, non-simplicity, in a world that strives to impose consistency and clarity of meaning on its "actors." At the same time, as Toby's inner self, she embodies a kind of innocence while displaying the

136

perverseness produced by cultural constraint and repression. As Toby's inner self, she is also the opposite of the Toby we see on screen. He is male; she is female. He is an adult; she is a child. He is defined by words; she is silent. He is dark; she is light. He is drunk; she is sober. He is too solid flesh; she is fantasy.

As the film progresses, he begins to take on more of her qualities. He leaves words behind; he casts off his dark jacket to expose a bright white shirt; he sobers up; and he comes to live in the realm of the imaginative and symbolic. Equally important, his radical transformation occurs when he acquires two of the powers associated with the little girl's white ball: the defeat of gravity (the ball bounds weightlessly up a down escalator at the airport) and radical incompleteness (the ball approaches Toby, but the camera cuts away just before contact—something that is repeated when the ball rolls toward his head in the final scene).

The turning point in Toby's development comes at the awards show. First, he fails to complete the monologue he has been ordered to recite from *Macbeth*, thus ending his role as actor. The words he *does* recite—"Life's but a walking shadow, a poor player that struts and frets its hour upon the stage and then is heard no more"—expand the stage motif even beyond its religious (Catholic) model into existential totality (life itself), and his renunciation of the monologue proves to be a renunciation of this worldview in all its manifestations. Second, and almost simultaneously, he rejects a mysterious woman in black who has just offered him salvation in the guise of eternal love. Originating, it appears, from his producer's table, she is one of the "perks" through which society tries to ensure his captivity as an actor. Consistent with the film's equation of society and stagecraft, she, too, delivers a soliloquy, no doubt scripted for her, and tediously overwrought:

> Don't worry. I will look after you. I already know you. I have always known you. From this moment you will never be alone anymore. I will always be next to you. You'll never have to feel abandoned again. Every time you put out your hand you will find mine to hold. You won't have to try and escape anymore. At last you can stop running. Your loneliness is over. We will have a perfect life. The one we have always been looking for. I know that you have been searching. Now that you have found me you won't have to search any longer. I am the one you have always been waiting for, and now I am here, with you, forever.

Toby showed some susceptibility to this kind of solution at the television station, asking a mannequin-like woman in a kitchen commercial, "Will you marry me?" (She, too, is dressed in black, reinforcing the contrast between convention-bound women and Toby's white "devil.") At the awards show, however, he can vehemently renounce any temptation to succumb to woman-as-socialization.

Having renounced his role as actor along with its accompanying enticements, Toby makes a couple of other crucial moves. He rushes out of the awards dinner, grabs the keys to the Ferrari, and hits the road. His ability to maneuver the car in totally unfamiliar environs confirms the fact that he is now completely sober and intensely conscious. A driver where he was earlier a passenger, he now becomes director of his own actions. Moreover—and the significance of this will become clear toward the end of my analysis—he becomes a "director" working in a "medium" of light and motion: the equivalent of movies. The two things most heavily emphasized about the Ferrari are its piercing headlights and its speed. Having taken his life into his own hands, literally and figuratively, he now pushes himself to the edge of his world.

As we might expect given Fellini's preceding films about evolving consciousness, the head is a major symbol in Toby's story. As usual, the head is the alienated ego, the dissociated control—or, better, controlled—center, of the body. And Toby is nothing if not an alienated ego. Moreover, in *Toby Dammit,* the head is the basis for identity as an actor; the place from which (scripted) words emanate (see Foreman, 114–15). Accordingly, in a world that is continually seeking to determine Toby's words, he is always losing his head—metaphorically and actually. As Foreman puts it:

> When we first see Toby, he is trying to protect his head from the flashbulbs of the paparazzi. ... Of the two microphones at the TV studio, one is put around his neck like a noose and the other [boom mike) almost knocks his brains out. The TV monitors isolate his head or repeatedly clip it off with a moving line. ... The caresses of the woman in black ... cause his head to "disappear" (it sinks down on his chest). ... In the ride away from the awards ceremony, Toby's head often seems to be separated from his body and attached to the car's body. (115)

As we shall see, things do indeed "come to a head" in the film's final moments.

In the course of his Ferrari ride, Toby leaves the restraints of civilization behind, defying and at times destroying guideposts, toll booths, and the like. Suddenly the road itself ends, leaving him at an abyss where a bridge has collapsed. He is seemingly confronted with two choices. Two men, representing the last vestiges of the conventional world, advise him to find another route (that is, a different but still conventional road). His devil, silent as always, appears across the abyss. Toby smiles lovingly at her, seemingly viewing her apparition as a summons. He yells, "I am going to get across," gets back in the car, emits an exultant laugh, and speeds over the edge. We see his taillights disappear in the darkness and haze.

Not only does Toby appear to be confronted with two choices, but his entire world seems to have fractured in two, like the bridge. Consistent with earlier color

coding, the division appears largely to be light versus dark: one headlight glows, the other is extinguished; one side of his face is illuminated, the other is in shadow. At the same time, one of his eyebrows is normal or "human" while the other turns upward in a devilish twist. These splits, in turn, reflect the largest and most fundamental one: between Toby's society and himself, his world and his devil. The obvious interpretation is that this irreconcilable dualism ends in his destruction, his willful—almost gleeful—suicide. Yet such a view would invalidate the progress he has made in the course of the film. Moreover, a number of crucial subtleties both at the end of the film and (strange as it may seem) at the beginning call for quite another reading.

When Toby drives across the abyss, he does not go to or even toward his "devil." She first appears when he walks up to the abyss, and he only sees her by looking screen right. **(Figure 5.5)** In effect, when he drives across the abyss, he passes her by. The fact that Toby does not end up on her side, in body or in spirit, is crucial for a number of reasons. First of all, though the devil is fundamental to Toby's growth, she herself is defined entirely through the irreconcilable division of privacy (Toby's contrary inner self) versus socialization (Toby's role as actor). All she can offer Toby is the choice of one extreme over the other. (Her radical

FIGURE 5.5 Toby looks screen right toward his "devil," not straight ahead toward the road on the other side of the abyss, suggesting that his plunge toward the latter takes him beyond, not to, her. Source: *Toby Dammit*, episode of *Spirits of the Dead/Histoires estraordinaires* (1968) directed by Federico Fellini. Produced by P.E.A., Les Films Marceau, and Cocinor. Frame grab captured by Frank Burke from the 2010 Blu-ray version.

isolation and non-communicativeness are crucial indicators of her limitations.) Moreover, she proves as interested in possessing Toby's head as everyone else. This is implied throughout the film in her control over the white ball—Toby's symbol of his head made perfect and perfectly free.[15] By the time he prepares to leap the abyss, the ball has lost its anti-gravitational freedom and becomes her prisoner. Her desire for his head becomes explicit when she does, indeed, grab a facsimile of it after he has launched himself toward apparent destruction. In short, Toby's devil represents just another form of damnation. Nonetheless, the film closely aligns her with Toby's leap for good reason: though he does not succumb to her negativity, he uses it to leave a world of social constraint behind. It is in looking at her and accepting her silent "message" that he reaches his final resolve to keep on keeping on. In so doing, he lives up to the full suggestiveness of his name: to be, he damns not only the world of preordained roles, but the demonic negation of that world.

These two negatives ultimately make a positive, and Toby effectively changes the crucial conjunction from "or" to "and" in the Shakespearean phrase ("To be or not to be") from which his name derives. This becomes clear when we examine additional subtleties at the film's end. Whatever death Toby may experience in leaping the abyss, it is not physical. There is no sound of a crash, no wreckage, no Ferrari, no corpse. All we are left with are *symbols* of his death: a waxen head held by the devil and a bloody rope or wire (presumably the instrument of decapitation) that is attached to nothing, floats in midair, and is unrelated to the abyss itself. (The camera wafts out over the abyss but leaves it behind before the rope/wire appears.) The rope/wire has no prior existence in the scene and derives not from the film's diagesis but from Poe's story (one of the few things from Poe, ironically, that Fellini retains). In fact, Toby seems to have accomplished supraphysical feats. He has taken on the qualities of the white ball: defeating gravity and at the same time suspending his journey in a state of radical incompletion. In "tricking" the devil into possessing a mere material facsimile, he has guaranteed the freedom of his "spirit" while transcending the fatal dualism of the world he has left behind.

If we are to carry this line of argument all the way through, however, we must, as I suggested earlier, return to the beginning. The film opens with a camera wafting down from the skies toward earth, yet another Fellinian Second Coming, a la *La Dolce Vita* and *The Temptation of Dr. Antonio*. Moreover, the story quickly becomes one of incarnation, as the "spirit" of Toby becomes embodied in his physical presence after the plane has landed at the airport.[16] Disembodied point-of-view shots inside the airport imply that he continues to exist without a body until his name is called by a reporter, whereupon his point of view merges with a visible body or image.

Coupled with that, while we are still in the plane, we have the disembodied voice of Toby speaking *in the past tense* and thus establishing that his "spirit" is the narrator, recounting events that have already taken place: "The plane continued flying over the airport without deciding to land. It was the first time I had come to Rome, and I had the sensation that this voyage, which I had finally decided to make, had great significance for me. So much so that for a moment I had the absurd hope that the plane would reverse its course and take me far away—home. But this was impossible. Already the invisible webs of the airport had imprisoned the plane and were dragging it irresistibly toward earth."[17] Most important, when the film's title appears on screen, it does so in the form of Toby's *signature*, asserting beyond a doubt that he is the author of the tale. In other words, the film's beginning follows upon the events of the film's end, and the Toby of the final scene has survived to speak to us from "beyond the grave" or, more accurately, beyond the abyss.

Putting all this together, we can posit that what Toby experiences at the abyss is not annihilation but transformation—from actor or player in someone else's fiction to author or creator of his own. He enacts his own "Christian western" by moving to the "desolate frontier" and undergoing death and resurrection. Because he now directs his own tale, even his "character" (that is, the Toby we see on screen) is self-directed, and my earlier comments about Toby only being an actor stand revised. Seen as a story *told* by Toby Dammit, the film becomes (more than ever) not an account of suicide but a detailing of the means by which Toby became capable of telling his own tale. The film's end is in its beginning, and vice versa, making its very nature uroboric (the Uroborus is a snake biting its own tale in Egyptian symbology, signifying the power of self-begetting, self-slaying, self-wedding). As author of the tale, Toby is no longer a mere part of the fiction, as he would be as actor or talking head, but he is the total fiction. Accordingly, his name and that of his tale are identical.

In linking Toby's personal development with his evolution from actor to filmmaker, *Toby Dammit* becomes the perfect synthesis of Fellinian individuation and Fellinian high modernist reflexivity, as well as a stunning celebration of art and the artist. Paradoxically, however, *Toby Dammit* also becomes the moment at which individuality begins most noticeably to unravel in Fellini's work.

NOTES

1. *"Playboy* Interview: Federico Fellini," February 1966, 61. Emphasis Fellini's.
2. For additional discussion of the Pinocchio motif, see Albert Benderson, *Critical Approaches to Federico Fellini's "8½"* (New York: Arno Press, 1974), 224–42.
3. A link between the film's title and the child's age is supported by the fact that Fellini sought to cast someone who looked like an eight-year-old Marcello Mastroianni. It is further

supported by Fellini's recollection that the event on which the Saraghina episode was based occurred when he was eight years old. See Deena Boyer, *The Two Hundred Days of "8½,"* trans. Charles Lam Markham (New York: Macmillan, 1964), 6 and 174.

4. Benderson, too, has noted this (36).

5. Actually, Guido may have moved beyond the spa by the harem sequence. The setting for Guido's retreat into fantasy is a cafe that seems part of the spa world but is also a public place accessed by city streets.

6. See especially Carolyn Geduld, "*Juliet of the Spirits:* Guido's Anima," in *Federico Fellini: Essays in Criticism,* 137–51.

7. This character is unnamed in the film, but for ease of reference I am using the name given him in the screenplay (*Federico Fellini's "Juliet of the Spirits"*).

8. Most quotations are from the subtitles; when I use the screenplay, I cite page numbers in the text.

9. For a wonderful discussion of the camera work and Juliet's problematic presence in the opening scene, see Marguerite Waller, "Neither an 'I' nor an 'Eye': The Gaze in Fellini's *Giulietta degli spiriti,"* *Perspectives on Federico Fellini,* 214–24; hereafter cited in text as "Neither an 'I' nor an 'Eye.'"

10. It is also possible to hypothesize more specific links between the first two spirits and Juliet. When Iris appears, Juliet immediately translates her message, rather than relying on the medium, suggesting that Iris may in fact be part of Juliet. Olaf's accusation occurs after Juliet has responded with annoyance to the advances of a middle-aged male guest and as another guest, Valentina, responds with saccharine preciousness to Olaf's arrival ("[Tell us] something nice, something that could help us in our lives" [193]). Olaf's insulting and vulgar manner may reflect Juliet's projected response to Valentina's preciousness, and the reference to whores may be a kind of projected self-reproach as Juliet has trouble accepting her attractiveness to someone other than her husband.

11. As with so many expanded-consciousness quests of the 1960s, ritual transformation at Susy's actually means the annihilation of consciousness and identity, not their enhancement. Note the dialogue from the Egyptian rite during the party (which, like so much in Juliet's bourgeois world, is extremely pretentious):

> MAN WITH GOATEE: What is your name.
> WOMAN: Hildegarde.
> MAN WITH GOATEE: No, your name is SEX. What is your name?
> WOMAN: Sex.
> MAN WITH GOATEE: ... No, your name is that of the divinity. You are no longer yourself. You are ... the crown of the goddess. (283)

12. Fellini plays a bit fast and loose with continuity in this scene. When Juliet first enters the apartment, there is a phone on the table. However, it is notably absent in shots just

preceding her going to pick it up. The picture of Giorgio is never there, until she goes to take the phone.

13. There are several other subtle hints of Juliet's subjectivity at work in this sequence. As Giorgio tells Juliet of his plans for a "short rest," a phone rings and goes unanswered. Given the function of the phone call at Gabriella's, this may be Juliet's imagination telling her that Giorgio, with his infidelities, is a lost cause. While Giorgio eats and Juliet watches television, a clown looks out from the television and "blesses" Juliet with a smile. This seems like one of Juliet's beneficent spirits wishing her luck as she undergoes her trial by separation. Finally, when Giorgio says good-bye for what he claims to be a temporary respite, the furniture disappears from the room, reflecting Juliet's sense of finality.

14. My analysis dovetails with a fine essay on *Toby Dammit* by Walter C. Foreman, Jr., "The Poor Player Struts Again: Fellini's *Toby Dammit* and the End of the Actor," in *1977 Film Studies Annual: Part 1, Explorations in National Cinemas,* ed. Ben Lawton (Pleasantville, N.Y.: Redgrave Publishing Company, 1977), 111–23; hereafter cited in text. Foreman's essay and my analysis bespeak a shared view of the film that evolved over 20 years: because the two of us first saw it together in Lexington, Kentucky, circa 1974. He was a Shakespearean scholar and I a Fellini freak—a perfect marriage of interests, given *Toby Dammit.*

15. The ball is also perfectly mute, which satisfies Toby's need to escape his role as talking head. However, it is also inanimate and nonconscious, correlating with Toby's initial drive to blow his mind with booze.

16. The point of view of Toby's "spirit" is clearly distinct from later point-of-view shots we get from the aircraft, so we cannot assume that we are merely seeing things from a window of the plane. Also, a plane does not waft in the manner simulated by the opening shots.

17. For utmost precision with these very important words, I have translated from the Italian. Elsewhere, having verified their accuracy, I have used subtitles from the English-language print.

6

The Individual in Crisis from
8½ to *Fellini-Satyricon*

While individuation seems to dominate the narrative and thematic processes in *8½, Juliet of the Spirits,* and *Toby Dammit,* a rereading of these films reveals that individuality is qualified or conflicted in each. Fellini's short film following *Toby Dammit, Fellini: A Director's Notebook,* suggests a radical rejection of dominant individuality, particularly in its renunciation of the notion of a hero or central character. This, in turn, leads to *Fellini-Satyricon,* which functions at the intersection of *Fellini: A Director's Notebook* and the earlier films, reintroducing a protagonist and individuation but only on a level of extreme fragmentation and, at times, parody. This rejection of wholeness on the level of individual personality will be accompanied by a brief, implied, substitution of art as the locus of integration and unity, especially in a film such as *The Clowns.* In the long run, however, the death-of-the-subject will culminate in Fellini's late films of radical de-individualization, where even the artist (Casanova, the musicians of *Orchestra Rehearsal,* Ginger and Fred) are products rather than producers of culture.

This chapter inaugurates a strategy of rereading Fellini's work; it provides multiple rather than single interpretations of certain films or aspects of films. The intent is partly to depart from the more "single-minded" readings of preceding chapters and partly to suggest that Fellini's later work is itself an implicit rereading of the earlier. Mostly, however, this rereading seeks to convey the complexity and multivalence of Fellini's later work as it moves away from subject-centered individuation and wholeness.

8½

Revisiting *8½,* one can read the process of transcendence, whereby Guido ultimately disappears, as the killing off of Guido as hero and center of consciousness, rather than a pilgrim's progress to individuation. This revision is supported by Fellini's own comments about the relation of Guido to *I Vitelloni's* Moraldo: "Moraldo

was looking for the meaning of life as I, myself, was doing. Moraldo became Guido ... about the time that I understood that perhaps I wasn't going to find life's meaning after all" (quoted in Chandler, 141). That the failure rather than the success of Guido's search for meaning—and thus of his individuation—may be at the heart of *8½* seems confirmed by the difficulty Fellini encountered during the project, particularly in terms of envisioning his central character. As Fellini remarked, *8½* was born of a desire:

> to create the portrait of a man ... with all his contradictory, nuanced, elusive totality of different realities. A portrait in which all the possibilities of his being happened—their levels, story after story, like in a building whose facade is crumbling. ...
>
> A life made up of tortuous, changing, fluid labyrinths of memory, of dreams, of feelings, of the everyday ... a mingling of nostalgia and presentiment in a ... mixed up time, where our character doesn't know who he is any more or where his life is going. *(Grazzini, Comments, 158–59)*

In trying to build a film around a "shape-shifting" hero, Fellini found that "the plot began to unravel altogether. It didn't have a central core from which to develop, nor a beginning, nor could I imagine how it might end" (*Comments*, 160). Not only did his protagonist dissolve, but Fellini had repeated difficulty scripting other aspects of the film, and he could not decide on an ending. (He shot two, only fixing on one after an initial screening of the entire film [Baxter, 191].) Because of this, the project was sardonically named *la bella confusione* by one of Fellini's collaborators (Baxter, 189).

Not only do difficulties in Fellini's conceptualization and execution of *8½* call into question an unqualifiedly positive reading of individuation, but a second, closer look at the film reveals major problems in its representation of self-development—problems that my initial reading tended to ignore. For one thing, the seeming elimination of Guido as author and subjective consciousness, in the interests of rebirthing him as something greater, involves a good deal of cinematic sleight of hand. It may occur in terms of classic Hollywood coding of such things as point of view, but the entire ending of the film occurs with reference to Guido—from Luisa's sudden pliancy to the concluding child in white, who still represents Guido. In other words, because of the content and symbology of the ending, we perceive it from Guido's point of view, whether or not that point of view is still explicitly inscribed within cinematic language.[1] The transcendence I earlier asserted is "narratively" impossible.

On a less technical level, Guido's (and the film's) transformation of people into spirits seems disingenuous. This is strikingly the case with Luisa, who is eliminated

as a real woman with real concerns. In her last flesh-and-blood appearance, having just watched herself humiliatingly portrayed in the screen tests, she understandably tells Guido to go to hell. In the final sequences, however, she is re-created as a wish-fulfilling and compliant psychological tool for Guido's self-acceptance. Consistent with classic male illogic, "no" really means "yes," and men do not need to alter their behavior toward women. In fact, all the figures in Guido's life suddenly reappear to bring about his "moral evolution." And though he may give up trying to cast people in autobiographical roles and making them dance to his tune as a director, they end up dancing, in the final sequence, to the measure of his self-transcending imagination. This instrumentalism undercuts the use of white in the final scene to imply that love alters our way of seeing without altering others. Luisa has been fundamentally changed in the process of her "enwhitenment."

This transformation of people into spirits reflects a lingering and inescapable self-centeredness despite the film's attempts to see itself beyond the centered self. This is even reflected in the child-in-white who, on one level, seems to represent both Guido and ego transcended. For one thing, Guido as child has always tended to reproduce (among other things) the adult Guido's desire to be the center of attention, the chosen one—even for the terrifying Saraghina. This desire for attention is reinvoked as the child becomes the centered figure not only within the circus arena but within the circle of light that shines in the arena only for him. Guido, we might argue, disappears as a real figure only to come back and hog the spotlight as "the inner child." For another, the child reincarnates Guido's willful insistence on directing, as he marches around in imperious control of the clown musicians. And third, the child reinstates Guido's self-absorbed alienation and perhaps even escapism. He ends up alone when the clowns move off screen, then he dissociates himself further by breaking the frame and leaving us/the movie alone.

Given the number of complexities and obstacles in the representation of enlightened selfhood in 8½, I would argue that the film, in trying to articulate a model of individuation, ends up admitting to the profound limitations of the concept. (As I have noted before, I see the issue in Fellini's earliest films to be the failure of characters to individuate, not the impossibility of individuation itself.) I think that Fellini is fully aware of the problems and contradictions that I have just mentioned, and that the film foregrounds them rather than being oblivious to their existence. This is why the exhilarating celebration of togetherness becomes the rather absurd and jerky movement of people trotting on the raised circumference of the circus ring—and why darkness descends and the music turns more somber, paving the way for a final scene that is melancholic. (**Figure 6.1**) Consistent with this revision of individuation, I would like to reread three principal themes that contributed positively to my earlier discussion of spiritual development: the evolution of consciousness, the fragmentation of identity, and the loss of author-ity.

FIGURE 6.1 There is something quite melancholic about this little figure alone in the circus arena—even before his spotlight goes out and he exits, darkly, from the scene. Nino Rota's music makes this feeling all the more pronounced. Source: *8½* (1963). Directed by Federico Fellini. Produced by Cineriz. Frame grab captured by Frank Burke from the 2009 Blu-ray version.

The Evolution of Consciousness. In my earlier reading I downplayed the fact that the more conscious Guido becomes, the more he must face his own confusion, instability, and failure. One might even argue that, consistent with neo-Freudian psychology, the only thing Guido really becomes conscious of as *8½* progresses is the uncontrollable effect of an unconscious (culturally produced in large part) that generates little more than chaos. In this light, what initially seems evolution may in fact be increasingly sophisticated displacement. By end of the screen tests, Guido has had to come to terms with the fact that he is a near total failure. His marriage is over, his film is dead, and his dream of being saved by another woman (the real Claudia Cardinale, whom he tries to court en route to the deserted piazza) is unrealizable. Moreover, the last two times we see Guido as a real person, he is cut off from society. Just prior to the press conference he is alone with Claudia. Just prior to the concluding vision, he is isolated on a barren landscape with Daumier, ignoring even him.

The Fragmentation of Identity. The "splitting" that Guido experiences can be seen not only as a becoming-many on the path to spiritualization but as the proliferation of identities that makes single and simple identity itself impossible. At the screen tests he is actually split into at least four figures, not just the two I identified earlier. In addition to the director who created the test footage and the

147

spectator in the audience, there is the Guido whom we see on screen. And Guido the spectator is actually twofold: the "ideal" Guido who whispers "I love you" to Luisa and the "real" Guido who "lies with every breath" (the words of an actress playing Luisa on screen that appropriately describe Guido as philanderer). This view of identity as the collision of roles and subject positions may well be the origin of all the partitioned and "ventilated" subjects that populate Fellini's final films.

The Loss of Author-ity. Similarly, Guido's loss of authorship can be seen not as transcendent self-surrender (becoming "one with the universe") but as the evacuation of (impossible) identity. His status as author-ity is challenged and undermined in conjunction with his most painful self-confrontations: the end of the harem sequence, when Luisa unmasks his exploitative view of women, negating his "masterful" vision of polyamorous bliss; the piazza scene, when (the real) Claudia Cardinale tells Guido (through reference to his film's protagonist) that he does not know how to love; and the final sequence, when Daumier soliloquizes about the meaninglessness of Guido's work. Following upon these (and other) assaults on Guido's mastery or authority, the final sequence can be viewed as the conclusive evacuation of identity. Guido's subjectivity, which is initially established with a close-up as his vision unfolds, becomes projected out onto the image of him as director, organizing the figures from his past. Then, it becomes displaced via the purely symbolic child in white, and finally it evaporates altogether as the child exits the screen.

8½ and poststructuralist theory

Much of what I have just argued aligns 8½ with poststructuralist theory.[2] Such theory is an attack on the notion of "presence"—of any grounded sense of being, meaning, reality. This in turn leads to a denial of such essentialist concepts as identity (self) and the stable, meaningful artwork or text, as well as a repudiation of the notion of origins or of a "center" to things. Not only does 8½ struggle to create identity only to dissolve it by the end, but it also seems to be specifically about an impossible search for origins and a center.

Reading 8½ this way requires, among other things, a third look at the child in white. We must no longer view him as a symbolic and transcendent Guido (in the light of a narrative of evolving consciousness) or as a reincarnation of Guido's self-centeredness (in light of the film's problematic representation of individuation) but as a means of interrogating the purely symbolic and fictitious nature of unified selfhood. In this context, what becomes important is that 8½ only *almost* culminates in the image of Guido as child, centered in a spotlight within a circus ring. As already noted, the child leaves the center and breaks the circle, exiting screen right and eliminating himself as recovered origin. Moreover, both he and the

spotlight are continuously on the move, hence neither can function as a center in a conventional, stable way. They are, in fact, always decentering themselves. And because the child exits, leaving the ring empty, any lingering presence of Guido or his emanation(s) is denied.

This absence of presence in fact turns the film into a celebration of *"différance/ difference,"* which is crucial to deconstructive theory and its originator, Jacques Derrida. Briefly, *différance* is the general process that incessantly produces differences. *Différance* is the distinguishing characteristic of existence. It is the opposite of differentiation, which is the production of distinct unities and identities. While differentiation moves toward closure and definition, *différance* bespeaks their very impossibility. Instead of "origins" there are "originations" ("events" rather than "sites"); instead of "centers" there are "dispersals" and "disseminations." Rather than "presence," "facts," and "things" (that is, solid and substantial entities) what counts are the gaps and spaces *between,* where difference-making occurs—the *traces* of difference-making that can never be fully apprehended. Accordingly, Fellini ends *8½* with a series of dispersals that result not in any implied fullness of being but in the emptiness of the deserted circus ring.

The demise of Guido-as-auteur is tied to another favorite poststructuralist motif: the replacement of the author with the audience (in film the spectator; in literature the reader): "Deconstruction . . . disarticulates traditional conceptions of the author and the work and undermines conventional notions of reading and history. ... It kills the author. ... And celebrates the reader" (Leitch, 105). I have already noted that Guido himself is turned from author into audience during the harem sequence and screen tests. In addition, the film moves to its conclusion through two audience rebellions. At the press conference, reporters surge out of their seats and virtually drive Guido-as-filmmaker to suicide. In the final scene it is Guido's turn to revolt as an "audience." Initially forced to listen as Daumier pontificates, he gradually deletes Daumier, and his own imaginative powers take over.

Most important, the disappearance of Guido and the child at the end transfers authority from the film/text to the audience. Gone is the notion of external direction. One of the reasons the child, arguably, must be jettisoned is that he, too, is a "director." This plus the emptying out of the center leaves the circus ring as a far more open site of possibility than the Guido-centered, Guido-constructed, child in white. *8½* sets the table for us as the woman in white had done for Guido. Now, however, there is no defining symbol ("Claudia"), no guiding light (lamp). Even the few dim lights visible in the background ultimately dim. The ring, like the piazza with Claudia Cardinale and like Daumier's nihilism, creates the undifferentiated space where *différance* can begin anew—ours, as it were, rather than the film's. This transference from film to spectator is entirely consistent with Fellini's

comments about the endings of his movies: "as far as I'm concerned the public writes the ending. ... If the story has moved you, the ending is up to you" ("Long Interview," 63).

The dissemination of director, individual (child in white), and text (Guido's film and, to some extent, with its "emptied-out" ending, 8½ itself) is somewhat tentative at this stage of Fellini's career. Not only is there the strong pressure toward individuation that remains evident in Guido's film-long experience, but 8½ gets made as a "meta-film," offering some feeling of completeness, presence. Furthermore, it is preceded and succeeded by films—*Nights of Cabiria* and *Juliet of the Spirits*—that strongly emphasize coherence and wholeness. Nonetheless, 8½ implies a questioning of the centered self and a critique of author and text that will become central as Fellini's work moves beyond a modernist context to an insistent—though at times grudging—postmodernism.

In reassessing 8½ along these lines, I would emphasize that the dissipation of euphoria that occurs when the circus-ring reunion turns more somber reflects Fellini's recognition that peak experiences are fleeting and perhaps even deceiving, eventuating in inevitable deflation. In a conversation with Charlotte Chandler in *The Ultimate Seduction*,[3] the director remarks "... I used to think about being happy. Happiness is not something I think about now." When Chandler interjects "But it's something that you feel," Fellini responds, "Yes I feel it now as we sit here. But I know it will not last. And unhappiness will return. But there is a consolation in knowing it will not last, either."

Juliet of the Spirits

Like 8½, *Juliet of the Spirits* is paradoxical or ambivalent in its representation of the individual. While the film virtually trumpets personal liberation and integration, Juliet is fragmented into far more pieces than Guido. The film's title even suggests that she represents the many (all her spirits), not the one, and that her subjectivity is radically dispersed. Moreover, far more than any of Fellini's preceding films, *Juliet of the Spirits* makes cultural representation its inescapable subject. Juliet's spirits are nothing if not culturally coded (saints, whores, patriarchs, queens, sex objects). And though the film seems intent on working Juliet beyond that coding, the ending makes clear it cannot. Juliet is still a compendium of cultural symbols. Her diminutive size and whiteness make her a composite of child, bride, and virgin. Fairy-tale allusions through the film plus the storybook surreality of the woods outside her house turn her into a princess as well. Her "individuality," in short, is infected with typicality if not archetypicality. In short, *Juliet of the Spirits* marks the beginning of a shift in Fellini's career toward an

aesthetic of cultural reproduction, citation, imitation, and so on, versus authenticity and uniqueness.

Juliet's seeming oneness is further complicated if we accept my earlier reading of the interrelatedness, the mutual dependency, of Juliet and camera eye (us/Fellini) at the end. If indeed she exists because she is seen, her identity is intersubjective, rather than autonomous. One could also argue that Juliet exists by the end not just through positive self-definition but through numerous negations and structuring absences: her rejection of Bhisma, José, Susy, the Godson, her mother, and so on. To a large extent she is because she is not, or, in contemporary psychoanalytical terms, her "identity" lies in her lack. This kind of paradox will be made quite explicit in *Toby Dammit*.

Nonetheless, while the representation of dispersal in *Juliet of the Spirits* is in many ways more advanced, more compelling, than in *8½*, the film works even harder than the preceding film to disguise or reverse it. And rather than concluding with the kind of decentering that occurs at the end of *8½*, *Juliet of the Spirits* concludes with Juliet ever centering herself—moving to the middle of an image that itself keeps moving. Mobile centeredness rather than dispersion and disappearance seems to reflect Fellini's gender views about the relative groundedness of the feminine in contrast with the masculine.

Toby Dammit

With its ingenious fusion of actor-turned-storyteller-turned-film, *Toby Dammit* might be seen as the supreme achievement of aesthetic and narrative unification within the Fellini canon. Yet it also foregrounds gaps and fragmentation in a manner previously unseen. Emblematic is the final image of the huge abyss that separates the two fractured sections of highway. The film's ability to simultaneously represent opposites marks an opening out of signification, a refusal to settle on one particular interpretable structure, that heralds the increasingly polysemic nature of Fellini's later work. Intriguingly, *Toby Dammit* tends to achieve unification by opening up gaps—a process reflected in my reliance on hyphens to express fusion. Though difference can ostensibly be collapsed through naming in my analysis (I can claim that *Toby Dammit* ends up referring to film, actor, and storyteller all at once), unification only has meaning with reference to the differences it embraces. The whole remains the accretion of parts, the accumulation of hyphens.

Consistent with the film's balancing of opposites is the fact that Toby, while indisputable subject and center of consciousness in the film, is at the same time a *dead* subject, making explicit what I was largely inferring from the ending of *8½*. Because Toby ends up only as the film that bears his name, identity is again

radically dispersed. In fact, this time it has become disseminated throughout a text (that is, the film) that itself is consummately disseminated—via new prints, new screenings, re-viewings, and so forth. Moreover, as a text within a photographic medium, it is properly reproducible only through its negative (To Be and Not to Be). Character, story, and even medium of expression all conspire to place identity and selfhood under erasure.

In keeping with *Juliet of the Spirits, Toby Dammit* heavily emphasizes cultural reproduction. Toby is not an "original," he is derived from Edgar Allan Poe; in fact, Fellini had Terence Stamp made up to resemble Poe. He can only resolve his crisis by (1) appropriating the story of Christ, (2) acting out the implications of his Hamlet-inspired name, and (3) impersonating Macbeth (not only reciting Macbeth's lines but losing his head). Toby's very psychology is a compendium of conventional oppositions: dark versus light, salvation versus damnation, head versus body, private versus professional. In fact, with *Toby Dammit,* the motif of the Second Coming begins to take on new meaning within Fellini's work, signifying less a triumph of spiritual incarnation and renewal than a process of recycling by which everything is (at least) the second coming of something prior. The issue of the dead subject in *Toby Dammit* is born of an almost eerie intermingling of the aesthetic and the personal, given Fellini's life-threatening illness noted in the first chapter. Fellini's growing concern with mortality is reflected not just in the film's story but in a kind of aesthetics of death that Fellini began to propound around the time of *Toby Dammit* and *Fellini-Satyricon,* his first feature following his near death. In reference to the former, he said, "I tried to make fun of myself . . . to throw myself into the sea, to exacerbate my style to the point of parody and grotesqueness in such a way that I could never go back to it."[4] He called the making of *Fellini-Satyricon* "one long suicide,"[5] claiming, "I have had to forget my style, which is kind of an autodestruction" (quoted in Hughes, 159). Consistent with this concern with mortality was his obsession, beginning in the mid 1960s, with a project he never completed—"Il viaggio di G. Mastorna"—about a figure who has died at the beginning of his story but needs a good deal of time to come to that realization.

Fellini: A Director's Notebook

The death of the hero or individual is linked to another thematic and aesthetic issue—the death-of-the-actor—which is not only raised in *Toby Dammit* but made a central theme of *Fellini: A Director's Notebook* (1969), the short pseudo-documentary Fellini made for U.S. television (NBC) between *Toby Dammit* and *Fellini-Satyricon.* The film's point of origin is the evasiveness,

the non-materialization, of a hero or main character, as Fellini claims that G. Mastorna—the protagonist of "The Journey of G. Mastorna"—"has not arrived yet."[6] This harkens back to Fellini's struggles to find his protagonist for *8½*, and it leads to an examination of Marcello Mastroianni as an inadequate stimulus to Fellini in the realization of his project. A central sequence of *Director's Notebook* shows Fellini trying to turn Mastroianni into Mastorna, but to no avail. Marcello as international star has become too well-defined an image (a "Latin lover") and is no longer sufficiently pliable to become Mastorna.[7] In short, two things seem to be happening simultaneously: a single dominant hero is too restrictive a form for Fellini's purposes, and Mastroianni has himself become a fixed entity resistant to the filmmaker's desire for flexibility, multiplicity.

Giulietta Masina also makes an appearance, and her restrained, almost matronly, demeanor is contrasted with her role as Cabiria (she is watching footage from *Nights of Cabiria)*. This not only accentuates the gap between person and role, it implies the kind of manipulation or abstraction involved in turning the former into the latter, an issue that Fellini also addressed in *8½*.[8]

The newly discovered problematic of Mastroianni and Masina—too well defined as both individuals and professional actors to be cast in roles—effectively signals the end of a 10-year period in which all Fellini's major movies had starred one or the other. Moreover, Caterina Boratto's strained effort to play a Roman matron, as Fellini does some preliminary experimentation on *Fellini-Satyricon*, signals the end of professional role-casting altogether in *Director's Notebook*. (Boratto was the elegantly mysterious older women in *8½* and Juliet's mother in *Juliet of the Spirits.)* Instead, Fellini (re)commits to a way of casting that he had employed even when he was using professional actors such as Sordi, Quinn, Basehart, Crawford, Franco Fabrizi, Cardinale, Anouk Aimée, etc. He seeks out nonprofessionals— in this case men and women who work in a modern Roman slaughterhouse and can help define his sense of Roman-ness. And he opens his office to anyone and everyone who wants to come, so that he can inundate himself with human images (not solely actors and actresses) and revitalize his work with the uniqueness and variety of new faces. As a result, he opts for a cinema of image or surface over one of character and depth, and the success of this strategy is implied in the fact that, by the end of *Fellini: A Director's Notebook,* Fellini has cast off (at least for the moment) the albatross of "Mastorna" and begun to direct *Satyricon*.[9]

Intriguingly, Fellini's rejection of the actor/star/hero functions in several different and even contradictory ways:

> (1) it represents a desire to cast off abstraction, the past, the known—all the things that presumably inhibit originality and novelty. In this respect it seems continuous with the Fellinian high-modernist quest for authenticity.

(2) It is a rejection of the single, the dominant, and the stable in favor of the multiple, the democratic, and the dynamic. Yet the death of the hero occurs in conjunction with Fellini's name appearing for the first time in his film titles and with Fellini himself becoming a visible figure on screen, suggesting that the site of the hero is being shifted from protagonist to auteur. This, like (1), is consistent with high modernism, this time in its valuation of the artist as unified and controlling individual.

(3) Despite (1) and (2), the ultimate *effect* of the death of the hero in Fellini's work is not to promote high modernist values but to accelerate the dissolving of identity and sabotage such things as originality, uniqueness, creativity, and individuation, which go along with the notion of a unified self.

As a result of (3), even when Fellini himself returns as a central figure in *The Clowns* and *Roma,* he does so only to inaugurate on the level of author the same process of destabilization that has already been enacted on the level of character. By *Roma,* Fellini-the-director will disappear as a dominant, autonomous, figure and, in particular, as the determining principle of narrative invention. He will come to function not as producer but as product of cultural discourse, represented by the film itself and by Rome as a complex matrix of cultural meanings. (One might say that this is already implicit in *Toby Dammit* to the extent that the hero becomes a film. Here, however, an individual *evolves into* a text, whereas in *Roma* the individual is the product of textuality from the start.) Moreover, when Fellini returns to actors such as Mastroianni and Masina in a later film such as *Ginger and Fred,* he will do so not to reinstitute identity and individuality but—as the reference to Astaire and Rogers makes clear—to further deny them, as Marcello and Giulietta come to represent the endless recycling of roles and stereotypes in a world from which originality has vanished.

The decentering of the hero/protagonist is inextricably linked to another simultaneous development: the fragmentation of narrative far beyond anything we have seen thus far in Fellini's work. As the term "notebook" suggests, *Fellini: A Director's Notebook* is a series of sketches unencumbered by the usual demands for plot coherence. As Fellini put it, "that sketchiness . . . made me feel very joyful. I felt I was walking faster, unhampered by luggage. ... I saw the chance of doing something new" (*FF,* 117). As I suggested earlier, the breaking apart of narrative almost inevitably means the dissolution of dominant characterization, as the former has usually been coextensive with the latter not only in the Western storytelling tradition but in Fellini's highly psychologized character-centered narratives from *La Strada* through *Toby Dammit.*

Fellini-Satyricon

The breaking up of narrative in turn paves the way for *Fellini-Satyricon* (1969), Fellini's first major work of adaptation (albeit with numerous omissions, additions, and embellishments), based on an author who had intrigued him since his school days. Fellini described his attraction to Petronius as follows: "the missing parts; that is, the blanks between one episode and the next. … [T]hat business of fragments really fascinated me" (quoted in Grazzini, 171–72). One of the "missing parts" in *Fellini-Satyricon* initially appears to be character itself. Fellini himself has claimed that "the film does not have … psychology, characters" (Hughes, 159), and the principal figure, Encolpio, lacks the consistent centrality of a Guido, Juliet, or Toby. A close look at the film suggests that Encolpio is somewhat more of a character than Fellini is willing to admit, but he clearly represents individuation generously ventilated by gaps and absences. Moreover, he displays familiar Fellinian characteristics of growth and enlightenment in a manner so erratic and contradictory as to place self-development even more emphatically under erasure than in *Toby Dammit*. I will even argue that individuation becomes parody at crucial points of the film.

Individuation revisited

There are numerous apparent indicators of both personal and aesthetic development in *Fellini-Satyricon*. The film opens in relative darkness with Encolpio a mere shadow hemmed in against a graffiti-covered wall. By the end he has become a defined and mustachioed (mature) figure who evolves in the final moments into a portrait, painted on a rock and grouped among colorful renderings of the film's principal characters. Crude scribblings have turned into more fully articulated art, and, consistent with individuation, the emphasis is on complete human images.[10]

Moreover, at film's end Encolpio seems optimistic and quite together. His recovery of potency through the agency of the "maga" Oenothea leads to his observation that "life is a precious gift."[11] (His words are quite similar to Guido's "life is a holiday, let's live it together," spoken to Luisa near the end of *8½*.) This stands in sharp contrast to his maudlin soliloquy in the opening scene, bemoaning the loss of his loved one, Gitone. Then he concludes his activity in the film smiling at Eumolpo's sardonic will (his heirs must consume his flesh to claim their inheritance) and embarking on a voyage of discovery. The atmosphere is bright, warm, and sunny, much like the end of *Juliet of the Spirits,* and one of his new companions remarks, "The wind is favorable, the clouds are breaking."

There are other signs of development throughout the film. Encolpio's self-absorption and inability to care for anything beyond his sexual and emotional gratification diminish about midway through. He demonstrates strong affection for Ascilto in the home of the patricians. He shows solicitude when the Hermaphrodite is dying. At the same time, his initial reactiveness and dependency is replaced by a seeming capacity for self-transformation in the Oenothea sequence, which in turn leads to his self-assurance and self-determination in the concluding moments.

He also seems to evolve from whining monologist to self-assured narrator: telling us in articulate detail the circumstances surrounding his capture by Lichas and, at the end of the Lichas sequence, narrating crucial historical and personal events (including the overthrow of Caesar). He even concludes the film as narrator, choosing not just to live his life of adventure but to communicate it to us: "I decided to go with them. We left that night. I was a member of the crew. We touched on the ports of unknown cities. For the first time I heard the names of Kelisha, Rectis. On an island covered with high, perfumed grass, a young Greek told us that in the years…" (my translation/subtitles). It is tempting to say that Encolpio, like Toby, ends up as the teller of his own tale.

Encolpio's moments of greatest seeming development occur during the Minotaur and Oenothea sequences. In the labyrinth he awakens to his mortality and implies he is capable of deep attachment ("Dear Minotaur, I will love you if you will let me off with my life" [236]). This newfound passion for existence might be seen as the seed of his later proclamation about the preciousness of life. His killing of an old man coupled with his sexual impotence in the Minotaur sequence seems to awaken a sense of moral responsibility as he confesses to Oenothea: "Guilty I stand before you. I killed a man. I profaned a temple. Now I am a soldier without a weapon" (my translation; he is talking figuratively here of his impotence).

Consistent with signs of individuation in earlier Fellini films, Encolpio's encounter with Oenothea seems largely visionary or imaginative. Oenothea herself is "otherworldly" ("Nobody knows where Oenothea is. You have to search"). She appears to dwell as much in Encolpio's psyche as anywhere else, appearing to him as a series of visions. In her presence, and reminiscent of 8½ and *Juliet of the Spirits*, reality is infused with the irreal, and boundaries between the two are difficult to determine. Within this context Encolpio's quest seems to be metaphoric—involved with spiritual empowerment rather than mere sexual potency—as is reflected in the profound sense of well-being with which he leaves Oenothea's cave.

That Encolpio's encounter with Oenothea exceeds the purely sexual is accentuated by the multiplicity of her manifestations. She is a beautiful young woman, a statuette of frightening decrepitude, and an earth mother. Moreover, it is not the young woman (the most sexually appealing figure) with whom Encolpio copulates. It is the earth mother. In short, Oenothea seems to offer access to the unknown and

the profoundly vital, linking her with other large Fellini females such as Saraghina. Finally, because Oenothea/the unknown lies both without and within, Encolpio is able to access creativity and potency not just as an external reality but as his own undiscovered self.

Such, at least, would be a reading consistent with several of Fellini's preceding films. However, Encolpio's characterization and growth are sporadic at best. He is absent from important scenes such as the Widow of Ephesus tale and the patricians' suicide. He seems to achieve a kind of contemplative distance and self-control at the art gallery, only to debauch at Trimalchio's. Though he seems to take over the narrative in the Lichas sequence, he does not utter another word of voice-over until the final moments of the film—and here his narrative trails off in mid-sentence to become yet another fragment. Contemplativeness and caring at the patricians' villa are followed shortly by the brutality of his actions in the Hermaphrodite scenes. And nearly all the principal signs of moral development are bunched in the last quarter of the film, rather than comprising a film-long process as in *Nights of Cabiria, 8½, Juliet of the Spirits,* and *Toby Dammit.* The seeming arbitrariness of Encolpio's "growth" lends strong credence to Fellini's claim that *Fellini-Satyricon* is fundamentally lacking in psychology.

Equally important, Encolpio is far more a creature of luck than self-determination. He is saved from apparent suicide by the collapse of the apartment building he inhabits early in the film.[12] He is spared by Lichas after losing their wrestling match. Then he is spared by the Minotaur and the proconsul who presides over the labyrinth scene because he is "cultivated" and "educated" (we are hard-pressed to find any evidence for this). Finally, he is offered a magical solution to his impotence at the Garden of Delights. He seems far more a child of fate than were Cabiria, Guido, Juliet, or Toby later in their stories. Perhaps most important, Encolpio's moments of greatest trial and awareness are clearly parodied. There is something quite comic in Encolpio's plea to the Minotaur: "There should be a gladiator here in my place. I am only a student." (This always gets a howl in a university environment.) (**Figure 6.2**) Encolpio's incapacity with Ariadne is played for laughs, and his greatest crisis in the film is nothing more than an inability to get it up. His "cure" is also comical, for he looks quite absurd as he shouts "Oh, Mammina" and runs into the arms of the Great Earth Mother. (This moment is inclined to get a howl whether in a university setting or not.) With the simultaneous emphasis on enormous phalluses outside Oenothea's, the film seems to be poking fun at the broad sexual symbolism that often characterizes mythological drawings.

Encolpio's cure is not just comic: it is troubling. Having taken a potion in preparation for Oenothea, he fails to answer Ascilto's call for help when he is attacked by a boatman., though Ascilto had recently answered Encolpio's summons when *he* was attacked by the Thief as the Hermaphrodite lay dying. Following his "cure,"

FIGURE 6.2 Fellini must have anticipated his largely university-age audience for *Fellini-Satyricon* with this one-liner. Source: *Fellini-Satyricon* (1969). Directed by Federico Fellini. Produced by Produzioni Europee Associate. Frame grab captured by Frank Burke from 2015 Blu-ray version.

Encolpio remains oblivious to his friend's condition, blathering, "The great gods have cured me. ... Life is a precious gift. ... Run, Ascilto, run." As a result, when he finally notices that Ascilto is dead and eulogizes "Great Gods, how far lie lies from his destination," his words seem hollow, the self-serving rhetoric of a student who has learned his oratory well. In short, the realm of imaginative or heightened experience, so affirmative in earlier Fellini films, leads not just to a cure but to fatal disconnection. And we might even view the potion as a denial of imagination, reducing Encolpio's vision to a drug trip, further negating any sense of a pilgrim's progress.

The individual and the social order

Consistent with its devaluation of the individual, *Fellini-Satyricon* is more an analysis of a changing social order than of a changing protagonist. This emerges in part from the film's "doubled" historical context: a Roman world verging on Christianity and, at the same time, a contemporary (late 1960s) world seemingly undergoing its own radical, but as yet undefined, shift. Fellini shared a rather common apocalyptic sensibility of the times, evident in his response to visiting a U.S. nightclub during the promotion of *Fellini-Satyricon*:

> I remember going to The Electric Circus, with its dance floor aswirl with multicolored tropical fish, the floor carpeted with semi-nude bodies, and those

enormous holes in the walls from which four five six pairs of feet, male and female, black white yellow, protruded. ...

To be able to lose oneself in that caldron, where everything is burning, and where the old myths, and yesterday's utopias, are all melting away, there is something sacrificial in that moment. It is a total and ever so gentle suicide, a moment in which a new way of being a man, and in which salvation, is perhaps still possible.[13]

Although *Fellini-Satyricon* seems unable to represent "a new way of being a man," it does offer a sacrificial suicide (explicitly enacted by the patrician couple) giving way to new forms of social organization.[14] This in effect divides the film in two, with the consecutive deaths of Caesar, Lichas, and the patricians marking the boundary between the old and the new.

The first half of *Fellini-Satyricon* divides into three phases: from the beginning to the collapse of the Insula Felicles, from the art gallery scene to Encolpio's (and his companions') capture by Lichas, and the Lichas sequences. The overall trajectory is toward the increasing domination of the social order.

In the first phase, Encolpio and his world remain marginal to society. The principal setting is the "Suburra"—the Roman underground, physically, economically, socially, and morally. Authority is peripheral, represented only by a magistrate who briefly intervenes on Encolpio's behalf at Vernacchio's theatre. Encolpio seeks greater and greater privacy, ending up making love with Gitone in an apartment high up in the Insula Felicles.

When the Insula Felicles collapses, Encolpio's marginality is pretty much ended. The next sequence occurs in an art gallery, filled with canonized cultural artifacts. Moreover, the thrust of the following scenes is toward greater assimilation, as Encolpio joins up with Eumolpo, who takes him to the powerful Trimalchio's banquet. Greater assimilation also implies being subject to greater domination. At Trimalchio's, Eumolpo is punished for accusing Trimalchio of plagiarism, and Trimalchio's guests end up traipsing to his mausoleum to watch him play-act his death and the bequeathal of his wealth. With the telling of the Widow of Ephesus tale, the guests become entirely passive; authority (Trimalchio's and the storyteller's) becomes absolute.

Assimilation-as-subjection is the overwhelming condition of Lichas's world. Not only is the ship filled with prisoners, but Encolpio is dominated physically and sexually, ending up "married" to Lichas. Moreover, unlike Trimalchio, Lichas is not a free-enterprise businessman but an employee of Caesar—so tied to the political system that when Caesar is killed, so is he. Equally subjected is the patrician couple, who can only respond to Caesar's death with their own suicide.

The first half of *Fellini-Satyricon* not only makes clear that engagement in the social order and proximity to power inevitably mean entrapment, it equates power with violence, as the leading figures militarily (Lichas), politically (Caesar), and socially (the patricians) end up dead. This is largely because society is founded on self-interest: the acquisitiveness of a Trimalchio or Caesar in conjunction with whatever force they can muster to further that acquisitiveness. The "communities" we do see, such as Trimalchio's and Lichas's, are organized in an arbitrary and often brutal hierarchy. There is little valuation of individual worth (a man's arm is cut off at Vernacchio's theater just to provide amusement), hence there is no stake in individual development. Survival is paramount, and people remain outer-focused, relying on aggression or sycophancy and submissiveness in order to succeed. To most, life appears arbitrary and meaningless ("we're no more than buzzing flies," as one of Trimalchio's guests puts it). Personal change means only changes in fortune (for instance, becoming a free person rather than a slave), and because changes in fortune are determined from without, people such as the patricians cannot imagine themselves beyond the determinations of a sudden and arbitrary political shift.

With the death of the old order, a significant transformation occurs. At first anarchy and excess reign as the Nymphomaniac displays uncontrolled sexual need and desire and the Thief uncontrolled aggression and greed. However, the labyrinth restores a sense of order, balance, and, most important, socialization, representing aggression and sexuality (the Minotaur and Ariadne) as civilizing ritual. The society of the Minotaur is far more unified and purposeful than anything we have seen before, and social organization works to the enhancement, not the enslavement, of the individual. This is true also with the Garden of Delights and with Oenothea, who provides her fellow townspeople with fire and Encolpio with his cure.

The evolution of the social order culminates with a threesome generated at the end of the film: Encolpio, a young black, and the young white figure whom the screenplay identifies as a Greek. This seems to signify another major shift in the social, following the death of Eumolpo. This small group is fluid, diverse, and beyond even the limited materialism of the recent, post-Caesar societies in the film. It is committed not to settlement (the communities of the Minotaur and the Magician) or inheritance (Eumolpo's heirs) but to life on the move, freed of the past and in search of an ever-unfolding future. Most important, it consists principally of peers, with no hierarchy and no imbalance in either power or wealth. (The young Greek is the ship's captain but is presented as an equal to the other two.) In both its composition and its commitment to adventure, it is of course a society, quintessentially, of the young, consistent with the 1960s mantra "Don't trust anyone over 30." (It is also all male, a gender issue I address later.) Oppressive political order has not disappeared entirely, for Encolpio notes, after he leaves

Oenothea's, "The new Caesar is very severe with outlaws," but this new community on-the-move seems beyond Caesar's reach.

There is something of the irrational, the fantastic, and the mythic throughout this half of the film present in settings (the scene with the Nymphomaniac), characters (the Hermaphrodite, the Minotaur, the Magician, and Oenothea), and Encolpio's own oneiric experience. Moreover, the fact that societies are organized largely in mythic and imaginative terms responsive to individual needs means that, in direct contrast to the world under Caesar, the more engaged Encolpio becomes with the social, the more empowered he becomes. "Authority" in fact becomes authorization to become what one wishes to be. It is no wonder, then, that whatever character development we might discern in *Satyricon* occurs in the post-Caesar world. It is crucial to emphasize, however, that such development seems much more the product of changing social organization than individual initiative. In fact, the kind of user-friendly society we find in the second half of the film reflects a classic 1960s optimism about the end of oppressive, militarist capitalism and its replacement with social forms more conducive to emancipation.

It is also conceivable to link the shift in relationships between the individual and society in *Fellini-Satyricon* to changing theorizations of power that began to emerge about the time of the film and that I addressed, briefly, in the first chapter. In particular, *Fellini-Satyricon* seems to reflect the shift from dominance (the imposition of power from above) to hegemony (the perpetuation of existing power relations through the enculturation and consent of the individual). Theories of hegemony have been necessitated by a shift in political form from traditional hierarchy to liberal democracy and, more recently, consumer-sensitive late capitalism, and it seems that something like this shift (allowing, of course, for the pre-Christian context of the film) is reflected in the movement from the first to the second part of *Fellini-Satyricon*. In this respect the film might serve as useful commentary on the failed revolutionary fervor of the late 1960s, implying that the promise of personal and social transformation became (paradoxically) Western hegemony's way of containing real change, fostering illusory and depoliticizing "personal empowerment" (for example Encolpio's) or nightclub rituals of death and renewal (the Electric Circus).

Fellini-Satyricon like *Toby Dammit* ends up being a divided or multiply coded film. (In fact, I later provide yet another reading, from a gay-positive perspective.) Less and less can we reduce the trajectory of Fellini films to single identifiable processes, linked always to a single identifiable hero. We are confronted with growing irresolution—something Fellini built into *Satyricon* by making it evocative rather than definitive, requiring the constant active engagement of the audience:

> What interests me is ... to work as the archeologist does, when he assembles
> a few potsherds or pieces of masonry and reconstructs not an amphora or a

temple, but an artifact in which the object is implied. … [T]his artifact suggests more of the original reality, in that it adds an indefinable and unresolved amount to its fascination by demanding the participation of the spectator. Are not the ruins of a temple more fascinating than the temple itself? (Quoted in Zanelli, 4)

NOTES

1. This explains the insistence of such critics as Robert Stam *(Reflexivity in Film and Literature from "Don Quixote" to Jean-Luc Godard* [Ann Arbor: UMI Research Press, 1985]) and Edward Branigan *(Point of View in the Cinema: A Theory of Narration and Subjectivity in Classical Film* [New York: Mouton, 1984]) that Guido's subjectivity is central throughout 8½. As I argue in "Fellini: Changing the Subject," both these critics are a bit simplistic in their assessment of point of view in the film.

2. For a description of Deconstruction, several texts are quite useful: Vincent B. Leitch, *Deconstructive Theory: An Advanced Introduction* (New York: Columbia University Press, 1983), hereafter cited in text; Jonathan Culler, *On Deconstruction: Theory and Criticism* (Ithaca, N.Y.: Cornell University Press, 1982); Christopher Norris, *Deconstruction: Theory and Practice* (London: Methuen, 1982); and John Sturrock, ed. *Structuralism and Since: From Levi-Strauss to Derrida* (New York: Oxford University Press, 1979).

3. (New York: Doubleday), 139–40.

4. Quoted in Eileen Lanouette Hughes, *On the Set of "Fellini-Satyricon": A Behind-the-Scenes Diary* (New York: William Morrow, 1971), 3; hereafter cited in text.

5. Quoted by Dario Zanelli in "From the Planet Rome," in *Fellini's Satyricon,* ed. Dario Zanelli, trans. Eugene Walter and John Matthews (New York: Ballantine, 1970), 9–10; hereafter cited in text.

6. The film is in English, so quotations from the dialogue are taken directly from the soundtrack.

7. Throughout my discussion of *Fellini: A Director's Notebook,* I am indebted to Walt Foreman. Many of the ideas expressed here were formulated over years of discussion with Walt, and some appear in unpublished writings that he generously shared with me.

8. Fellini's growing critique of this kind of manipulation may well have been fueled by his experience in the making of *Juliet of the Spirits*. There were frequent disagreements between Giulietta Masina and him on the character of Juliet, and Masina remained dissatisfied with the decisions often forced on her by Fellini. Liliana Betti refers to the "collisions" between Masina and Fellini on the set of *Juliet of the Spirits,* 64.

9. For more on Fellini's cinema of image and surface, see A.J. Prats, "The New Narration of Values: *Fellini: A Director's Notebook,"* in *The Autonomous Image: Cinematic Narration and Humanism* (Lexington: University of Kentucky Press, 1981), 1–37; and A.J. Prats and John Pieters, "The Narratives of Decharacterization in Fellini's Color Movies," *South Atlantic Bulletin* 45, no. 2 (1980): 31–41.

10. For a discussion of Encolpio's individuation and its relation to art and color, see A.J. Prats, "The Individual, the World, and the Life of Myth in *Fellini-Satyricon*," *South Atlantic Bulletin* 44, no. 1 (1979): 45–58; Robinson, "The Visual Powers Denied and Coupled"; and Snyder, "Color, Growth, and Evolution in *Fellini-Satyricon*."

11. In quoting dialogue from *Fellini-Satyricon*, I rely on subtitles, the screenplay, or my own translation, depending on which provides the greatest accuracy.

12. Having just been jilted by Gitone, Encolpio spies a knife—then the building caves in. It is conceivable that he is contemplating murder, but the fact that he lets Gitone go off with Ascilto without a struggle seems to belie this. It seems more probable that suicide is on his mind—a supposition supported by the screenplay, which maintains that Encolpio, just prior to the collapse, "climbs onto [his bed] to throw a rope around a beam in order to hang himself" (120).

13. *Esquire*, August 1970, 23.

14. Fellini has claimed (Chandler, 173) that the patrician suicide is a reference to Petronius. The circumstances of Petronius's death were quite different, but the film's "killing off" of Petronius in this scene would be consistent with the fact that, from here on in, Fellini's version radically departs from the original.

7

The Individuation of Art versus Character: *Fellini-Satyricon* and *The Clowns*

As the protagonist/hero undergoes crisis within Fellini's work, there is a shift in emphasis to art: while characters no longer become individuated, texts do. Guido may abandon his film and vanish, but *8½* survives the loss. Toby may die off as actor/protagonist at the abyss, but he leaves his signed and completed story behind. Encolpio may disappear as character and fragment as narrator at the end of *Fellini-Satyricon,* but his image is transformed into a portrait. Art, I would suggest, briefly offers Fellini an opportunity to maintain the kind of affirmative vision that characterizes to a greater or lesser extent *Nights of Cabiria, 8½, Juliet of the Spirits, Toby Dammit,* and perhaps even *Fellini-Satyricon.* However, as Fellini's films come to emphasize the artwork over the individual, characters become the products rather than creators of art. Moreover, art is increasingly represented as the result of cultural rather than individual production, and individual experience is increasingly seen as a response to art and culture rather than vice versa. The influence of clowns on Fellini as a child will be a clear case in point.

The issue of the artwork vs. the individual in *Toby Dammit* should be clear from my discussion of that film. It could be addressed with further discussion of *8½,* but it is best illustrated—particularly as it occupies an important position in early mid-career for Fellini—in relation to *Fellini-Satyricon* and *The Clowns.*

Fellini-Satyricon: *Art as regeneration*

As my discussion of the Oenothea sequence might imply, one of the principal themes of *Fellini-Satyricon* is false or questionable regeneration.[1] We could, in fact, view the film as a series of meditations on the subject, perhaps inspired by Fellini's life-threatening illness and the failure of the Mastorna project, but also consistent with the themes of redemption and the Second Coming that recur in preceding films.

At Vernacchio's theater, regeneration is parodied and effectively denied as a man has his arm amputated, then replaced with a golden "prosthesis." This is renewal as mere substitution—something that also characterizes the Roman political system as one Caesar merely replaces another. In potential contrast is the kind of renewal suggested at Oenothea's. Here a loss is recuperated rather than merely substituted. Moreover, to the extent that the recovery might be imaginatively induced, it can be seen as self-regeneration rather than the mere adding on of a prosthetic device. Finally, the seeming result—Encolpio's sense of empowerment—far exceeds what was originally lost. In short, this model of regeneration is far superior to Vernacchio's in terms of spiritual promise. However, as I suggested earlier, it remains a model rather than anything more, undermined by parody and the death of Ascilto.

Throughout *Fellini-Satyricon* the problem of regeneration is related to the issue of an afterlife. The film's characters seem to possess little or no faith in one; consequently, there is little veneration for the dead. The Widow of Ephesus is easily wooed from her mourning by a handsome young soldier and, more than that, protects her new lover by substituting her husband's corpse for that of a criminal. Nonetheless, several characters do seek to live beyond the grave through bequeathal. Trimalchio, as we noted, play-acts his own death and distribution of wealth. The patricians bequeath freedom to their slaves and a safe future to their children. Eumolpo, in a drunken stupor, bequeaths the seasons and a host of other things to Encolpio early in the film, and at the end he leaves his worldly goods to those willing to cannibalize his remains. This kind of "afterlife," however, affects only others, not the person who dies. It is another instance of substitution (the living for the dead) based largely on material goods and values. There is nothing approaching a Christian sense of resurrection and eternal life. Linked with this is the absence of any sense of sacrifice, of a death (such as Christ's) having redemptive communal value. The closest we get is the labyrinth scene, based on a myth (Theseus/Minotaur) in which sacrifice is central. However, as enacted in *Fellini-Satyricon,* the myth not only eliminates death but, by becoming merely a matter of Encolpio's potency, becomes individualist rather than communal. Then Encolpio appropriates a communal myth of suffering or sacrifice—Oenothea providing fire for the village—for purely personal ends.

The film's denial of death and rebirth is particularly striking given its potential relationship to Christianity. *Fellini-Satyricon* could have portrayed a society in the process of discovering the kind of metaphysics of the soul and the afterlife that would signal Christ on the horizon. Instead, it is a pre-Christian film made from a post-Christian perspective: it rejects resurrection not only as a religious model but as a psychological one that would be consistent with the experience of a Cabiria or, in a more conflicted sense, Guido.

While rebirth and regeneration seem impossible on both a religious and a psychological level, they *do* seem to occur through art. In addition to becoming a portrait, Encolpio undergoes a kind of rebirth that recalls Toby's. He disappears from the final scene to be reborn as storyteller, recounting in past tense, "I decided to go with them." Like Toby's waxen head, the painting of Encolpio becomes the symbolic trace of his former self. This constitutes a kind of transcendence in Fellini's work that has a number of important implications. For one thing, art is far more "immanently transcendent" than the evolution of matter into spirit a la Cabiria and, briefly, Paola. The paintings at the film's end are clearly situated in the world. They are drawn upon natural materials (the stone walls of a ruined villa) and closely linked to the other elements: wind, sea, and sun. They are subject to both transformation and decay, transformation *as* decay.

Art at the end of *Fellini-Satyricon* is also fragmentary. It consists, to use Fellini's term, of "potsherds," lifted out of a culture and able at best to allude (not even refer) to the context from which it came. The images we see at the end are not only culturally decontextualized with the passage of time but visually split off from one another, despite the fact that they represent whole human figures. Encolpio's portrait is only one among many, and each figure is separated from adjoining figures by cracks and differing color schemes. Moreover, the series of portraits is painted on three separate wall fragments. (**Figure 7.1**) And not only does Encolpio's narration end in *mid*-sentence, it speaks of his journeying to *islands*—as we see one dimly off in the distance. In fact, fragmentation is the key to a highly provisional form of freedom suggested, I feel, by the film's end. It is Encolpio's ability (like Toby's before him) to split off from his character and become voice-over narrator, then artwork, that makes survival ("immanent transcendence") possible. And to the extent that the film's structure (like the world of Caesar) fixes Encolpio in a particular role, he (again like Toby) is able to escape that role through self-segmentation and rebirth as artwork.

In accentuating the fragmentary, *Fellini-Satyricon* prioritizes absence over presence, a point implied by Fellini's rhetorical question, "Are not the ruins of a temple more fascinating than the temple itself?" (Zanelli, 4). The implications of this in terms of our role as spectators become intriguing if we compare the last moments of Encolpio with those of Cabiria, the little girl or Cupid figure in *The Temptation of Dr. Antonio*, Paola in *La Dolce Vita*, and Juliet. Each of these figures was a living presence who looked directly into the camera and, by implication, at us. This look signified a fullness of being and accessibility (both on their part and ours) but also, in a sense, anchored us in a subject-object relationship. (Here again I am again revisiting and revising earlier comments.) Encolpio, however, as painting rather than living presence, has no power to overwhelm, no gaze with which to pin us down. Moreover, he and the other figures by the sea, all characters from

FIGURE 7.1 Wholes become fragments, ruins, gaps, and fissures. The ceaseless activity of the sea behind the murals bespeaks the flows of time and history that fiercely miniaturize the significance of individual life and even art. Source: *Fellini-Satyricon* (1969). Directed by Federico Fellini. Produced by Produzioni Europee Associate. Frame grab captured by Frank Burke from 2015 Blu-ray version.

the film, refer to something that is already in a sense invisible: the past of the film. We are free to move back to the film as and only if we choose. Representation has become not mimesis but something far more allusive and elusive.

Art in this way—and in Hemingway's famous terms—operates as the tip of the iceberg. It also becomes uncollectible and anti-monumental, running counter to the materialist desires of a Trimalchio, Caesar, or Lichas and to the self-enshrining art of "great men." (Trimalchio has an enormous portrait of himself painted during his banquet; the arrival of the new Caesar brought with it self-celebratory art.) Consistent with this, the fragmented wall paintings at the end take on the quality of a site-specific and untransportable installation.

In its function as evocative trace, left behind for an audience to address in its own way, art at the end of *Fellini-Satyricon* becomes the most open-ended bequeathal in the film. In fact, we can view the film as a whole, and Petronius's work before it, as bequests with no strings attached. We are not constrained to venerate as were Trimalchio's heirs or consume as were Eumolpo's. The art bequest here granted is the sort Encolpio received from the Master of the Garden of Delights, who told him of Oenothea. It consists of the sharing of fiction, to be acted upon by the individual for himself or herself. In this way, art negotiates the transition from itself as authority to its recipient as self-author(iz)ing. This, of course, is putting an extraordinarily positive face on art, retaining a 1960s emancipationist spirit. Ultimately, the self-splitting and self-reproduction that can here

be argued as potentially liberatory will be viewed by Fellini in an increasingly nega-
tive light, particularly as he engages critically with technologies of postmodern
reproduction, most notably television.

The Clowns

The Clowns (1970) was Fellini's first feature-length film for television. It was
funded by RAI, the Italian national network, partly in response to difficulties
Fellini had with NBC developing projects to follow upon *Fellini: A Director's
Notebook*. The film, in some ways, seems to mark a temporary retreat from
Fellini's post-*Juliet* explorations, harkening even as far back as *Nights of
Cabiria*. For one thing, there is a dominant main character (Fellini himself)
rather than the relatively sporadic protagonist of *Fellini-Satyricon*. For another,
there is clear narrative structure and progression. For a third, the film seems to
offer a harmonious vision (in Fellini's terms, "the reconciliation of opposites,
the unity of being" [*FF*, 124]) in sharp contrast to the increasing fragmenta-
tion of his immediately preceding work. In several respects, however, the film is
clearly related to *Fellini-Satyricon*. As with Encolpio and Toby, the protagonist
(Fellini) is superseded by art—his disappearance a crucial component of the
film's conclusion. And, even more strongly than *Fellini-Satyricon*, *The Clowns*
links art and regeneration, as Fellini seeks to "resurrect" the art of the clown
through film. In terms of the individuation of art rather than character, *The
Clowns* is a clear step beyond *Fellini-Satyricon*, as the film is at no point about
the personal growth or regeneration of its main character. Rather, the focus is
entirely on how the film itself gets made. Fellini's use of himself as documen-
tary filmmaker—a strategy that originated with *Director's Notebook*—will
become the basis, in *Roma,* for a radical "dissemination" of identity, stability,
and unity, whereby the Fellinian quest for individual synthesis and wholeness
will once and for all be abandoned.

Although *The Clowns* seems at first glance a rather simple homage to the art
of the clown, it is, in fact, a highly complex attempt to render the artistic or cre-
ative process.[2] The film has three major parts: Fellini as a child and young adult
(Fellini's childhood clown experiences and associations), Fellini as documentary
filmmaker (Fellini seeking to make a movie about clowns), and Fellini as fiction
filmmaker (Fellini, having abandoned documentary, seeking to direct a personal
tribute to the art of the clown). The trajectory of the film is from principally sen-
sate to intellective and then to imaginative experience, culminating in a synthesis
of imagination and reality that occurs through a narrative shift akin to that of the
press conference and succeeding sequences of *8½*. (**Figure 7.2**)

FIGURE 7.2 Fellini as a young child encountering the circus and initiating a film-long evolution of primary experience into fascination, rational exploration, and imaginative creation. Source: *The Clowns* (1970), Directed by Federico Fellini. Produced by RAI Radiotelevisione Italiana, Compagnia Leone Cinematografica, Office de Radiodiffusion Télévision Française (ORTF), Bavaria Film. Frame grab captured by Frank Burke from 2011 Blu-ray version.

During the first phase, Fellini as a child moves from merely seeing and hearing what is around him to contemplation. This occurs through his visit to a circus and his fearful response to the seemingly irrational and violent energy of the clowns, who intrude beyond the circus ring and invade the child's space as spectator. Following this early fall into self-consciousness and into an awareness of danger and his own fragile existence, the young Fellini compares the clowns to various townspeople, appropriating the unknown and frightening to the known through the rudimentary rational tool of analogy. He also develops the rudimentary imaginative skill of symbolically fusing clowns and "enlightened" women (women, generally blond, dressed in white or off-white who seem to radiate light). This fusion, linked to adolescence and the birth of sexuality, helps turn the clowns into a magnetic emotional force, explaining why he returns to them as a film subject later in life.

The second phase involves the refinement of both the rational and imaginative capabilities born in the first phase. The former is evident in the adult Fellini's efforts to research and document the history of the clown—efforts that fail partly because of the decline of the clown and the paucity of useful historical materials but largely because Fellini finds the mere intellectual documentation of reality inadequate to his purposes. The latter is clear in the five imaginative "vignettes" that punctuate Fellini's intellectual search. These are historical re-creations or inventions that burst onto the scene without explanation (though usually in relation to what has been occurring on screen) and express far more adequately than factual documentation the spirit of the clown. They also enable Fellini (the director of the metafilm, not the character in the film), to continue filmmaking, once his documentary project has failed. The energy generated by the vignettes, plus the information garnered through Fellini's research, fuel the extensive spectacle that comprises most of the third phase and helps, in effect, to resurrect the art of the clown.

The final phase has its own three divisions (which, for purposes of clarity, I shall call stages) that both recapitulate and advance the three phases of the film. For point of reference, the events of the third phase are (1) mourning for a dead clown Fischietto, (2) the transformation of mourning into celebration and into the resurrection of Fischietto, and (3) the (re)enactment of an old clown routine described to Fellini by one of his performers, Fumagalli.

The first stage extends to the moment a "lawyer" in charge of Fischietto's "estate" swings a hammer toward the camera eye and thus draws attention to the camera's presence as source of all we have been seeing. Till then, we have a series of visual and aural experiences without any seeming source of rational organization or conscious control, corresponding to young Fellini's initial sensory experience. The lawyer's hammer swing, by turning the film into a self-reflective process, corresponds with young Fellini's fall into awareness. The lawyer's initiation of self-consciousness becomes even clearer when a clown-photographer appears and makes the other clowns pose for a picture. Their prior unstructured activity is now organized into the deliberate art of portraiture. Portraiture in turn is precisely what Fellini was attempting to achieve through documentary in the second phase. The full extent of self-consciousness, self-reflexivity, is made clear when Fellini, who has not been visible before, suddenly appears as director of all the action. (He corresponds, in a sense, to the clown-photographer.)

Like the film's second phase, this section of the third phase ends in failure: the resurrection of Fischietto is highly contrived (dependent on lots of elaborate machinery). It also comes to a sudden anticlimactic end. When it concludes, Fellini proclaims without much enthusiasm, "It's over," matching his remarks at the end of his documentary activity: "Maybe [historian] Tristan Remy was right.

Maybe the clown is dead." Like the end of the second stage, this ending turns out to be temporary. As documentary failure gave way to fictional invention, the unsatisfying resurrection of Fischietto gives way to Fumagalli's old clown routine.

At this point an entirely different narrative situation emerges. Instead of creating and imposing his own vision as director, Fellini becomes a conduit. In fact, he disappears, never to reappear, and Fumagalli's words materialize as images without any apparent authorship on Fellini's part. The materialization of Fumagalli's story, I would suggest, is meant as a more authentic act of resurrection—miraculous, fluid, involving the seamless interpenetration of reality and imagination—as opposed to the symbolically forced and mechanical rebirth of Fischietto. In short, this final moment or stage of the third phase enacts the same kind of movement beyond rationality that we witnessed when documentary gave way to invention at the movement from the second to the third phase. However, it seeks to strip inventiveness of its contrivance while moving art and imaginative experience beyond the province of the individual artist's controlling ego. (The latter recalls the late sequences of *8½*.)

Central to the growth of imaginative activity in *The Clowns* is the dynamic allegory of the white clown-Auguste tradition uncovered by Fellini during his research in the second phase. Fellini has described the allegory as follows:

> The white clown stands for elegance, grace, harmony, intelligence, lucidity, which are posited in a moral way as ideal, unique, indisputable divinities. ... [T]he white clown becomes Mother and Father, Schoolmaster, Artist, the Beautiful, in other words *what should be done*. Then the Auguste, who would feel drawn to all these perfect attributes if only they were not so priggishly displayed, turns on them.
>
> The Auguste is the child who dirties his pants, rebels against this perfection, gets drunk, rolls about on the floor and puts up an endless resistance.
>
> This is the struggle between the proud cult of reason (which comes to be a bullying form of aestheticism) and the freedom of instinct. *(FF, 124)*

Although the white clown-Auguste relationship tends toward radical polarity, it also holds the potential for harmony ("the reconciliation of opposites"). The former's facility for order can provide structure for and be dynamized by the latter's vitality and rebelliousness. In short, the white clown-Auguste relationship represents the conflict and potential synthesis of various forces traditionally seen to be at war within us: the Dionysian and the Apollonian, the revolutionary and the repressive, the creative and the conservative, the imaginative and the rational. With this in mind, we can view the final phase of *The Clowns* as a succession of white clown-Auguste situations.

The phase opens with various authoritarian clowns trying to enforce mourning for the deceased Auguste, Fischietto. Their attempts fail. Then a white clown leads a funeral procession into the circus ring and initially reestablishes mourning. However, a disruptive donkey refuses to pull the hearse, rebels against the imperious coachman, and commands lively music from the resident "maestro." The clowns join in his rebellion, and the procession erupts into a maelstrom of activity culminating in the resurrection of Fischietto. During the rebellion, the white clown removes himself, complaining of a twisted ankle, and, following Fischietto's resurrection, the coachman, too, bows out.[3] Although this appears to signify the total victory of the Dionysian over the Apollonian, energy over structure, *The Clowns* does not end here. Instead, we move to the Fumagalli tale that picks up, on a symbolic level, where the rebellion and rebirth of Fischietto left off: with an Auguste (Fumagalli) dominant and a white clown (Fumagalli's old partner, Fru-Fru) absent. Fumagalli, missing his old companion, summons him by playing their old tune on the trumpet. Fru-Fru is "resurrected," and the two play a duet as they come together within a spotlight in the center of the arena. Thus is articulated the "unity of being" noted by Fellini and embodied in the (re)union of the two complementary clown opposites.

The white clown-Auguste motif not only proves significant in the final phase, it defines relationships throughout the film: the child Fellini and his mother, clowns and their ringmasters, a group of irreverent boys and a stationmaster, and so on. In terms of my preceding analysis, however, the most important white clown-Auguste division is psychological and aesthetic: the split between Fellini's rational and imaginative tendencies, reflected in the tension between documentary research and imaginative vision. Documentary is presented largely as an attempt to impose categorical meaning on what was once a living art, and the principal embodiment of documentary/ historical consciousness—Tristan Remy—is a white clown in the extreme; pompous, judgmental, absolutist. Imaginative activity, on the other hand, is associated with the rebellious, irrational, and inexplicable. (None of the spontaneous vignettes emerges from authorial control on the part of Fellini, the director-within-the-film.) In the final phase, what appears to be imaginative creation becomes associated with mechanical contrivance because Fellini, even as a creator of fiction, remains "The Director" and hence a white clown. As such, he is subject to "Augustan" ridicule. As soon as he appears, the special effects misfire. And when he and a journalist commence to discuss the profound meaning of his fictional extravaganza, they both get buckets over their heads. (**Figure 7.3**) In the end, he must disappear, giving way to Fumagalli.

Yet the split between rational and imaginative, documentary and fiction, fails to remain absolute. Though Fellini disappears, another white-clown, Fru-Fru, does appear, and the film ends in equality. (In fact, we can also see the final scene

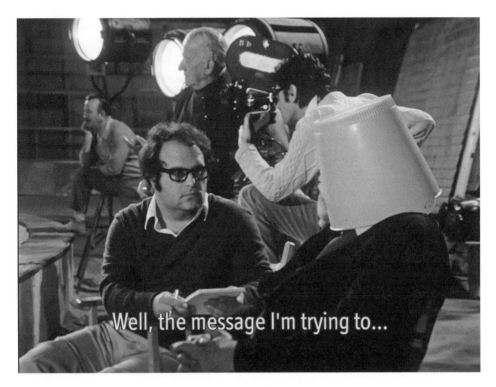

FIGURE 7.3 Fellini the "metadirector" subverts rational analysis of his film with a genial "killing of the head," as his character—and shortly after the journalist who wants to talk about the message of his film—get "bucketed" for trying to intellectualize imaginative activity. Source: *The Clowns* (1970), Directed by Federico Fellini. Produced by RAI Radiotelevisione Italiana, Compagnia Leone Cinematografica, Office de Radiodiffusion Télévision Française (ORTF), Bavaria Film. Frame grab captured by Frank Burke from 2011 Blu-ray version.

as a union of white-clown director Fellini and Auguste storyteller Fumagalli.) The art of the clown *does* get represented and expressed within Fellini's film, hence his documentary labors *do* bear fruit, although in a manner that ideally transcends both documentary aridity and fictional distortion. Moreover, in the final moments of the film, as narrative is born out of reality, fiction and the real become indistinguishable. The reunion of Fumagalli and Fru-Fru conveys something "truer than true": not the facticity of the clown but the imaginative fecundity of the white clown-Auguste reunion.

Much of the preceding should help confirm the fact that *The Clowns* is far more about the individuation of art than of character. A brief comparison with 8½ offers further confirmation. Whereas the latter spends a great deal of time on Guido's self-scrutiny and spiritual development, *The Clowns* does none of this

with Fellini. In effect, *8½* is the portrait of a man who is also an artist, while *The Clowns* is the portrait of neither a man nor an artist—only an artwork. (In the latter, even childhood memories are important only insofar as they "explain" an adult quest to make a film.) Though *8½* may leave the realm of personal individuation behind for the circus ring in the final moments, it does so only having pushed that process of individuation to its limits. All of *The Clowns,* in a sense, takes place in the circus ring. Its concerns and crises are entirely those of representation (for example, documentary versus fiction) rather than of life.

As a film about art and representation, *The Clowns* becomes, like *Juliet of the Spirits,* a truly conflicted film in terms of authenticity. On the one hand, it seems to seek the truer than true in a flight from abstraction to a world of creative imagination in harmony with a transformed real. On the other, by enacting only the reproduction of art (the clown, the white clown-Auguste motif), it calls into question the status of originality, effectively casting its lot with preexisting cultural forms as the only ground from which it can operate. The struggle between authenticity and reproduction will resurface in *Roma* as Fellini seeks to construct a true vision of the Eternal City from preexisting cultural materials, but from *Amarcord* on, Fellini's work will, for the most part, become resigned to the fact that all artistic production is reproduction and that authenticity itself is a symbolic, cultural, construct.

NOTES

1. I am indebted to W.R. Robinson for pointing out the issue of regeneration in *Fellini-Satyricon.*

2. For an intensely auteurist version of the following, see my "The Three-Phase Process and the White Clown-Auguste Relationship in Fellini's *The Clowns,*" *1977 Film Studies Annual: Part 1. Explorations in National Cinemas* (Pleasantville, N.Y.: Redgrave, 1977), 124–42. See also Prats, "Plasticity and Narrative Methods: *The Clowns,*" *The Autonomous Image: Cinematic Narration and Humanism,* 122–52. For yet another extensive discussion of the film, see William J. Free, "Fellini's *I Clowns* and the Grotesque," in *Federico Fellini: Essays in Criticism,* 188–201.

3. Fumagalli, an Auguste, also removes himself from the action during the rebellion, but unlike the white clown figures, he remains intimately involved as a spectator, cheering on the resurrection of Fischietto.

8

Art and Individuality Dissolved: *Roma, Amarcord,* and *Orchestra Rehearsal*

The films addressed in this chapter complete the movement from enlightened individualism and films about film and art to postmodernist expression as I outlined it in Chapter l. The attempt to formulate experience in terms of unity and singleness of being on the level of either the individual (*Nights of Cabiria, 8½,* and *Juliet of the Spirits*) or the artwork *(8½* to a certain extent and especially *The Clowns*) is abandoned. Fragmentation and multiplicity begin to dominate, and the self-determining individual is replaced by culturally constructed systems. This in turn entails a shift from art (individually authored autonomous objects) to signification (culturally produced, endlessly intertextual codes and systems of meanings). As this occurs, representation loses its lingering modernist relation to a real and becomes, instead, a play of absences—of meanings constructed in relation to one another rather than in relation to a referenceable world "outside." The increasingly arbitrary play of signification also means that Fellini films become ever more susceptible to multiple readings. Fellini's texts become more "porous," inviting one to read in and around them, rather than following a narrative line or argument from beginning to end. This will be my strategy here with *Roma* and *Orchestra Rehearsal* and, in ensuing chapters, with *Fellini's Casanova, And the Ship Sails On,* and *Intervista.* Certain films

Amarcord, Ginger and Fred, and *The Voice of the Moon* still also require a degree of more conventional narrative analysis, consistent with the fact that Fellini films never completely abandon a commitment to sequential storytelling.

Roma

Like *Fellini: A Director's Notebook* and *The Clowns, Roma* (1972) is a documentary of sorts, starring Fellini as director-protagonist. And like *The Clowns,* it appears to be an exploration of the creative process leading to imaginative synthesis. Seen in this way, *Roma* traces Fellini's relationship—as child, young adult,

and film director—to a host of experiences and symbols associated with Rome, a relationship that culminates in the final moments with a motorcycle "ballet" through and beyond the Eternal City. This elaborate movement, which circles all the major monuments before exiting onto the Via Cristoforo Columbo, seems to forge a dynamic unity of space and time, past and present, humanity and technology—in short, all or many of the principal tensions explored throughout the film. However, as Fellini-focused and unitive as the film initially appears, a close reading suggests that both Fellini and narrative unity are subjected to a process of radical dissemination or, in the terminology of poststructuralism, *différance*, in which meaning works centrifugally rather than becoming organized around a center (that is, either artist or artwork). So much so, in fact, that *Roma*, as city and film, ultimately comes to represent dissemination/*différance* itself, in effect reversing the trajectory of aesthetic "gathering" and integration that characterized *The Clowns*.

In a compelling analysis of *Roma*,[1] Walter C. Foreman, Jr., analyzes the film in relation to two basic themes found in myth and epic: the founding of a city and the search for a center, with the former implying the latter, as the city functions as a center. These themes, Foreman argues, are uniquely dynamized in *Roma* in that Rome is founded through moving images, not through the establishment of political authority. As a result, a center is never attained. "Roma" comes to embody only the journey toward then away from the center, rather than a moment of attainment and final grounding. As Foreman points out, the cinematic or aesthetic equivalent of the center sought within the film is the documentary or "portrait" of Rome that Fellini, as artist-protagonist, sets out to create. And because Rome fails to materialize as a fixed entity, so does the documentary/portrait. (**Figures 8.1–8.4**)

Of course, as we have seen in *The Clowns*, the failure of a documentary does not necessarily mean the failure of the film—or art—as a whole. In fact, as in *The Clowns*, documentary can be seen as a principally rational activity that gets in the way of the more authentic imaginative work of art-making. Moreover, we seem to have a moment of artistic fulfillment at the end of *Roma* precisely as we had in *The Clowns*. Fellini as filmmaker and as narrative voice claims that the streets of Rome are empty, while we see motorcyclists approaching in the distance. In other words, he is "wrong" here, just as he was when he claimed his film was over following Fischietto's gimmicky resurrection in *The Clowns*. Then the cyclists, like Fumagalli in *The Clowns*, conclude the film in a more profound way than the Fellini within the film has been able to envision.

Roma, in short, seems to embody the same basic opposition found in *The Clowns*: a critique of order, completeness, and imposed meaning in terms of Fellini's inability to adequately represent his subject, yet a recuperation of the very things that prove impossible as documentary on a "more authentic" level,

FIGURE 8.1-8.4 Unattainable "centers" in *Roma*'s celebration of *différance* and dissemination: the Colosseum blocked off in a traffic jam; frescoes of an old Roman villa disappearing as they are exposed to the air and light of the present; the Pope as distant and inaccessible as is the God of institutional Catholicism; and Anna Magnani, a numinous embodiment of *romanità*, rebuffing Fellini's attempts to ensnare her in his "portrait of Rome." Source: *Roma* (1972). Directed by Federico Fellini. Produced by Ultra Film and Les Productions Artistes Associeés. Frame grab captured by Frank Burke from the 2016 Blu-ray version.

- May I ask you a question?
- No, I don't trust you. Ciao.

FIGURE 8.1-8.4 (Continued)

beyond the conscious intent and control implied by documentary filmmaking. This, of course, recapitulates the familiar romantic distinction between reason and imagination—and the simultaneous coupling of self-transcendent imaginative activity with the "creative life process." What on one level is pure contradiction (life is too varied and dynamic to allow of synthesis, but the "life process" magically unifies all) becomes, on another, the mystical truth of romantic/symbolic paradox.

Roma, however, works far more than *The Clowns* to emphasize discontinuity and thus deny overall narrative coherence. Though *The Clowns* is clearly organized around Fellini's activity and point of view, *Roma* downplays any such singleness of experience or perception. In fact, the narrator in the English version specifically warns us that "the film [we] are about to see does not have a story in the traditional sense, with ... characters you can follow from beginning to end."[2] Although our own viewing habits no doubt incline us to create one persona out of the central child figure in the provinces (circa 1930), the young adult played by Peter Gonzales (Rome, 1939), and Fellini himself (Rome, 1971), Fellini refuses to identify either the child or the young adult as himself. When the child first appears in the Italian screenplay he is referred to only as *"un ragazzino"* (a little boy), and when the young adult appears he is designated only *"un ragazzo"* (a young man). In the film the narrator is consistently vague in flashbacks, using such pronouns as "we" and "one" that avoid identifying any of the figures on screen as younger versions of the narrator himself.[3]

In the beginning English-language voice-over, the narrator does suggest that the opening scenes represent his experiences as a child. However, he never identifies any of the children we see in the early scenes as himself. The Italian version has no voice-over whatsoever at the beginning, and Fellini only added some to the English version because United Artists wanted the kinds of links Fellini was avoiding. (This is true elsewhere in the film as well.)[4] Fellini's choice of an American actor (Peter Gonzalez) to play the *"ragazzo"* further qualifies self-representation. Gonzalez's mannerisms are American rather than Italian—something that helps accentuate the young man's "out-of-placeness" his first day in Rome. The circumstances of the young man's arrival in Rome also defeat autobiography. Fellini first arrived in Rome in January 1938, not in the late spring or summer heat of 1939, and he first lived with his aunt, not at a pensione (Alpert, 130–31).

Not only are there few if any real links between the actual adult Fellini and the two younger figures, but the figures themselves lack narrative centrality. The child figure is missing from or indistinguishable within most of the scenes from 1930. The young adult is marginal to the Barafonda variety theater sequence and missing from the first two of three brothel sequences. Fellini as an adult is only in evidence sporadically in the contemporary (1971) segment of the film, and he exerts little directorial control—none for the last 45 minutes, except for a brief exchange with Anna Magnani in which his exertion is rebuffed. Near the film's end, the camera with which Fellini's documentary is presumably being made is stolen, and Fellini disappears from the screen. We do not see enough of any of the three figures to witness character development or an evolving point of view, much less comprehensive autobiographical representation.

Perhaps the most important yet most subtle way in which self-representation is undercut lies in the fact that the narrator in both the Italian and the English film versions is not Fellini (in the Italian it is famed dubber and imitator Alighiero Noschese), even though the narrator himself is presumably representing Fellini's opinions and introducing Fellini's flashbacks (hence my earlier reference to him as Fellini's "narrative voice"). This is in direct contrast to *The Clowns* and prepares for the undermining of identity and authorship in Fellini's next film, *Amarcord,* whose title translates as "I remember" but offers no single narrator or character who remembers. Not only does *Roma* fail to represent a single, unified reality, rooted in individual consciousness, it does not offer—as did *The Clowns*—a unified world that ultimately transcends individual consciousness. *Roma* offers multiple realities linkable to Rome but irresolvable into one. We witness reminiscences, personal and historical associations, cultural constructs. We see Rome in relation to three different twentieth-century periods as well as three different stages of life. Contemporary Rome is itself extremely diverse: represented by a traffic jam, tourists at the Villa Borghese, subway construction, the ecclesiastical fashion show, and the Festa de' Noantri. Not only does each sequence present a vastly different image of Rome, but unbridgeable differences surface within the sequences themselves: contemporary sexual freedom is juxtaposed with repression in the brothel flashback, engineering is at odds with archaeology in the building of the subway, and Fellini's filmmaking can satisfy neither stately old Roman conservatives nor student activists at the Villa Borghese.

The radical operation of difference in the film is dramatically symbolized when the subway excavation apparatus breaks through into an old Roman villa and the frescoes of the past are destroyed by the breath of the present. Given its proliferating juxtaposition of differences, *Roma* proves not, as the English-language narrator claims, a portrait of the Eternal City. It is, instead, a partial and inconclusive collage. Within this context, the individual functions much more as a footnote to history than a controlling consciousness that gives meaning to self and environment—and the dominance of history and culture over individual psychology is reflected in the film's title. (It is not *Fellini's Roma,* despite a common tendency to rename it thus.) The one figure who might seem to represent the control of history, Julius Caesar, is quickly demythologized by the headmaster's absurd "crossing of the Rubicon," by a town loony who makes obscene comparisons between Caesar and Mussolini, and by the pomposity of the actor who portrays him onstage. By his second "appearance," Caesar is a decayed statue named "half head," and in his third he is assassinated.

Nature is entirely rewritten by culture in *Roma.* The rock that constitutes the film's first image of Rome has the city's name and a mileage marker (km 340) inscribed on it. A trip to the countryside in the film's second sequence becomes

the Rubicon reenactment. (A stream is not a stream but a history lesson.) No longer can we have an opening sequence as in *La Strada,* where someone aligned with nature enters into culture, initiating a film-long nature/culture conflict. Concomitantly, what we might assume to be an important rite of passage within male individuation—a boy's initiation into sexuality—has little to do with biology, puberty, or individual development and everything to do with cultural power and iconography. The principal child of the opening scenes has two moments of initiation and, indicative of their status as cultural rather than biological, each involves public representations of women rather than private, direct, involvement with them. The first occurs in school as the child and his companions are subjected to a slide show. When the image of a semi-nude woman suddenly appears on screen, it does so as cultural symbol and monument: preceded and followed by a slide of "the She-Wolf of the Capitoline" (stepmother to Romulus and Remus). And although sexuality seems initially to take on the character of transgression (the image disrupts an authoritarian church-school spectacle), transgression is not an individual response to authority, as it was in such earlier Fellini films as *Juliet of the Spirits.* Instead it is programmed and conventional. When the slide appears, the camera zooms in on the young child, who reacts by grinning and jumping up and down—but only after he has been framed in close-up. It is as though the camera has positioned itself for the "expected" response, which it then automatically receives. Conformity is further indicated when the entire group of uniformed children react in exactly the same way.

The second of the child's sexualized experiences occurs as he fantasizes about the wife of the town dentist at a movie theater. Again, he is in an environment dedicated to the transmission of cultural norms. The movies we see on screen are a historical epic that represents the transition from pagan Rome to Christianity and a documentary promoting Fascism. Moreover, the dentist's wife is introduced to us as "Messalina," linking the child's imaginings with strong historical precedent. Her name and social reputation, in turn, ensure that his fantasy has far more to do with power and empowerment than with sex. (He imagines "Messalina" having sex in a car, while numerous men line up submissively outside, then he sees her dancing in a kind of self-absorbed, self-assertive frenzy while men in tunics sit passively at her feet.) Significantly, both of the women who contribute to the youth's sexual initiation are strongly associated with projection apparatus: slides and movies. As we have seen in *The Temptation of Dr. Antonio,* Fellini is fond of aligning mechanical and psychological projection: the culturally constructed and the personal. The containment of sexuality within the cultural is also implied by the age of the child (roughly 10). He is too young for "real" sex and puberty, too immature for clearly felt or articulated sexual feelings and desires, so when he *is* old enough, he will experience them as already written over with social meaning.

The cultural construction of gender in *Roma* extends beyond character to the symbolic core of the film: the gendering of Rome itself as mother, prostitute, and lover. The child's experience in the slide show and the theater clearly predisposes him to conflate the city with feminine roles and functions. More than that, Fellini's representation of childhood—both here and in films such as *8½*—suggests that the repressive-projective nature of sex and desire under Catholicism leads men to turn virtually everything into symbols of the feminine.

Accordingly, Rome takes on the quality of archetypal nurturer, ideal, undemanding mother in later phases of the film, when the young adult acts out the child's desire to escape the provinces. As Fellini put it, "[Rome] is a mother with too many children. She has no time for you, therefore does not ask you for anything, does not expect anything of you. You can come to her when you wish—she will not stop you when you are ready to go. You are made to feel like a free guest. You do what you want. . . nobody cares."[5] More specifically, Rome functions for the young adult as a world of self-gratification: eating, tourism, leisure, entertainment, and sex. He never works as far as we can tell, and, even more significant given the times, he never goes to war. (For Fellini's miraculous escape from the war, see Alpert, 43–49.) Rome is, in short, a protective womb that enables avoidance. Related to this is the ever-present Fellinian theme of prostitution—in this case, mothering for a price. Rome is subtly designated a "woman-for-pay" when Fellini enters the city in 1971 via a toll booth.

Rome is not only mother/prostitute in the film, but she is also unfathomable lover: "Rome ... has remained totally outside my film on her. ... [W]ith an air of defiance she stands aloof, even more elusive than before. And this of course makes her all the more charming and fascinating to me. She is like a woman: you feel that you have possessed her, known her . . . and then you meet her a week later, and you realize that she bears not the slightest resemblance to that person whom you thought you had made yours."[6] This switch in symbolism is occasioned by a perspective shift from the young man's experience in the city to the older Fellini's attempt to document it. For the youth, Rome appears as a (huge) external phenomenon, whereas for the middle-aged Fellini it is internal (*his* past, *his* city, *his* experience) hence potentially (re)possessable. However, even as the latter, it remains unencompassable, making even Fellini's interiority partially estranged.

If we view Fellini's words and his symbolism apart from scenes of the child's cultural conditioning, they are not only problematic, they suggest an attempt to impose a kind of conceptual unity on *Roma* that runs counter to the emphasis on difference everywhere else. If we view them as the outgrowth of that conditioning, however, they serve to undercut the very symbolism they espouse, emphasizing the extent to which it is the reproduction of convention and socialization. In fact, I think that from here on in, Fellini's work exhibits a strong tension

between his attraction toward the kind of gender symbolism and gender essentialism that appears in earlier films and throughout his interviews and the critique of that symbolism as culturally founded and—because it derives from childhood experience—profoundly immature. In fact, gender seems the point of greatest divergence between Fellini's films and his pronouncements in interviews. His later films seem far more ideologically contextualized, while his comments often reflect conventional views of gender (see especially Chandler passim).

In light of the above, the Rome of *Roma* adds up to far more than a purely personal experience for the various figures who encounter it. Rome also tends to mean something quite different for each figure, emphasizing its function as a place of difference. For the young boy, its largest signification seems to be that of adventure and escape, most graphically represented in the scene of the boy staring at the Rome-bound train. For the young adult it seems to signify a quest for belonging, as he has come to Rome a stranger from the provinces. For the adult Fellini, it is an object of inquiry that proves. like clowns in his preceding film, resistant to mastery. It is also the past, which makes it "not here" and possibly "nowhere," though in a far different way than for the child.

Not only is Rome a melange of unsynthesized differences, but Fellini's *film* of Rome becomes a place where cinematic conventions and forms collide. *Roma* pretends to be both autobiography and documentary—an impossible mixture of subjectivity and objectivity—while ultimately being neither. It further blurs the boundaries between subjective and objective (truth and illusion) by mixing documentary, re-creation (the documentation of memories), and blatant invention (for instance, the ecclesiastical fashion show). Scenes that begin in a documentary mode become downright surrealistic (the traffic jam, whose ring road, the Grande Raccordo Annulare, was not shot on location but reconstructed at Cinecittà). And scenes that seem to be unscripted[7] on-the-spot reporting turn out to be clearly orchestrated symbolic statements (for instance, the subway sequence). The frequent contradictions between authorial effacement and intrusion are often quite subtly accented. The Festa de' Noantri sequence begins visually as direct cinema (the camera seems merely to be catching events as they happen), while on the soundtrack we can catch the narrator's voice intoning "one, two, three," cuing a singing group that then provides a clearly scripted musical accompaniment.

There are even more blatant contradictions. Not only is the narrator who presumably voices the opinions of Fellini not Fellini, but he seems either an inveterate prevaricator or downright blind to what is going on in "his" film (see Foreman, 89ff). He promises a portrait, yet *Roma* provides no such thing. He claims at the Festa de' Noentri that "Italians celebrate themselves," while there are so many non-Italians present that, as Foreman puts it, "the Romans' feast of themselves seems almost ... a feast of everyone else" (Foreman, 84). He describes the Festa

as "not much different from ... the beginning of this picture," whereas the differences between this street sequence and that of 1939, especially in terms of internationalization, are huge. The most blatant "lie" occurs just prior to the final sequence, when he claims, "there is nobody around," and we can clearly see the motorcyclists approaching.

To further complicate things, the narrator's voice becomes Fellini's for the only time in the film when Anna Magnani appears. Moreover, while Fellini speaks to *us* as a *narrator* ("This lady ... walking along the wall of a patrician palazzo, is a Roman actress, Anna Magnani. She could very well be the living symbol of this city"), Magnani treats him as a *character in the scene,* responding to his words with a question ("You think so?"), thus turning his voice-over into dialogue. Because the manipulation and unreliability of authorial voice peak in this scene, it seems more than fitting that Magnani respond to Fellini's request for a more extended conversation with "No, I'm sorry, I don't trust you."

Much of the analysis of cinematic codes and of the relationship of cinema to the real recalls earlier Fellini work, yet with significant differences. *Marriage Agency* and *La Dolce Vita* were, in many ways, critiques of journalism and documentary—the former in particular serving as a parody of hardline neorealism. The basis of this critique, however, lies in a strong subjectivist and individualistic bias: there is no objective truth, but there is individual perspective, personal truth. In *Roma,* I would suggest, there is no subjectivist stance to offset the objectivist illusions of documentary, as subject and object alike are constructed within cultural codes and meanings. Similarly, *The Temptation of Dr. Antonio* used mediation and cinema (particularly the psycho-cinematic symbolism of projection) to represent an increasing gap between fantasy and reality—a "gap" obviated in *Roma,* as "reality" is just as much a construction or fabrication as "fantasy."

As *Roma* deconstructs simple meaning and straightforward cinematic coding, the film obviously renounces Fellini's earlier seeming quest for unmediated fullness of being. However, as with the best of postmodern work, emphasis on the arbitrariness of coding and signification does not descend into meaningless. The documentary aspect of *Roma* is not completely undermined; it is contextualized as one among several operative dimensions in the film's creation of meaning. Moreover, the film's more clearly fabricated moments (including even the ecclesiastical fashion show) have their own kind of persuasiveness as representations of a Rome that may not be real in a conventional, documentable sense but that nonetheless provide access to multiple significant discourses of culture, history, and contemporary Italian society. *Roma's* undermining of simple referentiality is not merely cynical but rather an opening out of interpretive possibility. The result is a more complex, and ultimately more "realistic," response to experience, art,

and culture: "neo-neorealism," with all the ironies that must now attend the term "realism."

The indeterminacy of meaning in *Roma* is linked to one of the principal themes associated with the city: desire. *Roma* defeats the commonsensical view of desire as the property of individuals, clearly identifiable in terms of needs and goals. In *Roma* desire is, like everything else, systemic and dispersed: it emerges more from a cultural environment than from individuals and is the product of so many conflicting influences that it can never be simply defined or fulfilled.[8] Moreover, the experience of desire is that of always wanting to be somewhere else, hence it is a "no place," a relationship between here and there, an absence or lack rather than a presence or substance. Related to its fundamental "negativity," desire in *Roma* is usually based on interdiction. The narrator implies this in discussing visits to the brothels: "everywhere the sound of bells followed us. They even chased us inside as a warning, a [recrimination],[9] but also as an invitation to sin, a sin that we could then go and confess the next day." Desire grounded in interdiction can never satisfy, given its link to guilt, hence it merely sets in motion a cycle of desire, transgression, guilt, atonement, more desire, transgression, guilt, and so on.

This condition of desire inevitably unfulfilled is reflected in the representation of women in *Roma*. The figure in the school slide show has her back(side) to the schoolboys. "Messalina" (the dentist's wife) becomes remote and self-absorbed in her dance of power. A prostitute on the Appian Way is forbidding in size and ends up turned away from the camera eye (arguably the point of view of the "Fellini" youth his first evening in Rome). Even the dark-haired woman the youth pursues at the brothel ends up at an open window on the other side of the room by the end of their scene together. Finally, Anna Magnani, whom Fellini courts as a totalizing symbol of Rome, shuts the door on him, turning away even more emphatically than prior women in the film.

This emphasis on remoteness helps explain, at least in part, the seeming obsession in Fellini's later films with women's derrieres. Because women, as the embodiment of male desire, are inevitably inaccessible, men can only approach them (with awe, fear, fascination, and so on) "from behind." What in some respects seems a highly sexist and demeaning view of women becomes, in another respect, a revealing representation of masculine desire, especially in a prohibitive Italian-Catholic context.

The issue of inaccessibility relates not only to women but to all objects of desire, linking up with Foreman's discussion of the recurrent unfulfilled search for a center. Accordingly, the attempt to move into Rome in the first contemporary (1971) sequence ends up stalled in a traffic jam outside the city's principal (and significantly walled-in) archaeological center: the Colosseum. Another archaeological center, the old patrician villa beneath the subway excavations, effectively

disappears into thin air at the moment of contact. Rome itself, as Foreman and I have noted, is a center that never gets "founded" or documented on film. What *does* get documented instead is the *play* of desire or, in Foreman's terms, the movement toward and away from a center.

The final sequence of *Roma* helps (re)define all the film's crucial issues. At the same time, it helps situate the film's position at the crossroads between the preceding Fellini films of increasingly problematic wholeness, authenticity, and originality and his more recent films of fragmentation, repetition, and seemingly endless cultural reproduction. In terms of the former, the sequence offers a unitive summation characteristic of the endings of *The Clowns, Nights of Cabiria,* and, at least in Guido's circle of reunion, *8½,* In addition to embracing the principal monuments of Rome and fusing space and time, present and present, humanity and technology, the motorcyclists encompass the feminine (women cyclists as well as circular motion) and the masculine (men plus phallic or linear thrust); "found" documentary (the cyclists just happen on the scene) and scripted, directed fiction (their movement is clearly choreographed); settlement (that is, community) and adventure (community-on-the-move); and uniformity (helmets and shared activity) and individuality (each cyclist is distinguishable from the others).

The sequence also has the quality of a revelation, linking it to Fumagalli's tale at the end of *The Clowns* and the heightened reality of the final scenes of *Nights of Cabiria* and *8½.* It is the kind of event that Fellini has claimed will occasionally disrupt quotidian life in Rome: "suddenly an explosion of light will illuminate [Rome's] battered space, and if you are not frightened you will be comforted and sense a profound peace, a widening of consciousness. It is a unique experience, a Roman experience" (quoted in Krim, 37). Yet the very status of the sequence as epiphany—as sudden, irrational, unmotivated event—undercuts its promise as summation. To the extent that the cycle ballet provides a moment of fusion, affirmation, and revelation, it does so as a fundamental "difference" from all that has preceded. It is not, as in *Nights of Cabiria* and *The Clowns,* the culmination of a coherent, purposeful unfolding.

Consistent with this, the final scenes of films such as *8½* and *The Clowns* are coded in such a way as to ensure that we perceive them as imaginative rather than real. For example, Guido's spirits are at least initially transformed by white, and Fru-Fru is "magically" dissolved into the scene—and in each case the transformation of reality into imagination has been building throughout the film. In *Roma,* however, there is no such clear coding. The cyclists appear from nowhere, yet they appear to be real figures cycling into the very real landscape of late-night Rome. What we have is a conflict of codes—fiction and documentary—that have been in contestation throughout the film. Moreover, the codes are juxtaposed in such a way that we have no resolution or fusion. The shift from evolution to juxtaposition also

affects the role of authorial effacement, as we compare *Roma* to *The Clowns*. In the latter, as we have noted, the film concludes with a kind of transcendent creative force replacing Fellini-the-director and bringing the film to a close, as the culmination of a film-long evolutionary process. In *Roma*, with evolutionary process eliminated, we have only the foregrounding of contradictory authorial codes. On the one hand, Fellini and the narrator vacate the film by claiming no knowledge of the cyclists, no relation to what is going on. On the other, we have a sequence whose coherence, aesthetic power, and clear constructedness cry out "Author, Author." Because there is no transcendent imagination (as in *The Clowns*) to answer this cry, we are stuck with Fellini, and codes of his effacement remain locked in equal battle with codes of his presence.

The emphasis is again on "difference" versus singleness or unity, and difference is quite strikingly evidenced in the commitment to motion. Once the cyclists appear and catch the camera eye up in their journey, there is a not a single still image for the remaining three and a half minutes of the film. The dynamism of this cinematic passage prompted noted French filmmaker Alain Resnais to exclaim, "Nothing like it has ever been seen in the cinema" (Alpert, 235). Either the camera is capturing the thunderous movement of the cycles, or it is moving with them, harnessing their headlights to transform the statues and monuments of Rome into a dance of light and shadow. The result is a relentless unsettling of the city, as everything is de- and recontextualized spatially, temporally, and conceptually. The city/center is, as Foreman has argued, "un-founded," turned wholly from metropolis into moving image. The relentless movement and un-founding begets an unceasing differing and deferring as one thing becomes another becomes another in a journey and process without end. The movie ends, but the cyclists' motion, as we see it, does not.

There is also a strong assertion of difference on the level of association. Perhaps most important, the motorcycle ballet is simultaneously utopic and dystopic. These youths who seem to signal a new relation to Rome as well as a movement beyond also evoke comparison with the Vandals and Visigoths who sacked the Eternal City. Their uniformity and bikes recall Fascists from other Fellini films, including one especially ludicrous military figure in *The Clowns* who zooms about in a motorcycle with a sidecar. Their helmets even recall the cops who just three minutes earlier beat up on hippies at the Festa de' Noantri. The roar of their bikes, I have discovered, proves exhilarating to some (myself included) and off-putting to others. Problematic associations are exacerbated, not resolved, as the bikers leave Rome behind and select as their route the Via Cristoforo Colombo. On the one hand, the road's name implies the movement toward a new world with all the promise and hope such a world presumably portends. On the other, Columbus invokes not just discovery but European imperialism, and the road leads to the

EUR district of Rome, built by the Fascists as a monument to their power—and to the mythology of power so integral to the myths of Roman/Italian adventure and discovery. As the bikers exit on to the Via Cristoforo Colombo, it is well past midnight. We might in fact surmise that we are getting quite close to dawn. However, the dawn has not arrived, and as *Roma* comes to an end it offers not the upbeat palliatives of classic narrative and some of Fellini's preceding films but rather a troubling final question: Are we moving toward the light of a new and enabling day or merely continuing our journey in the darkness?

Amarcord

While *Roma* takes Fellini's adult home as its point of departure, *Amarcord* (1973) returns to the provincial world of Fellini's youth and the kind of town we saw represented in *I Vitelloni* 20 years earlier. With its foregrounding of Fascism, *Amarcord* would seem to suggest the latter response to the question posed at the end of *Roma*. Certainly, the film marks a point at which the affirmative potential of Fellini's preceding films disappears.

Like so many of Fellini's films, *Amarcord* points backwards as well as forwards both formally and thematically. It suggests the kind of thematic and narrative unity present in pre-*Roma* films, and while its renunciation of creative unity makes it a "late" film, its renunciation is accompanied by sadness and nostalgia rather than the resignation or ironic critique that mark many of Fellini's final films. *Amarcord's* tone of sadness is clearest in the concluding sequences: Miranda's death and funeral and even Gradisca's wedding celebration. A sense loss is built into the narrative process, particularly as it is framed by the first and last social gatherings in the film: the burning of the witch of winter and the wedding party. The first takes place in the center of town and has a single unifying activity that, despite frequent divergences, focuses everyone's energy. There is a strong sense of participation, a sense of promise (the end of winter/the coming of spring), and a sense of ritual in complicity with nature. Though the sequence offers some indication of negative things to come, we get the general impression of a community with at least some common purpose and a great capacity for fun. Moreover, there is a potential protagonist, the adolescent Titta, who is alert, active, and independent.

In contrast, the final gathering takes place in a barren field on the outskirts of town, where nature seems dead and alien rather than promising and complicit. A much smaller percentage of the town is gathered, and the sequence presents not the wedding (that is, the coming together) but the aftermath, which, despite moments of unity, is largely disjointed. The wedding itself is presented as a source of rupture, taking Gradisca away from the town. Community breakdown

is poignantly represented when Gradisca throws her bouquet and it drops unceremoniously (in the fullest sense) to the ground. Titta is alienated, intoxicated, and marginal, relating to neither Gradisca nor his friends and showing none of his earlier capacity for adventure.

One of the clearest aspects of fragmentation in *Amarcord* lies in its multiple voices. Though Titta is arguably the film's most important figure, he is only one of several narrators, his voice-over is insignificant, he is missing from far more scenes than Encolpio in *Fellini-Satyricon,* and the film is rarely organized around his point of view. In fact, in terms of its multiple, discontinuous, and flawed narrators, *Amarcord* puts the lie to its own name. The title, in Romagnolo dialect, means "I remember,"[10] but there *is* no "I" who remembers, a "prevarication" that only draws attention to the absence of a single, organizing, intelligence.

Amarcord achieves its rather somber ending through what I perceive as a four-part progression reflecting a partial return to the narrative coherence of earlier Fellini films: (1) relative social cohesion marked by events within the town, (2) increasing disunity and reliance on external forces, marked by a movement outside the town, (3) return to a town that has lost all internal cohesion and meaning, and (4) a concluding state of exile (or "eviction" or "evacuation," to use terms that apply elsewhere in Fellini's work). One of the central issues of the film, harkening back to earlier Fellini films of failed individuation, is the absence or death of consciousness, particularly reflected in the problematic idealization of women.

Relative cohesion

At the beginning, as the burning of the witch of winter would suggest, *Amarcord* focuses on events and institutions central to the community: seasonal ritual, school, work, and Titta's family. Though this might imply a good deal of conformity, there is also a great deal of rebelliousness. The latter makes for wonderful comedy in the school scenes and even in the home, where we discover that Titta has pissed on the hat of a local dignitary—no doubt an affront to the dignitary himself, but even more so, from what we see, to Titta's father. All this begins to change with the film's second evening gathering, which lacks a unifying event such as the witch-burning. The only thing that unites people in the course of the sequence is the arrival of the newest contingent of prostitutes who parade down the main street in a carriage. As the townspeople line the sidewalks to observe and in some cases ogle, participation gives way to witnessing, internally motivated activity to motivation from outside.

Of course, motivation from without has been evident from the opening scene, as the "puffs"—the swirling, floating seeds of springtime—occupy everyone's attention and even control the narrative, ushering the camera eye from Titta's house

to the town square to the cemetery to the Grand Hotel. Moreover, fragmentation surfaces even during the witch of winter celebration, not only in conflicts among participants but in the clear division of society into middle class, aristocracy, school and military authorities, and outcasts (especially Volpina and a mystery motorcyclist). The opening sequences also reveal a society partitioned into play and work (the latter with its own labor-management partition), school and home. Home and family, in turn, quickly become the site of extreme (though hilarious) argument.

Absent from the start is anything resembling creative intelligence. The first narrator we encounter, Giudizio, is inarticulate in the extreme, having difficulty even repeating a simple rhyme associated with the puffs. The second, the town lawyer, is a virtual parody of intelligence with his pedantic recitation of boring facts that merits an understandable anti-intellectualism from unseen hecklers. The critique of intelligence continues at school, where students have to suffer through a disjointed curriculum in which they nod their heads in unison to the "tick tock" of a pendulum, mindlessly repeat the phrase "pro-spet-tiva" ("perspective"),[11] and recite meaningless facts and phrases on demand. Unable to exercize creative intelligence and self-expression in school, people turn to fantasy. Ciccio writes poetry to the unattainable Aldina; Titta wonders what is going on by the sea. While in such films as Nights of Cabiria and 8½ fantasy provided characters with a heightened sense of their own reality, in Amarcord it serves only to create a world apart.

A turning point seems to be the confession sequence, introduced by a brief scene of a group of boys, standing in a downpour, contemplating the naked behind of the statue Vittoria (Victory). The statue itself suggests a serious confusion in terms of the real: a representation of female sexuality serves as a monument to war. (The fact that this kind of conflation is highly conventional does not make it any less confused.) Moreover, the boys are positioned behind "her," indicating a withdrawal from any direct encounter with women or even their representations. This is the first sustained instance in the film of women reduced to body parts, and it is also part of the growing derriere mentality in Fellini's work, constructing women as inaccessible. The confession scene highlights the double operation of institutional repression and privatized fantasy. Titta responds to the priest's questions about masturbation by narrating to us or at least himself a series of obsessive thoughts that he does *not* confess. Then Candela's confession details four boys in a closed garage getting into a car, shutting their eyes, and masturbating to their separate fantasies of local sex objects. The closed, secretive, and isolate nature of this activity contrasts sharply with the large social gatherings of earlier scenes.

The lack of internal unity or meaning plus the growing urge to fantasize lead to the emergence of Fascism as the dominant, external, wish-fulfillment mechanism for the town. In fact, Fascism replaces the idealization of women in a manner that suggests the strong interplay of sexuality, repression, idealization, dependency,

and power. For Fellini's Italian Catholic males, women are physically unattainable for both religious and psychological reasons, hence desire is frustrated—and a continual reminder of powerlessness. Desire gets deflected into the creation of ideals or the reduction of women to fetishized objects, both of which allow for a disavowal of lack[12] as the strength of the obsession masks the anxiety that has generated it. This also allows for aggressive, though usually symbolic, assertions of power over women (for instance, the scapegoating of the witch of winter). Ultimately, the need for power displaces sexual desire altogether, and male relationships, male power systems (in this case Fascism), come to take over for sexual pursuit or the idealization of women. Accordingly, in terms of narrative substitution, the arrival of the Fascist leader, Il Federale, replaces the earlier arrival of the prostitutes, and the veneration of the Fascists replaces the ogling of both the prostitutes and *Vittoria*.

Women within this male-dominant system are powerless on their own and conditioned to acquire power through male authorities. Gradisca is attentive to the admiring gaze of the local Fascist dignitary, Il Gerarca; excited to the point of frenzy by the arrival of Il Federale; and willing to serve as the town's sexual offering to the Prince (hence her nickname Gradisca, which can be translated "do what you like with me"). Moreover, she, like the Fascists, is always in a uniform, signifying her enlistment in a male social and psychological order. By day she wears the white clinical garb of the hairdresser, by night the seductive red overcoat of the town siren. In the last scene her hairdresser's uniform has become a bridal one, through which she declares her eternal love to another uniform: that of the absurd policeman (*carabiniere*) whose conjugal toast is not to Gradisca but to the Patria: "Viva l'Italia!"

Consistent with all this, Gradisca idealizes not only Fascists but the prostitutes who ride through town, seeing in them an appropriate model of service to men. And the prostitutes, in turn, highlight the complicated position of women within the town and Italian Catholicism: simultaneously condemned and valorized for their sexuality, as their sexuality becomes conflated with mothering. The visual paradox *Amarcord* offers in the second evening sequence—store-window madonnas juxtaposed with the arrival of prostitutes—proves not so paradoxical after all, as the "fallen woman" can also be "ministering angel" or saint in the contorted Catholic logic of the feminine.

In the course of all this, women, idealization, and ultimately Fascism all come to operate as spectacle and, more to the point, spectacle as the realm of *missing* power. Because women cannot exist physically or immediately for men (that is, as partners), they exist purely as visual objects. (Gradisca is turned into spectacle in her very first appearance: introduced beside a curtain then wiggling her derriere as a barber plays a flute.) As such, they are invested with enormous symbolic power.[13]

191

However, this power does not *belong to* them, as it is projected. And it ultimately makes men feel powerless, as it is larger than life. Once spectacle is discovered by men to be a place of power, they must usurp it—precisely the role played by Fascism with its massive parade and speeches accompanying Il Federale and the huge flowered mosaic of Mussolini.

Though Fascism is initially presented as an instrument of unity, gathering all the town under its sway, its arrival quickly prompts dissent, in the form of gunfire in the town square. An ensuing inquisition then causes a major rupture in Titta's family. Aurelio (the father) is force-fed castor oil, returns home humiliated, loses dignity in the eyes of Titta, and denounces Lallo (his brother-in-law) as the one who turned him in. This is the last time we see the entire family together.

Exodus

Following the community breakdown of the Fascist sequences, the town disappears, and its inhabitants become "exiled" in fantasy. Though there is a seeming return to women and to sexuality, both exist at a great distance from the real and purely on a level of manipulation and exploitation. First there is the Grand Hotel, the realm of transience and exotic dreams for the locals. Two of the three sequences here are at a double fictional remove from actuality: the story of Gradisca and the Prince is presented as town mythology, retold by the lawyer; the story of Pinwheel and the harem, which turns into a Busby Berkeley extravaganza, is the lawyer's retelling of Pinwheel's tale. The lawyer, who previously had been concerned only with "facts" and history, now resorts to gossip—even admitting that he doubts the truth of the Gradisca and Pinwheel stories.

Within this realm of fantasy and gossip, we witness the civic prostitution of Gradisca, as she is offered as a sexual gift by the town to the Prince. This not only emphasizes the objectification of women within a male power system, but it suggests the town's lack of self-respect and loss of grounding in the aftermath of Fascism, as it cheapens its most revered object of worship to get recognition from outside. (Fascism, unlike the Prince, had some roots within the town through town members such as the Gerarca.) Exploitation of women is, of course, also a factor in Pinwheel's harem tale, not only on the part of the sheik but on the part of both Pinwheel and the lawyer, narratively using the exotic notion of women-enslaved to amuse their audiences. For Titta, the joint problems of desire and the unattainability of women surface in the final episode at the Grand Hotel, as he and his friends can be no more than voyeurs, spying not even on women, but on the older male generation in its pursuit of female tourists.

Following the Grand Hotel, Titta and some members of his family pick Uncle Teo up at an insane asylum and drive out to an old family farm. Rather than

feeling at home and back in touch with its roots, the family is uncomfortable and out of place. In addition, they can now be united only by leaving home—and by a figure marginal to the family and a madman to boot. Teo's mental disorder reflects the extent to which intelligence is fragmented and ultimately ineffectual in the film. He focuses with enormous intensity on one thing (a stone, an egg, the turning wheel of the carriage), disregarding all else. He can answer nature's call to urinate, but he can't remember to unzip his pants. The intensity of his relation to real objects is, in fact, fetishization. Ultimately, of course, Teo fails to bring or keep the family together. When he climbs a tree and pleads *voglio una donna* ("I want a woman"), Aurelio loses control (as always), and the group ends up in disarray.

Teo's insistent pleas juxtapose yet again the crucial issues of woman, impossible desire, and power. Because there is no conceivable referent for Teo's demands, woman occupies the position of absolute absence and (consequently) absolute power. The more inaccessible She is, the more insistently She is needed—but purely as abstraction. On the other hand, Teo may merely be game-playing, *simulating* desire. In this case woman is erased altogether. If woman as signifier is detached from woman as physical presence or possibility, "*una donna*" can even become equated with male power. Accordingly, Teo concludes his presence in the film completely submissive to a domineering, foul-mouthed, midget nun (Teo does get his "*donna*" after all) summoned from the asylum and representative of male religious and medical institutions.

The externalization of power and town desire, as well as the expression of desire through male symbols, becomes clear in the pilgrimage to witness the passing of the grand ocean liner, the *Rex*. The arrival of the *Rex* corresponds to the earlier arrival of the prostitutes, then the Fascists, and this middle section of the film (Grand Hotel, Uncle Teo, *Rex*) recapitulates an earlier movement from the idealization of female sexuality to the veneration of male power, although, as has already been suggested, the position of women is far more compromised here than earlier in the film.

The *Rex* also completes a movement to increasingly dissociated institutions: from the Grand Hotel (transient home, but at least related to the town) to Teo's asylum (home for the permanently displaced, unrelated to town) to a floating hotel that merely passes by somewhere out in the ocean. Consistent with this, *Amarcord* has moved from town rituals to national symbology (Fascism) to an event that represents the national projected out on to the international. Although the *Rex* was built in Italy as a kind of advertisement for Fascism, the film emphasizes not its indigenous origins but the fact that it has come from America. Unlike the burning of the witch or even the Fascist parade, the *Rex* offers spectacle without participation.

Return to dis-integration

The journey out to sea is the last attempt to mobilize the entire community in the film. And though the film moves back to town, the return home is really a return to the death of town, community, and relatedness. In the scene immediately following the passing of the *Rex,* a dense fog envelops everyone. Titta's grandfather steps out the front door and cannot find his way home. He cannot even see his own grandchild (Titta's brother) who is on his way to school. The grandfather imagines himself dead, which, along with the progression of the seasons from spring to summer and now to fall, indicates that the world of the film has moved toward ends rather than beginnings.

In the fog, Titta and his friends gather by the Grand Hotel. Finding it deserted (tourist season is over), each begins to dance or pretend to play a musical instrument, separately but in synch with the soundtrack music. This group fantasizing recalls the masturbation scene, but here there are no female referents for the fantasy. Each youth is lost in private reverie, and specific objects of desire remain unnamed. In effect, the inner lives of the boys, so vividly expressed during the confession/masturbation sequence, remain as empty as the lobby of the Grand Hotel. The fact that the soundtrack—the "source" or "motivation" of their activity—is entirely external to the scene, suggests how fully they dance to the tune of an external "drummer."

The growing impossibility of healthy idealization, especially in regard to women, is crystallized in Titta's encounter with the tobacconist. In fact, the tobacconist represents the *collapse* of idealization, the return to an overwhelming immediacy devoid of conscious distance and conceptualization. The banging of the tobacconist's head on the hanging lamp, the consequent wild fluctuations in light, the poster of a man with the top of his head missing, and the repeated use of the word *pazzo* or "crazy" all constitute typical Fellinian symbology of absent or dissolving consciousness. Moreover, Titta's experience is marked by sheer physicality in terms not only of the tobacconist's size but his attempts to prove how strong he is. Ultimately, the sequence becomes a parody of infantile needs without any of the complexity that marked Titta's idealization of Gradisca, as he is virtually smothered by the tobacconist's plenitudinous breasts. At the end of the sequence Titta is rudely expelled from the mock-maternal environment of the tobacco shop only to revert to dependence on his mother, who must nurture him through a delirium that makes quite explicit his diminished consciousness. The regressive nature of his behavior is underscored when Miranda insists that he is still a boy in "short pants."

Isolation is a major component in both the tobacconist sequence and the scene between Titta and his mother. The tobacconist verbalizes her own isolation, in her repeated insistence that she is "closed," and the town to which the film returns

following the *Rex* is, as the fog sequence immediately reveals, itself closed—not just to an outside world but within itself. With the arrival of a record snowfall, the town square is turned into a labyrinth of snow-banked corridors. The earlier gathering place of the community becomes entirely a space of non- or miscommunication. Titta spots Gradisca in one of the corridors, only to lose her. **(Figure 8.5)** The lawyer begins to narrate the history of town snowfalls, only to get bombarded into submission by an unidentifiable antagonist. And the mystery cyclist twice drives Titta into snowbanks, compounding his futile search for Gradisca. The cyclist, with no concrete ties to the town, seems to represent a kind of radical disconnectedness, in contrast to the community of night riders we saw at the end of *Roma*. The seeming alienation of the biker recalls another cyclist-powered Fellini figure: Zampanò.

The loss of active and meaningful idealization is reflected in the fact that Titta no longer plans or initiates pursuit of Gradisca; he only responds when she is physically present. Gradisca in turn becomes an object of town abuse rather than veneration when she becomes the principal target in a snowball fight. The prior fascination with women, Fascists, and the Rex becomes abuse—coupled with passive wonder at a huge (male) peacock who happens onto the scene in the midst of the fight.

Titta's failure to individuate in the course of *Amarcord* becomes clear from the scenes leading up to and including his mother's death. Ill in the hospital, sensing

FIGURE 8.5 Gradisca and Titta remain separated in the snow "tunnels" that reflect the breakdown of interconnectedness and community as *Amarcord* unfolds. Source: *Amarcord* (1973). Directed by Federico Fellini. Produced by FC Produzioni, PECF. Frame grab captured by Frank Burke from 2007 DVD version.

her imminent death, and trying to get Titta to take responsibility for himself, Miranda proclaims, "You're a man now." This directly contradicts her "short pants" remark just a couple of sequences prior and suggests an attempt to confer adulthood on him by proclamation, in the absence of his attaining it himself. The impossibility of this is revealed when Titta locks himself in Miranda's room and stamps his foot in childish anger on hearing of her death.

Dénouement and dissolution

Miranda's death ushers in a concluding period of exile. Titta's grandfather is banished to a farm, the funeral sequence moves from home to church to a road en route to the cemetery, a post-funeral scene concludes with Titta alone on the pier, and the film's final sequence takes place in a field with no definable relation to town, or to anything prior in the film. I have already discussed the final sequence in terms of family and town dissolution and the absence of initiative on the part of Titta. Perhaps the most distinctive aspect of the sequence is its lack of symbolic, communal significance. Though there are some feeble poetic attempts to resurrect Gradisca as a town icon, she has lost her mythic standing—a fact confirmed by her marriage (an act of resignation?) to the unattractive and pompous *carabiniere*. Gradisca's bouquet becomes the film's final "puff" when she throws it and it plops like a leaden seed on barren soil. (**Figure 8.6**)

The film concludes with a melancholy sense of rupture and dispersal. Pinwheel rather perfunctorily dismisses us ("goodbye, go home"). Titta disappears without a trace. Gradisca is dragged off by her husband, stopping to blow a kiss to a past that is instantaneously dissolving. Then, as Titta's friends wander about in a post-party quest for something to do, the film itself just disappears with a slow fade to black, concluding not as though something has been completed but merely as though all energy and impetus have dissipated.

Conclusion

Although the preceding discussion strives for accuracy in terms of the social and (for Titta) personal implications of *Amarcord,* it does not sufficiently emphasize the humor of the film. Until Miranda's illness, *Amarcord* is strongly comic, part of the reason for its international box-office success. Even the final sequence reintroduces some amusing observations on the absurdities of the town. And scenes such as the family dinner fight, though indicative of serious problems within both family and town, are riotous rather than somber. In this respect *Amarcord* points less to the grimness of some of Fellini's earliest movies than to his final films of detachment and resignation. Many of the early films (*I Vitelloni, La Strada, Il Bidone,* and

Good-bye! I love you all!

FIGURE 8.6 As the film draws to a close, the newly married Gradisca launches her bouquet with no one around to catch it, and it lands on the barren ground where her wedding celebration has taken place. A sharp contrast to the flying puffs exuberantly pursued at the start of the film. Source: *Amarcord* (1973). Directed by Federico Fellini. Produced by FC Produzioni, PECF. Frame grab captured by Frank Burke from 2007 DVD version.

La Dolce Vita) were tragic in tone, marked by the earnestness of a much younger director, severely troubled by the problems of his world and perhaps hopeful that change might be effected through the representation of those problems. The final films tend—like the late films of Luis Buñuel and even Alfred Hitchcock (for instance, *Family Plot)*—toward the mellow and amused contemplation of human absurdity. None approaches the pathos of *La Strada* or the extensive social commentary of *La Dolce Vita*. Certainly, there are films that communicate serious concerns (*Orchestra Rehearsal*), hint at the pathos of Fellini's earlier work *(Ginger and Fred)*, or reflect Fellini's painful struggle with his subject matter (*Fellini's Casanova*). However, there is usually a strong distancing element, and films such as *City of Women, And the Ship Sails On, Intervista,* and *The Voice of the Moon* are absurd and playful even at their most critical.

Orchestra Rehearsal

Although *Orchestra Rehearsal* (1978) comes after *Fellini's Casanova,* I have chosen to deal with it here because it defines with great clarity the kinds of shifts in Fellini's filmmaking that I am detailing in this chapter. Moreover, *Fellini's Casanova* is the

best point of departure for addressing the emergence of full-fledged postmodernism in Fellini's films, the principal topic of Chapter 9.

Orchestra Rehearsal was Fellini's second feature-length made-for-television movie. It was developed and shot during a hiatus in the production of *City of Women* caused by financial difficulties and problems with producers. The film evolved during a period of widespread terrorism in Italy that included the kidnap-killing of Christian Democrat leader Aldo Moro, an event that had enormous impact on Fellini and contributed significantly to the tenor of *Orchestra Rehearsal*. This, plus the film's content and structure, invites one to interpret *Orchestra Rehearsal* as political allegory. Claudio G. Fava claims *Orchestra Rehearsal* to be "one of Fellini's most revealing films, if for no other reason than that it is his first and, in a certain sense, only 'political' film."[14] David Denby maintains that *Orchestra Rehearsal* "is intended as a 'metaphor' for the collapse of European civilization" (Fava and Vigano, 174). From this point of view, Fellini's portrayal of an orchestra disintegrating into senseless violence, then yielding to the authority of its conductor, becomes emblematic of contemporary (Italian) society—so fragmented by self-interest that it lacks cohesion and strength, making it ripe for dictatorial takeover. Fellini himself has encouraged not only a metaphoric but a moralistic view of the text by referring to an exchange that occurs as the violence begins to escalate (though one that ended up being cut from the final version of the film): "In my picture, two old musicians ask the conductor, 'When did it happen, maestro?' And he answers, 'When we weren't paying attention, when we were ignoring our responsibilities.'"[15]

Fellini has been accused by those who insist on finding fault with his politics of making a reactionary film that attacks the revolutionary impetus of the 1960s. As my discussion of both the operation of power and the nature of individualism in the film will reveal, this is hardly the case. In fact, *Orchestra Rehearsal* can be read as a profound post-1968 analysis of why revolution failed. One implication of the film is that much of the 1960s commitment to greater freedom and radical change was in the interests of gratification rather than social transformation, ultimately motivated more by a burgeoning consumer culture and a sense of bourgeois entitlement than by a genuine commitment to jettisoning capitalist relations of power.

One of the most distinctive elements of the microcosmic society portrayed in *Orchestra Rehearsal* is the operation of authority within it. First there is the authority of Church and the past, reflected in the rehearsal site: an antique oratory with the tombs of three popes and seven bishops. Then there is the authority of the already written: the music that the orchestra is required to rehearse slavishly. Next there is the authority of the union—wholly responsible, according to one of its representatives, for the self-worth and political awareness of its members: "We've succeeded in ... restoring to the music worker his human dignity.

He's no longer a minstrel or a puppet ... but an integrated worker, conscious of his cultural function for the masses."[16] Then there is the visiting documentary television crew that determines what we see and, in effect, validates the musicians' feelings and opinions by soliciting them for filmed interviews. Most obvious, of course, is the conductor, who initially has great difficulty maintaining control but who ultimately assumes absolute authority. He ends up screaming at the musicians in German with the screen gone black, and his voice and invisibility recall radio broadcasts of Hitler's speeches.

The most interesting authority of all is a figure designated in the screenplay as the *capo-orchestra* or "orchestra head." Unnamed and untitled in the film, he is a mysterious mafioso type who operates largely in the background (for instance, on the phone) and seems to exert an unspecified but pervasive power from behind the scenes. He clearly has nothing to do with the musical side of things, and he has no direct connection to the union, though the union rep acts like his flunky. In effect, he signifies a kind of power in the abstract: willful, irrational, arbitrary, with no grounding in an accessible political or social reality. It is precisely this nameless but omnipresent power on which the orchestra—and, allegorically, contemporary Italian society—seem to depend for their existence.[17] The disappearance of the *capo-orchestra* at the end does not bring about the elimination of groundless power but rather its objectification in the master-slave relation of conductor and orchestra. Motivated by helplessness rather than by musical purpose (or purpose of any sort), this relation is one of pure dominance/submission without rationality.

The issue of authority (and its corollary, conformity) links *Orchestra Rehearsal* with earlier Fellini films. It also invokes the problem of individuality vs. conformity, so crucial to a film such as *Amarcord*. However, in contrast to *Amarcord*, whose sadness seems a lament for lost individuality, *Orchestra Rehearsal* does not lament its loss so much as acknowledge its impossibility as a constructive force. The first figure we encounter in the film is a "copyist" (a figure who duplicates sheet music), and every character in the film is a "copy," in the sense, of carrying out a predetermined role, either within or in relation to the orchestra. This is not to say that all forms of individuality are missing. On the contrary, the mysterious operation of power within the film encourages a certain kind of individuality—institutionalized and ultimately depoliticized. The musicians' rights—repeatedly invoked by the union representative in relation to the union contract—insistently imply individual freedom, even though such freedom is imposed and controlled by the union rather than self-generated. (Even leisure is legislated by union authority.) Moreover, characters are individualized not by meaningful personal differences but by instrument. This both literal and figurative instrumentalization of self-image leads each musician to over-identify with his or her specialized function, which in turn leads to battles over whose instrument is more important, more

199

mellifluous, and so on. Individualization in this sense divides musician from musician, destroying the possibility for political alliance or social harmony. Television becomes the major instrument of divisive individualization, isolating one musician or group at a time, encouraging a kind of masturbatory introspection, and substituting the egoism of objectified self-expression (that is, televised self-expression) for critical analysis. In short, individuality is not some pristine and authentic reality outside the institutional but is fabricated entirely within it.

The rebellion that occurs is thus not a collective act but an explosion of egos marked by hostility not only toward authority but toward fellow musicians. It leads not to social change but to depletion and isolation, requiring the introduction of external forces (wrecking ball and conductor) to reanimate and redirect the musicians. The implications of all this, in terms of an analysis of contemporary society, are clear. However, in assessing *Orchestra Rehearsal* to determine the extent to which it functions as an extended metaphor for moral and social malaise, we might contrast it with an earlier Fellini "moral fable," *La Dolce Vita.* The latter was a relatively realistic work, at least in comparison with Fellini's more recent films. Society was a visible referent throughout. *Orchestra Rehearsal,* on the other hand, is a film of missing referents, a missing "real." The film takes place entirely within the confines of an auditorium, and the external world is excluded with the exception of street and airplane sounds heard over the opening credits. Virtually anything else that we might consider external, including the wrecking ball that partially demolishes the auditorium, must enter the auditorium, become part of the "inside," in order to exist. The auditorium, in turn, and with it the film itself, remain "internal" worlds of political and social *allegory* rather than "external" worlds of direct political or social representation.

In this context—and given that the auditorium is meant to be a place of exclusively aesthetic activity—*Orchestra Rehearsal* ends up being, to some extent, an analysis of artistic production rather than of society at large. There are even similarities between the orchestral situation and the conditions of Fellini's filmmaking. The auditorium suggests Cinecittà, the movie studio from which Fellini seldom ventured in making his mid and later films. The union's insistence on fidelity to a contract—rather than engaged and quality work—reflects labor difficulties Fellini experienced in getting films made.[18] And, of course, the fascistic conductor who insists on imposing his own point of view on the orchestra is not entirely unlike the Fellini we see, imposing *his* view on cast and crew in *The Clowns.* As a result, we can see *Orchestra Rehearsal* to some extent as a self-critique.

The analogies with filmmaking are not, however, that many or that strong, and to see the film as *principally* self-critique would be to force the issue. To the extent that the film focuses on aesthetic production, I think it makes more sense to see *Orchestra Rehearsal* as a critique of high art and its valorization of tradition,

elitism, the artist as inspired hero or god, the spiritual or transcendent nature of art, and the concomitant superiority of art over life. The principal spokesmen for these values—the copyist and the conductor—are the figures who most blatantly adhere to the kind of hierarchy and domination that asserts itself at the end of the film. The copyist is especially enamored of the aesthetic authoritarianism of the good old days:

> With the permanent director they had once, the musicians didn't carry on like this at all. ... And with his baton, such lashings on the hands and fingers of the musicians who made mistakes. It would hiss. And you want to know something? They were happy to have these blows on the hand. They came up to him like schoolchildren. Like this, look, they would offer their hands and say "I made a mistake, me too, hit me too." Oh, those were the times.

The conductor emphasizes the inspired uniqueness of the artist/conductor and the transcendent religiosity of art—again in a context of absolute authority:

> Ingenuity is the child of caprice and quirkiness. ... [The] exalted character of the artist is vital for the energy which pulls everyone along, dominates everyone, and expresses the themes of the symphony ... I remember Koplinsky, my great maestro. ... He was music personified. And we followed him happily, full of trembling, to carry out the rite of transubstantiation. ... Music is always sacred, every concert is a mass. We were there, enchanted, everyday preoccupations were forgotten. ... Nothing was more beautiful than his authority. ... He was within us.

One of the most frequently invoked values of high art, harmony, is also demystified in *Orchestra Rehearsal*. Although there are moments of strongly affective music in the film, the price paid seems too high. The unity (musical and social) achieved by film's end is based on the suppression of individual differences as well as the absence of any politicized collectivity. Central to the film's critique is an alignment of the most romantic notions of art—especially the artist-as-genius and the unity of the whole—with neo-Nazism or neo-Fascism.

Orchestra Rehearsal's indictment of art seems to repudiate the high-modernist ideology that so strongly characterized Fellini's work of the 1950s and 1960s. In the process it undermines the kind of unmediated relation between film and viewer, art and world, that Fellini appeared to imply by having Cabiria and Paola look directly into the camera at the end of *Nights of Cabiria* and *La Dolce Vita*. *Orchestra Rehearsal* begins with the voice of the copyist addressing us directly. He actually invites us to try out the marvelous acoustics of the rehearsal space. But

the very impossibility of our acting on the invitation makes clear from the outset that the world of celluloid and the "real" space of the spectator are different and unbridgeable. Moreover, as the copyist talks, instruments and music stands mysteriously dissolve into the scene. In an earlier Fellini film this might have implied the "spiritual" or "imaginative" dimension of the world he inhabits. However, his obliviousness to their appearance is comical, making the "miracle" absurd rather than profound. It underscores the gimmickry of the scene, the technology and materiality of filmmaking, and the radical separateness of this world of movie tricks and metamorphoses from our too, too solid real.

The separateness and inaccessibility of the filmed world are accentuated when both the copyist and television become filters between us and the film. At the very beginning, the copyist is invisible and unidentified. His voice is the voice of the film, suggesting direct and unmediated communication. But as the instruments and music stands appear, he, too, dissolves into the scene, taking up a position "between" us and the film world. Then, when the television interview crew arrives, their apparatus takes over the role of the camera eye, and as a result characters, including the copyist, talk to the television personnel rather than us. No longer is there (even simulated) direct access between figures on screen and us. We are clearly "put in our place," unceremoniously relegated to our separate world as audience, as the film becomes, like the oratory, a closed or "inside" world. Moreover, though Fellini never identifies himself as the television interviewer, it is his voice asking the questions. Thus, the creator of the film himself, subtly, becomes an agent of mediation rather than interpenetration.

Linked to *Orchestra Rehearsal's* critique of art is the death or absence of the author, which has become so crucial in preceding Fellini films. In this respect *Orchestra Rehearsal* is a kind of *Amarcord* by way of *Fellini: A Director's Notebook, The Clowns,* and *Roma.* Given Fellini's fondness for pseudo-documentary in the latter three, we might initially assume that when the copyist addresses the camera at the beginning of *Orchestra Rehearsal* he is addressing Fellini as documentary presence. (In fact, the project originated in Fellini's thinking as a documentary, and the opening scene seems an allusion to that original intent [Davis, 15].) Fellini-as-documentarian, however, like the "I" in *Amarcord,* never appears. He remains only the "absent" voice of television, implying his demise as author, in accord with the end of *The Clowns* and *Roma.* More to the point, he references the extent to which his author-ity has become reliant on television by implying that he exists in *Orchestra Rehearsal* not as filmmaker but as television employee.

Television, too, is a missing author. Not only is the television documentary crew responsible (in terms of conventional filmic point of view) for many of the images we see and much of the dialogue we hear, but RAI, the Italian state television

network, produced *Orchestra Rehearsal*. Like Fellini, however, the RAI documentary crew never materializes. It is only spoken to, which is another "allusion" at best. Most important, the principal author, given the musical subject of the film—the composer—is nowhere to be found. This takes on tragic extra-textual significance in that Nino Rota, who served as composer for all Fellini's feature films, including *Orchestra Rehearsal*, died shortly after completing his work for the movie.

There is no originality associated with symphonic art, merely the interpretation and enactment of the already composed. The closest thing we get to the author is the copyist. After that there is only the conductor, who uses the already written merely as a means of inscribing power and, equally important, insisting on the endless repetition of mere rehearsal.

We might be inclined to see all this as a lament for something lost, hence an implicit reinstatement of the author/subject through nostalgic allusion. However, the artist or creative source—like its correlative, individuality—is not lost in *Orchestra Rehearsal;* it is just plain impossible. Just as the film depicts a closed system of power always at work precluding self-determination, it presents a closed system of textuality (that is, the musical score) always precluding novelty in a realm of reproduction, with no hint of an original. In this respect *Orchestra Rehearsal* moves us beyond the sadness of *Amarcord* and ushers us into the "postmodern condition" of Fellini's most recent work.

NOTES

1. "Fellini's Cinematic City: *Roma* and Myths of Foundation," *Forum Italicum* 14, no. 1 (Spring 1980): 78–98. Reprinted in *Perspectives on Federico Fellini*, 151–65; hereafter cited in text.

2. Quotations from *Roma* are, for the most part, from the film's English-language version, which is partially dubbed (with Fellini contributing voice-over) and partially subtitled. However, I make crucial distinctions between this version and the original Italian version, which is the source of the 1994 laser disc. (Note from 2019: the Criterion Collection Blu-ray is consistent with the laser disc, with none of Fellini's added voice-over.)

3. For instance, when we cut from the child at the train station, looking intently at the Rome-bound train, to the arrival of the young adult in Rome in 1939, the narrator says, "Finally, some years later, one fine morning, here we are in Rome." The "we," rather than forging a direct link solely among the child, the young adult, and the narrator in the present, generalizes even to the point of incorporating us, the audience, in the scene. Similarly, following the young adult's first night in Rome, we cut to Fellini's camera and crew approaching toll booths on the outskirts of Rome, in 1971. The narrator says, "Thirty years and more have gone by since that fabulous evening," implying a link, but he refuses to identify himself by

saying something like *"my* fabulous evening," and he immediately attenuates the link by moving to a general, detached, query: "But what about today? What sort of an impression does the Rome of today make on someone arriving here for the first time?"

4. Fellini told me of United Artists' wish for more narration—and their representatives' desire to have things more conventionally comprehensible—during a conversation in June 1983. In terms of the scenes discussed in the preceding endnote, there is *no* voice-over in the Italian version, linking the scene of the child at the train station with the young man's arrival in Rome, and there is no reference to a "fabulous evening" at the beginning of the first 1971 sequence.

5. Milton Krim, "Fellini's Rome," *Holiday Magazine,* January 1974, 37; hereafter cited in text.

6. "Madame Roma," *Atlas,* Spring 1972, 64.

7. In fact, the film was all scripted to some extent (allowing, as always with Fellini, for substantial improvisation). Even the words of Gore Vidal, presented entirely as the writer's own opinion, were carefully crafted during the dubbing stage by Fellini. See Alpert, 233–34.

8. This is desire as it is defined in post-Freudian and poststructuralist terms. For a useful introduction to this notion of desire, see Kaja Silverman, *The Subject of Semiotics* (New York: Oxford University Press, 1983).

9. The English-language narrator says "a remorse," which makes no sense. I have taken the liberty of assuming that "recrimination" is closer to Fellini's intent.

10. Fellini has at times denied this (see Riva, 24), but as Louis D. Gianetti has pointed out, the word is an amalgam of *amo* (I love), *amaro* (bitter), and *mi ricordo* (I remember), thus expressing the bittersweet quality of memory—and of the film itself (*"Amarcord:* The Impure Art of Federico Fellini," *Western Humanities Review* 30 [1976]: 155). Giannetti has also pointed out the discrepancy between the title, implying a single center of consciousness, and the film's numerous narrators.

11. Although in *Juliet of the Spirits* the development of perspective is part of a gradual expansion of consciousness, here it suggests only the oppressive limiting of attention to a single, imposed point.

12. For a brief and useful description of fetishism and disavowal, see Gaylyn Studlar, "Masochism and the Perverse Pleasures of Cinema," in *Movies and Methods: An Anthology,* vol. 2, ed. Bill Nichols (Berkeley: University of California Press, 1985), 613.

13. This equation of power with the site of spectacle rather than with the (male) spectator is at odds with a good deal of contemporary theory. I think it is one of the ways in which Fellini's (and a good deal of Italian) cinema differs from much classic Hollywood film in the construction of gender.

14. Claudio G. Fava and Aldo Vigano, *The Films of Federico Fellini,* trans. Shula Curto (Secaucus, N.J.: Citadel, 1985), 170; hereafter cited in text.

15. Quoted in Melton Davis, "Fellini's Latest Creates a Ruckus in Rome," *New York Times,* 18 February 1979, sec. 2, p. 15; hereafter cited in text.

16. Federico Fellini, *Prova d'orchestra* (Milan: Aldo Garzanti Editore, 1980). Quotations from the film's dialogue are based on this text, as it is an accurate transcription of the film. Translations are mine.

17. This view of power is remarkably similar to that of French theorist Michel Foucault: "Power in the substantive sense, *'le pouvoir,'* does not exist. ... [P]ower is not an institution, a structure, or a certain force with which certain people are endowed; it is the name given to a complex strategic relation in a given society" *(Power/Knowledge: Selected Interviews and Other Writings, 1972–1977*, ed. Colin Gordon, trans. Colin Gordon, Leo Marshall, John Mepham, and Kate Soper [New York: Pantheon Books, 1980], 235–36).

18. Frustrations with union rules and regulations creep into Fellini's interviews on several occasions, though he has also expressed awareness of the exploitation film industry workers have experienced, necessitating union protection.

9

Postmodern Reproduction: *Fellini's Casanova* to *Intervista* and *La Dolce Vita* Revisited

The films I address in this chapter serve as the culmination of the two narratives I posited in Chapter 1. Individualism, and with it art and the artist, are now merely the products of cultural codes and systems. Realism has long since disappeared, and representation (and with it any implied relation between art and the world) is supplanted by signification: the construction of reality entirely out of the same codes and systems that produce "individuals." Consequently, virtually all the issues that I identified as central to *Orchestra Rehearsal* recur here: the absence of the real, the death of the subject and author, the ungroundedness of power and authority, and the effacement of originality by endless reproduction. The only basis for potential qualification to all this is *Intervista*, which reintroduces the issue of individual and authorial agency, though in a distinctly postmodern key.

Fellini's Casanova

Fellini's Casanova (1976) was one of the most difficult projects Fellini undertook in his four-decade career as a filmmaker. It was marked, among other things, by extensive producer problems, the theft of film negatives, and Fellini's distaste for the subject matter. Much of the unpleasantness of Fellini s experience in making the film seems directly reflected in the film itself, particularly in the portrayal of its protagonist.

In some of the following, I may appear to be treating Casanova as though he were a realistic figure, undergoing experiences of sufficient verisimilitude to enable us as spectators to identify with him. This is particularly true when I discuss issues such as homelessness, powerlessness, and failed relations with women— seemingly viewing Casanova as a psychologically consistent character in relation to them. I would emphasize, however, that the "reality" of these issues— and of any consistently psychologized relation to them on the part of Casanova—is highly qualified by the hypertextuality of the film and its hero. Casanova is not a person

or a representation of one so much as an ungrounded fiction produced by his and Fellini's texts. Moreover, his problems are, to a large extent, mere humanist *effects* or posturings in what is principally a post- or antihumanist context.

Home/womb/mother

Casanova is ungrounded throughout by a condition of exile, which links his story to many earlier Fellini films. This begins on a relatively conventional autobiographical note, as the movie recapitulates some of Casanova's memoirs, but it builds into something far more complex in terms of his relation to women, power, and narrative. Early in the film Casanova escapes from his birthplace, Venice, and, despite a confessed longing to return, never does. (Fellini here departs from history, for the real Casanova did.) A clear link is established between Venice and Venus in the opening sequence: a carnival celebrating Venice's love-patron but marred by the failed communal attempt to raise a bust of Venus from beneath the water. This initiates not only the link but a process of substitution, as the failure of home/woman to materialize sets in motion Casanova's endless pursuit and loss/abandonment of women. The link and loss of home are later emphasized in Casanova's London encounter with the giantess Angie, whom Casanova follows, captivated, after spotting her on the bank of the Thames. She comes from the environs of Venice but has been harshly uprooted, sold by her husband "like a circus animal" to a traveling carnival. Her origins and itinerant existence—plus the misty, decontextualized landscape in which she appears—suggest Casanova's dissociation, by this point in the film, from anything resembling home. The association between Angie or woman and home is confirmed when Angie and her two dwarf companions create a scene of domestic intimacy and harmony, playing together as Angie takes a bath. Casanova's disconnection is further underscored as he can only gaze on this scene from afar, through a small slit or flap in their tent.

In the same segment of the film, a symbolic link between woman and home or origin is forged by another carnival attraction, Mouna, a beached whale surrounded by images of displacement: a contortionist with her head beneath her crotch and her toes next to her ears, a man with a woman's face painted on his belly, and so forth. Mouna, of course, comes from the sea, and as her male huckster and "interpreter" exclaims, "out of Mouna has flowed the world with its trees and its clouds and one at a time all the races of man. ... He who dares not into the whale's belly will not find his heart's desire. Go in and see for yourselves. Down through her throat then down deeper ever deeper into the warm welcoming womb."[1] Mouna is, in fact, a purely male symbol of the "female principle"—a "womb" intended to recuperate the very origin that is impossible in Casanova's world. She is a site not of comfort but of male hysteria, of a slide show of images

FIGURE 9.1 The vagina is a site of fear not desire for insecure masculinity. In *Fellini's Casanova*, it provokes male hysteria that encompasses fear of castration and fear of the "other." The slide show is also a site of hysterical representation, which has implications for a Fellinian self-critique around gender, which will be addressed more directly in *City of Women*. Source: *Fellini's Casanova* (1976). Directed by Federico Fellini. Produced by Produzioni Europee Associate. Frame grab captured by Frank Burke from the 2008 Blu-ray version.

that are not only feminine but grotesque and frightening. The final images reveal a vagina cradling the face of a black woman with prominent teeth, aligning woman not only with the promise of fellatio but with the danger of castration. The image of racial alterity also makes the womb a place of alienness rather than grounding, while making otherness threatening. This conflation of pleasure, pain, womb, otherness, and emasculation accentuates the impossibility of being "at home." It also illustrates the misogyny and racism generated by male anxiety, which, in turning woman as home/womb into threat, becomes more ungrounding still. (**Figure 9.1**) Finally, as a projected exhibit, the slide show implicates Fellini's own representations of women, something he will address more explicitly in *City of Women*.

The impossibility of home/woman/origin is most clearly exemplified in Casanova's encounter with his mother. The meeting is pure coincidence. Though Casanova is visiting Dresden, where she lives, he has made no effort to look her up and appears to have difficulty recognizing her. She is as unpleasant as he is unfeeling, complaining repeatedly that he never sends money. Though he offers physical assistance, carrying her out to her carriage on his back, it is clear that he has little intention of renewing their relationship. She knowingly mocks him

when he claims he will try to visit, and as she rides off, he notes without regret, "I forgot to ask her for her address." Reminded, by meeting her, of his origins, Casanova can only refer to them vaguely and incompletely: "Have you had any word of our relations in Venice? I have hopes of returning there, you know, as soon as. ..." The notion of maternal origin or "roots" is visually reversed by the image of Casanova's mother up off the ground, piggyback, "grounded" by her son.

Power and/or the father

Unable to locate himself vis-à-vis home/womb/mother/origin, Casanova has no better luck in relation to power or the traditional realm of the "father." For one thing, he has no real father or biologically grounded authority. More important, his relation to political authority ranges from the highly problematic to the impossible. In his first appearance he ends up having sex to amuse the French ambassador de Bernis, who has apparently had his mistress, Maddalena, arrange an assignation so he can watch Casanova in action. Yet de Bernis only exists as an eye peering out from behind the image of a fish on the wall. And when Casanova uses sex as a way to ingratiate himself (his sexual acrobatics are followed by a curriculum vitae: "I have studied engineering and literature, I am conversant in the art of politics"), the fish eye becomes blank. In one sense, power is absent except as signifier (the eye and Maddalena's claim that it belongs to de Bernis). In another, power exists only through its effects on Casanova. He becomes the objectification of the putative ambassador's putative (voyeuristic) sexual urges. To the extent that there is an actual ambassador, Casanova becomes for him what his mechanical bird, on which he depends for simulated excitement, is to him.

Following the de Bernis episode, Casanova's impossible relation to the father is underscored when he is imprisoned by the Venetian Inquisition for crimes (heresy among them) that are merely asserted, never proven. Casanova seems to be a transgressor without having transgressed, which is an interesting reflection of the Counter-Reformation climate in which he lived,[2] the psychology of sin in Christianity, and the kind of guilt-tripping mind games played by Fascists in a film such as *Amarcord*. Later in the film, Henriette, designated by Casanova as "the great love of my life," is whisked off by invisible authority, whose mysteriousness and inaccessibility are accentuated in the third-person report Casanova receives following her disappearance: "a person of the utmost importance at a certain European court has full powers over her, and D'Antoine is only the emissary sent here to bring her back to her rightful place." By the end of the film, authority is either utterly irrational (the inebriated Duke in the militaristic madhouse of Württemberg) or missing (the Count who is away when the old and decrepit Casanova needs him at Dux). The absent leader or the vacant Dux (the word "Dux"

means "leader") becomes the film's definitive statement of Casanova's lack as an authority-dependent figure in a world where power remains unidentifiable.[3]

One might well argue that the irrationality and virtual absence of male, paternal power reflects not just cultural and historical factors (Counter-Reformation Catholicism, Fascism) familiar to Fellini but his own relation as a filmmaker to those representatives of power most crucial to his work: movie producers. In fact, *Fellini's Casanova* was the director's most conflicted film in terms of "artist-patron" relations. Originally, Dino De Laurentiis signed on as producer, but only on the condition that the film be made in English. Then, De Laurentiis backed out, and Andrea Rizzoli came and went. Then came Alberto Grimaldi with Universal Studios, under the condition that (1) Fellini use Donald Sutherland, (2) Sutherland's part be spoken with his own voice and recorded in direct sound (Fellini had *always* dubbed after shooting), and (3) the script be Gore Vidal's (see Alpert, 250). Midway through the shoot, Grimaldi claimed that Fellini had already spent almost all the budget and suspended production. Fellini went to court, and only after a three-month delay did production resume. With backers appearing and disappearing—and making ever-changing demands on Fellini—one could well argue that, in *Fellini's Casanova,* Fellini is documenting, not just imaginatively construing, the relationship of the artist to paternal power.

Women and power

Just as Casanova seeks to use women or the feminine as a way of recuperating origins, he relies on them to reinstitute his sense of power in a world in which authority and the father fail to provide it. Perhaps the most disturbing example occurs as he languishes in the Piombi prison, having been jailed arbitrarily by the Venetian Inquisition. In apparent compensation for his helplessness, he narrates a story of extreme self-aggrandizement in which he restores a sickly and weakened young woman (Annamarie) to health by having sex with her. In effect, he rapes her—taking her while she is unconscious—and, at least from his point of view, she both needs and enjoys it. This need to empower himself through conquest is repeated in the Roman sequence, where his ego is goaded into a virility contest with Prince del Brando's coachman—and he ends up again having sex with a woman (Romana) without her full consent. The most grotesque instance involves the mechanical doll, Rosalba, whom Casanova "seduces" at Württemberg. Casanova's use of women for macho validation is reflected in other forms of masculine appropriation. Not only does woman get turned into technology, Casanova explicitly identifies technological reproduction as male, "telling" Rosalba: "What a genius of an inventor your *father* must have been" (emphasis mine). Then, he implicitly turns his own lovemaking into sexual competition with the father/inventor by

making the father's relation to Rosalba incestuous. (He asks the doll, "Did you lie with him?")

As the Rosalba incident suggests, woman, in her forced role as empowerer for Casanova, is reduced to a cipher in a male system of symbolic exchange, with gender and otherness effectively erased. This becomes even more explicit when Casanova seeks empowerment not only through the desire of women but through women-as-the-desire-of-other-men. This occurs when Casanova performs for de Bernis and when he articulates his "relationship" with Rosalba in terms of sexual rivalry with her inventor. It is also an ingredient in Casanova's contest with the coachman, as Romana is identified as the desired object of the Prince del Brando.

Because power for women is defined solely in male terms, women become self-effacing. Madame d'Urfé willingly seeks to renounce her sex by performing the alchemic feat of dying as a woman and being "transformed into a man ... who will live forever." Henriette proves to be the consummate woman-as-symbol-of-male-desire. She begins in hiding, in the care of a Hungarian officer. She then dons a man's military outfit and, while wearing it, is handed over by the officer to Casanova. She finally becomes fully visible as a woman by donning an elegant white dress, but, as the prominence of a tailor's dummy in this scene suggests, her gender resides not in her person but in the cultural constructions of clothing and of role. In "becoming woman" Henriette does not become herself; she becomes virgin bride and symbol of perfection, a role she plays exquisitely throughout her brief appearance. She also represents woman as art object intended for the male gaze, forming part of a continuum from Annamarie, whom Casanova compared to a statue, to Rosalba.

By the end of the sequence Henriette has changed male hands yet again, from Casanova to D'Antoine, and is again "in hiding"—this time irrevocably. Casanova's inability to hold on to Henriette has nothing to do with love and everything to do with Henriette's nonexistence except as a token for exchange in the ever-circulating economy of male power. Moreover, in the very act of figuring male power in virtual absentia, Henriette—and, for that matter, all women in Casanova's world—confirm its lack except as projection. That all women are projections is reflected in the fact that Casanova is the presumed author of all we see. (This would qualify my comments about women becoming self-effacing on their own, though one could argue that the text reflects *both* Casanova's reduction of all women to male projection *and* a predisposition common within male-dominant society for women to define themselves in relation to men—largely in the interests of survival.) The kind of gender slide in which women become male signifiers is matched and reversed by Casanova. He struts about as presumed object of desire, which places him, paradoxically, in a conventionally female position. This is reflected in his vanity, his costuming and makeup, his posing, and his catering to

211

the male gaze (de Bernis and everyone else for whom he performs, including himself as teller of his own tale). Although Casanova's self-display is partly explained by the era in which he lived, the film uses it to other than merely historical ends.

Casanova's positioning as woman is perhaps most profoundly evident in his perpetual economic dependency on male authority and his concomitant need to please. In fact, he assumes the recurrent role in Fellini's films of the prostitute without any of the spunk and rebellious dynamism that Fellini's female sex workers possess. As the paradoxes of Casanova's impossible relation to women and the feminine accumulate, women increasingly come to represent male masochism and self-destruction. This is obvious in the hysterical symbolization surrounding Mouna, but it is even true in Casanova's prattlings in the company of Henriette: "A man who never speaks ill of women does not love them. To understand them and to love them, one must suffer at their hands." This willingness to suffer becomes quite physical and direct in Casanova's encounter with Moebius's daughters. Science becomes sadism here, as the sisters take obvious relish in spearing their objects of classification—worms—with long needles. Their sadism, in turn, becomes Casanova's masochism when he passes out in their presence, having identified completely with the pierced worms, and awakens madly in love with Isabella. Pain, loss of consciousness, and love become interchangeable, and, given the clearly phallic nature of the worms, love also becomes identical with Casanova's symbolic wounding or castration. He and Isabella then make explicit the link between love and self-destruction that was implied earlier with Mouna:

CASANOVA: I want to annihilate myself in you, my wise Minerva.
ISABELLA: What a strange man you are, Giacomo. You can't talk of love without using funereal images. ...What you really want is not to love but to die.

As women increasingly signify only Casanova's own pathological lack, their physical identifiability as women lessens in importance. Casanova seeks out giants (Angie) and hunchbacks (in Dresden) in a quest for novelty that makes size and shape more important than biology or gender. In short, the relationship between sign and referent or signifier and signified (that is, between the image of woman and the "reality" of gender or sexuality) breaks down. In the case of Casanova's mother, the relationship dissolves completely, amidst a welter of simultaneous associations. When Casanova hoists his mother onto his back, her identity is largely effaced as he becomes a hunchback—much like the woman with whom he has recently had sex. Moreover, because his mother looks birdlike, their joined image resembles Casanova's mechanical bird: symbol of Casanova's presumed masculinity. Their mechanization as "moving parts"

in turn anticipates Rosalba, whom the mother resembles in size, coloring, and "gender." This kind of associative play subverts any potential grounding offered by the final image of the mother: trapped behind the glass of her carriage windows like Venus beneath the waters of Venice. Without all the other complicating associations, this image might make the mother equatable on some level to Venus/Venice and the missing or submerged origin, feminine principle, and Mother with a capital M. Linked also with hunchback-lover and surrogate penis, however, mother-under-glass is only one in a chain of meanings whose mutual incompatibility makes simple identification, much less psychological coherence, problematic in the extreme. (**Figure 9.2**)

Ultimately, women disappear altogether even as *potential* signifiers. At Dux, Casanova no longer has lovers, no longer relates to women at all. The only object of desire remaining is an image of himself, younger, pasted with excrement on a latrine wall. Casanova's infatuation with his own image tends to confirm a suspicion that his obsessive pursuit of women has tended to promote throughout the film: women for Casanova have always only been reflections of his own (missing) self. It also makes clear that, too old, feeble, and unattractive to participate in the symbolic exchange of gender(ed)/power, Casanova is reduced to a kind of absolute sameness or self-mirroring.

FIGURE 9.2 Casanova with his mother draped over his back like a hump, ungrounded and birdlike, triggers a host of associations around, home, (surrogate) mothers, sexual escapades with nonnormative women, and Casanova's mechanical bird. Source: *Fellini's Casanova* (1976). Directed by Federico Fellini. Produced by Produzioni Europee Associate. Frame grab captured by Frank Burke from the 2008 Blu-ray version.

Textuality

Perhaps the most significant aspect of *Fellini's Casanova* is its sheer textual excess. For one thing, it is a film reproduced from a book. This is not uncommon for Fellini, who has redone Petronius (*Fellini-Satyricon*) and Poe (*Toby Dammit*) and taken other art forms (*The Clowns*) as his point of departure. Here, however, he chooses a figure who, in effect, has no history or existence apart from his memoirs; whose compulsion to narrate produced anywhere from 6 to 12 volumes, depending on which edition one cites; and whose work, as Fellini has put it, is a "kind of telephone book ... [a] boundless, paper-like ocean ... [an] arid listing of ... facts amassed without any selection, feeling, or amusement."[4] In short, Fellini has chosen as his subject a figure who is nothing more nor less than the overproduction of signs—a figure exiled in language that, because Casanova wrote in French and *Fellini's Casanova* was made in English, is not even his own.

Appropriately, Casanova begins the film as himself a text: he is dressed in the costume of Pedrolino (Pierrot in the French tradition), a stock character from the Italian commedia dell'arte.[5] In fact, he does not become identifiable until the following scene, when he takes off his hood to read another text: a letter claiming that a nun who has seen him in church wishes to meet him. The first words he speaks—even though he is presumed author/narrator of all we see—are not his own.

Repeatedly, acts of narration and dramatization take priority over any reality that Casanova might be narrating about—or dramatizing. The effect is very much like that of the "garbage-bag sea" of the opening scenes, where the artificiality of the signifier—the plastic Fellini uses to "simulate" the sea—is so comic and dramatic that it detracts all attention from the signified: the sea itself.

Casanova's escape from prison is a feat of storytelling, not physical activity, as we never see the brilliant machinations by which he claims to have broken out.[6] His response to Henriette's disappearance is pure play-acting. In a passionless tone of voice that belies his words, he asserts, "[Henriette's] rightful place is with me, and I will find her and bring her back even if I have to face all the armies of Europe." Then he does no such thing, reverting instead to narration, as he recounts yet another episode from his "life." Moreover, the only thing that connects the end of the Henriette tale and the beginning of the next is not lost love but melodramatic posturing: "In a delirium of grief I considered taking my life or burying myself in a monastery and ending my days as a monk. But that time I chose neither grave nor cloister. Death, beloved friend of noble unfortunate souls! Many years later in London, I nearly did indeed cross of my own volition the final threshold." Even his "near suicide" is pure theater, as he dresses up in his finest clothes, quotes Torquato Tasso, strides pompously into the Thames, and fixes to whack himself on the head with a rock. Suicide is just another text to be

performed (in fact, he refers to it as "the last and greatest *ceremony*"). And, of course, he fails to go through with it.

The dissociation of Casanova's words from any meaningful reality also becomes clear in his increasing authorial unreliability. He claims that Württemberg "boast[s] the most brilliant court in Europe" while we see mindless mayhem on screen. At Dux he claims, "As librarian to the count, I hold a position of considerable import-ance, in keeping with the attainments and congruous with the temperament of a scholar and a man of letters," while we see an old and decrepit figure, treated with no special respect by authorities and contemned by coworkers. Consistent with his role as librarian, Casanova defines himself solely in terms of books, and consistent with his existence solely within a world of signs without substance, he speaks only of copies, images, simulations. Referring to his portrait on the latrine wall, he tells a group of visitors: "It's a striking likeness. It was printed as an illustration to my famous novel, *Icosameron*. Have any of you happened to have read it? Allow me to give each of you a copy. I believe after my death that I will be talked about for many long years to come as the author of that work." Then, staring at his own image, he says, "I am a well-known Italian writer," and exits the scene, leaving only his portrait framed within his shadow, which becomes larger and larger as he moves off screen. In short, as we approach the end of the film, Casanova becomes an increasingly indistinct replica of himself—as well as a figure who embraces himself principally in terms of his own textuality.

Expelled from the womb/home of Venus/Venice, lacking biological pater-nity (Casanova is not linked to any progeny in the film), and now deprived by decrepitude of sexual identity, Casanova reconfigures birth, paternity, and sexu-ality as compulsive self-production through language. Yet self-production is not a recuperation of identity or coherence, nor even a reflection of authorial inten-tion. Casanova's voice-over is sporadic, and narrative structure is arbitrary if not nonexistent.[7] We cannot even attribute any consistent motivation to Casanova as writer. As Fellini suggests, Casanova is nothing more than a "glassy eye which allows itself to slide over reality—and to pass through and to erase it—without intervening with a judgment, without interpreting it with a feeling" (quoted in Tassone, 28). He certainly is not seeking self-understanding: his tales are lacking in introspection. He does not seem to be trying to impress us, for he repeatedly shows himself in an extremely negative light. He does not employ any of the con-ventional lures for entertainment: plot, appealing characterization, closure. He clearly has no moral purpose such as education or edification. It appears that his narration—like his reported life—is just another pose, a literary conceit. Conse-quently, no episode need relate to any other, nothing need build into something larger or more meaningful. His tale comprises the kind of mindless seriality that Fellini's *Ginger and Fred* will critique in terms of television. The result of all this

is a pervasive surficiality (surface plus superficiality) to the film. There is nothing beneath, behind, or outside the sheer accumulation of words and images to serve as a cause, source, or context.

Casanova's dream

The final scene of *Fellini's Casanova* helps crystallize the principal issues of the film. As a humiliated and lonely Casanova ponders, "Venice. Will I ever see Venice again?" he recalls a dream he had the night before. We see Venice again, but the canals are now frozen and the bridges devoid of people. The eyes of "Venus," trapped in ice, stare blankly at Casanova and at us. Casanova kneels, and the lower torso of a figure in pants and boots appears. Casanova turns toward this seemingly male figure and whispers "Isabelle." ... Casanova walks toward a figure in white who laughs and keeps receding. ... A golden coach arrives. Suddenly Rosalba appears. We cut back to the coach and discover the Pope and Casanova's mother within. The Pope points the doll out to Casanova with a mixture of complicity, amused approbation, and commanding expectation. We cut back to the doll. Casanova courts her, and they begin to dance. We cut to the eyes of the old Casanova, observing the scene he is recollecting, then we cut back to Rosalba and the younger Casanova dancing. They end the film turning in circles like a couple on a music box.

Casanova's dream underscores his unceasing exile. Venice is only an image from his unconscious, and frozen over at that. He remains surrounded by signs of absent love, including those of his mother and a surrogate "father." His relationship to women continues to exist in the shadow of male power as the Pope must be there to authorize his liaison with Rosalba while his mother remains subordinate. The only "female" of substance to appear is a technological product that Casanova has earlier attributed to male ingenuity.

Like so many dreams, Casanova's is a series of displacements. In some instances, the displacement is single: for instance, the real Venice is now merely a dream image. Often, however, it is doubled. Casanova is both a dream image and, by the end, a mere mechanized simulation of his former self. Similarly, the doll is a dream image of earlier displacements: robot for actual women, such as Annamarie and Henriette, whom the doll resembles. As displacement doubles, signifieds recede. The representation of women contributes to the defeat of meaning and identification. Not only does Casanova misrecognize a male image as Isabella, but a figure in white who might be Henriette appears only from the back and only partially on screen. Significantly, the only woman Casanova seeks to name is the one woman who has stood him up (at Dresden) and failed to become his lover: another sign, in short, of absence and lack.

Casanova's recollection reinstitutes both spectacle and voyeurism, so crucial to the opening scenes of the film. However, there are differences that further accentuate the dominance of sign play. What was originally a public space (the bridges and walkways of Venice) is now lodged within Casanova's dreaming unconscious and narrating consciousness. And instead of our watching Casanova perform, he is watching himself (we recall the portrait at Dux). His story has become entirely self-referential, narcissistic.

Inevitably, this dream triggers no self-awareness. We just see Casanova looking, without apparent regret or acknowledgment of any kind. We do hear some sounds of breathing that might be construed as crying, but the brief shot of the old Casanova shows no tears. Moreover, Casanova devolves in the course of this recollection from narrator to mere spectator—observing himself as mannequin. The final simulation of Casanova can neither speak nor see; it can only move in circles, staring blankly.

City of Women

Like *Fellini's Casanova*, *City of Women* (1980) was made amid extraordinary production difficulties, including a forced hiatus that gave rise to *Orchestra Rehearsal*. However, the most painful aspect of *City of Women* for Fellini may well have been the fact that it was made in the shadow of the death (10 April 1979) of Nino Rota, who had written all the music for Fellini's prior films except *Marriage Agency*. Fellini viewed Rota not just as a professional collaborator but as an abiding inspirational spirit. The principal cultural context in which *City of Women* was made was the feminist movement of the 1970s. As my discussion of the film here and especially in Chapter 12 is intended to suggest, Fellini's response to feminism is extraordinarily complex. The film's genre and title both suggest an intriguing link to feminism not just of the 1970s but of much longer duration. As a "dream vision," Fellini employs a storytelling strategy that dates back to medieval and early modern Europe. In the classic version of the genre, the dream helped enlighten the (characteristically male) dreamer about problems in his life, though the focus was often religious or political and certainly not psychoanalytical as it is in the case of Fellini. One of the most important dream visions, though disregarded for centuries because it did not have a male protagonist and was authored by a woman, was Christine de Pizan's *La Cité des dames* (1405) which is known in English as *The Book of the City of Ladies* (1999).[8] The book was written specifically to contest the misogynist male literature—and dream visions—that had preceded it; in particular, *The Romance of the Rose*.[9] It seems hardly coincidental that Fellini would have given his film, which addresses the problematic attitudes

of his male character toward women, a title virtually identical to that of Christine de Pizan's work. Though this text was well known in the Renaissance, it was not widely known in Italy at the time Fellini made *City of Women*. However, Christine was of Italian origin, and would certainly have been known to the Italian feminists Fellini consulted during the making of the film.[10] That Fellini's film was conversant with contemporary feminist discourse is confirmed by Marguerite Waller:

> The laughter on the soundtrack that prefaces the opening credits evokes the work of Hélène Cixous, one of French feminism's founders, whose essay "The Laugh of the Medusa" was published in 1975 and ... widely translated soon thereafter. The theorizing of another French feminist, Luce Irigary (... author of "When Our Lips Speak Together") echoes in the commentary accompanying a slide show on female genitalia. ... Mary Shelley's *Frankenstein* [is evoked] in a ... skit portraying the typical housewife as the victim of a Frankensteinian monster husband. ... Katzone's ... soon to be demolished "master's house," pays homage to Audre Lorde's presentation, "The Master's Tools Will Never Dismantle the Master's House," at a 1979 feminist conference in New York City ... alluded to by attendees [at the film's feminist convention][11]

The titling of Fellini's work accentuates the fact that Fellini takes feminist discourse seriously even as he caricatures its rhetorical excesses. The film itself makes clear that a city of women constructed and dreamed by men will highlight problems far different from those that would be the focus of a woman author and dreamer.

As the credits appear at the start of *City of Women,* we hear a woman's voice say "Marcello yet again? Please, maestro."[12] Because of the casting of Marcello Mastroianni and Fellini's blatant acknowledgment of it, and because the film's dream structure makes it a kind of psycho-symbolic pilgrim's progress, it is tempting to view the film as a late-middle-age version of the individuation process we discussed in *8½*: an attempt to render a growth process whereby the protagonist Mastroianni/Fellini seeks to mature and integrate various aspects of his life and inner self. However, the film does not reward that kind of analysis, in part because Fellini, as I have been suggesting, moved away from stories of psychological individuation as his career unfolded, and in part because while, in Jungian thought, dreams viewed in sequence over a long period of time may reflect a person's journey toward individuation, no one dream can constitute such a process in and of itself. Each dream is limited to raising certain issues, addressing certain repressions and projections, reflecting only one moment in an individuation trajectory.

The gentle critique of Fellini for again using Marcello Mastroianni underscores Fellini's growing tendency to cannibalize earlier work. Reproduction and repetition are being presented not merely as a cultural or postmodern phenomenon but

in relation to aging. As the past acquires more weight than the present or future, memory outperforms the imagination, and the individual or artist engages more in recapitulation than in making anything new. With Fellini's return to the "Latin lover" Mastroianni, Fellini seems to abandon the commitment he highlighted in *Fellini: A Director's Notebook* to seek out new faces and not use established stars and actors.[13] The hackneyed and overused—rather than the fresh and original—announces a changing esthetic.

In fact, the film emphasizes cliché, beginning with recasting of Mastroianni as Snàporaz and the opening (then closing) images of a train hurtling toward the tunnel—a la Alfred Hitchcock's *North by Northwest* (1959). Cliché merges with cartoon, as we have characters named Snàporaz, Dottor Sante Katzone ("*cazzone*" or "big prick"), and "the Signora," while Snàporaz frequently makes cartoon-like sounds: "smick smack, smick smack." Parody and self-parody allow us to view everything from at least two points of view simultaneously: they can be taken seriously (the feminist movement, men's fear of women, male immaturity, profound problems of interrelatedness) but also seen with a certain ironic distance. Similarly, the film's dream structure means we are always dealing with representations that are emanations and/or evasions of the unconscious, hence of something else, something hidden. Nothing is (just) what it seems. The shot of the train hurtling toward the tunnel is a parody of a psychoanalytic and cinematic cliché, while inviting rather than foreclosing interpretation.

Further complicating things are at least four principal sites or layers of signification: the unconscious eruptions of the dream, the dreamer's actions as protagonist of the dream, the film, and the audience's reception and interpretation of the film. Fellini had become acutely aware of multiple levels of signification through his involvement with Jungian psychology, but especially from keeping a diary, beginning in the 1960s, illustrating and commenting on his dreams. In reference to the diary he says, "They are really visions, not dreams. A man's subconscious creates the dream, but his vision is a conscious idealization." But then he goes back to calling them dreams ("These are very old dreams")—and then provides an explanation for one followed by the comment "now you need the explanation of the explanation."[14] The numerous facets of dreamwork acknowledged here give *City of Women* much of its undecidability and intricacy.

As the above might suggest and the film's title would confirm, the contrast between multiplicity and singularity is a major aspect of *City of Women*. The train/tunnel shot is referential (to Hitchcock), diegetic (the concrete beginning of the story), and, as I just noted, symbolic. This is followed by a lengthy tale that becomes increasingly bizarre and, in the end, is revealed to have been all a dream. Yet much of the beginning of the film seems more realistic than oneiric. A man who vulgarly pursues a woman on a train, follows her to a feminist convention, and

observes various feminist rituals until he is roundly castigated for his predatory crudeness seems rather plausible as a non-dream-inflected narrative. It is only at a moment late in the convention sequence when drums start beating loudly, loudspeakers harangue Snàporaz, a woman fire-eater emits a huge and frightening ball of flame, and a crowd of women shout in menacing unison to Snàporaz to "get out," that oneiric structure seems to announce itself. So, Fellini is "deceptive" from the start in his coding.

The reduction of the many to the one is repeatedly critiqued in the film. Snàporaz's single-minded pursuit of the Signora at the beginning is contrasted with the diversity of extraordinarily interesting women who populate the feminist convention and vary in appearance, spoken language, behavior, and artistic creativity (music, theatre, film documentary, etc.). Moreover, multiplicity and its concomitant energy undercut those aspects of radical academic rhetoric that seek to reduce feminism to this or that single issue. All the talk of banning fellatio, penetration, and even marriage (*matrimonio manicomio*)–or of championing (mass, we presume) castration–comes off as partial and absurd, particularly since the film frequently juxtaposes other points of view on the subject. Along with the anti-marriage discourse, there is the celebration of Enderbreit Small, who has seven husbands. One woman wants to banish fellatio, another confesses to liking it, and a third doesn't know what it is—and is admonished by a fourth to read Catullus, reflecting the middle-class and intellectually elitist bent of the convention. Women wax hyperbolically eloquent about the vagina, renaming it "the son's tongue," "smile of life," and "moon violet," but before we can get caught up either in ridicule or in anger with Fellini for his parody, a woman lecturer shows us enormous phalli on classic statures, reminding us that men have been even more hyperbolic for far longer about their private parts. The critique of phallocentrism explicit in one woman's slide of a giant phallus, is counterbalanced by another woman's wondering, with self-ironized desire, where one might find a penis "così."

In contrast to these multiplicities, there are instances in which some feminists fall prey to overgeneralization, claiming for example that "all women are 20 years old" and "all women are beautiful." These generalizations reproduce precisely those male criteria of eternal beauty and youth that have been so detrimental to women—and that the film assiduously renounces with female figures who encompass an enormous range of physical types and ages.

The spirit of multiplicity is most insistently threatened by the Signora whom Snàporaz earlier stalked, at a moment in which the convention reaches a high-spirited peak, celebrating both unity and the many. Having put aside ideological squabbles, women are either dancing or moving in unison to music that fills the room. The song they sing, "A Woman Without a Man," may suggest segregationist sentiment, but that is undermined by the nonsense lyrics of the song, the

genial energy of the singers, and those conference participants who have made clear their continuing investment in heterosexual relations. The co-existence of segregation and its denial is just one more instance of plurality, but the Signora turns a moment of choral harmony into a univocal diatribe. She is shown in isolation from the women whom she rhetorically refers to several times as "sisters," and her insistent hectoring voice gradually usurps their exuberant conviviality, reducing them to passivity and silence.

Her speech, in part, goes as follows:

> The eyes of this man ... are the eyes of the perennial male, which deform what they see in a mirror of derision and of mockery. The cad is always the same. We women are only pretexts for allowing him to recount once again his bestiary, his circus, his neurotic vaudeville show. With us there to play the clowns, the Martians. To provide a spectacle for him of our passion, our misery. Dismal, gloomy, spent caliph: know once and for all that we are not Martians. We want to inhabit the earth. This earth. But no longer to serve as fertilizer as has happened for 4,000 years. He doesn't know us, and he doesn't want to know us. But this will be his mortal mistake because enclosed in the darkness of his harem, or isolated in our miserable or luxurious ghettos, we have had the time to spy on him, to observe him, our jailer, our master. Oh, yes, we have spotted you. We know everything about you. It is you who are the clown, the Martian.

Having reduced the many to the one through her usurpation of the scene, she performs a similar operation in her speech, turning Snàporaz into Everyman—"the perennial male," the "cad" who "is always the same"—so that he can be easily summarized and dismissed. Following upon her jeremiad, what had been a celebration of togetherness becomes a furious hunt to expel the "intruder," as the conventioneers unite in shouting "FUORI" ("OUT").

Ironically, the Signora's behavior is itself "perennially male," in its insistence on stealing the scene and explaining everything in a totalizing manner. She is anything but a "sister" in her relationship to the other women, and instead of feminist goals of community, collaboration, and solidarity, she reinstitutes classic male hierarchy grounded in a will to domineer. She seems a combination of Daumier from *8½* and the conductor from *Orchestra Rehearsal*.[15]

The reductive and singular logic of the Signora is reflected much later in the film in a banner carried by feminists in the company of the Signora. It proclaims "PROGRESS SENZA" or "PROGRESSENZA" ("PROGRESS WITHOUT or PROGRESSESSENCE"), depending on how one reads it. "Progressenza" is not an Italian word, but the banner suggests 1) progress can only occur "senza" or "without"—i.e., excluding men, and 2) progress depends on "essences" or

reducing things to fixed and immutable entities. In a Fellinian universe, progress depends on inclusivity, diversity, and change—not on discriminatory (or any other kind of) essentialism.

We must also note that singularity on one level can become multiplicity on another—because there is more than one way to view the Signora. First of all, from the perspective of gender and feminism, she is an equal and opposite reaction to Snàporaz's earlier behavior. His predatory vulgarity gives plenty of justification for her single-minded rage, and a vast amount of what she says is true. Snàporaz has begun the film as an unregenerate objectifier of women, viewing them only as instruments for his pleasure and unable to see or appreciate their multiplicity. Moreover, what sets her off on her soliloquy is her observing the obvious condescension with which he watches the women singing. So, this sequence embraces critique of both the Signora and of Snàporaz.

Secondly, she is Snàporaz's invention: a dream figure thrown up by his unconscious to offset his puerile masculinity, a corrective to hold him accountable—one of many to appear in his dream/film. As a figure from his unconscious, she also embodies suppressed feelings; for example, guilt at his treatment of women and anxiety deriving from his deep sense of alienation from women if they are not part of a game of pursuit and conquest.

Most profoundly, as with all the figures in this dream/film, the Signora *is* Snàporaz. She embodies totalizing strategies and mechanisms that mirror his. So, while her behavior might be criticized in terms of Fellini's general views on multiplicity and inclusion vs. exclusivity, she is part of a dynamic for which Snàporaz is ultimately responsible.

We can move beyond the specific Signora-Snàporaz encounter and recognize the representational complexity of the entire feminist convention—and thus of Fellini's response to feminism. We see both the creativity of women's art and enactments—most powerfully embodied by the "daily bliss of the housewife"/ *Bride of Frankenstein* skit that recalls, in some ways, the harem sequence of *8½*—and the stultifyingly ideological rhetoric that characterizes some of the more extreme and academic versions of feminism. Moreover, any critique of feminist ideology must also be attributed to Snàporaz's defensiveness in the face of women's demands for their dignity and autonomy. He would inevitably imagine a feminist convention that is, in many ways, a ludicrous as well as ludic event. Given that Snàporaz/Mastroianni is in some ways Fellini's alter ego—especially in the context of *8½* and this film—we can also assume that Fellini is acknowledging his own sense of male privilege under siege. (**Figure 9.3**)

Strategic multiplicity in the form of dramatic reversals informs the film's narrative/dream logic, as Snàporaz repeatedly encounters figures who qualify or "correct" his behavior and attitudes, often introducing either an extreme threat or relief

FIGURE 9.3 Snàporaz's dream includes women at the feminist convention watching a photograph of him at his most ridiculous moment: fruitlessly awaiting a kiss from the Signora. His and Fellini's dream logic in this sequence has numerous things going on simultaneously: fear of autonomous women; a (consequent) critique of feminism; self-critique; a (consequent) valorization of feminist politics and aesthetics; and Snàporaz as both subject and object of the gaze. Source: *City of Women* (1980). Directed by Federico Fellini. Produced by Opera Film Produzione/Gaumont. Frame grab captured by Frank Burke from the 2013 Blu-ray version.

from such threat. Each major character clearly functions in dream-logic relation to preceding characters and situations, never allowing events to become singular, dominant, or static. His pursuit of the Signora "requires" the feminist convention as antidote, culminating in her diatribe and his virtual expulsion. He is saved from the irate conventioneers by Donatella, who is an invaluably versatile dream figure: "maternal," as she herself proclaims, while also proud winner of a testicle-kicking contest. She "saves" Snàporaz only to end up watching with amusement as he is pushed down a flight of stairs and into the custody of a furnace-stoking, motorcycle mamma (another versatile figure), who is literally his match—mirroring his attempted sexual conquest of the Signora with her attempted "rape" of him. He is "saved" by the cyclist's mother, who puts him in the hands teenaged girls, whose indulgence in recreational drugs renders them indifferent or mocking—and then ultimately threatening as they stalk him through the woods (more turnabout is fair play) in their cars. The next savior is Katzone, but Snàporaz's self-indulgent play amidst his host's sex toys, images, and gallery of sexual conquests generates Elena—his wife and an accountability figure on a par with the Signora. And so

on through the film till the final scenes, when he dreams that he is encountering his "ideal woman"—a hot air balloon likeness of Donatella that is also a hideous combination of saint/Madonna, soubrette/whore, and bride—only to have it and himself shot down by the original Donatella, dressed as a terrorist down below.

The film then concludes with two more "reversals"—Snàporaz moves from dream to awakening, then chooses to return to sleep—though these are not of the same order as the dream reversals just described. On the other hand, as with the dream reversals, each shift works in relation to what preceded it.

The Katzone segment of the film helps illuminate both the contrast between multiplicities and singularity central to *City of Women* and the film's relational logic. Katzone's world is, in many ways, the polar opposite of the feminist convention. But the two have in common a tendency to reduce the many to the one: the latter to "man" and the former to "woman." The 10,000 conquests Katzone is celebrating, as well as the video gallery of innumerable lovers that Snàporaz discovers in Katzone's villa, reduce women to sexual objects. His obsessive veneration of "Mama" suggests that there has really only been one woman in his life—and all others have been compensation for her loss or absence. But most telling, when he announces his decision to renounce all women, he refers to them as "…Woman… Woman with a capital W." This, of course, anticipates Snàporaz's quest for his one, ideal, Woman. On the other hand, the 10,000 conquests, celebrated with 10,000 candles on a huge cake, and the innumerable videos in Katzone's gallery deny singularity. His house is filled with heterogeneous people to celebrate with him. And relationships are inflected with complexity. He is the last person in whose home one would expect to find Elena, but…. The military police who arrive include, of all people, the furnace-stoking biker. And another policewoman turns out to be a good friend of Elena's. When Snàporaz is put to bed in the master's bedroom, there are numerous women attending him. The scenes in the gladiatorial complex and arena are filled to overflowing with diverse multitudes.

The issue of multiplicity vs. singularity is important in addressing Snàporaz's fanny fetish in *City of Women*. The term Fellini invents for it in Italian is "culità," based on "culo" meaning "ass." "Assophilia" might be an accurate equivalent. There are several instances in which women's derrieres are prominently displayed. The "singular" response, a la the Signora—and a response common to many Fellini critics—would be to dismiss them all as simply Fellini's hang up, here and wherever they appear in Fellini's work. However, consistent with what he does when the young child sees the "monumental" rear end during a school slide show in *Roma*, Fellini contextualizes and complicates the issue. He also draws attention to the fact that it *is* an issue, by having the two soubrettes who entertain and coddle him at Katzone's ask him "how is it possible that that's the only thing you notice?" In terms of contextualization, Snàporaz shows us that his fetishizing was

born in his first full sexual experience, at a bordello. The scene is frightening. The Madame is an automaton. The woman who introduces him to intercourse is stern and unwelcoming—a bespectacled school teacher type, reflecting her educational function. Perhaps most important, the bordello is under bombardment. Added to this is the inevitable anxiety around a male's first sexual encounter. Amidst all this, the only thing he can focus on is the behind of the woman as she leads the way upstairs.

The objectification of the derriere is the result of a complex psychological experience that encompasses desire, alienation, death (or its threat), intimidation, and a sense of being overwhelmed. Snàporaz's psyche, in its state of fright, holds on to one image that becomes overdetermined from that moment on. The image from behind of a widow polishing a grave, though shown before the bordello scene, represents reinforcement, later in his life, of Snàporaz's experience of the connection between the ass and not just sex but mortality.

The bordello scene is also quite complex in its representation of subjectivities. We see the disproportionately huge image of the sex worker's ass, which is, we might assume, the point of view of a highly stressed Snàporaz who has, in effect, dissociated from himself. The image of her rear end, on which he has fixated, is now all he can see—magnified tenfold. At the same time, the image of the ass is linked to a number of people watching and whispering. (We don't see them, but we hear them.) The whispering continues until the woman turns around, stares firmly at the chatterers, and silences them. In this context, the watching, commenting crowd seems to be Snàporaz's superego, administering guilt for having sex and being at a bordello. As well, it implies his imagining himself watched as he has sex (i.e., his extreme self-consciousness). The woman's silencing of the voices thus reflects (in Snàporaz's memory) a sensitivity to his needs that humanizes her. We also see him as a character in the scene, tiny beneath the imposing body of the prostitute. This would be the site of his actual subject position, though quite significantly it is divorced from anything resembling point of view. Instead, the woman's formidable gaze provides the most effective and powerful embodiment of subjectivity, revealing Snàporaz's awareness of her agency and undermining any simplistic Signora-style assumptions about female objectification.

There is at least one other way in which assophilia is meaningfully complicated. When Katzone has retired, an old woman presides over a vaudeville routine by Donatella and one of the several "Loredanas," who appear in the film as her sidekicks. The two women have bare asses, which might prompt the more judgmental viewer to leap to the response "Maestro, not again." However, as they dance and eventually walk ahead of him up the stairs, Snàporaz does not display any sexual desire. He is lost in nostalgia remembering the "Duo Smash" performers whom the women reincarnate, and he joins unerotically in their dancing with a few his

own, Fred Astaire-like, moves. As they ascend the stairs, his gaze follows but does not focus on their rear ends. What we see instead is an expression of total bitter-sweet recollective absorption. Fellini here de-fetishizes, de-assophiles Snàporaz, affirming that women's bodies can be expressive and scantily clad without inciting "erotomatic" responses. (We had witnessed something similar when a frazzled and frightened Snàporaz entered the elevator at the convention and remained oblivious to Donatella's attractiveness.)

In sum, Fellini's representation of male desire and female desirability is certain to offend some sensibilities, but it is never superficial or thoughtless. It is always contextualized and nuanced.

Multiplicity and complex interconnectivity characterize (inevitably) Snàporaz's experience in the film's final scene. As he awakens from his failed ascent to attain his Ideal Woman, he is back in the train, now seated across from Elena, not the Signora, though she is dressed much as the Signora had been—complicating sig-nification for the protagonist. Snàporaz is no longer limited to one female com-partment mate. Elena is quickly joined by the Signora, while Donatella and her soubrette companion Loredana appear as students. Elena and the Signora seem to know each other, or at least share some common but unexpressed understanding of Snàporaz. And both look at Snàporaz in such a way as to suggest they know things about him that he does not know about himself. The young students' obliviousness to Snàporaz's presence is refreshing and comical given their earlier dream-dictated catering to his neediness. The appearance of dream figures sug-gests that the magic of dream logic has now penetrated his waking reality, in a positive way. Perhaps it is this that gives a puzzled but accepting Snàporaz the confidence to go back to sleep perchance to dream, comfortable with the mys-teries of life and of women.

There is also something much larger at stake. Women have repeatedly been associated with death in Snàporaz's dream. In conjunction with Snàporaz's age—and frequent references to it in the dream—we can read the opening images of the camera eye hurtling toward the darkness as Snàporaz's fear of mortality. His womanizing then becomes his evasion of addressing/accepting the inevitable—yet for this very reason, women and death become, at times, inseparable. In his chute flashbacks, he looks like a cadaver in the final two images of the German nurse at the spa. The two daredevil motorcyclists he recalls, Angela and Ginette, perform the "Circle of Death." His "assophilia," as I have already noted, is linked to bom-bardment and reinforced by a widow polishing a grave. Women appear several times in terrorist garb or as Nazi/Fascist military oppressors. And, of course, his encounter with the Ideal Woman ends with him being shot down. And though he does not plummet to earth, the fear of so doing gets displaced onto an apparition of four startling female faces, which become progressively older as they appear.

Ultimately, as Fellini has noted on many occasions (see Bachman, passim), women represent, for man, the unknown: everything—particularly about himself—that he cannot and never will understand. For this reason, the relationship of men to women (speaking of course in heteronormative terms) is metaphysical. Epistemology (knowing and the mastery promised by knowledge) is defeated, as is ontology (the capacity to determine the nature or "essence" of objects and beings). The relationship is always in some way under erasure, porous with dark holes and ruptures, obscured by a million points of blindness. It is fraught, mystifying, frightening, enticing, and addictively open ended and irresolvable. In coming to terms with the inexplicability of women's roles and presence in the final scene, and especially in withdrawing his formerly oppressive subjectivity, Snàporaz is accepting not just an immediate, present enigma, but the full enigma of living.

Just as women are freed of an oppressive Snàporazian subjectivity, so is the film. The dream is ended, and after Snàporaz settles down to sleep (again), and the camera eye hurtles toward and into a tunnel (again), we do not cut back to Snàporaz. He is no longer the implicit author of this imagery. A new kind of reality has been created, confirmed by the small light that appears at the end of the tunnel in the film's final seconds. The notion of a movie-camera reality different from subjectivity and traditional (literary) point of view has not only been with us at least since Dziga Vertov,[16] Fellini has invoked it on several occasions, as discussed earlier in this study: when the abandonment of Guido's film in 8½ is followed by an explosive vision unanchored to his subjectivity; when the abandonment of Fellini's documentary in The Clowns is followed by the marvelous "rebirth of the clown" that ends the metafilm; and when the documentary camera has been stolen near the end of Roma and a motorcycle ballet magically unfolds, offering a seemingly unscripted opportunity to see things in a radically new way.

But perhaps the closest analogy to the end of City of Women lies in the ending of La Dolce Vita when Paola—Marcello and his fellow debauchees having exited the scene—is suddenly able to find the camera eye and us, forging a direct and compelling relationship that was not possible in the company of the sweet-lifers. While misdirected desire seemed to be the obstacle to numinous interaction in the earlier film, it seems to be male subjectivity—Snàporaz's dream and projections—that obscures the light at the end of the tunnel in City of Women. Once Snàporaz is out of the way, that light can appear.

The light can be viewed in other and even somewhat contradictory ways, consistent with Fellini's insistence on multiplicity rather than singleness of meaning. It is a cliché, a cartoon "panel," in this film so full of them. And the camera eye never gets any closer once the light appears. The light remains a distant and inaccessible bobbing circle. In this respect, it seems to exceed any restrictively narrative role and point to the human capacity to find reasons, even if self-delusory and laughable,

to keep on keeping on. The promising but undelivering light is also an invitation to value the journey over the destination.

For Fellini, that journey means making movies, and the light's appearance following the final credits suggests that it lies beyond the end of *City of Women*, luring the director to make yet another film. "You again Federico? Please maestro." Whatever the next film might be, it will, like *City of Women*, provide not answers but a glimmer of light—and the incentive to keep on going. Something quite similar will occur with a "ray of light" at the end of *Intervista*.

In concluding this segment of my discussion of *City of Women*, I would like to draw attention to the extent to which the film is a throwback to high-energy works such as *La Dolce Vita, 8½,* and *Juliet of the Spirits*—films of countless characters and constant motion, with people and images entering and exiting the frame in dynamic and surprising ways. The energy of those films recurs here through all the means of connection and movement. We have noted the tunnels, corridors, chutes, and ladders—sites of transition and connection. There are also trains, elevators, sliding poles, roller skates, stairs, motorcycles, cars, planes, the cart that takes Snàporaz to the gladiator complex, and the air balloon. His dream is a world in which everything seems to lead somewhere else, connect with something or someone else, generating not only multiplicity and diversity but ceaseless transformation.

And the Ship Sails On

Given its focus on an opera company, *And the Ship Sails On* (1983) might be seen as homage to Nino Rota and his love for opera (Alpert, 270). Given the absurdity of the company, however, it is more likely that the film reflects a combination of cultural reverence for and comic distance from Italy's dominant musical art form, of which he talked in increasingly positive terms later in his life. Like *City of Women, And the Ship Sails On* reproduces aspects of earlier Fellini films while, in crucial ways, undermining the "originals" by highlighting issues of reproduction and simulation. In fact, *And the Ship Sails On* seems to combine aspects of *La Dolce Vita* and *8½*. Like the former, it focuses on a journalist, thus promising to raise issues central to *La Dolce Vita*: the subversion of realism, the shortcomings of a protagonist who records rather than creates experience, and so on. Certainly, media and reality are central concerns in the film:

> It seems to me that [*And the Ship Sails On*] refers to ... the unsettling effect ... which an excess of information can have—the information of mass media, completely stripped of responsibility, a river of lava which covers everything.

> I refer to that invasion of news which accustoms you to a kind of contact with reality that is completely mediated by that very news, as a result of which you no longer know directly what is the world and life but end up knowing only through the vitreous and milky eye of television.[17]

However, whereas *La Dolce Vita* offers the viewer a recognizable social and geographical real—along with the intrusions and simulations of media—*And the Ship Sails On* (like *Fellini's Casanova, Orchestra Rehearsal,* and *City of Women*) denies such a real from the start. All is film, all is media, all is sign without referent.[18] Whereas *La Dolce Vita* tends to suggest that meaningful reality is being ignored, *And the Ship Sails On* implies that it no longer exists. Moreover, while *La Dolce Vita* presents its protagonist as a realistic and potentially self-determining figure with a choice between creating (writing "literature") and merely recording (remaining a journalist), *And the Ship Sails On* turns its protagonist, Orlando, into a kind of comic-strip figure, a two-dimensional character within a story that itself is entrapped on celluloid. Orlando ends up being completely produced, and his references to a personal diary seem more the clichéd posturings of a fictional "type" (over-the-hill hack) than the reflection of a meaningful inner life. Consistent with this, he functions only sporadically as a center of consciousness, whereas Marcello in *La Dolce Vita* was more consistently central to the action.

Like *8½, And the Ship Sails On* is a film about film. It opens with the sound of a projector[19] and evolves in the first sequence from black-and-white silent documentary to silent comedy and finally to color musical comedy. Near the end it briefly abandons the fictional world of its story (that is, the ship) to reveal the filmmaking apparatus of Cinecittà, and it concludes with cartoonlike images accompanied, again, by the sound of a projector. However, the humanist dimension of *8½*—the struggle of an individual to come to terms with himself—is entirely lacking. Moreover, while film is seen in the former as a potential instrument of self-scrutiny and self-discovery, it is pure fictional and mechanical reproduction in the latter. *And the Ship Sails On* begins, in effect, where *8½* leaves off: with the death of the author and "subject." (Actually, despite its surface similarities to *La Dolce Vita* and *8½, And the Ship Sails On* ends up having more in common with *The Temptation of Dr. Antonio,* which Fellini made between the two earlier films.)

For further useful parallels to earlier Fellini films, we can look to the three films that immediately precede *And the Ship Sails On: Fellini's Casanova, Orchestra Rehearsal,* and *City of Women.* Some surface similarities are immediately apparent. The train in *City of Women* becomes a ship, reprising the theme of a restricted, controlled journey outside the direct control of the passengers. The symphony of *Orchestra Rehearsal* becomes an opera company, recapitulating the issue of closed communities organized in terms of artistic role rather than personal compatibility

or individual need. And the domination of fictional or artistic structure (memoir in *Fellini's Casanova*, music in *Orchestra Rehearsal*, dream in *City of Women*) becomes "tripled," via opera, journalistic narration, and film in *And the Ship Sails On*. The parallels I would most like to pursue, however, are political allegory (*Orchestra Rehearsal*), signification or surficiality *(Fellini's Casanova)*, and both the paradoxical relationship of interior and exterior and a fraught relationship with otherness *(City of Women)*.

Like *Orchestra Rehearsal, And the Ship Sails On* seems to originate at least in part from an impulse for political or social commentary. It situates itself at the outset of World War I, alluding to the assassination of Archduke Ferdinand of Austria, simulating the sinking of the *Lusitania,* and culminating in the representation of military violence triggered by a confrontation between Austria-Hungarians and Serbs. At the same time, the issue of assassination evokes a more recent referent, the killing of Aldo Moro, which influenced the making of *Orchestra Rehearsal* and suggests Fellini's continuing preoccupation with terrorism and the violent irrationality of an Italian politics of radical disillusionment. More broadly, the film's company of opera singers can be seen, like the musicians in *Orchestra Rehearsal*, to represent a general social malaise characteristic both of Europe at the outbreak of World War I and Italy in the 1980s. Like the orchestra, the singers can be accused of "[not] paying attention," of "ignoring [their] responsibilities"—lost in a self-indulgent and exclusive art world—while crucial political events are unfolding. Like the orchestra, the company lacks any inner cohesion. It is, both literally and figuratively, "at sea," and the film again and again emphasizes uprooting or dispersal: the movement away from the Italian mainland, the scattering of the recently deceased diva Edmea Tetua's ashes, the mysterious appearance of exiled Serb gypsies, and the ultimate evacuation of the ship.

The singers, like the orchestra members, are egoistic and competitive, making the outbreak of war a kind of inevitable, metaphoric, extension of their bellicose behavior. They are also entirely dependent on authority: the ship's captain and militarist crew, the company's conductor (less visible than his counterpart in *Orchestra Rehearsal* but of similar importance musically), and the dictates of the deceased "goddess," Edmea Tetua. The company's insularity, exclusivity, and elitist aestheticism turn political and historical reality into an inaccessible "other" represented on the ship by the Austrian contingent with whom the singers have no contact and ultimately embodied by the Serbs and Austro-Hungarian warship, both of which come from without. Like the wrecking ball in *Orchestra Rehearsal,* World War I functions as an external apocalyptic force that renders the film's characters helpless and reactive.

Here, as in the earlier film, we have a metaphoric Fellinian evocation of Italian society: weak, self-indulgent, collective in a negative sense, and ever ripe

for domination—whether by Fascism, terrorism, or a global upheaval occurring largely through society's indifference. Two historical points might well inform the film's implied critique of indifference: (1) Italy remained neutral at the outbreak of World War I, and its eventual involvement was marked by serious political and military problems, and (2) the war—and Italian ambivalence toward it—contributed to the rise of Mussolini and the birth of Fascism. As with *Orchestra Rehearsal,* however, we never get beyond the domain of broad historical allusion. Moreover, the absurdity of the film's historical dimension ends up dissolving any context for serious analysis or commentary. The Austrian entourage is bizarre to the point of political irrelevance, the Serbs' appearance is inexplicable, the sinking and evacuation of the *Gloria N* (ne *Lusitania)* are pure mock-opera—in short, World War I seems far removed from the hermetically absurd events of the movie.

Ultimately, history, politics, and the social are replaced by the media and mediations: voice-over narration, journalism-become-pure-fiction, contemporary (1980s) film simulating film circa 1914, and so forth. Put another way, the film's social commentary consists solely of an analysis of the domination of the media, precisely because the media *are* our contemporary social "reality," rendering a more direct encounter with a historical or social real impossible. *And the Ship Sails On* implies that everything in the contemporary world, including history, is produced as absurd fiction. We ourselves are produced as spectators, disempowered and dissociated from what we see, continually on the verge of an apocalypse that itself is more fiction than reality, with no possibility of social transformation, no new world to follow.

In effect, then, the message is effaced by the medium, and any stable construction of meaning is impossible. This is aptly illustrated by the scene in which Orlando interviews the Archduke about the impending war. Orlando asks how the Archduke views the international situation. The response, channeled through a translator, is, "We're sitting on the edge of a mountain." Orlando scrupulously transcribes this while trying to surmise what exactly it means. The Chief of Police then corrects the translator, who maintains that the Archduke said "mouth of a mountain." In response to Orlando's continuing perplexity, the Prime Minister explains (again through the translator) that the Archduke has used a metaphor and that "it's not a question of mouth or edge." Then the interpreter and the Chief of Police get into a heated argument over whether it was mouth or edge, and the Archduke suddenly exclaims, "Pum! Pum! Pum!" This creates further confusion for Orlando, who wants to know if the Triple Alliance is renouncing its commitments. The Archduke then marches forward and shouts, "Pum! Pum! Pum!" He insists that his outburst be translated, and the translator dutifully complies: "Pum! Pum! Pum!" Orlando ponders for a moment then suddenly has a flash of illumination: "The mouth of a mountain. The crater of a volcano. We're

sitting on the mouth of a volcano." He and everyone else are so relieved that the crisis of translation has been resolved, they all laugh hilariously—even Orlando, who treats impending world cataclysm merely as the delightful solution to a verbal puzzle: "It's perfect! Now I understand. It's a tragedy. Thank you, thank you. The mouth of the mountain. Certainly, it's a catastrophe." Utterly detached from reality, the characters focus solely on signifiers, not signifieds.

The priority of signification over reference is present from the outset of *And the Ship Sails On,* even before things become absurdly fictionalized. When the movie starts off with the sound of a projector over scratched black-and-white film, we seem to be watching historical footage of an event circa 1914. In short, we seem to be in the realm of documentary or "objective truth." This is, in a sense, confirmed when a man enters screen right, looks at the camera and poses, is eliminated (deliberately) when the camera pans left, reenters the frame to again look at the camera, and is yanked out of the frame. The man does not "fit" because he draws attention to the camera, inscribing its presence and "subjectivity" rather than preserving its invisibility as an objective recorder of facts. However, rather than validating the objectivity of film recording, this comical event underscores the fact that objectivity is itself based on codes, the product of a carefully shaped relation between camera and event.

When the black-and-white film continues to give us on-site coverage of events, as well as jump cuts that seem to convey not editing in the sense of shot selection but the splicing together of old and damaged pieces of film, we are inclined to read "old and damaged" as "historically authentic." However, the film's highlighting of codes soon encourages us to realize that we *are* reading or translating rather than encountering reality as it really was. As this happens, we begin to get match cuts, and the pseudo "recording of reality" quickly gives way to the construction of narratively coherent actions and relationships. The camera even begins to pan right in anticipation of certain characters about to enter the frame. The documented has now become the staged. We begin to get medium close-ups, and the camera soon allows itself to be acknowledged by characters on screen.

Next there is shot-reverse-shot and so on, as the opening sequence evolves gradually into a full-fledged, classically coded, color and sound narrative. As this occurs, we get interesting reversals that further accentuate the arbitrariness of documentary coding. On the one hand, color cinematography and sync sound are more "real" than black and white or the sound of a projector, because we perceive the world in color and in "sync sound." However, because they are associated with the movement of *And the Ship Sails On* into fiction, they come to bespeak "realism," a stylistic and technical coding system, rather than "reality." The film also plays on a historical paradox and reversal: with the increasing domination of color in fiction films from the 1950s to the present, we have come to

identify "truth" or "reality" with the "unreal" black-and-white of documentary. (Black and white was initially more economical, hence a necessity for documentary filmmakers working on much lower budgets than Hollywood.) In short, the opening sequence becomes both more and less realistic at the same time, underscoring the arbitrariness of our notions of real, realism, and realistic. In this light, documentary becomes not the opposite or alternative to fiction but just another form of it.

The introduction of Orlando into the paradoxically fictional landscape of documentary underscores journalism as make-believe. He begins by grumbling (as "translated" on intertitles): "Get the news, tell them what's going on. But does anybody know?" His very skepticism dims the hope for factuality. Then, he starts posing for the camera, trying on different hats, and becoming more and more comical as he seems to ape Gelsomina doing *her* Charlie Chaplin routine in *La Strada*. He then waves to the camera—not only us, but a movie camera within the film—and both he and the cameraman begin shooing children out of the way so that the "perfect picture" can be had.

Once journalism is introduced as make-believe, history, too, can easily be dismissed as fiction, and the outbreak of World War I can serve as a plot motivator in a ludicrous story rather than as an actual momentous event. Perhaps more to the point, history gets arbitrarily injected into fiction and vice versa, so that history and fiction are equally revealed to be mediations, rather than opposites in a truth/illusion dichotomy. Consistent with this, the most dominant figure in terms of narrative motivation—Edmea Tetua—exists only as a complex of signs: photographs, a home movie, a bust, a recording, her will, and, most pervasively, the stories people tell about her. Edmea the great "original" exists only through reproductions.

The radical fictionality of experience is also central to the film's treatment of narrative and Orlando as narrator. Initially, he is in charge, exerting a good deal of control over what we see and know. However, once military and historical factors intervene, he becomes marginal and stops narrating. This seems to signal a shift from fiction (that is, storytelling) to reality (events relating to World War I). Suddenly, however, there is another shift. As the ceremony honoring Tetua concludes and the Austro-Hungarian warship looms on the horizon, Orlando leaves the main deck, enters his cabin, and narrates nearly all the remainder of the film. Moreover, the nature of his narration changes. Earlier it was based to a large extent on reportage. Now there is no reportage whatsoever, reflected by Orlando's physical removal from events. Fiction, in short, returns with a vengeance to wrest the film from its temporary and tentative encounter with history. Consistent with this, Orlando invents a scenario in which the luxury liner refuses to surrender the Serbs on board: "It would have been even more beautiful if we, in the face of [Austro-Hungarian] bullying, had said 'No, we will not give them to you.'" His

words are accompanied by comically operatic singing and posturing on the part of the company ("No, no, we'll not give them up!"). Then this moment of fabricated rebellion is succeeded by operatic romance, as a young Serb revolutionary and the ethereal young Dorotea find each other and true love, complete with lush musical accompaniment, dramatic zooms, close-ups, and love-struck posing for the camera.

Not only does Orlando invent fictions, but his only remaining relation to actual events is speculation from the far remove of his stateroom: "It is almost impossible to reconstruct the exact order of events. It seems that everything originated from the thoughtless act of the young Serb terrorist who threw a bomb against the side of the battleship." Even his speculations become increasingly qualified: "But is it possible that...? Are we entirely sure...? Others say ... still others maintain. ... Then there is a fourth version, which I don't even dare relate." His final stab at explanation—"It seems that"— ends in mid-sentence: speculation without any content whatsoever. While he emphasizes the impossibility of determining the truth of any one version of the story, Orlando still shows us "footage," as we see the young terrorist (the youth from the operatic romance) lobbing a bomb at the warship—and the warship exploding. This creates an irresolvable conflict between showing and telling, with the former (the usual source of journalistic credibility) undermined by the latter. The eradication of truth and the real is further reflected in the fact that Orlando narrates in the past tense, indicating that the events he is speculating about have already taken place, while he hastily changes into a bathing suit and prepares to jump ship, as though the events are occurring in the present.

Orlando makes one last stab at reportage, at anchoring things in the realm of the factual, as the film comes to a close: "I want to say that many of the people you have met were saved. A hydroplane recovered the survivors from the lifeboat *Aurora*. The lifeboat *Sea of the North* arrived miraculously at Ancona." Here there is no showing, only telling—and the fact that Orlando is sitting in a lifeboat with a rhinoceros makes it rather difficult to take him seriously. Moreover, he then professes ignorance ("I have no information about the rest") and then ends the film with a ridiculous comment: "As for me, I feel that I have great news to give you. Did you know that the rhinoceros gives great milk?" The word "news" in this context underscores the dissociation of the media—and Orlando as reporter—from meaningful events. And the fact that Orlando whispers these final words to us so that the rhinoceros cannot hear brings his role in the film to a close on the level of gossip, which is entirely consistent with the film's critique of the media and mediation.

In short, Orlando becomes the highest authority—the voice and the eyes— within the film as the film detaches itself from a reportable real. And, despite his narratorial authority (and contrary to what I implied earlier), he is not *really* in

control. As in *The Temptation of Dr. Antonio,* the ultimate authority becomes the mechanism of cinema—relentlessly producing fiction beyond human determination. As the evacuation concludes, the camera pans away from a cameraman, on board ship, presumably recording the "catastrophe," and begins to focus on the filmmaking crew and equipment at Cinecittà. The technicians seem attached to their filmmaking machinery, and the replacement of location sound with gentle music turns their activity into a disembodied, mechanical ballet. (**Figure 9.4**) Perhaps most important, there is no director, no Fellini, just the unauthorized process of filming.[20] The sequence ends with a camera on screen dollying toward the "meta" camera (that is, the one filming all the action) and the latter zooming into the former, creating, in effect, a marriage of glassy, technological eyes. There is not even a definable reflection of the one in the other. All content collapses into representational apparatus.

At this point Orlando appears as a distinctly cartoonish image in a rowboat on sepia-tinted, scratched, heavily spliced film. At the same time, the location sound that briefly returns following the move out to sea gives way to the sound of a projector. In both respects Orlando is reduced to an image on a filmstrip whose existence will end with the running out of the film. When the film concludes with an iris-in, he falls victim to a cliched cartoon ending, and the film concludes as it

FIGURE 9.4 *And the Ship Sails On* unveils the machinery behind the making of the film as the film moves to a close. Source: *And the Ship Sails On* (1983). Directed by Federico Fellini. Produced by Rai1, Vides Production, Gaumont, Società Investimenti Milanese. Frame grab captured by Frank Burke from the 1999 DVD version.

began: the mere simulation of old movie footage. The iris is not even a filmmaking strategy but a laboratory optical, further emphasizing the removal of the film from a "real."

The reduction of everything to mediation links up with an issue crucial to *City of Women*: interiority. In *And the Ship Sails On* the focus seems to be on the absence, inaccessibility, or emptying out of the interior rather than on the infinite reversibility of inside and out. There is a recurrent obfuscation of motive—and the consequent necessity on the part of the viewer to merely speculate about characters' intentions on the basis of their purely external behavior. In contrast to such films as *8½*, *Juliet of the Spirits*, *Toby Dammit*, and *City of Women*, there is no "inner life" either of images or interior monologue from which we can ascertain intent. For example, on the first day of the journey, as light of day gives way to darkness, we seemingly move from the externals of ship life to the inner life of several characters. Most extensively, we view the highly charged "love life" of Sir Reginald and his wife, Violet. However, their emotional energy is fueled entirely by innuendos of infidelity, and Reginald seems to get off only on Violet's simulation of nymphomania. Because there is no evidence, only implication, we cannot finally fathom what, in fact, their relationship and (pseudo)sexuality are based on.

Similarly, as a recording of Edmea plays during her memorial service, Hildebranda becomes inconsolable. Is she experiencing grief for the departed Tetua or a sense of inferiority as she listens to the voice of her great rival? The latter seems more likely than the former, as we have seen earlier indications of apparent resentment for Tetua's talent. However, she could finally be coming to terms with her jealousy and perhaps even acknowledging Tetua's greatness. It is impossible for us to know.

The most opaque figures in the film are the Austrians, whose interiority is both foregrounded and effectively denied, because it is so thoroughly concealed. The princess is blind, a figure of inward rather than outward vision. She confirms her inwardness by talking in dream allegories to the Prime Minister. The word *dentro* ("in" or "inside") is used repeatedly when Orlando tries to get an interview with the Archduke, as his wanting to get "inside" is feared as espionage. The relationship between the archduke and his sister (the Princess) is virtually incestuous in its inwardness. Yet, the Austrians' interiority is never breached. Orlando can only access the ludicrous interpreters' aforementioned squabble. And even though we witness some relatively intimate moments between the Princess and both the Prime Minister and the Archduke, we end up stymied as to the nature of the political intrigue implied yet concealed by that intimacy. Following the ash scattering, the Austrian Chief of Police informs the Prime Minister he is under arrest on orders of the Princess. This contradicts everything we might have assumed about the earlier plotting between Princess and Prime Minister. Moreover, as the arrest takes place,

we cut to the Princess at a window, seemingly sighted. Is it possible she is *not* blind? Was her inner vision itself only an appearance? The upshot of this world of missing or opaque interiority is wholesale evacuation. Most obviously, the travelers are forced to abandon their ship. The rhino, who serves as an absurd symbol of interiority for the company (it is described as "lovesick"), ends up expelled—first from the hold, then from the ship. (The rhino himself is an "evacuator," suffering from diarrhea!) Evacuation, of course, links up with the motif of projection, which culminates in the final moments not only with the sound of the projector but with the Count di Bassano watching films of his beloved Tetua instead of leaving the ship. And finally, evacuation comes to characterize the relationship of history or the "real" to the media, as all meaning is vacated as the product of pure mechanical-cinematic reproduction.

Although I have tended to treat *And the Ship Sails On* as an all-out assault on reference, my analysis should also make clear that the film itself is anything but meaningless. Its relation to the real is far more than simple denial. On one level, especially if we invoke Fellini's own comments about mediation and the loss of the real, the film constitutes a consistent questioning of the conditions under which meaning is created. In other words, the defeat of meaning within the film is circumscribed by a consistent methodology and theme that ensures a significant level of coherence. This is somewhat paradoxical as meaning ends up depending on its own denial—and rushes in to fill the vacuum created by its loss. In this respect, and from the perspective of postmodern notions of signification, meaning becomes a form of nostalgia: an absence masquerading as a presence. Consistent with all Fellini's final work, *And the Ship Sails On* remains quite hermetic. It becomes a perfect model of the media solipsism Fellini so much deplored—which can be seen either as clever critique or an unfortunate reproduction of the very problem it seeks to address.

Ginger and Fred

Ginger and Fred (1985) was the last Fellini film to receive theatrical distribution in North America prior to his death. It offered him an opportunity to make one final film with his two principal "stars" and two of his most intimate companions: Giulietta Masina and Marcello Mastroianni. It also offered him the opportunity to satirize with sustained vehemence the bane of his latter-day existence: television.

As a film detailing two days in the lives of a couple come to Rome, *Ginger and Fred* recalls *The White Sheik*, with crucial differences and similarities. In the latter Ivan and Wanda are a married couple on their honeymoon, visiting Rome for the

first time with aims, at least on Ivan's part, of meeting the Pope. In *Ginger and Fred*, Amelia and Pippo (Ginger and Fred) are a vaudeville duo who never married and who are returning to Rome to reprise their former dance routine for a Christmas television spectacular. Marriage seems out of the question in the more contemporary film, and religion, even as mere institution, has no place in the radically secularized Yuletide world of mid-1980s Rome. On the other hand, just as Ivan and Wanda's relationship ultimately ends up defined entirely in terms of *fotoromanzi*, Ginger and Fred are defined solely in terms of television. The centrality of the media in each points to an extraordinary commonality of concern, despite radical reconfigurations of that concern, throughout Fellini's career.

Ginger and Fred returns in some measure to the kind of coherent narrative and characterization we associate with Fellini's earlier work. Yet this is not in the interests of recuperating a stable, comprehensible means of reasserting humanist individualism. It is partly because *Ginger and Fred* imitates Astaire/Rogers films, with their formulaic, classic Hollywood narrative and dramatic structure. In this respect coherence, meaning, and character (or identity) do not comprise anything authentic, along the lines of Fellini's narratives of individuation. Rather, they are mere "imitations" or, in terms of a crucial theme in *Ginger and Fred*, "doubles." At the same time, narrative functions within *Ginger and Fred* to reflect the absorption of everything, including classic Hollywood film as referenced by "Ginger" and "Fred," into the world of the purely televisual, a world without narrative, development, character, or meaning. This is part of the reason that the kind of happy ending that so often occurs in Astaire/Rogers films does not transpire in *Ginger and Fred*. The kind of climactic dance that symbolizes or effects resolution in Astaire/Rogers is followed in *Ginger and Fred* by letdown and anticlimax, as Fellini departs from classic Hollywood coding to critique it.

Narrative Process

For my purposes, the most significant narrative process within *Ginger and Fred* is Amelia's incorporation into the world of television. As a realm of make-believe similar to that of the *fotoromanzi*, television seems to represent illusion, while Amelia seems to embody a more concrete relationship to life, reinstituting the familiar Fellinian overtaking of the latter by the former. However, this simple opposition does not really hold, as Amelia herself is a performer, and it becomes clear during the film's television extravaganza that the life of housewife and mother—what Amelia has become since her vaudeville days—is also a role, part of television's totalizing construction of our sense of the real.

At the start of the film, Amelia appears to have some independence from television. Though she has come to Rome to appear on the Christmas special, her motive

seems less to star on TV than to see Pippo. And though she quickly falls under the sway of TV representatives, she is able at least briefly to experience Rome directly. Moreover, in the opening moments, television itself is only part of the landscape rather than the landscape itself. On the other hand, the Rome Amelia encounters, as a compendium of advertising displays and billboards, is far more simulacrum than concrete reality. And the person with whom she has the most intimate contact early on—the transvestite Evelina Pollina—is above all a figure of spectacle, whose raison d'être is to have his/her story aired on TV.

Once Amelia enters her hotel room, the film emphasizes her susceptibility to television as well as to television's growing domination of her urban environment. She first practices dance steps and examines herself up close in a mirror, suggesting that her self-image is that of a performer. Then she turns from the mirror and her own image to the TV, which has already been turned on. Initially, she keeps it at a distance with the remote, but after placing a call to her daughter, she not only stops using the remote but gets up, moves closer to the set, and begins to reproduce what she sees (doing the facial exercizes broadcast on a youth and beauty show). By the time she moves off to the window and looks out, she can see little else but a huge television transmitter. And by now the light from the top of the transmitter has begun to sweep her room like a spotlight, turning it into a stage or studio. The TV never gets turned off before she leaves the room and ventures back down to the lobby.

Part of Amelia's susceptibility to television emerges from her fractious relationship to the contemporary Roman world. As she stands outside the hotel enjoying the shenanigans of her television co-stars, she is intimidated by masked figures on motorcycles. And as she walks alone back toward the hotel, she is terrified by an apparent drug addict. She is in fact "saved" by the television van, which arrives with a group of performers, and she is virtually forced by her experiences back up to her room, to watch TV and hope that Pippo will arrive.

Her encounter with Pippo would seem to be a turning away from television to something more authentic and personal. However, despite his occasional moments of rebellion, Pippo functions entirely, albeit unwittingly, as television's agent. This is subtly implied by the fact that we never see Pippo, like Amelia, enter Rome and the world of television. He is, in fact, already within. Moreover, he never leaves. At film's end he decides to remain in Rome to seek a job as a TV host.

With Pippo on the scene, the inexorable process of "televisualization" accelerates. On the following morning, the hotel lobby turns into a rehearsal space. Next there is the bus ride to the CST studio, where Ginger and Fred become TV images (on a surveillance monitor) as soon as they enter the lobby. Everything at the studio, in turn, is geared toward turning them into TV performers. After the show, the train station seems to offer an opportunity for the pair to free themselves

from TV. However, a moment of potential intimacy is interrupted by two young-sters who have seen the special and ask, "Are you Ginger?" She says, "Yes," she and Pippo sign autographs, and intimacy never materializes. Their final moment of communication is then articulated in terms of the Ginger-Fred romance, which has become their television, not just vaudeville, identity. As she prepares to board her train, Pippo calls out to her and makes the ship-horn sound that marked the beginning of their stage routine. She responds briefly in character then shrugs and moves off. We might see her shrug and her movement away as a renunciation, at long last, of the Ginger-Fred role. However, their relationship past and present and the sadness of their parting suggest a less upbeat view: Amelia and Pippo have only existed as a couple to the extent that they have been Ginger and Fred. Without the latter there is no former.

Television, Simulation, and Reproduction

While virtually everything 1 have said about *Ginger and Fred* implies a consistency of plot and characterization absent since earlier in Fellini's career, the film also links up with Fellini's more recent films and their questioning of meaning and value amidst a constant play of signification and reproduction. One of the most obvious elements of reproduction is Fellini's (re)use of Mastroianni and Masina, which recalls the objection voiced at the start of *City of Women:* "Marcello yet again? Please, Maestro." With the use of Mastroianni in *City of Women,* (self)citation competes with originality, and the use of *both* Masina and Mastroianni in *Ginger and Fred* seems a pronounced substitution, especially as Fellini once renounced stars and familiar actors—including, specifically, Mastroianni and Masina—in a quest for newness and originality. Reproduction is, of course, emphasized in the fact that Amelia and Pippo must reprise their prior imitations of Astaire and Rogers. Moreover, the "original" imitations were themselves based on imitations (that is, Astaire and Rogers simulating characters on film), and the two movies stars are themselves "imitations," having effaced their identities of Frederick Austerlitz and Virginia Catherine McMath.

As the film's representation of television makes clear, the emphasis on imita-tion is not just specific to Amelia/Pippo and Ginger/Fred, nor to the television special on which they appear. It relates to the broader fact that, in a television world, everything exists only to the extent that it is reproducible, able to be turned into a marketable commodity. People must be interesting as a recogniz-able type (mafioso villain, military hero), a duplication of someone famous (all the "doubles" of figures from Clark Gable to Pope Pius XII), a source of titilla-tion or amazement (the transvestite, the various religious/miraculous types, the lover of an extraterrestrial), or even a reinforcement of our sense of normalcy or

the all-too-real (the vagrants). They exist only in terms of what they are seen as by other people. Most important, because market analysis involves determining what an audience will like on the basis of what it has liked in the past, marketability is determined by one's ability to be recognizable as a reproduction. This even applies to the shockingly new, which is experienced not in its novelty but as part of the familiar category of "the shockingly new," making originality itself a form and effect of reproduction.

The emphasis on "doubles," then, proves not just an isolated gimmick for the Christmas special, it is emblematic of the underlying logic of television programming itself. And when Fred tells a TV employee early on "I am Pippo Botticella, stage name Fred. I imitate anything," earning Amelia's approving "Bravissimo," we know that both "Ginger" and "Fred" are fully in tune with that logic.

The prominence of reproduction in the TV world of *Ginger and Fred* offers an intriguing variation on the Fellinian Second Coming. All the psychological rebirths and resurrections of prior characters (Cabiria, Guido, and Toby among others), all the reincarnations—mock and otherwise—of spirit in the world (the statue of Christ in *La Dolce Vita,* Eros in *The Temptation of Dr. Antonio,* Toby at the outset of *Toby Dammit),* and all the implied religiosity of Christmas Day have been reduced to the eternal return of Ginger and Fred and the market-driven doublings of television culture. (**Figure 9.5**)

Along with its seemingly infinite process of doubling, the TV world of *Ginger and Fred* is characterized by radical decontextualization. For the most part, people appearing on the show are meant to reference a reality that is never revealed. An admiral presumably saved a burning ship, its crew, and the port city that was threatened by the blaze; the transvestite supposedly provided sexual consolation for numerous young men in prison; a plastic surgeon has apparently bestowed beauty and youth on countless patients. However, all we ever get are interviews and reports on the original events, and the TV environment where the information is presented has nothing to do with the context in which the events occurred.

The destruction of context is especially pronounced when people are reporting on the seemingly impossible, such as the famous "flying monk" and his numerous miracles. It is carried to its most extreme with the whacky mother-son duo who claim to capture voices from beyond the grave on a tape recorder, without a microphone, left in a closed room. What gives this and all the other reported events their reality is not the likelihood that they happened but the fact that they are reported on TV, which has become the sole arbiter of the real.

Contributing to television's construction of the real is its desperate search for content. With cable companies broadcasting around the clock, there is insufficient fiction available to fill all the slots, so television must "program the real" via news shows and documentaries, "reality shows," and reenactments. As the Christmas

FIGURE 9.5 Fellinian Second Comings have become the endless reproduction of copies from other copies in a world of television simulation. Ginger and Fred reprise their stage identities from the days of vaudeville, when they imitated the movie personas of Rogers and Astaire—who "*persona*-fied" their original identities as Catherine McMath and Frederick Austerlitz. Source: *Ginger and Fred* (1986). Directed by Federico Fellini. Produced by Produzioni Europee Associati (PEA). Frame grab captured by Frank Burke from 2007 DVD version.

special demonstrates, all the "real" is fair game: wealth, spirituality, sexuality, heterosexuality, homosexuality, romance, kidnapping, terrorism, and so on. Moreover, there is no evaluation, interrelation, or comparison amid the proliferation of content. Because the only criterion is viewer appeal, the mafia and the Church (for example) can appear together—not because they represent conflicting moral issues, but because each is sensational.

If we couple TV's voracious obsession with the real with its reduction of reality to reports and simulations we have a medium whose principle mode of operation seems to be the total documentation of the completely unverified. This is the realm of "documentary allusion," of pure spectacle multiplied exponentially to the point where everything is "covered" (literally and figuratively) so there is, in effect, nothing to see. The supreme irony is that, for the viewer, the hyper allusiveness of television breeds the delusion of being completely in touch. Everything seems accounted for from the passive yet plenitudinous position of the couch potato.

As a black hole of the real, television ultimately turns all referentiality into self-referentiality. As Christmas Day progresses, not only do the TV monitors begin to dominate in the bus and the studio, but they refer solely to the upcoming show. The TV guest who precedes Ginger and Fred is there to witness to the trauma one can experience from going without television for a month. The film ends with an isolated figure watching television in the train station. Moreover, as he watches, an antenna salesman talks about people now being able to pick up broadcast signals without ever having to leave the house, even to go up to the roof. No longer associated with the representation of something outside it (such as the soccer game that the hotel employees were watching) or even with "allusions" to things outside it (the guests and their stories on the special), television is now identified only with perpetuating and enhancing the conditions of its own existence—and, in so doing, eliminating the need ever to get outside (it).[21]

Television is confirmed, then, as a communications system that serves only to signify and reproduce noncommunication. This, intriguingly, brings us almost full circle to concerns voiced by Fellini in relation to his earliest films: "Our trouble, as modern [people], is loneliness. … No public celebration or political symphony can hope to be rid of it. Only … through individual people can a kind of message be passed, making them understand—almost *discover*—the profound link between one person and the next" (FF, 61). Of course, the tone of these remarks suggested hope on Fellini's part. In *Ginger and Fred* all that remains is parody.

Television, movies, and high art

There is some irony in the fact that Fellini's critique of media ignores film altogether. After all, movies can turn viewers into "sheep" (a word Pippo uses to assail TV audiences in the course of one of his pseudo-political rants to Amelia). In fact, it can be argued that domination and manipulation are even greater with film, given the hugeness of the screen and the relative smallness of the audience, especially in Italy, where multiplex theaters had not become the rage even as of the mid-1980s. And while the TV viewer can change channels, the film has a captive audience in a theatre. One can also argue that the coherent happily-ever-after fictions of classic cinema are more coercive than the segmented, fleeting, pluralist, and closure-less constructions of serialized television. It seems curious that someone who has had a healthy career based on the willingness of people to submit to (his) fictions would be so critical of compliant spectatorship in the context of television.

A movie "cover-up" is not just specific to *Ginger and Fred;* it is present in *And the Ship Sails On*. On the one hand, this film demonstrates with great cleverness how movies can simulate just as well as television. On the other, in comments about the film quoted earlier, Fellini blames it all on TV. Equally interesting in Fellini's

television critique is his assault on fragmentation—something he praised at the time of *Fellini-Satyricon*. The disjoint seriality of television merits much of Fellini's parody in the Christmas special. And it was commercial interruptions that made him an outspoken critic of TV broadcasts of his films in the 1980s (see Bondanella, 221–22). Clearly there is a privileging here of film as unitive high art in contrast to the scattershot commercialism of television. This is intriguing given not only the mass-entertainment roots of film but the importance of cartoons and comic strips in Fellini's artistic development (Bondanella, chap. 1). It seems from the perspective of *Ginger and Fred* that Fellini's fondness for fragmentation remains a largely modernist fascination with parts that still (even if only vaguely) imply a whole, rather than a postmodern repudiation of unity. (Consistent with this are Fellini's comments at the time of *Fellini-Satyricon* about the "potsherds or pieces of masonry," which are meant to imply an original reality or complete object [Zanelli, 4].)

In fact, Fellini's stand on television seems a high-modernist reaffirmation of the very artistic integrity and authorial control that seem extinct in many of his late films:

> I ... think that the cinema has lost authority, prestige, mystery, magic. The giant screen that dominates an audience devotedly gathered in front of it no longer fascinates us. Once it dominated tiny little men staring enchanted at immense faces, lips, eyes. ... Now we have learned to dominate it. ... What a bore that Bergman! Who said Buñuel was a great director? Out of the house with them. ... Thus a tyrant spectator is born, an absolute despot who does what he wants and is more and more convinced that he is the director or at least the producer of the images he sees. *(Comments, 207–8)*

Equally intriguing, Fellini's remarks valorize cinema as thinly disguised Fascism and the director as the kind of unfettered authority who was portrayed so negatively at the end of *Orchestra Rehearsal*. The final irony in Fellini's conflicted relation with television involved Silvio Berlusconi, the largest private television magnate in Italy (and more recently prime minister of Italy). It was Berlusconi who rebroadcast Fellini's films with numerous commercial interruptions, compelling Fellini to take him, unsuccessfully, to court. Yet in 1989 Mario and Vittorio Cecchi Gori, whose projects Berlusconi funded, became the producers for *The Voice of the Moon*, Fellini's last film. Fellini did manage to get a clause inserted in his contract that prohibited Berlusconi from showing the film on his own network, and he managed to insert a mural of Berlusconi, being kicked in the bum by a waiter, within the film itself (Bondanella, 222).

In notes published with the Italian screenplay of *Ginger and Fred*, Fellini yet again blasted the medium, decrying "the abnormal, the monstrous, the delirious,

the alienated, the exceptional-fall reproduced ... as the most obvious, normal, familiar, and customary aspect of the quotidian."[22] Fellini's description of TV could have been lifted from any number of reviews and criticisms of his own work. After all, he has been nothing if not the poet extraordinaire of "the abnormal, the monstrous, [and] the delirious." Is it possible that Fellini's profound aversion to the medium derived in part from the fact that it became, in true *Ginger and Fred* fashion, his own double or imitation, and not just an unwelcome intruder into his turfdom of the grotesque?

La Dolce Vita *revisited*

The importance of journalism and the media in *And the Ship Sails On* and of sensationalism and spectacle in *Ginger and Fred* invites a return to a much earlier Fellini film, *La Dolce Vita,* in which all four played important parts. It is especially interesting to see how a film made in a more modernist phase of Fellini's career presaged postmodernity—not because of any authorial intent but because the film was exploring a contemporary world verging on postmodernity. I earlier argued that *La Dolce Vita* sought to represent the recovery of innocence and authenticity, through a film-long process of annulment or "creative negation," leading to the concluding image and gaze of the angelic, virginal Paola on the beach. From the hindsight of postmodernity, I would now like to suggest ways in which the film points to the impossibility of such renewal in a world in which everything—including the real and the authentic—has turned into image, spectacle, and sign. Much of the following is at odds with my earlier reading of *La Dolce Vita*. I do not intend to efface that reading but rather suggest that different historical moments—including those in the oeuvre of an artist such as Fellini—can yield significantly different results in the analysis of a particular artwork. I suggested something of the same thing with my earlier double reading of *8½*.

A Society of the Spectacle. This phrase, employed by Guy Debord in his book of the same name to describe our contemporary, hyper-mediated, society,[23] is a perfect description of the world of *La Dolce Vita*. From the opening shots of the statue of Christ to the closing "apparition" of the monstrous dead fish, society in the film is fueled by the visually sensational. It is thus little surprise that one of the most persistent legacies the film has left us is the name of Marcello's picture-grabbing sidekick Paparazzo, now commonly used in the plural *paparazzi*, to denote freelance yellow-journalist photographers. It is also no surprise that one of the film's major focal points is the huge 1950s Hollywood filmmaking presence in Rome, which led one Hollywood reporter to refer to the Eternal City as "Hollywood on the Tiber."[24] Not only do we have Lex Barker, a former Tarzan,

playing Sylvia's boyfriend (who is also described as a former Tarzan), but Sylvia herself is a Hollywood star. Most important, Marcello ends up as a publicity agent willing to market his client (French actor Jacques Sernas) as a reincarnation of anyone from Paul Newman to John Barrymore—depending on how much Sernas is willing to pay him. Here the society of the spectacle loses its specifically Italian character and becomes the reflection of an American media imperialism that has indeed been a principal characteristic of postmodernity and image globalization.

An "Information" Society. As in *Ginger and Fred,* the obsession with spectacle helps define a society in which everything is reduced to news and newsworthiness. This is reflected in Marcello's initial job as yellow journalist; in his workplace, the Via Veneto, where people go to be seen and reported on; in the transformation of the "miracle" site into a huge media event; and, most brutally, in the callous treatment of Steiner's wife by Paparazzo and his colleagues following Steiner's murder-suicide. Fellini's words about the media in *And the Ship Sails On,* cited earlier, seem to apply equally to *La Dolce Vita:* "It seems to me that [the film] refers to ... the information of mass media, completely stripped of responsibility" (158; my translation).

In *La Dolce Vita* the mediation and construction of reality is more conspicuously tied to economics than in *And the Ship Sails On* and *Ginger and Fred,* as media vultures such as Paparazzo are motivated entirely by cash. This links *La Dolce Vita* to numerous of Fellini's early films—especially *Marriage Agency, La Strada, Il Bidone,* and *Nights of Cabiria*—which, in keeping with Fellini's neorealist heritage, were at least partly focused on economic realities. In the later films, capitalism is no longer singled out as the source of abstraction, mediation, or the death of the real. Instead, it functions as merely one more set of signs within a larger universe of signification from which the real has long since been banished. More specifically, capitalism has become as much an effect as a cause of signification gone wild.

Reproduction and Simulation versus Originality. As I noted in discussing *Ginger and Fred,* newsworthiness implies reproducibility rather than originality: the ability to be typed (for instance, as hero or outlaw, bizarre or exceedingly normal) in order to meet preconceived standards of what is entertaining, hence marketable. This in turn involves simulation in the Baudrillardian sense: the endless imitation not of originals but of models.

The statue of Christ offers an excellent example of reproduction with no original. Christ or God exists at most as myth in the modern/postmodern environment of the film. Moreover, this particular statue is of Christ the Laborer, a modern, industrialization-era invention that imparts to Christ a role that he did not possess in his day. (Fellini's work in general seems to suggest that Catholicism, in its construction of an entire worldview out of representation—images of Christ, the

Blessed Mother, the saints, heaven, hell, and so forth—is an institution, par excellence, of simulation, of signs without referents and signifiers with absent signifieds. Certainly, this possibility gives Fellini lots of scope for parody in the ecclesiastical fashion show of *Roma*.)

Simulation and the media are explicitly combined when photographers, including Paparazzo, help stage and orchestrate conflict between Robert and Sylvia and Robert and Marcello. Even more explicit is media orchestration of the "miracle": having the mother of the miracle children pretend to see things she has not seen, giving the children's uncle a script from which to read an account of what has (supposedly) happened, and even constructing a movie (no doubt "neorealist") of the events surrounding the miracle. The miracle serves as the film's most comprehensive reproduction of an original that never existed.

One of the principal sites of an origin-gone-missing in *La Dolce Vita* is nature, which had served as a source of authenticity in such earlier Fellini films as *La Strada*. The broken aqueducts signify missing water as the helicopters make their way toward Saint Peter's. Steiner's party repeatedly highlights the abstraction or sheer duplication of the natural: Steiner and Marcello discuss a still life owned by the former, and a guest plays Steiner's tape-recording of a thunderstorm, birds, and the forest. Steiner's children appear amidst the tape recording as Platonic ideals of childhood more than real kids.

The most comic and perhaps most sustained erasure of the natural occurs through Sylvia. On the one hand, she seems to represent natural "feminine" energy, occasioning Marcello's rhapsodic identification of her as "the first woman on the first day of creation." She is linked with water not only at the Trevi but through the Baths of Caracalla, where her exuberant dancing turns into a quasi-religious procession. And after howling with the dogs on the outskirts of town, she communes with one of Rome's countless kittens as she walks through the streets of the city. On the other hand, Sylvia is the most completely produced or artificial figure in the film: a Hollywood persona, ever aware of her audience, who even responds to personal crisis with her public image in mind. (She tells Robert when he slaps her, "You shouldn't do things like that, especially in front of people.") Accordingly, her—and Marcello's—most profound "return to nature" occurs not at the sea but at the Trevi, a monument to rococo theatricality, spectacle, and tourism. The inauthenticity of it all is comically underscored when the roar of "nature" is abruptly silenced as the mechanically controlled and timed waters are turned off with the coming of dawn. (Similarly, the Baths are devoid of water in their 1950s nightclub incarnation.)

Though nature may seem recuperated with Paola at the sea in the film's closing moments (the interpretation offered in my earlier reading of the film), the ending also allows for a more postmodern analysis. For Paola herself, though seemingly

aligned with the imagery of childhood, innocence, and authenticity that we find in a film such as *La Strada,* has been turned into a reproduction long before the film's final scene. When Marcello encounters her earlier, at the beachside cafe, he is able to relate to her only as an icon, asking her to pose in profile and claiming she is like an angel from an Umbrian church. In fact, as Marguerite Waller suggests, he relates to her purely as simulation:

> Marcello's elegantly turned compliment ... betrays a significant pattern in his treatment of both art history and the young woman. Raphael's angels look the way they do in part because the Umbrian physiognomy served as his mode. The waitress is Umbrian. Therefore it might have been more appropriate to note that Raphael's angels resemble the waitress. By putting the case the other way around, Marcello avoids the recognition that even the most sacred or captivating cultural icons have their local, historical roots. ... He flattens her into a static, two-dimensional image and detaches that image from the context that presented it to him. He decontextualizes and dehistoricizes both Raphael's art and the young woman.[25]

Waller goes on to suggest that the film is quite critical of Marcello turning Paola into an abstraction, and my own prior analysis of the film would suggest the same. However, in the hindsight of postmodernity, it is also possible to argue that Marcello's activity is far more valid than the film's critique in representing the fact that cultural codes have come to predetermine all our perceptions, all our experience. One could also argue that the film itself does precisely to Paola in the final scene what Marcello did earlier: detaching her from her concrete surroundings and "reproducing" her as an icon of spirituality. Her "nature" is thus entirely predicated upon her—and Fellini's—"culture." The same can be said of the sea and the huge fish that, as my earlier reading made clear, are cultural *symbols* of nature, religion, and depth psychology rather than anything truly natural.

Postmodern "Signage." The pervasive substitution of signs, models, and reproductions for origins and originals is part of a larger ungrounding of signification, a jumbling and at times reversal of conventional values and hierarchies of meaning. When Marcello and Maddalena decide to make love early in the film, Maddalena insists on doing it in the apartment of the prostitute Adriana. The aristocrat (Maddalena) thus adopts Adriana's role of "working girl/whore." Sex for money then gets displaced onto money for accommodations, as Maddalena pays Adriana for the use of her place. This in turn makes Adriana's home into a hotel (from which Adriana is, in effect, evicted for the night).

The Baths of Caracalla becomes a perfect example of postmodern sign play, particularly in the juxtaposition of styles and eras, myths and realities. It is a Roman

ruin turned into a rock-and-roll nightclub, an underworld with a celestial goddess (Sylvia). It features American actors who play Roman satyrs (Frankie Stout) or British lords-gone-native (Barker's and Robert's Tarzan). Its waiters are dressed, as Robert puts it, "[in] a silly mixture of Roman and Phoenician." Steiner further contributes to the film's crazy concatenation of signs when he produces a Sanskrit grammar in a high-modernist church and then proceeds to play jazz on the church organ.[26]

The most consistent source of disruptive signage—juxtaposition, contradiction, displacement, and substitution—may well be Sylvia. For one thing, she represents the principal international developments of the 1950s that have helped destroy conventional boundaries and paved the way for postmodernity: Americanization, globalization (she is Swedish as well as American), and media saturation. More precisely, she represents capital turned into image and image divorced from context. Accordingly, her identity and origins are multiple. Not only is she described as American and Swedish, but her last name, Rank, is German. Her first and last names imply radically opposed qualities: the sylvan or natural and the rational or numerically ordered. She descends from on high and frolics in the depths (the Baths), parades as a sex goddess and dresses as a priest. She represents nature but in a totally socialized way—nowhere more involved in sign play than when she emulates the dogs in the wild and plays Roman She-wolf to the stray cat.

As her Hollywood career (and priest's outfit) would suggest, Sylvia is nothing more nor less than the transformation of self into sign—and Marcello's attempt to see her as The Origin, "the first woman on the first day of creation," is both laughable in terms of his quest for totality and apt in turning her into yet another sign. Sylvia is, in fact, a "sign of signification" rather than of identity—something that Marcello's words unwittingly confirm.

The Disembodied Eye. Sylvia is a striking example of the death of the subject. This is not a quasi-tragic loss of self that, in my earlier analysis, I attributed to Marcello and viewed—in the light of Fellinian humanism—as the failure (rather than the impossibility) of individuation. Rather, it is the simultaneous exteriorization of self and implosion of media culture that reduces inside and out to a single, two-dimensional plane, Baudrillard's "pure screen" or "switching center," where all subject-object relations have collapsed. In the course of *La Dolce Vita*, this kind of subject-less realm becomes discernible in the motif of the disembodied eye.

By the term "disembodied eye" I mean something different from the death of vision associated with loss of consciousness or intelligence: for instance, Marcello reduced to a mere "camera" by Steiner's death, able only to register or record information without any significant response. This is still humanist disillusionment (alienation and loss rather than pure absence of self). So is the disembodied eye of instrumental modernity (the detectives at Steiner's, their subjectivity emptied out into institutional rationality). In each case the death of vision refers or at least

FIGURE 9.6 Perhaps one of the most brilliant images in a film and a body of work replete with them: Marcello's uncomprehending eyes dissolve into a staircase of receding, empty, eye sockets, arriving at a vanishing point occupied by the meaningless flash of a paparazzo's camera. Source: *La Dolce Vita* (1960). Directed by Federico Fellini. Produced by Riama Film/Cineriz. Frame grab captured by Frank Burke from 2014 Blu-ray version.

alludes to a centered consciousness or subjecthood that, under more humanized circumstances, might conceivably be recovered. The disembodied eye of postmodernity, on the other hand, is the eye as pure exteriority and sign. The most striking example in *La Dolce Vita* is the elliptical staircase of Steiner's apartment that, as Marcello looks upward to the roof, creates a series of pupil-less eyes-within-eyes, with the final "eye" being the opening at the top, out to the sky. (**Figure 9.6**) There, a photographer does occupy the position of a pupil, sticking his camera—another disembodied eye—into the final "eye" and detonating a flash that obscures rather than abets vision. This series of narrowing empty sockets is radically disconnected from intelligence or agency, and the photographer himself is performing a meaningless act, mechanically snapping a picture of what is effectively a void.[27] The receding ellipses form a kind of perverse version of Renaissance perspective, parodying the classic model of modern visuality and subjectivity. The disembodiment of vision returns at the end of the film, when Marcello, staring at the eye of the dead fish, says, "What is there for it to look at?" The fish's dead eye is the glassy, disembodied, equivalent of Marcello's, and Marcello, at the same time, is the disembodied content of the fish's gaze—nothing for the fish "to look at."

Intervista

Occasioned by the fiftieth birthday of Cinecittà, *Intervista* (1987) is a celebration of both the famed Italian film studio and the filmmaking process. It is an

extraordinary display of storytelling virtuosity. *Intervista* turns away from the world of television so thoroughly critiqued in *Ginger and Fred*. However, as we shall see, television also plays a subtle and significant role in the film's play of meaning.

In isolation, *Intervista* seems to be nothing more than Fellini amusing himself in his Cinecittà playpen, interweaving an interview he is apparently granting to a Japanese television crew, liberally distorted memories of his first visit to Cinecittà, preparations for his supposed filming of Kafka's *Amerika,* presumably spontaneous events such as a visit with Marcello Mastroianni to Anita Ekberg's villa, and preparatory events (casting, makeup, dramatic coaching) for *Intervista* itself. Of course, "*Intervista* itself" is a complicated notion, as the film ends up including everything I have just noted. However, seen in the light of preceding Fellini movies, *Intervista* becomes an examination of meaning itself, both in and around cinema. In this respect Cinecittà is not just a movie studio, but—like Casanova's memoirs, Snàporaz's dream, the music in *Orchestra Rehearsal,* cinema and history in *And the Ship Sails On,* and television in *Ginger and Fred*—a highly complex and self-referential system and (in this case) institution of signification.

Much of the play of meaning in *Intervista* focuses, as so often in Fellini's work, on codes of cinema and of storytelling. The first scene is a perfect example. At night at Cinecittà, film technicians circulate, filmmaking equipment is wheeled about, a camera is ceremoniously unveiled, and a Japanese television crew appears. Suddenly, Fellini is there also, and the crew asks him what film he is making. He replies that it is one that begins with a dream—then he begins to direct the shooting of the dream. The megaphone dies, however, and all filmmaking is apparently abandoned. Fellini then begins to describe the dream as one that he himself has had, and images of the dream materialize on screen. It is a dream of flying (recalling in some ways the opening scenes of *8½, Toby Dammit,* and *La Dolce Vita),* and as Fellini narrates it, initially indistinct images give way to an aerial view of Cinecittà. In terms of filmmaking codes, the opening sequence presents us with: (1) a film beginning (*Intervista*), (2) Fellini talking of beginning a film (arguably still *Intervista,* but in fact it cannot be, as *Intervista* has already begun), (3) the failed attempt at (2), and (4) the materialization, paradoxically, of (2). We also have Fellini as two different directors: of the "meta film" (*Intervista*) and of the film-within-the-film. Moreover, as the second, he is both a failure and a success. This of course recalls *8½, The Clowns,* and *Roma,* in which a director (Guido in the first, Fellini in the latter two) apparently gives up on a film, only to have the film take on a life of its own and keep on going.

In addition, we have the interplay of several different modes of signification: film, dream (or its recounting), and interview, which all become intertwined in such a way as to dissolve their distinctness. Moreover, we have the inversion

of normal Hollywood storytelling procedure, which moves from an establishing shot of a scene to a breakdown into component parts. Here we begin in medias res, and the establishing shot is the final shot of the sequence: the bird's-eye view of the studio.

At the same time, we have an intricate examination of two fundamental conventions of cinema: the effacement of the filmmaker within the text proper, yet the valorization, beyond the text, of the filmmaker as auteur, the godlike figure who receives credit for all facets of the film's production. On the one hand, Fellini debunks classic effacement of the filmmaker, making himself entirely visible within the filmmaking process. On the other, he presents himself as a product more than a source of that process. He does not precede and control the filmmaking activity. Instead he is born out of the studio itself (he is already inside Cinecittà); the apparatus and technicians necessary to his function as filmmaker; and, most important, the appearance of the Japanese interviewers, who are presented as the cause for much of *Intervista*. (Fellini does not appear until the interviewers do.) Moreover, the sequence Fellini has come to shoot gets made despite authorial intent. Or, as with the ending of *Roma*, it is perhaps more accurate to say that the proposed sequence gets made *both* because of and despite Fellini's intent—and it is through this paradox that the twinned issues of effacement/author-ity become expressed.

Much as the film simultaneously emphasizes and effaces the director/author, it also simultaneously foregrounds and hides the filmmaking process. Perhaps the best example is Fellini's reconstruction of his first visit to Cinecittà. The sequence begins by detailing all the background work of preparation: location scouting, set construction, makeup, coaching, and the placing of old trams on flatbeds to simulate the original journey (as the actual tram tracks have long since disappeared). Then, as the trams start out, the sequence quickly but seamlessly becomes illusionistic (that is, realistic to the point where we unquestioningly accept the illusion).[28] All the work of filmmaking disappears, and we seem to be back in 1940, heading toward Cinecittà. Yet illusionism itself is quickly undercut by absurd images outside the windows: Hollywood-style Indians on the hillsides, a splendid waterfall, elephants from Abyssinia, and so forth. It is not the physical work of filmmaking but dominant film imagery of the time (along, of course, with blatant rear projection) that here works to undercut realism and the illusionism on which realism depends. Finally, the behind-the-scenes realities of filmmaking again become visible when the trams arrive at Cinecittà, and we see not only them, signifying 1940, but Fellini, in the same space, being interviewed in the film's present.

The implications and effects of this are numerous. Clearly, the purely illusionistic sequences are contextualized by the heavily self-reflexive moments, so that, even when Fellini's direction seems absent or when the film seems most documentary in style, we cannot help but be aware that what we are watching is not

"real." At the same time, the fact that we see some but not all of the behind-the-scenes machinations implies that self-reflexivity has its limits. No film can ever completely lay bare the process of its construction. Otherwise there would be no film, just the process of trying to make one. So self-reflexivity is its own kind of illusionism, just as documentary is a kind of fiction, and fiction filmmaking inevitably employs documentary techniques. There is no absolutely "honest" mode of filmmaking, nor, I think we can infer, would Fellini wish there to be. *Intervista* takes as much pleasure in constructing illusionistic scenes as in highlighting the process of construction. Finally, the complex and ever-shifting relation of illusionism to self-reflexivity raises the question central to Fellini's late films and to much modern and postmodern cultural expression: How do we know what we know? The answer, of course, is that we know only through codes that are arbitrary, provisional, and ultimately unstable.

One of the principal thematic issues that links *Intervista* to preceding Fellini films is that of political authority. The film weaves a complex web of associations around imperialism and what has come to be a crucial dimension of postmodernity: postcolonialism. In reconstructing his first trip to Cinecittà, Fellini implicitly links the movie studio with authoritarianism by having a Fascist *gerarca* (leader) provide a kind of running commentary through much of the tram ride. (The link between movies and power is comically underscored by the fact that the Fascist is played by Fellini's executive producer, Pietro Notorianni, who was committedly communist.) Moreover, the *gerarca* immediately invokes the Roman Empire when he responds to a group of singing peasants by claiming, "These voices express the same joy of those workers who made this land fertile in the days of Julius Caesar."[29] The scene then turns into a parody of a Fascist propaganda film (linking colonization and representation) as the tram stops and three women offer the *gerarca* bounty from their fields—"with Fascist enthusiasm," as they put it.

The references to imperialism become even broader and more explicitly linked to representation when American Indians appear outside the window, and the Fascist exclaims, "It is a race of courageous but treacherous people. Who knows, why not exterminate them all, these tribes, maybe leaving some only as specimens for their [i.e., America's/Hollywood's] films." Here Fascist colonialism becomes forcefully linked to its American equivalent. Links among Cinecittà, empire, and representation are further consolidated when the elephants appear. The Fascist says, "Do you know Abyssinia, young man? Extraordinary land, our empire," and concludes with "If we've encountered elephants, we must have arrived at Cinecittà." In effect, Cinecittà's colonizing of reality—and of its audience—becomes equatable with Mussolini's invasion of Abyssinia (Ethiopia). This sustained process of association also alludes to several historical and political facts never directly acknowledged by the film: Cinecittà was built by the Fascists, Mussolini's son Vittorio was

closely associated with it, and Mussolini himself was of the opinion that "motion pictures are the most powerful weapon"[30] in political and cultural persuasion. Fellini expressed concern about the "problem-ghost" that would haunt any film about Cinecittà: "How could one tell the story ... without mentioning Mussolini, whom Italians prefer to forget?" (Chandler, 239). He found a way. While not turning a tribute to Cinecittà into overt political commentary, *Intervista* acknowledges the problematic roots of the studio. At the same time, the film implies the inevitable link between the media and domination: that is, the former's inevitable role in dispensing dominant ideology.

Links between colonization and representation were also implied, though more subtly, when Fellini and the Japanese earlier walked around contemporary Cinecittà during the filming of television commercials. The first was for Imperial typewriters. The second, for lipstick, featured an American marching band with a black majorette propped on top of a cannon. The cannon shoots at a billboard with two huge lips on it, magically generating the product name on the billboard. This latter commercial interrelates Cinecittà, television, consumerism, black oppression, and American militarism. Both commercials, with their emphasis on words, images, and advertising equate imperialism with the work of meaning-making in contemporary capitalism.

The association of Fascism/imperialism with Cinecittà has several important implications in terms of Fellini's self-representation in *Intervista*. For one thing, it aligns his own founding moment in film with the very political system that so many of his movies have critiqued. In fact, in the tram sequence he presents himself as utterly wonderstruck and vulnerable to precisely the kind of spectacle that not only Cinecittà but Fascism represents. At the same time, the most notable thing the young Fellini encounters on entering Cinecittà is the dictatorial activity of a film director, making ludicrous demands and imposing his will on everyone. This kind of caricature repeats itself shortly, as young Fellini sees yet a second film shoot with an equally obnoxious director. More important, the present-day Fellini indicts himself by interrupting the second shoot to throw a tantrum because the actor playing the director knocked over the wrong cardboard elephant during *his* staged tantrum. In short, Fellini presents himself as doubly susceptible to Cinecittà/Fascism, as spectator and as dictator. In doing so he implicitly acknowledges a double paradox in his own politics: he has been able to critique Fascism (1) only from within one of its principal bastions, and (2) only by becoming a small "f" fascist himself.

Intervista's interrelation of Cinecittà, signification, and power is also where the film begins to engage issues of postcolonial theory. I do not mean to suggest that *Intervista* does so with conscious authorial intent. Moreover, postcolonialism as a theory of cultural production and interpretation may appear initially to be a rather complicated way of approaching *Intervista*. However, the film's own emphasis on

Fascism and imperialism, and its sustained references to Kafka, whose relevance to postcolonial discourse will shortly be explained, serve as an invitation to employ a critical approach that, I believe, proves quite useful in relation to Fellini's film.

Strictly speaking, postcolonialism refers to a post-World War II phenomenon in which European powers were, for economic and political reasons, forced to relinquish their colonies. At the same time, newly decolonized countries obtained independence only to face the fact that (1) their economy, political system, language, and culture had been altered by the experience of colonization and (2) their freedom from colonization proper was accompanied by increased neo-colonization—that is, the spread of global capitalism and the dominance of American ideology, disseminated through mass communication, especially, in recent years, television. The "postcolonial condition," in this context, has come to mean living one's local existence, even one's "independence," within the shadow of certain material and ideological structures that were once imposed from without but are in continuing need of contestation even when the source of those structures has, for the most part, withdrawn.

Postcolonialism, then, has a specifically historical origin and meaning. However, the postcolonial condition has also become a metaphor for the prison house of dominant cultures in a larger sense than the specifically historical. It has come to stand in for the more general notion that virtually everyone exists, at least to some extent, within a cultural context that is other: women within patriarchy, racial and ethnic minorities within white Anglo-European heritage, gay men and lesbians within heterosexual society, white Anglo-Europeans within postwar American culture, white Americans within a discourse of multinational capital, conscious subjects within the discourse of the unconscious, and so on. In this sense no one can presume to speak in an original, pristine voice. Instead, one must turn to appropriation, citation, cannibalization, to speaking within colonizing forms of language and discourse but using them against themselves. Only in this way can new meanings be forged and discourse reinvented so that one can claim one's own place within them.

In this more general and metaphoric sense, there are numerous postcolonial relationships throughout *Intervista*. To begin with, we have Japanese television paying homage to a Western European director and working with technology and media developed in the West. Yet the Japanese represent a high point in creative appropriation, having responded to the postwar influence of American technology and capitalism by becoming a true competitor of America in each. Moreover, within *Intervista* itself, the Japanese crew is occasionally positioned in such a way that it might well be taking some of the footage we are seeing as *Intervista*, suggesting that they are able to appropriate the dominant language of Fellini's film and make it their own.[31]

A number of metaphorically postcolonial relations are also introduced via Kafka's *Amerika*. In fact, though his work predated by far the actual political process of postwar decolonization, Kafka has become an important tool for studying postcolonialism in literature, largely through the work of Gilles Deleuze and Felix Guattari. In their study *Kafka: Toward a Minor Literature*,[32] the two French intellectuals emphasize the fact that Kafka was a Czechoslovakian Jew who, rather than writing in either Czechoslovakian or Yiddish (with which he was familiar), wrote in German. The result, they note, is a kind of creative misuse and disfiguring of the dominant language, rooted in the fact that it is not his language of origin. His writing thus leads to an unsettling of meaning that has a "deterritorializing" and subversive effect. Deleuze and Guattari are able to use this aspect of Kafka's writing to help found their notion of "minor literature," which is neither literature written in a marginal language nor marginalized literature but rather the literature of a minority written in the language of the majority (Deleuze and Guattari, 16ff).

In terms of *Amerika* itself, postcolonialism functions on the level of theme as well as language, as the novel is about a 16-year-old German boy sent off to the United States by his parents—hence forced to operate as a minority within a majority language and culture. Moreover, the fact that Fellini is seeking to adapt *Amerika* makes *him* dependent on an alien language (the German of the novel) *and* a foreign culture (early twentieth-century America, which he must reproduce as part of Kafka's story). Of course, the reworking of "master texts" has become a distinguishing characteristic of all Fellini's postmodern work, beginning with *Fellini-Satyricon* and continuing on to his final film, *The Voice of the Moon,* based on the Po Valley novel *Il poema dei lunatici.* Through *Intervista's* citation of *Amerika*, the postmodern/postcolonial permutations become elaborate and quite comical: a Czech Jew writes about America in German and has his work adapted by an Italian who stages it as part of an interview for the Japanese. They ask him if he will shoot in America, while in fact he is shooting in Rome, but, then again, he is simulating as much as shooting. These permutations reflect the kind of "deterritorialization" that attracted Deleuze and Guattari to Kafka and minor literature.

One master discourse within which *Intervista* operates is not Kafka or *Amerika* but Italian cinema as institution—precisely what Cinecittà represents. This is humorously conveyed in Fellini's construction of his first trip to Cinecittà. There is no personal memory whatsoever. Instead, everything is created in the mode of the cinema of the time: Fascist propaganda, rear-projected spectacle of wondrous sights, romantic comedy. Fellini implies that he has no experiences from his youth other than scenes from movies.

Both Fellini and Italian cinema are also in the grip of another dominant discourse: American film and ideology. This helps explain the American Indians on the hillside—and why the film ends with a comical Fordian Indian attack on

Fellini's cast and crew. It also helps explain the need for an American comic book figure, Mandrake the Magician (Mastroianni in costume from a commercial in which he is appearing), to summon up scenes of *La Dolce Vita* at Ekberg's villa. And, of course, it is part of the reason for the marching band and cannon in the lipstick commercial. (The influence of America, within this film but also but on European culture in general, is reflected in the title of Kafka's novel.)

A third significant and determining force with which Fellini must struggle is that of his past as a director: the themes, mannerisms, images, and completed films by which he is now held prisoner. Yet another is the interview to which Fellini is subjected: it not only dictates much of the content of *Intervista* but introduces what for Fellini was the most troubling "dominant discourse" of his final years—television. In fact, one of the most significant aspects of *Intervista* from a postcolonial perspective is the fact that Fellini's filmmaking is initiated by television: a Japanese network deciding to do a documentary on the director.

In response to all these forces that constrain Fellini's work, *Intervista* uses a number of "deterritorializing" strategies:

Hyperbole. This is perhaps the most obvious way in which *Intervista* appropriates and undermines dominant cultural institutions and forces. For instance, the scene with the "peasant women" and the "Fascist" is over the top, as is the entire tram ride to Cinecittà, which underscores the absurdity of Fascist rhetoric and the rhetoric of various Cinecittà productions of the time. So, too, is the lipstick television commercial.

Self-Parody. Fellini tends to undermine "colonizing" systems within *Intervista* by ridiculing himself as representative of those systems. The director-as-egotist becomes a critique of Fascism, Cinecittà, film, and even television (the lipstick commercial has a comically self-important director). It also serves as a critique of Fellini himself, whether as "grand auteur" or as an amalgam of now predictable mannerisms and codes. In terms of the former, he not only mocks himself through association with other petty-tyrant directors at Cinecittà, but he lampoons his directorial ego directly. In the bar at Cinecittà he waxes eloquent to the Japanese on one of his favorite interview themes—the director as God: "Out of the bareness of a studio where everything is to be made, everything to begin, you must give light, a beginning, life, to everything. You feel like God Almighty."[33] However, just before this less than humble assessment of his vocation, he has been shown to be quite vainly primping, as he is about to be filmed. (This critique of vanity has recurred in his work since *Fellini: A Director's Notebook*.) Equally important, right after Fellini asserts his omnipotence, Nadia, whom he has been trying to persuade to speak with the interview crew, rebuffs him for a second time—and with obvious disregard.

The critique of the grand auteur is amplified by the emphasis on Fellini as a now predictable and in fact quite clichéd set of mannerisms that his assistant has down pat. His mode of filmmaking has become so codified that his assistant, Maurizio Mein, can do much of his work for him, including finding actors for his films. Faces, which Fellini once claimed to be the sine qua non of authenticity and originality in his work (*FF*, 104), can now be categorized as "Felliniesque" for the sake of casting—and spotted as easily by Maurizio as by Fellini himself. At one point, Mein even coaches potential actresses in Fellinian mannerisms. Fellini's incessant repetition of old tricks is also suggested when the scene he chooses to stage from *Amerika* looks less like Kafka than one more Fellinian brothel sequence, complete with obligatory prostitute, Brunelda. The attempt to cast Brunelda, in turn, allows *Intervista* to indulge in the usual Fellinian parade of large women, while at the same time making fun of it. All of this implies the repeatability, reproducibility of the Fellini canon: "Fellini film" after "Fellini film."

Fellinian repetition is also emphasized through narrative structure and theme. The interview in the present mirrors Fellini's first trip to Cinecittà, when he, too, conducted an interview with a diva. The Japanese film crew is thus a "reincarnation" of Fellini, although (consistent with the evolution of the media) print journalism has given way to television. At the same time, as object of the TV interview, Fellini "becomes" the diva in the present. Fellini's journey to visit the 1940s diva is then "repeated" in his trip to see Anita Ekberg.

Much of the self-parody in *Intervista* is directed precisely at this kind of Fellinian self-enclosure. In this respect Fellini and Cinecittà become synonyms for escapism and isolation, and *Intervista* reengages the issue of otherness and exclusion, central to other recent Fellini films. One clear example of this is Fellini's and the film's refusal to engage in any meaningful way with the Japanese film crew. They are profoundly other in the insular world of Cinecittà. As Earl Jackson notes: "Although the Japanese interview is ostensibly the stimulus and premise for the film, the team is never part of a conversation. They merely witness monologues only one of them can understand. When the Japanese do not simply disappear, they are on display. Never is their interest in Fellini the focus of attention; it is presented, rather, as baffling or exotic, an index of the strangeness of Fellini's on-screen world."[34]

Insularity is also reflected in the fact that *Intervista* is much less about people (the Japanese crew) making a film about Fellini, than about the process of its own making. The elimination of difference becomes most pronounced in the visit to Ekberg's villa. The one event in the film not directly related to or feeding back into Cinecittà—Fellini's "fortress," as he calls it at one point—turns into a screening of *La Dolce Vita*.

Self-enclosure is accentuated in other ways. The trip begins with Fellini choosing to take the actor Sergio Rubini and Marcello along, while leaving a principal

actress, Antonella, behind. Not only does Sergio play Fellini in *Intervista* and Marcello have a history of playing Fellinian alter egos, but Sergio's last name is the same as that of Marcello's character in *La Dolce Vita,* as well as of the semi-autobiographical Moraldo in *I Vitelloni.* Fellini, in short, has surrounded himself with surrogate selves for this one trip out of Cinecittà. Then the group gets lost on its journey, further implying an inability to negotiate anything new, and is "saved" by a priest on a motorbike who looks remarkably like Richard Basehart as swindling prelate in *Il Bidone.* Basehart, of course, was also in *La Strada;* the motorbike recalls Zampanò; and the word "strada" is used twice in the discussion of being lost. Meanwhile, the musical theme for the trip is from *Il Bidone.* It seems that in virtually every respect Fellini can journey only back into himself and into representations from his cinematic past.[35]

Self-evasion, Self-dissolution. From his first moments on screen—when he declines the offer of his head technician to get up on the camera crane and see what is about to be shot—Fellini repeatedly seems to evaporate, often being replaced by mediators. (The function of Maurizio is clear evidence of this.) This, in turn, is part of an incessant drive on the part of Fellini as person and as "noted filmmaker" to disappear. He is late for the second sequence of the film, putting Maurizio front and center. He responds to questions about his career and technique not through direct communication but by constructing and reconstructing scenes. Confronted with obstacles and funding constraints (albeit themselves simulated) in the production meeting over *Amerika,* he not only escapes to Anita Ekberg's villa but is barely visible once he goes inside and is replaced by the Trevi fountain scenes from *La Dolce Vita.* When rain appears to turn the filmmaking crew for *Amerika* into a tightly knit community in temporary shelters, Fellini again disappears and is replaced by the scene of the Indian attack. Finally, he plays no part in the extensive Christmas greetings that crew members offer to one another in the penultimate scene. Instead, he retreats into a deserted Cinecittà studio to shoot yet another scene, the (simulated) beginning of yet another movie.

Mediation, linked to a kind of missing self is further reflected in the lack of personal experience in *Intervista,* despite the fact that the film could easily have functioned as a diary. In addition to the purely cinematic nature of Fellini's first trip to Cinecittà, the sequence with Ekberg and Mastroianni projects nostalgia entirely (both literally and figuratively) onto the two actors. Moreover, though the scene is clearly about the anxiety of growing old, Fellini refuses to address his anxiety directly. While *Intervista,* as a film about Fellini, would seem to contribute to the cult of personality that has helped construct Fellini's persona through the years, it works in quite the opposite way. The personal is evacuated even more so than in *Roma,* and one could easily argue that a film such as *8½,* in which Fellini does not even appear, is more intimately about Fellini-the-person than is *Intervista.*

Narrative and Cinematic Decontextualization. Perhaps the most insistent strategy of decontextualization in *Intervista*—the means by which the text most completely subverts the language of cinema and ideology in which it must, inevitably, be "written"—is through the constant undermining of cinematic context. My discussion of the opening sequence and of the re-created trip to Cinecittà included numerous examples in which expectations are thwarted and radically different modes of filmmaking (documentary/fiction, self-reflexive/illusionistic) undermine conventional realism. The series of scenes that conclude the film, beginning with the screen tests for *Amerika,* are particularly effective at playing with codes, context, movie clichés, and narrative sequencing to further de-realize representation. While the tests are in progress, Mein is explaining to the Japanese crew what Fellini is doing, so we cannot be sure if Fellini is using the tests in actual preparation for *Amerika* or merely staging the tests for the benefit of his interviewers. (In fact, *Amerika* repeatedly functions with this kind of indeterminacy, undercutting its role as "master text.")[36] Moreover, while Fellini is directing the tests, he is also directing other unrelated activities: characters dancing while Sergio and Antonella play the piano and sax, Nadia complaining about being overlooked, and so on. In fact, he is simultaneously directing various components of *Intervista,* including the screen tests, in a way that jumbles together scenes that, in conventional narrative, would unfold separately and in sequence.

Then, in answer to the Japanese asking if Fellini will film *Amerika* in America, we move outside, to an American street reconstructed at Cinecittà, where screen tests magically turn into an actual shoot. (We "know" this because the details of the street scene were discussed at length at the production meeting in terms of actual filming.) The shoot, in turn, becomes a party, complete with Sergio's and Antonella's musical accompaniment, as the storm forces people together. This then becomes the Indian raid, which becomes the farewell and exchanging of Christmas wishes, which becomes the final scene with Fellini alone in a Cinecittà theater.

While the proliferation of disparate events unhinges plot, the comic use of the Indian raid undermines classic Hollywood film. Meaning is further confused when the Indians attack with TV antennas instead of lances. This substitution can be interpreted in a host of ways and, consequently, in no exclusive way. Given Fellini's telephobia, we can read this to mean that television now represents the threat to "civilization" that the Indians once embodied for colonizing Europeans. In this context we might also read the raid as the "last stand" of film (Fellini's crew) against the onslaught of television. Or we could see the linking of television antennas and Indians, along with the earlier linkage of Indians and Cinecittà, as a comment that the only Indians (and the only reality) Fellini (or anyone) knows are those encountered through mass media. This in turn would serve as a comment on the fate of Indian culture: colonized militarily, cinematically, and now

260

televisually, it is reduced to "reruns" of earlier forms of colonization. The absence of native culture within mainstream media representation is further suggested when the "chief" who leads the "charge" quickly steps out of character once the raid/shoot is over to show a (white) actor's deference toward his director ("Was it alright, *dottore*?").

Whatever we wish to make of the Indian attack, it destabilizes precisely those conventions (film, western, even television) that it represents. In so doing it implies that representation itself is a postcolonial strategy, a refusal to accept the given (that is, the already represented) as is and an insistence on re-representing and reproducing in order to undermine its dominance.

The final scene of *Intervista* recaps much if not all of the deterritorializing play that has occurred throughout the movie. As crew members depart and Maurizio confirms the end of the shoot on a walkie-talkie outdoors, the camera suddenly places us back inside a theater. We can see sunlight filtering in through an open door, but this connection to the outside quickly disappears, and the sun's ray is replaced by bright illumination from the theater's elaborate lighting system. Fellini says, "So, the film should end here. Indeed, it is finished. I seem to hear the voice of my old producer: 'but why do you end like this, without a thread of hope, a ray of sunshine? Give me at least a little ray of sunshine," he begged me at the first screenings of my films. A ray of sunshine? I don't know, let's try." As he speaks, the lights within the theater dim, and two spots illuminate a circle or "ray of sunshine" in front of a camera and cameraman.[37] We can hear the sound of footsteps, and a man appears with a clapboard in his hand. He shouts "One, two," and claps the board, signaling the beginning of yet another shoot. The images stop, and the titles appear in superimposition.

For one thing, we have the same kind of beginning-end reversal that occurred when the opening sequence concluded with an establishing shot. Here the beginning of a shoot becomes the end of the film. We also have an interesting play on inside versus outside, which has interesting connotations in terms of colonization/decolonization. The initial ray of sunlight is an "invading" force that gets fully appropriated by Cinecittà. Moreover, it never operates as a pristine "original," a "nature" that gets turned into "culture." Rather, it becomes meaningful, appropriatable, only because it already exists within culture—as a "ray of hope," a "happy ending"—in short, a metaphor in the making. It is an "outside" that is already inside, reversing the traditional colonizer-colonized relationship, in which power is imposed from without.

A reversal of positioning is also reflected in Fellini's relation to the old producer. Fellini cannot simply end his film where it "should end." He must "obey" the words of this figure who represents cinema as institution, and, particularly, as capitalist institution. This strongly qualifies the seeming reassertion of authorship

(that is, autonomy, self-motivation, artistic control) that occurs through Fellini's voiceover in this scene. At the same time, however, Fellini appropriates the producer and his words by making them the occasion for the beginning of yet another Fellini film.

The postcolonial dimension (as I have termed it) of *Intervista* seems to imply a possible shift in Fellini's work toward the end of his career. First, the notion of "rewriting" dominant paradigms allows for a rethinking of the power/dependency issue so central to Fellini's oeuvre. In the earlier films characters seemed to be either blindly submissive to external forces (*Variety Lights* through *The Temptation of Dr. Antonio,* with the exception of *Nights of Cabiria*) or capable of self-determination and "self-creation" (*Nights of Cabiria, 8½, Juliet of the Spirits,* and, in increasingly conflicted ways, *Toby Dammit* through *Roma*). The onus in many of these films seemed to be on the individual who, along existential lines, chose or refused freedom. More recently, as I have emphasized, characters have tended merely to be produced by the signifying systems of which they are part. Now there seems to be some possibility for agency within the system(s).

This is further implied in the treatment of authorship within the film. On the one hand, in sharp contrast to *Fellini: A Director's Notebook, The Clowns,* and *Roma,* Fellini is object (of an interview) more than subject (artist and film director embarked on a creative project). Consistent with this, his reputation, not any personal creativity, is the film's point of departure (the Japanese interview him because of what he has done, not what he is doing). On the other hand, Fellini's "object-hood" becomes the condition of his "subjectivity," as he turns the occasion of the interview into his own film. And I use "his own film" advisedly because, along with all the "deterritorialization" that goes on—including the undermining of the "master discourse" of Fellini's past work—some territory is reestablished, for we have another film recognizable as "a Fellini film." Moreover, though the Fellini we see is endlessly mediated, endlessly disappearing, there is also a "logic" to this self-loss that suggests psychology, hence agency, at work. While the visit to Anita Ekberg's villa and the scenes from *La Dolce Vita* project anxiety about the passage of time onto Ekberg and Mastroianni, they do strongly imply a Fellini doing the projecting. **(Figure 9.7)** In fact, the film is consistently about evasion and displacement—and about Cinecittà and filmmaking as opportunities for both. Underlying all this is the implication that art itself is evasion and, paradoxically, an escape from—as much as an act of—communication. The systems of signification into which Fellini is repeatedly dissolved thus function not just as the origin of a totally constructed identity but as occasions for him to act out certain compulsions and needs. And while needs and compulsions themselves call into question the power of self-determination, they exist at least partly in the realm of individual action, as well as in that of the culturally constructed.

FIGURE 9.7 Anita Ekberg, sitting next to Marcello Mastroianni, wipes away a tear following the projection, at her villa, of their scenes together in *La Dolce Vita*. Fellini, a master of evasion, "projects" his own nostalgia and sense of loss onto Ekberg and Mastroianni. Source: *Intervista* (1987). Directed by Federico Fellini. Produced by Aljosha, Cinecittà, Rai Radiotelevisione Italiana et al. Frame grab captured by Frank Burke from the 2005 DVD version.

The return of agency and the emphasis on "rewriting" rather than merely "being written" contribute to a sense of energy and play that make *Intervista* more consistently upbeat than many or all of the films that recently precede it. One gets the sense that Fellini has momentarily made peace—or at least forged a truce—with a postmodernity that so much of his later work contests.

NOTES

1. Dialogue is directly from the film, which is in English.
2. Fellini has emphasized that Casanova is less a figure of the Enlightenment than of the Counter-Reformation (*Oui*, 154).
3. Dale Bradley has noted the thematic significance of the absent Count at Dux in "From History to Hysteria: *Fellini's Casanova* Meets Baudrillard," *Canadian Journal of Political and Social Theory* 13, nos. 1–2 (1989): 138.
4. "*Casanova*: An Interview with Aldo Tassone," in *Federico Fellini: Essays in Criticism*, 27; hereafter cited in text.
5. Appropriately, given Casanova's parasitical relation to male power, Pedrolino as a stock character is a humble servant, and Casanova is first seen—though not yet identifiable—assisting the Doge in the ceremonial attempts to raise Venus.

6. The narrative effacement here is all the more significant in that Casanova's escape may well be the only event in the film that can be historically verified. For the most part, the film recounts episodes from *The Story of My Life* that remain uncorroborated by external evidence.

7. Fellini has claimed, "There is no narrative either in the romantic or the psychological sense. There are no characters, there are no situations, there are neither premises nor developments, nor catharses" (quoted in Tassone, 31).

8. Christine De Pizan, *The Book of the City of Ladies*, 1405, trans. Rosalind Brown-Grant (London: Penguin, 1999).

9. See Renate Blumenfeld-Kosinski, "Christine de Pizan and the Misogynistic Tradition," *Romanic Review*, 81, no. 3 (1990): 279–92 and Maureen Quilligan, The Allegory of Female Authority: Christine de Pizan's "Cité des Dames" (Ithaca: Cornell UP, 1991).

10. In terms of European feminist awareness of Christine de Pizan, Simone de Beauvoir wrote about *La Cité des dames* as early as 1949. For Fellini's consultation with feminists, see Andrea Minuz, *Political Fellini: Journey to the End of Italy*, trans. Marcus Perryman (New York: Berghahn, 2015), 125–26. Adele Cambria, a militant feminist, was approached by Fellini to provide some language for the film. She obliged but trashed Fellini tirelessly before and after the movie. Nonetheless, she recognized his familiarity with certain aspects of French and American feminism (Minuz, 121, 122, 128). The fact that Christine de Pizan was very much "in the air" at the time Fellini was preparing *City of Women* is reflected in the fact that in Judy Chicago's extraordinarily famous and powerful installation 1979 "The Dinner Party," a place was set for the medieval writer.

11. "'*Il Maestro*' Dismantles the Master's House: Fellini's Undoing of Gender and Sexuality." In Wiley Blackwell's *A Companion to Federico Fellini*, ed. Frank Burke, Marguerite Waller, and Marita Gubareva, 311–29. (Chichester, UK: John Wiley & Sons, 2020).

12. Quotations from the film are based on the subtitles when the subtitles are accurate; otherwise they are my own translation.

13. Although Donald Sutherland was not an unknown, Fellini claimed to have liked Sutherland for his Casanova precisely because of his blandness.

14. Charlotte Chandler, *The Ultimate Seduction*, 123.

15. Marguerite Waller notes the Daumier similarity in her "'*Il Maestro*' Dismantles the Master's House: Fellini's Undoing of Gender and Sexuality."

16. My thanks to Marguerite Waller for this observation. See also Waller, "Introduction," in *Federico Fellini: Contemporary Perspectives*, ed. Frank Burke and Marguerite Waller (Toronto: University of Toronto Press, 2002), 4.

17. *E la nave va* (Milan: Longanesi, 1983), 158; my translation. Quotations from the dialogue are based on the film's subtitles.

18. For a discussion of *And the Ship Sails On* that addresses certain of the postmodern issues covered here, see Paula Willoquet-Maricondi, "Federico Fellini's *E la Nave Va* and the

Postmodern Shipwreck," *Romance Languages Annual 1994,* vol. 6 (West Lafayette, Ind.: Purdue Research Foundation, 1995), 383–88.

19. The Italian screenplay claims that the sound we hear at the beginning and end of the film is of a camera rather than a projector. However, the sound is identical to that of the projector on which the Count di Bassano watches the home movie of his beloved diva, Edmea.

20. Fellini has claimed (Chandler, *I Fellini,* 222) that he is revealed on the set in this scene, but this is not the case. Nor is it indicated in the Italian screenplay. There is one figure who looks somewhat like Fellini, but he is a lighting technician, working with a cameraman. There is no evidence of a director.

21. We encountered this salesman and his spiel as Ginger approached a van in the opening scene, but there he and the television set were just part of a much larger Roman environment. At the end, both dominate.

22. *Ginger e Fred,* ed. Mino Guerrini (Milan: Longanesi, 1986), 33; my translation.

23. Guy Debord, *A Society of the Spectacle* (Detroit: Red and Black, 1983).

24. Quoted in Bondanella, "America and the Post-War Italian Cinema," 112.

25. "Whose *Dolce Vita* Is This Anyhow? The Language of Fellini's Cinema," *Quaderni d'italianistica* 11, no. 1 (Spring 1990): 130.

26. Steiner appears right after Marcello, who is supervising a fashion shoot, tells the photographer to "put the horse on the table and the [fashion model] on the ground," which implicitly acknowledges the reversibility and substitutability of signs divorced from solid matter. This, of course, characterizes the fashion world and, for that matter, Marcello's journalistic career.

27. Something quite similar happens in Rene Magritte's painting *The False Eye.* Arthur Kroker discusses the Magritte painting as well as postmodernity and the disembodied eye in *The Postmodern Scene: Excremental Culture and Hyper-Aesthetics* (New York: St. Martin's Press, 1986), 73ff.

28. As used in discussions of classic realism, the term "illusionism" is a bit confusing because it expresses a quasi-contradiction: realism is an illusion that seeks to conceal (the construction of) illusion in order to appear real.

29. Quotations are from the film's subtitles.

30. Quoted in Federico Fellini, *Cinecittà,* trans. Graham Fawcett (London: Studio Vista, 1989), 11.

31. The Japanese crew is working in video for television transmission, but Fellini could have transferred video to film. Intriguingly, this would create a doubled postcolonial relationship at the level of the two media themselves: film as the once-dominant media, now appropriated by television, reappropriating television at the point of transfer.

32. Trans. Dana Polan (Minneapolis: University of Minnesota Press, 1986); hereafter cited in text. I am grateful to Sylvia Söderlind for sharing with me her doctoral work on Deleuze, Guattari, and minor literature—in the context of English Canadian and Quebec literature.

Her work has been published as *Margin/Alias: Language and Colonization in Canadian and Quebecois Fiction* (Toronto: University of Toronto Press, 1991).

33. Unfortunately, though Fellini's words are entirely audible in Italian, they are not subtitled in the English-language version.

34. "Fellini in Japan." In Wiley Blackwell's *A Companion to Federico Fellini*, 440.

35. Self-enclosure and the exclusion of difference or novelty are emphasized apart from Fellini as well. Not only is Antonella, as a woman, excluded from the journey, but both Sergio and Marcello sing the praises of masturbation over sex with women during the car trip.

36. Fellini's preparations for *Amerika* are actually all mere simulation. Though Fellini had once considered such a project, he had abandoned it by the time of *Intervista*. (See Bondanella, *The Cinema of Federico Fellini*, 206–86.) This is not clear within the film itself, yet it does serve as yet another way in which Fellini undermines Kafka's text as master discourse.

37. Camera and cameraman are seen only in silhouette and are probably just cutouts, especially given the emphasis on cutouts in the preparations for *Amerika*.

10

The Voice of the Moon

The Voice of the Moon (1990), Fellini's final film, was loosely based on the novel, *Il poema dei lunatici,* by Ermanno Cavazzoni. It is set in Gambettola, where Fellini spent a good deal of time in childhood. I have chosen to devote a separate chapter to the film because it seems, uncannily, to offer an almost perfect summation to Fellini's filmmaking career. It has much of the organization and thematic consistency of Fellini's early work. Moreover, its focus on "enlightened deviancy" recalls Gelsomina and the emphasis on authenticity and natural, unmediated intelligence in Fellini's most loved early film, *La Strada.* Through its emphasis on quasi-mystical or visionary experience, it also recalls the creative head trips of Fellini's 1960s films, which brought him his widest acclaim as an auteur. And, at the same time, it clearly situates itself in postmodernity, equating visionary experience with insanity (not necessarily as a negative thing) and reproduction rather than originality, and thus qualifying any presumed discourse of the authentic. As in *Ginger and Fred,* a major focal point for the examination of postmodernity is television.

Setting the scene

The first two sequences of *The Voice of the Moon* establish virtually all the film's crucial issues. Ivo, out in the fields, with the moon overhead, hears a voice from a well calling his name, "Salvini." (We can hear this, too.) Suddenly a group of men appears, Ivo is distracted from his pursuits, and the men spy on a woman through the windows of her house as she dances half-naked in front of a television. Her nephew, without her knowing, collects money for the spectacle.

The well and the moon introduce a host of conceptual divisions, many of which are familiar from earlier Fellini films, especially *La Strada*: natural/man-made, down/up, inside/outside, immediate/distanced, active/passive, visual/aural, image/word, watching/listening, private/shared, dark/light. The natural/man-made division, in turn, implies a feminine/masculine opposition that is strengthened by the

apparent masculinity of the voice from the well and the traditional designation of the moon as feminine. (The moon will become hyper-feminized in the course of the film.)

Ivo's initial gravitation toward the well and indifference toward the moon imply several tendencies that will be overridden during the film: a preference for the inner over the outer, down over up, immediacy over distance, dialogue or interaction over spectacle and voyeurism. These tendencies in turn suggest an initial capacity on Ivo's part to be in touch with himself, rather than caught up in external pursuits and stimulation. Yet this capacity is undercut by the fact that the voice from the well is itself external: it may be inside the well, but it is outside Ivo, and in this respect, interiority is symbolic, displaced. Unlike the séance voices in *Juliet of the Spirits,* which have no fixed physical place of origin and can be seen to reflect the protagonist's inner life, the voice at the start of *The Voice of the Moon* is both identified with the well and unrelated, so far as we can see, to any activating mechanisms within Ivo. Moreover, the fact that the well is man-made suggests that the voice comes from the realm of the social rather than being some natural or original source of inspiration.[1] In fact, Ivo relates solely to the man-made rather than engaging with the natural in the form of either landscape or the moon. (I use the gendered term "man-made" because I think it is appropriate to the film's analysis of masculinity.)

Of course, the distinctions I have just noted make clear that the moon is no more natural than the well, having already become heavily encoded with cultural associations. In addition to "the feminine," the most important of these will prove to be psychological possession or madness. In fact, as the film progresses, the "choice" between the well and the moon will prove merely to be a choice between two variations of culturally constructed insanity, as is implied by the Italian words for each: *pozzo,* which is quite close to "pazzo" or "mad," and *luna,* which of course implies "lunacy."[2]

When Ivo quickly abandons the (quasi) interiority of the well and joins up with the men, a crucial process is initiated: the commodification and "consumption" of woman-as-spectacle, which substitutes for any attempt at an inner life on the part of men. In keeping with this externalizing of male experience and desire, the remainder of *The Voice of the Moon* weaves a complex narrative web of repression, projection, commodification, possession, and consumption. More precisely, what social convention represses and abstracts (for instance, openness, curiosity, desire, interiority) gets distorted then projected. The site of projection (women, the moon) becomes commodified, and those doing the projecting (men and especially Ivo) become possessed by their projections, trying to "take back" what has been displaced. In the late-capitalist world represented in the film, introjection becomes not the healthy psychological activity—the "bringing-back-home" of

displaced interiority—that we might associate with some of Fellini's earlier films. It becomes, instead, addictive consumption, wherein the two principal meanings of "possession," psychological and material, coalesce. In a postmodern realm of simulation, the ultimate mechanism for projection/objectification/consumption is television. As a result, consumption involves culturally processed, rather than personally meaningful, images. Consumption or introjection thus remains "screened" in two senses of the word: deriving purely from an external surface and screening out anything in the way of individualized feeling and affect. In short, postmodern, televisual, consumption effectively sustains rather than reverses the process of "evacuation" that begins with repression and projection.

As the preceding might suggest, *The Voice of the Moon* offers a comprehensive analysis of masculinity in crisis. This links Ivo to a host of earlier Fellini characters such as Zampanò, Marcello, Dr. Antonio, Guido, Toby, Encolpio, Casanova, and Snàporaz, providing an appropriate conclusion to a canon largely committed to examining male anxiety and, with it, compulsive notions of and relations to women.

The narrative and thematic process

The founding moment for the cycle of repression and projection that will dominate the film's activities proves not to be the opening sequence but a flashback to Ivo's childhood. The agent of repression turns out to be his grandmother, who "saves" him from the thunderstorms he so much loves by covering him up—then engulfs him in a cowl even when he is at home. (Her reaction to thunderstorms recalls the self-protective society of *I Vitelloni*.) Moreover, she calls him Pinocchino, imposing on him the role of a puppet or social tool, a "child" who is man-made, rather than natural.[3] And she insistently tries to get him to bed, under the covers, and to sleep, though he wants to stay awake and continue exploring new possibilities.

The link between repression and projection becomes clear when Ivo undergoes a significant change in the company of his grandmother—a change that affects his behavior in the present as well as the past. Initially, despite his interest in wells, Ivo had a kind of go-with-the-flow interest in everything. He was easily distracted from the well by the passing group of men, and while they were obsessively focused on the dancing woman, he was more interested in reciting mythology about the origins of the Milky Way than in any one object of desire. Similarly, through most of the scene with his grandmother he displays a host of interests—pretending to become a huge poplar (**Figure 10.1**), then climbing under the bed to marvel at multiplicities and mysteries: "It's beautiful under here: all sorts of things … the fire. Where do those sparks go? And the fire when it goes out? And music. Where does it go

I was in heaven, it was very high.

FIGURE 10.1 Ivo, climbing to the highest reaches of his grandmother's farmhouse, imagines himself a poplar—before becoming "bedridden" and deprived of his polyvalent interests. Source: *The Voice of the Moon* (1990). Directed by Federico Fellini. Produced by Cecchi Gori Group Tiger Cinematografica in coproduction with Films A2, La Sept Cinéma, Cinémax and in association with Rai1. Frame grab captured by Frank Burke from the 2017 Blu-ray version.

when it ends?"[4] However, when his position shifts from beneath the bed to the bed itself (from his own perspective to where his grandmother has wanted him to be), he suddenly begins to find multiplicity problematic: "So many ideas come to me. They fly away like sparks. How can I stop them, Granny?" Then, as he sits up in bed, the present takes over completely, and the adult Ivo says, "I remember that same night, amidst the thunderstorm, the desire came over me to go see ..." Ivo has become "moonstruck," and past and present coalesce as the object of desire turns out to be Aldina, a figure on whom the adult Ivo is now revealed to be fixated.

The Ivo we now see is transformed. As he bullies his way into Aldina's room, using her friend Susy's attraction to him to reach his goal, this initially flaky, nonsexual, laid-back figure has become goal-oriented, masculine, and aggressive. In short, he has become emphatically heterosexual. More than that, he becomes fetishistic, stealing Aldina's slipper, which he will carry around with him for a good part of the film. Two implications of this radical shift are that the suppression of polymorphic desire and curiosity (what we saw in Ivo as a child) leads to singlemindedness, and that there is no better example of singlemindedness than heterosexual "romance," especially male obsession with a woman.

270

Ivo's obsession is a culturally produced response, complete with overtones of the Cinderella story, and consistent with this, his encounter with Aldina is framed entirely within the cultural. She lives in the center of town, and as Ivo prepares to enter her home, he is drawn to a store window where mechanized bridal mannequins, mirroring the extreme socialization of desire, turn in circles. Once in her presence, he not only compares and conflates her with the moon ("she's like the moon, she *is* the moon"), turning experience into cliché, but he starts quoting from the Italian poet Leopardi ("what are you doing, moon in heaven, tell me what you are doing"). Leopardi's words themselves seem clichés, but even more important, Leopardi's romantic poetry is classic male projection, classic male appropriation of woman-as-nature. In this context, Ivo's heterosexuality marks a crucial movement toward the act of total appropriation represented near the end of the film, when he imagines the "capture" of the moon. Moreover, the poetry of Leopardi marks *him*, not just Ivo, as a "lunatic" in the literal sense of the term—beginning to blur any simple distinction between Ivo as insane and his cultural environment as normal.

The cycle of repression and projection that emerges in the grandmother/ Aldina scenes accelerates the following day when Ivo runs into Giuanin, one of the Micheluzzi brothers. Giuanin works in the sewer, a familiar symbol of the interior overtaken by industrial civilization—and turned into a netherworld of the hidden and forbidden. Giuanin himself "socializes" the sewer through metaphor, referring to it as "the Inferno" (a concept from Catholicism-cum-Dante). Both projection and fixation or possession enter in when he blames the problems of the sewer on "the spy" in the sky—that is, the moon. The inferno/moon pairing recalls the well/moon duality of the opening scene and provides a clear spatial representation of repression (what's below or within) and projection (what gets "blamed" above or without). Moreover, the element of blame will feed into Ivo's increasingly negative experience of women, culminating not only in his fantasy of the capture of the moon but in his concluding vision of the moon as a nasty, mocking Aldina.

The next major event in this process is Ivo's encounter with Nestore, in which the latter recollects his relationship with his estranged wife, Marisa, and provides a vivid and hyperbolic depiction of lovemaking with her, equating her sexual insatiability with a locomotive. This meeting also contributes to Ivo's growing experience of disconnection or displacement in his obsession for Aldina and via his conversation with Giuanin. More precisely, the scenes with Nestore reveal the kind of alienation that occurs between men and women when their relationship is overdetermined by cultural conditioning. That alienation, in turn, gets expressed in the locomotive flashback as precisely the kind of male hysteria that will eventuate in the capture of the moon.

Nestore is a profoundly alienated figure. He first appears—and remains—high off the ground, and as he and Ivo discuss his failed relationship with Marisa, they climb out onto the roof and talk about soaring and flying away. This seems quite a shift for Ivo, given his earlier fascination with the supreme groundedness of wells, reflecting perhaps the influence of Giuanin and his displacement of what is down under onto what is up in the sky.

Nestore's accounting of his failed love affair with Marisa strongly implies the social foundations of that failure. Their relationship has been framed entirely by the institutions of marriage and (impending) divorce. Equally important, it has been characterized by the social roles into which each has been inserted. Marisa is rather like Gradisca in *Amarcord,* a town sex goddess or caricature of (male notions of) sexuality whose blatant simulation of sexiness has, in all likelihood, made her unmarriable in a society that draws sharp distinctions between wedlock and sexuality. Nestore, on the other hand, is a town nerd, suffering from a severe case of insufficient masculinity. Their brief union can be read in terms of these heavily coded positions. Desperate for the social sanction of matrimony, Marisa becomes infatuated with the one person willing to offer it to her; equally desperate for the validation of his masculinity, Nestore becomes mad to possess the town bombshell in marriage, her dubious marriageability notwithstanding.

In fact, Nestore and Marisa's relationship is wholly a matter of appearances, so it is no accident that it develops in the town barbershop, where one is groomed according to custom and fashion. Given the links among simulation and appearance, projected needs, and profound non-relatedness, it is no accident that their courtship is punctuated by the first mention in the film of a television station for the town.

Because their desire is framed entirely by (quite different) social needs, it masks a radical incompatibility. This incompatibility in turn explains the locomotive sequence. On a realistic, psychological level, one can explain Marisa's sexual insatiability as a displacement of the anxiety of being in an absurd relationship. In this respect, her sexuality becomes the forced, excessive, and ultimately counter intimacy born out of the impossibility of real communication. It is also an extreme acting out of the "sexy" role that got her into this predicament in the first place. At the same time, Nestore's inability to reciprocate is perfectly consistent with the fact that his desire for Marisa came not from sexuality but from a lack of it—and from the compensatory need to marry (not relate physically to) the local sex symbol.

It also makes sense to read the sequence as a commentary on male fantasy, male hysteria. Both Marisa's sexpot role and Nestore's initial response to it are the product of a patriarchal society that denies the actuality of women by fetishizing them. When Nestore's fantasy comes true and he is confronted with the possibility of having real sex with a real woman, he can only deny and evade again: he sees

Marisa as overwhelming and threatening, which creates an even more disfiguring fantasy. This process of distortion parallels what happens to the moon.

Through this new fantasy, Nestore manages to deny even the reality and pain of his split from Marisa, proclaiming, "Eternal thanks to Marisa" and blathering about flight and transcendence. When he says (pointing to his chest), "[The ability to fly] all comes from here. It's the petals of this flower that must be opened. Right in the solar plexus," his strategy of displacement links up with Ivo's, for the latter has Aldina's slipper concealed in his shirt, next to *his* solar plexus. And as the slipper is rediscovered, Ivo decides to renew his obsessive quest for Aldina's affections.

The psychological possession in Ivo's encounters with Giuanin and Nestore is accompanied by growing material possession, as a clothing vendor takes over the town square, the local priest displays the latest in his vast collection of identical sculpted Madonnas, and Japanese tourists energetically accumulate images of the town on film. The psychological still tends to outweigh the material, as is usually the case in Fellini's work, but the latter begins to establish itself as an underlying condition of the former, preparing for the capture of the moon, which serves as a (symbolic) materializing of psychological possession. Psychological and material converge emphatically in the Gnoccata or "Dumpling Festival." Voyeurism, projection, objectification, and fetishization are given free rein by the election of "Miss Farina" (Miss Flour) as the embodiment of local beauty and an excuse for male ogling. The material escalates through the literalizing of consumerism—that is, ingesting vast quantities of gnocchi. The film pointedly conflates the psychological and the material when Dr. Brambilla, smitten by Aldina as the newly elected Miss Farina, starts licking her fingers and exclaiming "how delicious."

Ivo's own twofold problem with possessiveness—being possessed by the desire to possess Aldina—is exacerbated at the Gnoccata as he gets trapped under the stage and can only watch his beloved through knotholes and slits in the flooring. (A perfect instance of his experience being "framed" entirely by his world.) Then, as Brambilla turns Aldina into a snack, Ivo dumps a bowl of gnocchi on Brambilla's head, indicating an increasing aggressiveness amidst his frustration. In fact, Ivo's experience at the Gnoccata leads to radical disillusionment and a renunciation of his film-long quest for Aldina. At a discotheque, he decides to find a new Cinderella and tries Aldina's slipper on anyone who is willing. It fits most everyone, undercutting both Aldina's "specialness" and Ivo's passion to possess her as someone special. He leaves her slipper behind, marking the end of his pursuit of her—and of idealization altogether. This, coupled with his growing aggressiveness, paves the way for purely negative behavior in his displacement of blame for his failed quest onto the moon.

The capture and televising of the moon

Although Ivo's vision of the capture of the moon is motivated largely by the events of the day or so that precede it, the mechanism of repression and projection entailed in the vision is, as I suggested above, founded in childhood. Accordingly, the vision emerges out of a return to his boyhood home and to a sister and brother-in-law who, in their stifling bourgeois uptightness, are unable to relate to him. Like Ivo's grandmother, they seek to rush him to sleep. The reunion thus proves a return to the origins of a life-long need to escape.

Out of this is born Ivo's yearning for the "empty room" that he earlier described as the childhood source of all sound and experience ("everything began in that room ... the racket of the birds, the whistles, the tolling of bells"). When he asks his sister if this room still exists, she pointedly ignores the question. When she leaves, however, he enters it. This event parallels the moment, in his grandmother's bed, when he said, "The desire came over me to go see," and he appeared outside Aldina's house. The parallel in turn suggests that Ivo's fantasy of the capture of the moon is an alternative to his earlier desire for Aldina, which itself was an alternative for repressed, polymorphous, desire and curiosity. The fact that the room is located at the center of home and family strongly implies the fundamental alienation that lies at the heart of the social in *The Voice of the Moon*. And in keeping with its origins within the (a)social, Ivo's vision proves not a rejection of society (a lunatic's assault on normalcy) but the reproduction of all its dominant tendencies—repression, projection, objectification, possession, consumption—which in turn is part of a relentless process of institutionalization emphatically represented by television.[5]

The raw materials of Ivo's fantasy are not created ex nihilo but are drawn entirely from things he has experienced in the film—coupled with dominant cultural influences such as Leopardi's poetry:

The Moon. Early in the film, an oboist, who has buried his instrument because of the diabolical sounds it makes, claims that when the moon is full he can still hear the oboe's infernal sounds. Giuanin, as we noted, has designated the moon a feminine "spy in the sky." And Ivo's friend Nestore has cemented the symbolic relationship between the moon and negative femininity by associating it with the insatiable sexuality of Marisa.

Television. From the single TV set in the opening sequence (on, but broadcasting only "noise") to the multiple antennas on the town rooftops as Ivo talks with Nestore to the dominant TV reportage at the Gnoccata and the town's acquisition of its own station, television has grown to the verge of taking over its world, as it did in *Ginger and Fred*.

Capture. Earlier in the film Giuanin's brother Terzio tells Ivo of his plan to capture the moon with a large crane. He does so, having just "captured" Ivo himself

in a crane, thinking mistakenly that Ivo cannot get down from the roof. And Ivo has, at least metaphorically, been captured on two other occasions: when he is trapped beneath the stage at the Gnoccata and when his sister and brother-in-law take him home from the discotheque.

The Empty Room. Nestore's apartment is sadly empty, apart from a little washing machine that just accentuates the emptiness, following his separation from Marisa—and provides yet another link between women-as-presumably-negative-influence and Ivo's fantasy. It also motivates Nestore's appearance in Ivo's "empty room" as a threshold figure bridging the real and the imaginary.

For Ivo, the capture of the moon and the transmission of its captive image on the town's TV station is a means of compensatory empowerment, in response to his radical disillusionment. Within his fantasy, this process of surrogate empowerment gets projected onto the town and implied by a local journalist: "The moon, the satellite of the earth, the pale sun of our nights, the star of lovers, with an effort unprecedented in the history of humanity, has been captured by three of our own people. ... The fact then that it is indeed *our* station transmitting to the world with our first live broadcast an event destined to remain in history, brings another burden of emotion to the overwhelming turbulence in which we have been swept up."

It is not enough that the moon be captured in "punishment" for all Ivo's disappointments; it must also be assassinated. One of the television spectators, Onelio (acting out Ivo's unconscious desire), takes out all his frustration and dissatisfaction on the moon and ends up shooting "her."[6] Because of the clear gendering of the moon, Ivo's fantasy is strongly misogynist. Linked with such things as the consistent objectification of Aldina and Nestore's comparison of Marisa to a hyperactive steam engine, it allows for a strong feminist critique of *The Voice of the Moon* (see O'Healy). However, I am inclined to see the fantasy less as Fellinian misogyny than as part of a film-long critique of masculinity, which includes a critique of Ivo's vicarious killing of the moon.[7] (I relate this to my more general discussion of Fellini and gender in Chapter 12.) Starting with the pathetic voyeurism of the opening sequence and moving through the poetry of Leopardi, the machinations of the Micheluzzis, Nestore's obsession with Marisa, and Ivo's lunatic fascination with Aldina, virtually everything in *The Voice of the Moon* bespeaks an absurd and destructive male world that, in refusing to deal with its own insufficiencies, displaces responsibility onto "women" (in fact, a totally abstract "feminine"). In this respect Ivo's fantasy serves as the dramatic culmination of culturally inscribed, manic masculinity. Even the fantasy seems to suggest this kind of critique in the concluding words of Falzoni: "Once again I must bitterly note that we never miss any opportunity to demonstrate our immaturity. ... We are indeed a nation of shitheads." He is referring specifically to the riot and dash for cover that have occurred as a result of the shooting of the moon. However, his remarks also apply

275

to Onelio's violent actions—and consequently to Ivo, for whom Onelio is a fantasized stand-in.

The fantasy's aftermath

Ivo's vision seems to end with Falzoni's words and with a subsequent shot of the empty square that reveals one of the huge television screens, now blank. However, in terms of both narrative cues and Ivo's repressive/projective psychology, important aspects of his vision "bleed" into the following scenes, suggesting the interpenetration of fantasy and reality and the inability of Ivo merely to withdraw his projections once they have so powerfully dominated the real. In terms of narrative cues, though the screen is blank, it also is solely a product of Ivo's vision: it was not a part of the town prior to the vision. Moreover, one of the large lights from the fantasy remains briefly on, shutting off only after we have seemingly returned to normalcy. And, finally, Ivo encounters a couple, Rossella and Angelino, who have become boyfriend and girlfriend, as far as we know, only during or as a result of the fantasy.

The psychological cues are more important. Though the moon is back in the sky, it is more anthropomorphized than ever—and more than ever a projection of Ivo's disempowerment and resentment toward women. In fact, it functions as an even more personalized symbol than ever before, though even the hint of anything authentically personal will be demolished at the end of the sequence. The moon begins by addressing Ivo in a viciously mocking way: "What a funny face you have. Your grandmother was right that she couldn't look at you without laughing." The moon's intimate knowledge of Ivo's grandmother, hence childhood, suggests that its voice is really Ivo's own self-abusing imagination, indicating that his fantasy of capturing and shooting the moon did not purge him of his sense of failure. The "voice of the moon" has now replaced Ivo's voices from wells (presumably more beneficent spirits), and "she" offers commentary on those voices in a way that further undercuts Ivo: "And what do you want to talk about, the voices, eh? Trips from one well to another? You're not happy? But it's a great gift, great luck, so-called Salvini. Double lucky. It makes me angry how lucky you are. You shouldn't understand. It's a disaster to understand. What would you do after? You should only listen, only hear those voices and wish that they never tire of calling you." There is something potentially positive to what the moon says (to what Ivo in effect tells himself), but the tone of her voice is so sarcastic, so full of (self)derision that anything constructive is neutralized.

Moreover, the moon promises the kind of revelation Ivo earlier sought from his wells ("You almost made me forget the most important thing"), only to turn into the face of Aldina, shout "time for a commercial" ("*Pubblicita!*"), and end

276

the "conversation." The moon, Aldina, and Ivo's projected self (which the first two represent) have all become "televised." At the same time, the natural satellite has become one with the electronic, blatantly collapsing any prior, pretended difference between nature and culture.

In many ways this sequence repeats the process of Ivo's preceding fantasy. Male angst is projected onto moon/woman and thus "captures" it, this time, however, turning it into a site of self-opprobrium. And, again, the moon/woman becomes synonymous with television as the site of evacuated selfhood. A crucial difference seems to lie in the fact that Ivo can no longer imagine the assassination of the moon. He can no longer seek to reclaim himself, even symbolically, through such an assertive act.

The final scene

In the final moments, as Aldina's resounding "*Pubblicita*" is gradually replaced by the sound of frogs, Ivo moves back into the fields where we saw him at the film's beginning. After asserting, "I believe that if there were a little more silence, if everyone made a little silence, perhaps we could understand something," he moves back to the well and sticks his head in it, and the film fades to black.

To some extent this appears just to repeat the opening scene. However, there are some significant changes. For one thing, the voices, which we could hear along with Ivo at the beginning, seem to have disappeared, squelched, we might assume, by "the voice of the moon." Second, there is much greater separation of Ivo from the audience. Though he addresses us—as he did at the start—there is no close-up this time. The figure who goes and sticks his head in the well is tiny and distant. This suggests Ivo's dramatic retreat from a world of potential sharing and communication. Despite the fact that his fantasies have ended, he remains emphatically in his own world. This seems confirmed by a third significant change. While Ivo stuck his head in the well only briefly in the opening scene, there is something ostrich-like about his actions here, as though he is never going to come up for air.

On a more positive note, Ivo *does* keep on keeping on. There may not be a whole lot out—or in—there, but we cannot be entirely sure that he is beyond finding or inventing something.

Postmodernism and postmodernity

In terms of its construction of meaning, *The Voice of the Moon* seems more anchored than many of Fellini's other postmodern films. Images and symbols such

277

as "Aldina," "woman," and "moon" acquire a degree of fixity along an associ-ational chain that is further fixed by television as the omnipotent institutional mechanism of cultural projection. Yet, *The Voice of the Moon* clearly operates as a postmodern text. The social construction of reality in the film—and the conse-quent absence of any pristine realm of origin or authenticity—is one indication. Not only is Ivo the product of numerous cultural influences such as Leopardi, Cinderella, and Pinocchio, but the film as a whole is partly citation—of Méliès's *Voyage to the Moon*. In addition, the emphasis on the cultural prefabrication of meaning is its own form of destabilization, suggesting that meanings do not inhere or remain fixed but endlessly circulate, reproduce, and attach themselves to new contexts. However, the most insistent way in which *The Voice of the Moon* qualifies its seeming semantic stability is its conflation of normalcy and insanity. Not only is Ivo's alienated, "crazy" vision of the capture of the moon completely consistent with the values of his culture, particularly as reflected through poetry (Leopardi), public ritual (the Gnoccata), and television, but the psychology of the film, at least as I have laid it out, *makes perfect sense*. Thus "lunatic" is, in many respects, curiously "rational"—and vice versa. An interesting paradox here is that, as a filmmaker in postmodernity, Fellini can only return to a story of consistent psychological "development" when his hero is mad.

Another postmodern issue central to *The Voice of the Moon* is reproduction or endless duplication. The most comic instance involves Don Antonio, the local priest. His vast accumulation of identical Madonnas leads a heckler (the local lawyer) to comment, "Is this not a ... compelling demonstration that the Madonna can be considered a race?" The absence of uniqueness and originality implied here is, of course, further suggested when Aldina's slipper fits virtually all the women Ivo approaches at the disco. Then, when the moon is captured, no one is interested in the real thing; everyone settles for its televised image.

The most extensive analysis of postmodern reproduction is supplied by one of the film's own characters, Gonnella, who reads all human activity, including that of his son, as role-playing or the enactment of, as he puts it, "archetypes":

> GONNELLA: They train so that each one interprets his part perfectly. Did you see the doctor? Did you notice his suit? Indeed, the typical suit of a doctor. To be more authentic than that is not possible. Yet it's faked, all faked.
>
> IVO: But your son ...?
>
> GONNELLA: Ah, that is the capstone. We are in the realm of great art. No one could take it any further. The archetype of the son, the pla-tonic ideal.
>
> ... It's all a fiction, only a representation, all faked.

278

Gonnella furnishes a perfect description of Baudrillardian copies derived from models rather than originals—exactly what the Madonna has become for the local prelate.

While *The Voice of the Moon* can clearly be situated within postmodernism in terms of theme, it is equally interesting as an analysis of postmodernity. ("Postmodernism" here refers to a particular set of aesthetic or signifying practices, while "postmodernity" is the contemporary socioeconomic environment within which those practices occur.)

Much of the film's narrative hinges on the fact that many of the characters, not just Ivo, are recently released from the local insane asylum. Though the large-scale release of inmates relates to a specific moment in Italian society—the closing of the CIMs (Centers of Mental Hygiene) in 1978—what we might call asylum culture remains a persistent entity in the film. In part, this helps minimize any clear distinction between normalcy and lunacy. Equally important, it points to a world of perpetual rehabilitation. One of the distinguishing characteristics of contemporary Western society is its loss of a sense of discovery and its substitution both economically (as the result of numerous recessions) and psychologically (as the result of heightened sensitivity to abuse) of an ethos of recovery. Twelve-step programs have become the Ignatian exercizes of late capitalism, as we seek to recover not from isolated instances of social hurt and injustice but from society itself. The path to enlightenment no longer leads forward, but backwards, as we seek out the founding moments of trauma. In fact, we have returned to the Christian notion of the Fall without the counterbalancing Western dreams of a kingdom of heaven, a capitalist/industrialized heaven on earth, or a classless society. Concomitantly, we no longer seek some original moment of authenticity, just cures or palliatives for original inauthenticity.

Ivo as repressed and traumatized Pinocchino—as well as asylum inmate—also speaks to an age of abuse victims. Though the "empty room" in his family home may merely be a figment of his imagination, it may also be a place of original physical or emotional trauma, which Ivo is compelled to use as the launching pad for his resentful vision.

Ivo's vision of the capture of the moon clearly references two other crucial contemporary issues—violence/backlash against women and environmentalism—while much of the film's "insanity" (fragmentation, dissociation, loss of community) is linked to globalization. In terms of the last, African street vendors populate and Japanese tourists inundate a small town in rural Italy, while the town walls are plastered with slogans in a variety of different languages. The prevailing influence, as in *Intervista,* is the United States. Nestore gets married at the Las Vegas restaurant, the Gnoccata contestants parade to the sounds of *Stars and Stripes Forever,* the title they vie for is "Miss" (not "Signorina") "Farina," and the disco

crowd dances to the music of Michael Jackson. Ritual and public celebration are expressed in largely American rather than Italian cultural terms. The principal force for Americanization/globalization is, of course, the media and more specifically television. The communal loss of self that occurs amidst media globalization is reflected by the town's great pride in transmitting the capture of the moon—something of absolutely no indigenous cultural significance—to the world at large.

As the allusion to CIMs might suggest, *The Voice of the Moon* also addresses postmodernity within a specifically Italian context. The loss of faith in a public and political sphere, resulting from universal political corruption and leading to the "Tangentopoli" scandals of the early 1990s, is reflected in the consistent absurdity of politicians. The mayor turns the Gnoccata into an occasion for ridiculous and contorted policy statements: "Dumpling and fried gnocchi become thus a test of the hold, we might say, of certain cultural models which must coexist with others through challenges more dramatic and real." The Minister of the Interior (a true representative of the void on the inside) turns the televising of the captive moon into a party platform: "Our position has always been steadfast, unequivocal, courageous, I would say. Every voice should have an aware hearing in the social, civil, and democratic context—national and international and now even interplanetary." The haste with which the politicians escape the scene upon Onelio's outburst confirms a lack of civic commitment that is also a refusal to assume responsibility. Onelio's actions reflect the ongoing threat of terrorism—an issue of concern to Fellini since the 1970s—and an inevitable effect of a society in the stranglehold of self-interested authorities. In fact, if we include (with a bit of exaggeration) Ivo's ragù attack on Brambilla, both major communal celebrations end in terrorist acts.

The death of both politics and community is further implied by the Gnoccata's origin as revolutionary act of solidarity: "The Gnoccata was born a century ago," the media commentator tells us, "... as a protest against the rulers, who with their taxes were starving out the millers." Such committed and unified political activity is clearly an impossibility in the present.

The problem of community, on a larger scale, is reflected in the film's allusions to "the Third Italy"—prosperous sections of the center and northeast of Italy defined by flexible industrialization spread out in small firms and small urban centers. Ivo's town clearly reflects *la compagna urbanizzata* (the "urbanized country") of Third Italy, as well as the kind of economic and cultural fragmentation that this segment of Italian society represented at the time the film was made. The very division of Italy into three—conventionally industrialized North, agrarian and underdeveloped South, and alternatively industrialized pockets in the center and northeast—points to the regional divisions and hostilities that continue to characterize the problematic nationhood of Italy. Moreover, the Third Italy itself is a

compendium of isolated centers. A TV station is the only way for Ivo's town to respond to its isolation, and it does so with communal egoism and aggressiveness.

Gonnella is possibly the strongest indicator of the kind of contemporary insanity that characterizes Italian society in the film. For one thing, he represents more fully than anyone else the convergence of the institutional and the crazed. His ever-present umbrella (a "weapon" we have seen in the hands of Dr. Antonio) and raincoat reflect studied bourgeois self-protection. Moreover, he protects himself psychologically with a form of absolute bureaucratic rationality—categorizing, analyzing, and putting everything in its place. His paranoia is both a reflection and a logical extension of this. Terrified by intimacy or contact (again recalling Dr. Antonio), he constructs a perfectly consistent fantasy in which everyone is out to get him. This in turn leads to an amusing paradox. While Gonnella conforms absolutely to the bureaucratic, institutional standards of his world, he asserts—because of his refusal to connect—his absolute difference. This childish assertion of individuality in the midst of reproducing the status quo makes Gonnella much like the musicians in *Orchestra Rehearsal,* and much as the musicians, in their enervating self-centeredness, become subservient to a Hitlerian conductor, Gonnella ends up sneaking into the Minister's car during the televising of the moon capture, hoping to snuggle obsequiously up to power.

This kind of fundamental conservatism has, of course, been part of Fellini's analysis of the Italian psyche from the beginnings of his career. In this respect, it is not specific to postmodernity but, in the case of *The Voice of the Moon,* becomes specific to the Fellini's view of the Italian character in postmodernity.

One additional aspect of Italian postmodernity—immigration—I will address reserve for discussion in the context of Fellini and politics in Chapter 12.

NOTES

1. Áine O'Healy, using the language of French theoretician Louis Althusser, has described Ivo as being "interpellated"—or given his social role and identity—by the voice from the well: "Unspeakable Bodies: Fellini's Female Grotesques," *Romance Languages Annual 1992,* vol. 4 (West Lafayette, Ind.: Purdue Research Foundation, 1993), 327; hereafter cited in text.

2. "Lunacy" is an English rather than an Italian term. However, there are Italian terms and phrases such as *avere la luna* and *lunatico* that have to do with moodiness. Moreover, both the moon and the well are so clearly aligned with madness in *The Voice of the Moon* that it does not seem unreasonable to indulge in this *pozzo/pazzo/lunacy* wordplay, even though it involves some license in terms of language-crossing.

3. Guido, too, is linked to Pinocchio in *8½,* but Guido seems to make much more progress than Ivo in growing from puppet-child to man. My negative interpretation of the grandmother

in *The Voice of the Moon* is at variance with Fellini's feelings toward his own Gambetollan grandmother, whom he loved dearly (Chandler, 63).

4. Dialogue is based on subtitles except where my own translation was necessary.

5. This ironizes the fact that, as the fantasy begins, Ivo is without his glasses for the only time in the film. (The film cuts from Ivo moving toward the door of his own room with his glasses on to his standing in the empty room without them.) Normally this would imply a movement into "uncorrected" or personal vision. However, the origin of his fantasy within the house and the fact that it is so dominated by the cultural (television, the symbology of the moon, and so forth) makes clear that his "inner" or make-believe world is as culturally "corrected" as his sight through eyeglasses.

6. One might argue that he also shoots television as he fires at the screen, but the screens continue to transmit images for the remainder of the scene.

7. Within this reading, the controlling behavior of Ivo's grandmother, which seems to initiate his cycle of repressive-projective activity early in the film, is neither the fault nor result of her gender. The film does not "blame the woman" and thus justify Ivo's misogyny. Rather her behavior is the outgrowth of a patriarchal society that turns women into instruments of at times stifling socialization. In fact, *both* women's tendency toward controlling behavior *and* the misogyny that this triggers are the product of male culture.

11
Fellini's Commercials[1]

Fellini is probably better known for his parodies of advertising than for the fact that he authored five television commercials later in his career. We can easily recall the monumental billboard in *The Temptation of Dr. Antonio*, the absurd television commercials of *Ginger and Fred*, and the call for a *pubblicità* break at the end of *La voce della luna*. But few in the English-speaking world have had easy access to the spots he directed for Campari, Barilla, and Banca di Roma. They appeared on television only in Italy and had extremely limited exposure in North America, screened principally at events such as the Guggenheim Fellini retrospective (November 2003–January 2004) and the "Felliniana" conference at the University of Washington (November 2003), both of which marked the 10th anniversary of Fellini's death. One can now track them down on YouTube, and a relatively recent French DVD, *Fellini au travail*, contains all of them,[2] although I think it safe to say that they remain largely unseen even by those who specialize in Italian cinema studies. The commercials are significant within the Fellini oeuvre for a number of reasons. First of all, they close a creative circle within Fellini's career. He had always been fascinated with advertising, publishing a series of parodic pieces on the subject in 1939,[3] hence his commercial work late in his career marks not a deviation so much as a return to origins. Secondly, the commercials employ signifying strategies that are consistent with those found in his films—especially the later ones. Thirdly, the commercials are a powerful indictment of the very things they are presumably seeking to sell: individual products but, far more broadly, consumer society and capitalism. They serve as a telling example of "complicitous critique," as Linda Hutcheon long ago dubbed the principal and perhaps only critical stance open to artists within postmodernity: opposition from within that which one seeks to critique.[4] Finally, the commercials are self-reflexive in the manner in which Fellini's best work from *8½* on tends to be, critiquing above all those things with which Fellini himself was most closely identified: celebrity (his own), cinema, dream psychology, masculinity, and the representation of women.

Fellini's turn to television occurs at precisely the same time he begins to attack the medium with great passion in films and interviews. As we have seen, beginning with *And the Ship Sails On*, continuing with *Ginger and Fred* and *Intervista*, and culminating with *The Voice of the Moon*, Fellini launches a scathing critique of the atomizing and dehumanizing effects of the small screen. Moreover, through the mid- and late-1980s, as we have noted, he brought legal action (unsuccessfully) against the insertion of television commercials during the transmission of feature length films. Despite his increasingly jaundiced view of television, Fellini directed a commercial for the Italian aperitif Campari in 1984 and another for Barilla pasta in 1986. According to various accounts,[5] Fellini sought to keep the Campari commercial a secret and was embarrassed when it became known that he was its author. However, once it aired, it became the source of endless discussion, even receiving coverage in American media outlets. The Barilla spot, on the other hand, was heavily publicized before it aired.[6] It too received strong post-airing coverage and became endlessly cited within Italy because of its provocative invocation (to be discussed shortly) of "rigatoni."

In 1992, Fellini directed a series of three commercials for Banca di Roma, which turned out to be the last film work realized before his death in 1993. They did not generate the excitement of his earlier commercial work and attracted an audience of only about 20 people when shown at the 1992 Venice Film Festival.[7]

Given Fellini's increasing inability to obtain funding for his projects, it is more than likely that Fellini took on these television projects to keep active, and, in the case of Barilla and Banca di Roma, to remain visible not just as an entertainment personality (this was never much of a problem from *La Dolce Vita* on) but as a director. Regardless, his television spots do not reflect a sell-out on Fellini's part. He certainly did not intend that they interrupt screenings of his or anyone else's films. Moreover, his outspoken critiques of television had never constituted wholesale condemnation of the medium; he was perfectly happy to acknowledge and support quality television. His animosity was directed at the poor quality of Italian television, which Italians themselves frequently refer to as *spazzatura* or "garbage," and the willingness of spectators to subject themselves to it: "Television has infinite possibilities. The faults are not with the technological creation, but with the people who make the programs and those who watch them."[8] Most important, Fellini's commercials embody the same level of social analysis as do so many of his films and thus are anything but simple capitulations to the logic of advertising.

There must have also been a certain aesthetic appeal for Fellini in directing television commercials. The numerous spots and other short televisual pieces that he filmed during the making of *Ginger and Fred* reveal a strong attraction to the abbreviated format characteristic of television advertising. More important, in his early career as a cartoonist, he learned to condense complex expression into

extremely limited space, and he continued to exercize that skill virtually till his death in the countless sketches he drew in preparation for his films and in frequent illustration of his dreams. In turning to commercials, he was converting what had become a daily artistic exercize into cinematic form.

Fellini's commercials also hearken back to *Carosello*, the half-hour program slot allotted to advertising by the RAI when commercials were first allowed on Italian television in 1957. No other commercials appeared on television, and *Carosello* ran nightly at the end of prime time, just before the 9 p.m. news. Advertisements ran for up to 110 seconds, and the product could only be mentioned at the conclusion. Instead of a typical product promotion, the advertisement had to consist of stories, cartoons, or fairy tales, generating high-quality entertainment, often the work of major Italian creative figures. *Carosello* became a staple of Italian family life, appealing not only to adults but to children, who stayed up to watch it as the last thing they did before going to bed. By 1960 *Carosello* was the most-watched show on Italian television.[9] With the advent of private broadcasting in the 1970s, *Carosello* was cancelled, and American-style television advertising won the day. However, *Carosello* remained a significant part of Italian popular consciousness, providing fertile ground for both the creation and reception of Fellini's advertising work. Moreover, though his Campari and Barilla commercials employ (and parody) the format of American-style spots, his Banca di Roma commercials clearly adopt the more creative *Carosello* format.

It should be noted that Fellini's entry as a famous film director into the world of television advertising did not occur in a vacuum. During the years of *Carosello*, major directors, including Orson Welles, participated. At the time of Fellini's first two commercials, other Italian directors, such as Franco Zeffirelli and Michelangelo Antonioni, were being courted by the advertising industry to shoot spots. Moving to the international scene, the early 1980s marked the moment in which the celebrity (whether performer, director, television personality) became central in an entirely new way to the television advertising enterprise. 1983 was the year in which Michael Jackson signed his first contract for extensive music video spots with Pepsi. The 1984 Super Bowl marked the airing of *1984* (shot in 1983), the famous commercial introducing the Apple Computer and directed by Ridley Scott. Before long, innumerable international feature film directors were to become involved in television via ads, music videos, or some combination of the two (if one should even distinguish, given that music videos are themselves commercials). In short, Fellini entered the fray at the moment in which entertainment personalities were becoming brand names to an extent not seen before, often seemingly overshadowing the products they were asked to publicize.

The years since Fellini's entry into television advertising have witnessed an exponential increase in self-reflexive commercials: spots that make fun of themselves;

foreground the manipulative nature of advertising; deconstruct video/advertising language, gimmickry, and hype; and generally intimate to the viewer that he/she is too clever to be taken in (which, of course, is just another strategy for taking in). Film directors were not by any means the sole cause of this increased self-reflexivity; it was also the inevitable result of the familiarity and contempt all of us, advertisers included, have vis-à-vis public relations and commercials. We are inundated, satiated, and all too boredly aware. From the perspective of such awareness, Fellini's commercials may seem less impressive, less innovative, than they would have at the time they were shot. But his deconstructive work occurred at a time when critiques from within the medium were much less common.

Placing Fellini within the history of advertising and consumer theory and criticism lies beyond my scope; nonetheless, it is illuminating to discuss his spots in relation to Baudrillard.[10] I am not suggesting direct influence, though, contrary to the anti-intellectual image popularized by Fellini himself, he was widely read—and had two Baudrillard's texts in his library, including the Italian version of what is so appropriately titled in English "The Ecstasy of Communication."[11] Baudrillard makes the following five fundamental points about advertising, the commodity, and the advertising system in consumer culture:

1) We consume signs, not objects (goods), largely as a result of the transformation of goods into sign values via advertising.[12]
2) The advertising system has the function of inserting consumers, through signs or sign values, into social hierarchy.[13]
3) The interaction of identity and the system's mode of coding is fundamentally negative. As Baudrillard scholar William Pawlett phrases it:

> the codes ... are ... a system of arbitrary signs that derive their meaning from their position in relation to other terms in the system, *never by absolute, intrinsic, or essential value*. How do we know to look "cool', 'trendy', 'wealthy', ... We do so by displaying signs or terms in the system that are not (yet) being displayed by those from whom we wish to differentiate ourselves and *are* being displayed by those whom we want to resemble. Thus, the meanings of our sign displays are arbitrary, coded and only meaningful in *negative* terms.[14] (Emphases Pawlett's)

4) Consumer capitalism is not a matter of autonomous individuals choosing freely from a universe of possible meanings or choices in such a way as to build or enhance selfhood. We are a product of the needs of the system and our very sense of individualism derives from it.[15]
5) Our attempts to differentiate ourselves, via consumption, in order to claim our specialness in relation to social status has, in the end, the very opposite

effect: "To differentiate oneself is precisely to affiliate to a model, to label one-self by reference to ... a combinatory pattern of fashion, and therefore relin-quish any real difference, any singularity"[16]

These five points cast an illuminating light on my discussion of Fellini's media-centered postmodern films as well as preparing for the analyses that follow.

Because of the limited accessibility to Fellini's commercials and because they are so dense, with major changes in signification occurring virtually from second to second, I have found it useful to introduce each analysis with a detailed summary of the commercial's narrative progression. The summaries select and frame details with ensuing interpretations in mind, and are, therefore, part of the interpretive process.

The following analyses exploit the rare opportunity provided by brief texts to do extremely close readings of Fellini's work in order to reveal its enormous precision. That precision is arrived at intuitively. It is not rationally thought out. Nonetheless, it belies an often-voiced assumption that Fellini was just improvisa-tional or, worse, undisciplined, in his art. At the same time, because of his work's seemingly boundless suggestiveness, the readings are anything but exhaustive. I found that the closer I read the commercials, the more I realized I was responding not to embodied significations but to the invitation to do my own, free-wheeling, invention of meanings. And that made me realize that it was the invitational nature of Fellini's films that has attracted me to them all these many years. They have incited me to think about serious matters in serious ways, and they have guided me in that process. They have modeled the complexity of human experience—and especially human relationships—and have moved me to wonder in both senses of the phrase. Concomitantly, the practice of close analysis has always been, for me, a mode of embracing complexity—the very opposite of reducing texts to simple or single readability. So, I offer the following rather elaborate interpretations only as invitations to the creation of meaning—and the contestation of mine—on the part of the reader. I hope this distances me clearly from the interpretive smugness of the psychoanalyst whom Fellini parodies in his trilogy of Banca di Roma spots.

One of the many wonderful things about these commercials as concluding objects of analysis in this book is their humor and high-spiritedness. They are, in a certain sense, live-action cartoons, bringing us back to Fellini's work as a satirical journalist and reminding us of the extraordinary comic sensibility that underlies so much of his most appealing art.

It is also striking how these small pieces, produced under near total control of the filmmaker, are so tightly analogous to his longer works that involved far more extensive collaboration and were often produced under financial duress. They reveal the same issues, cinematic and narrative strategies, self-reflexivity, and so on. The seamless interrelationship of Fellini's commercials and his films serves

as compelling support that, despite the tendency in academic film studies to dismiss auteurism as untenable, Fellini was indisputably an auteur, able to create an enormously consistent body of work under a variety of different circumstances. And while he, like everyone, was a product of his culture, not some autonomous figure who stood apart or above, he was able to produce distinguished and original work within it.

Campari/Oh che bel paesaggio! *("Oh what lovely landscape"; 1984)*[17]

Interpretive Summary

We see a long shot of a train emerging from a tunnel, and then we cut to the inside of a belle époque first class compartment. An elegantly dressed middle-aged man, with an all-knowing smirk, observes a restless and self-absorbed young woman, mid- to late-twenties, seated across from him, dressed in jeans with a fur coat draped around her. He is played by Victor Poletti, one of the snooty opera singers in *And the Ship Sails On*, and sports precisely the kind of hat and scarf that have become the trademark of Fellini in numerous photos and in sketches he has drawn of himself. The woman conveys a sense of bored exasperation, as she chews gum and looks out the window at the rainy landscape moving past. She seizes a remote control and, while the man continues to look on in his condescending way, begins zapping, summoning up images of exotic and famous landmarks—pyramids, Greek ruins, moonscapes—each of which seems to make her more irritated than did the last. Finally, in frustration, she throws the remote over to the man and sinks back in her seat. Making a gesture that seems to signify "just wait, I've got the answer," he zaps once and summons up a pan from a clearly artificial image of the Leaning Tower of Pisa to the Baptistery of Pisa, with the shadow of a bottle in front of it. The young woman sits up, takes notice, and displays a sense of wonderment completely unexpected given her earlier ennui. We cut to him gesturing as though to say, "see what I've got for you?" as the bottle in shadow turns out to be Campari aperitif, superimposed on what would be the entrance to the Baptistery. As the religious monuments appear and give way to Campari, the music, composed of two irritatingly simple and repetitive alternating refrains, is faintly but audibly punctuated by the sound of church bells. The young woman is now radiant (in fact "enlightened" with her face aglow) as she turns expectantly away from the window and towards the corridor. We cut to a three-shot in which a uniformed woman, presumably a railway hostess, approaches the man and the woman with a tray, a bottle of Campari, and two glasses. The man and young woman wink at each other and pick up the glasses, toasting the hostess,

each other, and us, as the hostess winks at us.[18] We hear the off-screen voice of a woman say "Campari."[19] We then cut to the hostess in close-up, who again winks at us. Cut to black.

Analysis

The ostensible message is, of course, that Campari is an Italian landmark whose distinction can still generate enough excitement to win over even the most bored of the younger, television-sated generation. The commercial would seem to be an excellent example of brand marketing, as well as bridge marketing designed to woo new customers to an older product in danger of appearing passé. The age of Campari is carefully relativized: though a well-established product, it is significantly younger than the Tower or the Baptistery and thus represents a "modern past." The train itself, as belle époque technology, does likewise. Erect, the Campari bottle "corrects" the deficiencies of the Tower and, superimposed on the Baptistery and accompanied by church bells, it equates consumption with salvation. In both ways, it evokes the notion of *corretto* as contained in Italian *caffè corretto*: that is, improvement through the addition of alcohol. Campari as implied by the commercial is a landmark not of tourism (Italy as object of others' attention) but of *la dolce vita* (Italy as subject of its own pleasures). At the same time, the commercial suggests the ability of Campari to bring together consumers not only of different ages but also of different lifestyles and classes. The man is more reserved and of a higher class than the woman, as well as old world by association with the operatic and aristocratic European world of *And the Ship Sails On*. The young woman, with her long blond hair, jeans, chewing gum, and remote control, signifies middle-class Americanness—if not by nationality, certainly by style and culture. And, of course, the commercial sells the idea that Campari transmutes isolation and ennui into joyful sociability and may transform individuals into couples, if not communities.

Behind the ostensible celebration of Campari lies extensive critique. The commercial implies suffocating closure, reflected in the narrow confines of the train and the exclusiveness of first class. Moreover, it traces the elimination of novelty, of difference, of a meaningful real, and of the desire to discover, all linked to the effects of television, brand advertising, and consumer society. Much of this is introduced in the opening seconds of the commercial when landscape or "the world" turns quickly into the world-seen-only-through-a-window (from inside the train) and then into a television screen, as the young woman picks up the remote and starts zapping. At first, raindrops and dirt remain visible on the window, but, as the visual field of the window turns completely into a screen, the surface becomes pristine, eliminating signifiers of any world beyond television. As tourist-y images

of distant landscapes and sites come to predominate, "reality" has become programmed, "channeled," and the already produced has replaced the potentially new and undiscovered. At the same time, ruptures in screen direction, which characterize the editing early in the sequence, disappear, making everything more "orderly" and less cinematically random. This will also occur in the dream structure of the Banca di Roma spots, such as *La cantina* and *Il sogno del 'déjeuner sur l'herbe,'* where oneiric creativity erodes in the face of the rational sterility Fellini associates with [Freudian] psychoanalysis and banking.[20]

When the woman's travelling companion takes control of the remote, the possibility of novelty and difference is further eroded, as the images of exotic places, "other" even if televised and thus already produced, give way not only to purely Italian images, but to the most clichéd of all tourist and all Italian images: the Leaning Tower of Pisa. The images of the Tower and then the Baptistery trigger the first positive reaction from the woman, and she is won over entirely by the appearance of Campari. It is, in short, the thoroughly recognizable and, in the case of Campari, the already tasted and consumed, that inspires enthusiasm. It is clear that her excitement over the image of the bottle is the excitement of recognition not of discovery. The domination of the familiar is even present in the attitudes and gestures of the main characters, which were so easy to translate into words in my interpretive summary. There is the gestural transparency, in effect, of silent cinema.

The commercial concludes with the elimination of any sense of a journey or an external world, as the characters turn away from the window that once oriented them outwards, and towards the woman in uniform carrying a bottle of Campari and two glasses. When they turn back to what once was the window, then a screen, all three either toast or wink at us. In other words, what once was access to an outside world is now a space occupied by us the television spectators. The audiovisual field has been reduced to a closed circuit: performers conveying a sponsor's message to those for whom the message is intended.

The deterioration of a varied and unfolding visible reality negates the possibility of meaningful vision and thus engenders a kind of "atrophy of the eye" that culminates in the winks that, along with the three toasts, conclude the commercial on a note of hyper camaraderie. The wink is a kind of visual "twitch," a form of compulsion. It is learned behavior and generally a clichéd response to a situation. There is nothing new in a wink, as is confirmed by the fact that its usual meaning is "yes, we're all in on it." It is also often if not always coercive, because it places the person being winked at in the position of having to accede to the winker, and to what he or she knows we are all in on. (We are reminded of the callous wink Zampanò flashes at Gelsomina during the wedding sequence in *La Strada* as he is about to go off and have sex with another woman.) In the Campari commercial,

the wink becomes the consummate correlative of brand name advertising; every invocation of a brand name is, in effect, a wink. (**Figure 11.1**)

Fellini's spot implies a fundamental contradiction between brand name advertising and the psychology of consumer society. Having illustrated through the woman's channel surfing the insatiable desire to desire that consumer society promotes, the commercial then proffers a solution: "conversion" (the combination of religion implied by the Baptistery and soundtrack and seduction implied by the male-female interplay) to a tried and trusted product that delivers satisfaction and a cessation of torturous want. The sudden shift from neurosis to peace and fulfillment is largely parodic, underscored by the absurdity of the symbolism and the commercial's persistent tonal excess and self-mockery.

The commercial's representation of gender relations is perhaps as important as its critique of consumer society. It follows closely upon Fellini's most complex analysis of gender, *City of Women*. As with several of Fellini's later films, the commercial contains a significant dose of ironic phallocentricism. The characters are enclosed within a train (*City of Women* was organized around a similar phallic trope), and of course there are the Leaning Tower and the bottle of Campari. The

FIGURE 11.1 Atrophy of the eye: visual activity reduced to a wink. Source: Campari: *Oh che bel paesaggio!* (1984). Directed by Federico Fellini. Produced by Giulio Romieri for Brw & Partners. Frame grab captured by Frank Burke from 2009 French DVD *Fellini au travail*.

woman accedes to the male, who "speaks for" Campari, and then to Campari itself. One could even argue that woman becomes the phallus with the arrival of the hostess. She incarnates the train (she is presumably a railway employee), Campari (she not only brings the aperitif but wears its colors), and even the Leaning Tower, as she towers over the couple and leans down to serve them.

Gender symbolism will be central to a number of Fellini's commercials and will reiterate several points that underlie much of Fellini's later work:

- the world is insistently gendered
- gendering is social and psychological, not "natural"
- it is principally the work of patriarchy and male insecurity
- it is inevitably problematic for women.

As much of my commentary on the Campari spot suggests, Fellini responds to the apparently embarrassing compromise of having to make a commercial with a strategy of resistance, often humorous, coupled with the kind of self-deconstruction that is at the heart of so many of the films in which he is an implied or actual protagonist. The man who seduces the woman into enjoying Campari is not just a familiar Fellini figure from *And the Ship Sails On*, he *embodies* Fellini, as the quintessentially Fellinian hat and scarf proclaim. Like Fellini, he is a "magician," a Mandrake, a summoner-up of fantastic images. But as a master of smarm, he is also the filmmaker transformed into snake-oil salesman, hawking Campari and selling out to television, master not of anything new and creative but of a remote control and the storehouse of banal images (and advertising gimmicks) that is all the remote has to offer. Fellini good-naturedly highlighted his complicity and compromise during the shooting of the spot, when he was frequently heard to mutter: "Che cosa tocca fare per Campari." On the one hand, it means, "what one must do to satisfy Campari?" but it is also a play on the lament "Che cosa tocca fare per campare": "what one must do to get by!"

Perhaps the subtlest form of resistance in the commercial lies in its kitsch: at once representation and its denial. Not only are the train and the original landscape abundantly fake, but so also are all the supposedly realistic landscapes that are remote-controlled into view by the young woman. All are painted and alienating in an almost Brechtian sense. The tone, the maddening musical jingle, and ultimately the excessive toasting and winking further contribute to a commercial that is ultimately in very bad taste, representing the ultimate double-cross given its (com)mission to sell something that (presumably) tastes good. Fellini, in short, winks at us throughout the commercial, recuperating the "twitch" as a means of saying, "don't believe a thing, especially a commercial made for Campari in order to *campare.*"

Barilla/Alta società *("High Society"; 1986)*

Interpretive Summary

Panning and tracking from behind a veil and accompanied by music from *La Dolce Vita*, the camera eye ushers us into the dining area of a fancy restaurant. (The name F. Fellini appears briefly in the lower left-hand corner of the screen on currently viewable versions of the commercial, but see endnote 7). The camera reveals a table of priests in animated conversation, and in the background, we see a line of waiters approaching a table, in slow motion. We cut to the table, and the camera reveals an elegantly dressed woman in her mid- to late-forties, played by Greta Vayan, performer in soft porn films such as *Eros Perversion* (Ron Wertheim, 1979) and *Interno di un convento* (Walerian Borowczyk, 1978), and cover girl for the June 1971 issue of *Playmen*, the Italian equivalent of *Playboy*. The dress and hairstyle of the woman, as well as the general décor, seem more 1940s–1950s than 1980s. The woman looks up at the first waiter in the line, who addresses her and then her partner, precipitating a cut to a younger man seated across from the woman, stroking his moustache. The waiter suggests a number of elegant French dishes, while the couple flirts, rather gauchely, given the context. A long shot reveals the couple seated in front of a window that mirrors back part of the room but also reveals an outside world in which a neon sign displays concentric circles expanding outward, contracting and disappearing, then repeating the process. As the waiter concludes his list of specialties, the woman, in close-up, requests (instead) "rigatoni." We cut to the waiter, who says "ah" in response, reflecting a perfectly trained waiter's capacity to both muffle surprise and be thoroughly accommodating. He then looks directly at us and says, "and we, echoing your choice, respond 'Barilla!'" All the waiters chime in, and then three cuts reveal guests and waiters at other tables looking or turning to look toward the sources of the word "Barilla." At the same time, a chorus of voices chimes in with "Barilla" three more times. We cut to a long shot of the woman at her table, as the waiters exit screen left. What had been a window is now solely a mirror. The camera zooms in on the woman. As she self-consciously fiddles with her necklace and looks at the camera, we hear a male voice off screen (not that of the waiter) saying: "Barilla makes me feel always *al dente*." We fade to black on the image of the woman still fiddling and looking pleasingly at the camera/source of the male voice.

Analysis

As an endorsement of Barilla, Fellini's commercial can be read in at least two ways: Barilla, and with it "Italianness" (read as simplicity, authenticity), trumps

French pretension and fussiness; or, conversely, Barilla has its place in the best of international restaurants, even the most exactingly French. In the latter case, the ad, like the Campari spot, performs a bridging function: in this instance between high culture and the everyday; the art of haute cuisine and mass consumption; France and Italy; the world of the traditionally rich and powerful (the old world elegance of the restaurant) and the nouveau riche (the couple); the postwar generation (the décor) and the 1980s (which was often viewed as the moment of a second Italian Economic Miracle, following upon that of the 1950s).

In short, like the Campari commercial, Barilla seems on a superficial level to do its desired work vis-à-vis its sponsor, but, of course, there are innumerable less flattering ways in which to read the spot. Like the first class train compartment, the French restaurant is an enclosed and exclusive space. Moreover, while the Campari commercial begins with motion and a sense of journeying before ending in stasis, the Barilla ad represents a sedentary world that is going nowhere and whose most mobile figures (the waiters), move, *à la And the Ship Sails On*, in slow motion.

Like the Campari ad, the Barilla spot is organized around a process of constriction and elimination. Seemingly in contrast to the closed world of the restaurant, the spot begins with a "documentary" eye that is active and probing, moving up and forward, exploring and displaying the room. Moreover, characters initially are themselves free: conversing without any awareness of the camera and without their words registering on the soundtrack. However, almost immediately, the camera hitches itself to the slow-motion march of waiters (order, servility, discipline, uniformity) moving in a line towards the table of the protagonists.

Moreover, with the cut to a medium close-up of the woman at the table, the camera loses its mobility. Reality begins to be edited instead of discovered; tight shots begin to replace more inclusive visual display as Fellini's manipulation of cinematic language recalls the opening of *And the Ship Sails On*. Nonetheless, there remains a good deal of initial resistance to containment. The characters repeatedly look beyond the frame, the editing creates several independent spaces (the waiters', the woman's, her companion's), zooming is offset by a wide shot of the room, and the man and woman flirt, retaining momentary independence from what will become the all-powerful presence of the sponsor. The resistance seems to end when the waiter finishes his list, the camera zooms to a tight shot of the woman, and she turns towards the camera and says "rigatoni." (**Figure 11.2**) However, though words are now captured by the soundtrack and despite the tightness of the shot, her response is subversive. While she does limit what had been a plethora of choices to her one desire, she does not want any of the fancy French stuff; she wants pasta.

Real loss of independence occurs when the headwaiter takes her "order" and transforms it into the commercial message: "and we, echoing your choice, respond

FIGURE 11.2 A woman's desire, culinary and otherwise. Source: Barilla: *Alta società* (1986). Directed by Federico Fellini. Produced by Fabrizio Capucci for International Cbn. Frame grab captured by Frank Burke from 2009 French DVD *Fellini au travail*.

'Barilla.'" The waiter lies; he is not an "echo," repeating her proclamation and mirroring her desire, but someone who turns them into a promo for Barilla. However, as the word "echo" suggests, his response is "automatic" ("you say pasta, I think Barilla," to paraphrase), a Pavlovian association that might please the sponsor but is the antithesis of the kind of spontaneity and originality habitually prized by Fellini. The waiter's automatism becomes that of the diners, who chant "Barilla, Barilla, Barilla," and their echoing becomes the aural equivalent of the serial winking in Campari. As this occurs, visual representation becomes ever more dominated by tight shots, cuts, and zooms. Moreover, when the waiter makes his pitch for Barilla, he looks directly at us, meaning that by this point in the spot, we have arrived more or less where the Campari commercial ended. The camera eye is gone as an instrument of disclosure and has become identified with us, sutured into the commercial by the waiter's direct address, as mere spectator. Concomitantly, a world outside the restaurant has disappeared, as the window behind the couple has become a mere mirror.

The reductive process associated with the camera eye then continues beyond that of Campari. When a final zoom fixes the woman, subjecting her to the assertion "Barilla makes me feel always *al dente*," the camera eye loses its identification with us as spectators. The voiceover turns it into the point of view of the male voice, which, in delivering the sponsor's message, embodies the point of view of the sponsor itself. One can thus argue that, by the end of the spot, there is no camera eye in the sense of a disclosing force, and no position for us as audience to witness something disclosed, just the sponsor and his message, which have now taken up the major positions of subjectivity within the spot.

As the above might suggest, the Barilla commercial, like Campari, is structured as the seduction of an initially independent woman. At first, she seems fully at ease, perhaps even in charge, with her younger companion. To the extent that she is coy and submissive, she is largely role-playing for her own amusement and for that of her partner. She commands much more of the camera's attention than does her partner. Perhaps most important, her "rigatoni" is far more than a refusal of French culinary coercion, it is a thinly veiled dirty thought, a "biting" assertion of her female desire, a sexual provocation, and a subtle allusion to women's agency. "Rigatoni" in Emilia-Romagna, refers to a form of fellatio that involves the teeth (hence the multivalence of the eventual *al dente* remark) employed in such a way as to treat the penis as a fluted tube a la rigatoni.[21] (What follows is a thoroughly heterosexual reading of an act that need not be so, but, in this context, such a reading is required.) While fellatio might suggest subjugation or a mere servicing of the male, the performance of "rigatoni" seems to invest the woman with a significant degree of power, judging from the high degree of anxiety expressed by men on the subject: "The "rigatoni" must be carried out with great care, if not, we're talking of castration and not oral sex"[22]; "it just takes sinking the teeth in a bit deeper, and then there's real risk of pain!!!!!"[23]; "Yes, but if it is done gently ... it depends on the woman's ability to control her jaw and on the level of tolerance on the part of the man."[24]. One entry to the online discussion I am citing took the path of most resistance: "I think I am not interested."[25] Given men's vulnerability vis-à-vis "rigatoni," the potentially subjugating act of fellatio becomes, in this variant, an occasion for women's agency, especially since the male imaginary tends to turn the "rigatonista" into a vagina dentata—that perennial expression of male castration anxiety.

The fact that the signora's choice of rigatoni is about not just food but her sexual desire makes the waiter's reduction of rigatoni to "Barilla" an emphatic suppression of her agency and independence. As Barilla comes to dominate everyone's attention, she becomes "interpellated" by the sponsor, ending the commercial silent and passive and with the same enamored look for "him" that she earlier had for her companion.

The sexual implications of "rigatoni" were the reason for its contagious reiteration throughout Italy following the airing of the commercial. (An enormous coup for Barilla.) And no doubt Fellini's decision to employ it was closely related to his choice of a porn-inflected actress for his spot. Both gave the stiflingly bourgeois setting an oppositional touch. How much more oppositional it might have been had the waiter truly functioned as a "echo," inciting the roomful of diners to exclaim not "Barilla," but, in effect, "fellatio," "fellatio," fellatio" (I have refrained from using a more vulgar but more pointedly oppositional English term for the act).

Turning to the second double entendre in the commercial, in Italian cuisine *al dente* means somewhat firm to the tooth (the perfect way to prepare certain pastas), while, in conjunction with the rigatoni joke, it presumably implies feeling like one always has (a woman's) teeth on one's "rigatone." Somewhat firm in this context would also imply a perpetual state of semi-excitement—readiness at any moment to take things to the next level. This resembles the state in which we find Snàporaz at the beginning of *City of Women*.

Since it was the woman who first proclaimed "rigatoni" and since the male voice is addressing her as he speaks of feeling *al dente*, we can infer that it is she who makes him feel *al dente*, turning the commercial into soft porn. More than that, it completes a trajectory in which the woman's "rigatoni" (her implied sexual desire)—having already been effaced by "Barilla"—is now replaced by an expression of male sexual desire, which turns her into object rather than subject.

The initial centrality of the Vayan character is accompanied by a largely "feminine" atmosphere.[26] A gauzy veil envelops the visual field at the beginning; there is an abundance of flowers; and rounded and curved forms predominate, two of which are large hanging lamps shaped like breasts. (An image of this sort will recur in the second Banca di Roma spot). Concomitantly, there is a seeming emphasis on what we might term de-masculinization: the proliferation of priests (men who have renounced their sexuality); the prissiness of the waiters; the implied effeteness of French ways hence of the ambience in general; the slight effeminacy of the woman's lover; the decorative candles (feminized phalli); and even the voice of the sponsor, who talks about (of all things) "feelings." The most masculine figure on display is actually the woman, with her padded shoulders; her Italianness (rigatoni) proclaimed over and against French effeminacy; and, in the brief moment she is able to exercise it, her assertiveness. She also reverses traditional gender positions, especially in the context of Italian culture, as an older female with a younger male. However, the final shot of the commercial is a zoom that eliminates the surroundings and her companion and makes the male voice not only prominent but domineering.

In the end, rather than being subversive, the Vayan figure turns out to be the hinge upon which the selling of Barilla turns—her "rigatoni" offering the *frisson*

that makes the advertisement work. She (and to a much lesser extent her partner) is also the principal point of interpellation for the viewer-as-consumer. She starts the commercial listening to a pitch (the elaborate menu), mirroring our position as we watch the spot. She ends up listening to quite a different pitch when the male sponsor implies his readiness to satisfy extra-culinary desires. In the second instance, she offers no resistance, no equivalent to her earlier intervention, and her acquiescence is precisely what is desired of us (though certainly not by Fellini) as targets of consumer advertising.

Banca di Roma

The order in which I treat Fellini's three Banca di Roma commercials is the order in which Tullio Kezich, Fellini's most authoritative biographer, and the critic who addressed Fellini's commercials with the greatest attention when they were aired, places them.[27] Most important, it is the order to which the internal evidence of the three seems most convincingly to point.

The structure for all three spots is the same: the protagonist experiences a nightmare, awakens with a start, visits a psychoanalyst[28] who recommends the Banca di Roma, and ends up, at night, in bed, in the protective confines of a grandiose bank building. According to the words that accompany the bank logo in the three spots, this institution will serve our hero as both "bank" and "friend" and, in so doing, bring him "serene nights" by eliminating his troubled sleep. The stability of the old and trusted will offer refuge from the new and unpredictable, and the enormous difference in empowerment between institution and individual will be leveled by the former's commitment to being a "friend" and, beyond even that, a home.

Perhaps the first indication of the commercials' subversive intent lies in the casting of the two principal characters: Paolo Villaggio as the nightmare-prone protagonist/patient and Fernando Rey as his psychoanalyst. Villaggio had appeared in The Voice of the Moon, where he portrayed Gonnella, a figure characterized by profound paranoia, an obsession with self-protection, and marked obsequiousness in the face of power. Extremely relevant to the Banca di Roma commercials, Gonnella manifested an aversion to dreams and to whatever they might offer him. Early in the film he returns home at night and rejects the offer of hospitality extended by neighbors. He falls asleep and dreams that they have come to his room to offer sustenance. His response to their kindness is, to say the least, negative: "Now one can't even be at peace in one's own room. All I need to do is close my eyes and you sneak in with your bad breath ... to infect me. But watch out for me. Pay attention. I know martial arts." Then, with a "zac, zac, zac," he

lets loose with karate moves, "destroying" his dream visitors and, with them, the dream itself. As we will see, the commercials implicitly advocate the annihilation of dream life, with the Villaggio figure a willing accomplice.

Gonnella was likely Fellini's homage to Villaggio's written and film portrayals of Fantozzi, a hapless low-level white-collar worker at the *Megaditta ItalPetrolCemeTermoTessilFarmoMetalChimica*, and a figure with whom the image of Villaggio had become largely fused by the early 1990s. The mountain shaped like a fist that we see looming over the tunnel that collapses on Villaggio in the first spot is quite possibly a refashioning of the famous *nuvola di Fantozzi*—the cloud that hovers over Fantozzi wherever he goes, even if, for everyone else, it is a bright sunny day. The Fantozzi films are a trenchant denunciation of Italy from the mid 1970s on. Three were made between 1988 and 1993, the same period in which Fellini made his Banca di Roma spots.[29] There are at least three principal objects of critique: an Italy that, in its belated haste to modernize and industrialize, and in its predisposition towards massive and unresponsive bureaucracy, has created a corporate hell for many of its citizens; an Italy that in its postwar rush to adopt American-style capitalism has become a moral vacuum; and the petit-bourgeois Italian who, living in a society transformed by Americanization and the Economic Miracle of the late 1950s and early 1960s, willingly partakes of his/her own victimization within it. Fantozzi has little money but plenty of pretensions to a certain lifestyle. For that reason and because of a lack of fundamental meaning to his life, he has become attached to work in the most servile of ways.

The image of Fernando Rey operates on the *megaditta* side of the equation, forged, as it was, in his roles for Luis Buñuel as a high-bourgeois patriarch, using cultural capital and suaveness to seduce and exploit women.[30] He is precisely the kind of figure to whom Fantozzi might say, as he does to his boss in *Fantozzi 2000 - La clonazione* (2000; Domenico Saverni), "Do with me what you will. For me it is an honor to be your slave." Rey's role as French drug lord—an elegant and wealthy "pusher"—in *The French Connection* (1971; William Friedkin) and *French Connection II* (1975; John Frankenheimer) resonates quite nicely with his salesmanship on behalf of the Banca di Roma in Fellini's commercials.

Fellini's commercials upgrade the Fantozzi figure to something more than petit-bourgeois and downgrade the Rey image to something less than Buñuelian haute bourgeois. They meet more or less on the level of middle- to upper-middle class, as do the characters of the preceding commercials. Nonetheless, the two figures represent a significant discrepancy in power, with the psychotherapist on the side of institutional authority and his patient blithely acquiescent to it.

It is fairly clear then, a priori, that Fellini is not celebrating the virtues of banking or of psychological counselling, in the Banca di Roma commercials. The

full extent of the commercials' irony becomes clear when they are viewed in light of characteristic Fellinian themes, particularly from the more modernist phase of his work, such as the primacy of the individual and the creative imagination and the threat posed to both by institutional authority. Irony is especially obvious in the spots' treatment of dream life and the unconscious. As anyone familiar with his work knows so well, Fellini was profoundly committed to the inner life. As he put it in *Gli ultimi sogni di Fellini*:

> ... it seems to me that, among the many adventures life has to offer, that which, more than any other, is worth undertaking, is a dive into your inner dimensions, exploring the unknown part of yourself. And notwithstanding all the risks it may bring, what other adventure could be as fascinating, marvelous, and heroic?"[31]

The recently published *Federico Fellini: Il libro dei sogni (Federico Fellini: The Book of Dreams)*[32] reveals the passion with which Fellini not only dreamt but recorded and interpreted his dreams, illustrating them in vivid drawings, at least as late as 1991. As his vision grew darker (from the 1970s on), his films sometimes seemed to contradict his pronouncements on the subject, but it is safe to say that, at its best, Fellini viewed the dreaming imagination as a creative source necessary for the individual to evolve beyond over-determined unconscious behavior (defensive, reactionary) towards increasingly responsible and meaningful experience. In contrast, the Banca di Roma spots, reflecting a materialist and instrumental world in which even psychotherapists operate solely on behalf of moneyed interests, the creative unconscious is seen only as a problem: something to be repressed and ultimately eliminated in favor of "serene nights": the dreamless sleep and death-in-life of institutional surrender. At the same time, the protagonist is so out of touch with his inner life, that he must present himself to a mental health provider instead of dealing with his dreams himself.[33]

One might argue that Villaggio, the psychoanalysis, and the bank only seek to eliminate bad dreams, but even the elimination of troubling visions would have been a censuring of imaginative activity thoroughly antipathetic to Fellini. Moreover, had that been the case, the protagonist would have wished us *sogni d'oro* or "golden dreams"—the typical goodnight salutation for Italians—instead of, effectively, no dreams at all.

The following discussions, while occurring within the seeming ambit of dream analysis, do not seek to apply any particular psychoanalytical theory or method. They are first and foremost narrative and cinematic analyses, following Fellini's lead as he plays with cinematic signification and with figures such as Jung and Freud.

La galleria *("The Tunnel'; 1992)*

Interpretive Summary

As the overture from *Il barbiere di siviglia* plays on the soundtrack, the camera zooms towards a tunnel on a highway that passes under a mountain shaped like a threatening fist. We cut to a car approaching the tunnel and see the headlights of the car light up. We see the inside of the tunnel from the car's perspective and then cut to see the driver/protagonist, a well-dressed and rather dapper middle-class, middle-aged man, singing to the music. He seems pleased with himself as his hand, extended out the window, taps the top of the car. Suddenly he hears strange noises, looks around concerned, and puts his hand back on the top of the car, this time to check if everything is all right. The tunnel begins to collapse. The protagonist tries to clear the window of dirt and debris. There is a pan, amidst sudden quiet, of the inside of the tunnel. We see his car, though he is no longer visible inside, and hear his agitated heavy breathing. The breathing becomes an audio cut, followed by a shout, with the protagonist waking up in bed. A lamp turns on, and we see him alone in his small room. We hear a clock ticking, and it continues to tick as a cut coincides with the laughing voice of a psychoanalyst who leans forward over his office desk towards the protagonist and suggests the protagonist is "blocked" and "can't pass through," and he needs to find a "way out." Moreover, in this endeavor, "the Banca di Roma could provide excellent protection." As he makes his confident pronouncements, we cut to the protagonist and witness, next to him, the comical photograph of a baby with its mouth wide open, which, on one occasion, the protagonist draws towards him. The protagonist responds to the therapist's Banca di Roma suggestion with the partial sentence, "Yes, but excuse me, the money …" and is interrupted by the psychoanalyst who says: "I don't specialize in financial matters but in psychological problems. For all else, there is the Banca di Roma. Follow my advice, and your nightly anguish will be defeated." As he speaks, a zoom carries us into a picture on his wall that then is transformed, via further zooms and dissolves, into the lobby of a bank, where the protagonist has moved his bedroom furniture. We hear his voiceover proclaiming his happiness to be there and his desire for serene nights. He rubs his hands together gleefully, takes a flying leap into his bed, then looks into the camera and speaks his final words directly to us: "the same serene nights that I wish for you. Goodnight." He turns his light off, and the logo of the bank, with the words "Banca di Roma, your bank and friend," appears on screen, lighting the scene and revealing the protagonist perfectly framed and still in his bed. Fade to black. Music from *Fellini's Casanova* (1976) accompanies the final images.

Analysis

Keeping in mind the precedent not only of Gonnella but also of an even more timid and conformist Fantozzi, we can, I believe, read the protagonist's tunnel nightmare in terms of a fundamental fear of the unknown and of "the journey," in every sense of the term. He imagines his future, the road that literally and figuratively lies ahead, as threatened by a huge fist about to descend and crush, and then he imagines that his world does indeed collapse around him as soon as he ventures ahead. His dream suggests disorientation as he passes a sign for Pescara that should either be facing the opposite way for drivers such as he entering the tunnel, or be on the opposite side of the road for those exiting. Equally important, the figure within the dream is cautious and self-protective. He is sure to turn on his lights as soon as he approaches the tunnel. (This is required by Italian law but is also consistent with his characterization.) He wears a coat over a suit even though he is inside a car. The car itself is insulation, as is emphasized when he taps the protective shell of the roof before things start to go wrong. And, most important, the tunnel seems initially to serve as an impenetrable barrier, a secure defense against the fist pressing down from above. Here the will towards self-protection seems to extend beyond the protagonist in the dream to the figure dreaming the dream, who has provided this seemingly safe tunnel for his protagonist. In fact, the tunnel changes its function quite quickly in the dream from entryway or threshold to container. It is also meant to function as a road, but, quite significantly, it retains that function only briefly; as soon as it fails to protect it loses its capacity to transport. The turning point of the dream occurs when its seeming invincibility is breached, abruptly concluding the journey and leading to the disappearance of the protagonist.

A fear of venturing becomes clear in light of the dream's more conventional psychological symbolism. We have a journey from outside to inside and from light to (relative) dark, which could be read as a journey from the daylight world of consciousness into a nocturnal world of the unconscious, the imagination, the inner life. We could also speak of a journey into the unknown, the interior, the sexual (tunnel as both womb and phallus), death, and so forth. All of this is familiar Fellinian oneirology. However, upon close inspection, distinct poles to the symbolism dissolve. The tunnel is not "other" to the outside world, it is the continuation of that world with its road and its high level of illumination, deriving not only from an extensive lighting system, but also from the headlights that the protagonist imports from outside. The tunnel has, in short, been built in the image of its supposed opposite. And though the tunnel undergoes some changes in function, it never represents true alterity as does, for example, its counterpart in Friedrich Dürennmatt's famous short story "Der Tunnel."[34] It begins to collapse before, and instead of, becoming other. One might say that, as a psychological journey,

the protagonist's dream has nowhere to go, because in effect the destination is the same as the point of departure.

At the same time, the journey falls victim to the one-sided conflict of two other paired opposites, above and below, the mountain/fist and the tunnel underneath, which again have psychological corollaries: conscious and unconscious, outer and inner life, perhaps even institutional superego and individual imagination. Clearly the first element in each pair weighs upon, dominates, and crushes the latter. So again, there is no truly separate and integral space for the unconscious and the inner life, into which the protagonist can truly venture.

The imagery of the broken road and the interrupted journey call to mind another psychological journey (though not strictly speaking a dream): that of Fellini's protagonist in *Toby Dammit*. There, as I suggested in chapter 5, the hero reacts quite differently when the journey seems ended, propelling his car towards a yawning abyss and challenging the unknown in a radically transformative manner. Here, our hero exhibits no initiative. He remains inside his car, fiddling with the windshield wipers until the dream, not his own actions within it, transport him out. Both the stalled car and his breathless terrified awakening recall another Fellini hero, Guido, at the start of *8½*, and again the difference in response is telling. Whereas for the latter, a nightmare was the point of departure for self-examination and attempted individuation, the former makes no apparent effort to engage with his dream and, instead, takes himself off to a therapist who offers anything but nourishment for an inner life. First of all, the psychoanalyst leaps to his hopelessly facile and simplistic analysis "Blocked? Can't pass through?" He ignores all the richness of the dream, all the raw material that might help his patient confront his problems and begin to resolve them. Much worse, he launches into a diatribe against the psyche that, in its paranoia, makes him a perfect match for both Gonnella and his patient: "We know that the fables of our unconscious are ruthless, catastrophic, in their aggression. But we, in our conscious life, with intelligence and fantasy, must know how to best organize our defenses." He actually contradicts the spatial symbology of the dream, whose fist suggests that violence lies with the conscious, not the unconscious. He presents the relationship between conscious and unconscious as a battleground (not unlike his patient), requiring the very protective strategies that have already rendered his patient incapable of psychological risk or adventure. In so doing, he places himself in direct opposition to Fellini who, like the noted psychoanalyst C.G. Jung whom he greatly admired, viewed the conscious and the unconscious as potentially complementary forces capable of interacting in extraordinarily positive ways.

The key to the psychoanalyst's mental health orientation becomes clear in the second commercial, when we see a picture of Freud on display in his office.

FIGURE 11.3 The photo of Freud (screen right) tells us all we need to know about our protagonist's psychoanalyst—and much about Fellini's opinion of Freud vs. Jung. Source: Banca di Roma: *Che brutte notti*: *La cantina* (1992). Directed by Federico Fellini. Produced by Sergio Castellani for Film Master. Frame grab captured by Frank Burke from 2009 French DVD *Fellini au travail*.

(**Figure 11.3**) Fellini remarked (and he was hardly the first to do so), "The difference between Freud and Jung … is that Freud represents rational thinking, and Jung imaginative thinking,"[35] and we do not have to wait till the second spot to see a counterproductive rationalism at work. The ticking clock should be our first indication, signaling the quantification of experience temporally and financially (the 50-minute hour). As he talks of "organizing defenses," the psychoanalyst draws a square on his writing pad, then, with a vigor that approaches violence, draws a diagonal line through it. All straight lines and angles, he is the perfect antechamber to the quintessential repository of institutional rationality: the bank. The transition from the psychoanalyst's office to the bank makes their twinning, and the logic of Fellini's critique, perfectly clear. The camera zooms into a frame of a picture on the psychoanalyst's wall. As the psychoanalyst talks of the Banca di Roma, the zooms and dissolves produce the image of a perfectly rational and geometrical building that has been constructed via the repetition of identical lines, rectangles, columns, and so on. Once the series of zooms and dissolves is complete,

the protagonist and we have become encapsulated in a bank lobby: the heart of reason, which, for Fellini, is, to mix metaphors, the belly of the beast.

Needless to say, our hero finds himself completely at ease in his new environment: "I am happy to think that I have followed some good advice." His most enthusiastic moment in the commercial (in fact in each of the three) is his leap into bed to cover himself up and remove his glasses, no longer needing or wanting to see. Seduced, as were the figures in the Campari and Barilla commercials (though they were more resistant than he), he concludes the spot, as do his predecessors, looking toward the camera eye, again reducing it to a television spectator trapped by the direct address of the advertising message.

Despite the insistent framing and containment of the tunnel nightmare and its aftermath, there is one striking detail in the psychoanalyst's office that offers a point of resistance, a moment of release, similar to the winks and bad taste of Campari and the double entendres of Barilla: the photo of the open-mouthed baby. (Figure 11.4) On the one hand, the baby seems to evoke the protagonist in his helplessness, particularly in the face of his aggressive mentor. The wide-open mouth reflects oral-phase dependency while also glossing the ceaseless babbling—another form of oral dependency—of the therapist. However, the photo ultimately defies any limiting interpretation. It is "other" in terms of its comic unexpectedness in the scene and also for its suggestion of infant irrationality, vitality, and promise, which strongly contrast with the domineering analyst and his office. Out of place, the photo seems to point to that "way out" that the therapist has reserved only for the Banca di Roma. The first time it appears, the protagonist picks it up during the therapist's diatribe against the unconscious—against the nonrationality that the baby so luminously exudes. However, the protagonist quickly puts it back rather than seeing it as an antidote to his mentor. The second time, it is next to him, but he ignores it. The next time we see him, the photo is no longer visible. We then dissolve to the bank. The photo never reappears in the psychoanalyst's office; nonetheless, it outlives its disappearance as something excessive and inassimilable to the logic of reason-based psychotherapy and banking.

La cantina *("The Cellar"; 1992)*

Interpretive Summary

A middle-aged man (Villaggio) dressed as a little boy in a sailor suit follows an older women, who is carrying a bucket downstairs into a cantina. He whispers breathlessly in voiceover "Signora Vandemberg! She was the most beautiful woman in the world. She was Dutch and lived above us when I was in high school."

FIGURE 11.4 A baby picture provides a potential moment of reprieve before the protagonist succumbs to monetized psychoanalysis and the Banca di Roma. Source: Banca di Roma: *Che brutte notti*: *La galleria* (1992). Directed by Federico Fellini. Produced by Sergio Castellani for Film Master. Frame grab captured by Frank Burke from 2009 French DVD *Fellini au travail*.

Then, he calls out to her, "Signora, let me help; I will carry the bucket for you." She turns and says in Dutch, "You're not up to it; you're still a little boy." He clearly understands because he responds, "But I'm not still a little boy; I'm the director of a company—a man who is important, respected, feared." Smiling and laughing, she responds, again in Dutch, "you have remained a little boy" and moves off, not to be seen again. This time, he doesn't understand. He looks backwards and off screen and asks, "Please, is there anyone who can translate?" A gate swings open in the darkness, and a voice says, "Yes, I can. She says that, deep down, you have remained a little boy."[36] A lion enters through the gate, and we presume he is the author of the translation. The protagonist flattens himself against the wall in fear and calls out for the caretaker. There is eerie quiet, though we can hear the sound of dripping and lightly coursing water, whose source we cannot see. The lion turns his head, and we see his left eye gleam. He jumps down from a ledge. He approaches the protagonist who calls out again for the caretaker. We see tears coursing down from the right eye of the lion, and the protagonist rubs tears from his left eye and turns away. Fade to black. We hear heavy breathing. The protagonist turns on his

light whimpering "why, why?" Cut to the psychoanalyst drinking tea in his office. The protagonist talks of "an expression that broke my heart" and adds "even now I feel like crying." The doctor responds, "But why are you keeping your lion in the cellar, humiliating it, degrading it. Come on, don't make it cry. Sometimes, pride, dignity, even a certain aggressiveness, can make you feel more secure in life. The same secureness that the Banca di Roma can give you in many other situations." The commercial then concludes exactly as did the first, with zooms and dissolves into the structure of what becomes a bank and with the protagonist settling into his new "home," with the same dialogue, logo, music, and so on.

Analysis

In contrast to *La galleria*, *La cantina* offers a dream in which the protagonist's unconscious is seeking to address crucial issues in his life instead of just revealing to him his paranoia, self-protectiveness, and an inner life gone missing because of them. It also contains a number of positive implications. The cantina, as a dark place where one can store things when they are not needed and retrieve them when they are, and, in this case, where one can draw upon hidden wellsprings (implied by the bucket[37] and sounds of water), is a fairly obvious and affirmative representation of the unconscious. Reminiscent of the tunnel, the cantina is lit, both artificially and from outside. But its lighting is much less obtrusive, and the protagonist does not bring his own protective illumination. Moreover, it includes or at least offers access to a space beyond (into which the Signora disappears), something "other" to all the limitations that emerge within the existing space. The protagonist seems to be open and adventurous (potentially, though ultimately falsely, implied in the sailor suit); capable of desire and love in their childhood manifestations; bilingual (initially); and willing to take on work or responsibility beyond his years. In offering to carry the bucket, he seems predisposed to draw up(on) the restorative powers implied in the water symbolism of the dream. In seeming to represent the protagonist revisiting, as an adult, a childhood moment of failure, the dream suggests a will on his part to revise the past and make things right.

Unfortunately, the protagonist proves extremely limited, nullifying the possibilities present in the dream. The sailor suit ends up pointing more to arrested development (a theme that recalls *La Strada*, 1954) than adventure. Juxtaposed with his claims to have known the Signora when he was in "ginnasio" or high school, the outfit—which would only be worn by a much younger boy—suggests a figure unable to grow into adolescence, much less adulthood. So (comically) does the cover for the cantina's overhead light, shaped, as it is, like a breast complete with nipple. The woman's comments confirm what we see on screen.

While arrested development seems part of *La cantina*'s problematic, there are other more important considerations that help us arrive at a more compelling interpretation of the spot. Whereas *La galleria* addressed, among other things, the issue of self-protection, *La cantina* introduces the issue of mediation: of relating to the unconscious and addressing one's innermost needs through mechanisms or symbolic figures that end up replacing more direct means of pursuing those needs. Protection and mediation are, obviously, closely related as defense strategies, the former particularly apropos of the bank and the latter of psychoanalysis. More precisely, the dream and more broadly the commercial entail an initial misrecognition on the part of the protagonist of a vital source of agency, then his substitution of that source with progressively less valid alternatives. The Signora embodies movement, energy, and force: powers that the protagonist desperately needs. She is an incentive for change, capable of leading the protagonist, in every way, beyond the scene/seen. She moves insistently toward the rear of the cantina, bucket in hand, in order to exit it. She proves unencompassable, and she quickly disappears. She is, we may posit, a spiritual, not material, resource. The protagonist sees things differently. He fixates on her instead of giving himself over to her guiding energy, and he seeks to stop her with his insistent voice. (I am reminded of Snàporaz's treatment of the Signora at the beginning of *City of Women*.) He succeeds only briefly, and she never remains still. He, on the other hand, manages to stop himself entirely, quickly, and only part way into the cantina. He then begins to look behind him rather than forward, in search of a "translation," indicating that he has very quickly lost the capacity to understand, literally and figuratively, his potentially transformative guide.

The protagonist's reliance upon language and his need to "understand" the Signora suggest a need to mediate her immediate and initially non-verbal force. More than that, he sexualizes her, treating her as an objectified manifestation of his own desire instead of as an incitement to a creative encounter with otherness, difference. Once he loses her, mediation dominates in the form of the lion, whose role as intermediary is highlighted by the call for translation. Within the logic of the dream, the lion replaces the Signora. On the one hand, and this is something the psychoanalyst ends up missing completely, the lion is quite gifted. Not your ordinary king of the forest, he not only has language skills (Dutch and Italian), he conveys a sense of self-confidence and maturity lacking to the protagonist. He encompasses light (the gleaming eye) and dark (the hidden space from which he comes), and he is enormously sensitive. In fact, he understands not just the words of the woman but the profound tragedy, the lost opportunity, embodied by the dream, hence his copious tears. Like the woman, he can be read as part of the protagonist/dreamer: embodying not the capacity to access the unknown as did she, but at least the capacity to acknowledge the tragedy in not so doing.

Unfortunately, he also embodies a marked deterioration in the quality of the protagonist's guides. Spatially as well as psychologically he is further removed than the woman from any implied source of replenishment or wholeness. He is clearly domesticated, a circus lion so tame he has no need of a trainer, a wild animal for whom submissiveness has become habit. Gender-wise, he replaces Signora Vandemberg's otherness as woman with the "feminine side" of a male. This is reflected in his sensitivity but also suggested when, as soon as he appears, we begin to hear the sound of water, the presumed "feminine principle." (This seemingly simplistic symbolism will prove part of a gender critique.) His tears become what remain of the regenerative source, for which we might assume the bucket, in the logic of the dream, was intended. He may be positive in terms of what he retains of the Signora, but he displays none of her energy or humor; he is listless, sad, resigned—like the protagonist in his waking life.

At the same time, the protagonist distances himself from the lion, particularly in its otherness as a (potentially) wild and powerful creature, shrinking back against the wall and crying out for help. This contrasts sharply with his breathless haste to connect with the Signora. When no one answers his call and he is confronted with the lion's sadness, he evades the wisdom that it entails. At first this does not seem to be the case, for within the dream he cries too, partaking on some level of the lion's understanding. However, when he awakens crying out "why, why?" we realize that he has repressed whatever understanding he might have had in his dream, necessitating another visit to the therapist and foreclosing any meaningful reflection on his part.

Though I have employed psychosexual notions such as "phallic" and "the feminine" to describe images, characters, and at times even the ambiance in Fellini's commercials, *La cantina* encourages meditation on their use, particularly in relation to Fellini's oeuvre. While (largely Jungian) sexual symbolism was a means for psychological growth on the part of earlier Fellini protagonists such as Guido (*8½*) and Juliet (*Juliet of the Spirits*), his later films, particularly *Fellini's Casanova*, *City of Women*, and *The Voice of the Moon*, suggest that such symbolism can be highly problematic. As long as male characters see the world in gendered terms, projecting their identity onto women and constructing a metaphysics based on such projection, they remain fixed in a state of immaturity that is inevitably detrimental to women. Thus, as soon as I begin to speak of a world as phallic (Campari) or feminine (Barilla, *La cantina*), I am already speaking of a world that, in terms of late Fellini, has "fallen into" gender. From this perspective, the protagonist's problems in *La cantina* begin when he sees Signora Vandemberg as a beautiful woman instead of as something profoundly else—though even constructing the issue in terms of woman as other is problematic. His difficulties accelerate when he is reduced to dreaming up symbols of the feminine, such as the sound of water

and the lion's tears, in a continuing quest to recuperate what the Signora embodies in psychologically gendered terms.

Ultimately, the problem lies in turning energy (what the Signora embodies and initially releases in the dream) into symbol (what she "means," particularly narcissistically, in regard to the dreamer). And in this light, *La cantina*'s critique of mediation is not limited to gender projections and displacements. It seems to query whether the oneiric imagination can *ever* escape symbolic substitution. In Jungian, as opposed to Freudian, psychology, the answer would be "Yes." Certain mediations, such as archetypes, creative symbols, dreams, and art, can in Jungian psychology, by organizing profound meanings in dynamic and open-ended forms, whether socially constructed or not, serve as stimulants to growth and, to that most desired of Jungian possibilities, individuation. Their energy can exceed their symbolic bounds. In his writings, interviews, and *Libro dei sogni/Book of Dreams*, Fellini seems to remain convinced that dreams can serve this positive Jungian function. However, he seems disinclined or unable in his later film work (of which *La cantina* is, obviously, a part) to portray individuals capable of dreaming in a healthy and liberating way. In that work, dreams seem almost inevitably to be evasions and distortions. In his final film, *The Voice of the Moon*, they both emerge from and lead back to madness. One might even say that Fellini as filmmaker abandons Jung for Freud. He certainly does not embrace rationality, but he seems to feel that the symbols generated by dreams and the creative unconscious remain so confined to activities such as sublimation and displacement that they cannot serve as guides to conscious development. The opportunities missed and potential unfulfilled that we find in *La cantina* (and, as we shall shortly see, in Fellini's final Banca di Roma spot) still imply the possibility for productive dream work—hence the faith in the dreaming unconscious that lingers till his death in Fellini's non-cinematic expressions on the subject. Nonetheless, it seems that Fellini ended his career caught in a dream dilemma he could not resolve.

Returning to the narrative trajectory of *La cantina*, when the protagonist goes off to his therapist, he is, of course, relying on yet another mediating figure. More-over, when he follows, yet again, the therapist's advice and places himself in the hands of the Banca di Roma—to sleep perchance *not* to dream—mediation is, argu-ably, absolute, effacing any remaining agency on the part of our hero. This explains his will to the leap into bed, cover up, and discard his glasses. The therapist proves even more inadequate than before. He reduces the entire dream to the figure of the lion and reduces the latter to a symbol of the protagonist's repressed "pride," "arrogance," and "aggressiveness," ignoring the fact that Signora Vandemberg possesses all three characteristics (substituting "assertiveness" for "aggressive-ness") without any sign of repression. He ignores altogether the lion's obvious

virtues and, especially, his complexity. Moreover, his advice contains a fundamental contradiction: the protagonist should a) be more aggressive, and b) put himself in the hands of the Banca di Roma.

Il sogno del "déjeuner sur l'erbe" ("*The Dream of Luncheon on the Grass*"; 1992)

Interpretive Summary

The dream opens with a tree in full springtime bloom, surrounded by the swirling "puffs" or seeds we have seen in the opening and closing scenes of *Amarcord* and accompanied by the sound of birds and wind. A young woman, holding a long-stemmed poppy, laughs with great pleasure at the protagonist, a middle-aged man, presumably on a country outing with this much younger companion. Both are seated at a well-appointed table for a picnic. Waiters on roller skates appear and serve the couple, and when the woman toasts the protagonist ("to us") with an aperitivo, the protagonist is suddenly jolted in his chair. It now appears that he has been sitting on railroad tracks, and two of his chair legs have become caught by two rails brought together by some unseen switching device. The woman reacts to his predicament with some surprise but not dismay. We cut to her up in a tree straddling a bough and calling out: "quick, you jump up too." We get a shot, from her perspective, of the protagonist, still in his chair and immobile, though there is no apparent reason why he cannot rise and join her. She shouts out excitedly, "the train's coming." We cut to a train, blowing its whistle, off in the distance. We see the table from her perspective, placed between the tracks. We cut to the train bearing down. We cut to the protagonist, and this time he is tied to the chair. He says, "And just now, when I had decided to tell my wife everything." As the train nears, he turns to the camera and mouths the words "help, help," though he cannot actually speak them. He does voice them when we cut to him thrashing in bed. He turns on the light and sits up. There is an audio then video cut to the psychoanalyst who says:

> But the risk is severe; there's no time to lose. And salvation lies not with what the beautiful young woman suggests. YOU must become the engineer and brake in time to avoid catastrophe. Dear friend, the tiller of life is in our hands only. The Banca di Roma however will prove to be providential in pointing out the right path to you.

The commercial then ends exactly like the prior two.

Analysis

It seems fitting that Fellini's cinematic career end with *Il sogno del "déjeuner"* because it combines the negative dream psychology of his later work with the more playful oneiric universe of films such as *8½* and *Juliet of the Spirits*. The opening moments of the dream seem to offer us a symbolic plenitude that Jung would have seen as empowering and individuating. The tree that fills and exceeds the frame strongly suggests the Tree of Life, exuding vitality in its rich foliage and surrounded by the seemingly boundless renewal of springtime. The waiters and wind fill the background with motion; the laughter of the young woman is intoxicating; and she herself is quintessentially alive.

The protagonist has summoned up a vision far more expansive and promising than that of the cantina, visualizing conditions that hold the potential for rebirth and renewal, and the young woman seems even more irrepressible and propulsive than Signora Vandemberg. Possessed of contagious good spirits, she moves the dream quickly beyond the fixed space of the table, taking us "out on a limb" and directing our eye to the farthest reaches of the scene with her announcement "the train's coming." Moreover, she resists the reduction to mere sexualized mediator that led to Signora Vandemberg's early exit from the cantina. Largely because of this, the dream keeps alive a vibrant sense of difference much longer than did *La cantina*.

Part of the reason for the increased promise of *Il sogno del "déjeuner"* lies in what I perceive to be an implicit distinction between the dreamer as character and the dreaming imagination, or what we might term the dreamer as author. In fact, there is a growing distinction between the two in the course of the three Banca di Roma commercials. In *La galleria*, the ambience, events, and psychological symbolism seemed principally to mirror the limits of the protagonist: his fear of venturing, lack of a regenerative inner life, and so on. This was even true of the details that we could argue were placed in the scene by his dreaming unconscious, such as the looming fist, the out-of-place road sign, and the strongly protective tunnel itself, which merely reflected paranoia and an excessive need for direction. His dreaming unconscious was, in short, part of the problem, as we might expect in a dream about the absence of creative imagination. In *La cantina*, as we have seen, there is an implicit separation between the maker of the dream work and the protagonist. Through the symbolic potential of the cantina, the space "beyond," Signora Vandemberg, and even the lion, the "author" furnishes opportunities for the protagonist that remain unrealized. *Il sogno del "déjeuner"* offers the plenitude just noted above—and then repeatedly sets the protagonist in opposition to it. Most notably, he becomes ever more constrained and helpless while the young woman becomes freer and more energized. In effect, the protagonist is at odds

with his dreaming imagination, which is on the side of plenitude and energy and thus punishes the protagonist for his lack of both.

Il sogno del "déjeuner" seems to follow a negative dream trajectory similar to that of *La cantina*. This has begun by the moment we encounter the protagonist on screen, for he never sees the Tree of Life as we do. He sees the young woman in front of it, suggesting that he has already "fallen into gender." For another, he is even less mobile than he was in the prior two dreams. Concomitantly, he is unable to participate, even at the start, in his own imagined fullness-of-life scenario, summoning up a rather tepid "I'm happy" in response to the burgeoning energy of the tree, the springtime, the waiters, and the woman. His limits become even clearer once we realize that he seems more intent on escape (a picnic in the country) than transformation, and that he is not even good at getting away, dressed as he still is for his urban life: long-sleeved white shirt, vest, and suit jacket. His only concessions for the occasion are the open collar of his shirt and a scarf instead of a tie. That he is carrying his old life with him instead of starting anew is clear from the waiters and the elegantly appointed table that turns the countryside into a fancy restaurant a la the Barilla commercial. In light of all this, the numinosity of the opening images seems quickly compromised.

The biggest problem, of course, is that the Villaggio figure is (yet again) forfeiting spiritual development, this time in favor of a rather conventional and pathetic fairy tale in which he has an affair with a beautiful younger woman; transforms himself into a dapper Don Juan; and tells all to his wife (whom we assume from his other dreams he does not actually have)—presumably to announce he is leaving her for his new love. This is profoundly regressive, though it initially generates contrived reinforcement within the dream, as one of the waiters says, "you deserve it" in response to the protagonist's timid assertion of happiness. Accordingly, his dreaming imagination quickly moves from false encouragement to revenge, turning the young woman into a "castrating" threat. One might already glimpse this potential in her casual mastery of the poppy, but her actions are innocent, and unthreatening. However, her toast "to us" seemingly results in the protagonist's chair legs getting caught in the rails (the symbolism from a male standpoint should be quite obvious). And, most obviously, when she climbs astride the tree bough, it seems a huge phallus that she easily dominates. Her evolution from castrating to phallic becomes more pronounced when she seems to engender the train that bears down hard upon our hero. In terms of associational dream logic, her increasing linear mobility becomes that of the train, and the train replaces her much as the lion replaced the Signora in *La cantina*.

We have witnessed a rapid symbolic diminution in just a few seconds. At the outset, the tree, with its amplitude in every direction, exceeded any reduction to merely phallic symbolism: the Tree of Life is, in fact, traditionally holistic rather

313

than gendered. Thus, the dream has moved from an edenic state beyond the sexual to the sexually idyllic with woman as ideal, then to the sexually problematic with women as castrator, and finally to the sexually destructive or solely phallic as the Tree of Life is replaced by the onrushing locomotive.

In so far as the young woman "becomes" the train, she evokes Marisa in *The Voice of the Moon*. In both cases, we have a repressed and inadequate male projecting his desires onto a lively and powerful woman in such a way that she becomes a terrifying fantasy of uncontrollable phallo-feminine sexuality. In *Il sogno del "déjeuner,"* the male's inflation of the woman is accompanied by his own deflation to the classic stereotype of the weak woman, the "damsel in distress," tied to the rails a la *The Perils of Pauline* (Louis J. Gasnier and Donald MacKenzie, 1914), in dire need of a savior.

The trajectory of the dream is accompanied by the kind of diminishment we have seen before in the implied role of the camera eye: from explorative and creative force to mere spectator in a closed circle of direct address. When the protagonist mouths "help, help," to the camera eye, he is presumably addressing us, as spectators, so the camera has become mere passive witness—rather than the embodiment of the creative unconscious. The helplessness and hopelessness of the protagonist are confirmed as he can call only upon figures (the audience) incapable of intervening.

There is an alternative, more positive, reading of much of the above that would respect the multivalence of so much of Fellini's later work. What I have labeled the "revenge" of the protagonist's unconscious might be seen as operating in his best interests, with the dream and the dreamer modeling the destructive psychological consequences of the protagonist's behavior in a narrative that brings him to the point of symbolic death, allowing for transformation and the birth of someone new. This would be consistent with the symbolism of *Nights of Cabiria*, *8½*, *Juliet of the Spirits*, and *Toby Dammit*. In this context, the protagonist's plea to the camera eye could be an acknowledgement of his own dreaming imagination—a plea to himself-as-dream-author, not to us as audience, to "get me out of here." For the first time in the three Banca di Roma commercials, he would actually be asking the right person for help: himself. At least in the short term, the right person would be responding in the right way: waking up, ending the dream, and saving himself from annihilation. And ideally, this "right person" would also set himself the challenge of learning valuable lessons from the dream.

The dream's tendency to balance negatives and positives is obvious in the fact that the young woman, despite seeming to become a threat in relation to the protagonist's delimiting male perspective, also remains a potentially helpful psychic companion.[38] In fact, in saying "to us," she can be referring not to sexual or romantic coupling but to partnership in the inward journey of which Fellini speaks

314

in the quotation cited earlier. His getting ensnared in the tracks would be the result of his faulty reading of her words, missing her intentions. She is constantly on the protagonist's side, from her uplifting laughter to the toast, from inviting him up in the tree when his chair gets trapped to warning him about the approaching train. At the same time, she is always independent and free, with good-humored perspective on his rather ridiculous figure. She may become associated with gendered symbolism in the diminishing psychic logic of the dreamer, but her accelerating activity continues to resist any overall symbolic appropriation. Moreover, we have none of the naysaying Signora Vandemberg or the lugubriousness of the lion here. All this contributes to a persistently comic tone that is lacking to the protagonist's other two dream works. The young woman is certainly no compliant trophy on the arm of an older "important" man in a tawdry male menopause fantasy. If only he could free her from his gendered narrative and join him on another kind of journey....

Although the protagonist might be said to save himself at the end of his ill-fated picnic, the awakened Villaggio figure misses the point. He identifies his own crying out for help as a need to cry out to others (the oral phase revisited) and thus places himself again, immediately, at the mercy of psychoanalysis and then the bank. Yet again the therapist is of no use. He dismisses the woman as a false solution, seeing her only as a sexual, not as a potentially psychic, figure, and ignoring, as always, the most profound complexities of the dream. He makes the obvious comment "YOU must become the engineer and brake in time to avoid catastrophe" without suggesting any strategy to bring this about. Then he mixes his metaphors, moving from "brake" to tiller," and concluding with two implicit contradictions in his assertion "The Banca di Roma ... will prove to be providential in pointing out the right path to you." How empowering is it to have the tiller in one's hands if someone else has to tell one where to head? And who really holds the tiller if, in fact, we are ruled by Providence?

Parodying the inflationary rhetoric of advertising, Fellini invests the Banca di Roma with godlike powers, hearkening back to the equation of Campari with the entrance to the Pisa Baptistery. Obviously, the protagonist could find no better institution in which to place his faith given a world in which a reverse alchemy has transmuted spiritual value into psychological and economic materialism.

One of the crucial ironies of all three Banca di Roma commercials is that, instead of counteracting the image of banks as cold, impersonal places, Fellini accentuates inaccessibility. It takes a series of four zooms and dissolves in the psychoanalyst's office to get us inside the bank. The building is not only difficult to enter, it is devoid of people. Not only are there no clients, there are no employees to offer assistance. True the setting is at night, after hours, but the implications of profound unsociability cannot be avoided. In fact, the nocturnal setting and

315

sense of remoteness from life, as well as the dissolves and zooms that carry us into the bank's space, make the recurrent concluding scenes seem a vision or dream (reason-driven and instrumental of course) of the psychoanalyst: the articulation of a "perfect" space that does not exist and that could never therefore fulfill the promises he has made on its behalf. The protagonist, from this point of view, having given up on his own psyche, has ended up in that of his mentor and, having escaped from his own nightmares, has merely inserted himself, Fantozzi-like, into that of his superior. (**Figure 11.5**)

One thing I have not addressed in any detail is the music that accompanies the appearance of the logo at the end of all three commercials: a brief and very light refrain from *Fellini's Casanova*. Used repetitively, it takes on the quality of a jingle and has a slightly parodic effect, especially given our expectations of something more dignified in relation to a venerable European bank. But more to the point is

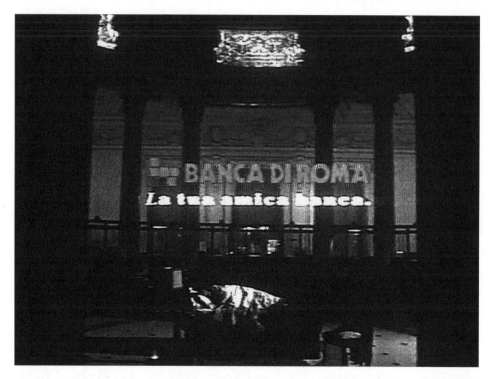

FIGURE 11.5 The protagonist snug in bed in the lobby of his bank and "friend"—the anesthetizing cradle of dreamless sleep. We are reminded of Ivan and Wanda firmly ensconced in the cold embrace of St. Peter's and the Vatican at the conclusion of Fellini's first sole-directed film, *The White Sheik*. Source: Banca di Roma: *Che brutte notti:La galleria, La cantina, Il sogno del "déjeuner sur l'herbe"* (1992). Directed by Federico Fellini. Produced by Sergio Castellani for Film Master. Frame grab captured by Frank Burke from 2009 French DVD *Fellini au travail*.

the extraordinary similarity between the psychosexual universe of Casanova and that of the Banca di Roma commercials. As I note in chapter 9, some of the principal characteristics of the life and world of Fellini's Casanova are exile (alienation from home but more profoundly from self), unending quest for a compensatory "womb" or comfort zone (the endless pursuit of women), displacement (women for self, women for a healthy relation to power), sycophancy (Fellini referred to Casanova on numerous occasions as proto-Fascist in his servility), phallic femininity (projection of male inadequacy onto women as instruments of pain and suffering), the objectification of psyche and soul (the mechanical doll that becomes Casanova's final lover), and shallow rationality (Casanova's thoroughly superficial embodiment of Enlightenment thought and method.) It is uncanny (but perhaps not, given the consistency of Fellini's worldview) that the Counter-Reformation world of Casanova and the post-humanist world of the Banca di Roma spots would so thoroughly converge.

Conclusion

In bringing to a close my analysis of Fellini's audiovisual oeuvre, I would like to reiterate its open-endedness and reflect briefly back over his cinematic career. From winks, double entendres, and a host of other cinematic strategies that can be read in multiple ways, to evocative spaces "beyond" and energies that resist symbolic reduction, Fellinian signification seeks to open out rather than close down imaginative play, even when his characters and their worlds seek to do the opposite. (My close readings of the commercials are only one among many possible—speculative rather than definitive.) This is linked to Fellini's sense of wonder at the mystery and uncontainability of experience, though he often struggled to maintain that sense later in his life. In fact, Fellinian wonder tended to turn into dismay at the society of the spectacle's ability to strip everything of numinosity, making it endlessly reproducible and all too facilely visible. The wonder of the childlike artist in the face of a world that always surprises seems to give way to the cynicism of the artist-as-adult who has found both the world and the wonder to have been manipulated, constructed, and exploited for commercial ends. In the course of this transition, we might speak of a kind of magic neorealism[39] characteristic of Fellini's early films;[40] followed by a magic self-reflexivity in films about film, art, or memory; and concluding with what I would call magic kitsch, beginning in earnest with *Fellini's Casanova* and continuing with various degrees of prominence till the end of Fellini's career.

Fellini's magic kitsch, of which his commercials form an integral part, is, among other things, a parody of both his sense of wonder and his inventiveness. It is a

form of strategic bad taste designed to prevent him and us from ever getting caught up (again) in illusions of authenticity, originality, and creativity that lie at the heart of Romantic and religious awe. Yet it is important not to underestimate the magic in the kitsch. *Intervista*, a film that combines kitsch with enormous cine-narrative dexterity, is an excellent case in point. There is never total renunciation of the marvelous, the unforeseen, and the undiscovered. In this respect, his Banca di Roma commercials are most apposite. They give us a figure who, despite all his conservatism and subservience to institutions, cannot help but dream interesting dreams and who, much as he wants to run away, lives to dream another day. Despite his and his psychotherapist's best efforts, the Villaggio figure cannot escape the serendipitously serial nature of the Banca di Roma spots. He may leap into bed in the bank lobby at the end of each, but there he is in the next, back home, back dreaming. The institutional dream of reason cannot fully suppress the emanations of the creative unconscious. And, however Fellini might have become disillusioned with dreams—or at least society's ways of cheapening them in consumer culture—he never stopped dreaming movies. One might argue that kitsch became a major tool of perseverance, allowing him to hedge his imaginative bets without ever ceasing to make them.

NOTES

1. The following is based, with permission, on "Biting the hand that feeds: Fellini's commercials," *The Italianist*, 31 (2011): 205–42.

 My thanks to Annette Burfoot, Alberto Farina, Romano Giammattei, Marco Vanelli, D.A. Miller, and D.A. Miller's students (Special Topics: Federico Fellini, University of California, Berkeley, winter term 2008) for information and insights that make their way into the text.

 Some Fellini scholars include within the corpus of Fellini commercials the mini-spots Fellini shot for *Ginger e Fred*, particularly those conceived for the Christmas television special that is central to that film. (See Millicent Marcus, "I misteriosi fegatelli di *Ginger e Fred*," in *Lo schermo "manifesto": Le misteriose pubblicità di Federico Fellini*, a cura di Paolo Fabbri, Rimini: Guaraldi, 2002: 57–67.) Some of these spots appear in the film; others have been included in Koch Lorber DVD issues of *La Dolce Vita* (1960). I do not address them because they were shot as part of a larger narrative project, rather than as autonomous works, though critical attention to them is certainly legitimate and illuminating.

2. Since YouTube postings come and go there is no point in providing citations for the commercials. However, at any given time, a search on YouTube for "Fellini Barilla," "Fellini Campari," and "Fellini Banca di Roma" will turn up versions of the commercials. *Fellini au travail* was released by Carlotta Films, 2009.

3. Bondanella, *The Cinema of Federico Fellini*, 4.

4. See Linda Hutcheon, *The Politics of Postmodernism* (London: Routledge, 1989).

5. See, for example, Alpert, 294, and Baxter, 341.

6. On currently available versions of the commercial, Fellini's name is displayed, at the start, in the lower left-hand corner. However, I have been told insistently by those who saw the spot when it first aired that Fellini's name was not present at the time.

7. The attendance number is reported in Kezich, 379. Contrary to Baxter (341), Fellini did not shoot a commercial for the Italian Republican Party.

8. Charlotte Chandler, *I, Fellini*, 190.

9. See Ginsborg, *A History of Contemporary Italy*, 240–41, and Omar Calabrese, *Carosello o dell'educazione serale* (Firenze: Clusf, 1975), *passim*, as well as Piero Dorfles, *Carosello* (Bologna: Il Mulino, 1998), 16–17 and chapter VI.

10. See Jean Baudrillard, *The Consumer Society: Myths and Structures*, trans. Chris Turner (London: Sage, 1998), and *Selected Writings*, edited and introduced by Mark Poster (Stanford: Stanford UP, 1988).

11. The other Baudrillard text was the Italian edition of *America* (*I libri di casa mia. La biblioteca di Federico Fellini*, ed. Oriana Maroni and Giuseppe Ricci--Rimini: Fondazione Federico Fellini, 2008).

12. Baudrillard, *Selected Writings*, 80.

13. Baudrillard, *Selected Writings*, 19.

14. William Pawlett, *Jean Baudrillard: Against Banality* (London: Routledge, 2007), 16.

15. See Baudrillard, *Selected Writings*, p. 52, and Pawlett, 12.

16. Baudrillard, *The Consumer Society*, 88.

17. The first two commercials need no translations; those from the Banca di Roma commercials are based on *Gli ultimi sogni di Fellini*, ed. Gianfranco Angelucci (Rimini: Associazione Federico Fellini, 1997).

18. There are two versions of the commercial. The winks between the couple are eliminated from the shorter one, but the wink of the hostess remains.

19. The versions of the Campari commercial found on *Fellini au travail* conclude with the words "Campari, una favola moderna" ("Campari, a modern fable") but I have not heard these words on any other version of the commercial, including a VHS version from the commercial's producer, BRW. I believe the additional words were added for French airings.

20. There is also a seeming randomness at the start in the alternation of "dirty" and "clean" shots of the train window. All becomes "perfect" as the real turns completely into screen.

21. Peter Bondanella, "Fellini e La grande tentatrice," in *Lo schermo "manifesto"* 35 and 37 and, Gianfranco Angelucci, https://www.facebook.com/gianfranco.angelucci.39/videos?lst=594630464%3A100000995049431%3A1570575758.

22. "Leo," <http://www.facebook.com/topic.php?uid=204203929197&topic=21768> [accessed January 19, 2011]. All translations of this rigatoni discussion are mine.

23. "Simpatico," http://www.sanihelp.it/forum/sesso-dintorni/29754-rigatoni-3.html, p. 3 [accessed January 19, 2011].

24. "Superl," <http://www.sanihelp.it/forum/sesso-dintorni/29754-rigatoni-3.html>, p. 1 [accessed January 19, 2011].

25. "Giovy9," http://www.sanihelp.it/forum/sesso-dintorni/29754-rigatoni-3.html, p. 1 [accessed January 19, 2011].

26. As I have noted earlier and will continue to argue, stereotypical gender symbolism, particularly with regard to notions of the feminine, becomes, in the course of Fellini's career, part of an extensive critique of gendering itself.

27. Kezich, 392.

28. My bet would be that he is a psychiatrist, although the Italian text of the commercials identifies him as a psychologist (*Gli ultimi sogni di Fellini*, 178). To avoid choosing, I use terms such as "'psychoanalyst," "therapist," and "psychotherapist."

29. *Fantozzi va in pensione* (Neri Parenti, 1988), *Fantozzi alla riscossa* (Neri Parenti, 1990), and *Fantozzi in paradiso* (Neri Parenti, 1993).

30. His films of note for Buñuel are *Viridiana* and *Tristana* (1970), *The Discreet Charm of the Bourgeoisie* (1972), and *That Obscure Object of Desire* (1977).

31. Federico Fellini, *Intervista sul cinema*, a cura di Giovanni Grazzini (Bari: Laterza, 1983), 130. Rpt. in *Gli ultimi sogni*, 22.

32. Federico Fellini, *Il libro dei sogni*, ed, Tullio Kezich and Vittorio Boarini (Milano: RCS Libri, 2007). Published in English as *Federico Fellini: The Book of Dreams* (trans. A. Maines and D. Stanton). New York: Rizzoli.

Although one can draw numerous connections between Fellini's "dream book" and the Banca di Roma commercials, the former is not germane to my analysis. Fellini's sketches are fragmentary and composed of still images. The entries never constitute complete narratives. They are not cinematic, except by the broadest of analogies. And they are never, needless to say, television commercials. On the other hand, my strategy in this essay is to deal with Fellini's spots as intense narrative processes, where the language is cinematic/televisual, and where the overriding issues are tightly linked to a critique of television publicity.

33. Fellini liked to emphasize that his frequentation of Jungian psychoanalyst, Ernst Bernhard, was "not in a professional way as a psychotherapist but as a stimulating social friend" (Chandler, *I, Fellini*, 142). Kezich (216–20) makes the relationship sound more clinical than does Fellini, but it is safe to say from all the analysis Fellini did of his own dreams, that he was not seeking someone else to interpret his dreams for him (or worse still, in the Villaggio figure's case, make them go away). He was seeking greater means of self-understanding.

34. In Dürrenmatt's story, a young man boards a train bound for his university, about two hours away. The train enters a tunnel he does not recognize. The tunnel becomes seemingly endless before finally becoming a slope down which the train hurtles at increasing speed towards the abyss. Friedrich Dürrenmatt, "'Der Tunnel," in *Die Stadt: Prosa I–IV* (Zurich: Verlag der Arche, 1961), 149–67. Certain aspects of this story recall Toby's journey in *Toby Dammit*.

35. Chandler, *I, Fellini*, 142.

36. *Gli ultimi sogni* (181) indicates that the lion's voice is that of Fellini, but this is difficult to believe. Fellini had a notoriously high voice while that of the lion is quite deep. Perhaps it is Fellini's voice electronically modified, but if so, the point would be to *not* make the voice recognizable as the director's. If it is Fellini's voice, it is likely that the director dubbed the lion for practical reasons (avoidance of hiring someone else, for example) and modified his voice in order not to make it a distraction or a signifying component of the spot.

37. It is possible that, in practical terms, the bucket would have been used to gather coal, but the indeterminacy of its use in the dream, plus the implied presence of water, allows for other interpretations.

38. Her "doubleness" seems to be confirmed by a small but intriguing visual detail: when she climbs out on to the tree bough, she has a boot on one foot but her other foot is bare. One can surmise that as a holistic force strongly associated with the Tree of Life but also capable of embracing with excitement the arrival of the train, she embodies both "nature" and "culture" without the crippling divisions these two terms so often imply.

39. To make a point, I take some license with the term "magic realism," used to describe an important strain of mid 20th-century Latin American literature that was more insistently magical than Fellini's early films and that worked to different ends than did they.

40. In terms of Fellini's "magic neorealism," one can cite, at the beginning of Fellini's career, the marvellous "apparition" of the *sceicco bianco* (*The White Sheik*, 1952): so far up in a tree that he appears to have descended from the heavens rather than ascended from the earth. Then there are the haunting images of the *vitelloni* on the beach in *I Vitelloni* (1953), Gelsomina's encounter with Osvaldo in *La Strada* (1954), the apparition of the celebratory youngsters at the end of *Nights of Cabiria* (1957), and the startling gazes of Cabiria and of Paola into the camera eyes and ours in the closing moments of *Nights of Cabiria* and *La Dolce Vita* (1960).

12

Politics, Race, Gender, and Sexual Orientation

As I suggested at the outset of this study, Fellini's reputation, as of the mid-1990s, was in marked decline among film theorists. Robert Phillip Kolker is representative of naysayers when he writes in the early 1980s that "8½ ... marks the end of [Fellini's] creative period. ... In his following works, Fellini moved into the artifice of spectacle, the fantasies of memory, which became more insular and repetitive as he proceeded."[1] Even more telling than critique is neglect. In the first volume of the 600-plus pages of *Movies and Methods*, Fellini receives one paragraph of discussion. In 1996, I found one reference (but no discussion) of Fellini in what was then the most recent edition of *Film Theory and Criticism: Introductory Readings*. His name does not appear once in *Movies and Methods* (vol. 2), *Issues in Feminist Film Criticism, Multiple Voices in Feminist Film Criticism,* or (based on recall and review, since the text lacks an index), *Narrative, Apparatus, Ideology: A Film Theory Reader.*[2] These six anthologies help delineate with great accuracy the critical and theoretical terrain of film studies from the 1970s to the 1990s. Basically, the only place Fellini's work continued to get serious academic attention was among scholars whose principal interest was Italian culture (including film) rather than broader film theory and criticism, and who, consequently, operated outside the mainstream of contemporary film studies.[3]

This chapter is an attempt to address three areas in which Fellini's films have tended to generate problems for theorist and critics: politics, gender, and sexual orientation. By "politics" I mean the realm and study of power relations within society, and I use the term to include not just engagement with overtly political issues but also social issues and the possibility for change within social relationships.[4] Gender and sexual orientation, strictly speaking, could be included within the realm of politics, particularly given my broad use of the term. However, because both have has become significant issues unto themselves in recent years—and because they are crucial issues within Fellini's work—they are best treated separately.

Politics

As 1 briefly noted in the opening chapter, Fellini's decline coincided with the emergence of a highly politicized form of film and cultural theory, deriving in large part from the revolutionary politics of the 1960s and from the crisis in political theory occasioned by the failure of the worker/student revolts of May 1968 in France. May 1968 was both product and cause of a radical rethinking of all aspects of life, public and private, which had crucial ramifications in the realm of cultural production and particularly film as a medium of mass consumption. The capitalist nature of the film industry was critiqued as was the cinema of individual authorship. Cinema was seen as an ideological tool and the filmmaker as a figure who reproduced—rather than contested—dominant ideology. In short, much of the theorizing I earlier discussed in relation to the death-of-the-subject and death-of-the-author was applied to cinema. Within this context Fellini came to be treated as a self-mythicizing example of bourgeois individualism and hubris—and of all the pitfalls of depoliticized high modernism and its veneration of the artist-genius.

This new kind of theorizing tended to divide into two subsets: the ideological analysis of classic Hollywood film and the promotion of what Peter Wollen termed "Counter Cinema"—that is, a cinema intent on the aesthetic "undoing" of classic mainstream movies.[5] Clearly, Fellini's work did not fall within the first. And while his self-reflexive explorations of cinema might have aligned him with the second, his work did not meet the terms set by Counter Cinema for an acceptable political aesthetic. Counter Cinema was explicitly theoretical and abstract, whereas Fellini saw himself working from concrete stimuli (images, memories, sensations, and so on). Counter Cinema was often opposed to spectacle and narrative, while Fellini reveled in the first and remained generally dependent (despite a lot of experimentation) on the second. Counter Cinema was a highly intellectual critique of pleasure; Fellini's cinema was often a critique of intellectualism and always a celebration of pleasure. Counter Cinema was explicitly political, with the aim of transforming its audience; Fellini eschewed ideological filmmaking, conflating it with his experience of Fascist propaganda and manipulation.

Of interest to neither theorists of the mainstream nor advocates of the political avant-garde, Fellini tended to drop out of sight as an object of study. Nonetheless, Fellini was a figure of enormous importance on the international film scene of the 1950s and 1960s, and he continued to be a major figure in the eyes of contemporary filmmakers well beyond. I would also like to address the issue of Fellini's "relevance" by viewing his work in relation to different forms of political and social significance. In so doing, I hope to provide a somewhat more complex response to the importance of Fellini's work than the academic neglect and implicit dismissal it experienced within film studies following the peak moments of the

art film. Consistent with my approach throughout this study, I do so principally in an international, rather than a specifically Italian, context. However, it should be pointed out that non-Italian critics, especially in the English-speaking world, have frequently misperceived and undervalued the critical dimension of Fellini's work because they have not understood its role within a specifically Italian tradition of representation.

It seems to me that there are three places to look for "politics" and social significance within Fellini's work: (1) films of broad and often insistent social critique from *Variety Lights* through *La Dolce Vita* but also including, to some extent, *8½* and *Juliet of the Spirits*; (2) films that seem to deal specifically with political moments or problems (*Amarcord, Orchestra Rehearsal*); and (3) films that analyze and critique representation and signification (films from *The Temptation of Dr. Antonio* through *The Voice of the Moon*). Though these areas are rough and overlapping and, in fact, (2) will end up being collapsed into (3) in my discussion, they provide a useful point of departure for discussing the "Fellinian sociopolitical."

The first group, perhaps best represented by *I Vitelloni*, was sufficient to validate Fellini as a socially committed filmmaker for the initial part of his career. Several of the early films (including *Il Bidone* and *La Dolce Vita*) offered a critical image of a postwar Italy under the influence of American materialism and moving (particularly in *La Dolce Vita*) toward a society of the spectacle. The sense, at this time, that Fellini was a socially significant filmmaker was enhanced by his part in the art film movement. Despite the links I noted in Chapter 1 among the art film, American postwar expansionism, and the ideology of individualism, the art film of the 1950s and early 1960s had a strong political dimension—by association and in fact. Neorealism, which through Rossellini and De Sica was foundational for the Italian art film, was enormously influential worldwide on cinemas of contestation and revolution.[6] Through figures such as Luis Buñuel, the art film had ties to an earlier avant-garde art that was openly critical of Western culture and politics. Moreover, its explicit sexuality, class consciousness, and emphasis on psychology or interiority constituted a critique of bourgeois repression and materialism, further linking it to the avant-garde. And the auteur cinema of Eastern Europe was a cinema of consistent political dissent. In the later 1960s the art film also became associated with Third World revolutionary cinema and with the overt politics of figures such as Godard in his Maoist period. Here, however, I am concerned with an earlier period of filmmaking.

The initial importance of Fellini's work resulted at least as much from its perceived social and psychological commentary than from purely aesthetic factors. Moreover, Fellini's championing of individualism and self-actualization, which now seems complicit with American cold war ideology, spoke intensely

and movingly to a society (both European and North American) that had just emerged from nearly half a century of wars, economic depression, and the threat of totalitarian domination. In terms of the last, it seemed more than justifiable to voice concerns that the political uniformity imposed by Fascism was in danger of emulation amid the social conformity of the safe, secure, and sterile middle-class materialism of the 1950s. Under the circumstances, the ideals of personal initiative and self-determination were not such terrible things; it was their atomizing effect as instruments of competitive capitalism and the cold war that made them problematic.

La Dolce Vita was paradoxical in relation to a "sociopolitical" Fellini. It was his final example of social realism and even earned him the support of Italian leftists (particularly in the face of Catholic condemnation). Yet it was also largely responsible for securing his international reputation as an auteur and giving birth to his persona as maverick-genius. Consistent with the latter, it was followed immediately by his 1960s films of largely bourgeois consciousness, which sealed his fate negatively for Italian—and ultimately most other—leftist critics.

The fact that Fellini's ensuing work was not social realist does not mean it was devoid of social critique. *The Temptation of Dr. Antonio, 8½,* and *Juliet of the Spirits* all sought to represent the crippling influences of Catholic Italian society in the formation of individual consciousness. In addition, *Juliet of the Spirits* provided a caustic parody of the Italian economic-boom bourgeoisie, as well as a strong critique of contemporary middle-class women's roles. However, the focal point seemed to shift from the reality being represented to a cinematic exuberance of representation, as Fellini sought to capture ways in which reality gets filtered through the imaginations of his protagonists.

If social realism has already disappeared by the time of *The Temptation of Dr. Antonio* and *8½,* what are we to make of the two films that seem to address a specific political and social moment: *Amarcord* (the 1930s and Fascist Italy) and *Orchestra Rehearsal* (the 1970s and Italian terrorism, particularly the kidnap-murder of Aldo More)? In the case of the former, as Fellini himself as argued, the focus is not political or social (or even fundamentally historical) but psychological: "I ... wish to say that today what is still most interesting is the psychological, emotional manner of being a Fascist. What is this manner? It is a sort of blockage, an arrested development during the phase of adolescence" (quoted in Riva, 20–21). The vagueness of setting and events and their distance from actual Fascist excesses and atrocities would seem to be a prohibitive limitation from the point of view of politicized theory and filmmaking. On the other hand, a good deal of post-1968 theory focused on the psychosocial construction of the individual.[7] Moreover, though Fellini's quotation would suggest that his version of psychology was still linked to the kind of humanist and depth psychology

of Jung that I discussed in relation to *8½* and *Juliet of the Spirits,* much of the psychology of *Amarcord* involves the construction of identity out of a culturally produced experience of lack, particularly in relation to sexuality, power, and spectacle. In this respect I feel that *Amarcord* offers a politically significant analysis of Fascism—and one that exceeds Fellini's earlier cold-war-compatible critique of Fascism merely as the denial of individuality. Perhaps most important, Fellini's engagement with psychoanalysis here does not generate purely symbolic solutions to real problems, as it did in his films of individuation. This view of *Amarcord* is largely supported by James Hay:

> Some critics can argue that Fellini fails to expose the material avenues for organizing the socioeconomic foundations of communal lifestyles. ... But by exploring the dominant myths of this community from within and without, Fellini portrays Fascism not simply as a political or economic reality but as mediated by a variety of codes—equally important of which are the cultural codes (particularly cinematic, photographic, and musical ones). And though Fascism (as a codified system) is diffused in this film, it is also seen as part of an inevitable and even necessary meta-language, i.e., as part of other discourses which intersect and overlap with it. Therefore, if *Amarcord* can be said to be about Italian Fascism, it is in that it goes outside of Fascism as political phenomenon or system to explore the *meanings of its messages.*[8]

As far as *Orchestra Rehearsal* is concerned, I once took the position that the film offered the illusion of political analysis only to retreat into the purely aesthetic.[9] While *Orchestra Rehearsal* alludes to Italian terrorism of the 1970s and was influenced by Aldo Moro's assassination, I argued that it ends up being more about the insularity of artistic production than about society at large, which never appears. I am inclined now to qualify my earlier critique on two grounds. First, I think the insularity of art is purposefully related to the (missing) realm of the political in the film. One of the principal themes of *Orchestra Rehearsal* is the evasion of responsibility that makes terrorism possible, and aesthetic retreat can serve as an example of that evasion. Second, as in *Amarcord,* there is sociopolitical efficacy to *Orchestra Rehearsal's* interrelation of psychology, ideology, power, and signification. More specifically, to the extent that postmodern power operates through the production of signs and the construction of meaning, individuality, politics, and the social as "missing matter," I feel that the film offers a good deal of insight into its historical moment. At the same time, *Orchestra Rehearsal,* as its critique of escapism, isolationism, and aestheticism implies, maintains a critical distance from *pure* signification and lack. Though the film reflects a strong postmodern sensibility in terms of its self-enclosed sign play and endless "rehearsal,"

its consistent and implicit allusion to a missing world outside strongly implies the need to access that world in order to avoid both the kind of apocalyptic disaster and the reemergence of authoritarianism that mark the end of the film.

In effect, we have already arrived at the third category of the Fellinian social: those films that explore issues of representation and signification. Although Fellini's films about representation (roughly *The Temptation of Dr. Antonio* through *The Clowns*) have been critiqued for their hermetic aestheticism, they prove indispensable in his movement toward the analysis of signification that, to my mind, makes films such as *Amarcord* and *Orchestra Rehearsal* politically relevant. For one thing, they introduce the kind of self-reflexivity that is a precondition for the latter. For another, as the films of representation shift in focus from the protagonist-hero to the work of art—effectively killing off the autonomous individual and individualism—they lay the groundwork for the subsequent films' analysis of individuals as products rather than producers of culture.

The films of signification, in line with *Amarcord* and *Orchestra Rehearsal*, all have significant things to say about the circulation and effects of meaning, particularly in relation to power and to various forms of cultural production: writing (*Fellini's Casanova*), opera (*And the Ship Sails On*), dream (which in *City of Women* I see as cultural as much as personal), television (*Ginger and Fred*), and film (*Roma, And the Ship Sails On, Intervista,* and to some extent *City of Women*). In some films the examination remains rather hermetic (*Fellini's Casanova, City of Women, And the Ship Sails On*). In others there is contemporary relevance to much of what happens *(Ginger and Fred* and *The Voice of the Moon*). And in *Intervista*, the "postcolonial" subtext offers a level of implicit political and theoretical commentary that is quite current.

Although Fellini's later films are generally at a far remove from his early films of relatively concrete social context, the social in postmodernity often operates less in physical or geographical space than in the realm of image, symbol, icon, signifier, spectacle, and simulation. Accordingly, whereas the earlier films, particularly in their relation to neorealism, constituted a politics of the real, the final films, in conjunction with postmodernity, embody a politics—and highly critical one at that—of signification.

I have addressed the issue of politics, the social, and Fellini in relation principally to post-1968 (1970s) cultural theory. New issues arise in relation to more recent theory, centered on cultural difference and generated by the increased demographic significance and visibility of previously marginalized groups. The causes of both the significance/visibility and the theory have been numerous: among them, decolonization, globalization, and late capitalism's pursuit of new labor forces, markets, and consumer groups. In light of recent multicultural theory, Fellini's films have been liable to the charge of Eurocentrism, of not seeing beyond the

perspective of traditional white European culture. Although a global rather than purely European perspective is suggested in films such as *La Dolce Vita* and *Juliet of the Spirits,* one might say that the emphasis is on an exotic and often decadent international elite rather than on racial or ethnic specificity and difference. In addition, in the latter film, the "other" seems to exist largely to fuel the fantasy life of a bored and idle bourgeoisie. Concomitantly, cultural multiplicity functions largely as the raw material for Juliet's visions and as a trope for imaginative plurality, making other cultures significant principally in terms of what they represent for a white middle-class European heroine.

Fellini's representation of black cultures in films such as *Variety Lights, La Dolce Vita, 8½, Ginger and Fred,* and *The Voice of the Moon* may seem at times to be clichéd and one-dimensional, romanticizing the "energy" or "musicality" of the "primitive." In *Fellini's Casanova* the image of a black woman is associated with the vagina dentata, aligning both women and racial otherness with the threat of castration. In *Fellini-Satyricon*, the two principal black figures, the slave girl at the home of the patricians and Oenothea, seem there purely for the benefit of whites. The Japanese do not seem to fare much better than blacks in *Intervista* and *The Voice of the Moon*, where they seem to be presented stereotypically and with condescension.

However, one has to view Fellini's racial representations within their narrative and historical contexts and as part of Fellini's critique of insularity and exclusivity—particularly given his propensity for (self)parody. Marguerite Waller has unpacked the complexity of the African-American singer at Steiner's party in *La Dolce Vita* in relation to colonialism and Orientalism.[10] Shelleen Greene has addressed not only Fellini's problematic racial representations but also his critique of "hyperwhiteness" in a film such as *The Temptation of Dr. Antonio*, linking both to Fellini's formation during Fascist colonialism.[11] Cihan Gündoğdu has addressed both the image of the Turk in *Juliet of the Spirits* and Fellini's comic representation of the emir and his cortege in *Amarcord* in relation to Fellini's own comments on nonsensical adolescent Italian attitudes toward the East.[12] *Fellini's Casanova* is precisely about a suffocatingly self-enclosed white male European protagonist and culture that would inevitably see women and blackness as threatening. While the subordinate presence of the black slave girl in *Fellini-Satyricon* is troubling, Encolpio's recovery of potency via Oenothea is both a culturally inflected hallucination and roundly satirized by Fellini. *And the Ship Sails On* critiques Eurocentrism in its clearly ironized representation of the Serbs as "opera gypsies," in keeping with the principal profession of the film's passengers: in short, as caricatures of naturalness, spontaneity, and childlikeness. And, as I noted in my discussion of *Intervista*, its peripheralizing of the Japanese tv crew is part of the film's critique of insularity and exclusion.

As a way of opening out the discussion of race and ethnicity in Fellini, I would like to readdress briefly *The White Sheik* and *The Voice of the Moon*. In the former, as Ivan awakens in his hotel room to confront the disappearance of Wanda and the flood and fog resulting from the feigned bath that has allowed her to escape, he encounters the one figure of true otherness in the film—a black priest. It is easy to dismiss him as a comical figure, merely contributing to the slapstick action of the scene. However, rather than merely adding to the chaos of the scene, he is a potential solution. He, unlike Ivan, is a boundary crosser at a moment in the film when crossing boundaries (e.g., Wanda's emigration to the world of the Sheik) is still a vital and promising activity. He pounds on the door, and his energy and "flow" align him with the overflowing water, the blurring steam, and the disappearing Wanda—liquidities that happily confound the solidities of Ivan's world. He speaks, with great passion, and though his language is non-Italian and remains unsubtitled, he is the most communicative, relational, figure in the film, other than the sex worker Cabiria. At first, he seems to be expressing his concern about the water, but as Ivan desperately asks "where is my wife," he puts his hand on Ivan's shoulder and seems intent on telling him something very important. The ardor and sincerity of his speech can be contrasted with the bombast of Ivan's. That his otherness remains largely inaccessible, untranslatable, tells us much about cultural closure in the film. We can trace a trajectory of otherness and its extinction in the film from the priest to the White Sheik (a patently fraudulent representation of cultural difference) and then to Ivan-as-White Sheik and the white saint/angel in the final sequence. The film's indictment of whiteness is evident from the title of the film and all it comes to signify in the course of the film's events, including the importance of the Pope, who as I suggested in chapter 2, is, by race, attire, and election via white smoke, the consummate White Sheik of Western/Catholic/Italian culture.

In terms of *The Voice of the Moon*, I take my cue from Shelleen Greene. The film, she suggests, points to a cultural obsession with whiteness; the focus on the moon, the truckload of identical white statues of the Madonna, the unearthly whiteness of the female protagonist Aldina, the "Gnoccata" or gnocchi/flour festival, Aldina's crowning as Miss Farina, the rain of flour that envelopes the festival attendees, and so on. Both the film and the novel upon which it was based—*Il poema dei lunatici* ("The Poem of the Lunatics"), Ermanno Cavazzoni, 1987—appeared at a crucial moment in Italy's postcolonial history. As Russell King notes, "During the 1980s, Italy became Europe's major country of mass immigration"[13] Consequently, "In the second half of the 1980s, the Italian press discovers 'immigration'.... [For] the press, immigration becomes of crucial importance for the entire social life of the country."[14] The novel has lengthy disquisitions by the main characters on frontiers and their consequent

329

complications—polyglotism, cultural and species difference, identity loss, and paranoia—that arise amid confusions around boundaries and borders. While, and perhaps because, the characters are "lunatics," their discourse reflects anxieties growing rapidly within Italy in relation to cultural and national protectionism and identity.

The fear of otherness eliminates difference, and this becomes reflected on a racial level. Although black figures are permitted as street vendors, as costumed Turkish servant/slaves who perform roles in the festival pageantry, and as farmworkers, there is not a single black attendee of the Gnoccata. In short, not a single black immigrant or Italian citizen is an integrated part of the community. The same is true when Ivo and fellow protagonist Gonnella find themselves at a discotheque in the countryside. Though the music is Michael Jackson's, though there are hundreds and hundreds of partiers, and though Gonnella refers to the club (contemptuously) as "the center of Africa," there is not a single person of color. This degree of exclusion is more than implausible; in the Italy of late 1980s, there would have been some participation, especially at a huge disco event. Clearly, Fellini is making a point. (Gonnella supplants Jackson and his music during a vision at the discotheque in which he dances to a Strauss waltz with the tellingly named Duchess of "Alba.")

Contributing to Fellini's articulation of race is Jackson's history of progressive whitening, beginning in the mid-1980s, resulting from the skin pigmentation disorder vitiligo and Jackson's attempts to compensate cosmetically for its effects, which recall the title of Frantz Fanon's work *Black Skin, White Masks*. (Fellini had a copy of Fanon's book in his library.) Jackson's history of whitening may have inspired Fellini's (de)coloring of Ivo, who often sports whiteface when within the reflected light of either Aldina or the moon. (**Figure 12.1**) Ivo's decolorization clearly equates whiteness with lunacy.

The Voice of the Moon can be read as a prescient message to an Italy that had already entered into globalized multiculturalism through both recent and ancient colonial ventures. By 1990, Italy was moving toward a period of enormous immigration that would both challenge the cultural and geographical territorialisms emerging from the Risorgimento and earlier and trigger xenophobic and racist reactions.

This is not to exonerate Fellini from all claims of Eurocentrism, but to suggest that his representation of otherness is often quite nuanced. He was also intensely aware of his own limitations with regard to cultural difference:

> I had a dream thirty years ago which sums up the meaning of my whole life. ...
> I was the chief of an airport. ... A great plane had landed, and as chief of the airport, I was proceeding to passport control.

I'm so melancholy. My poor heart doesn't know what to think anymore.

FIGURE 12.1 Ivo, whiteface, whiteness, and lunacy. The final moments of *The Voice of the Moon*. Source: *The Voice of the Moon* (1990). Directed by Federico Fellini. Produced by Cecchi Gori Group Tiger Cinematografica in coproduction with Films A2, La Sept Cinéma, Cinémax and in association with Rai1. Frame grab captured by Frank Burke from the 2017 Blu-ray version.

… Suddenly I saw a strange figure—an old Chinese man, looking antique, dressed in rags, yet regal, and he had a terrible smell. He was waiting there to come in.

He stood in front of me but spoke not a single word. He didn't even look at me. He was totally self-absorbed ….

… I didn't know what to do. I was afraid to let him in because he was so different, and I didn't understand him. I was tremendously afraid that if I let him in, he would disrupt my conventional life. So, I fell back on an excuse that was a lie that exposed my own weakness. … I said, "I don't have the power, you see. I'm not really in charge here …."

I hung my head in shame. I said, "Wait here, I'll be right back." I left to make my decision, which I didn't make. I am still making it, and all the while I wonder if he will still be there when I go back. But the real terror is I don't know if I am more afraid that he will be there or that he will no longer be there. I have thought about it constantly through the thirty years that have passed. I understand full well that there was something wrong with my nose, not with his smell; yet I still have not been able to bring myself to go back and let him in, or to find out if he is still waiting. (Chandler, *I, Fellini*, 208–09)

Gender and sexual orientation

Gender

The area of film and cultural theory for which Fellini's films have probably been most problematic is gender. Fellini's extravagant images of women have made him subject to the kind of comment he once made in reference to Snàporaz: "It is clear that he knows nothing about women, he isn't able to create in his imagination/film a single outstanding, real person" (Bachman, 8). And though Fellini's assessment of Snàporaz reveals self-awareness about his own "misrecognitions," their frequency in his work has made feminist film theory dismissive of his work.[15]

As with matters of sociopolitical relevance and cultural difference, gender in Fellini is more complex than may initially seem the case. As always, historical context is important. Early in his career Fellini gained positive international attention for his treatment of women (*La Strada*, 1954; *Nights of Cabiria*, 1957; and *Juliet of the Spirits*, 1965). His willingness to focus on female protagonists set his work apart from mainstream male-dominated cinema (though not from certain other male art film directors). And he clearly had significant insight into issues of abuse, sexual exploitation, and the commodification of women (*La Strada, Nights of Cabiria*), as well as socially constrictive roles and expectations for women (*Juliet of the Spirits*). Partly for this reason (though also because of his treatment of masculinity) Clive James, in a *New Yorker* piece shortly after Fellini's death, describes him as "a feminist *avant la lettre*."[16] This kind of assessment elicits resistance on two fronts.

First of all, feminist theory in the 1970s began to focus not just on whether women were visible in cultural production but on how their visibility was constructed, particularly in relation to centuries of male representations of women. Whereas Fellini could score pretty high on the issue of visibility itself, he seemed to fall short in terms of the *nature* of visibility, even when we set aside the extravagant imagery of the later films and focus on *La Strada, Nights of Cabiria*, and *Juliet of the Spirits*. While this involves the retroactive and thus de-historicized imposition of recently developed norms, it is still quite important to note. While the protagonists in these films may have power in terms of time on screen and narrative focus, all three are seen as victims of men rather than having agency of their own. "Liberation," when and if it occurs, is only defined over and against males. All three are associated with irrationality ("supra-rationality" might be more appropriate in Cabiria's case, but Gelsomina ends up mad, and Juliet nearly follows in her footsteps). All three are abandoned and stripped of home, family, and friends. Although this is seen as negative in *La Strada,* it is the basis for individuation in *Nights of Cabiria* and *Juliet of the Spirits*. As a result, though they

332

may be symbolically whole by the end of their stories, Cabiria and Juliet have no social power, no political base in relation to other strong and engaged figures (women especially), and no access to work and money. Such things are presented, literally and figuratively, as "immaterial" because, in keeping with the role of women in patriarchal Christianity, Cabiria and Juliet are symbols of spirit, hence not really of this world. Accordingly, they have also been seen as desexualized and as Fellini's ideal symbol of the feminine through the early part of his career: part clown, part innocent child.

The second problematic shift in terms of Fellini's representation of women occurs not in feminist theory but within the films themselves. Beginning with Anita Ekberg (*La Dolce Vita* and *The Temptation of Dr. Antonio*), Fellini starts to represent women as larger than life. It is not so much that woman-as-spirit disappears but, rather, that she becomes linked to her opposite as Fellini juxtaposes conventional male, Catholic stereotypes of virgin and whore. Madonna and mistress. Juliet becomes paired with her sexpot "opposite," Susy, in *Juliet of the Spirits*, and figures such as Oenothea in *Fellini-Satyricon* and the balloon "Feminine Ideal" in *City of Women* embody the opposites of spirit and sexuality simultaneously.

As some of this might suggest, the emergence of the "monstrous feminine" in Fellini is not just a matter of whim; it is part of a gender logic that his films insistently explore and that Fellini has defended on more than one occasion:

> I tell stories in which the principal figures are masculine: I explain how a slightly ridiculous and immature Italian sees "woman." Either he sees her ideally, as the Virgin Mary, as Dante's Beatrice, or as anthropophagous, voluptuous, dedicated to incest. Man won't be free until he liberates his wife, his girlfriend, his lover, from these false and degrading definitions. It's not my fault if sexual relationships here center on a mother figure represented by mountains of bosoms. (*Oui*, 165)

and

> I am Italian ... And in my pictures, I talk about things that I know. I am talking about men who are conditioned by a certain kind of education and certain environment. These men project all their insecurity onto women—all their ideas of sin, Catholic sin. ... I expect the audience will see that there is an ethical intention behind what I do. I am really ... satirizing the Italian male.[17]

Yet gender logic and sociological intent aside, there is still the sheer iteration of hyperbolic images of women in Fellini's later work. In order to consider whether that work is an accurate documentation of Italian masculinity rather

than something more sinister, it is necessary that we take at least three kinds of approaches: feminist, "masculinist," and postmodern. At times the three overlap in mutually enhancing ways. At times they lead in quite different directions.

By "feminist" I mean the kind of critique that explores the negative implications of Fellini's representation of women, particularly in relation to potential or actual patterns of misogyny throughout his corpus, in the history of male representation, and within contemporary society. The best example is Áine O'Healy's "Unspeakable Bodies: Fellini's Female Grotesques," an analysis of *The Voice of the Moon*. O'Healy argues that whereas the representation of Marisa (the "steam engine" whose sexuality overwhelms Nestore) might conceivably be viewed as subversive and emancipatory, the association of Aldina with the global disruptions of contemporary technology (particularly television) negates this.[18] According to O'Healy, "From the point of view of a feminist reading … the actively desiring woman … functions as a synecdoche for the threatening aspects of advanced technological communication" (328). O'Healy's close reading of the principal female characters in *The Voice of the Moon* in light of Fellini's other films, contemporary developments such as the "new age sensitive male" phenomenon, and feminist theory (particularly Julia Kristeva's theorizing of the "abject") makes a strong case for the negative in assessing Fellini's gender representations.

By "masculinist" I refer to the growing field of masculinity studies that ideally complements feminist analysis[19] by focusing on the way in which masculinity is constructed—and profoundly inclined toward controlling or marginalizing women.[20] In terms of a film such as *The Voice of the Moon*, a masculinist approach would emphasize the extent to which the representation of women is the result of male anxiety, paranoia, projection, and so on. It would also look for some immanent critique of masculinity that might help contextualize the representation of women and thus provide insight into the *dynamic* of gender—the *relationship between* masculinity and representation, not merely the problem of women or the feminine in and of themselves. This is the approach I adopted in Chapter 10, yielding a significantly different result from O'Healy's feminist reading. (This is not to say that O'Healy's reading is insensitive to masculinity; on the contrary, she offers significant insights into it. It is largely a matter of emphasis.) Ultimately, of course, the standpoint of the critic-theorist remains crucial. O'Healy, for example, might well accept all I have to say about masculinity in *The Voice of the Moon* and still conclude that, on the basis of Fellini's other work and larger sociocultural considerations, the representation of women exceeds any justification and remains, from a feminist perspective, unacceptable.

From the perspective of both masculinity studies and feminism, Fellini's work proves extremely revealing in terms of broader historical and biographical contexts—a point I would like to explore in some detail in relation to *La Dolce*

Vita, where Fellini's amplified representation of women begins.[21] Sylvia displays energy at once divine and demonic as she charges tirelessly up the steps inside Saint Peter's dome, then leads a raucous nightclub parade/dance in the Baths of Caracalla. She seems to transcend human dimension, and she becomes the first major Fellini female elevated to mythic status, as the protagonist Marcello intones: "You are everything, everything. You are the first woman on the first day of Creation. You are Eve. You are mother, sister, lover, friend. You are angel, devil, earth, home."

Sylvia's energy serves to reveal the exhaustion and impotence of the world around her, particularly as embodied by male figures such as Marcello and Steiner. Her energy not only highlights male crisis but seems excessive in direct proportion to male depletion. In this respect she represents a threat to masculinity, and it is perhaps for this reason that she is ultimately devalued by the film's tone and narrative development. Though her "natural" vitality helps institute the familiar Fellinian critique of abstraction, institutions, and conformity, her howling with the dogs in fields outside Rome is slightly ridiculous, and to the extent that she is "natural," she also lacks focus and direction, consciousness and self-determination (shades, to some extent, of Gelsomina). Even more graphically, her spontaneity is punished. When she returns from her evening with Marcello, her drunk and bullying fiancé, Robert, slaps her, and though his behavior is hardly valorized by the film, she ends her appearance beaten and humiliated.

In addition to Sylvia's ultimately contained excess, *La Dolce Vita* is filled with emphatically negative representations of women. Marcello's mistress, Emma, is clinging, hysterical, suicidal, and drug-dependent. Maddalena is a rich, spoiled, alienated nymphomaniac. Jane is a cynical sexual predator who lives off the energy of an aristocracy going nova. Nadia is a (self)destructive bourgeois wife who gets revenge on macho masculinity by performing a striptease. The woman of greatest intellectual force in the film—the poet Iris—is reduced, as she puts it, to an *"oracolo alcolico"* (drunken oracle). Moreover, to an unprecedented degree in Fellini, women are victims of physical abuse. Not only is Sylvia mistreated by Robert, but Maddalena first appears with a black eye, Marcello slaps Emma during an argument,[22] and in the "orgy" scene he persistently abuses the young woman Pasutt.

The sudden eruption of excess and abuse in Fellini's representation prompts the question: Why at this particular moment in his work? I think it has a good deal to do with the issue of male disempowerment mentioned briefly above. From the opening moments, in which a statue of Christ is being whisked by helicopter to *Il Papa*, *La Dolce Vita* relentlessly documents patriarchy or "the father" in crisis (not only male institutions such as the Church, the aristocracy, and the Italian intelligentsia but also Marcello's own father). This in turn reflects a general crisis of masculinity in the postwar—and particularly 1950s—Western world as well.[23]

The film depicts an international society with none of the structures that traditionally sustained male authority: nation, religion, community, and family. It is also a leisure society, reflecting the postwar boom or Economic Miracle as it was called in Italy, where consumption and display have replaced doing or making as the means of self-importance. Within this context, traditional bourgeois "women's work"—that is, buying, dressing, hanging out, and turning oneself into pleasing spectacle—has become the norm. Conventional forms of male testing and male performance are gone. This extends even to war, for in the atomic age evoked by the doom-and-gloom intellectual Steiner, the battlefield has disappeared, and war has been transformed from an arena of heroism into a guarantee of total annihilation.

With the end of World War II as testing ground, one of the major issues of the 1950s became the domestication of men: making them suitable husbands and fathers now that their place was back in the home. Not only did domestication threaten conventional norms of masculinity, but the threat "came from" women, who were given the ideological power within society to do the domesticating. The dangers of domestication in *La Dolce Vita* are clearly reflected in Steiner, whose seemingly placid and complete home life is actually a form of repression that helps turn him into a killer of self and children. The threat of domesticating women is embodied by Emma. From a conventional masculine perspective, postwar society had become effeminized, something *La Dolce Vita* implies and whose threat the film satirizes when, near the end, one of the film's gay-coded characters predicts, "Someday we'll all be homosexual."

In the context of Italian 1950s cinema and society, anxieties around feminization are clearly mirrored in the pseudohistorical beefcake epics (*Hercules, Hercules Unchained*, and so on) that celebrated with hyperbole the kind of masculinity that seemed extinct in the "real world" of the late 1950s. This type of machismo is both represented and undercut in *La Dolce Vita* through the character of Robert. This ex-Tarzan is now an alcoholic who seems more interested in sketching and in pointing out the historical inaccuracies of a waiter's costume ("a silly mixture of Roman and Phoenician") than in more manly pursuits.

Fellini's problematic representation of women, then, does not take place in a vacuum. It references a larger context of perceived male crisis.

Having explored feminist and masculinist approaches to gender in Fellini, I now turn to the postmodern—the analysis of gender as the product of cultural codes and systems of meaning. (This returns us to a "politics of signification.") There is room for a specifically feminist version of postmodern critique, which helps further collapse fixed boundaries to the three approaches I have posited. Christie Milliken exemplifies a feminist/postmodernist approach in her reading of *City of Women*, where she applies theoretical notions of the grotesque and

the carnivalesque to suggest that Fellini's representation of women undermines, through excess, normative and restrictive gender conventions, particularly those linked to bourgeois (male) individualism.[24] (O'Healy is willing to give Milliken the benefit of the doubt in relation to City of Women, though not The Voice of the Moon [327ff].)

A critique of gender in relation to culture was central to my discussion of the sexual initiation sequences in Roma and in City of Women. The relation between gender and signification was also part of my analysis of women or "the feminine" in Fellini's Casanova, functioning as the effects of sign play and lack in world of (missing) male power. It was also central to my discussion of a "fall into gender" in Fellini's commercials.

For my principal analysis of gender and postmodernity in Fellini, I return to City of Women, buoyed by Milliken's example, to offer a comprehensive rereading that incorporates postmodern critical strategies (particularly along the lines of reversibility and difference) in the context of a crucial cinematic issue: the male gaze.[25] The male gaze has been the object of extensive film theorization, much of it derived from a certain reading of psychoanalysis. The gaze functions as a means of organizing gender relations within patriarchy and, more specifically, confirming male subjectivity and identity through the objectification of women. Psychoanalytical discussions of the gaze can get rather abstruse, but for the purposes of what follows it is sufficient to focus on the fact that, historically in male representation, men have controlled the gaze. They have been the seers, women the seen. This has served to make men active, women passive; to give men control over the image of women (turning the latter into a reflection of male desire); and to reduce women to male possessions. This kind of theorization obviously assumes strictly heterosexual masculinity, which sets limits to its validity but also makes it apropos of City of Women.

O'Healy has identified the male gaze as a problem from the outset of Fellini's career: "Fellini's first film [Variety Lights] ... provides an immediate ... fixation on Woman as object of the male gaze. As dancers and cabaret performers, the female characters are repeatedly fetishized, fragmented, or distorted through tight closeups and other camera positions that correspond to the voyeuristic perspective of a ... male spectator [within the scene]' " (325). My earlier reading of Variety Lights would suggest that what O'Healy is describing is part of the film's critique of illusion, rather than a pure reinforcement of objectifying male desire. More-over, as Waller has argued ("Neither an 'I' nor an 'Eye'"), it is a mistake to make the camera eye consistently coincide with the male gaze in Fellini. Nonetheless, a certain prominence of the male gaze in Fellini's early work is largely what makes a woman's return of the gaze so significant at the end of The Nights of Cabiria, La Dolce Vita, and Juliet of the Spirits.

The gaze functions quite differently in *City of Women,* originating in the opening scene as a crucial reversal. Though Snàporaz is the dreamer, he is brought to life by and in the Signora's gaze. We get a brief "objective" shot of the protagonist, sound asleep, bouncing up and down with the movement of the train, but he begins to stir only as he is seen reflected in the dark glasses of the Signora, and as the camera zooms in on her watching (over) him. This introduces a structuring logic to the film, particularly in relation to the unconscious, linked to Fellini's Jung-inspired notions of a gendered psyche. Because Snàporaz is dreaming, his unconscious is in control, and the unconscious, unknown part of the male is, in Fellinian and Jungian terms, feminine. The term generally used by Jung to describe this was the "anima," and though the anima is not the only mechanism of the Jungian unconscious, the anima is "the image making capacity which [men] use to draw inspirational, creative and intuitive images from the inner world."[26] Given the extent to which women are unconscious propellants of Snàporaz's activity, his dream occurs firmly under the sign of woman.

On the one hand, this just seems to replay the age-old problem of the feminine being reduced to a facet of man and, more than that, associated with lack of consciousness. On the other, it introduces a strategy whereby the film forces Snàporaz to come to terms with his attitudes, fears, resentments, and projections by situating him always within the perspective of the feminine. It is not just a matter of being seen by women but of consistently having to occupy positions often associated with women: sex-abuse target of the motorcyclist; victim terrorized by teenagers; passive, timid partner in the company of Katzone; subject of unmotivated and bullying scrutiny by military and police. Snàporaz, in short, ends up being a character far more acted upon than acting and is thus made to identify with the subordinate status to which women have often been relegated.

Because gender is partly a matter of positioning, not just a biological or sociological given, it proves pliable, mutable. And because Snàporaz's gaze operates implicitly within the purview of women, it can undergo radical transformation or "feminization." It is associated initially with his glasses, which he first dons when he awakens and sees the Signora. The glasses immediately become instruments of sexual aggression as he identifies her as an object of prey, pursues her, and tries to possess her. Yet her gaze is more than a match for his. It is either inscrutable and imperious, concealed behind dark glasses, or confident and aggressive, as when she looks at Snàporaz in the mirror as he enters the washroom. Moreover, when he follows her off the train and into the fields, she abrogates his gaze, getting him to close his eyes in exchange for the (unfulfilled) promise of a "tremendous kiss."

During her extended monologue at the convention, she takes his gaze away in another sense, identifying it for what it is ("the eyes of the perennial male") and thus nullifying it. Moreover, she and her companions end up as the seers and

Snàporaz the derided "seen": "we have had the time to spy on him, to observe him, our jailer, our master. Oh, yes, we have spotted you ... look at him ... Sisters, look. There he is, in close-up."

During her speech she also looks straight into the camera (at Snàporaz-as-dreamer rather than character), affirming the strength of her gaze and her refusal to be objectified by the gaze of others. Her final words refer to the most compelling way in which she has commandeered vision: she has taken Snàporaz's picture as he waited for his "tremendous kiss," then projected that image for all to see.

It is not only the Signora who controls visual apparati and the visible in the convention; after a comic moment in which a woman stereotypically seeks male help to fix a tape recorder (a woman actually does the fixing), women are revealed to be documentary filmmakers, creators and choreographers of spectacles such as the "bliss of the housewife" skit, dancers, and last but not least skilled operators of slide and movie projectors, The convention is filled with original visual art, including fashion, as well as critiques of male "sounds" and artistic representation.

As the dream/film progresses, Snàporaz's glasses continue to function as a principal indicator of the gaze and Snàporaz's tenuous control over it. They become associated with things other than sexual aggression, preparing for his highly meaningful relinquishing of his spectacles in the final scene. It is no accident that he turns out to be most vulnerable to the Signora (and her photography) when he agrees to close his eyes. Vulnerability also manifests itself, through Snàporaz's glasses, as avoidance. He tends to take them off to clean them as a nervous response to not wanting to face something (the furnace woman bathing and muttering sexual innuendoes, Elena enumerating his weaknesses, the Fascist police accusing him of mistreating the teenagers). At one point, toward the end of the film, he also puts them *on* in avoidance—that is, to ward off sex as Elena plays the insatiable wife.

Orienting Snàporaz to an outside world, his glasses also represent denial of the world within. Consequently, self-awareness and self-confrontation occur when his glasses are off or damaged. As the furnace woman bathes, he begins to ponder the Signora's critical monologue. As the tribunal begins to question him about his motives and attitudes, he discovers that his glasses are cracked. He knocks the broken lens out as he prepares to encounter his inner or ideal woman. More than that, he closes his eyes, abjuring both glasses and vision, as he waits for the mystery woman to appear. (His expectation of the long-harbored ideal is far different from his earlier anticipation, with eyes closed, of the Signora's French kiss.) When he knocks the one lens out, his glasses simultaneously bespeak extraversion—the outwardly corrective lens—and introversion—the missing lens that encourages inner rather than outer vision, although he will not actually use his "doubled" glasses until the final scene.

One of the crucial factors in breaking down Snàporaz's spectacle-dependent, distanced orientation to self and world is women's insistence on looking back, refusing to accept the objectification of the male gaze. This occurs not only when women return Snàporaz's look as character within a scene but also when they look directly at the camera eye, hence presumably at Snàporaz as author of the dream. In returning the look, women destroy the safe and self-protected space of the male voyeur. More important, looking back is looking in—to the eyes and the "soul" of Snàporaz—turning extraversion into introspection. It is arguably this compelled inwardness that leads Snàporaz to encounter the vacuity of his feminine ideal in the air-balloon Madonna/soubrette/bride—and that conjures up a terrorist Donatella to shoot it down.

The destruction of the ideal is nothing if not the collapse of woman-as-spectacle: Madonnas for contemplation and edification; cabaret dancers for more sexualized ambitions—marking the end of the film-long visual extravaganza of Snàporaz's dream. The final shots of his dream emphasize not his gaze but women's, as the most striking aspect of the four blond figures who suddenly appear is the intensity with which they look.

Snàporaz's dream thus begins and ends with the gaze of women. Moreover, the gaze of the final four women is not for Snàporaz. They are neither looking at nor acknowledging him. The impersonality of their looks makes them inalterably other, contributing to his frightened response. Their appearance suggests that, contrary to what the tribunal would have predicted, he has finally withdrawn his projections.

In this context the final scene depicts not only a world no longer ruled by Snàporaz's projections but his movement from fright to acceptance in the face of this new development. Moreover, point of view (again) lies with women rather than with Snàporaz. The scene is born of a cut from the last of the four blond women's eyes to Snàporaz jerking awake in the train, making her, in cinematic logic, the source of his appearance. Moreover, we initially see Snàporaz from a point of view associated with Elena, not through eyeline match or shot-reverse shot but from a position located behind her hand, cigarette, and comic book visible in the frame. Then, his own vision is effectively gifted by Elena, who picks up his glasses and hands them to him. When the Signora from the dream enters the compartment, he can see/discover her only by following Elena's gaze. He ends up being a watcher of women's looks, as he stares in bafflement at their mutual, complicitous, glances.

Snàporaz's discovery that his glasses are (still) missing a lens signals a radical shift in the nature of his gaze from the film's beginning. The double function of the one-lens spectacles—that is, half outer-directed, half inner—is amplified by the fact that they are both his "real" glasses and the glasses he had in his dream. Because they put Snàporaz in touch with what is beyond him while keeping him in touch with himself, he no longer unconsciously imposes the inner on the outer,

340

the unconscious on the "real." This is reflected in the very way he looks when he puts his glasses on. Startled by the mysterious (re)appearance of the Signora—then of the two dream soubrettes as students—he responds with wonder rather than the urge to possess. The women themselves, no longer functioning as Snàporaz's projections, have acquired a new way of looking replete with humor, sharing, and understanding and without any of the alienating "male" aggression of the Signora's earlier gaze and treatment of Snàporaz.

What Snàporaz sees with his newfound sight is both obscure and mysterious, in contrast to the single-minded, instrumental clarity with which he earlier saw the Signora. Fundamental to Snàporaz's new way of seeing is the allowance of irresolvable differences. Whereas earlier, he and his male gaze sought to avoid the anxiety of difference through possession, his renewed vision lets him be both respectful and comfortable amid the inexplicable. This is so much the case that, after looking all about—not just in perplexity but in a kind of amused acceptance—he takes off his glasses, folds them up, and puts them on the table. The all-owning gaze is, once and for all, renounced, and with it a conventional male heterosexual foundation of identity: to be is to see (women).

Ultimately, the final scene is not just about Snàporaz's pilgrim's progress; it is equally, and perhaps more importantly, about the creation, at last, of a true city of women. The existence of Elena and the Signora, as well as the two younger women, solely for themselves and each other, creates the first male-independent community of women in the film—and the first substantive community of women in all Fellini's work. In this respect the film clearly and positively reflects the women's movement that became so powerful in Italy in the mid-1970s. It also helps better align Fellini's film with its medieval namesake than much of the rest of the film has done. Or perhaps we might put it this way: while Christine de Pizan created a city of women where, as one commentator put it, "women will for all time be safe from misogynist attack,"[27] Fellini has envisioned the possibility of that kind of community by deconstructing a city of (one) man where misogyny was free to flourish.

Sexual orientation

As much of the above would suggest, Fellini's films are for the most part conventionally heterosexual. Though Fellini had numerous gay friends and collaborators (Baxter, passim), his films often equate male homosexuality with effeminacy. In *I Vitelloni* the old actor Sergio Natale becomes threatening and grotesque at the moment he appears to have sexual designs on Leopoldo. His presumed sexual orientation seems to represent the horror of the unknown for Leopoldo, though this is also a reflection—as was the vagina dentata in *Fellini's Casanova*—of a world closed to difference. In *La Dolce Vita* there is a risk of associating gay

341

characters with moral deterioration amidst the pathetic decadence of the orgy sequence. However, in Fellini's later films, non-normative sexual relations tend to be presented in a more nuanced fashion. In *City of Women* lesbianism is associated both with Snàporaz's anxieties around feminism and Katzone's hysterical masculinity. Significant screen time is given to the trans person with whom Amelia dines in *Ginger and Fred*—and Amelia's gentility (despite her befuddlement), and the character's own dignity, bestow full legitimacy on her presence. In his *Fellini e la moda. Percorsi di stile da Casanova a Lady Gaga*, Gianluca Lo Vetro draws attention to Fellini's ground-breaking openness to homosexuality, particularly in his later work.[28]

The most complex representation of sexual orientation in Fellini's work is *Fellini-Satyricon*. The early phases of the film present gay experience non-normatively, but following the sequence at the patricians' home, all of Encolpio's sexual activity is heterosexual, as is his one great "moral" crisis (his impotency) in the film. And though Encolpio ends up in an all-male community at the end, it is clearly not gay. Moreover, homosexuality tends to be associated with promiscuity (the Suburra scenes), with emotional immaturity and character weakness (Encolpio's crush on Gitone, Lichas's lovesick adoration of Encolpio), and with debauchery (Trimalchio's flirtation with a young boy and his wife Fortunata's necking with another woman). In the case of Gitone, whose passivity, self-centeredness, and lack of self-determination seem to reflect Encolpio's own limitations, gay love seems equated with narcissistic self-indulgence and arrested development.

There is, however, another way to read things—one that is consistent with the strong ironizing of Encolpio's "growth" in the film. In this respect, we might see the film comprising a "gender trilogy," along with *8½* and *Juliet of the Spirits*. If we view Guido's story as an examination of masculine identity and consciousness and Juliet's as an analysis of the construction of femininity, I think we can see *Fellini-Satyricon* as an exploration of heterosexuality—pointing to underlying forces that give rise to normative sexuality. Perhaps the most important aspect of Encolpio's socialization in the film is his—and his world's—"conversion" to heterosexuality,[29] meaning that heterosexuality is not "natural," it is culturally induced. The turning point here—as it is for socialization in general in the second half of the film—is the labyrinth sequence, which leads to attempted copulation with "Ariadne." Although copulation fails, the following two sequences—the Garden of Delights and Oenothea—are dedicated to securing Encolpio's identity as a heterosexual. In and of itself, this might merely confirm that Encolpio "outgrows" his homosexuality. However, a number of things help qualify this. Most important, Encolpio is far more effective as a gay than as an emerging straight. At the beginning of the film, he is able to defeat Ascilto, rescue Gitone from Vernacchio, and

make love with his reclaimed lover. His movement toward heterosexuality, on the other hand, is marked by repeated failure: he must be saved by Ascilto in combat with the Thief, he is easily defeated by the Minotaur, he is unable to have sex with Ariadne or the women at the Garden of Delights, and the price of his "becoming a man" (that is, heterosexual) at Oenothea's is his inability or lack of desire to assist Ascilto. In other words, successful masculinity in *Fellini-Satyricon* tends to be associated with homosexuality, not heterosexuality.

Concomitantly, Encolpio has far more control over his life at the beginning. It is at the very moment that he loses Gitone to Ascilto that he begins to lose control in general. An earthquake destroys his home, making him rootless for the remainder of the film. Then he gets ushered into a series of situations in which he is a spectator (the art gallery, Trimalchio's), a possession (Lichas's ship), an intruder (the patricians' villa), a conquest (of the Thief and the Minotaur), and a subject of interpellation (the labyrinth to the end). In this context his proclamations of freedom and adventure in the final scenes are the blind optimism of someone who has bought into an *ideology* of freedom and adventure rather than someone who is enjoying the real thing(s). I would also argue that Encolpio is far more engaged as a gay than as a straight, and the most compelling indication of this is the intimacy of his lovemaking with Gitone. There is nothing to approach it in the film's heterosexual moments (while there *are* other intimate same-sex moments between Lichas and Encolpio and Encolpio and Ascilto), and it is by far the most explicitly intimate sexual moment in all Fellini's work. If we see *Fellini-Satyricon* as a critique rather than validation of normative and exclusive heterosexuality, we can also see that critique operating far beyond the level of characterization. There are strong implications that heterosexuality is an abstract gender economy based on the renunciation of concrete, sexual, relationships with both men and women. Not only is same-sexuality to be avoided, but so is sex with women. Encolpio never does copulate successfully with a "real" woman, only with an archetypal one. Moreover, the fact that she is at least partly a figment of his own (drugged) imagination confirms women's role within heterosexuality as projection of male identity. Oenothea's role also confirms that the function of heterosexuality is not (biological) procreation but (male) self-reproduction and self-regeneration—a fantasy in male literature and philosophy virtually since the origins of recorded storytelling.

Given its denial of concrete emotional or sexual relationships with men or women, heterosexuality allows only for homosociality—male community bound together in a celebration of such masculine ideals as adventure and exploration. In this respect heterosexuality is fundamentally "transcendent": it is a form of repression and projection directed away from intimate experience. If this is the case, while *Fellini-Satyricon* may not predict the emergence of Christianity in terms of

rebirth and an afterlife (a point I made in Chapter 7), it does suggest precisely the kind of abstraction that has characterized gender and sexuality in Christian society.

Conclusion

I hope that the preceding—not just in this chapter but throughout the book—has offered new perspectives on the historical and aesthetic context of Fellini's work, the evolving sophistication and openness of his cinematic language and signifying strategies, and the seriousness (often undervalued) with which he has addressed crucial issues of his time. Most of all, I hope that my musings encourage readers to return to Fellini's films and commercials and derive (or in many cases continue to derive) the same kind of extraordinary pleasure from them that they have afforded me.

NOTES

1. *The Altering Eye: Contemporary International Cinema* (New York: Oxford University Press, 1983), 87.
2. *Movies and Methods: An Anthology,* ed. Bill Nichols, 2 vols. (Berkeley: University of California Press, 1978, 1985); *Film Theory and Criticism: Introductory Readings,* 4th ed., ed. Gerald Mast, Marshall Cohen, and Leo Braudy (New York: Oxford University Press, 1992); *Issues in Feminist Film Criticism,* ed. Patricia Erens (Bloomington: University of Indiana Press, 1990); *Multiple Voices in Feminist Film Criticism,* ed. Diane Carson, Linda Dittmar, and Janice R. Welsch (Minneapolis: University of Minnesota Press, 1994); *Narrative, Apparatus, Ideology: A Film Theory Reader,* ed. Philip Rosen (New York: Columbia University Press, 1987).
3. The late Peter Bondanella was a prolific Italianist who did major work on Fellini. An excellent source of work on Fellini from the late 1980s to the mid-1990s was the *Romance Languages Annual,* published by the Purdue University Research Foundation in West Lafayette, Indiana.
4. Minuz's *Political Fellini: Journey to the End of Italy* would seem, from the title, to be relevant to my discussion, but its concerns are dissimilar. It focuses principally on Italian journalistic reception of Fellini's work and often discusses matters such as *italianità*—national character, "the Italian imagination," and so on—that for me are more sociological than political. My concern lies with the way in which Fellini addresses mechanisms such as authoritarianism, Fascism, patriarchy, consumer culture, television, conformity, that determine the relations of power in his world. Linked to this are attitudes around race, gender, and sexual orientation, that marginalize and subordinate. All of which ultimately reveals a sensibility that privileges inclusion; difference; and dynamic, nonhierarchical,

and numinous interconnectivity. While identifying his sources as Italian and journalistic, Minuz cites, as his first critic, Peter Bondanella—an American academic who was resolutely opposed, throughout his career, to the kind of political analysis that emerged in the wake of May 1968 and that informs my methodology in this chapter.

5. See Peter Wollen's "Godard and Counter Cinema: *Vent d'Est,*" *Afterimage* 4 (Autumn 1972): 6–17; and Sylvia Harvey, *May '68 and Film Culture* (London: British Film Institute, 1978), 33ff. For an overview of politicized film theory of the 1970s, see D.N. Rodowick, *The Crisis of Political Modernism: Criticism and Ideology in Contemporary Film Theory* (Urbana: University of Illinois Press, 1988), chap. 1.

6. See Laura E. Ruberto and Kristi M. Wilson, "Italian Neorealism: Quotidian Storytelling and Transnational Horizons," in *A Companion to Italian Cinema* (Malden, MA: John Wiley & Sons, 2017), 139–56; Laura E. Ruberto and Kristi M. Wilson, eds. *Italian Neorealism and Global Cinema* (Detroit: Wayne State University Press, 2008); and Saverio Giovacchini and Robert Sklar, eds., *Global Neorealism: The Transnational History of a Film Style* (Jackson: University of Mississippi Press, 2012).

7. In particular, there is Louis Althusser, whose theories of ideology fuse Marx and post-Freudian psychoanalyst Jacques Lacan. See Althusser's *For Marx,* trans. Ben Brewster (London: New Left Books, 1977), and *Essays on Ideology,* trans. Ben Brewster (London: New Left Books, 1977).

8. *Popular Film in Fascist Italy: The Passing of the Rex* (Bloomington: University of Indiana Press, 1987), xiv–xv.

9. Frank Burke, "Fellini's *The Orchestra Rehearsal:* Political Commentary or Aesthetic Retreat?" *Romance Languages Annual 1990,* vol. 2 (West Lafayette, Ind.: Purdue Research Foundation, 1991), 205–08.

10. "Introduction," in *Federico Fellini: Contemporary Perspectives,* 5–6.

11. "Racial Difference and the Postcolonial Imaginary in the Films of Federico Fellini," in *A Companion to Federico Fellini,* 331–46. (Chichester, UK: John Wiley & Sons, 2020).

12. "Fellini and Turkey: Image and Influence," in *A Companion to Federico Fellini* (Chichester, UK: John Wiley & Sons, 2020), 437–40.

13. Giuseppe Sciortino and Asher Colombo, "The flows and the flood: the public discourse on immigration in Italy, 1969–2001," *Journal of Modern Italian Studies,* 9, no. 1 (2004): 94–113. https://doi:10.1080/1354571042000179209.

14. Russell King, "Recent Immigration to Italy: Character, Causes and Consequences," *GeoJournal* 30, no. 3 (1993): 283–292.

15. Two of the film theory anthologies I cited at the outset of this chapter, neither of which contains any reference to Fellini, are feminist. Virtually the only visible attention Fellini has received from feminist film theorists has been de Lauretis's "Fellini's 9 1/2." However, even this piece is somewhat cursory. Other than that, the principal source of feminist critique (some of it pro-Fellini) has been the work of Áine O'Healy, Marguerite Waller, and Millicent Marcus in *Romance Languages Annual,* vols. 1–4 (West Lafayette, Ind.: Purdue

Research Foundation, 1989–92). However, appearing in the context of Italian film studies, this feminist critique has had little if any impact on the larger world of feminist film studies.

16. "A Critic at Large: Mondo Fellini," *The New Yorker,* 21 March 1994, 160.

17. Margaret Croyden, "Federico Fellini's *And the Ship Sails On:* The Maestro on Fantasy, Finance, and the Art of Film," *New York Times,* 22 January 1984, sec. 2, p. 22.

18. Although Teresa de Lauretis is a justifiably renowned feminist theorist, her aforementioned piece on *Juliet of the Spirits* is not, to my mind, as effective a feminist critique as O'Healy's. For one thing, it builds its argument less on Fellini's film than on another essay on the film: Carolyn Geduld's "Fellini's *Juliet of the Spirits:* Guido's Anima," in *Federico Fellini: Essays in Criticism,* 137–51.

19. A number of feminists have a quarrel with this, seeing masculinity studies as an attempt (even if unwitting) to wrest gender analysis away from women and put male theory front and center again. In fact, in an age of increasing economic constraint, there has been a tendency within universities to collapse feminism into gender studies, which is a source of great frustration to women who have fought long and hard to get feminism on the institutional map.

20. Masculinity studies is not the same thing as the men's movement—either in its drum-beating, back-to-the-woods, incarnation or its whiners' wing ("women are the lucky ones because we are far more victimized than they"). For a discussion of the emergence of masculinity theory, see Kenneth Clatterbaugh, *Contemporary Perspectives on Masculinity: Men, Women, and Politics in Modern Society* (Boulder, Colo.: Westview, 1990). For a good example of masculinity theory in action, see *Male Order: Unwrapping Masculinity,* ed. Rowena Chapman and Jonathan Rutherford (London: Lawrence & Wishart, 1988). For useful analyses of masculinity and representation, see *Screening the Male: Exploring Masculinities in Hollywood Cinema,* ed. Steven Cohan and Ina Rae Hark (New York: Routledge, 1993). For a comprehensive survey of masculinities and masculinity theories, see R.W. Connell, *Masculinities* (Berkeley: University of California Press, 1995).

21. Fellini has talked of drawing large women for shop windows during his early days in Rome (Chandler, *I, Fellini,* 36). And it is clear from films such as *8½* that fantastic images of women stem from his childhood. Nonetheless, they are not dominant in his early work.

22. He is provoked when she bites him, but even the fact that men are given an excuse to hit women in this film makes it exceptional within Fellini's canon.

23. For discussions of mid-20th century crises of masculinity, see Cohan; Barbara Ehrenreich, *The Hearts of Men: American Dreams and the Flight from Commitment* (New York: Doubleday, 1983); Elaine Tyler May, *Homeward Bound: American Families in the Cold War Era* (New York: Basic Books, 1988); Lynne Segal, *Slow Motion: Changing Masculinities, Changing Men* (London: Virago, 1990); and James Gilbert, *Men in the Middle: Searching for Masculinity Identity in the 1950s* (Chicago: University of Chicago Press, 2005).

24. "Fair to Feminism? Carnivalizing the Carnal in Fellini's *City of Women,*" *Spectator* (Spring 1990): 28–45.

25. Milliken and I cover some of the same ground in relation to the gaze, though we ultimately diverge quite a bit in terms of our emphases.

26. Stephen Farah, "The Archetypes of the Anima and Animus." https://appliedjung.com/the-archetypes-of-the-anima-and-animus/. Accessed September 29, 2019.

27. Maureen Quilligan, "The Allegory of Female Authority: Christine de Pizan's "Cité des Dames" (Ithaca: Cornell UP, 1991, 2. I am also indebted to Charity Cannon Willard for her discussion of *Cité des dames* in her *Christine de Pizan: Her Life and Works* (New York: Persea Books, 1984). One additional useful source of information is *Reinterpreting Christine de Pizan*, ed. Earl Jeffrey Richards with Joan Williamson, Nadia Margolis, and Christine Reno (Athens: University of Georgia Press, 1992).

28. Milan-Turin: Bruno Mondadori, 2015, 123ff.

29. My gay-positive reading of *Fellini-Satyricon* was inspired by a wonderful presentation given by David McCallum, Tad Seaborn, and Chris James in a fall 1993 fourth-year Fellini seminar in film studies at Queens University (Canada).

Works Cited

Alonge, Giaime. "Ennio, Tullio, and the Others: Fellini and His Screenwriters." In *A Companion to Federico Fellini,* edited by Frank Burke, Marguerite Waller, and Marita Gubareva, 167–76. Chichester, UK: John Wiley & Sons, 2020.

Alpert, Hollis. *Fellini: A Life.* New York: Atheneum, 1986.

Althusser, Louis. *Essays on Ideology,* translated by Ben Brewster. London: New Left Books, 1977.

——. *For Marx,* translated by Ben Brewster. London: New Left Books, 1977.

Angelucci, Gianfranco. *Gli ultimi sogni di Fellini.* Rimini: Associazione Federico Fellini, 1997.

Armes, Roy. *Patterns of Realism: A Study of Italian Neorealist Cinema.* London: Tantivy Press, 1971.

Bachman, Gideon. "Federico Fellini: The Cinema Seen as a Woman." *Film Quarterly* 34, no. 2 (Winter 1980–81): 2–9.

Baudrillard, Jean. *In the Shadow of the Silent Majorities; or, The End of the Social and Other Essays.* New York: Semiotext[e], 1983.

——. *Selected Writings,* edited and introduced by Mark Poster. Stanford: Stanford University Press, 1988.

——. *Simulations.* New York: Semiotext[e], 1983.

——. *The Consumer Society: Myths and Structures,* translated by Chris Turner. London: Sage, 1998.

——. "The Ecstasy of Communication." In *The Anti-Aesthetic: Essays on Postmodern Culture* edited by Hal Foster, 126–34. Port Townsend, WA: Bay Press, 1983.

Baxter, John. *Fellini.* London: Fourth Estate, 1993.

Bazin, André. "*Cabiria*: The Voyage to the End of Neorealism." In *What is Cinema?* Volume 2, translated by Hugh Gray, 83–92. Berkeley: University of California Press, 1971.

Benderson, Albert. *Critical Approaches to Federico Fellini's "8½."* New York: Arno Press, 1974.

Bertens, Hans. *The Idea of the Postmodern: A History.* New York: Routledge, 1995.

Betti, Liliana. *Fellini: An Intimate Portrait,* translated by Joachim Neugroschel. Boston and Toronto: Little, Brown & Co., 1979.

Bluestone, George. "Interview with Federico Fellini." In *Film Culture* 3 (October 1957): 3–4.

Blumenfeld-Kosinski, Renate. "Christine de Pizan and the Misogynistic Tradition." *Romanic Review,* 81 no. 3 (1990): 279–92.

Bondanella, Peter. "America and the Post-War Italian Cinema." *Rivista di Studi Italiani* 2, no. 1 (June 1984): 106–25.

——. "Early Fellini: *Variety Lights, The White Sheik,* and *I Vitelloni.*" In *Federico Fellini: Essays in Criticism,* 220–23. New York: Oxford University Press, 1978.

——. *Italian Cinema: From Neorealism to the Present,* New Expanded Edition. New York: Continuum, 1990.

——. *The Cinema of Federico Fellini.* Princeton, NJ: Princeton University Press, 1992.

Bondanella, Peter and Degli-Esposti, Cristina, eds. *Perspectives on Federico Fellini.* New York: G.K. Hall, 1993.

Boyer, Deena. *The Two Hundred Days of "8½."* Translated by Charles Lam Markham. New York: Macmillan, 1964.

Bradley, Dale. "History to Hysteria: *Fellini's Casanova* Meets Baudrillard." *Canadian Journal of Political and Social Theory* 13, nos. 1–2 (1989): 129–39.

Branigan, Edward. *Point of View in the Cinema: A Theory of Narration and Subjectivity in Classical Film.* New York: Mouton, 1984.

Burke, Frank. "Biting the hand that feeds: Fellini's commercials," *The Italianist,* 31 (2011): 205–42.

——. "Fellini: Changing the Subject." *Film Quarterly* 43, no. 1 (Fall 1989): 36–48. Reprinted in *Perspectives on Federico Fellini,* edited by Peter Bondanella and Cristina Degli-Esposti, 275–92. New York: G.K. Hall, 1993.

——. "Fellini's *The Orchestra Rehearsal:* Political Commentary or Aesthetic Retreat?" In *Romance Languages Annual 1990,* Volume 2, 205–08. West Lafayette, IN: Purdue Research Foundation, 1991.

——. "Peckinpah's *Convoy* and the Tradition of the Open Road." *Film Studies: Proceedings of the Purdue University Sixth Annual Conference on Film,* 79–84. West Lafayette, IN: Purdue Research Foundation, 1982.

——. "The Three-Phase Process and the White Clown-Auguste Relationship in Fellini's *The Clowns.*" In 1977 *Film Studies Annual: Part I, Explorations in National Cinemas,* edited by Ben Lawton, 124–42. Pleasantville, NY: Redgrave Publishing Company, 1977.

Calabrese, Omar. *Carosello o dell'educazione serale.* Firenze: Clusf, 1975.

Carson, Diana; Dittmar, Linda; and Welsch, Janice R., eds. *Voices in Feminist Film Criticism.* Minneapolis: University of Minnesota Press, 1994.

Chandler, Charlotte. *I, Fellini.* New York: Random House, 1995.

——. *The Ultimate Seduction.* New York: Doubleday, 1984.

Chapman, Rowena and Rutherford, Jonathan, eds. *Male Order: Unwrapping Masculinity.* London: Lawrence & Wishart, 1988.

Clatterbaugh, Kenneth. *Contemporary Perspectives on Masculinity: Men, Women, and Politics in Modern Society.* Boulder, CO: Westview, 1990.

Cohan, Steven and Hark, Ina Rae, eds. *Screening the Male: Exploring Masculinities in Hollywood Cinema.* New York: Routledge, 1993.

Collins, Jim. *Architectures of Excess: Cultural Life in the Information Age*. New York: Routledge, 1995.

Connell, R. W. *Masculinities*. Berkeley: University of California Press, 1995.

"Conversation with Federico Fellini." *Oui Magazine*, January 1977, 91; 92; 154–56.

Corrigan, Timothy. "The Commerce of Auteurism." In *A Cinema without Walls: Movies and Culture after Vietnam*, 101–36. London: Routledge, 1991.

Croydon, Margaret. "Federico Fellini's *And the Ship Sails On:* The Maestro on Fantasy, Finance, and the Art of Film." *New York Times,* 22 January 1984, Section 2, p. 22.

Culler, Jonathan. *On Deconstruction: Theory and Criticism*. Ithaca, NY: Cornell University Press, 1982.

David, Melton. "Fellini's Latest Creates a Ruckus in Rome." *New York Times*, 18 February 1979, Section D, p. 1. https://www.nytimes.com/1979/02/18/archives/fellinis-latest-creates-a-ruckus-in-rome-fellini-creates-a-ruckus.html. Accessed January 3, 2020.

de Pizan, Christine. *The Book of the City of Ladies*, 1405, translated by Rosalind Brown-Grant. London: Penguin, 1999.

Debord, Guy. *A Society of the Spectacle*. Detroit: Red and Black, 1983.

Deleuze, Gilles and Guattari, Felix. *Kafka: Toward a Minor Literature*, translated by Dana Polan. Minneapolis: University of Minnesota Press, 1986.

Docherty, Thomas. *Postmodernism: A Reader*. New York: Columbia University Press, 1993.

Dorfles, Piero. *Carosello*. Bologna: Il Mulino, 1998.

Dürrenmatt, Friedrich. "Der Tunnel." In *Die Stadt: Prosa I–IV,* 149–67. Zurich: Verlag der Arche, 1961.

Ehrenreich, Barbara. *The Hearts of Men: American Dreams and the Flight from Commitment*. New York: Doubleday, 1983.

Erens, Patricia, ed. *Issues in Feminist Film Criticism*. Bloomington: University of Indiana Press, 1990.

Farah, Stephen. "The Archetypes of the Anima and Animus." 4 February, 2015. <https://appliedjung.com/the-archetypes-of-the-anima-and-animus/>. Accessed September 29, 2019.

Fava, Claudio G. and Vigano, Aldo. *The Films of Federico Fellini*, translated by Shula Curto. Secaucus, NJ: Citadel, 1985.

"Federico Fellini." In *Interviews with Film Directors,* edited by Andrew Sarris, 176–92. New York: Avon, 1967.

Fellini, Federico. *Cinecittà*, translated by Graham Fawcett. London: Studio Vista, 1989.

——. *Comments on Film*. Edited by Giovanni Grazzini; translated by Joseph Henry. Fresno: California State University Press, 1988.

——. *E la nave va*. Milan: Longanesi, 1983.

——. *Early Screenplays: "Variety Lights," "The White Sheik."* Translated by Judith Green. New York: Grossman, 1971.

——. *Il libro dei sogni*, edited by Tullio Kezich and Vittorio Boarini with a contribution by Vincenzo Mollica. Milan: RCS Libri, 2007.

——. *Il primo fellini. Lo sceicco bianco, I vitelloni, La strada, Il bidone*, 310–12. Bologna: Capelli, 1969.

——. *Il viaggio di G. Mastorna*, edited by Ermanno Cavazzoni with an introduction by Vincenzo Mollica. Macerata, Italy: Quodlibet, 2008.

——. *Intervista sul cinema*, edited by Giovanni Grazzini. Bari: Latzerna, 1983.

——. *La Dolce Vita*. Translated by Oscar Deliso and Bernard Shir-Cliff. New York: Ballantine, 1961.

——. *"Moraldo in the City" and "A Journey with Anita."* Edited and translated by John C. Stubbs. Urbana: University of Illinois Press, 1983.

——. *Prova d'orchestra*. Milan: Aldo Garzanti Editore, 1980.

——. *The Book of Dreams*, translated by Aaron Maines and David Stanton. New York: Rizzoli, 2008.

——. *The Journey of G. Mastorna: The Film Fellini Didn't Make*, translated by Marcus Perryman. New York: Berghahn, 2013.

——. "The Road beyond Neorealism." In *Film: A Montage of Theories*, edited by Richard Dyer MacCann, 377–84. New York: E.P. Dutton, 1966.

——. *Three Screenplays:* "I Vitelloni," "Il Bidone," "The Temptation of Dr. Antonio." Translated by Judith Green. New York: Grossman, 1970.

Fofi, Goffredo and Volpi, Gianni, eds. *Federico Fellini. L'arte della visione*. Rome: AIACE, 1993.

Foreman, Walter C. Jr. "Fellini's Cinematic City: *Roma* and Myths of Foundation." *Forum Italicum* 14, no. 1 (Spring 1980): 78–98. Reprinted in *Perspectives on Federico Fellini*, edited by Peter Bondanella and Cristina Degli-Esposti, 151–65. New York: G.K. Hall, 1993.

——. "The Poor Player Struts Again: Fellini's *Toby Dammit* and the End of the Actor," in 1977 *Film Studies Annual: Part I, Explorations in National Cinemas*, edited by Ben Lawton, 111–23. Pleasantville, NY: Redgrave Publishing Company, 1977.

Foucault, Michel. *Power/Knowledge: Selected Interviews and Other Writings, 1972–1977*, edited by Colin Gordon; translated by C. Gordon, L. Marshall, J. Mepham, and K. Soper. New York: Pantheon Books, 1980.

Free, William J. "Fellini's *I Clowns* and the Grotesque." In *Federico Fellini: Essays in Criticism*, edited by Peter Bondanella, 188–201. New York: Oxford University Press, 1978.

Geduld, Carolyn. "*Juliet of the Spirits*: Guido's Anima." In *Federico Fellini: Essays in Criticism*, edited by Peter Bondanella, 137–51. New York: Oxford University Press, 1978.

Gianetti, Louis D. "*Amarcord*: The Impure Art of Federico Fellini." *Western Humanities Review* 30 (1976): 153–62.

Gilbert, James. *Men in the Middle: Searching for Masculine Identity in the 1950s*. Chicago: University of Chicago Press, 2005.

Ginger e Fred, edited by Mino Guerrini. Milan: Longanesi, 1986.

Ginsborg, Paul. *A History of Contemporary Italy: Society and Politics, 1943–1988*. New York: Penguin, 1990.

Giovacchini, Saverio and Sklar, Robert, eds. *Global Neorealism: The Transnational History of a Film Style*. Jackson: University of Mississippi Press, 2012.

"Giovy9," <http://www.sanihelp.it/forum/sesso-dintorni/29754-rigatoni.html>, p. 1. Accessed January 19, 2011.

Gorbman, Claudia. "Music As Salvation: Notes on Fellini and Rota." *Film Quarterly* 28, no. 3 (1974–75): 17–25.

Grant, Michael. *Myths of the Greeks and Romans*. New York: New American Library, 1962.

Greene, Shelleen. "Racial Difference and the Postcolonial Imaginary in the Films of Federico Fellini." In *A Companion to Federico Fellini*, edited by Frank Burke, Marguerite Waller, and Marita Gubareva, 331–46. Chichester, UK: John Wiley & Sons, 2020.

Guback, Thomas. "Hollywood's International Market." In *The American Film Industry*, revised edition, edited by Tino Balio, 387–409. Madison: University of Wisconsin Press, 1992.

Guilbaut, Serge. *How New York Stole the Idea of Modern Art: Abstract Expressionism, Freedom, and the Cold War*. Chicago: University of Chicago Press, 1983.

Gündoğdu, Cihan. "Fellini and Turkey: Influence and Image." In *A Companion to Federico Fellini*, edited by Frank Burke, Marguerite Waller, and Marita Gubareva, 435–38. Chichester, UK: John Wiley & Sons, 2020.

Harvey, David. *The Condition of Postmodernity*. Oxford: Basil Blackwell, 1989.

Harvey, Sylvia. *May '68 and Film Culture*. London: British Film Institute, 1978.

Hay, James. *Popular Film in Fascist Italy: The Passing of the Rex*. Bloomington: University of Indiana Press, 1987.

Hughes, Eileen Lanouette. *On the Set of* Fellini-Satyricon: *A Behind-the-Scenes Diary*. New York: William Morrow and Company, 1971.

Hutcheon, Linda. *The Politics of Postmodernism*. London: Routledge, 1989.

Huyssen, Andreas. "Mapping the Postmodern." In *After the Great Divide: Modernism, Mass Culture, Postmodernism*, 178–221. Bloomington: University of Indiana Press, 1986.

Jackson, Earl. "Fellini in Japan." In *A Companion to Federico Fellini*, edited by Frank Burke, Marguerite Waller, and Marita Gubareva, 439–44. Chichester, UK: John Wiley & Sons, 2020.

James, Clive. "A Critic at Large: Mondo Fellini." *The New Yorker*, 21 March 1994, 154, 155, 157, 158, 160, 161, 162, 164.

Jameson, Fredric. "Postmodernism and Consumer Society." In *The Anti-Aesthetic: Essays on Postmodern Culture*, edited by Hal Foster, 111–25. Port Townsend, WA: Bay Press, 1983.

——. *Postmodernism; or, The Cultural Logic of Late Capitalism*. Durham, NC: Duke University Press, 1991.

Keel, Anna and Strich, Christian, eds. *Fellini on Fellini*, translated by Isabel Quigley. New York: Delacourte/Seymour Lawrence, 1976.

Ketcham, Charles B. *Federico Fellini: The Search for a New Mythology*. New York: Paulist Press, 1976.

Kezich, Tullio. *Fellini: His Life and Work*, translated by Minna Proctor. New York: Faber and Faber, 2006.

——. "The Long Interview: Tullio Kezich and Federico Fellini." In *Federico Fellini's* Juliet of the Spirits, edited by Tullio Kezich; translated by Howard Greenfield, 17–64. New York: Ballantine, 1966.

King, Russell. "Recent Immigration to Italy: Character, Causes and Consequences." *GeoJournal* 30, no. 3 (1993): 283–92.

Kolker, Robert Phillip. *The Altering Eye: Contemporary International Cinema*. New York: Oxford University Press, 1983.

Kovács, András Bálint. *Screening Modernism: European Art Cinema, 1950–1980*. Chicago: University of Chicago Press, 2007.

Krim, Milton. "Fellini's Rome." *Holiday Magazine*. (January 1974): 37.

Kroker, Arthur. *The Postmodern Scene: Excremental Culture and Hyper-Aesthetics*. New York: St. Martin's Press, 1986.

Lawton, Ben. "Italian Neorealism: A Mirror Construction of Reality." *Film Criticism* 3, no. 2 (1979): 8–23.

Leitch, Vincent B. *Deconstructive Theory: An Advanced Introduction*. New York: Columbia University Press, 1983.

"Leo," <http://www.facebook.com/topic.php?uid=204203929197&topic=21768> Accessed January 19, 2011. [No longer available.]

Lev, Peter. *The Euro-American Cinema*. Austin: University of Texas Press, 1993.

Lo Vetro, Gianluca. *Fellini e la moda: Percorsi di stile da Casanova a Lady Gaga*. Milan & Turin: Bruno Mondadori, 2015.

"Madame Roma." *Atlas*, Spring 1972: 64.

Marcus, Millicent. *"Fellini's Casanova:* Portrait of the Artist." *Quarterly Review of Film Studies* 5, no. 1 (Winter 1980): 19–34.

——. "I misteriosi fegatelli di *Ginger e Fred*." In *Lo schermo "manifesto": Le misteriose pubblicità di Federico Fellini*, edited by Paolo Fabbri, 57–67. Rimini: Guaraldi, 2002.

Maroni, Oriana and Ricci, Giuseppe, eds. *I libri di casa mia. La biblioteca di Federico Fellini*. Rimini: Fondazione Federico Fellini, 2008.

Mast, Gerald; Cohen, Marshall; and Braudy. Leo; eds. *Film Theory and Criticism: Introductory Readings*, 4th Edition. New York: Oxford University Press, 1992.

May, Elaine Tyler. *Homeward Bound: American Families in the Cold War Era*. New York: Basic Books, 1988.

McBride, Joseph. "The Director as Superstar." *Screen* 41, no. 2 (Spring 1972): 78–81.

Milliken, Christine. "Fair to Feminism? Carnivalizing the Carnal in Fellini's *City of Women*." *Spectator* 10, no. 2 (Spring 1990): 28–45.

Minuz, Andrea. *Political Fellini: Journey to the End of Italy*, translated by Marcus Perryman. New York: Berghahn, 2015.

Mollica, Vincenzo. "Fellini the Artist and the Man: An Interview with Vincenzo Mollica." In *A Companion to Federico Fellini*, edited by Frank Burke, Marguerite Waller, and Marita Gubareva, 13–25. Chichester, UK: John Wiley & Sons, 2020.

Neumann, Erich. *The Origins and History of Consciousness*, translated by R.F.C. Hull. Bollingen Series, no. 42. Princeton: Princeton University Press, 1970.

Nichols, Bill, ed. *Movies and Methods: An Anthology*, Volumes 1–2. Berkeley: University of California Press, 1978, 1985.

Norris, Christopher. *Deconstruction: Theory and Practice*. London: Methuen, 1982.

Nowell-Smith, Geoffrey. "Fellini and Popular Culture." *Sight and Sound*, April 1993, 12–14.

O'Healy, Áine. "Unspeakable Bodies: Fellini's Female Grotesques." *Romance Languages Annual 1992*, Volume 4, 325–29. West Lafayette, IN: Purdue Research Foundation, 1993.

Pasolini, Pier Paolo. "The Catholic Irrationalism of Fellini." *Film Criticism* 9, no. 1 (1984): 64–73. Reprinted in *Perspectives on Federico Fellini*, edited by Peter Bondanella and Cristina Degli-Esposti, 101–09. New York: G.K. Hall, 1993.

"*Playboy* Interview: Federico Fellini." *Playboy* 13, no. 2 (February 1966): 55–66.

Prats, A. J. "Plasticity and Narrative Methods: *The Clowns*." In *The Autonomous Image: Cinematic Narration and Humanism*, 122–52. Lexington: University of Kentucky Press, 1981.

———. "The Individual, the World, and the Life of Myth in *Fellini-Satyricon*." *South Atlantic Bulletin* 44, no. 1 (1979): 45–58.

———. "The New Narration of Values: *Fellini: A Director's Notebook*." In *The Autonomous Image: Cinematic Narration and Humanism*, 1–37. Lexington: University of Kentucky Press, 1981.

Prats, A. J. and Pieters, John. "The Narratives of Decharacterization in Fellini's Color Movies." *South Atlantic Bulletin* 45, no. 2 (1980): 31–41.

Quilligan, Maureen. *The Allegory of Female Authority: Christine de* Pizan's Cité des Dames. Ithaca: Cornell University Press, 1991.

Richards, Earl Jeffrey with Williamson, Joan; Margolis, Nadia; and Reno, Christine; eds. *Reinterpreting Christine de Pizan*. Athens, GA: University of Georgia Press, 1992.

Riva, Valerio. "*Amarcord*: The Fascism within Us: An Interview with Valerio Riva." In *Federico Fellini: Essays in Criticism*, edited by Peter Bondanella, 20–26. New York: Oxford University Press, 1978.

Robinson, W.R. "If You Don't See You're Dead: The Immediate Encounter with the Image in *Hiroshima Mon Amour* and *Juliet of the Spirits*." Part 2, *Contempora* 2, no. 4 (January–April 1973): 11–22.

———. "The Movies Too Will Make You Free." In *Man and the Movies*, 112–34. New York: Penguin, 1969.

———. "The Visual Powers Denied and Coupled: *Hamlet* and *Fellini-Satyricon* as Narratives of Seeing," in *Shakespeare's "More than Words Can Witness": Essays on Visual and Nonverbal Enactment in the Plays*, edited by Sidney Homan, 177–206. Lewisburg, PA: Bucknell University Press, 1980.

Rodowick, D.N. *The Crisis of Political Modernism: Criticism and Ideology in Contemporary Film Theory*. Urbana: University of Illinois Press, 1988.

Rose, H.J. *A Handbook of Greek Mythology Including Its Extension to Rome*. New York: Dutton, 1959.

Rosen, Philip, ed. *Narrative, Apparatus, Ideology: A Film Theory Reader*. New York: Columbia University Press, 1987.

Ruberto, Laura E. and Wilson, Kristi M., eds. *Italian Neorealism and Global Cinema*. Detroit: Wayne State University Press, 2008.

Ruberto, Laura E. and Wilson, Kristi M. "Italian Neorealism: Quotidian Storytelling and Transnational Horizons." In *A Companion to Italian Cinema*, edited by Frank Burke, 139–56. Malden, MA: John Wiley & Sons, 2017.

Salachas, Gilbert. *Federico Fellini: An Investigation into His Films and Philosophy*. Translated by Rosalie Siegel. New York: Crown Publishers, 1969.

Samuels, Charles Thomas, ed. *Encountering Directors*. New York: G.P. Putnam's Sons, 1972.

Sciortino, Giuseppe and Colombo, Asher. "The Flows and the Flood: The Public Discourse on Immigration in Italy, 1969–2001." *Journal of Modern Italian Studies*, 9, no. 1 (2004): 94–113.

Segal, Lynne. *Slow Motion: Changing Masculinities, Changing Men*. London: Virago, 1990.

Silverman, Kaja. *The Subject of Semiotics*. New York: Oxford University Press, 1983.

"Simpatico," <http://www.sanihelp.it/forum/sesso-dintorni/29754-rigatoni-3.html>, 2. Accessed January 19, 2011.

Smith, Paul. *Discerning the Subject*. Minneapolis: University of Minnesota Press, 1988.

Snyder, Stephen. "Color, Growth, and Evolution in *Fellini-Satyricon*." In *Federico Fellini: Essays in Criticism*, edited by Peter Bondanella, 168–87. New York: Oxford University Press, 1978.

——. "*The White Sheik*: Discovering the Story in the Medium." In *The 1977 Film Studies Annual: Part I, Explorations in National Cinemas*, edited by Ben Lawton, 100–10. Pleasantville, NY: Redgrave Publishing Company, 1977.

Söderlind, Sylvia. *Margin/Alias: Language and Colonization in Canadian and Quebecois Fiction*. Toronto: University of Toronto Press, 1991.

Solmi, Angelo. *Fellini*. Translated by Elizabeth Greenwood. Atlantic Highlands, NJ: Humanities Press, 1968.

Stam, Robert. *Reflexivity in Film and Literature from "Don Quixote" to Jean Luc-Godard*. Ann Arbor: UMI Research Press, 1985.

Studlar, Gaylyn. "Masochism and the Perverse Pleasures of Cinema." In *Movies and Methods: An Anthology* Volume 2, edited by Bill Nichols, 602–21. Berkeley: University of California Press, 1985.

Sturrock, John. *Structuralism and Since: From Levi-Strauss to Derrida*. New York: Oxford University Press, 1979.

Sugg, Richard P., ed. *Seeing Beyond: Movies, Visions, and Values – 26 Essays by William R. Robinson and Friends*. New York: Golden String Press, 2001.

"Superl," <http://www.sanihelp.it/forum/sesso-dintorni/29754-rigatoni-3.html>, p. 2. Accessed January 19, 2011.

Tassone, Aldo. "*Casanova*: An Interview with Aldo Tassone." In *Federico Fellini: Essays in Criticism*, edited by Peter Bondanella, 27–35. New York: Oxford University Press, 1978.

Turim, Maureen. "Cinemas of Modernity and Postmodernity." In *Zeitgeist in Babel: The Post-Modernist Controversy*, edited by Ingeborg Hoesterey, 177–89. Bloomington: University of Indiana Press, 1991.

Waller, Marguerite. "*Il Maestro* Dismantles the Master's House: Fellini's Undoing of Gender and Sexuality." In *A Companion to Federico Fellini*, edited by Frank Burke, Marguerite Waller, and Marita Gubareva, 311–28. Chichester, UK: John Wiley & Sons, 2020.

——. "Introduction." In *Federico Fellini: Contemporary Perspectives*, edited by Frank Burke and Marguerite Waller, 3–25. Toronto: University of Toronto Press, 2002.

——. "Neither an 'I' nor an 'Eye': The Gaze in Fellini's *Giulietta degli spiriti*." in *Perspectives on Federico Fellini*, edited by Peter Bondanella and Cristina Degli-Esposti, 214–24. New York: G.K. Hall, 1993.

——. "Whose Dolce Vita Is This Anyhow? The Language of Fellini's Cinema." *Quaderni d'italianistica* 11, no. 1 (Spring 1990): 127–35.

Wallis, Brian, ed. *Art after Modernism: Rethinking Representation*. New York and Boston: The New Museum of Contemporary Art in association with David A. Godine, 1984.

Willard, Charity Cannon. *Christine de Pizan: Her Life and Works*. New York: Persea Books, 1984.

Willoquet-Maricondi, Paula. "Federico Fellini's *E la Nave Va* and the Postmodern Shipwreck." *Romance Languages Annual 1994*, Volume 6, 383–88. West Lafayette, IN: Purdue Research Foundation, 1995.

Wollen, Peter. "Godard and Counter Cinema: *Vent d'Est*." *Afterimage* 4 (Autumn 1972): 6–17.

Zanelli, Dario. "From the Planet Rome." In *Fellini's Satyricon*, edited by Dario Zanelli; translated by Eugene Walter and John Matthews, 3–20. New York: Ballantine, 1970.

Zavattini, Cesare. "Some Ideas on the Cinema." In *Film: A Montage of Theories*, edited by Richard Dyer MacCann, 216–28. New York: Dutton, 1966.

Index

Bold numbers denote references to illustrations

N

National Broadcasting Company (NBC) 14, 152, 168

nature vs. culture/dissociation from nature 38–39, 52, 53, 56, 60, 62, 64–65, 66, 180–81, 188, 247–48, 249, 261, 267–77, 279

Nazism 5

neo-colonialism *see* Americanization

neo-Fascism 201

neo-Nazism 201

neorealism 2–4, 5, 6, 17, 50, 184, 185, 317, 324, 327

New Criticism x, xi

O

O'Healy, Áine 334, 337

oneiric *see* dreams

Orientalism 328 *see also* otherness/difference *and* race/racialization

Oscars *see* Academy Awards

otherness/difference 4, **27**, 34–36, 52, 54, 126, 208, 211, 230, 258, 281, 287, 289–90, 308, 309, 312, 327–31, 337, 341 *see also différance and* race/racialization

P

Pasolini, Pier Paolo 3,

Path of Hope, The 6

patriarchy/patriarchal **32**, 33, 36, 40, 57, 80, 129, 150, 255, 272, 292, 299, 333, 335, 337 *see also* gender (representation of men, of women) *and* phallic/phallocentric

Paul, St. 98

Pepsi 285

The Perils of Pauline 314

Pertini, Sandro 15

Petronius Arbiter 16, 155, 167, 214

phallic/phallocentric 36, 157, 186, 212, 220, 291, 292, 297, 302, 309, 313–14, 317

Pinocchio 116, 278

Pisa
 Baptistery 288, 289, 290, 291, 315
 Leaning Tower 288, 290, 291–92

Playboy 293

Playmen 293

Poe, Edgar Allan 16, 152, 214
 "Never Bet the Devil Your Head" 135, 140

Poletti, Victor 288

politics/the (socio)political viii, ix, 1, 5, 6, 10, 11–12, 13, 38, 65–66, 159–61, 176, 198–201, 209, 217, **223**, 230–31, 236, 243, 253–56, 280, 281, 322–27, 333, 336 *see also* authority/authoritarianism *and* power *and* postcolonialism/postcolonial theory

Ponti, Carlo 105

postcolonialism/postcolonial theory viii, 253–63, 327, 329–30 *see also* Orientalism *and* race/racialization

post-humanist xv, 207, 317

postmodernism/poststructuralism viii, 10–17, 19–21, 92, 112, 150, 168, 175, 184, 198, 203, 206–66, 267, 269, 277–81, 287, 326, 334, 336–37

postmodernity 11, 13, 21, 102, 245, 246, 248, 249, 250, 253, 263, 267, 277–81, 283, 327, 337

power (political/cultural) 11–12, 29, 160–61, 181, 185, 188, 190–92, 193, 198–99, 203, 206, 207, 209–13, 216, 253–56, 281, 298, 299, 317, 322, 326, 327, 333, 336, 337 *see also* authority/authoritarianism *and* politics/the (socio)political *and* postcolonialism/postcolonial theory